DICTIONARY OF AMERICAN PORTRAITS

Dictionary of
AMERICAN PORTRAITS

———————— ✄ ————————

4045 Pictures of Important Americans

from Earliest Times to the Beginning

of the Twentieth Century

———————— ✄ ————————

EDITED BY HAYWARD AND BLANCHE CIRKER
AND THE STAFF OF DOVER PUBLICATIONS, INC.

Dover Publications, Inc., New York

Published in Canada by General Publishing Company, Ltd.,
30 Lesmill Road, Don Mills, Toronto, Ontario.

Published in the United Kingdom by Constable and Company, Ltd.,
10 Orange Street, London W.C. 2.

DOVER PICTORIAL ARCHIVE SERIES

The *Dictionary of American Portraits* is a new work, first published in 1967 by Dover Publications, Inc.

This volume belongs to the Dover "Pictorial Archive Series"; it is sold with the understanding that illustrations may be reproduced for advertising or editorial purposes without payment or special permission. Such permission is, however, limited to the reproduction of no more than ten illustrations in any one publication. For more extensive use of illustrations in this volume, please address the publisher for permission.

Many illustrations appear here with special courtesy lines indicating the source of the original portrait. Wherever such a courtesy line appears, the portrait may not be reproduced unless the courtesy line is also included.

No further credit line is required; however, in the interests of documentation the publisher would appreciate, in every instance, an indication that the material is reproduced from the *Dictionary of American Portraits*, published by Dover Publications, Inc., in 1967.

STAFF FOR DICTIONARY OF AMERICAN PORTRAITS

EDITORIAL:
Rita Weiss, Everett Bleiler, Robert Hutchinson, Alan J. Marks, Clarence C. Strowbridge

ART AND PRODUCTION:
Carol Belanger, John Dixon, Jules Perlmutter, Gail Quincy, Leonard Roland

International Standard Book Number: 0-486-21823-6
Library of Congress Catalog Card Number: 66-30514

Manufactured in the United States of America
Dover Publications, Inc.
180 Varick Street
New York, N. Y. 10014

Table of Contents

INTRODUCTION

The *Dictionary of American Portraits* attempts to provide within a single volume an American pictorial archive. No such work has been available in recent years, and it is hoped that the present undertaking, with its more than 4000 portraits of American men and women, many previously not shown, will be of assistance to those seeking such material.

The content of the present work was in large part shaped by several decisions outlining the nature and scope of the project. Of particular importance was that concerning a terminal or cutoff date. Since the establishment of such a limit seemed clearly necessary, a terminal date of 1905 was at last fixed upon because of the feeling of the editors that later material, while no less valid or interesting, seemed more properly the subject of a separate volume.

A few exceptions were made to this rule. Five categories—Presidents, Vice-Presidents, and Chief Justices of the United States, together with first ladies and White House hostesses—have been continued to the present day, since no collection of American portraits could be considered complete without such figures. In all other categories, however, where living or recently living figures have been included, it may be assumed that each made a significant contribution in his major field of endeavor before 1905.

Lesser considerations involved the size of the project and the interpretation of the word "American." A figure of approximately 4000 portraits suggested itself as a reasonable limit if the project were to be held to a single volume and portraits were to be shown at a size permitting sharpness and clarity of detail. It was decided, furthermore, to include not only Americans native-born and naturalized but also certain non-Americans who had lived on the American continent or contributed to American life in some vital way— whether to write about its people, like Frances Trollope, or fight against them like Thomas Gage.

Selection of Names. The selection, within the above confines, of names for inclusion in this volume presented certain obvious difficulties, with the specified length limit necessitating the most careful procedures if balance and accuracy were to be maintained. These problems were in part resolved by the establishment of (1) criteria for selection, and (2) a procedural method that would best guarantee historical objectivity and fairness.

The criterion chosen for inclusion in these pages was that of a significant contribution on the part of the subject to American life and culture in its diverse forms, as tempered in practice by the needs of the users of the volume. The editors wished to include, for example, all persons who had made a genuine and creative contribution to American history, provided space permitted and provided a suitable portrait could be found. For these portraits there would always exist a need. It was recognized, however, that there are many other persons—Chang and Eng, for example, or the child Charlie Ross—who have contributed not to America's history proper but to some aspect of its social history, for whose portraits there may exist no less urgent a need. To have ignored either of these needs would have been to impair the usefulness of the volume. In the final analysis, those persons are here for whose portraits there would seem to be greatest need on the part of the users of the volume, whether the persons have made their mark on the larger or smaller areas of American life.

The method of procedure devised which would best guarantee historical objectivity and fairness in the selection of names was that of substantial reliance upon recognized authorities in specific fields. A roster of such consultants, whose names follow this Introduction, was prepared, and to each was sent an extensive list of candidates in his particular field, with a request for recommendation and review. The consultants' recommendations were then compared and collated, and a master list of names was drawn up. Further research, part of which is indicated in the Bibliography (see page 713), was undertaken in an effort to locate names that might have been overlooked; additional suggestions came from the consultants themselves.

Not all names on the master list, of course, yielded portraits, since there are many individuals well known in American life for whom no authentic portrait is known to exist. A selective list of such persons is to be found on page 705. Similarly, there were some whose portraits could be located only after work on the project was well under way; these are added in the Supplement, which begins on page 701.

It was recognized, of course, that no two lists of names for a project of this kind could ever be identical, and that argument could as well be made for the

inclusion of alternative figures. It is to be hoped, however, that the list as finally established will be found to be not without its merits. An unusual degree of attention, it will be noted, has been given to industrial, engineering, and technological accomplishments, in contrast with their relative neglect in other reference works. And while figures have in general been included because of recognized accomplishment or reader's needs, a certain number have been included because the editors found them unusually interesting. The contributions of some were overlooked in their own lifetime; those of others—Herman Hollerith, for example—seem to belong as much to the future as to the past.

Selection of Portraits. The selection of portraits was made according to a single criterion: for each name on the master list the editors have attempted to reproduce that likeness which seemed most representative of the person. In most cases this has been a three-quarter view, though profiles and even silhouettes have been used when no other portrait has been available. Wherever possible, the subject has been shown at maturity or near the time of his major contribution.

Ideally, all important portraits would have been available for this project. In a few instances, however, permission to reproduce paintings could not be secured from their owners. In other cases, where paintings had been lost or destroyed or were for other reasons unavailable, reproduction had to be made from engravings after the original rather than from the original itself. For all figures in the book, nevertheless, every effort has been made to reproduce from those portraits available to the editors the best possible likeness.

A similar effort was made to verify the authenticity of all portraits used and to remove any whose historical accuracy was in doubt. An exception was made for several early figures—primarily explorers—whose presence in this volume was deemed indispensable. To publish a dictionary of American portraits without an image, say, of Christopher Columbus seemed to us unthinkable. In such cases a traditional (but very early) likeness has been used even though it may have been questioned by experts. These instances are few, however. For the great majority of portraits, and for virtually all those of the seventeenth through twentieth centuries, the portraits presented here may be considered authentic likenesses.

Subjects are shown, in general, in a single portrait, though for twelve figures—Washington, John Adams, Franklin, Hamilton, Jefferson, John Marshall, Madison, Jackson, Lincoln, Grant, Lee, and Franklin Delano Roosevelt—more than one portrait has been included. In reproducing all portraits there has been an attempt to show the face at optimum size within the picture area, and to that purpose cropping of illustrations has been allowed.

Wherever the names of the artist and/or engraver have been known, such information has been supplied in the caption. While artistic merit could not always be a prime consideration in the choice of portraits, it has by no means been overlooked. It is interesting, therefore, to note the presence, among the painters and engravers, of John Singleton Copley, Gilbert Stuart, Rembrandt Peale, and Charles Willson Peale, or, among the photographers, that of Mathew Brady and, in an interesting series, Southworth and Hawes.

Reproduction of Portraits. The illustrations in this volume may be reproduced, but persons planning such reproduction should refer to the statement on the copyright page for specific conditions and limitations.

Captions in the book are, in general, for identification purposes only, and there has been no attempt to duplicate the kind of detailed biography that may be found in other reference works. Readers seeking additional information are referred to the *Dictionary of American Biography, Webster's Biographical Dictionary,* and other reference works where such material may be found.

Standard rules of alphabetizing have been followed throughout. Persons with variant names—pseudonyms, aliases and the like—are listed under the name by which they are best known. Thus Billy the Kid is listed under Billy rather than Bonney, and Walter Hines Page under Page rather than Nicholas Worth. Variant names are retained, however, in brackets in the caption, and an Index of Variant Names is supplied on page 717. If a subject is not found in the alphabetical portrait section under a known name, this index should be consulted for a possible variant listing.

In the index proper, names are indexed under any of 77 categories, and are listed not only in the person's major field of endeavor but in any additional field in which he made a notable contribution. Index categories are listed in a special Contents preceding the Index.

Acknowledgments. No book of the scope and complexity of this one would be possible without the help of many persons. Acknowledgment has been made elsewhere in this volume and should be repeated here of the publisher's great indebtedness to those who contributed much: the many consultants who gave graciously of their time in the selection of names, as well as those persons and organizations who generously supplied and permitted the reproduction of portraits in these pages. A special word of commendation should be added for the following: Milton Kaplan of the Library of Congress; Robert Vogel, curator of heavy machinery and civil engineering, Division of Mechanical and Civil Engineering, Smithsonian Institution; Charles Mixer and Mrs. Patricia Park of the Columbia University Libraries; Michael Kraus, professor of history, City College of the City University of New York; Miss Romana Javitz of the New York Public Library; and James Thomas Flexner. Without their help and the help of others similarly responsive, it is doubtful that the present work would have been possible.

Of the uses of the *Dictionary,* little need be added. It will find obvious uses in museums, historical societies, libraries, and other institutions, but perhaps prove equally valuable to the individual scholar or the reader who, seeing the portraits, simply wants to browse. To speak of the extraordinary appeal of the human face is to state a truism, but the reality and universality of that appeal—as evidenced in contemporary motion pictures and present-day photography—cannot be lightly dismissed. It is hoped that the present volume, particularly among the young,

will serve both to stimulate and to satisfy that curiosity. Figures that have existed in the consciousness as little more than names may here be seen as individuals, whether they be Western figures like Belle Starr, Calamity Jane, Pawnee Bill, Virgil and Wyatt Earp, Horace A. W. Tabor and his wife Baby Doe, or such household names as R. H. Macy, Lydia Pinkham, or F. A. O. Schwarz. There may well be an interest in seeing the originals of Bigelow, Babbitt, and Burpee; Packard, Olds, and Willys; or Ballantine, Pabst, and Busch, as well as in seeing such prototypes as Father Lamy (the reputed original of Father Latour in *Death Comes for the Archbishop*) or Rebecca Gratz (Scott's original for Rebecca in *Ivanhoe*). Here too are persons usually known only as names on title pages: Josh Billings, John Bartlett, Carolyn Wells. A glance through the succeeding pages will indicate additional points of interest for the reader and perhaps further uses for the portraits.

No book of this kind has ever been compiled without certain feelings of regret on the part of the editors and publisher, that portraits of perhaps equally worthy persons might not also have been included had space permitted. Such are the difficulties of any encyclopedic work. It is felt, however, that the merits of the present selection will reveal themselves in use. The 4000 American portraits here presented represent, to our knowledge, the largest such collection ever assembled. Many of the portraits have not previously been shown, and many others have not been widely available. If the *Dictionary of American Portraits* does no more than make familiar to the general reader a world of pictorial matter previously inaccessible to him, it will be felt to have accomplished its purpose.

Robert Hutchinson

New York City
January, 1967

CONSULTANTS

It would not be possible to publish a book such as this without the help of many kind and well-informed persons, and the editors of the *Dictionary of American Portraits* owe a particular debt of gratitude to those who so graciously advised us in the selection of figures to be included in this book. The following consultants in no way constituted an editorial board for this volume, nor should they be assumed to be responsible for its content or in agreement with it. Each, however, at our request helpfully and individually evaluated lists of candidates in specific fields, making suggestions for inclusion or omission and often providing further information which we found to be invaluable; some gave considerable time from already busy schedules. As a result, what would have been a laborious task of selection and evaluation of the thousands of available candidates became, through the interest of our consultants, a creatively challenging endeavor.

All final decisions, however, were made by the editors of the volume, so that its faults are as much the editors' as its merits are those of the persons consulted. Whatever errors of omission or commission or mistakes in judgment may be found here are totally our own, and should in no way reflect upon the consultants who so ably caught the spirit of the volume and so graciously cooperated with the editors of Dover Publications, Inc., in making it possible.

J. Donald Adams, literary critic, biographer; former editor, *New York Times Book Review*, New York, New York. *Literature, Journalism*

Sydney E. Ahlstrom, Professor of American Church History, Yale University, New Haven, Connecticut. *Religion*

Raymond W. Albright, Episcopal Theological School, Cambridge, Massachusetts. *Religion*

Dean Amadon, Lamont Curator of Birds, American Museum of Natural History, New York, New York. *Ornithology, Natural History*

Brooks Atkinson, *The New York Times*, New York, New York. *Theater*

James W. Atz, Research Associate, American Museum of Natural History, New York, New York. *Ichthyology*

John Bakeless, Seymour, Connecticut. *Military History, Exploration and Discovery*

Harry Elmer Barnes, Malibu, California. *Education*

John I. H. Baur, Associate Director, Whitney Museum of American Art, New York, New York. *Sculpture, Painting*

William B. Bean, Editor-in-chief, *Archives of Internal Medicine*; Professor of Medicine, State Universtiy of Iowa, Iowa City, Iowa. *Medicine*

John Fred Bell, Professor of Economics, University of Illinois, Urbana, Illinois. *Economics*

Alexander M. Bickel, Professor of Law, Yale University, New Haven, Connecticut. *Law*

John B. Blake, Chief, History of Medicine Division, National Library of Medicine, Bethesda, Maryland. *Medicine and Public Health*

Joseph L. Blau, Professor of Religion, Columbia University, New York, New York. *Philosophy*

Edwin G. Boring, Edgar Pierce Professor of Psychology, Emeritus, Harvard University, Cambridge, Massachusetts. *Psychology*

Carl B. Boyer, Professor of Mathematics, Brooklyn College of the City University of New York, Brooklyn, New York. *Mathematics, Physics*

Robert H. Boyle, *Sports Illustrated Magazine*, New York, New York. *Sports*

Charles S. Braden, Professor of the History and Literature of Religion, Emeritus, Northwestern University, Evanston, Illinois. *Religion*

J. Chester Bradley, Professor of Entomology, Emeritus, Cornell University, Ithaca, New York. *Entomology*

Harvey W. Brewer, Closter, New Jersey. *Ornithology*

William W. Brickman, Professor of Educational History and Comparative Education, University of Pennsylvania, Philadelphia, Pennsylvania. *Education*

Barry S. Brook, Professor of Music, Queens College of the City University of New York, Flushing, New York. *Music*

Van Wyck Brooks, deceased. *Literature*

Stuart M. Brown, Jr., Dean, College of Arts and Sciences, Cornell University, Ithaca, New York. *Philosophy*

Roger Butterfield, New York, New York. *History, Literature*

John Chamberlain, Cheshire, Connecticut. *Business, Industry, Philanthropy, Engineering, Invention*

Elmer T. Clark, Executive Secretary, Emeritus, Association of Methodist Historical Societies, Lake Junaluska, North Carolina. *Religion*

Thomas C. Cochran, Professor of History, University of Pennsylvania, Philadelphia, Pennsylvania. *Business, Industry, Philanthropy*

I. Bernard Cohen, Professor of the History of Science, Harvard University, Cambridge, Massachusetts. *Engineering, Invention*

Donald Collier, Chief Curator, Department of Anthropology, Chicago Museum of Natural History, Chicago, Illinois. *Anthropology, Archaeology, Ethnology*

James E. Collier, Associate Professor of Geography, University of Missouri, Columbia, Missouri. *Geography, Cartography*

Reginald L. Cook, Professor of American Literature, Middlebury College, Middlebury, Vermont. *Literature*

Frank M. Cordasco, Professor of Educational Sociology, Montclair State College, Montclair, New Jersey. *Education*

Ernest N. Cory, Professor of Entomology, Emeritus, University of Maryland, College Park, Maryland. *Entomology*

Parke Cummings, Westport, Connecticut. *Sports*

Marcus Cunliffe, Professor of American Studies, University of Sussex, Sussex, England. *Architecture, Sculpture, Painting, Illustration, History, Literature*

Merle Curti, Frederick Jackson Turner Professor of History, University of Wisconsin, Madison, Wisconsin. *Social Reform, Education*

Bernard Davis, Professor of Bacteriology, Harvard Medical School, Cambridge, Massachusetts. *Bacteriology, Biology, Biochemistry*

David B. Davis, Professor of History, Cornell University, Ithaca, New York. *Social Reform*

J. J. Davis, Professor of Entomology, Emeritus, Purdue University, Lafayette, Indiana. *Entomology*

Wayne L. Decker, Professor of Climatology, University of Missouri, Columbia, Missouri. *Meteorology*

Wayne Dennis, Professor of Psychology, Brooklyn College of the City University of New York, Brooklyn, New York. *Psychology*

Frederick J. Dockstader, Director, Museum of the American Indian, New York, New York. *American Indian*

David Donald, Harry C. Black Professor of American History, The Johns Hopkins University, Baltimore, Maryland. *Politics and Diplomacy*

Frederick Drimmer, Editorial Director, Famous Artists Schools, Westport, Connecticut. *American Indian*

John Durant, Islamorada, Florida. *Sports*

Carolyn Eisele, Associate Professor of Mathematics, Hunter College of the City University of New York; New York, New York. *Mathematics, Physics*

Rear Admiral Ernest M. Eller, Director of Naval History, Department of the Navy, Washington, D.C. *Naval History*

Rt. Rev. John Tracy Ellis, Professor of Church History, University of San Francisco, San Francisco, California. *Religion*

John C. Ewers, Assistant Director, Museum of History and Technology, Smithsonian Institution, Washington, D.C. *American Indian*

Richard F. Fenno, Jr., Professor of Political Science, University of Rochester, Rochester, New York. *Politics, Diplomacy*

James Kip Finch, Dean, Emeritus, School of Engineering, Columbia University, New York, New York. *Engineering, Invention*

Max H. Fisch, Professor of Philosophy, University of Illinois, Urbana, Illinois. *Philosophy*

James Thomas Flexner, New York, New York. *Painting, Illustration*

Philip S. Foner, The Citadel Press, New York, New York. *Labor*

Gerd Fraenkel, Associate Professor of Linguistics, University of Pittsburgh, Pittsburgh, Pennsylvania. *Philology*

George Freedley, Curator, New York Public Library Theater Collection, New York, New York. *Theater*

S. W. Frost, Professor of Entomology, Emeritus, Pennsylvania State University, University Park, Pennsylvania. *Entomology*

Major-General J. F. C. Fuller, C.B., Sussex, England. *Military History*

Albert TenEyck Gardner, Associate Curator of American Art, The Metropolitan Museum of Art, New York, New York. *Architecture, Sculpture, Painting, Illustration*

John Gassner, Sterling Professor of Playwriting and Dramatic Literature, Yale University, New Haven, Connecticut. *Theater*

Leo Goldberg, Higgins Professor of Astronomy, Harvard University, Cambridge, Massachusetts. *Astronomy*

D. S. Gorsline, Associate Professor of Geology, University of Southern California, Los Angeles, California. *Geology, Mineralogy, Paleontology*

Norman A. Graebner, Professor of History, University of Illinois, Champaign, Illinois. *Politics, Diplomacy*

Mrs. Barbara Greener, Music Librarian, Queens College of the City University of New York, Flushing, New York. *Music*

Gottfried Haberler, Galen Stone Professor of International Trade, Harvard University, Cambridge, Massachusetts. *Economics*

Andrew Hacker, Associate Professor of Government, Cornell University, Ithaca, New York. *Politics, Diplomacy*

Robert T. Handy, Professor of Church History, Union Theological Seminary, New York, New York. *Religion*

Archibald Hanna, Curator of Western Americana, Yale University, New Haven, Connecticut. *Exploration and Discovery*

E. S. Harrar, Dean, School of Forestry, Duke University, Durham, North Carolina. *Natural History*

Brigadier General William H. Harris, former Chief of Military History, Department of the Army, Washington, D.C. *Military History*

James D. Hart, Professor of English, University of California, Berkeley, California. *Literature*

Charles Hartshorne, Ashbel Smith Professor of Philosophy, University of Texas, Austin, Texas. *Religion*

Stewart H. Holbrook, deceased. *Engineering, Invention*

Clarence J. Hylander, deceased. *Biological Sciences*

Bernard Jaffe, author of *Men of Science in America*, Brooklyn, New York. *Chemistry*

Saul W. Jarcho, M.D., New York, New York. *Medicine and Public Health*

O. E. Jennings, deceased. *Botany*

Frank H. Johnson, Professor of Biology, Princeton University, Princeton, New Jersey. *Biological Sciences*

Daniel J. Jones, Professor of Geology, University of Utah, Salt Lake City, Utah. *Geology, Mineralogy, Paleontology*

Howard Mumford Jones, Lowell Professor of the Humanities, Emeritus, Harvard University, Cambridge, Massachusetts. *Literature, History*

Thomas E. Keys, Librarian, Mayo Clinic, Rochester, Minnesota. *Bacteriology, Medicine and Public Health*

Morris Kline, Professor of Mathematics, New York University, New York, New York. *Mathematics, Physics*

Milton R. Konvitz, Professor of Law and Professor of Industrial and Labor Relations, Cornell University, Ithaca, New York. *Social Reform*

Stephan Körner, Professor of Philosophy, University of Bristol, Bristol, England. *Philosophy*

John Kouwenhoven, Professor of English, Barnard College, New York, New York. *Literature, History, Journalism*

Michael Kraus, Professor of History, City College of the City University of New York; New York, New York. *General Consultant*

Joseph Wood Krutch, Professor of Dramatic Literature, Retired, Columbia University, New York, New York. *Theater*

Oliver La Farge, deceased. *American Indian*

Oliver W. Larkin, Professor of Art, Emeritus, Smith College, Northampton, Massachusetts. *Architecture, Sculpture*

Chauncey D. Leake, Director, Medical Students' Research Training, University of California, San Francisco, California. *Medicine and Public Health*

Lewis Leary, Professor of English, Columbia University, New York, New York. *Literature, Journalism*

Henry M. Leicester, Professor of Biochemistry, College of Physicians and Surgeons of the University of the Pacific, San Francisco, California. *Chemistry*

Consultants

General Douglas MacArthur, deceased. *Military History*

Robert McCloskey, Professor of Government, Harvard University, Cambridge, Massachusetts. *Law*

Fritz Machlup, Walker Professor of Economics and International Finance, Princeton University, Princeton, New Jersey. *Economics*

Duncan A. MacInnes, deceased. *Chemistry*

James McQuigg, U.S. Weather Bureau; Research Associate, University of Missouri, Columbia, Missouri. *Meteorology*

Brigadier General S. L. A. Marshall, Birmingham, Michigan. *Military History*

Robert E. Mason, Professor of Education, University of Pittsburgh, Pittsburgh, Pennsylvania. *Education*

Sidney E. Mead, Professor of History, The State University of Iowa, Iowa City, Iowa. *Religion*

Donald H. Menzel, Director, Harvard College Observatory, Cambridge, Massachusetts. *Astronomy, Mathematics, Physics*

Wyndham D. Miles, NIH Historian, National Institute of Health, Bethesda, Maryland. *Chemistry*

John Miller, Jr., Deputy Chief Historian, Office of the Chief of Military History, Department of the Army, Washington, D.C. *Military History*

Samuel Eliot Morison, Rear Admiral U.S.N.R.(Ret.); Professor of History, Emeritus, Harvard University, Cambridge, Massachusetts. *Naval History*

Frank Luther Mott, deceased. *Journalism, Literature*

Lloyd Motz, Professor of Astronomy, Columbia University, New York, New York. *Astronomy*

Lewis Mumford, Amenia, New York. *Architecture, Sculpture, Painting*

Howard M. Munford, Professor of American Literature, Middlebury College, Middlebury, Vermont. *Literature, Journalism*

Gardner Murphy, Director of Research, The Menninger Foundation, Topeka, Kansas. *Psychology*

Robert Cushman Murphy, Lamont Curator of Birds, Emeritus, The American Museum of Natural History, New York, New York. *Ornithology, Natural History*

Walter F. Murphy, Associate Professor of Politics, Princeton University, Princeton, New Jersey. *Law*

Ernest Nagel, John Dewey Professor of Philosophy, Columbia University, New York, New York. *Mathematics, Physics*

Allan Nevins, Senior Research Associate, Huntington Library, San Marino, California. *Exploration and Discovery*

John A. Nietz, Professor of Education, Emeritus, University of Pittsburgh, Pittsburgh, Pennsylvania. *Education*

Saul Novack, Chairman, Department of Music, Queens College of the City University of New York, Flushing, New York. *Music*

W. Albert Noyes, Jr., Professor of Chemistry, University of Texas, Austin, Texas. *Chemistry*

Ralph E. Oesper, Professor of Analytical Chemistry, Emeritus, University of Cincinnati, Cincinnati, Ohio. *Chemistry*

Morris E. Opler, Professor of Anthropology and Asian Studies, Cornell University, Ithaca, New York. *Anthropology, Ethnology*

Jane M. Oppenheimer, Professor of Biology, Bryn Mawr College, Bryn Mawr, Pennsylvania. *Biological Sciences*

Gunhard-Æstius Oravas, Chairman, Department of Civil Engineering and Engineering Mechanics, Hamilton College, McMaster University, Hamilton, Ontario, Canada. *Engineering, Invention*

Donald Culross Peattie, deceased. *Botany*

Mario Pei, Professor of Romance Philology, Columbia University, New York, New York. *Philology*

Erwin Raisz, Cambridge, Massachusetts. *Geography, Cartography*

Joseph G. Rayback, Professor of American History, Pennsylvania State University, University Park, Pennsylvania. *Labor*

Henry Hope Reed, Jr., Director, Walking Tours of the Museum of The City of New York, New York. *Architecture, Sculpture, Painting, Illustration*

H. W. Rickett, Senior Curator, The New York Botanical Garden, Bronx, New York. *Botany*

Robert E. Riegel, Professor of History, Dartmouth College, Hanover, New Hampshire. *Social Reform*

Arthur H. Robinson, Professor of Geography, University of Wisconsin, Madison, Wisconsin. *Geography, Cartography*

Saul Sack, Professor of Education, University of Pennsylvania, Philadelphia, Pennsylvania. *Education*

Joseph F. Schreiber, Jr., Associate Professor of Geology, University of Arizona, Tucson, Arizona. *Geology, Mineralogy, Paleontology*

Samuel R. Sillen, Croton-on-Hudson, New York. *Labor*

George Gaylord Simpson, Agassiz Professor of Vertebrate Paleontology, Museum of Comparative Zoology, Harvard University, Cambridge, Massachusetts. *Natural History*

Joseph H. Smith, Professor of Law, Columbia University, New York, New York. *Law*

Red Smith, *New York Herald Tribune*, New York, New York. *Sports*

Joseph F. Spengler, James B. Duke Professor of Economics, Duke University, Durham, North Carolina. *Economics*

Robert E. Spiller, Felix E. Schelling Professor of English, University of Pennsylvania, Philadelphia, Pennsylvania. *Literature*

Laurence Stapleton, Mary E. Garrett Professor of English, Bryn Mawr College, Bryn Mawr, Pennsylvania. *Literature*

David Stimer, deceased. *Music*

The Rt. Rev. Anson Phelps Stokes, Jr., Bishop of the Protestant Episcopal Diocese of Massachusetts, Boston, Massachusetts. *Religion*

Dirk J. Struik, Professor of Mathematics, Emeritus, Massachusetts Institute of Technology, Cambridge, Massachusetts. *Astronomy, Engineering, Invention*

John Tebbel, Chairman, Department of Journalism, New York University, New York, New York. *Business, Industry, Philanthropy*

A. G. Unklesbay, Chairman, Department of Geology, University of Missouri, Columbia, Missouri. *Meteorology, Geography, Cartography*

Mark Van Doren, Professor of English, Emeritus, Columbia University, New York, New York. *Literature, Journalism*

Robert M. Vogel, Curator of Heavy Machinery and Civil Engineering, The Smithsonian Institution, Washington, D. C. *Engineering and Invention*

Wilson Wade, Assistant Professor of Philosophy and Religion, Doane College, Crete, Nebraska. *Religion*

Robert I. Watson, Professor of Psychology, Northwestern University, Evanston, Illinois. *Psychology*

William J. Wayne, Geological Survey, Indiana Department of Conservation, Indiana University, Bloomington, Indiana. *Geology, Mineralogy, Paleontology*

Mary Elvira Weeks, Detroit, Michigan. *Chemistry*

Bernard A. Weisberger, Professor of History, University of Rochester, Rochester, New York. *Religion*

Paul Weiss, The Rockefeller Institute, New York, New York. *Biological Sciences*

Frederick K. Wentz, Gettysburg Theological Seminary, Gettysburg, Pennsylvania. *Religion*

Herman O. Werner, Professor of English, U.S. Naval Academy, Annapolis, Maryland. *Naval History*

Alan F. Westin, Associate Professor of Public Law and Government, Columbia University, New York, New York. *Law*

Joshua Whatmough, deceased. *Philology*

George W. White, Head, Department of Geology, University of Illinois, Urbana, Illinois. *Geography, Cartography, Geology, Mineralogy, Paleontology*

Benjamin H. Willier, Professor of Biology, Emeritus, Johns Hopkins University, Baltimore, Maryland. *Biological Sciences*

Herbert Warren Wind, *New Yorker Magazine*, New York, New York. *Sports*

O. O. Winther, Professor of History, Indiana University, Bloomington, Indiana. *Exploration and Discovery*

PORTRAITS

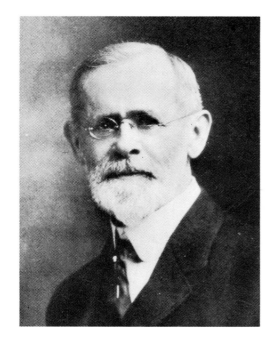

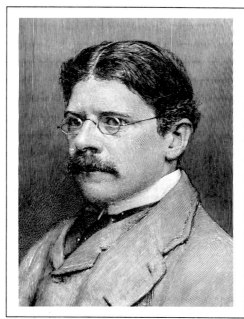

CLEVELAND ABBE (*left*)
(1838–1916)
Meteorologist, astronomer

EDWIN AUSTIN ABBEY (*right*)
(1852–1911)
Painter, illustrator, muralist
After a photograph by Napoleon Sarony

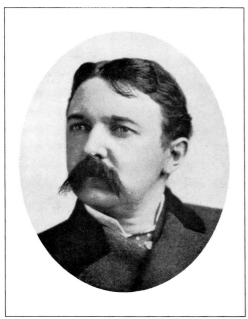

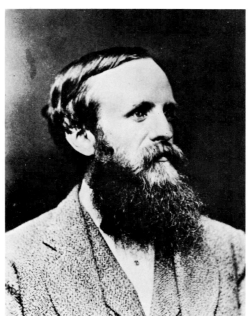

HENRY EUGENE ABBEY (*left*)
(1846–1896)
Theatrical impresario

FRANCIS ELLINGWOOD ABBOT
(*right*)
(1836–1903)
Philosopher, Unitarian clergyman

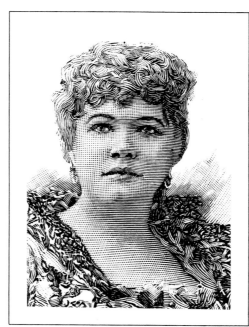

JOHN ABBOT (*left*)
(1751–1840)
Artist, naturalist

EMMA ABBOTT (*right*)
(1850–1891)
Operatic soprano

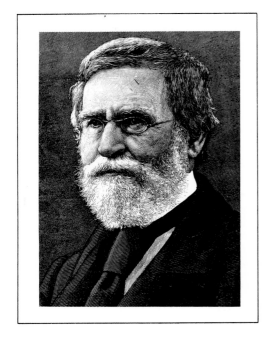

JACOB ABBOTT (*left*)
(1803–1879)
Congregational clergyman, educator; author
of *Rollo* books

LYMAN ABBOTT (*right*)
(1835–1922)
Congregational clergyman, editor, writer

JOHN JACOB ABEL (*left*)
(1857–1938)
Pharmacologist, physiological chemist

ARUNAH SHEPHERDSON ABELL
(*right*)
(1806–1888)
Newspaper publisher, founded *Baltimore
Sun*

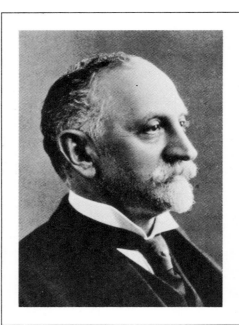

JAMES ABERCROMBY (*left*)
[James Abercrombie]
(1706–1781)
British general in French and Indian War
Courtesy Webster Collection, New Brunswick Museum

ABRAHAM ABRAHAM (*right*)
(1843–1911)
Philanthropist, merchant
Courtesy Abraham & Straus

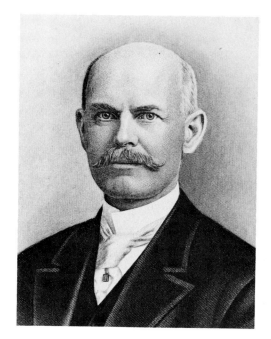

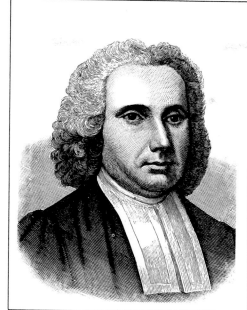

EDWARD GOODRICH ACHESON
(*left*)
(1856–1931)
Electrochemist, inventor, industrialist
Engraving by E. G. Williams & Bro.

ISRAEL ACRELIUS (*right*)
(1714–1800)
Swedish Lutheran clergyman, historian;
missionary to America

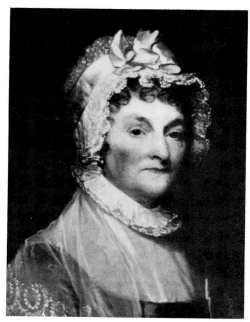

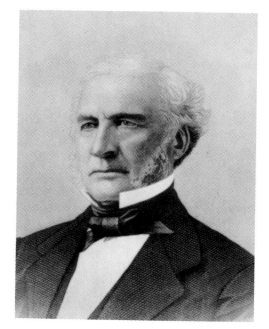

ABIGAIL ADAMS (*left*)
[Mrs. John Adams, nee Abigail Smith]
(1744–1818)
First lady, 1797–1801
Painting by Gilbert Stuart

ALVIN ADAMS (*right*)
(1804–1877)
Pioneer in express business; founded Adams
Express Co.
Engraving by George E. Perine

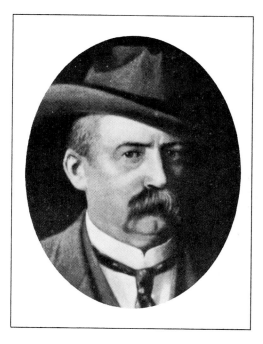

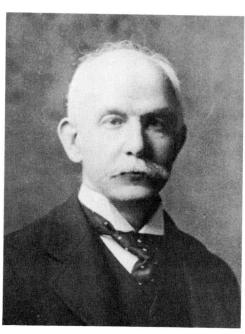

ANDY ADAMS (*left*)
(1859–1935)
Cowboy, writer

BROOKS ADAMS (*right*)
(1848–1927)
Historian, lawyer
Courtesy Adams National Historic Site

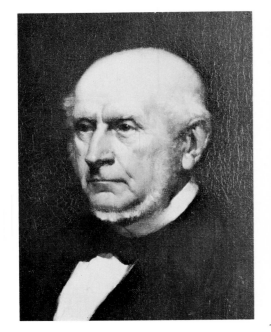
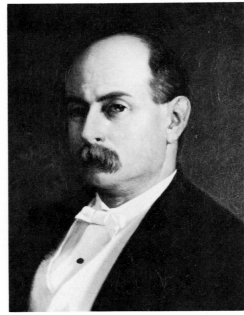

CHARLES FRANCIS ADAMS (*left*)
(1807–1886)
Lawyer, diplomat, biographer
Painting by Frederick P. Vinton. Courtesy Adams
National Historic Site

CHARLES FRANCIS ADAMS (*right*)
(1835–1915)
Railroad expert, historian, lawyer
Courtesy Adams National Historic Site

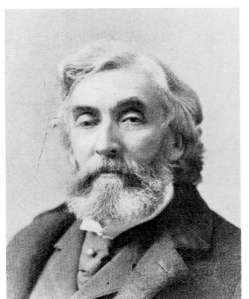
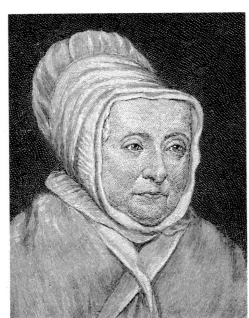

CHARLES KENDALL ADAMS (*left*)
(1835–1902)
Historian; president, Cornell University,
University of Wisconsin

HANNAH ADAMS (*right*)
(1755–1831)
Writer, compiled *Dictionary of Religions*
After a painting by Francis Alexander

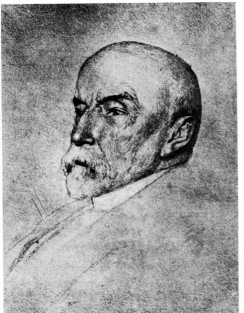

HENRY ADAMS (*left*)
[Henry Brooks Adams]
(1838–1918)
Historian, writer; author of *The Education*
of Henry Adams
Drawing by John Briggs Potter. Courtesy New-York
Historical Society

HERBERT BAXTER ADAMS (*right*)
(1850–1901)
Historian, political scientist, educator
Courtesy Library of Congress, Brady-Handy Collection

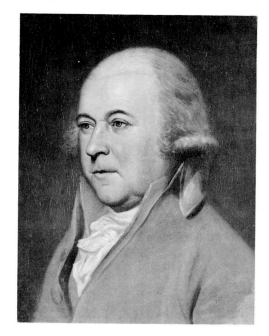

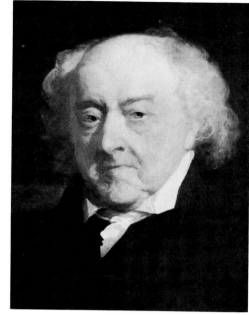

JOHN ADAMS (*left*)
(1735–1826)
President of the United States, 1797–1801
Painting by Charles Willson Peale. Courtesy Independence National Historical Park

JOHN ADAMS (*right*)
(*see above*)
Painting by Gilbert Stuart

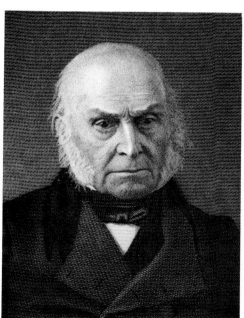

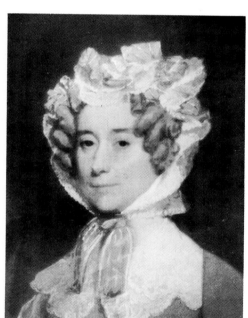

JOHN QUINCY ADAMS (*left*)
(1767–1848)
President of the United States, 1825–1829
Engraved by W. Wellstood after a photograph by Mathew Brady

MRS. JOHN QUINCY ADAMS (*right*)
[nee Louisa Catherine Johnson]
(1775–1852)
First lady, 1825–1829
Painting by Gilbert Stuart

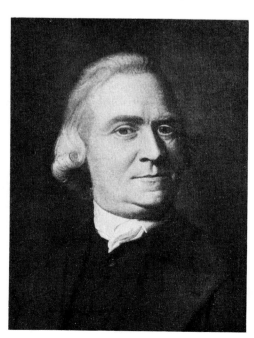

MAUDE ADAMS (*left*)
[Maude Kiskadden]
(1872–1953)
Actress

SAMUEL ADAMS (*right*)
(1722–1803)
Revolutionary patriot, signer of Declaration of Independence
Painting by John Singleton Copley

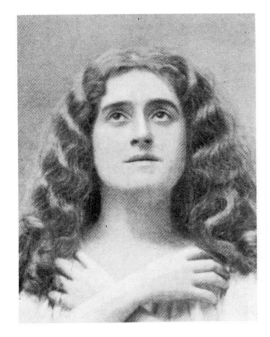
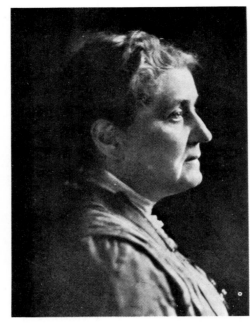

SUZANNE ADAMS (*left*)
(1872–1953)
Operatic soprano

JANE ADDAMS (*right*)
(1860–1935)
Social reformer, founder of Hull House,
Nobel Peace Laureate

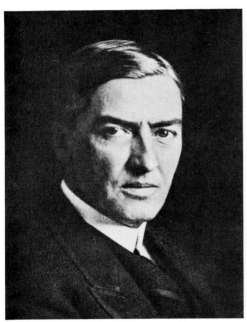
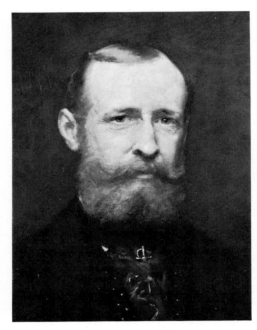

GEORGE ADE (*left*)
(1866–1944)
Humorist, journalist, playwright
*Photograph from "A Bibliography of George Ade"
by Dorothy Ritter Russo, published by the Indiana
Historical Society*

ALVEY AUGUSTUS ADEE (*right*)
(1842–1924)
Diplomat, statesman
*Painting by Robert Hinckley. Courtesy U.S. Depart-
ment of State*

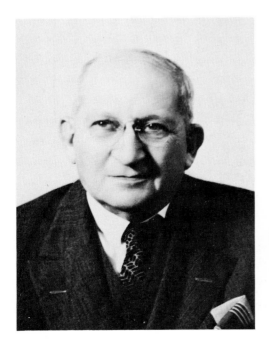
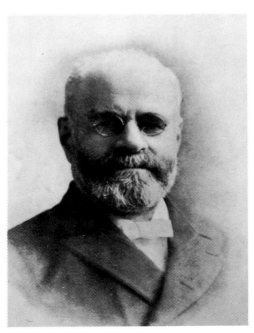

CYRUS ADLER (*left*)
(1863–1940)
Jewish leader, Orientalist, educator
Courtesy Jewish Theological Seminary of America

DANKMAR ADLER (*right*)
(1844–1900)
Engineer, architect

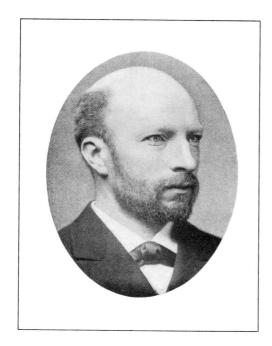

FELIX ADLER *(left)*
(1851–1933)
Educator, writer, reformer; founded Society
for Ethical Culture

JACOB ADLER *(right)*
(1855–1926)
Actor
Courtesy Museum of the City of New York

ROBERT ADRAIN *(left)*
(1775–1843)
Mathematician, educator, edited mathe-
matical journals

ALEXANDER AGASSIZ *(right)*
(1835–1910)
Zoologist, oceanographer, mine operator

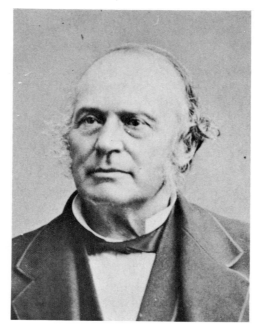

ELIZABETH CABOT AGASSIZ *(left)*
[nee Elizabeth Cary]
(1822–1907)
Educator; a founder and president of
Radcliffe College
Courtesy Radcliffe College

LOUIS AGASSIZ *(right)*
[Jean Louis Rodolphe Agassiz]
(1807–1873)
Naturalist, biologist, ichthyologist, writer,
educator
Courtesy Burndy Library

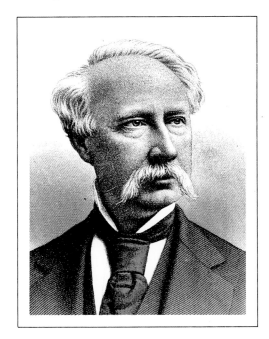

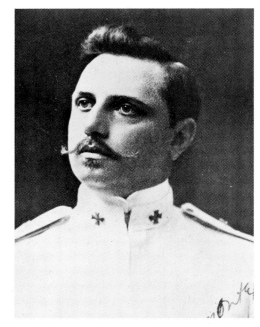

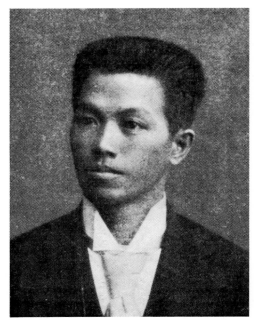

DAVID HAYES AGNEW (*left*)
(1818–1892)
Surgeon, educator, writer
Engraving by Samuel Sartain

ARÍSTIDES AGRAMONTE Y SIMONI
(*right*)
(1868–1931)
Bacteriologist, member of Reed yellow-fever board

EMILIO AGUINALDO (*left*)
(1869–1964)
Filipino patriot and insurrectionist

ROBERT GRANT AITKEN (*right*)
(1864–1951)
Astronomer
Courtesy Malcolm D. Aitken

CARL ETHAN AKELEY (*left*)
(1864–1926)
Explorer, taxidermist, naturalist, sculptor, inventor

AMOS TAPPAN AKERMAN (*right*)
(1821–1880)
Lawyer, Attorney General under Grant
After a photograph by Mathew Brady

HERNANDO DE ALARCÓN (*left*)
(*fl.* 1540)
Spanish explorer; explored Gulf of California and Colorado River
Engraved by B. Bázquez after a drawing by J. López Enguidanos. Courtesy Free Library of Philadelphia

EDWARD F. ALBEE (*right*)
(1857–1930)
Theater-chain manager, vaudeville agent

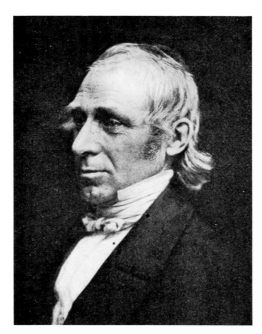

JACOB ALBRIGHT (*left*)
(1759–1808)
Clergyman, founder of Evangelical Church

AMOS BRONSON ALCOTT (*right*)
(1799–1888)
Transcendentalist, educator, writer

LOUISA MAY ALCOTT (*left*)
(1832–1888)
Novelist, author of juvenile books

HENRY MILLS ALDEN (*right*)
(1836–1919)
Writer; editor of *Harper's Weekly* and *Harper's Magazine*

EDWIN ANDERSON ALDERMAN
(*left*)
(1861–1931)
Educator, orator; president, University
of Virginia

NELSON WILMARTH ALDRICH
(*right*)
(1841–1915)
U.S. Senator, Congressman, financier

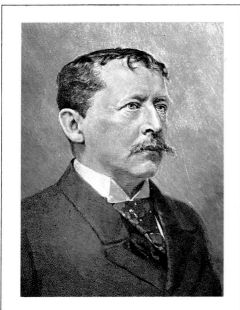

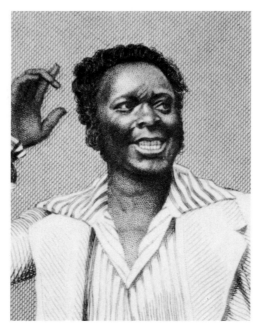

THOMAS BAILEY ALDRICH (*left*)
(1836–1907)
Writer, poet, editor of *Atlantic Monthly*
Engraving by R. G. Tietze

IRA FREDERICK ALDRIDGE (*right*)
(*c.* 1805–1867)
Shakespearean actor
*Engraving by T. Hollis. Courtesy Theatre Collection,
Harvard University*

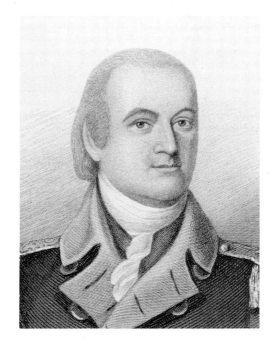

JOHN WHITE ALEXANDER (*left*)
(1856–1915)
Painter
*Photograph by Pirie MacDonald. Courtesy New-York
Historical Society*

WILLIAM ALEXANDER (*right*)
[Lord Stirling]
(1726–1783)
Revolutionary general
Engraving by G. R. Hall

HORATIO ALGER (*left*)
(1832–1899)
Author of boys' stories

RUSSELL ALEXANDER ALGER (*right*)
(1836–1907)
Politician; Secretary of War under McKinley

HORATIO ALLEN (*left*)
(1802–1890)
Civil engineer, railroad president, inventor
Courtesy Columbiana Collection, Columbia University

JAMES LANE ALLEN (*right*)
(1849–1925)
Novelist
Painting by Benoni Irwin

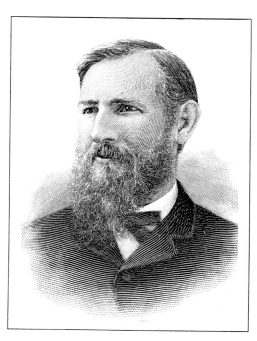

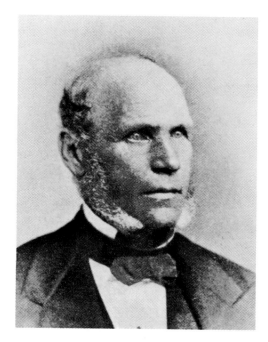

JOEL ASAPH ALLEN (*left*)
(1838–1921)
Zoologist, writer

JOHN ALLEN (*right*)
(1810–1892)
Dentist; devised modern dentures

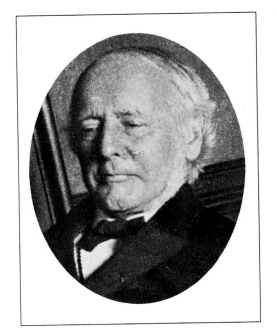

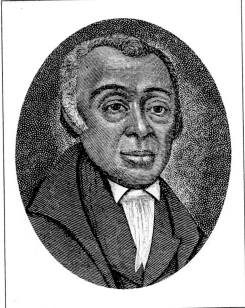

JOSEPH HENRY ALLEN (*left*)
(1820–1898)
Unitarian clergyman, writer, editor of
"Allen's Latin Grammars"

RICHARD ALLEN (*right*)
(1760–1831)
Founder and first bishop of African Meth-
odist Episcopal Church

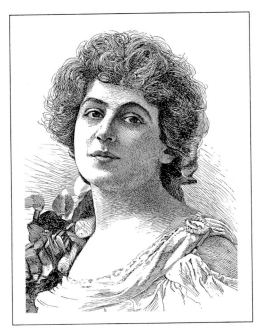

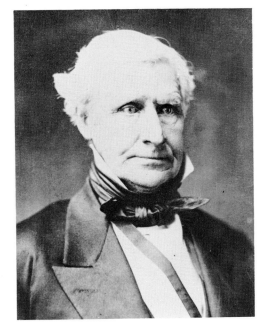

VIOLA ALLEN (*left*)
(1869–1948)
Actress

WILLIAM ALLEN (*right*)
(1803–1879)
U.S. Senator, Governor of Ohio, originated
"54–40 or Fight"
Courtesy Ohio Historical Society

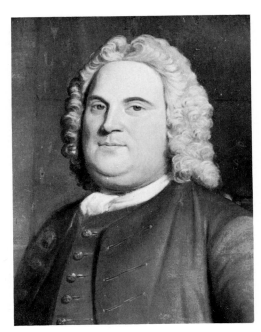

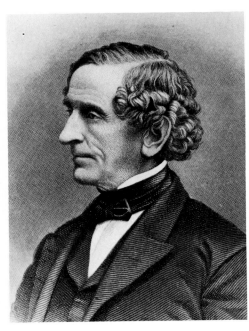

WILLIAM ALLEN (*left*)
(1704–1780)
Merchant, jurist, civic leader in Colonial
Philadelphia; eponym of Allentown, Penn-
sylvania
*Painting by Benjamin West. Courtesy Independence
National Historical Park*

ZACHARIAH ALLEN (*right*)
(1795–1882)
Inventor, developed standard automatic
cut-off valve for steam engines

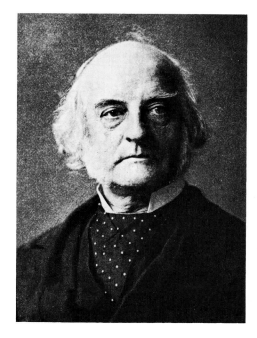

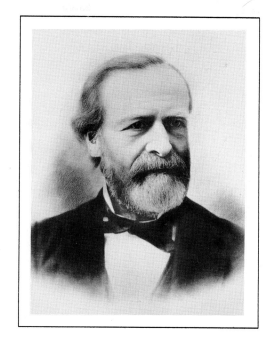

SAMUEL AUSTIN ALLIBONE *(left)*
(1816–1889)
Bibliographer, librarian

EDWARD PHELPS ALLIS *(right)*
(1824–1889)
Machinery manufacturer; founded Edward
P. Allis Co. (later Allis-Chalmers)
Courtesy Smithsonian Institution

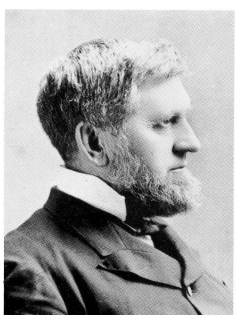

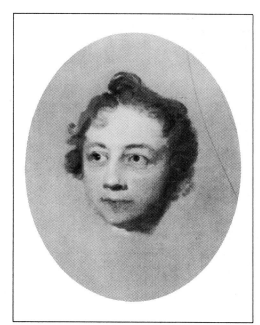

WILLIAM BOYD ALLISON *(left)*
(1829–1908)
U.S. Senator

WASHINGTON ALLSTON *(right)*
(1779–1843)
Painter, writer
Painting by Gilbert Stuart

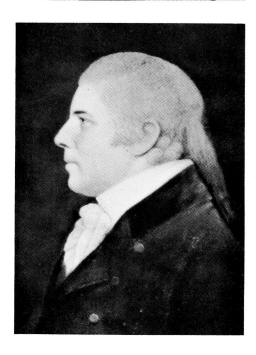

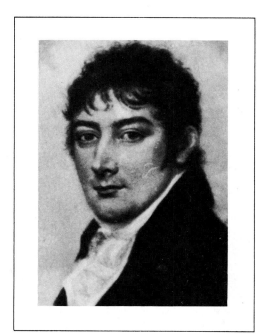

RICHARD ALSOP *(left)*
(1761–1815)
Satirist, poet; one of "Hartford Wits"
Painting attributed to James Sharples, Sr.

JOSEPH ALSTON *(right)*
(c. 1779–1816)
Governor of South Carolina, involved in
Burr conspiracy
*Painting by Edward G. Malbone. Courtesy Amherst
College*

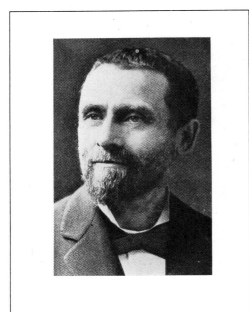

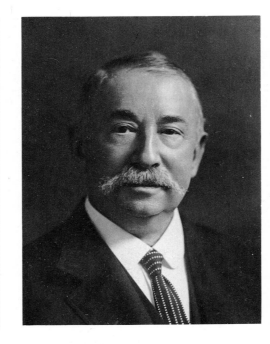

JOHN PETER ALTGELD (*left*)
(1847–1902)
Political leader, Governor of Illinois; pardoned Haymarket riot leaders

BENJAMIN ALTMAN (*right*)
(1840–1913)
Merchant, art collector, philanthropist
Courtesy B. Altman & Co.

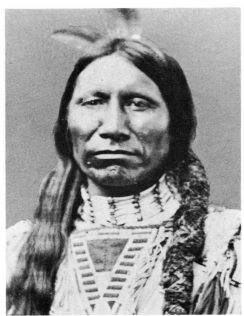

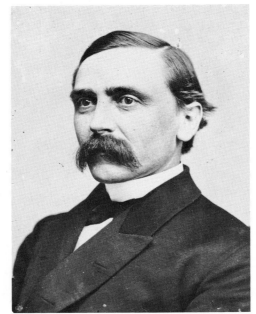

AMERICAN HORSE (*left*)
(*fl.* 1875–1905)
Sioux Indian chief
Courtesy Bureau of American Ethnology, Smithsonian Institution

ADELBERT AMES (*right*)
(1835–1933)
Union general in Civil War, U.S. Senator; Reconstruction Governor of Mississippi
Courtesy Library of Congress, Brady-Handy Collection

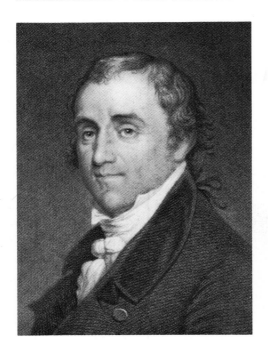

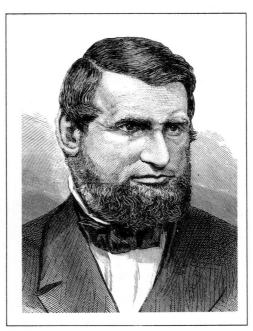

FISHER AMES (*left*)
(1758–1808)
Federalist leader, political writer
Engraved by J. F. E. Prud'homme from an engraving by David Edwin after a painting by Gilbert Stuart

OAKES AMES (*right*)
(1804–1873)
Financier, politician, manufacturer
After a photograph by Alexander Gardner

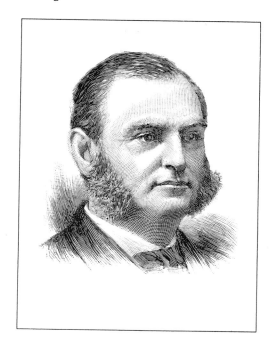

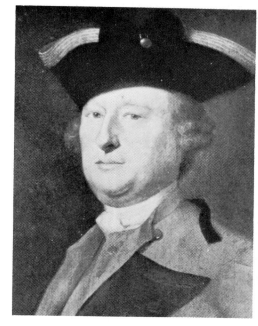

OLIVER AMES (*left*)
(1831–1895)
Governor of Massachusetts, industrialist, capitalist

JEFFREY AMHERST (*right*)
[Baron Amherst]
(1717–1797)
British officer, French and Indian War; Governor General of British North America
Painting by Joseph Blackburn

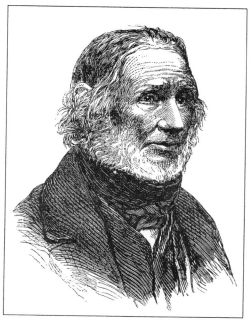

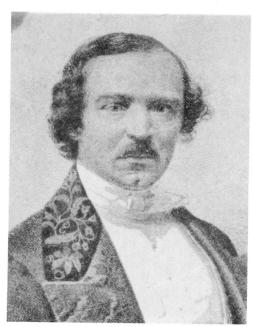

ALEXANDER ANDERSON (*left*)
(1775–1870)
Engraver
Self-portrait

JOHN HENRY ANDERSON (*right*)
(1815–1874)
Magician, "Great Wizard of the North"
Courtesy Milbourne Christopher Collection

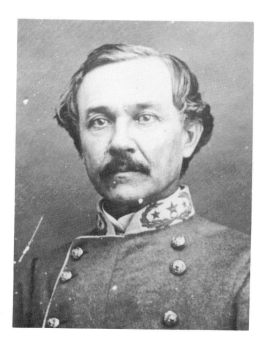

JOSEPH REID ANDERSON (*left*)
(1813–1892)
Confederate officer, manufactured munitions for Confederacy
Courtesy Meserve Collection

MARY ANTOINETTE ANDERSON
(*right*)
(1859–1940)
Actress

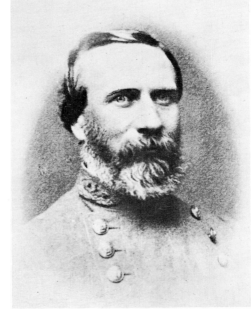

RASMUS BJÖRN ANDERSON *(left)*
(1846–1936)
Writer, editor, translator, diplomat

RICHARD HERON ANDERSON *(right)*
(1821–1879)
Confederate officer
Courtesy Library of Congress, Brady Collection

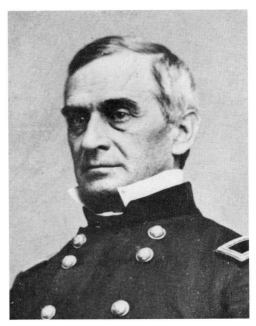

ROBERT ANDERSON *(left)*
(1805–1871)
Union officer, commanded Fort Sumter
Courtesy New-York Historical Society

JOHN ANDRÉ *(right)*
(1751–1780)
British officer in American Revolution,
hanged as spy
Engraving by W. G. Jackman

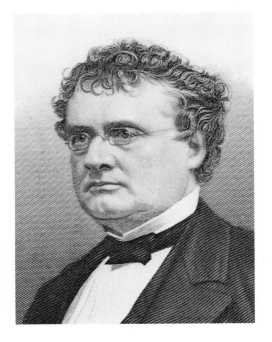

JAMES OSGOOD ANDREW *(left)*
(1794–1871)
Southern Methodist bishop; cause of pre-
Civil War division of church
Engraving by John C. Buttre

JOHN ALBION ANDREW *(right)*
(1818–1867)
Governor of Massachusetts, formed first
Negro regiment
Engraving by Alexander H. Ritchie

ELISHA BENJAMIN ANDREWS (*left*)
(1844–1917)
Educator, historian; president of Brown
University

JAMES J. ANDREWS (*right*)
(c. 1829–1862)
Union spy in Civil War

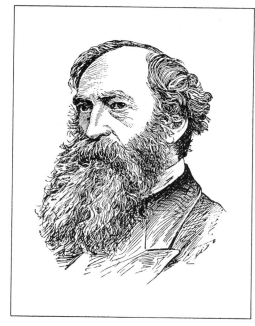

JOSEPH ANDREWS (*left*)
(c. 1805–1873)
Engraver

STEPHEN PEARL ANDREWS (*right*)
(1812–1886)
Eccentric philosopher, reformer, linguist;
founder of "Universology"

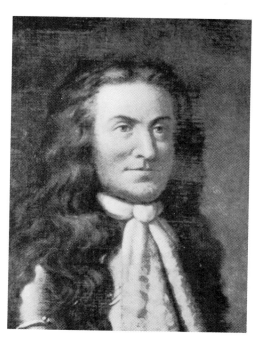
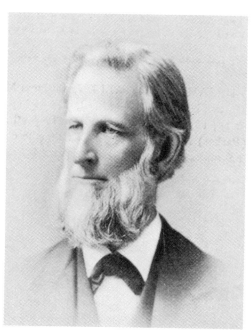

Sɪʀ **EDMUND ANDROS** (*left*)
(1637–1714)
Governor of Colonial New York, New
England, and Virginia

GEORGE THORNDIKE ANGELL
(*right*)
(1823–1909)
Philanthropist, reformer; promoted humane
treatment of animals

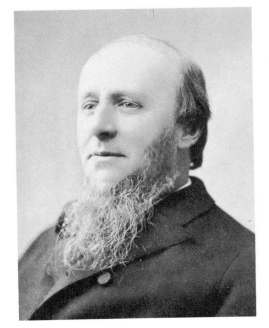

JAMES BURRILL ANGELL (*left*)
(1829–1916)
Educator, journalist, diplomat

MARGARET MARY ANGLIN (*right*)
(1876–1958)
Actress

THOMAS POLLOCK ANSHUTZ
(*left*)
(1851–1912)
Painter, art teacher; influenced "The Eight"

CAP ANSON (*right*)
[Adrian Constantine Anson]
(1851–1922)
Baseball player, manager, member of Baseball Hall of Fame
Courtesy National Baseball Hall of Fame

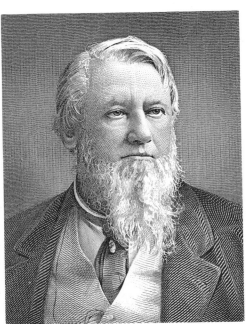

CHARLES ANTHON (*left*)
(1797–1867)
Classicist, educator, textbook editor
Courtesy Library of Congress, Brady-Handy Collection

HENRY BOWEN ANTHONY (*right*)
(1815–1884)
Newspaper editor, U.S. Senator, Governor of Rhode Island

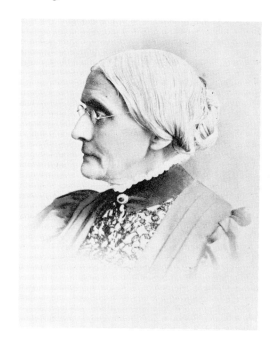

SUSAN BROWNELL ANTHONY
(*left*)
(1820–1906)
Woman-suffrage leader
Courtesy Tamiment Institute Library

JUAN BAUTISTA DE ANZA (*right*)
(1735–1788)
Explorer
Courtesy Mercaldo Archives

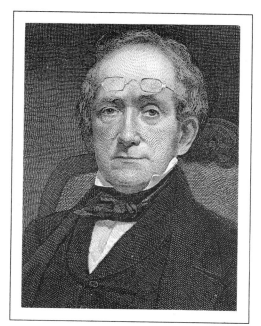

EDGAR APPERSON (*left*)
(1870–1959)
Pioneer automobile manufacturer
Courtesy Automobile Manufacturers Association, Inc.

DANIEL APPLETON (*right*)
(1785–1849)
Book publisher
Engraved by William E. Marshall from a painting by Charles Loring Elliott

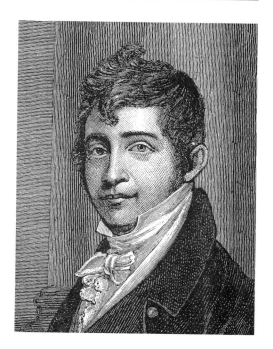
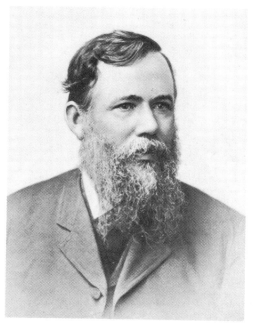

NATHAN APPLETON (*left*)
(1779–1861)
Pioneer textile manufacturer, banker, politician
After a painting by Gilbert Stuart

JOHN ARBUCKLE (*right*)
(1839–1912)
Coffee merchant, sugar refiner, shipowner

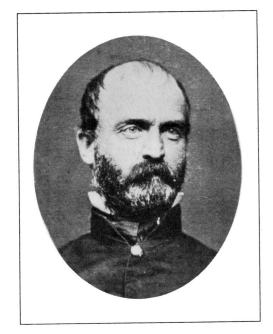

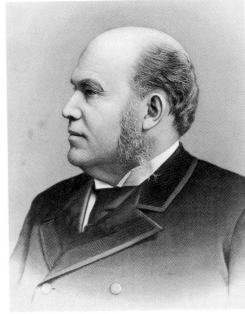

LEWIS ADDISON ARMISTEAD *(left)*
(1817–1863)
Confederate general
Courtesy Library of Congress

PHILIP DANFORTH ARMOUR *(right)*
(1832–1901)
Meat packer; founded Illinois Institute
of Technology

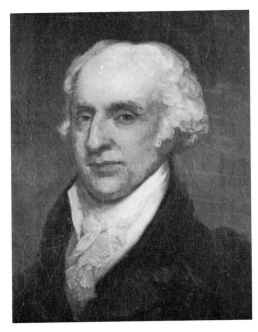

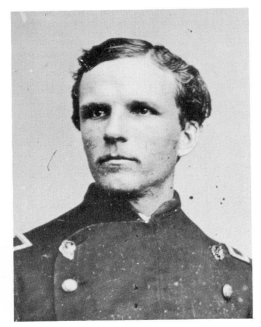

JOHN ARMSTRONG *(left)*
(1758–1843)
Army officer, diplomat, Secretary of War
under Madison
*Painting by Rembrandt Peale. Courtesy Independence
National Historical Park*

SAMUEL CHAPMAN ARMSTRONG
(right)
(1839–1893)
Educator, founded Hampton Institute
Courtesy National Archives, Brady Collection

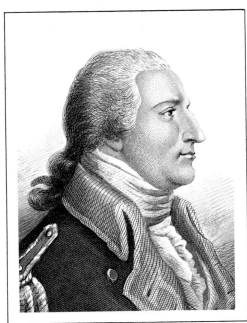

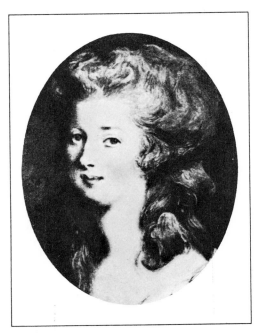

BENEDICT ARNOLD *(left)*
(1741–1801)
Revolutionary officer; traitor
Engraving by Henry B. Hall

PEGGY SHIPPEN ARNOLD *(right)*
[nee Margaret Shippen]
(1760–1804)
Philadelphia socialite, wife of Benedict
Arnold
Painting attributed to Daniel Gardner

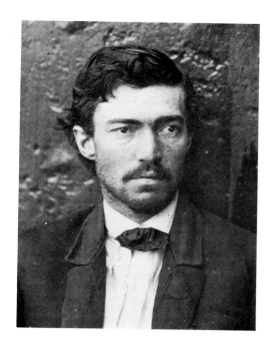

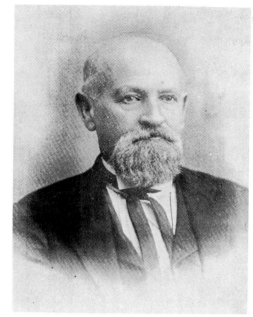

SAMUEL ARNOLD (*left*)
(*c.* 1838–1906)
Conspirator in plot to assassinate Lincoln
Photograph by Alexander Gardner. Courtesy New-York Historical Society

BILL ARP (*right*)
[Charles Henry Smith]
(1826–1903)
Humorist, journalist

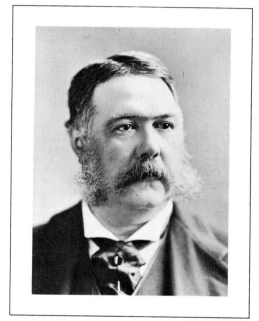

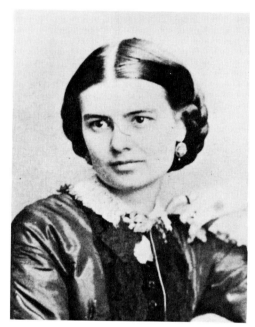

CHESTER ALAN ARTHUR (*left*)
(1830–1886)
President of the United States, 1881–1885
Courtesy New-York Historical Society

Mrs. CHESTER A. ARTHUR (*right*)
[nee Ellen Lewis Herndon]
(1837–1880)
Wife of Chester A. Arthur, died before he
took office
Courtesy Library of Congress

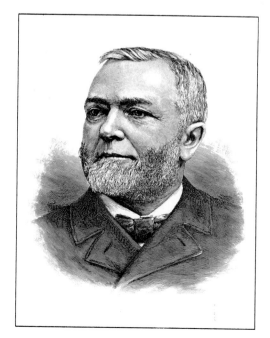

JOSEPH CHARLES ARTHUR (*left*)
(1850–1942)
Botanist, educator; received first science
degree awarded in U.S.
Photograph by George F. Weber

PETER M. ARTHUR (*right*)
(1831–1903)
Labor leader

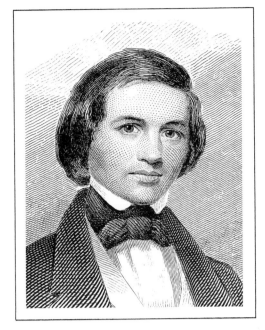
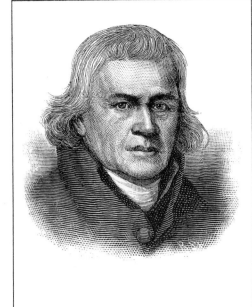

TIMOTHY SHAY ARTHUR *(left)*
(1809–1885)
Writer, editor; author of *Ten Nights in a Barroom and What I Saw There*
Engraving by William G. Armstrong

FRANCIS ASBURY *(right)*
(1745–1816)
A founder and bishop of Methodist Episcopal Church in U.S.

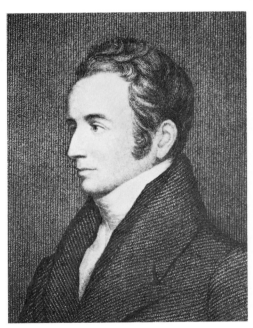
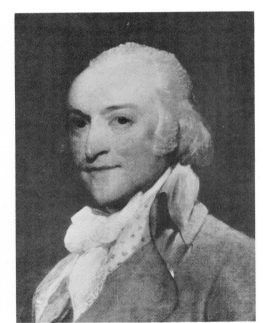

JEHUDI ASHMUN *(left)*
(1794–1828)
U.S. colonial agent in Liberia
Engraved by Simeon S. Jocelyn from a painting by Nathaniel Jocelyn

JOHN JACOB ASTOR *(right)*
(1763–1848)
Fur trader, capitalist, financier; founded Astor estate
Painting by Gilbert Stuart

JOHN JACOB ASTOR *(left)*
(1822–1890)
Capitalist; grandson of John Jacob Astor (1763–1848), son of William Backhouse Astor

JOHN JACOB ASTOR *(right)*
(1864–1912)
Capitalist, inventor

WILLIAM BACKHOUSE ASTOR
(*left*)
(1792–1875)
Capitalist
From a photograph by Mathew Brady

MRS. WILLIAM ASTOR (*right*)
[nee Caroline Webster Schermerhorn]
(1831–1908)
New York society leader

WILLIAM WALDORF ASTOR (*left*)
[First Viscount Astor of Hever Castle]
(1848–1919)
Capitalist, journalist, diplomat

GERTRUDE ATHERTON (*right*)
[nee Gertrude Franklin Horn]
(1857–1948)
Novelist

GEORGE A. ATZERODT (*left*)
(1835–1865)
Conspirator in plot to assassinate Lincoln
Photograph by Alexander Gardner. Courtesy New-York Historical Society

SAMUEL AUCHMUTY (*right*)
(1722–1777)
Anglican clergyman

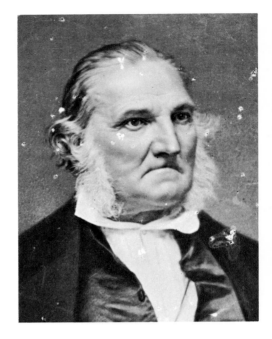

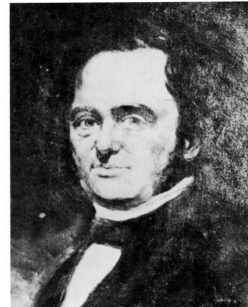

JOHN JAMES AUDUBON *(left)*
(1785–1851)
Ornithologist, artist, naturalist, writer
Courtesy Library of Congress, Brady-Handy Collection

MOSES AUSTIN *(right)*
(1761–1821)
Merchant, mine owner; planned colonization of Texas
Courtesy Texas State Library

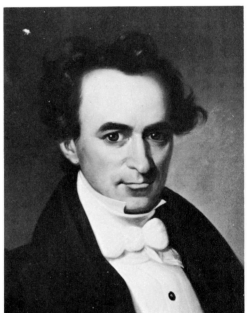

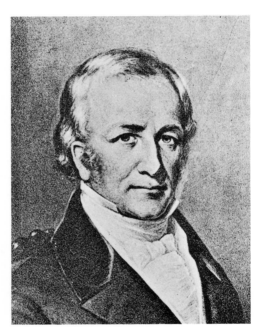

STEPHEN FULLER AUSTIN *(left)*
(1793–1836)
Colonizer of Texas, son of Moses Austin
Courtesy Texas State Library

WILLIAM AUSTIN *(right)*
(1778–1841)
Writer, lawyer; author of short fiction

ELROY McKENDREE AVERY *(left)*
(1844–1935)
Educator, historical writer

SAMUEL PUTNAM AVERY *(right)*
(1822–1904)
Art dealer, philanthropist, connoisseur

FRANCIS WAYLAND AYER (*left*)
(1848–1923)
Advertising executive, founded N. W. Ayer
& Son

HARRIET HUBBARD AYER (*right*)
(1854–1903)
Journalist, founded cosmetics company

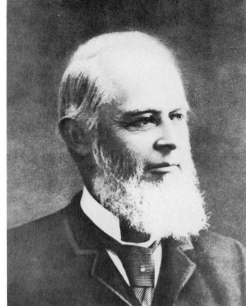

BENJAMIN TALBOT BABBITT (*left*)
(1809–1889)
Inventor, manufacturer, advertising pioneer

GEORGE HERMAN BABCOCK (*right*)
(1832–1893)
Inventor, engineer, manufacturer; founded
Babcock & Wilcox Co.
Courtesy Babcock & Wilcox Co.

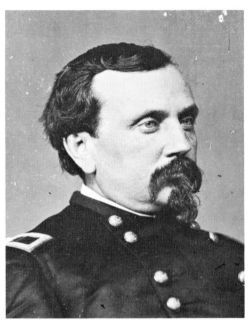
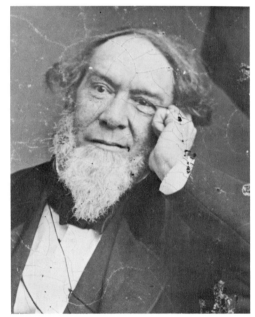

ORVILLE E. BABCOCK (*left*)
(1835–1884)
Army officer, engineer, private secretary to
President Grant
Courtesy Library of Congress, Brady-Handy Collection

ALEXANDER DALLAS BACHE (*right*)
(1806–1867)
Physicist, educator
Courtesy Library of Congress, Brady-Handy Collection

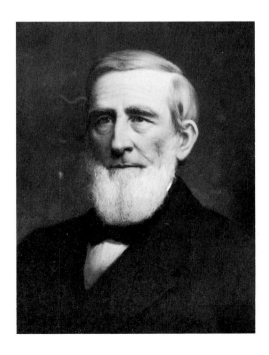
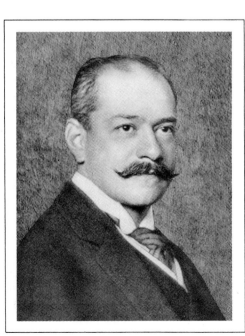

FRANKLIN BACHE (*left*)
(1792–1864)
Physician, chemist, educator, writer
*Painting by Samuel B. Waugh. Courtesy American
Philosophical Society*

JULES SEMON BACHE (*right*)
(1861–1944)
Financier, art collector; founded J. S.
Bache & Co.

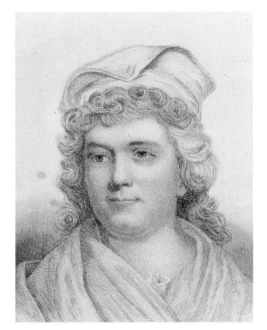

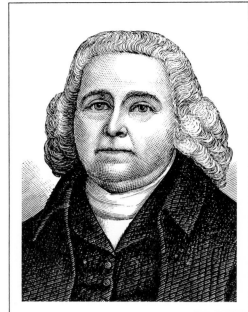

SARAH BACHE (*left*)
[nee Sarah Franklin]
(1744–1808)
Philanthropist, daughter of Benjamin Franklin
Engraved by Henry B. Hall after a painting by John Hoppner

ISAAC BACKUS (*right*)
(1724–1806)
Baptist clergyman, writer, advocate of religious liberty

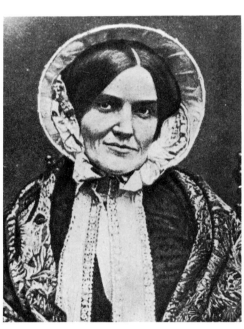

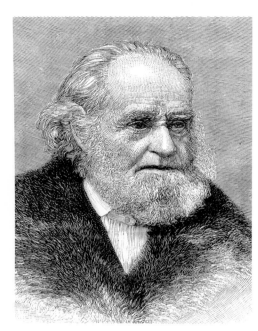

DELIA SALTER BACON (*left*)
(1811–1859)
Writer, originated theory that Francis Bacon had written Shakespeare's plays

LEONARD BACON (*right*)
(1802–1881)
Congregational clergyman, abolitionist, writer, editor

LEO HENDRIK BAEKELAND (*left*)
(1863–1944)
Chemist, inventor, developed Bakelite
Union Carbide Plastics Company, Division of Union Carbide Corp.

JACOB WHITMAN BAILEY (*right*)
(1811–1857)
Botanist, chemist, geologist
Painting by Robert W. Weir. U. S. Army Photograph. Courtesy U. S. Military Academy

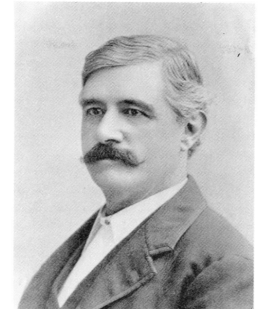

JAMES ANTHONY BAILEY (*left*)
(1847–1906)
Circus owner, partner in Barnum & Bailey

JAMES MONTGOMERY BAILEY
(*right*)
(1841–1894)
Journalist, humorist; edited *Danbury News*

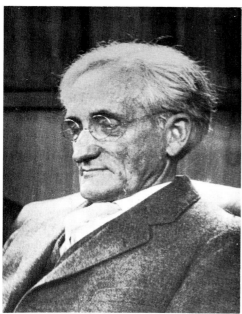

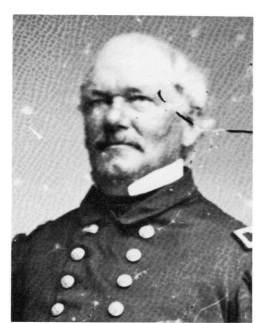

LIBERTY HYDE BAILEY (*left*)
(1858–1954)
Horticulturist, botanist
*Courtesy L. H. Bailey Hortorium, New York State
College of Agriculture at Cornell University*

THEODORUS BAILEY (*right*)
(1805–1877)
Naval officer
Courtesy Library of Congress, Brady Collection

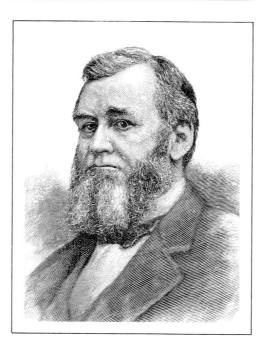

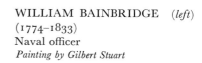

WILLIAM BAINBRIDGE (*left*)
(1774–1833)
Naval officer
Painting by Gilbert Stuart

SPENCER FULLERTON BAIRD
(*right*)
(1823–1888)
Zoologist; secretary, Smithsonian Institution

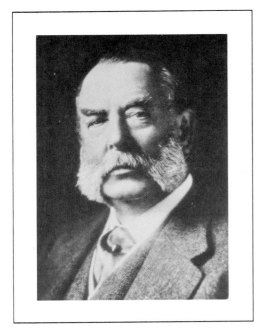

GEORGE FISHER BAKER (*left*)
(1840–1931)
Banker, philanthropist

LA FAYETTE CURRY BAKER (*right*)
(1826–1868)
Chief of U.S. Secret Service during Civil War
Engraving by Robert Whitechurch

ABRAHAM BALDWIN (*left*)
(1754–1807)
Congressman, U.S. Senator, signer of Constitution; a founder of University of Georgia
Engraving by J. B. Forrest from a drawing by Emanuel Leutze after a drawing by Robert Fulton

EVELYN BRIGGS BALDWIN (*right*)
(1862–1933)
Arctic explorer, meteorologist

JAMES MARK BALDWIN (*left*)
(1861–1934)
Psychologist, editor

LOAMMI BALDWIN (*right*)
(c. 1745–1807)
Engineer, Revolutionary officer; developed Baldwin apple

LOAMMI BALDWIN (*left*)
(1780–1838)
Civil engineer, lawyer
Painting by Chester Harding

MATTHIAS WILLIAM BALDWIN
(*right*)
(1795–1866)
Industrialist, manufactured locomotives

ROGER SHERMAN BALDWIN (*left*)
(1793–1863)
Lawyer, Governor of Connecticut
Engraved by Alexander H. Ritchie from a daguerreo-
type by Mathew Brady

SIMEON EBEN BALDWIN (*right*)
(1840–1927)
Jurist, educator, Governor of Connecticut

THOMAS BALL (*left*)
(1819–1911)
Sculptor

PETER BALLANTINE (*right*)
(1791–1883)
Brewer

ADIN BALLOU *(left)*
(1803–1890)
Universalist clergyman, reformer; founded
Hopedale Community
Engraving by F. T. Stuart

HOSEA BALLOU *(right)*
(1771–1852)
Universalist clergyman, editor
Engraving by H. W. Smith

HOSEA BALLOU *(left)*
(1796–1861)
Universalist clergyman, editor; first presi-
dent of Tufts College
Engraving by H. W. Smith

MATURIN MURRAY BALLOU *(right)*
(1820–1895)
Publisher, journalist; founded early illus-
trated periodicals

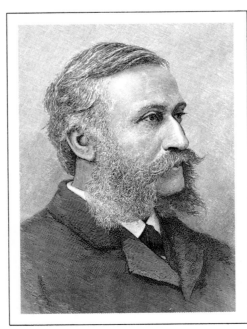

GEORGE BANCROFT *(left)*
(1800–1891)
Historian, diplomat

HUBERT HOWE BANCROFT *(right)*
(1832–1918)
Publisher, historian

ADOLPH FRANCIS ALPHONSE BANDELIER *(left)*
(1840–1914)
Explorer, archaeologist, anthropologist, historian
Courtesy Smithsonian Institution

JOHN KENDRICK BANGS *(right)*
(1862–1922)
Humorist, editor, lecturer

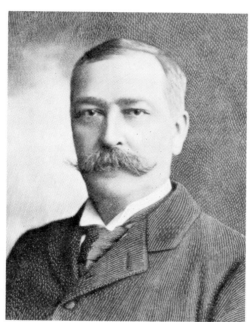

NATHANIEL PRENTISS BANKS
(left)
(1816–1894)
Union general in Civil War, Congressman, Governor of Massachusetts
Courtesy New-York Historical Society

OHIO COLUMBUS BARBER *(right)*
(1841–1920)
Manufacturer, president of Diamond Match Co.

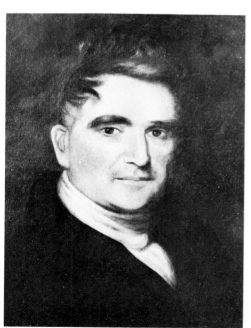

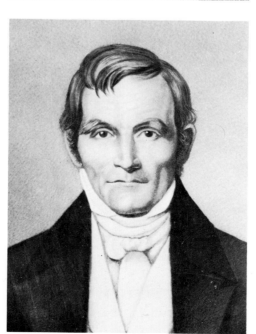

JAMES BARBOUR *(left)*
(1775–1842)
Governor of Virginia, U.S. Senator, diplomat; Secretary of War under J. Q. Adams
Courtesy Virginia State Library

PHILIP PENDLETON BARBOUR
(right)
(1783–1841)
Virginia political leader, Congressman; associate justice, U.S. Supreme Court
Courtesy Virginia State Library

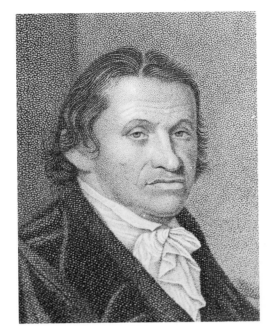

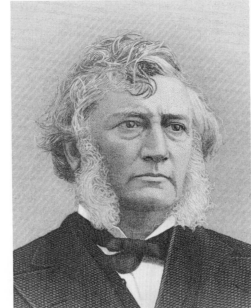

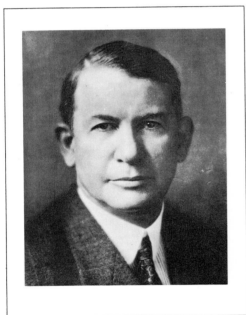

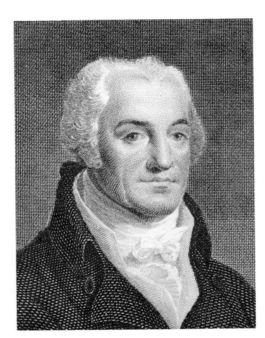

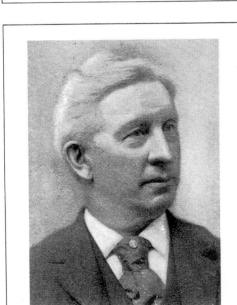

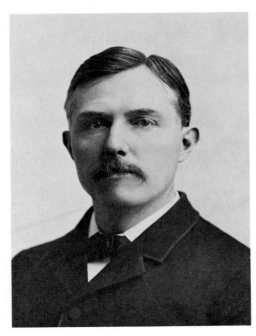

SAMUEL BARD (*left*)
(1742–1821)
Physician, medical educator; helped found first New York medical school and New York Hospital
Engraved by William Main from a painting by John Vanderlyn. Courtesy New York Academy of Medicine

BENJAMIN FORDYCE BARKER
(*right*)
(1818–1891)
Gynecologist
Engraving by George E. Perine

ALBEN W. BARKLEY (*left*)
(1877–1956)
Vice-President of U.S., 1949–1953
Courtesy Library of Congress

JOEL BARLOW (*right*)
(1754–1812)
Poet, diplomat; one of "Hartford Wits"
Engraved by A. Smith from a painting by Robert Fulton

HENRY CLAY BARNABEE (*left*)
(1833–1917)
Actor, singer

EDWARD EMERSON BARNARD
(*right*)
(1857–1923)
Astronomer
Courtesy Lick Observatory

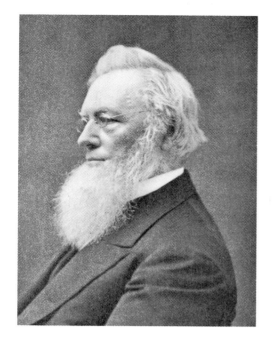

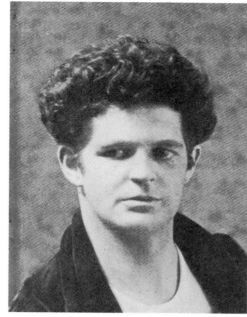

FREDERICK AUGUSTUS PORTER BARNARD *(left)*
(1809–1889)
President of Columbia College; eponym of Barnard College

GEORGE GREY BARNARD *(right)*
(1863–1938)
Sculptor

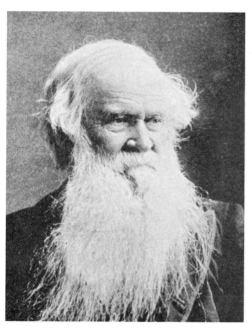

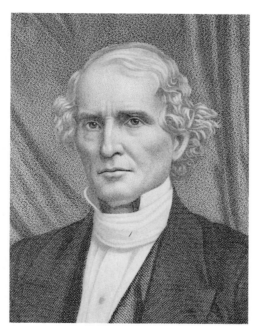

HENRY BARNARD *(left)*
(1811–1900)
Educator, editor; first U.S. Commissioner of Education

ALBERT BARNES *(right)*
(1798–1870)
Presbyterian clergyman
Engraving by George E. Perine

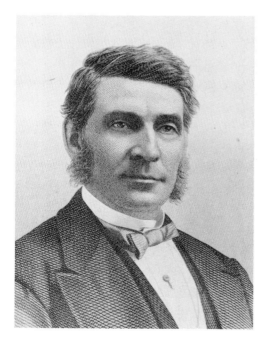

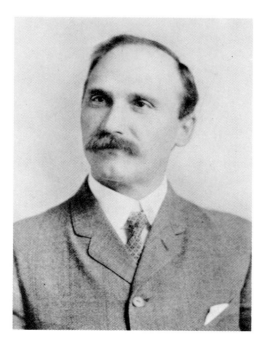

ALFRED SMITH BARNES *(left)*
(1817–1888)
Book publisher
Engraving by George E. Perine

CHARLES REID BARNES *(right)*
(1858–1910)
Botanist
Courtesy University of Chicago

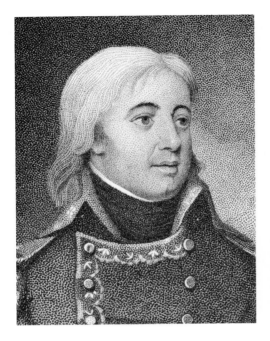

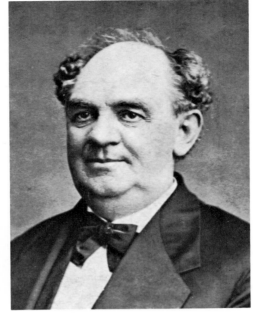

JOSHUA BARNEY (*left*)
(1759–1818)
Naval officer
Engraved by J. Gross from a drawing by William G.
Armstrong after a painting by Jean Baptiste Isabey

P. T. BARNUM (*right*)
[Phineas Taylor Barnum]
(1810–1891)
Showman
Courtesy Loan Collection of Elizabeth Sterling Seeley,
Barnum Museum

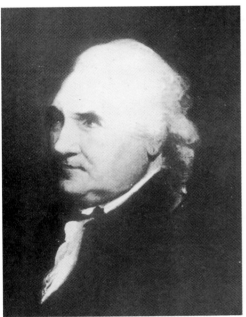

ISAAC BARRÉ (*left*)
(1726–1802)
British officer, championed American free-
dom; eponym of Wilkes-Barre, Pa.
Painting by Gilbert Stuart

LAWRENCE BARRETT (*right*)
(1838–1891)
Tragedian
After a painting by John Singer Sargent

JOHN BARRY (*left*)
(1745–1803)
Revolutionary naval commander
Painting by Gilbert Stuart

ETHEL BARRYMORE (*right*)
(1879–1959)
Actress
Courtesy Walter Hampden Memorial Library at The
Players, New York

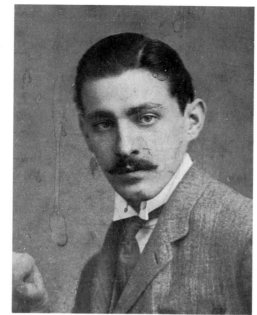

GEORGIANA EMMA DREW BARRYMORE (*left*)
(1856–1893)
Actress
Courtesy Walter Hampden Memorial Library at The Players, New York

JOHN BARRYMORE (*right*)
(1882–1942)
Actor
Courtesy Walter Hampden Memorial Library at The Players, New York

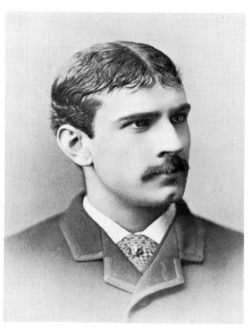
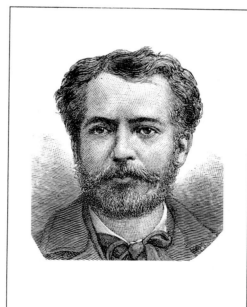

MAURICE BARRYMORE (*left*)
[Herbert Blythe]
(1847–1905)
Actor
Courtesy Walter Hampden Memorial Library at The Players, New York

FRÉDÉRIC AUGUSTE BARTHOLDI (*right*)
(1834–1904)
French sculptor, designed Statue of Liberty

JOHN BARTLETT (*left*)
(1820–1905)
Editor, publisher; compiled *Familiar Quotations*
Courtesy Little, Brown and Co.

JOHN RUSSELL BARTLETT (*right*)
(1805–1886)
Bibliographer, librarian; compiled *Dictionary of Americanisms*
Engraving by John C. Buttre

JOSIAH BARTLETT (*left*)
(1729–1795)
Physician; signer of Declaration of Inde-
pendence; first governor of New Hampshire
Engraving by Henry B. Hall

PAUL WAYLAND BARTLETT (*right*)
(1865–1925)
Sculptor
Courtesy American Academy of Arts and Letters

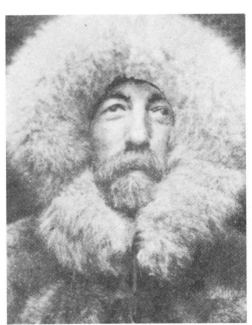

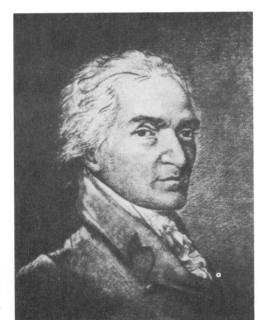

ROBERT ABRAM BARTLETT (*left*)
[Captain Bob Bartlett]
(1875–1946)
Arctic explorer

BENJAMIN SMITH BARTON (*right*)
(1766–1815)
Physician, naturalist

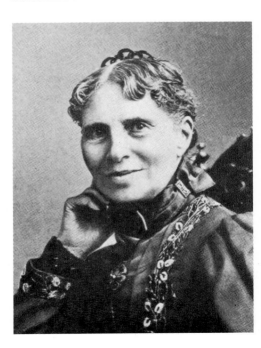

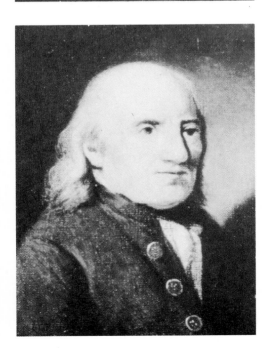

CLARA BARTON (*left*)
[Clarissa Harlowe Barton]
(1821–1912)
Founder of American Red Cross

JOHN BARTRAM (*right*)
(1699–1777)
Botanist
Courtesy Library of Congress

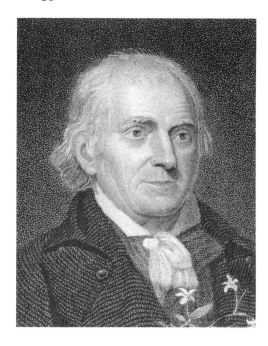

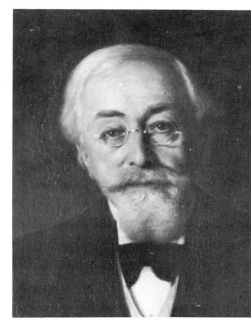

WILLIAM BARTRAM (*left*)
(1739–1823)
Naturalist
*Engraved by Thomas B. Welch from a painting by
Charles Willson Peale*

SIMON BARUCH (*right*)
(1840–1921)
Physician, hydrotherapist, philanthropist
Courtesy New York University Medical Center

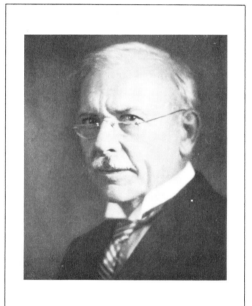

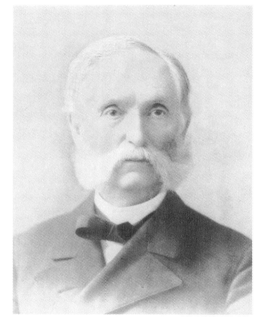

CARL BARUS (*left*)
(1856–1935)
Physicist

JOHN BASCOM (*right*)
(1827–1911)
Educator; president, University of Wisconsin

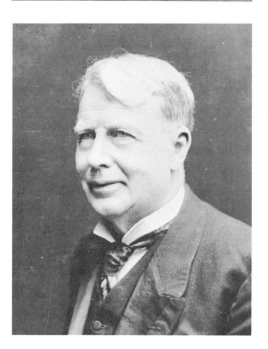

JAMES WHITFORD BASHFORD
(*left*)
(1849–1919)
Educator, Methodist bishop in China
Courtesy Ohio Wesleyan University

SAM BASS (*right*)
(1851–1878)
Western outlaw
Courtesy University of Texas Library

RICHARD BASSETT (*left*)
(1745–1815)
Revolutionary leader, Governor of Delaware; signer of Constitution
Courtesy Historical Society of Delaware

KATE JOSEPHINE BATEMAN (*right*)
(1843–1917)
Actress
Courtesy Library of Congress, Brady-Handy Collection

ARLO BATES (*left*)
(1850–1918)
Educator, writer
Courtesy Massachusetts Institute of Technology

BLANCHE BATES (*right*)
(1873–1941)
Actress, singer

EDWARD BATES (*left*)
(1793–1869)
Attorney General under Lincoln

JOSHUA BATES (*right*)
(1788–1864)
Financier, philanthropist; leading founder of Boston Public Library

KATHARINE LEE BATES (*left*)
(1859–1929)
Educator, writer; wrote "America the Beautiful"
Courtesy Mrs. Dorothy Burgess

LYMAN FRANK BAUM (*right*)
(1856–1919)
Writer, author of *The Wizard of Oz*
Courtesy Fred Meyer

JAMES PHINNEY BAXTER (*left*)
(1831–1921)
Historian, merchant
Painting by August Benziger. Courtesy Percival P. Baxter

JAMES ASHETON BAYARD (*right*)
(1767–1815)
U.S. Senator, Congressman, diplomat, lawyer
Engraved by E. Wellmore from a painting by Adolph U. Wertmuller

THOMAS FRANCIS BAYARD (*left*)
(1828–1898)
Diplomat, U.S. Senator, Secretary of State under Cleveland

WILLIAM BAYARD (*right*)
(1761–1826)
Merchant, banker
From a painting by Joseph Ames

NORA BAYES (*left*)
[Dora Goldberg]
(1880–1928)
Actress, singer
Photograph by Napoleon Sarony

ALFRED E. BEACH (*right*)
(1826–1896)
Inventor, typewriter pioneer; editor of *Scientific American*
Engraving by John W. Orr. Courtesy Smithsonian Institution

MOSES YALE BEACH (*left*)
(1800–1868)
Journalist, inventor; owner of *New York Sun*
Engraving by George E. Perine

ERASTUS FLAVEL BEADLE (*right*)
(1821–1894)
Publisher, popularized the dime novel

WILLIAM JAMES BEAL (*left*)
(1833–1924)
Botanist, educator
Courtesy Michigan State University

EDWARD FITZGERALD BEALE
(*right*)
(1822–1893)
Naval officer, courier, pioneer

ROY BEAN (*left*)
(*c.* 1825–1903)
Western judge

TARLETON HOFFMAN BEAN (*right*)
(1846–1916)
Ichthyologist

DAN BEARD (*left*)
[Daniel Carter Beard]
(1850–1941)
Writer, illustrator; organized first American
Boy Scout group
Photograph by Pach Brothers

GEORGE MILLER BEARD (*right*)
(1839–1883)
Neurologist

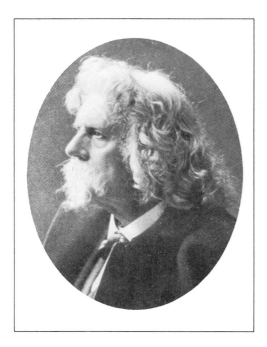

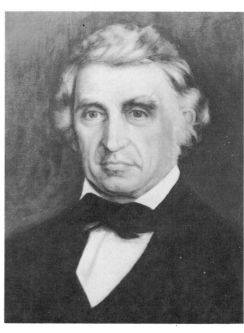

WILLIAM HOLBROOK BEARD
(*left*)
(1824–1900)
Painter, illustrator

WILLIAM BEAUMONT (*right*)
(1785–1853)
Surgeon, pioneer researcher of digestive
processes
Courtesy New York Academy of Medicine

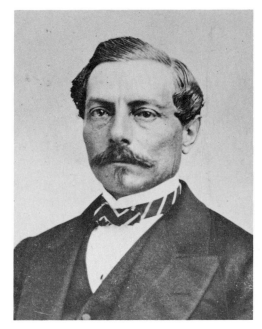

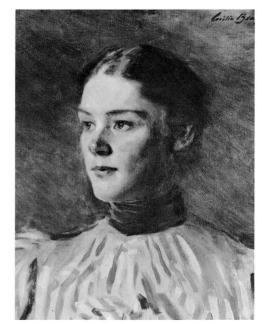

PIERRE GUSTAVE TOUTANT DE
BEAUREGARD (*left*)
(1818–1893)
Confederate general, commanded bombardment of Fort Sumter
Courtesy New-York Historical Society

CECILIA BEAUX (*right*)
(1863–1942)
Painter
Self-portrait. Courtesy Peter A. Juley & Son

THEODRIC ROMEYN BECK (*left*)
(1791–1855)
Physician, expert in medical jurisprudence
Engraved by J. F. E. Prud'homme from a painting by Robert W. Weir

GEORGE FERDINAND BECKER
(*right*)
(1847–1919)
Geologist, physicist, pioneer researcher in chemicophysical problems

JAMES CARROLL BECKWITH (*left*)
(1852–1917)
Portrait painter

JAMES P. BECKWOURTH (*right*)
(1798–c. 1867)
Fur trader, hunter
Courtesy Mercaldo Archives

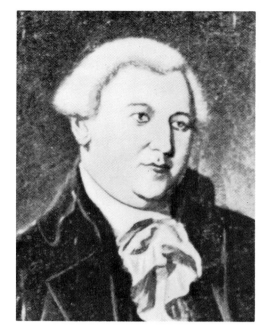

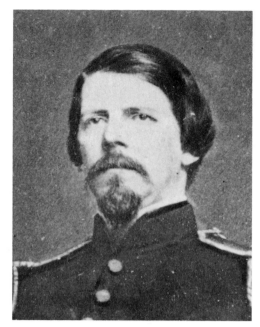

GUNNING BEDFORD (*left*)
(1747–1812)
Revolutionary political leader in Delaware;
signer of Constitution

BARNARD ELLIOTT BEE (*right*)
(1824–1861)
Confederate general; applied "stone wall"
epithet to Stonewall Jackson
Courtesy Library of Congress, Brady Collection

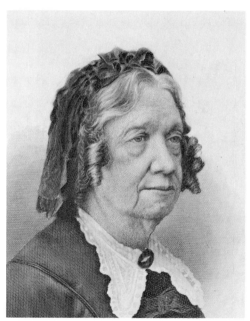

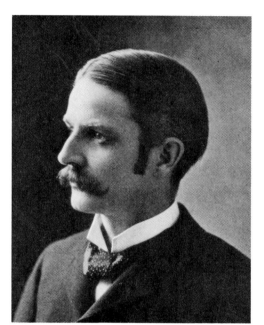

CATHARINE ESTHER BEECHER
(*left*)
(1800–1878)
Educator, reformer, writer; opposed woman
suffrage
Engraving by J. A. J. Wilcox

CHARLES EMERSON BEECHER
(*right*)
(1856–1904)
Paleontologist

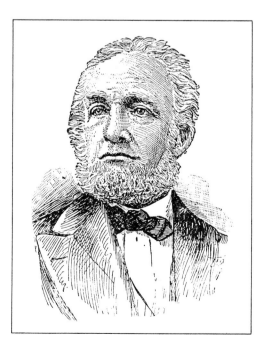

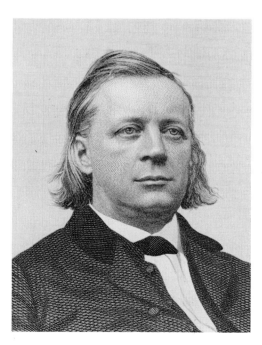

EDWARD BEECHER (*left*)
(1803–1895)
Congregational clergyman, educator; foun-
ded *The Congregationalist*

HENRY WARD BEECHER (*right*)
(1813–1887)
Congregational clergyman, orator, aboli-
tionist, reformer
Engraving by George E. Perine

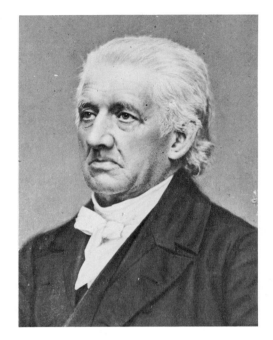

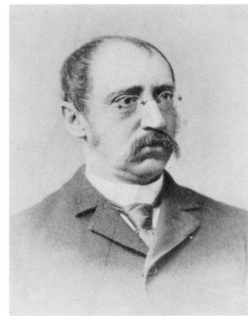

LYMAN BEECHER *(left)*
(1775–1863)
Presbyterian clergyman
Courtesy Library of Congress, Brady-Handy Collection

HENRY AUGUSTIN BEERS *(right)*
(1847–1926)
Educator, author

DAVID BELASCO *(left)*
(1854–1931)
Theatrical producer, playwright

JONATHAN BELCHER *(right)*
(1682–1757)
Colonial governor, merchant

JEREMY BELKNAP *(left)*
[Jeremiah Belknap]
(1744–1798)
Congregational clergyman, historian
Engraving by John W. Orr

WILLIAM WORTH BELKNAP *(right)*
(1829–1890)
Union general in Civil War, Secretary of
War under Grant
Courtesy Library of Congress, Brady-Handy Collection

ALEXANDER GRAHAM BELL *(left)*
(1847–1922)
Inventor, educator of the deaf

ALEXANDER MELVILLE BELL
(right)
(1819–1905)
Educator, elocutionist; father of Alexander
Graham Bell
Courtesy American Telephone and Telegraph Co.

JOHN BELL *(left)*
(1797–1869)
Congressman, U.S. Senator
Courtesy New-York Historical Society

EDWARD BELLAMY *(right)*
(1850–1898)
Writer, author of *Looking Backward*

ALBERT FITCH BELLOWS *(left)*
(1829–1883)
Painter, etcher

HENRY WHITNEY BELLOWS *(right)*
(1814–1882)
Unitarian clergyman, reformer; founded
U.S. Sanitary Commission
Courtesy Library of Congress, Brady-Handy Collection

AUGUST BELMONT (*left*)
(1816–1890)
Banker, diplomat, art collector, sportsman
Daguerreotype by Mathew Brady. Courtesy Library of Congress

AUGUST BELMONT (*right*)
(1853–1924)
Banker, sportsman
Photograph by Pach Brothers

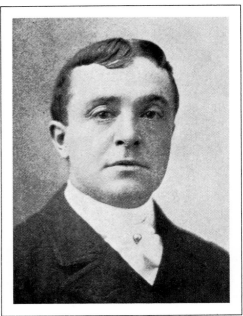

OLIVER HAZARD PERRY BELMONT
(*left*)
(1858–1908)
Banker, society leader

Mrs. OLIVER HAZARD PERRY
BELMONT (*right*)
[Mrs. William Kissam Vanderbilt, nee Alva
Ertskin Smith]
(1853–1933)
Society figure

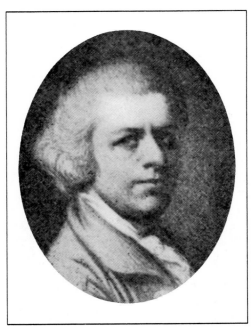

WILLIAM BARNES BEMENT (*left*)
(1817–1897)
Machine-tool designer, manufacturer; art
patron

HENRY BENBRIDGE (*right*)
(1744–1812)
Portrait painter
Self-portrait

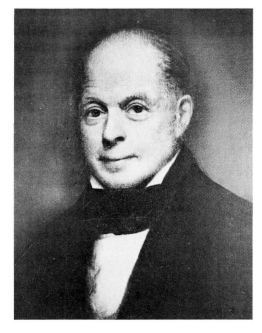

ASHER BENJAMIN (*left*)
(1773–1845)
Architect, writer
Courtesy Greenfield Public Library

JUDAH PHILIP BENJAMIN (*right*)
(1811–1884)
Confederate cabinet member; lawyer

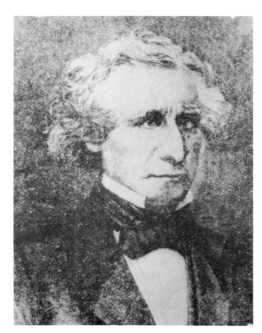

PARK BENJAMIN (*left*)
(1809–1864)
Editor, writer
Engraving by John C. Buttre

JAMES GORDON BENNETT (*right*)
(1795–1872)
Editor, publisher; founded *New York Herald*

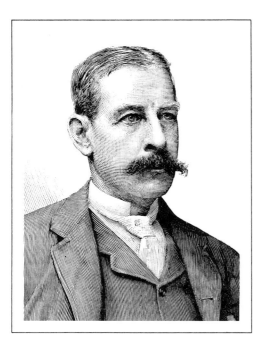

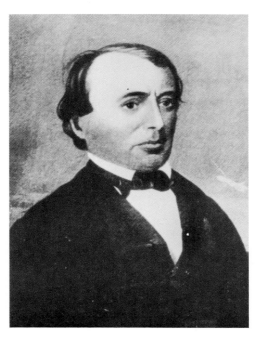

JAMES GORDON BENNETT (*left*)
(1841–1918)
Editor, publisher; dispatched Stanley to search for Livingstone

CHARLES BENT (*right*)
(1799–1847)
Pioneer, fur trader
Courtesy Mercaldo Archives

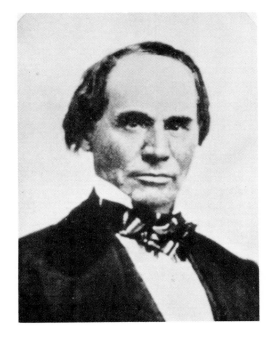

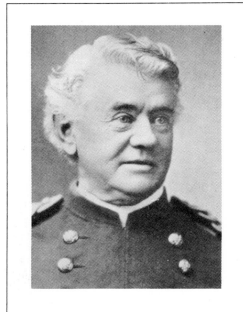

WILLIAM BENT (*left*)
(1809–1869)
Pioneer, fur trader
Courtesy Mercaldo Archives

FREDERICK W. BENTEEN (*right*)
(1834–1898)
Army officer, commanded auxiliary force
while Custer fought at Little Big Horn

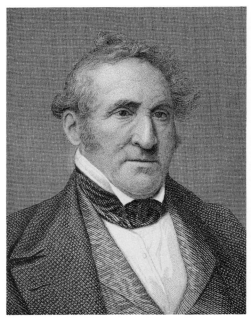

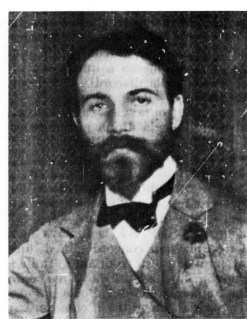

THOMAS HART BENTON (*left*)
["Old Bullion" Benton]
(1782–1858)
U.S. Senator
Engraving by John Rogers

BERNARD BERENSON (*right*)
[Bernhard Berenson]
(1865–1959)
Art critic, writer; authority on the Italian
Renaissance

VICTOR LOUIS BERGER (*left*)
(1860–1929)
Socialist leader and editor, first Socialist
elected to Congress
Courtesy Library of Congress

HENRY BERGH (*right*)
(1811–1888)
Philanthropist; founded American Society
for Prevention of Cruelty to Animals
Engraving by George E. Perine

VITUS BERING *(left)*
[Vitus Behring]
(1680–1741)
Danish navigator, explored North Pacific
Ocean; eponym of Bering Strait

SIR WILLIAM BERKELEY *(right)*
(1606–1677)
Governor of Colonial Virginia
Courtesy Maurice duPont Lee

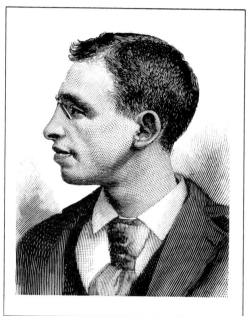

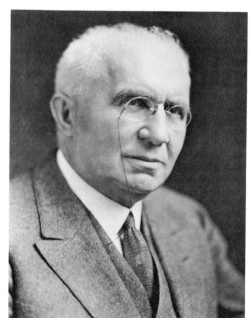

ALEXANDER BERKMAN *(left)*
(1870–1936)
Anarchist, editor, writer

EMILE BERLINER *(right)*
(1851–1929)
Inventor
Courtesy Library of Congress

SARAH BERNHARDT *(left)*
[Rosine Bernard]
(1844–1923)
French actress, toured U.S.

JOHN MacPHERSON BERRIEN
(right)
(1781–1856)
U.S. Senator, Attorney General under
Jackson
Engraving by John C. Buttre

CHARLES EDWIN BESSEY *(left)*
(1845–1915)
Botanist, educator
Courtesy New York Botanical Garden

LOUISE BETHUNE *(right)*
[nee Louise Blanchard]
(1856–1913)
First woman architect in U.S.

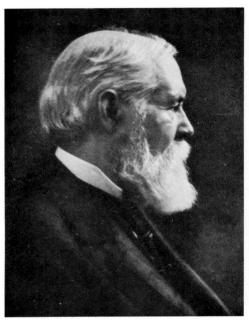

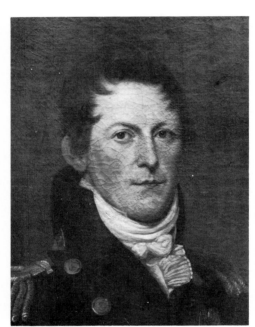

ALBERT SMITH BICKMORE *(left)*
(1839–1914)
Educator, active in founding American
Museum of Natural History

JAMES BIDDLE *(right)*
(1783–1848)
Naval officer, diplomat
Painting by Charles Willson Peale. Courtesy Independence National Historical Park

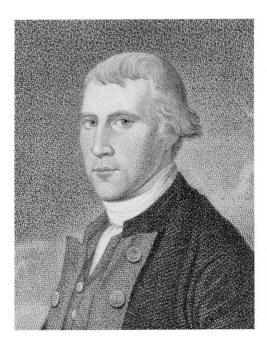

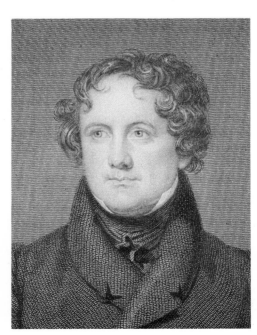

NICHOLAS BIDDLE *(left)*
(1750–1778)
Naval officer
Engraving by David Edwin

NICHOLAS BIDDLE *(right)*
(1786–1844)
Financier, writer; president, Bank of United States
Engraved by James B. Longacre and Thomas B. Welch from a painting by Rembrandt Peale

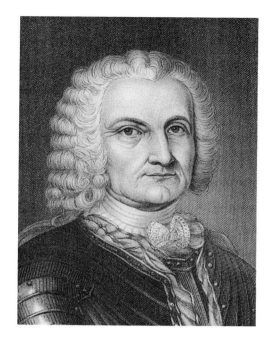 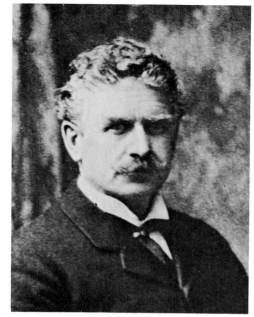

JEAN BAPTISTE LEMOYNE,
SIEUR DE BIENVILLE (*left*)
(1680–1768)
French explorer, provincial governor of
Louisiana, founder of New Orleans
Engraving by John C. Buttre

AMBROSE GWINNETT BIERCE
(*right*)
(1842–*c.* 1914)
Author, journalist
Courtesy California Historical Society

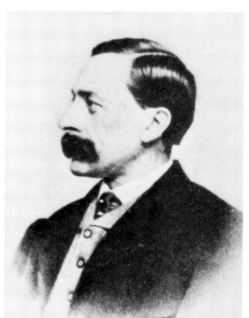 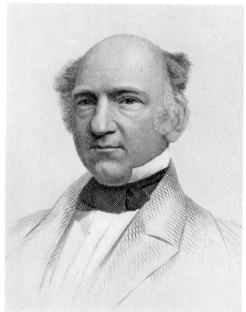

ALBERT BIERSTADT (*left*)
(1830–1902)
Painter

ERASTUS BRIGHAM BIGELOW
(*right*)
(1814–1879)
Inventor, economist; developed power looms
for carpet manufacture
Engraving by W. G. Jackman

JACOB BIGELOW (*left*)
(1786–1879)
Physician, botanist
Courtesy New York Academy of Medicine

JOHN BIGELOW (*right*)
(1817–1911)
Editor, writer, diplomat
Courtesy Library of Congress, Brady-Handy Collection

POULTNEY BIGELOW　(*left*)
(1855–1954)
Journalist, historian; founded *Outing*, first
American sports magazine

HERMANN MICHAEL BIGGS　(*right*)
(1859–1923)
Physician, bacteriologist, public health
pioneer; first to use diphtheria antitoxin
in U.S.
Courtesy New York City Department of Health

FRANK BILLINGS　(*left*)
(1854–1932)
Physician, educator
Courtesy New York Academy of Medicine

JOHN SHAW BILLINGS　(*right*)
(1838–1913)
Librarian, physician

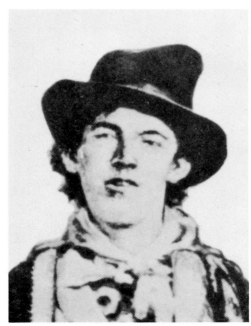

JOSH BILLINGS　(*left*)
[Henry Wheeler Shaw]
(1818–1885)
Humorist
Courtesy New-York Historical Society

BILLY THE KID　(*right*)
[William H. Bonney]
(1859–1881)
Western outlaw

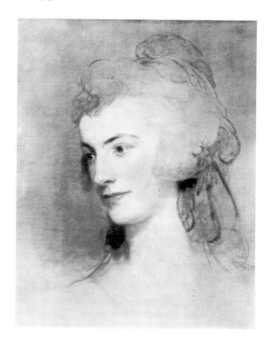

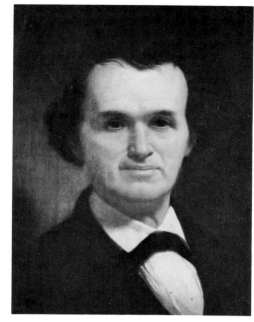

ANNE WILLING BINGHAM (*left*)
[nee Anne Willing]
(1764–1801)
Society leader, wife of William Bingham
Painting by Gilbert Stuart

GEORGE CALEB BINGHAM (*right*)
(1811–1879)
Genre and portrait painter; state official
Self-portrait. Courtesy School District, Kansas City, Missouri

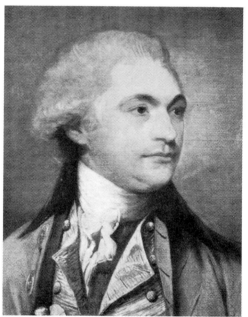

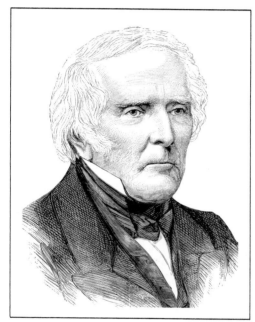

WILLIAM BINGHAM (*left*)
(1752–1804)
Banker, political leader
Painting by Gilbert Stuart

HORACE BINNEY (*right*)
(1780–1875)
Lawyer, legal writer

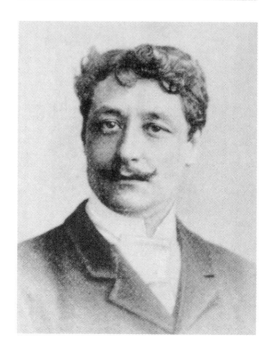

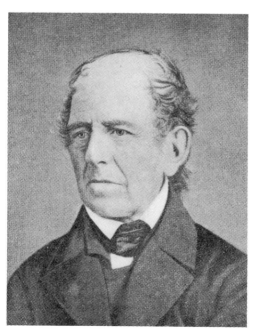

REGINALD BATHURST BIRCH
(*left*)
(1856–1943)
Magazine illustrator

THOMAS BIRCH (*right*)
(1779–1851)
Painter

ROBERT MONTGOMERY BIRD
(*left*)
(1806–1854)
Playwright, novelist, editor, physician
Courtesy University of Pennsylvania

DAVID BELL BIRNEY (*right*)
(1825–1864)
Union general in Civil War
Courtesy Library of Congress, Brady-Handy Collection

JAMES GILLESPIE BIRNEY (*left*)
(1792–1857)
Abolitionist, politician

WILLIAM BIRNEY (*right*)
(1819–1907)
Union general in Civil War; lawyer, reformer

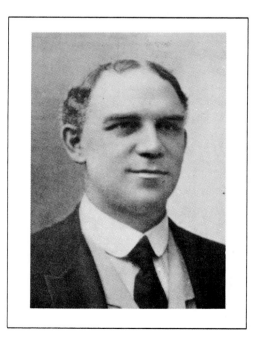

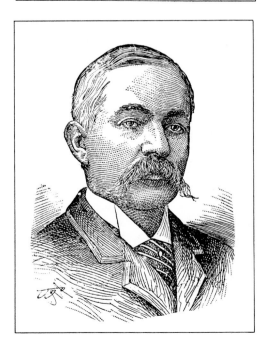

DAVID SCULL BISPHAM (*left*)
(1857–1921)
Operatic baritone

MELVILLE REUBEN BISSELL (*right*)
(1843–1889)
Inventor, manufactured first carpet sweeper

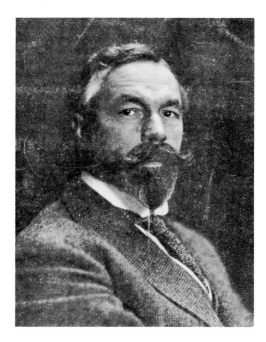

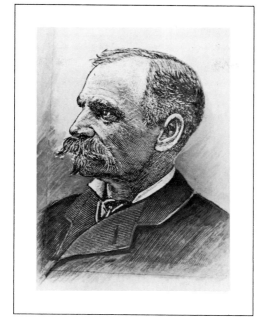

KARL THEODORE FRANCIS
BITTER (*left*)
(1867–1915)
Sculptor

BLACK BART (*right*)
[Charles Boles; Charles E. Bolton]
(*c.*1835–*c.*1899)
Western outlaw; poet
Courtesy Mercaldo Archives

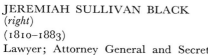

GREENE VARDIMAN BLACK (*left*)
(1836–1915)
Dental pathologist, educator; developed
basic method for making dental amalgam
alloys

JEREMIAH SULLIVAN BLACK
(*right*)
(1810–1883)
Lawyer; Attorney General and Secretary
of State under Buchanan
Courtesy Library of Congress, Brady-Handy Collection

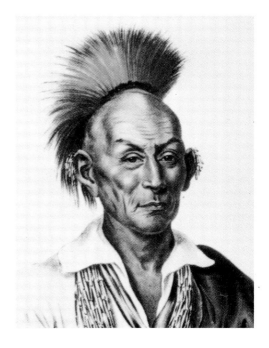

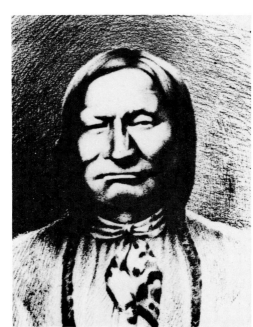

BLACK HAWK (*left*)
[Ma-ka-tae-mish-kia-kiak]
(1767–1838)
Sac (Sauk) Indian chief

BLACK KETTLE (*right*)
(*c.* 1803–1868)
Cheyenne Indian chief
*Drawing by Herschel Lee. Courtesy Library, State
Historical Society of Colorado*

ANTOINETTE LOUISA BLACKWELL
(*left*)
[nee Antoinette Louisa Brown]
(1825–1921)
Congregational minister, reformer

ELIZABETH BLACKWELL (*right*)
(1821–1910)
Physician, first woman medical doctor in
modern times

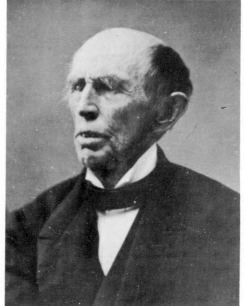

JAMES GILLESPIE BLAINE (*left*)
(1830–1893)
U.S. Senator, Secretary of State under
Garfield and Benjamin Harrison

FRANCIS PRESTON BLAIR (*right*)
(1791–1876)
Journalist, politician; owned Blair House,
Washington, D.C.
Courtesy National Archives, Brady Collection

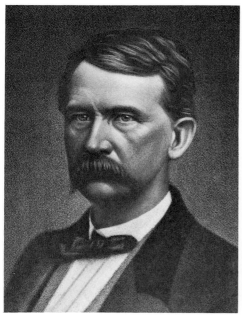

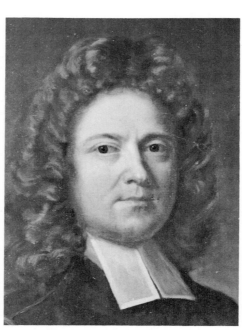

FRANCIS PRESTON BLAIR (*left*)
(1821–1875)
Congressman, Union general in Civil War
Engraving by George E. Perine

JAMES BLAIR (*right*)
(1655–1743)
Educator; founder, first president, College
of William and Mary
Courtesy College of William and Mary

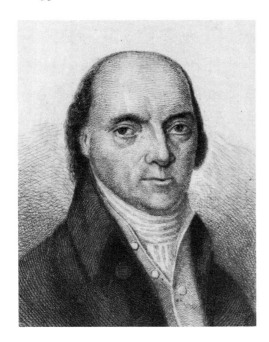
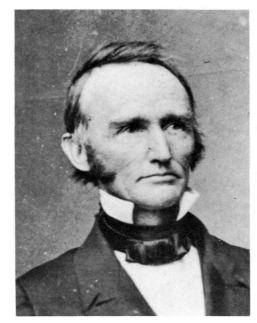

JOHN BLAIR (*left*)
(1732–1800)
Associate justice, U.S. Supreme Court; signer of Constitution
Engraving by Albert Rosenthal

MONTGOMERY BLAIR (*right*)
(1813–1883)
Postmaster General under Lincoln; lawyer
Courtesy New-York Historical Society

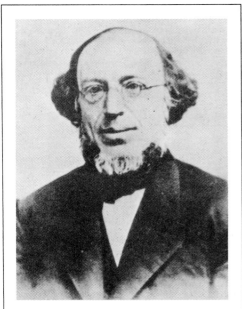
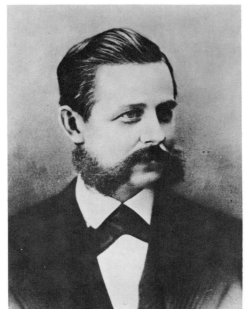

JAMES BLAKE (*left*)
(1815–1893)
Clinician, chemical biologist; first to recommend open-air treatment of tuberculosis
Courtesy New York Academy of Medicine

LYMAN REED BLAKE (*right*)
(1835–1883)
Inventor, shoe manufacturer
Courtesy Smithsonian Institution

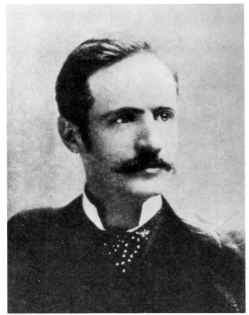
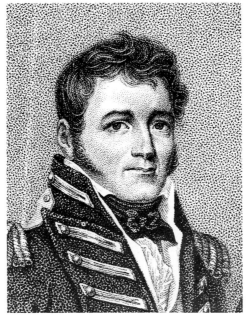

RALPH ALBERT BLAKELOCK (*left*)
(1847–1919)
Landscape painter

JOHNSTON BLAKELY (*right*)
(1781–1814)
Naval officer; commanded the *Wasp*, War of 1812
Engraving by Thomas Gimbrede

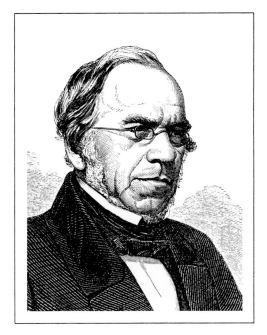

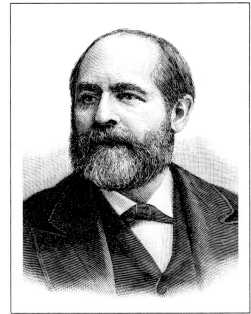

THOMAS BLANCHARD　(*left*)
(1788–1864)
Inventor
Courtesy Burndy Library

RICHARD PARKS BLAND　(*right*)
(1835–1899)
Lawyer, Congressman

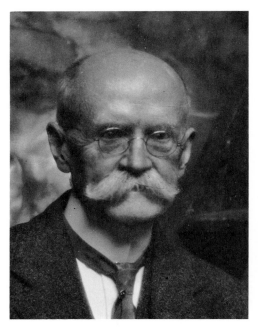

EDWIN HOWLAND BLASHFIELD
(*left*)
(1848–1936)
Painter; decorated central dome of Library
of Congress
Courtesy Peter A. Juley & Son

SAMUEL BLATCHFORD　(*right*)
(1820–1893)
Associate justice, U.S. Supreme Court
Engraving by R. G. Tietze

HELENA PETROVNA BLAVATSKY
(*left*)
[nee Helena Petrovna Hahn]
(1831–1891)
Occultist, organized Theosophical Society
Courtesy United Lodge of Theosophists

ALBERT TAYLOR BLEDSOE　(*right*)
(1809–1877)
Confederate official, editor, writer

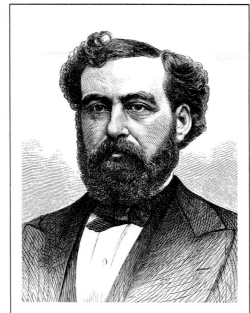

HARMAN BLENNERHASSETT (*left*)
(1765–1831)
Planter, involved in Burr conspiracy
Engraving by Alexander H. Ritchie

PHILIP PAUL BLISS (*right*)
(1838–1876)
Singing evangelist, writer of gospel hymns

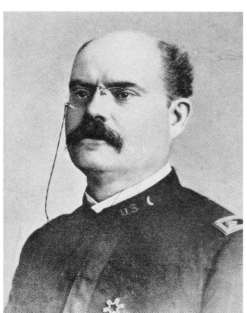

TASKER HOWARD BLISS (*left*)
(1853–1930)
Army officer, diplomat

ANTONIO BLITZ (*right*)
(1810–1877)
Magician, ventriloquist
Courtesy Milbourne Christopher Collection

CHARLES BLONDIN (*left*)
[Jean François Gravelet]
(1824–1897)
French acrobat, crossed Niagara Falls on
tightrope
Courtesy New-York Historical Society

AMELIA BLOOMER (*right*)
[nee Amelia Jenks]
(1818–1894)
Social reformer; advocated full trousers for
women, called "bloomers"
Engraving by John C. Buttre

MAURICE BLOOMFIELD (*left*)
(1855–1928)
Philologist, Orientalist
Courtesy Julia Bloomfield

LYMAN GUSTAVE BLOOMINGDALE
(*right*)
(1841–1905)
Merchant
Courtesy Bloomingdale Properties

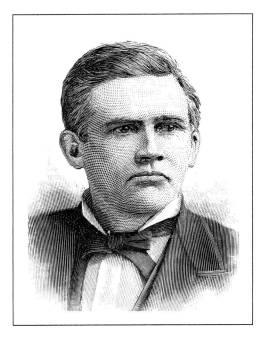

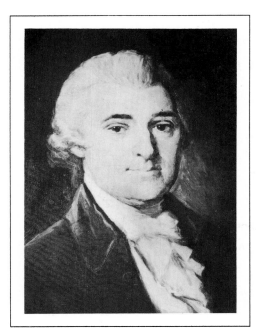

JAMES HENDERSON BLOUNT (*left*)
(1837–1903)
Lawyer, Congressman, diplomat

WILLIAM BLOUNT (*right*)
(1749–1800)
Politician, signer of Constitution

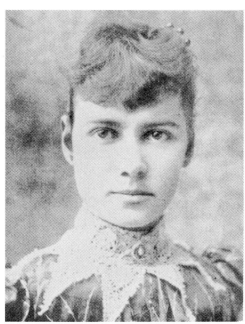

NELLIE BLY (*left*)
[Elizabeth Seaman; nee Elizabeth
Cochrane]
(1867–1922)
Journalist; traveled around world in 72 days
to outdo Verne's Phileas Fogg

FRANZ BOAS (*right*)
(1858–1942)
Anthropologist, ethnologist, writer
Courtesy Columbiana Collection, Columbia University

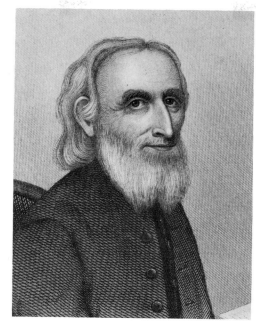

MAXIME BÔCHER (*left*)
(1867–1919)
Mathematician

MARTIN BOEHM (*right*)
(1725–1812)
Mennonite bishop; a founder and bishop of
the Church of United Brethren in Christ

JOHN BOGART (*left*)
(1836–1920)
Civil engineer

EDWARD WILLIAM BOK (*right*)
(1863–1930)
Editor, writer, philanthropist

GEORGE HENRY BOKER (*left*)
(1823–1890)
Playwright, poet, diplomat

JACOB BOLL (*right*)
(1828–1880)
Geologist, naturalist
Courtesy Peabody Museum, Harvard University

FRANK BOLLES (*left*)
(1856–1894)
Nature writer
Courtesy Harvard University Archives

WENDEL BOLLMAN (*right*)
(1814–1884)
Bridge designer, developed first iron-truss
railroad bridge
*Courtesy Smithsonian Institution and Dr. Stuart
Christhilf*

HENRY CARRINGTON BOLTON
(*left*)
(1843–1903)
Chemist, folklorist, bibliographer; compiled
bibliography on uranium

ELIZABETH BONAPARTE (*right*)
[nee Elizabeth Patterson]
(1785–1879)
American-born wife of Jérôme Bonaparte;
marriage annulled by Napoleon
Painting by Gilbert Stuart

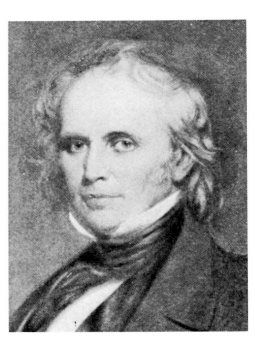

CARRIE JACOBS BOND (*left*)
(1862–1946)
Songwriter, author of "A Perfect Day"
Courtesy Library of Congress

WILLIAM CRANCH BOND (*right*)
(1789–1859)
Astronomer, director of Harvard Obser-
vatory

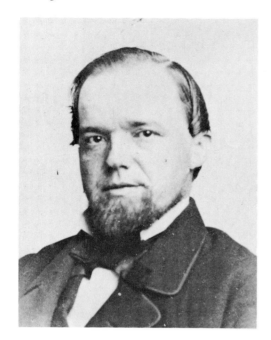

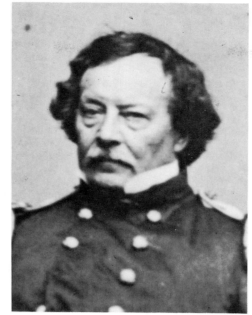

ROBERT BONNER (*left*)
(1824–1899)
Publisher, turfman; founded *New York Ledger*
Courtesy New-York Historical Society

BENJAMIN LOUIS EULALIE
DE BONNEVILLE (*right*)
(1796–1878)
Army officer, explorer
Courtesy Meserve Collection

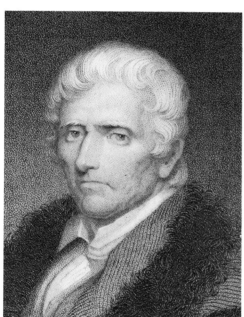

DANIEL BOONE (*left*)
(1734–1820)
Pioneer
Engraved by James B. Longacre from a painting by Chester Harding

AGNES BOOTH (*right*)
[nee Marian Agnes Land Rookes]
(1846–1910)
Actress

BALLINGTON BOOTH (*left*)
(1859–1940)
Leader of Salvation Army in U.S., founded
Volunteers of America

EDWIN THOMAS BOOTH (*right*)
(1833–1893)
Actor
Courtesy New-York Historical Society

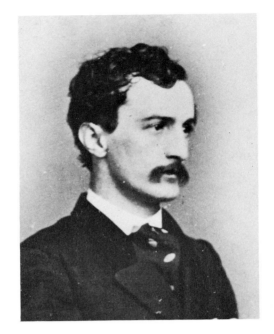

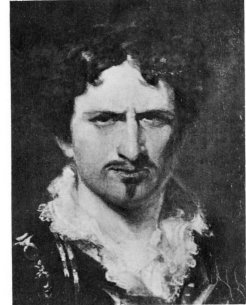

JOHN WILKES BOOTH *(left)*
(1838–1865)
Actor, assassin of Abraham Lincoln
Courtesy New-York Historical Society

JUNIUS BRUTUS BOOTH *(right)*
(1796–1852)
Actor
Painting by John Neagle. Courtesy Library of Congress

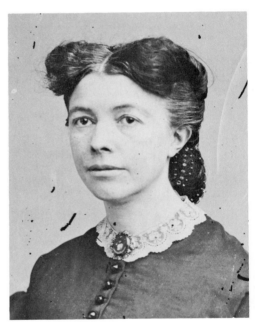

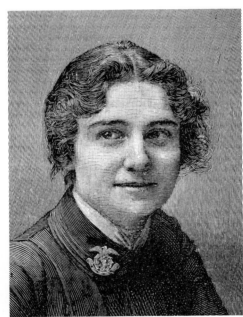

MARY LOUISE BOOTH *(left)*
(1831–1889)
Translator, historian; first editor, *Harper's Bazaar*
Courtesy Library of Congress, Brady-Handy Collection

MAUD BALLINGTON BOOTH *(right)*
[nee Maud Charlesworth]
(1865–1948)
Reformer, president of Volunteers of America; a founder of Parent-Teachers Association

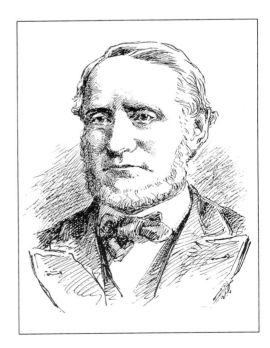

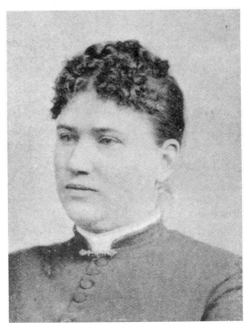

ANDREW J. BORDEN *(left)*
(c. 1822–1892)
Banker in Fall River, Massachusetts; father of Lizzie Borden; murder victim

Mrs. ANDREW J. BORDEN *(right)*
[nee Abby Durfee Gray]
(1828–1892)
Stepmother of Lizzie Borden; murder victim

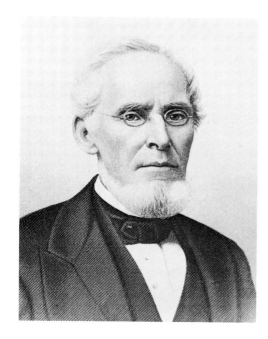

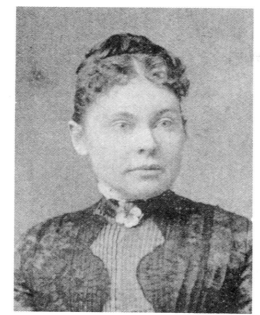

GAIL BORDEN (*left*)
(1801–1874)
Surveyor; developed condensed milk
Courtesy Borden Co.

LIZZIE ANDREW BORDEN (*right*)
(1860–1927)
Defendant in murder trial, Fall River,
Massachusetts, 1892; acquitted

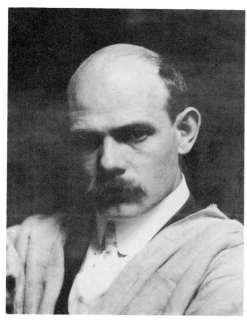

GUTZON BORGLUM (*left*)
[John Gutzon de la Mothe Borglum]
(1871–1941)
Sculptor, painter; designed presidential
figures on Mount Rushmore
Courtesy Library of Congress

SOLON HANNIBAL BORGLUM
(*right*)
(1868–1922)
Sculptor

LEWIS BOSS (*left*)
(1846–1912)
Astronomer

DION BOUCICAULT (*right*)
[Dion Bourcicault; Dionysius Lardner
Boursiquot]
(c. 1820–1890)
Playwright, actor; wrote *The Octoroon*

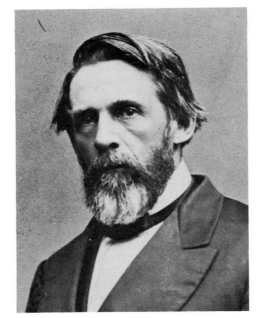

ELIAS BOUDINOT *(left)*
(1740–1821)
President of Continental Congress
Engraved by John W. Paradise from a painting by
Samuel L. Waldo and William Jewett

GEORGE SEWALL BOUTWELL
(right)
(1818–1905)
Congressman, U.S. Senator, Secretary of
the Treasury under Grant
Courtesy New-York Historical Society

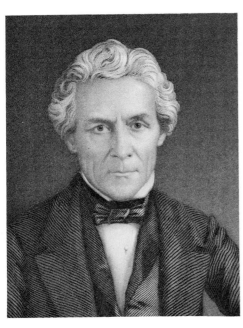

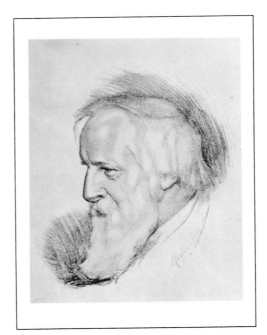

JOHN BOUVIER *(left)*
(1787–1851)
Jurist, compiled *Law Dictionary*
Engraving by Thomas B. Welch

HENRY INGERSOLL BOWDITCH
(right)
(1808–1892)
Physician, abolitionist; instituted public
health measures
Courtesy New York Academy of Medicine

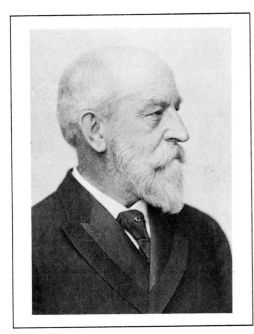

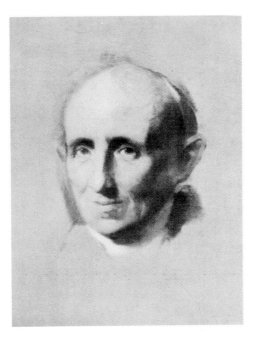

HENRY PICKERING BOWDITCH
(left)
(1840–1911)
Physiologist, educator; pioneered in study of
the growth of children
Courtesy Harvard University Archives

NATHANIEL BOWDITCH *(right)*
(1773–1838)
Mathematician, astronomer
Painting by Gilbert Stuart

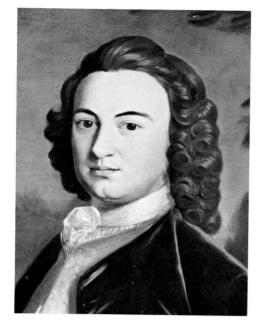

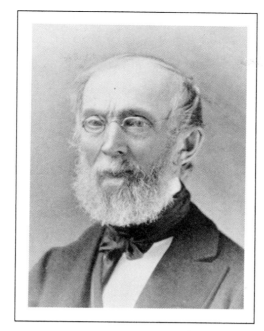

JAMES BOWDOIN (*left*)
(1726–1790)
Revolutionary leader, delegate to Constitutional Convention; eponym of Bowdoin College
Painting by Robert Feke. Courtesy Bowdoin College Museum of Art

FRANCIS BOWEN (*right*)
(1811–1890)
Philosopher, political economist, educator

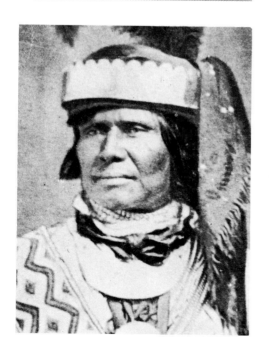

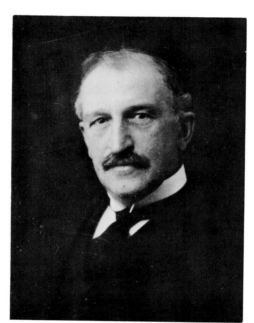

JAMES BOWIE (*left*)
(c. 1796–1836)
Texas soldier, reputed originator of Bowie knife
Courtesy Texas State Library

RICHARD ROGERS BOWKER (*right*)
(1848–1933)
Publisher, editor, writer
Courtesy R. R. Bowker Co.

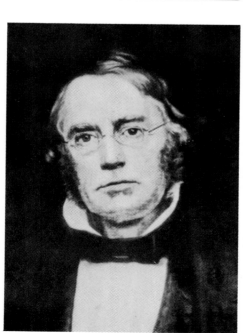

BILLY BOWLEGS (*left*)
[Holatamico]
(1808–1859)
Seminole Indian chief
Courtesy Bureau of American Ethnology, Smithsonian Institution

SAMUEL BOWLES (*right*)
(1797–1851)
Publisher, editor; founded *Springfield Republican*
Courtesy "Springfield Republican"

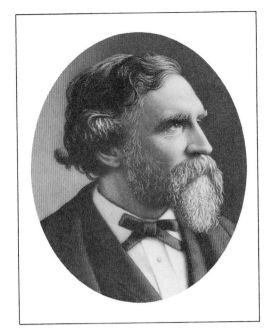

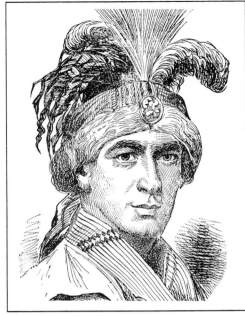

SAMUEL BOWLES (*left*)
(1826–1878)
Journalist, editor of *Springfield Republican*
Engraving by Samuel Sartain

WILLIAM AUGUSTUS BOWLES
(*right*)
(1763–1805)
Adventurer among Creek Indians; sought
to drive Spaniards from Florida

BORDEN PARKER BOWNE (*left*)
(1847–1910)
Philosopher, educator; author of *Personalism*
Courtesy Boston University Archives

BELLE BOYD (*right*)
[Belle Boyd Hardinge]
(1843–1900)
Confederate spy
Courtesy Confederate Museum

SETH BOYDEN (*left*)
(1788–1870)
Invented patent leather

URIAH ATHERTON BOYDEN (*right*)
(1804–1879)
Engineer, invented turbine water wheel
Courtesy Smithsonian Institution

HJALMAR HJORTH BOYESEN
(*left*)
(1848–1895)
Novelist, critic, educator

JOHN M. BOZEMAN (*right*)
(1835–1867)
Miner, trailmaker; crossed Continental
Divide at Bozeman Pass
Courtesy Montana State College

CHARLES LORING BRACE (*left*)
(1826–1890)
Social reformer, writer; founded Children's
Aid Society

HUGH HENRY BRACKENRIDGE
(*right*)
(1748–1816)
Jurist, political writer, novelist, playwright
Painting by Gilbert Stuart

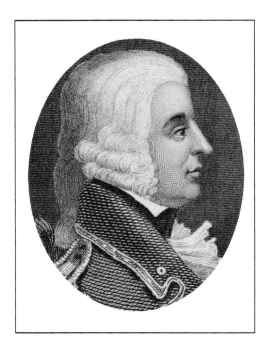

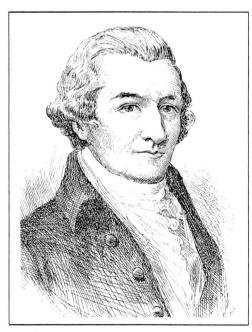

EDWARD BRADDOCK (*left*)
(1695–1755)
Commander of British forces in American
colonies

WILLIAM BRADFORD (*right*)
(1722–1791)
Pioneer printer; "Patriot Printer of 1776"

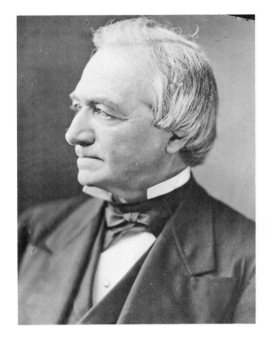
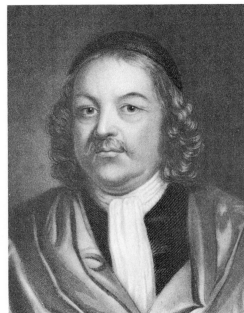

JOSEPH P. BRADLEY *(left)*
(1813–1892)
Associate justice, U.S. Supreme Court
Courtesy Library of Congress, Brady-Handy Collection

SIMON BRADSTREET *(right)*
(1603–1697)
Governor of Massachusetts Bay Colony;
husband of Anne Bradstreet
Engraving by H. W. Smith

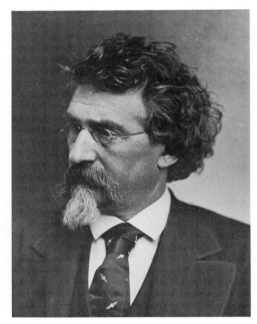

DIAMOND JIM BRADY *(left)*
[James Buchanan Brady]
(1856–1917)
Financier, playboy
Courtesy Free Library of Philadelphia

MATHEW B. BRADY *(right)*
(c. 1823–1896)
Photographer
Photograph by L. C. Handy

BRAXTON BRAGG *(left)*
(1817–1876)
Confederate general
Engraving by John A. O'Neill

THOMAS BRAGG *(right)*
(1810–1872)
Confederate Attorney General
Courtesy New-York Historical Society

DAVID LEGGE BRAINARD (*left*)
(1856–1946)
Arctic explorer, army officer

LOUIS DEMBITZ BRANDEIS (*right*)
(1856–1941)
Lawyer, social reformer; associate justice,
U.S. Supreme Court
Courtesy Library of Congress

WILLIAM COWPER BRANN (*left*)
(1855–1898)
Journalist, founded *The Iconoclast*

SAMUEL BRANNAN (*right*)
(1819–1889)
California pioneer, led Mormon group to
California
Courtesy California Historical Society

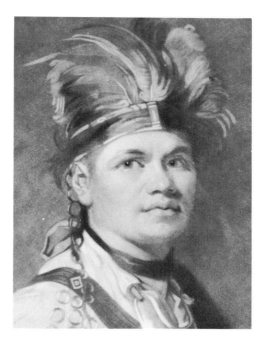

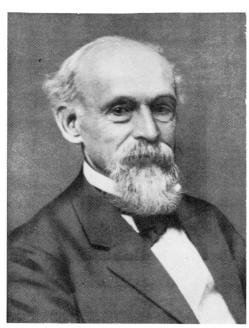

JOSEPH BRANT (*left*)
[Thayendanegea]
(1742–1807)
Mohawk Indian chief, leader in Cherry
Valley massacre
Engraved by John R. Smith from a painting by George
Romney. Courtesy New-York Historical Society

JOHN ALFRED BRASHEAR (*right*)
(1840–1920)
Manufacturer of astronomical lenses

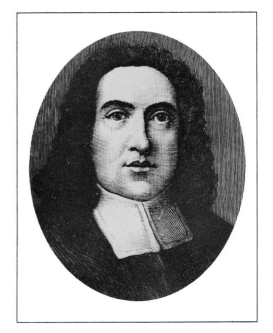

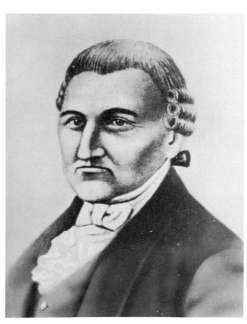

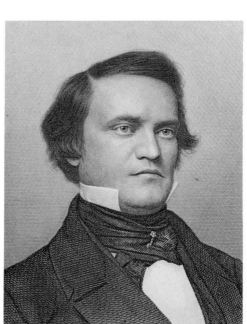

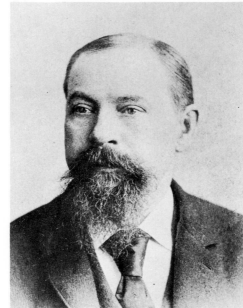

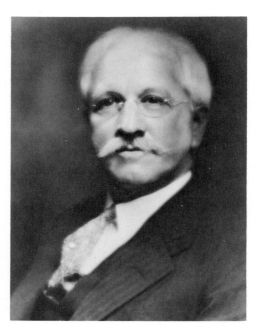

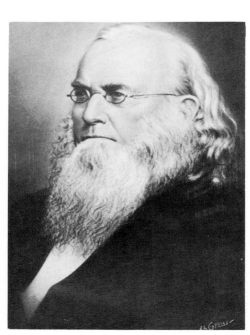

THOMAS BRAY (*left*)
(1656–1730)
Clergyman; organized Anglican Church in Maryland; founded Society for Propagation of Gospel
Courtesy Maryland Historical Society

GEORGE BAILEY BRAYTON (*right*)
(1830–1892)
Inventor, developed first successful heavy oil internal-combustion engine in U.S.
Courtesy Smithsonian Institution

DAVID BREARLY (*left*)
(1745–1790)
Jurist, signer of Constitution; wrote landmark decision concerning judicial review

JAMES HENRY BREASTED (*right*)
(1865–1935)
Orientalist, Egyptologist, archaeologist, historian
Courtesy University of Chicago

JOHN CABELL BRECKINRIDGE
(*left*)
(1821–1875)
Vice-President of U.S., 1857–1861; Confederate Secretary of War
Engraved by John C. Buttre from a daguerreotype by Mathew Brady

SIDNEY BREESE (*right*)
(1800–1878)
Illinois political leader, jurist, U.S. Senator
Courtesy Illinois State Historical Library

ROGER PATRICK BRESNAHAN
(*left*)
(1880–1944)
Baseball catcher, member of Baseball Hall of Fame
Courtesy National Baseball Hall of Fame

GEORGE PLATT BRETT (*right*)
(1858–1936)
Book publisher, president of Macmillan Co.
Photograph by Pirie MacDonald. Courtesy George P. Brett, Jr.

DAVID JOSIAH BREWER (*left*)
(1837–1910)
Associate justice, U.S. Supreme Court

JAMES BREWSTER (*right*)
(1788–1866)
Manufacturer, railroad promoter, philanthropist

JIM BRIDGER (*left*)
[James Bridger]
(1804–1881)
Pioneer, scout
Courtesy National Archives

LAURA DEWEY BRIDGMAN (*right*)
(1829–1889)
First blind deaf-mute successfully educated

CHARLES AUGUSTUS BRIGGS
(*left*)
(1841–1913)
Theologian, educator; tried for heresy by
Presbytery of New York

JAMES WILSON BRIGHT (*right*)
(1852–1926)
Philologist, educator, editor
Courtesy Modern Language Association of America

DANIEL GARRISON BRINTON
(*left*)
(1837–1899)
Anthropologist

ALBERT BRISBANE (*right*)
(1809–1890)
Social reformer, exponent of Fourierism
Courtesy Tamiment Institute Library

ARTHUR BRISBANE (*left*)
(1864–1936)
Editor and columnist for Hearst newspapers

BENJAMIN HELM BRISTOW (*right*)
(1832–1896)
Lawyer, Secretary of the Treasury under
Grant

ELIZABETH BRITTON (*left*)
[nee Elizabeth Gertrude Knight]
(1858–1934)
Botanist
Courtesy New York Botanical Garden

NATHANIEL LORD BRITTON (*right*)
(1859–1934)
Botanist, director of New York Botanical
Garden
Courtesy New York Botanical Garden

STEVE BRODIE (*left*)
(c.1863–c.1901)
Daredevil, reputed to have jumped from
Brooklyn Bridge, July 23, 1886
Courtesy New-York Historical Society

Sɪʀ PHILIP BOWES VERE BROKE
(*right*)
(1776–1841)
British naval officer in War of 1812; cap-
tured the *Chesapeake*

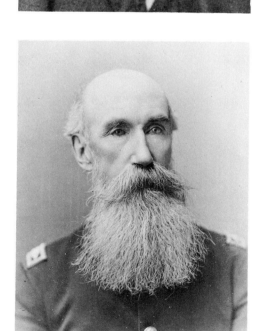

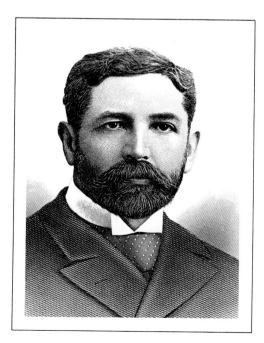

JOHN MERCER BROOKE (*left*)
(1826–1906)
Scientist, inventor, naval officer; refitted
the *Merrimack*
Courtesy Virginia Military Institute

ROBERT SOMERS BROOKINGS
(*right*)
(1850–1932)
Merchant, philanthropist; founded Brook-
ings Institution
Engraving by E. G. Williams & Bro.

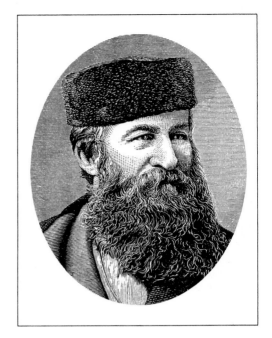

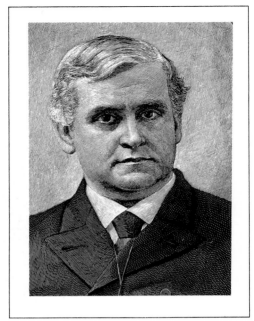

NOAH BROOKS *(left)*
(1830–1903)
Journalist, writer

PHILLIPS BROOKS *(right)*
(1835–1893)
Episcopal bishop, author of "O Little Town
of Bethlehem"
Engraving by Thomas Johnson

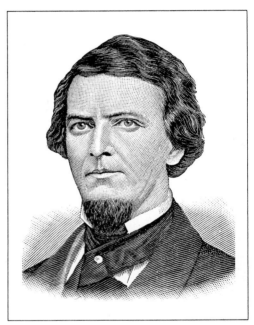

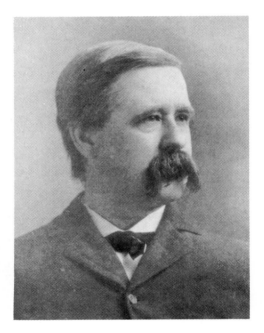

PRESTON SMITH BROOKS *(left)*
(1819–1857)
Congressman; assaulted Senator Charles
Sumner in Senate chamber

WILLIAM KEITH BROOKS *(right)*
(1848–1908)
Zoologist, educator

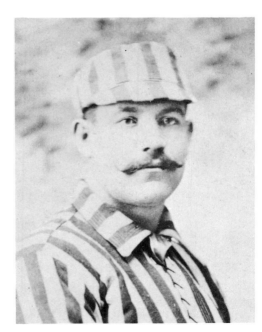

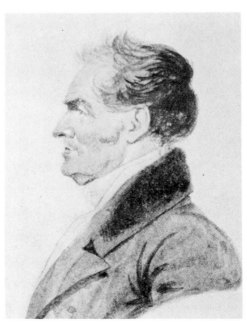

DAN BROUTHERS *(left)*
[Dennis Brouthers]
(1858–1932)
Baseball infielder, member of Baseball Hall
of Fame
Courtesy National Baseball Hall of Fame

JOHN HENRI ISAAC BROWERE
(right)
(1792–1834)
Sculptor

ADDISON BROWN (*left*)
(1830–1913)
Jurist, botanist

ALEXANDER BROWN (*right*)
(1764–1834)
Banker, financier

BENJAMIN GRATZ BROWN (*left*)
(1826–1885)
U.S. Senator, Governor of Missouri

CHARLES BROCKDEN BROWN
(*right*)
(1771–1810)
Novelist
Engraved by Henry B. Hall from a painting attributed to James Sharples, Sr.

FRANCIS BROWN (*left*)
(1784–1820)
Clergyman, educator; president of Dartmouth College
Painted by H. C. Pratt from a painting by Samuel F. B. Morse. Courtesy Dartmouth College

GEORGE LORING BROWN (*right*)
(1814–1889)
Landscape painter
Engraving by W. G. Jackman

HENRY BILLINGS BROWN (*left*)
(1836–1913)
Associate justice, U.S. Supreme Court

HENRY KIRKE BROWN (*right*)
(1814–1886)
Sculptor
Courtesy Library of Congress, Brady-Handy Collection

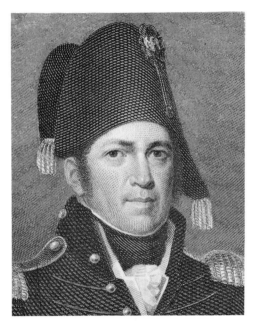

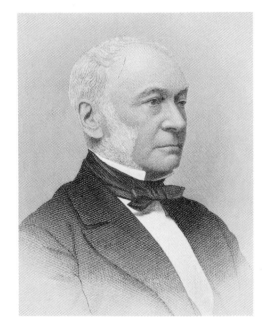

JACOB JENNINGS BROWN (*left*)
(1775–1828)
Army officer
*Engraved by Asher B. Durand from a painting by
James Herring after a painting by John Wesley Jarvis*

JAMES BROWN (*right*)
(1791–1877)
Financier
Engraving by George E. Perine

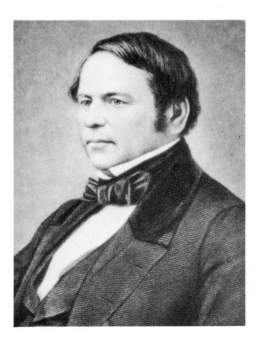

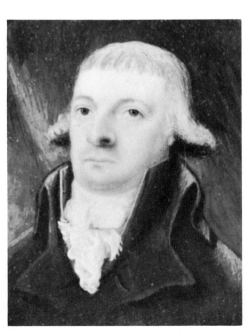

JAMES BROWN (*left*)
(1800–1855)
Book publisher, organized Little, Brown
and Co.
Courtesy Little, Brown and Co.

JOHN BROWN (*right*)
(1736–1803)
Rhode Island merchant, philanthropist
*Painting by Edward G. Malbone. Courtesy New-York
Historical Society*

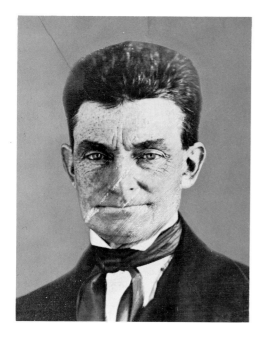
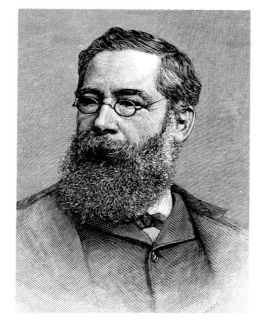

JOHN BROWN (*left*)
[John Brown of Osawatomie]
(1800–1859)
Abolitionist, Northern martyr
Courtesy Library of Congress, Brady-Handy Collection

JOHN GEORGE BROWN (*right*)
(1831–1913)
Genre painter

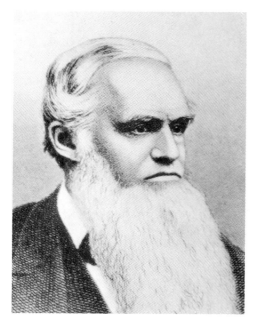
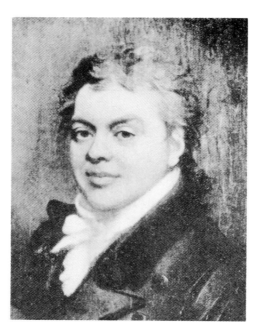

JOSEPH ROGERS BROWN (*left*)
(1810–1876)
Precision tool inventor, manufacturer; co-founder, Brown & Sharpe Co.

MATHER BROWN (*right*)
(1761–1831)
Portrait painter
Self-portrait

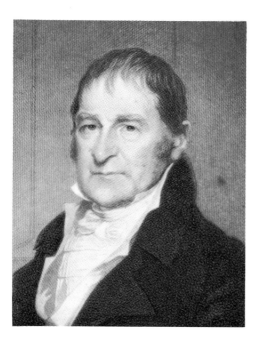
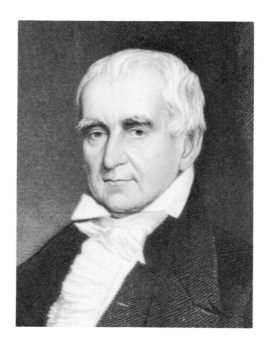

MOSES BROWN (*left*)
(1738–1836)
Textile manufacturer, philanthropist
Engraved by H. W. Smith from a painting by Gilbert Stuart

NICHOLAS BROWN (*right*)
(1769–1841)
Merchant, philanthropist; eponym of Brown University
Engraved by H. W. Smith from a painting by Chester Harding

OLYMPIA BROWN (*left*)
(1835–1926)
Woman-suffragist; first woman ordained
minister in regularly constituted church in
U. S.

FRANCIS FISHER BROWNE (*right*)
(1843–1913)
Editor, anthologist

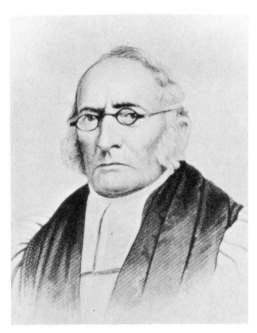

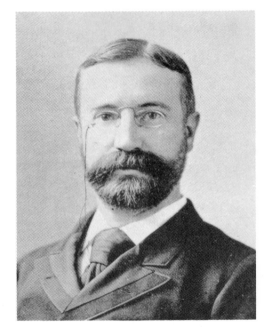

THOMAS CHURCH BROWNELL
(*left*)
(1779–1865)
Episcopal bishop, educator
Engraving by John C. Buttre

WILLIAM CRARY BROWNELL
(*right*)
(1851–1928)
Editor, literary critic

JOHN MOSES BROWNING (*left*)
(1855–1926)
Arms manufacturer; invented Browning
automatic rifle, machine gun
Courtesy Church of Jesus Christ of Latter-Day Saints

ORVILLE HICKMAN BROWNING
(*right*)
(1806–1881)
Lawyer, U.S. Senator, Secretary of the
Interior under Andrew Johnson
Courtesy Library of Congress, Brady-Handy Collection

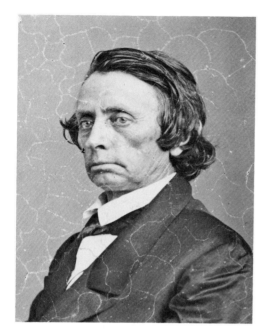

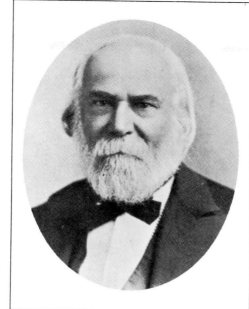

WILLIAM GANNAWAY BROWNLOW
(*left*)
(1805–1877)
Itinerant Methodist preacher, Governor of Tennessee, U.S. Senator; known as "The Fighting Parson"
Courtesy Library of Congress, Brady-Handy Collection

CHARLES ÉDOUARD BROWN-SÉQUARD (*right*)
(*c.* 1817–1894)
Physician, endocrinologist
Courtesy New York Academy of Medicine

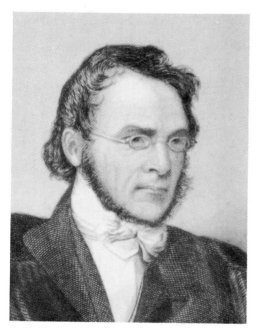

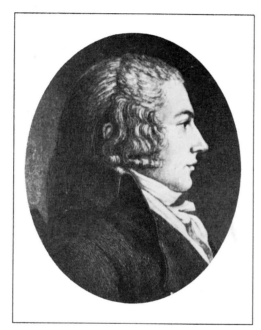

ORESTES AUGUSTUS BROWNSON
(*left*)
(1803–1876)
Clergyman, writer
Engraving by Alexander L. Dick

ARCHIBALD BRUCE (*right*)
(1777–1818)
Mineralogist, physician
Engraving by C. B. J. F. de Saint-Mémin

BLANCHE K. BRUCE (*left*)
(1841–1898)
U.S. Senator from Mississippi
Courtesy Library of Congress, Brady-Handy Collection

GEORGE BRUCE (*right*)
(1781–1866)
Type founder, printer
Engraving by George E. Perine

CONSTANTINO BRUMIDI *(left)*
(1805–1880)
Painter, created frescoes of U.S. Capitol
Courtesy Library of Congress, Brady-Handy Collection

CHARLES FRANCIS BRUSH *(right)*
(1849–1929)
Electrical engineer, inventor

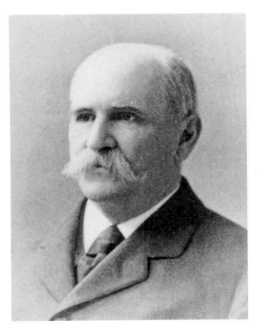

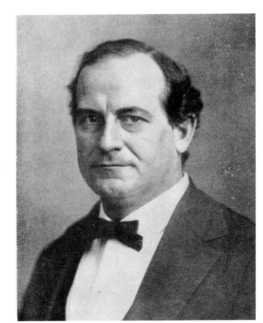

GEORGE JARVIS BRUSH *(left)*
(1831–1912)
Mineralogist, educator

WILLIAM JENNINGS BRYAN *(right)*
(1860–1925)
Political leader, orator, presidential candidate; Secretary of State under Wilson

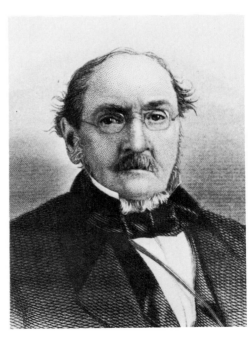

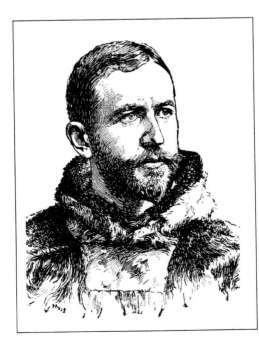

GRIDLEY BRYANT *(left)*
(1789–1867)
Pioneer railroad engineer, inventor
Engraving by Henry B. Hall

HENRY GRIER BRYANT *(right)*
(1859–1932)
Arctic explorer, geographer

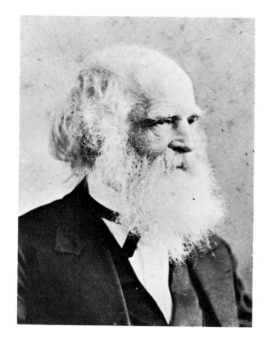
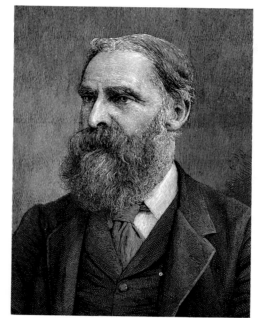

WILLIAM CULLEN BRYANT *(left)*
(1794–1878)
Poet, editor
Photograph by Napoleon Sarony. Courtesy New-York Historical Society

JAMES BRYCE *(right)*
[Viscount Bryce of Dechmont]
(1838–1922)
British ambassador to U.S., author of *The American Commonwealth*
Engraving by Thomas Johnson

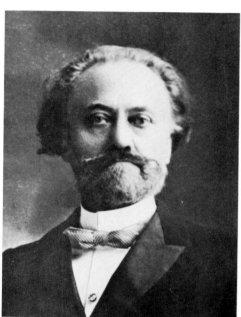
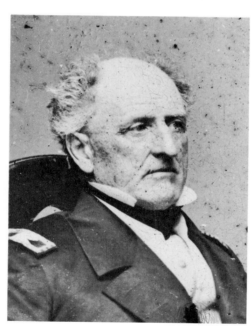

JOSEPH BUATIER *(left)*
[Buatier de Kolta]
(1847–1903)
Magician
Courtesy Milbourne Christopher Collection

FRANKLIN BUCHANAN *(right)*
(1800–1874)
U.S. naval officer; Confederate admiral
Courtesy Library of Congress, Brady Collection

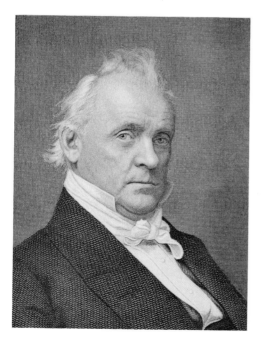
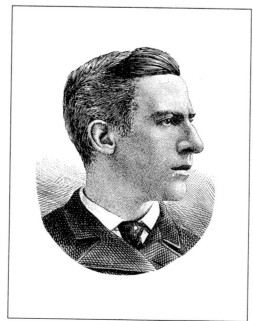

JAMES BUCHANAN *(left)*
(1791–1868)
President of the United States, 1857–1861
Engraving by John C. Buttre

JOSEPH RAY BUCHANAN *(right)*
(1851–1924)
Labor leader, journalist

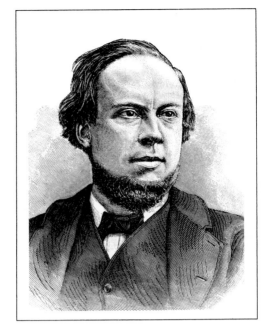

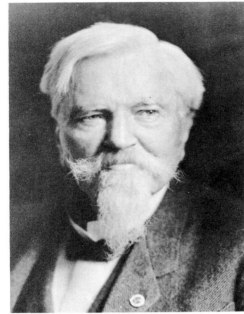

DUDLEY BUCK (*left*)
(1839–1909)
Composer, organist

SIMON BOLIVAR BUCKNER (*right*)
(1823–1914)
Confederate general, Governor of Kentucky
Courtesy Filson Club

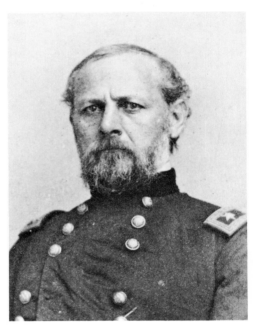

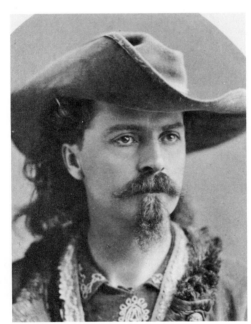

DON CARLOS BUELL (*left*)
(1818–1898)
Union general in Civil War
Courtesy Library of Congress

BUFFALO BILL (*right*)
[William Frederick Cody]
(1846–1917)
Western scout, showman
Courtesy New-York Historical Society

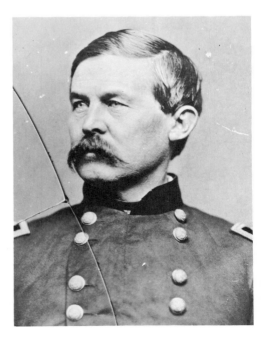

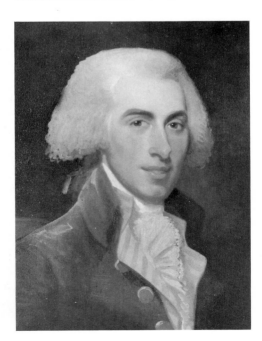

JOHN BUFORD (*left*)
(1826–1863)
Union general in Civil War
Courtesy National Archives, Brady Collection

CHARLES BULFINCH (*right*)
(1763–1844)
Architect
Painting by Mather Brown

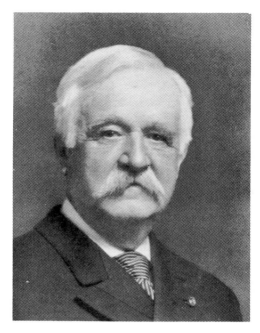

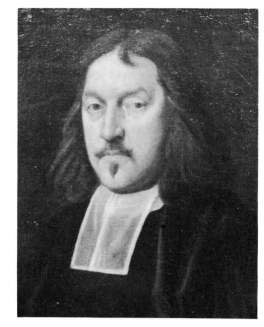

MORGAN GARDNER BULKELEY (*left*)
(1837–1922)
Governor of Connecticut, U.S. Senator;
first president of National League (baseball)

PETER BULKELEY (*right*)
[Peter Bulkley]
(1583–1659)
Puritan clergyman, founder of Concord,
Massachusetts

OLE BORNEMANN BULL (*left*)
(1810–1880)
Norwegian violinist, composer; unsuccess-
ful colonizer in Pennsylvania
Courtesy National Archives, Brady Collection

HENRY CUYLER BUNNER (*right*)
(1855–1896)
Writer, editor, author of light verse

NED BUNTLINE (*left*)
[Edward Zane Carroll Judson]
(1823–1866)
Adventurer, author of dime novels
Courtesy Mercaldo Archives

LUTHER BURBANK (*right*)
(1849–1926)
Horticulturist, plant breeder

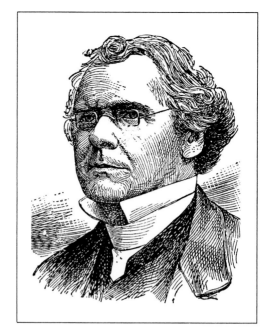

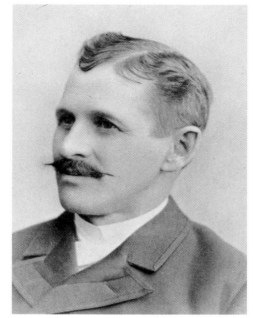

SAMUEL DICKINSON BURCHARD
(*left*)
(1812–1891)
Presbyterian clergyman; author of phrase
"Rum, Romanism, and Rebellion"

ROBERT JONES BURDETTE (*right*)
(1844–1914)
Humorist, Baptist clergyman

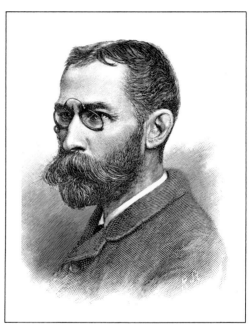

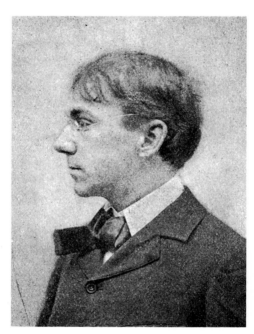

EDWARD BURGESS (*left*)
(1848–1891)
Yacht designer, entomologist

GELETT BURGESS (*right*)
[Frank Gelett Burgess]
(1866–1951)
Humorist, illustrator, author of "The
Purple Cow"

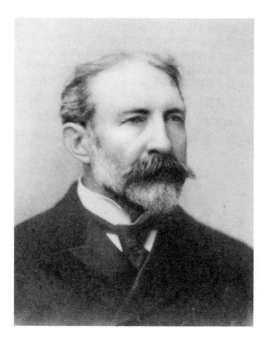

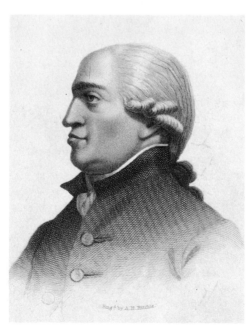

JOHN WILLIAM BURGESS (*left*)
(1844–1931)
Political scientist, educator

JOHN BURGOYNE (*right*)
(1722–1792)
British army officer during American Rev-
olution; dramatist
Engraving by Alexander H. Ritchie

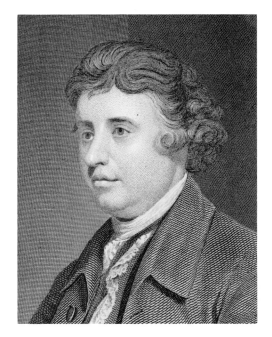

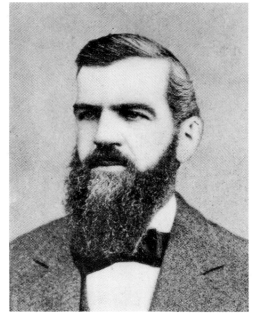

EDMUND BURKE *(left)*
(1729–1797)
British statesman, orator, advocated liberal
treatment of American colonies
*From a painting by Alonzo Chappel after a painting
by Sir Joshua Reynolds*

CHARLES BURLEIGH *(right)*
(1824–1883)
Inventor, manufacturer; invented practical
pneumatic rock drill
Courtesy Smithsonian Institution and Edward Burleigh

ANSON BURLINGAME *(left)*
(1820–1870)
Congressman, minister to China; later rep-
resented China in negotiations with U.S.
and England

EDWARD LIVERMORE
BURLINGAME *(right)*
(1848–1922)
Editor, writer; first editor, *Scribner's Magazine*

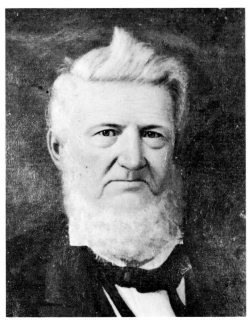

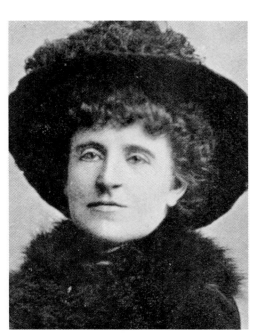

DAVID GOUVERNEUR BURNET
(left)
(1788–1870)
Texas politician; first president, Texas
Republic
*Painting by William H. Huddle. Courtesy Texas
State Library*

FRANCES HODGSON BURNETT
(right)
[nee Frances Eliza Hodgson]
(1849–1924)
Writer, author of *Little Lord Fauntleroy*

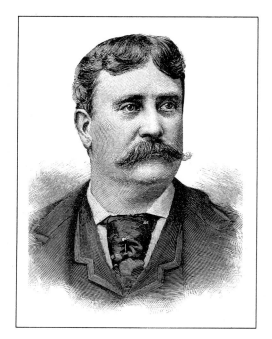

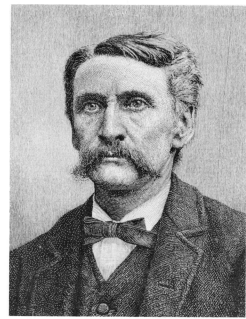

DANIEL HUDSON BURNHAM (*left*)
(1846–1912)
Architect, city planner

SHERBURNE WESLEY BURNHAM
(*right*)
(1838–1921)
Astronomer

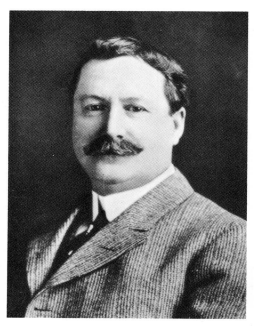

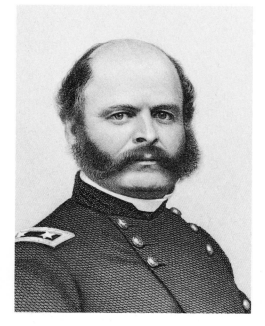

WILLIAM JOHN BURNS (*left*)
(1861–1932)
Detective, founded Burns Detective Agency;
director, Justice Department Bureau of
Investigation

AMBROSE EVERETT BURNSIDE
(*right*)
(1824–1881)
Union general in Civil War; Governor of
Rhode Island, U.S. Senator
Engraving by John C. Buttre

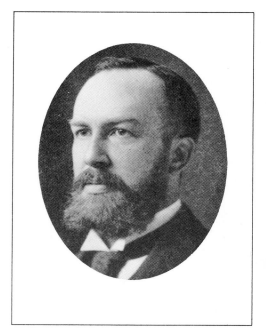

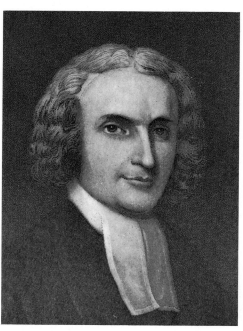

WASHINGTON ATLEE BURPEE
(*left*)
(1858–1915)
Seed merchant, developed mail-order seed
business

AARON BURR (*right*)
(1716–1757)
Presbyterian clergyman, educator; father of
Aaron Burr (1756–1836)
Engraving by John Sartain

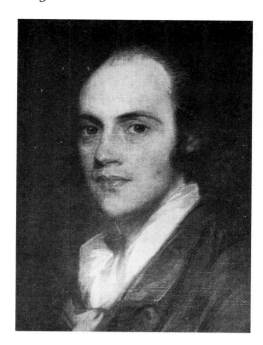

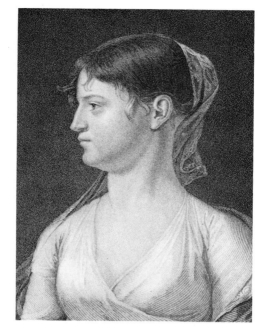

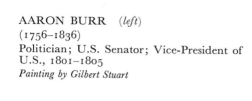

AARON BURR (*left*)
(1756–1836)
Politician; U.S. Senator; Vice-President of
U.S., 1801–1805
Painting by Gilbert Stuart

THEODOSIA BURR (*right*)
[Mrs. Joseph Alston]
(1783–1813)
Social leader, daughter of Aaron Burr
(1756–1836)
*Engraved by George Parker from a painting by John
Vanderlyn*

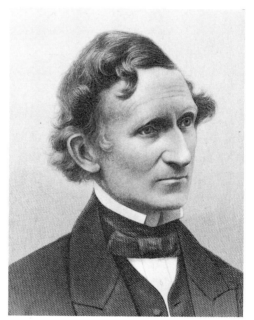

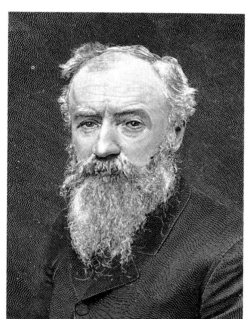

ELIHU BURRITT (*left*)
(1810–1879)
Linguist, peace advocate; known as "The
Learned Blacksmith"
Engraving by John C. Buttre

JOHN BURROUGHS (*right*)
(1837–1921)
Naturalist, author

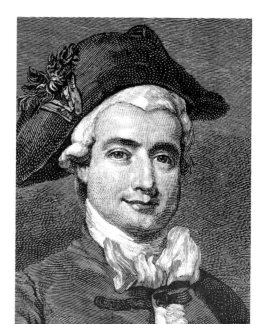

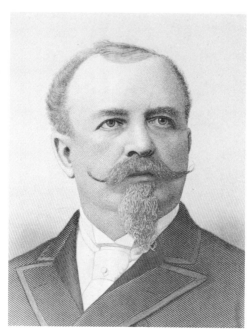

WILLIAM EVANS BURTON (*left*)
(1804–1860)
Comic actor, theater manager, playwright

ADOLPHUS BUSCH (*right*)
(1842–1913)
St. Louis brewer
Engraving by E. G. Williams & Bro.

HORACE BUSHNELL *(left)*
(1802–1876)
Congregational clergyman
Engraved by J. A. J. Wilcox from a drawing by Samuel W. Rowse

ANDREW PICKENS BUTLER *(right)*
(1796–1857)
U.S. Senator, cause of Brooks-Sumner fight

BENJAMIN FRANKLIN BUTLER
(left)
(1795–1858)
Lawyer; Attorney General and Secretary of War under Jackson
Courtesy Library of Congress, Brady-Handy Collection

BENJAMIN FRANKLIN BUTLER
(right)
(1818–1893)
Union officer in Civil War; Congressman, Governor of Massachusetts
Courtesy Library of Congress, Brady-Handy Collection

NICHOLAS MURRAY BUTLER
(left)
(1862–1947)
Educator, president of Columbia University, Nobel Peace Laureate
Courtesy Columbiana Collection, Columbia University

PIERCE BUTLER *(right)*
(1744–1822)
U.S. Senator, Governor of South Carolina; author of Constitution's fugitive-slave clause, signer of Constitution
Courtesy South Caroliniana Library, University of South Carolina

DANIEL BUTTERFIELD (*left*)
(1831–1901)
Union general in Civil War; banker

JOHN BUTTERFIELD (*right*)
(1801–1869)
Financier; president of Overland Mail Co.

EBENEZER BUTTERICK (*left*)
(1826–1903)
Inventor, devised paper patterns for clothing
Engraving by W. T. Bather. Courtesy Butterick Co., Inc.

MATHER BYLES (*right*)
(1707–1788)
Congregational clergyman, essayist, poet
Painting by John Singleton Copley

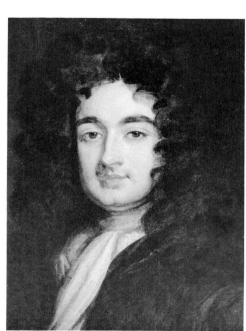

EVELYN BYRD (*left*)
(1716–1737)
Colonial belle, "Ghost of Westover"
Courtesy Colonial Williamsburg

WILLIAM BYRD (*right*)
(1674–1744)
Planter, Colonial leader; founded Richmond, Virginia
Courtesy Colonial Williamsburg

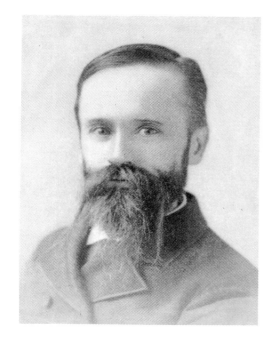

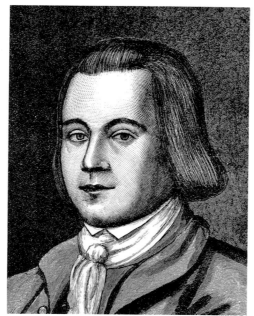

GEORGE WASHINGTON CABLE
(*left*)
(1844–1925)
Writer, author of local-color stories, *Old Creole Days*
Photograph by Napoleon Sarony

GEORGE CABOT (*right*)
(1752–1823)
Merchant, banker, U.S. Senator

RICHARD CLARKE CABOT (*left*)
(1868–1939)
Physician, educator, reformer
Courtesy Harvard University Archives

SEBASTIAN CABOT (*right*)
(*c.* 1476–1557)
Navigator, explored northeast coast of North America
Painted by G. Thompson after a painting by Hans Holbein the Younger

MOTHER CABRINI (*left*)
[Saint Frances Xavier Cabrini]
(1850–1917)
Roman Catholic nun, charitable leader; canonized in 1946

THOMAS CADWALADER (*right*)
(*c.* 1708–1799)
Physician

ABRAHAM CAHAN (*left*)
(1860–1951)
Novelist, editor; founded *Jewish Daily Forward*
Courtesy "Jewish Daily Forward"

FLORIAN CAJORI (*right*)
(1859–1930)
Historian of mathematics
Courtesy Florian A. Cajori

CALAMITY JANE (*left*)
[Martha Jane Burke]
(*c.* 1852–1903)
Frontier woman, marksman
Courtesy Library of Congress

ALEXANDER MILNE CALDER
(*right*)
(1846–1923)
Sculptor

JOHN CALHOUN (*left*)
(1806–1859)
Illinois lawyer, politician, accused in Kansas slavery–free-state election abuses
After a photograph by Mathew Brady

JOHN CALDWELL CALHOUN (*right*)
(1782–1850)
Vice-President of U.S., 1825–1832; U.S. Senator, Secretary of War, Secretary of State; political theorist for the South
Daguerreotype by Mathew Brady. Courtesy Library of Congress

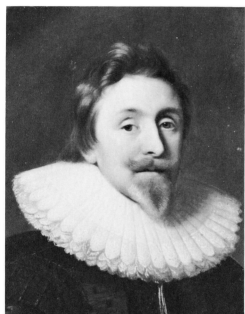

CALIFORNIA JOE (*left*)
[Moses Embree Milner]
(1829–1876)
Frontiersman, pioneer, scout
Courtesy Mercaldo Archives

CECILIUS CALVERT, 2ND BARON
BALTIMORE (*right*)
(*c.* 1605–1675)
First proprietor of Maryland, received
charter after father's death
*Painting by Gerard Soest. Courtesy Enoch Pratt Free
Library*

CHARLES CALVERT, 3RD BARON
BALTIMORE (*left*)
(1637–1715)
Provincial governor and proprietor of
Maryland
*Painting by Sir Godfrey Kneller. Courtesy Enoch Pratt
Free Library*

GEORGE CALVERT, 1ST BARON
BALTIMORE (*right*)
(*c.* 1580–1632)
British colonizer, granted territory now
called Maryland
*Painting by Daniel Mytens the Elder. Courtesy Enoch
Pratt Free Library*

SIMON CAMERON (*left*)
(1799–1889)
U.S. Senator, Secretary of War under
Lincoln, diplomat
Courtesy National Archives, Brady Collection

WALTER CHAUNCEY CAMP (*right*)
(1859–1925)
Sports figure, influenced development of
American football

GIUSEPPE CAMPANARI (*left*)
(1858–1927)
Italian operatic baritone, cellist; popular in U.S.

ITALO CAMPANINI (*right*)
(1846–1896)
Italian operatic tenor, toured U.S.

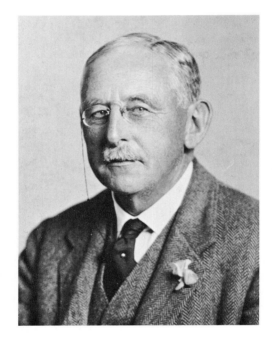

ALEXANDER CAMPBELL (*left*)
(1788–1866)
Founder of the Disciples of Christ

DOUGLAS HOUGHTON CAMPBELL
(*right*)
(1859–1953)
Botanist
Courtesy Stanford University

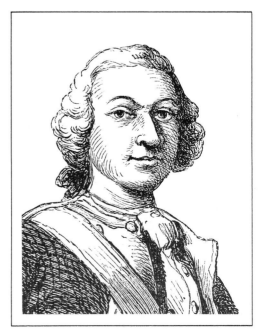

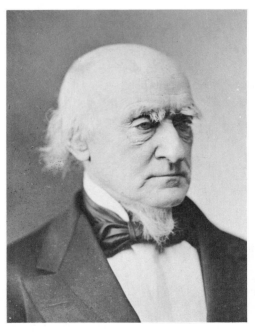

JOHN CAMPBELL, 4TH EARL OF LOUDOUN (*left*)
(1705–1782)
British general in Colonial America

JOHN ARCHIBALD CAMPBELL
(*right*)
(1811–1889)
Associate justice, U.S. Supreme Court; Confederate Assistant Secretary of War
Courtesy Library of Congress, Brady-Handy Collection

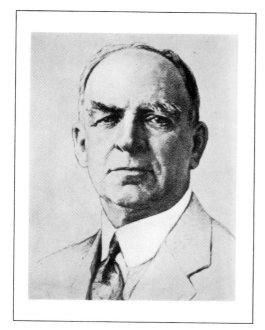

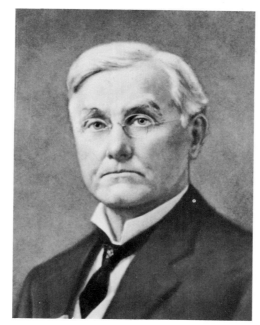

WILLIAM WALLACE CAMPBELL
(*left*)
(1862–1938)
Astronomer, educator

ASA GRIGGS CANDLER (*right*)
(1851–1929)
Manufacturer, developed Coca-Cola; bene-
factor of Emory College (later University)
Courtesy Emory University

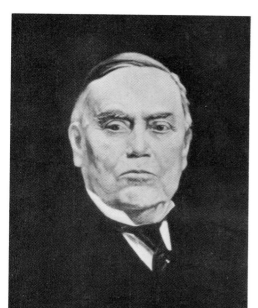

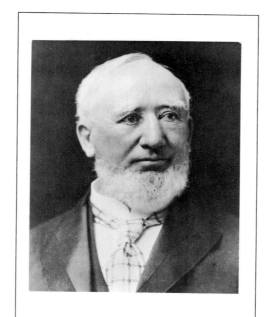

WARREN AKIN CANDLER (*left*)
(1857–1941)
Methodist bishop, president of Emory Col-
lege (later University)
Courtesy Emory University

GEORGE QUAYLE CANNON (*right*)
(1827–1901)
Mormon leader
Courtesy Utah State Historical Society

JOSEPH GURNEY CANNON (*left*)
["Uncle Joe" Cannon]
(1836–1926)
Member of Congress for 46 years; Speaker
of the House for 8 years
Courtesy Illinois State Historical Library

ELMER HEWITT CAPEN (*right*)
(1838–1905)
President of Tufts College
Courtesy Tufts University

HENRY CHARLES CAREY (*left*)
(1793–1879)
Economist, book publisher
Engraving by John Sartain

MATHEW CAREY (*right*)
(1760–1839)
Publisher, bookseller, nationalistic economist

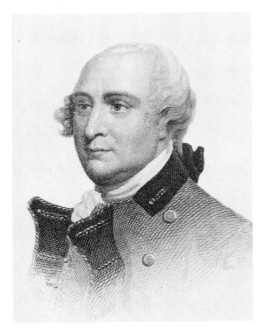

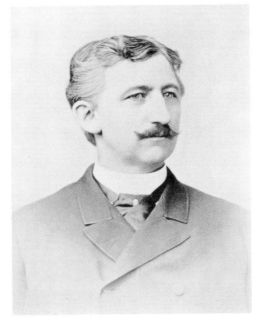

SIR GUY CARLETON, 1ST BARON
DORCHESTER (*left*)
(1724–1808)
British general and administrator during
American Revolution
Engraving by Alexander H. Ritchie

WILL CARLETON (*right*)
[William McKendree Carleton]
(1845–1912)
Writer, poet; wrote "Over the Hill to the
Poor House"

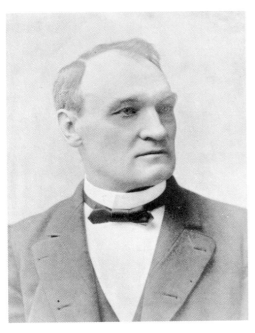

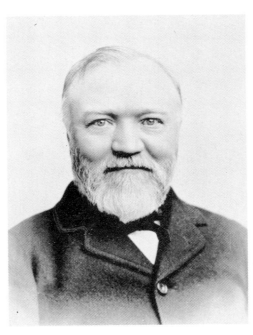

JOHN GRIFFIN CARLISLE (*left*)
(1835–1910)
Congressman, U.S. Senator, Secretary of
the Treasury under Cleveland

ANDREW CARNEGIE (*right*)
(1835–1919)
Steel magnate, writer, philanthropist

FRANCIS BICKNELL CARPENTER
(*left*)
(1830–1900)
Portrait painter
Courtesy Meserve Collection

MATTHEW HALE CARPENTER
(*right*)
[Merritt Hammond Carpenter]
(1824–1881)
Lawyer, U.S. Senator, argued Reconstruction cases before Supreme Court

BENJAMIN CARR　(*left*)
(1769–1831)
Composer

JOHN MERVEN CARRÈRE　(*right*)
(1858–1911)
Architect; co-designer, New York Public Library

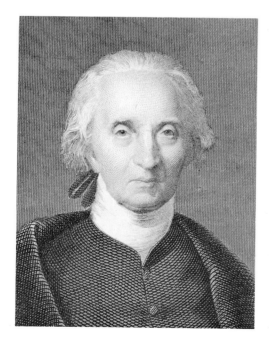

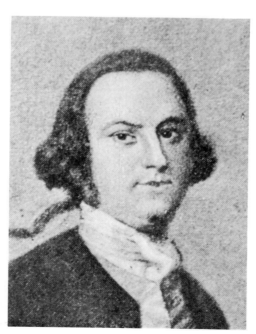

CHARLES CARROLL　(*left*)
[Charles Carroll of Carrollton]
(1737–1832)
Revolutionary leader, U.S. Senator, signer of Declaration of Independence
Engraved by Asher B. Durand from a painting by Chester Harding

DANIEL CARROLL　(*right*)
(1730–1796)
Signer of Constitution, Commissioner of District of Columbia
Courtesy Library of Congress

JAMES CARROLL (*left*)
(1854–1907)
Physician, bacteriologist, pathologist; assisted Reed in yellow-fever study
Courtesy New York Academy of Medicine

JOHN CARROLL (*right*)
(1735–1815)
First Catholic bishop in U.S.; founded Georgetown University
Painting by Gilbert Stuart. Courtesy Georgetown University News Service

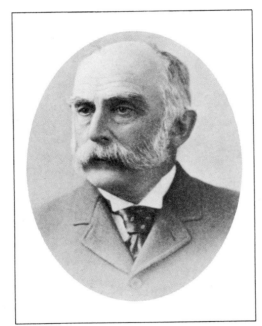

KIT CARSON (*left*)
[Christopher Carson]
(1809–1868)
Trapper, scout, Indian agent
Courtesy Mercaldo Archives

JAMES COOLIDGE CARTER (*right*)
(1827–1905)
Lawyer

JAMES GORDON CARTER (*left*)
(1795–1849)
Educator, reformer; advocated Pestalozzi method

MRS. LESLIE CARTER (*right*)
[nee Caroline Louise Dudley]
(1862–1937)
Actress
Photograph by Napoleon Sarony

NICK CARTER (*left*)
[John Russell Coryell]
(1848–1924)
Writer and reputed originator of Nick
Carter detective stories
Courtesy Hubert V. Coryell

ROBERT CARTER (*right*)
["King Carter"]
(1663–1732)
Landholder in Colonial Virginia

JACQUES CARTIER (*left*)
(1491–1557)
French explorer in Canada, discovered St.
Lawrence River

ALEXANDER J. CARTWRIGHT
(*right*)
(1820–1892)
Early baseball promoter, helped develop
baseball rules
Courtesy National Baseball Hall of Fame

PETER CARTWRIGHT (*left*)
(1785–1872)
Methodist minister, frontier circuit rider
Engraving by John C. Buttre

JOHN JOSEPH CARTY (*right*)
(1861–1932)
Electrical engineer, pioneer in development
of telephone

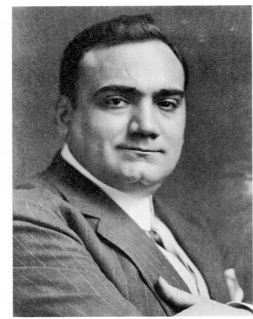

PAUL CARUS (*left*)
(1852–1919)
Philosopher, editor; founded Open Court
Publishing Co.
Courtesy Library of Congress

ENRICO CARUSO (*right*)
(1873–1921)
Italian operatic tenor; popular in U.S.
Courtesy Library of Congress

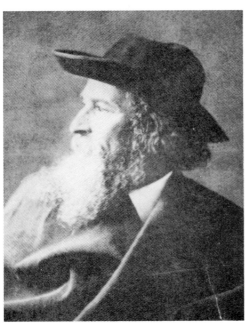

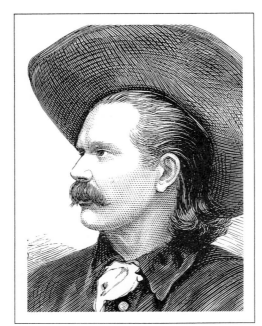

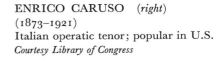

SOLOMON NUNES CARVALHO
(*left*)
(1815–1894)
Artist, traveled with Frémont across Rocky
Mountains

DOC CARVER (*right*)
[William Frank Carver]
(1840–1927)
Western marksman

GEORGE WASHINGTON CARVER
(*left*)
(1864–1943)
Botanist, educator, known for fundamental
research on the peanut
Courtesy Tuskegee Institute

JONATHAN CARVER (*right*)
(1710–1780)
Explorer, sought Northwest Passage

ALICE CARY (*left*)
(1820–1871)
Poet
Engraving by J.A.J. Wilcox

ANNIE LOUISE CARY (*right*)
[Mrs. Charles Monson Raymond]
(1842–1921)
Operatic contralto

PHOEBE CARY (*left*)
(1824–1871)
Poet
Engraving by H. W. Smith

THOMAS LINCOLN CASEY (*right*)
(1831–1896)
Military engineer, completed work on
Washington Monument

LEWIS CASS (*left*)
(1782–1866)
Secretary of War under Jackson, Secretary
of State under Buchanan; Congressman,
U.S. Senator
Engraving by John C. Buttre

ALEXANDER JOHNSTON CASSATT
(*right*)
(1839–1906)
Engineer, industrialist, president of Pennsyl-
vania Railroad

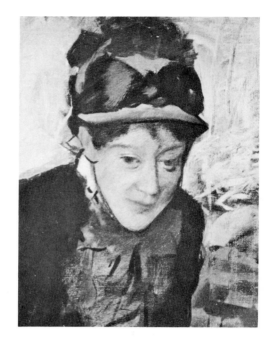

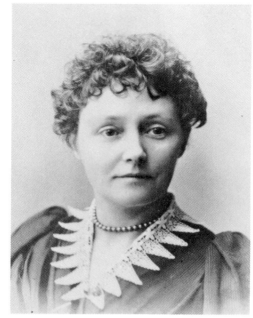

MARY CASSATT *(left)*
(1845–1926)
Painter
Painting by Edgar Degas

MARY CATHERWOOD *(right)*
[nee Mary Hartwell]
(1847–1902)
Novelist

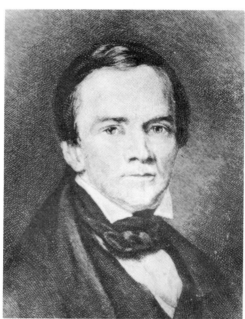

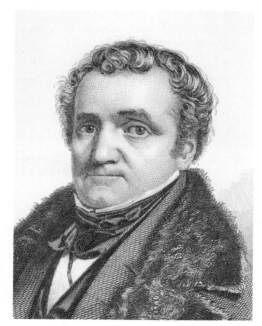

GEORGE CATLIN *(left)*
(1796–1872)
Painter, writer; early student of the American Indian

JOHN CATRON *(right)*
(c. 1786–1865)
Associate justice, U.S. Supreme Court
Engraving by Frederick Girsch

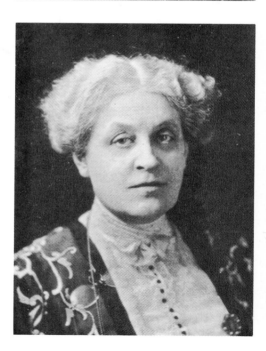

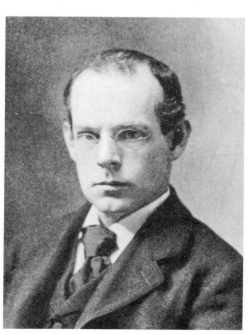

CARRIE CHAPMAN CATT *(left)*
[nee Carrie Lane]
(1859–1947)
Woman-suffragist

JAMES McKEEN CATTELL *(right)*
(1860–1944)
Psychologist, editor

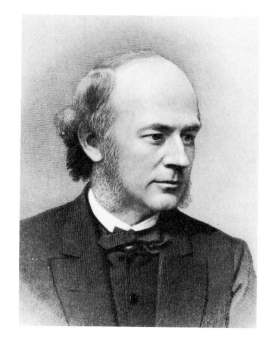

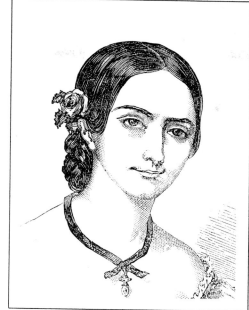

WILLIAM CASSADAY CATTELL
(*left*)
(1827–1898)
Presbyterian clergyman, president of Lafayette College
Engraving by John Sartain. Courtesy Lafayette College

MADAME CÉLINE CÉLESTE (*right*)
(*c.* 1814–1882)
French dancer and actress in America

LUIGI PALMA DI CESNOLA (*left*)
(1832–1904)
Army officer, diplomat, archaeologist; director, Metropolitan Museum of Art
Engraving by George E. Perine

FRENCH ENSOR CHADWICK (*right*)
(1844–1919)
Naval officer, historian

GEORGE WHITEFIELD CHADWICK
(*left*)
(1854–1931)
Composer; director, New England Conservatory of Music

HENRY CHADWICK (*right*)
(1824–1908)
Sports writer, promoter of professional baseball
Courtesy National Baseball Hall of Fame

ADNA ROMANZA CHAFFEE (*left*)
(1842–1914)
Army officer
Photograph by Pach Brothers

THOMAS CHROWDER
CHAMBERLIN (*right*)
(1843–1928)
Geologist, editor; president, University of
Wisconsin
Courtesy University of Wisconsin

ROBERT WILLIAM CHAMBERS
(*left*)
(1865–1933)
Novelist, illustrator

SAMUEL DE CHAMPLAIN (*right*)
(*c.* 1567–1635)
French explorer, founder of Canada
After an engraving by Baltazar Moncornet

CHARLES FREDERICK CHANDLER
(*left*)
(1836–1925)
Sanitation engineer, chemist, mineralogist,
educator

SETH CARLO CHANDLER (*right*)
(1846–1913)
Astronomer

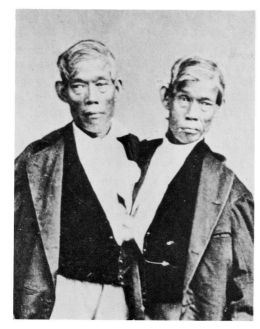

FRANCIS S. CHANFRAU (*left*)
(1824–1884)
Actor
After a photograph by Napoleon Sarony

CHANG AND ENG (*right*)
[Chang and Eng Bunker]
(1811–1874)
Barnum's Siamese twins
Courtesy Mercaldo Archives

EDWARD CHANNING (*left*)
(1856–1931)
Historian

WILLIAM ELLERY CHANNING
(*right*)
(1780–1842)
Clergyman, writer; a founder of American
Unitarianism
Painting by Gilbert Stuart

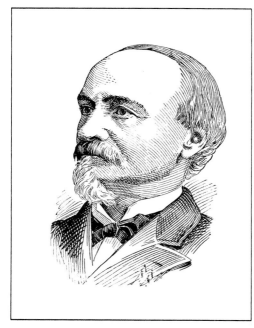

WILLIAM HENRY CHANNING
(*left*)
(1810–1884)
Unitarian clergyman, reformer
Courtesy Andover-Harvard Theological Library

OCTAVE CHANUTE (*right*)
(1832–1910)
Engineer, aviation pioneer

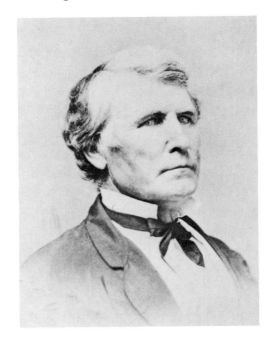

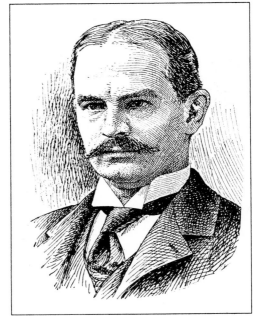

ALVAN WENTWORTH CHAPMAN (*left*)
(1809–1899)
Botanist, physician
Courtesy Smithsonian Institution

FRANK MICHLER CHAPMAN (*right*)
(1864–1945)
Ornithologist, writer

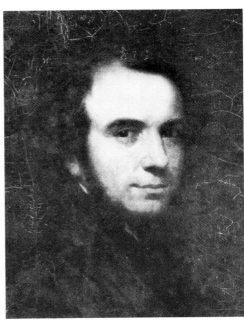

JOHN GADSBY CHAPMAN (*left*)
(1808–1889)
Painter, etcher, illustrator

JOHN JAY CHAPMAN (*right*)
(1862–1933)
Essayist, poet, pamphleteer

MARIA CHAPMAN (*left*)
[nee Maria Weston]
(1806–1885)
Abolitionist
Courtesy Library of Congress, Brady-Handy Collection

NATHANIEL CHAPMAN (*right*)
(1780–1853)
Physician, educator, editor; first president,
American Medical Association

PIERRE FRANÇOIS XAVIER
DE CHARLEVOIX (*left*)
(1682–1761)
French explorer, educator, historian

CALEB CHASE (*right*)
(1831–1908)
Merchant, founded Chase & Sanborn Co.
Courtesy Standard Brands, Inc.

PHILANDER CHASE (*left*)
(1775–1852)
Protestant Episcopal bishop, founded Kenyon College
Courtesy Kenyon College Archives

SALMON PORTLAND CHASE (*right*)
(1808–1873)
Governor of Ohio, U.S. Senator, Secretary
of the Treasury under Lincoln; Chief Justice
of U.S., 1864–1873
Courtesy National Archives, Brady Collection

SAMUEL CHASE (*left*)
(1741–1811)
Revolutionary leader; signer, Declaration
of Independence; associate justice, U.S.
Supreme Court
*Engraved by J. B. Forrest from a drawing by James
B. Longacre after a painting by John Wesley Jarvis*

WILLIAM MERRITT CHASE (*right*)
(1849–1916)
Painter

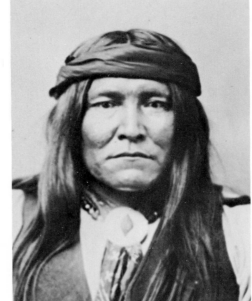

MARQUIS FRANÇOIS JEAN DE CHASTELLUX (*left*)
(1734–1788)
French general in American Revolution
Painting by Charles Willson Peale. Courtesy Independence National Historical Park

CHATO (*right*)
(*c.* 1844–1934)
Apache Indian leader
Courtesy Mercaldo Archives

ISAAC CHAUNCEY (*left*)
(1772–1840)
Naval officer
Painting by Gilbert Stuart

CHARLES CHAUNCY (*right*)
(1592–*c.* 1672)
Clergyman, president of Harvard College
Engraving by H. W. Smith

CHARLES CHAUNCY (*left*)
(1705–1787)
Boston clergyman, liberal theological leader

WILLIAM CHAUVENET (*right*)
(1820–1870)
Astronomer, mathematician, educator; influenced founding of U.S. Naval Academy
Courtesy Washington University

CHARLES EDWARD CHENEY (*left*)
(1836–1916)
Organizer and bishop of Reformed Epis-
copal Church
Courtesy Chicago Historical Society

JACK CHESBRO (*right*)
[John D. Chesbro]
(1874–1931)
Baseball pitcher, member of Baseball Hall
of Fame
Courtesy National Baseball Hall of Fame

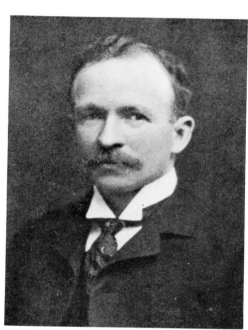

**ROBERT AUGUSTUS
CHESEBROUGH** (*left*)
(1837–1933)
Manufacturer, developed Vaseline

CHARLES WADDELL CHESNUTT
(*right*)
(1858–1932)
Writer, lawyer, educator

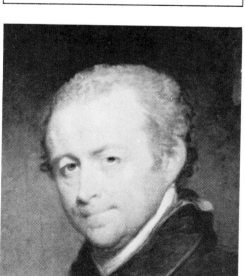

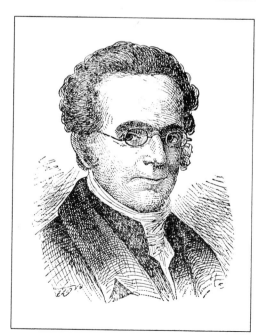

**JEAN LOUIS ANNE MADELEINE
LEFEBVRE DE CHEVERUS** (*left*)
(1768–1836)
First Catholic bishop of Boston
Painting by Gilbert Stuart

LANGDON CHEVES (*right*)
(1776–1857)
Congressman, financier, president of Bank
of United States

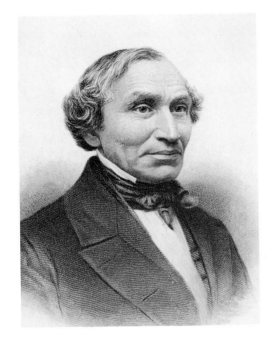

JONAS CHICKERING (*left*)
(1798–1853)
Piano manufacturer
Engraving by H. W. Smith

FRANCIS JAMES CHILD (*right*)
(1825–1896)
Philologist, authority on ballads

LYDIA CHILD (*left*)
[nee Lydia Maria Francis]
(1802–1880)
Abolitionist, writer
Engraving by F. T. Stuart

GEORGE WILLIAM CHILDS (*right*)
(1829–1894)
Bookseller, publisher of Philadelphia *Public
Ledger*
Engraving by John C. Buttre

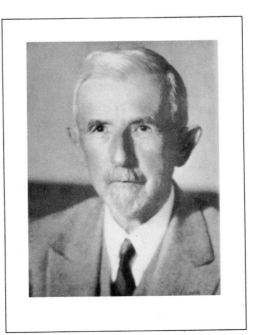

JESSE CHISHOLM (*left*)
(*c.* 1805–1868)
Indian trader, government agent; probable
eponym of Chisholm Trail
Courtesy Texas State Library

RUSSELL HENRY CHITTENDEN
(*right*)
(1856–1943)
Chemist, educator; director, Sheffield Scientific School, Yale University

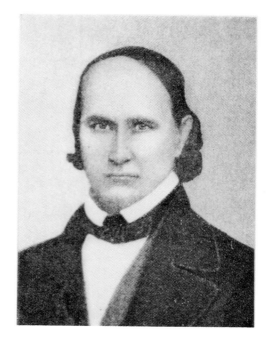

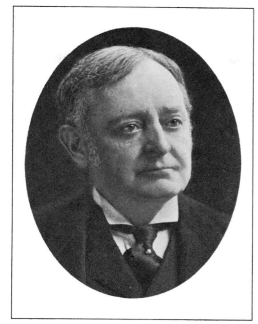

THOMAS HOLLEY CHIVERS *(left)*
(1809–1858)
Poet

JOSEPH HODGES CHOATE *(right)*
(1832–1917)
Lawyer, diplomat, philanthropist

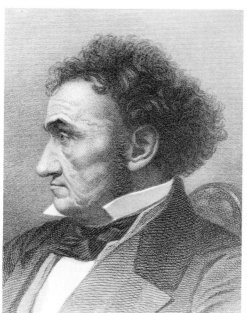

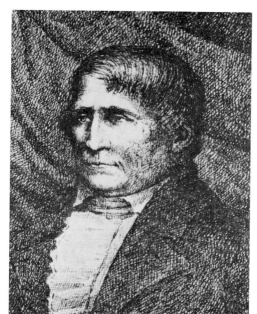

RUFUS CHOATE *(left)*
(1799–1859)
U.S. Senator, lawyer, orator
Engraved by H. W. Smith from a photograph by Southworth and Hawes

JEAN PIERRE CHOUTEAU *(right)*
(1758–1849)
Fur trader, Indian agent
Courtesy Library of Congress

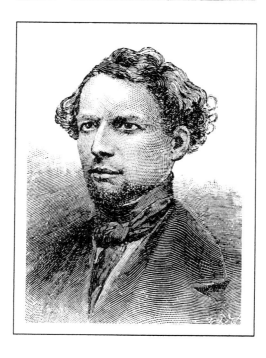

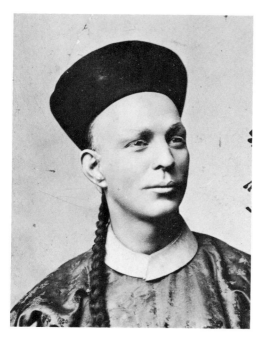

EDWIN P. CHRISTY *(left)*
(1815–1862)
Originator of the Christy Minstrels

CHUNG LING SOO *(right)*
[William Ellsworth Robinson]
(1861–1918)
Magician, killed during bullet-catching trick
Courtesy Milbourne Christopher Collection

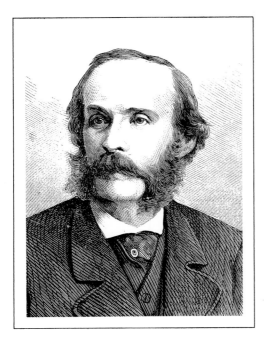

FREDERICK EDWIN CHURCH
(*left*)
(1826–1900)
Landscape painter

FREDERICK STUART CHURCH
(*right*)
(1842–1924)
Illustrator, painter
Photograph by Pach Brothers

WINSTON CHURCHILL (*left*)
(1871–1947)
Novelist

TENNESSEE CELESTE CLAFLIN
(*right*)
[Lady Francis Cook]
(c. 1846–1923)
Spiritualist, reformer, lecturer
Courtesy New-York Historical Society

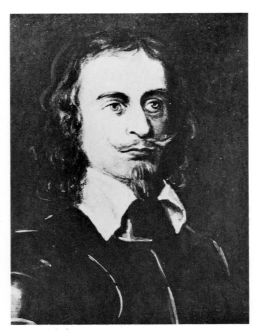

VICTORIA CLAFLIN (*left*)
[Mrs. Canning Woodhull]
(1838–1927)
Spiritualist, reformer, lecturer
Courtesy New-York Historical Society

WILLIAM CLAIBORNE (*right*)
(c. 1587–c. 1677)
Leader in Colonial Virginia
Courtesy Virginia Historical Society

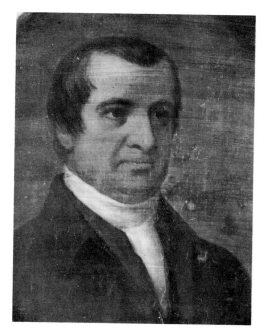

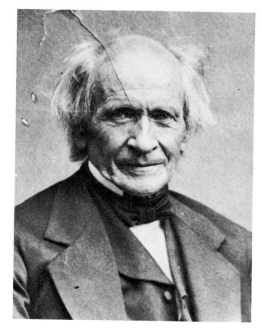

ABRAHAM CLARK (*left*)
["Congress Abraham"]
(1726–1794)
Colonial leader, Congressman, signer of Declaration of Independence
Painting by James Reid Lambdin from a painting by John Trumbull. Courtesy Independence National Historical Park

ALVAN CLARK (*right*)
(1804–1887)
Lens and telescope manufacturer
Courtesy Lick Observatory

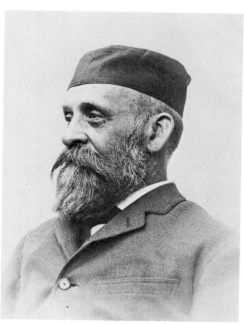

ALVAN GRAHAM CLARK (*left*)
(1832–1897)
Astronomer, telescope manufacturer
Courtesy Lick Observatory

CHAMP CLARK (*right*)
[James Beauchamp Clark]
(1850–1921)
Politician, Speaker of the House of Representatives
Courtesy Library of Congress

EDWARD CLARK (*left*)
(1811–1882)
Lawyer, partner of Singer in manufacture of sewing machine
Courtesy Singer Manufacturing Co.

FRANCIS EDWARD CLARK (*right*)
(1851–1927)
Congregational clergyman, founded Christian Endeavor movement

GEORGE ROGERS CLARK *(left)*
(1752–1818)
Revolutionary officer, conqueror of Old
Northwest
*Engraved by Thomas B. Welch from a painting by
James B. Longacre after a painting by John Wesley
Jarvis*

JOHN BATES CLARK *(right)*
(1847–1938)
Economist, educator

JONAS GILMAN CLARK *(left)*
(1815–1900)
Manufacturer, merchant; founded Clark
University

LEWIS GAYLORD CLARK *(right)*
(1808–1873)
Editor and owner of *Knickerbocker Magazine*
*Engraved by John Cheney from a painting by Charles
Loring Elliott*

WILLIAM CLARK *(left)*
(1770–1838)
Army officer, explored American Northwest
with Meriwether Lewis
Painting by Charles Willson Peale

WILLIAM ANDREWS CLARK *(right)*
(1839–1925)
Mining executive, U.S. Senator

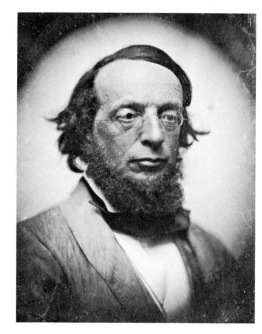

FRANK WIGGLESWORTH CLARKE
(*left*)
(1847–1931)
Geochemist

JAMES FREEMAN CLARKE (*right*)
(1810–1888)
Unitarian clergyman, writer
Daguerreotype by Southworth and Hawes. Courtesy Metropolitan Museum of Art, Stokes-Hawes Collection

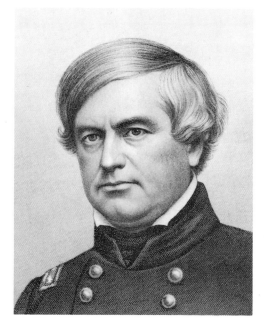

JOHN MASON CLARKE (*left*)
(1857–1925)
Paleontologist

CASSIUS MARCELLUS CLAY (*right*)
(1810–1903)
Abolitionist, politician, diplomat
Engraved by John C. Buttre from a photograph by Mathew Brady

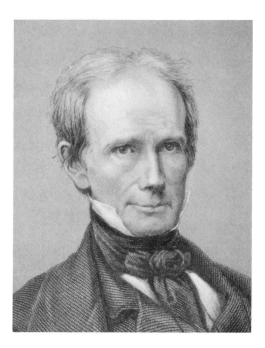

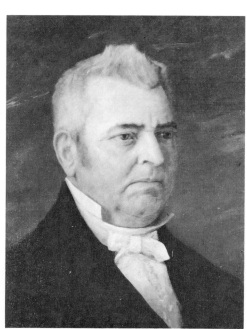

HENRY CLAY (*left*)
(1777–1852)
Speaker of the House of Representatives, U.S. Senator, Secretary of State under J. Q. Adams; "The Great Compromiser"
Engraved by W. J. Edwards from a daguerreotype by Mathew Brady

JOHN MIDDLETON CLAYTON
(*right*)
(1796–1856)
U.S. Senator, Secretary of State under Taylor
Painting by Robert Hinckley. Courtesy U.S. Department of State

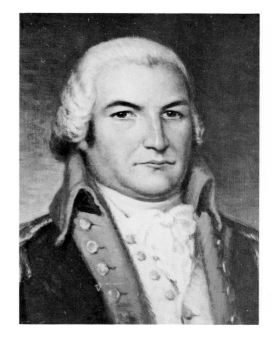

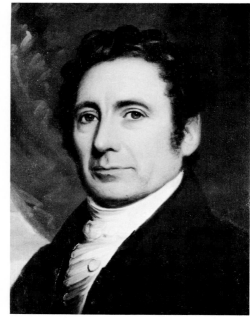

MOSES CLEAVELAND (*left*)
(1754–1806)
Pioneer, founded Cleveland, Ohio
Courtesy Western Reserve Historical Society

PARKER CLEAVELAND (*right*)
(1780–1858)
Mineralogist
Painting by Thomas Badger. Courtesy Bowdoin College

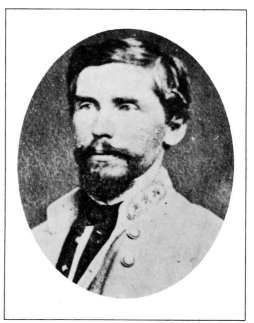

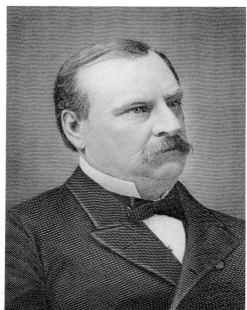

PATRICK RONAYNE CLEBURNE
(*left*)
(1828–1864)
Confederate general
Courtesy Library of Congress

GROVER CLEVELAND (*right*)
[Stephen Grover Cleveland]
(1837–1908)
President of the United States, 1885–1889,
1893–1897
Engraving by Henry B. Hall, Jr.

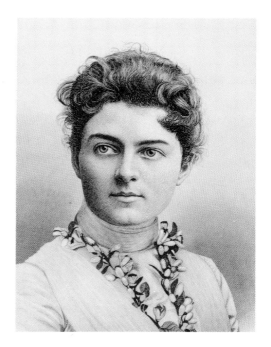

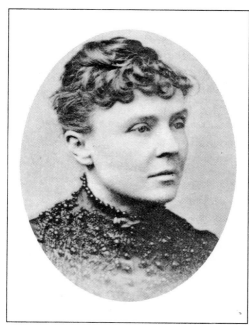

MRS. GROVER CLEVELAND (*left*)
[nee Frances Folsom]
(1864–1947)
First lady, 1886–1889, 1893–1897
Engraving by John C. Buttre

ROSE ELIZABETH CLEVELAND
(*right*)
(1846–1918)
Sister of Grover Cleveland; White House
hostess, 1885–1886

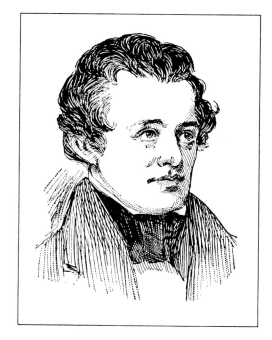

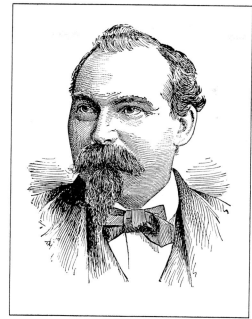

SHOBAL VAIL CLEVENGER (*left*)
(1812–1843)
Sculptor

SHOBAL VAIL CLEVENGER (*right*)
(1843–1920)
Psychiatrist, neurologist, biologist, reformer

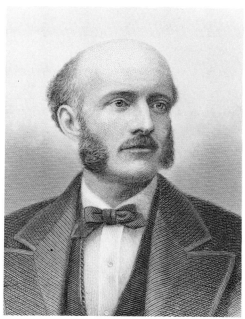

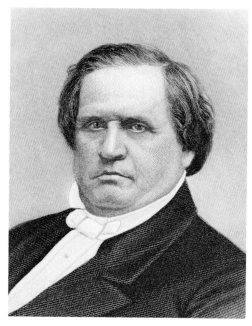

HENRY CLEWS (*left*)
(1834–1923)
Investment banker
Engraving by H. B. Hall & Sons

NATHAN CLIFFORD (*right*)
(1803–1881)
Associate justice, U.S. Supreme Court;
Attorney General under Polk
Engraving by H. B. Hall & Sons

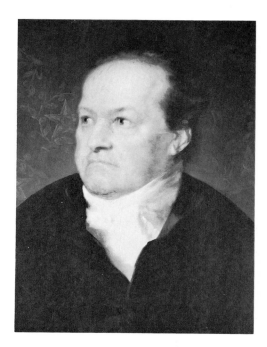

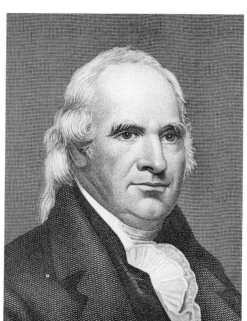

DeWITT CLINTON (*left*)
(1769–1828)
Mayor of New York City, Governor of New
York; principal promoter of Erie Canal
Painting by Samuel F. B. Morse

GEORGE CLINTON (*right*)
(1739–1812)
Revolutionary general; Governor of New
York; Vice-President of U.S., 1805–1812
*Engraved by E. G. Williams from a painting by
Ezra Ames*

S� HENRY CLINTON *(left)*
(c. 1738–1795)
British general during American Revolution

Mᴍᴇ FORTUNE CLOFULLIA *(right)*
[Josephine Boisdechene Clofullia Ghio]
(b. 1831)
Barnum's bearded lady
Courtesy Loan Collection of Elizabeth Sterling Seeley,
Barnum Museum

ISAAC HALLOWELL CLOTHIER
(left)
(1837–1921)
Philadelphia merchant, founded Straw-
bridge & Clothier

GEORGE CLYMER *(right)*
(1739–1813)
Revolutionary political leader, signed Dec-
laration of Independence and Constitution
Courtesy Pennsylvania Historical and Museum Com-
mission

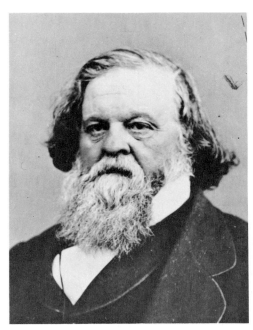

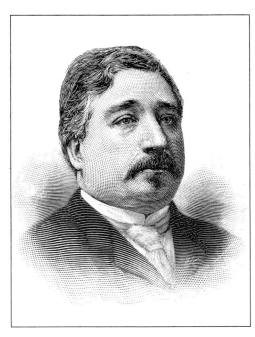

HOWELL COBB *(left)*
(1815–1868)
Congressman, Governor of Georgia, Secre-
tary of the Treasury under Buchanan; an
organizer of the Confederacy
Courtesy National Archives, Brady Collection

WILLIAM BOURKE COCKRAN
(right)
(1854–1923)
Congressman, member of Tammany Hall

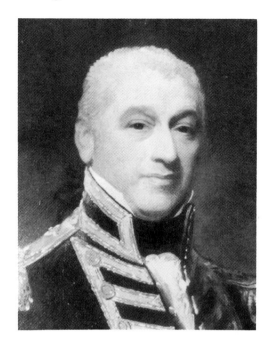

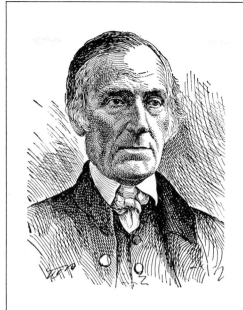

Sɪʀ ISAAC COFFIN (*left*)
(1759–1839)
American-born British admiral
Painting by Gilbert Stuart

LEVI COFFIN (*right*)
(1789–1877)
Abolitionist, leader of the Underground Railroad

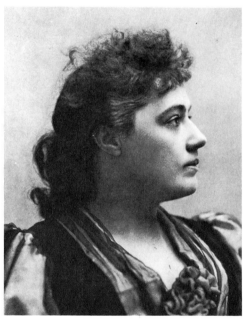

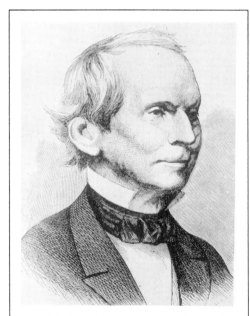

ROSE COGHLAN (*left*)
(*c.* 1853–1932)
Actress

JOSEPH GREEN COGSWELL (*right*)
(1786–1871)
Librarian, educator; developed Astor Library, New York

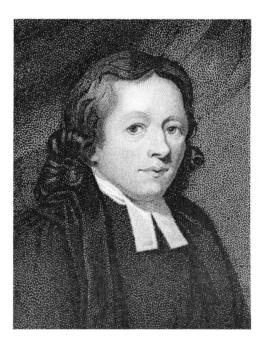

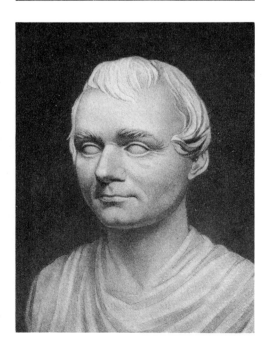

THOMAS COKE (*left*)
(1747–1814)
British missionary, first Methodist bishop in America

WARREN COLBURN (*right*)
(1793–1833)
Writer of mathematical textbooks
Engraving by H. W. Smith

CADWALLADER COLDEN *(left)*
(1688–1776)
Loyalist colonial administrator, naturalist,
philosopher
Painting by John Wollaston. Courtesy Burndy Library

THOMAS COLE *(right)*
(1801–1848)
Painter of Hudson River school

TIMOTHY COLE *(left)*
(1852–1931)
Wood engraver; illustrator
*Photograph by Pirie MacDonald. Courtesy New-York
Historical Society*

LORD THOMAS COLEPEPER *(right)*
[Lord Thomas Culpeper]
(1635–1689)
Governor of Colonial Virginia

SCHUYLER COLFAX *(left)*
(1823–1885)
Vice-President of U.S., 1869–1873; Speaker
of the House of Representatives
Engraving by H. W. Smith

SAMUEL COLGATE *(right)*
(1822–1897)
Soap manufacturer, benefactor of Colgate
University

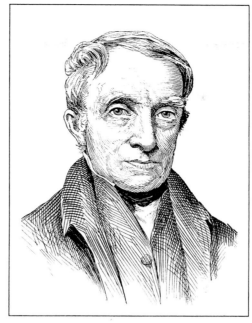

WILLIAM COLGATE (*left*)
(1783–1857)
Founder of soap-manufacturing firm

CHRISTOPHER COLLES (*right*)
(1739–1816)
Inventor, engineer, early promoter of Erie
Canal

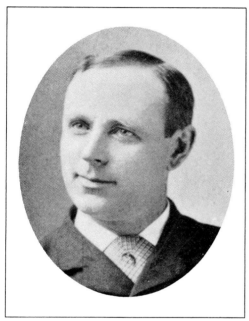

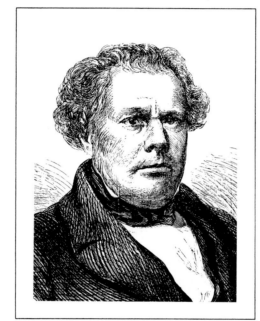

PETER FENELON COLLIER (*left*)
(1849–1909)
Publisher; founded *Collier's Weekly*

EDWARD KNIGHT COLLINS (*right*)
(1802–1878)
Shipowner, pioneer steamship builder

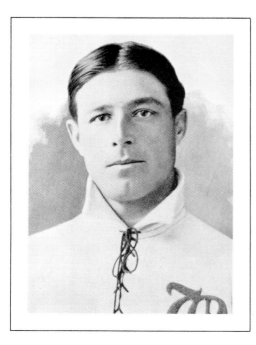

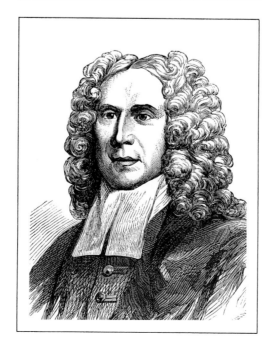

JAMES JOSEPH COLLINS (*left*)
(1873–1943)
Baseball infielder, member of Baseball Hall
of Fame
Courtesy National Baseball Hall of Fame

BENJAMIN COLMAN (*right*)
(1673–1747)
Nonconformist Boston clergyman
Engraving by John W. Orr

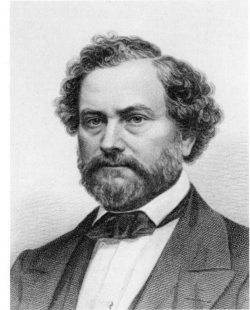

NORMAN JAY COLMAN *(left)*
(1827–1911)
Agriculturist, editor; first Secretary of
Agriculture (1889)
Courtesy U.S. Department of Agriculture

SAMUEL COLT *(right)*
(1814–1862)
Inventor and manufacturer of the revolver
*Engraved by H. W. Smith from a photograph by
Mathew Brady*

GARDNER QUINCY COLTON *(left)*
(1814–1898)
Pioneer in use of nitrous oxide, primarily for
painless tooth extraction
Engraving by George E. Perine

WALTER COLTON *(right)*
(1797–1851)
Congregational clergyman, editor, writer of
travel books
Engraving by George Parker

CHRISTOPHER COLUMBUS *(left)*
(c. 1446–1506)
Explorer
Courtesy Eric Schaal

CHARLES ALBERT COMISKEY
(right)
(1859–1931)
Baseball infielder, manager; owner of Chi-
cago White Sox
Courtesy National Baseball Hall of Fame

ANTHONY COMSTOCK (*left*)
(1844–1915)
Reformer; Secretary of Society for Suppression of Vice

HENRY TOMPKINS PAIGE COMSTOCK (*right*)
(1820–1870)
Prospector, staked "Comstock Lode"

JOHN HENRY COMSTOCK (*left*)
(1849–1931)
Entomologist
Courtesy New York State College of Agriculture at Cornell University

ROSCOE CONKLING (*right*)
(1829–1888)
Republican politician, U.S. Senator

HEINRICH CONRIED (*left*)
(1855–1909)
Actor, theatrical manager

MONCURE DANIEL CONWAY (*right*)
(1832–1907)
Unitarian clergyman, abolitionist, writer

THOMAS CONWAY　(*left*)
[Count de Conway]
(1735–*c.* 1800)
Revolutionary general, conspired against
Washington in Conway Cabal

RUSSELL HERMAN CONWELL
(*right*)
(1843–1925)
Baptist clergyman, known for lecture, "Acres
of Diamonds"; founded Temple University

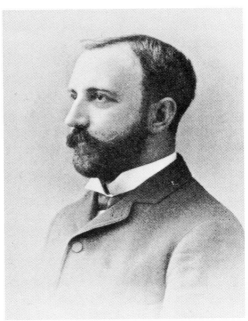

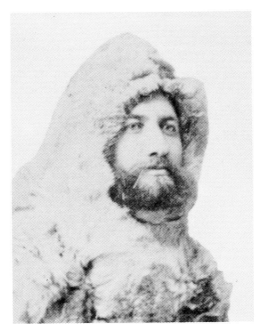

ALBERT STANBURROUGH COOK
(*left*)
(1853–1927)
Philologist, educator

FREDERICK ALBERT COOK　(*right*)
(1865–1940)
Physician, explorer; claimed priority in
reaching North Pole

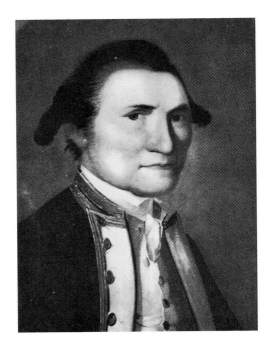

JAMES COOK　(*left*)
[Captain Cook]
(1728–1779)
British navigator, charted Pacific coast of
North America
Painting by John Weber

ELISHA COOKE　(*right*)
(1637–1715)
Leader in Colonial Boston

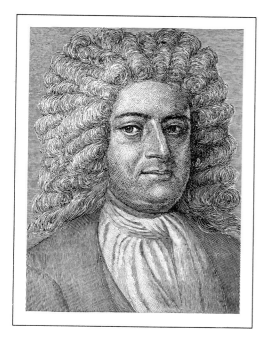

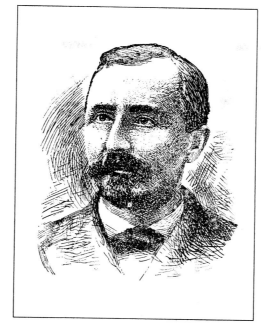

ELISHA COOKE (*left*)
(1678–1737)
Political leader in Colonial Massachusetts

GEORGE WILLIS COOKE (*right*)
(1848–1923)
Unitarian clergyman, reformer, literary critic

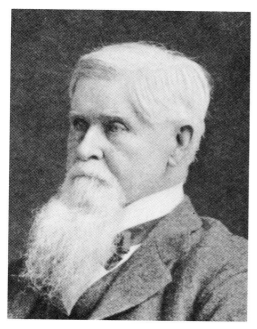

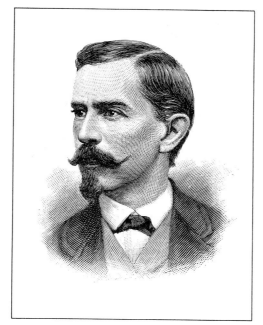

JAY COOKE (*left*)
(1821–1905)
Investment banker

JOHN ESTEN COOKE (*right*)
(1830–1886)
Novelist, historian

JOSIAH PARSONS COOKE (*left*)
(1827–1892)
Chemist, educator

ROSE TERRY COOKE (*right*)
[Mrs. Rollin H. Cooke]
(1827–1892)
Poet, short-story writer

INA DONNA COOLBRITH (*left*)
(1842–1928)
Poet

THOMAS McINTYRE COOLEY
(*right*)
(1824–1898)
Jurist, educator, author of *Treatise on Constitutional Limitations*

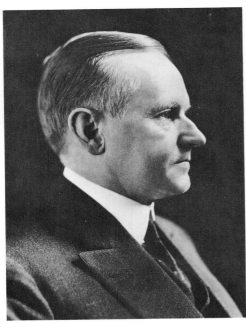

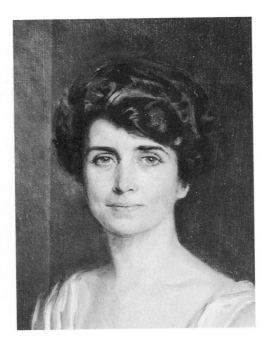

CALVIN COOLIDGE (*left*)
[John Calvin Coolidge]
(1872–1933)
President of the United States, 1923–1929
Courtesy Library of Congress

Mrs. CALVIN COOLIDGE (*right*)
[nee Grace Anne Goodhue]
(1879–1957)
First lady, 1923–1929
Painting by Howard Chandler Christy. Courtesy Forbes Library

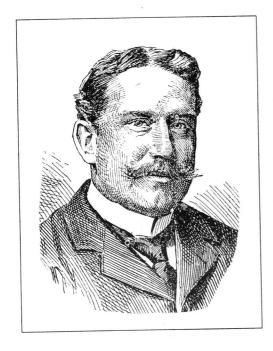

CHARLES ALLERTON COOLIDGE
(*left*)
(1858–1936)
Architect, leader in college and institutional design

THOMAS JEFFERSON COOLIDGE
(*right*)
(1831–1920)
Diplomat, merchant, philanthropist

EDWARD COOPER (*left*)
(1824–1905)
Iron and steel manufacturer

JAMES FENIMORE COOPER (*right*)
(1789–1851)
Novelist
Painting by John Wesley Jarvis

PETER COOPER (*left*)
(1791–1883)
Inventor, manufacturer; built first American steam locomotive; founded Cooper Union
Courtesy Burndy Library

SAMUEL COOPER (*right*)
(1798–1876)
Senior general of the Confederacy

THOMAS COOPER (*left*)
(1759–1839)
Political agitator, economist, scientist, educator

THOMAS ABTHORPE COOPER
(*right*)
(1776–1849)
Actor
Painting attributed to William Dunlap. Courtesy The Players, New York

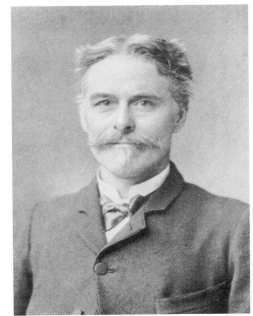

RICHARD COOTE, 1st Earl of
BELLAMONT (*left*)
(1636–1701)
British governor of Colonial New York,
Massachusetts, and New Hampshire

EDWARD DRINKER COPE (*right*)
(1840–1897)
Zoologist, paleontologist

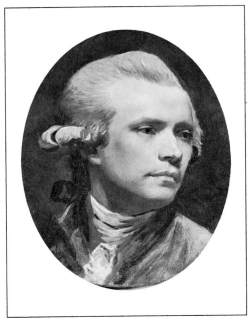

JOHN SINGLETON COPLEY (*left*)
(1738–1815)
Portrait painter
Self-portrait

JAMES JOHN CORBETT (*right*)
["Gentleman Jim" Corbett]
(1866–1933)
Heavyweight boxing champion, defeated
John L. Sullivan
Courtesy Mercaldo Archives

WILLIAM WILSON CORCORAN
(*left*)
(1798–1888)
Investment banker; established Corcoran
Gallery of Art, Washington, D.C.

GEORGE HENRY CORLISS (*right*)
(1817–1888)
Inventor, developed Corliss reciprocating
steam engine

ALONZO B. CORNELL (*left*)
(1832–1904)
Governor of New York; Western Union executive

EZRA CORNELL (*right*)
(1807–1874)
Telegraph promoter, leader in organizing Western Union; founder of Cornell University
Courtesy Cornell University

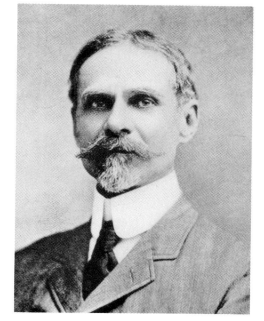

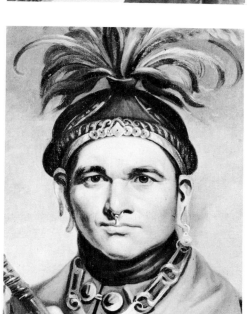

JAMES LEONARD CORNING (*left*)
(1855–1923)
Neurologist, pioneer in spinal anesthesia

CORNPLANTER (*right*)
[Garganwahgah; or John O'Bail]
(c. 1740–1836)
Iroquois leader, chief of the Senecas; supported British in American Revolution
Painting by F. Bartoli. Courtesy New-York Historical Society

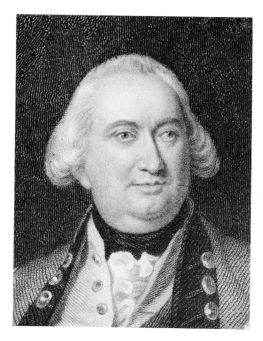

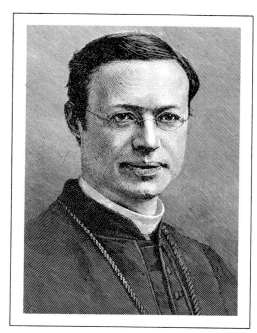

CHARLES CORNWALLIS, 1ST
Marquis CORNWALLIS (*left*)
(1738–1805)
British general in American Revolution, defeated at Yorktown
After a painting by John Singleton Copley

MICHAEL AUGUSTINE CORRIGAN
(*right*)
(1839–1902)
Roman Catholic archbishop of New York
After a photograph by Napoleon Sarony

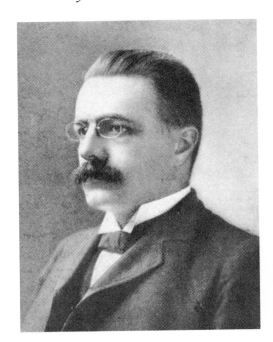
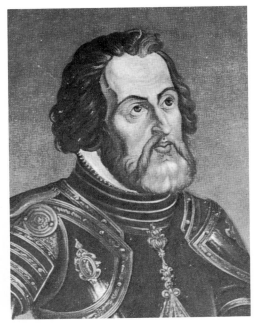

GEORGE BRUCE CORTELYOU
(*left*)
(1862–1940)
First Secretary of Commerce and Labor (1903); Secretary of Treasury under T. Roosevelt; president, Consolidated Gas Co.

HERNANDO CORTES (*right*)
[Hernando Cortez]
(1485–1547)
Spanish explorer, conqueror of Mexico; discovered Lower California

THOMAS CORWIN (*left*)
(1794–1865)
U.S. Senator, Congressman, Governor of Ohio, Secretary of the Treasury under Fillmore
Engraving by T. Doney

CHARLES BARNEY CORY (*right*)
[Owen Nox]
(1857–1921)
Ornithologist
Courtesy Chicago Natural History Museum

JOHN COTTON (*left*)
(1584–1652)
Puritan clergyman, leader in early Boston; "Patriarch of New England"
Engraving by H. W. Smith

CALVERT BYRON COTTRELL
(*right*)
(1821–1893)
Inventor, developed improved printing methods
Courtesy The Cottrell Company

FREDERIC RENÉ COUDERT (*left*)
(1832–1903)
Lawyer, expert in international law

ELLIOTT COUES (*right*)
(1842–1899)
Ornithologist, writer, editor

JOHN MERLE COULTER (*left*)
(1851–1928)
Botanist, educator

CHARLES EDWARD COURTNEY
(*right*)
(1849–1920)
Single sculls champion; coach of crew,
Cornell University
Courtesy Cornell University

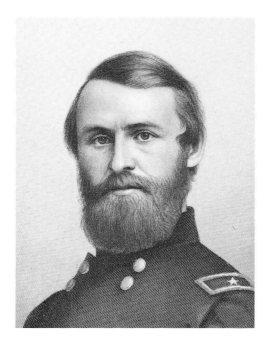

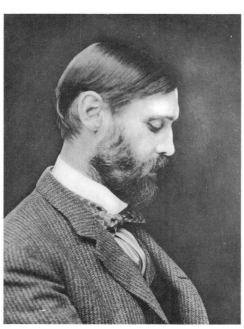

JACOB DOLSON COX (*left*)
(1828–1900)
Union general in Civil War; Governor of
Ohio, Secretary of the Interior under
Grant
Engraving by John C. Buttre

KENYON COX (*right*)
(1856–1919)
Painter, art critic
Courtesy Peter A. Juley & Son

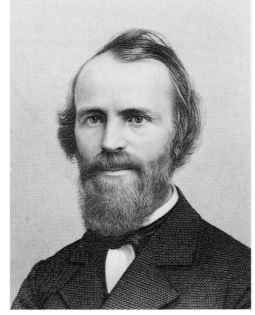

PALMER COX (*left*)
(1840–1924)
Illustrator, author of *Brownie* books

SAMUEL SULLIVAN COX (*right*)
(1824–1889)
Lawyer, Congressman, diplomat, journalist
Engraved by John C. Buttre from a photograph by Mathew Brady

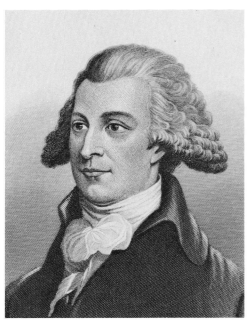

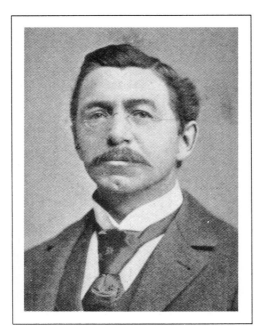

TENCH COXE (*left*)
(1755–1824)
Political economist, lawyer, public official
Engraving by F. T. Stuart

JACOB SECHLER COXEY (*right*)
(1854–1951)
Political figure, leader of "Coxey's Army"
of unemployed

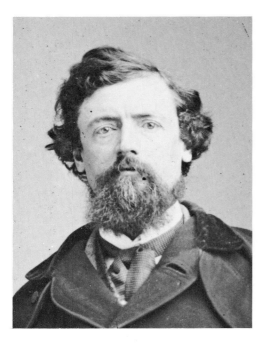

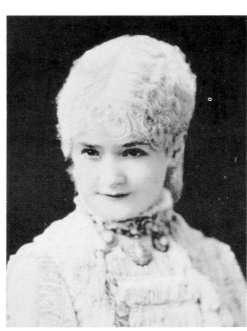

FREDERICK SWARTWOUT
COZZENS (*left*)
[Richard Haywarde]
(1818–1869)
Humorist
Courtesy Library of Congress, Brady-Handy Collection

LOTTA CRABTREE (*right*)
(1847–1924)
Actress
Photograph by Napoleon Sarony

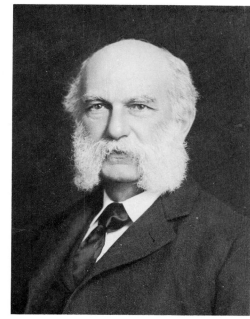

CHARLES EGBERT CRADDOCK
(*left*)
[Mary Noailles Murfree]
(1850–1922)
Short-story writer, novelist

JAMES MASON CRAFTS (*right*)
(1839–1917)
Chemist, president of Massachusetts Institute of Technology
Courtesy Massachusetts Institute of Technology

RALPH ADAMS CRAM (*left*)
(1863–1942)
Architect, educator, architectural critic

CHARLES HENRY CRAMP (*right*)
(1828–1913)
Shipbuilder, naval architect

WILLIAM CRAMP (*left*)
(1807–1879)
Shipbuilder

CHRISTOPHER PEARSE CRANCH
(*right*)
(1813–1892)
Painter, poet, critic, Unitarian clergyman

PRUDENCE CRANDALL *(left)*
(1803–1889)
Teacher, leader in Negro education
Painting by Francis Alexander. Courtesy Cornell University Library

STEPHEN CRANE *(right)*
(1871–1900)
Novelist, short-story writer, poet, war correspondent
Courtesy Public Library, Newark, New Jersey

WILLIAM HENRY CRANE *(left)*
(1845–1928)
Comic actor

WINTHROP MURRAY CRANE *(right)*
(1853–1920)
Manufacturer, developed paper for banknotes; Governor of Massachusetts, U.S. Senator

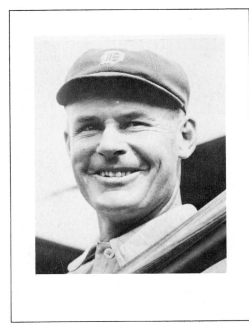

FRANCIS MARION CRAWFORD
(left)
(1854–1909)
Novelist
Photograph by Napoleon Sarony

SAM CRAWFORD *(right)*
[Samuel Earl Crawford; "Wahoo Sam"]
(1880–1968)
Baseball outfielder, member of Baseball Hall of Fame
Courtesy National Baseball Hall of Fame

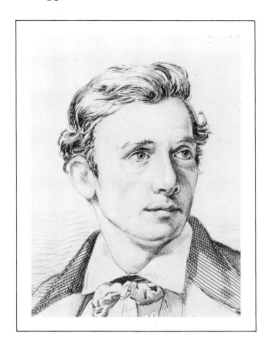

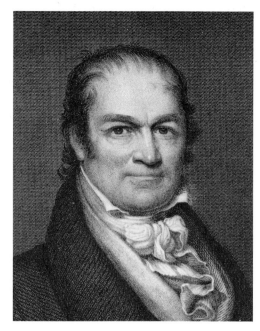

THOMAS CRAWFORD *(left)*
(c. 1813–1857)
Sculptor

WILLIAM HARRIS CRAWFORD
(right)
(1772–1834)
U.S. Senator, diplomat, Secretary of War under Madison, Secretary of the Treasury under Madison and Monroe
Engraved by Stephen H. Gimber from a painting by John Wesley Jarvis

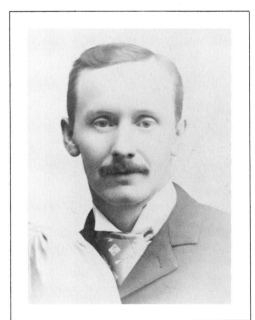

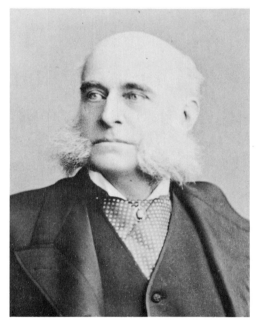

JAMES EDWIN CREIGHTON *(left)*
(1861–1924)
Philosopher, educator; co-editor, *Philosophical Review*
Courtesy Cornell University

JOHN CRERAR *(right)*
(1827–1889)
Manufacturer, financier; endowed John Crerar Library, Chicago
Courtesy John Crerar Library

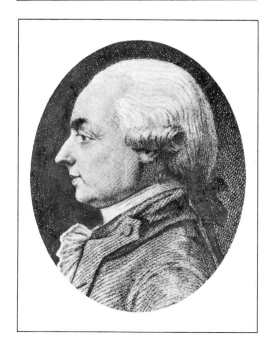

J. HECTOR St. JOHN CRÈVECŒUR
(left)
[Michel Guillaume Jean de Crèvecœur]
(1735–1813)
French essayist in U.S.; wrote *Letters from an American Farmer*

HENRY CREW *(right)*
(1859–1953)
Physicist, educator
Photograph by Eugene L. Ray, Evanston, Illinois. Courtesy Northwestern University

JOHN DANIEL CRIMMINS (*left*)
(1844–1917)
Contractor, constructed much of New York City elevated railway
Engraving by H. B. Hall's Sons

JOHN JORDAN CRITTENDEN (*right*)
(1787–1863)
U.S. Senator; Attorney General under W. H. Harrison, Tyler, and Fillmore; Governor of Kentucky
Engraving by Robert Whitechurch

CHARLES CROCKER (*left*)
(1822–1888)
Railroad industrialist, merged Central Pacific and Southern Pacific railroads

FRANCIS BACON CROCKER (*right*)
(1861–1921)
Electrical engineer, educator, established American electrical standards

DAVY CROCKETT (*left*)
[David Crockett]
(1786–1836)
Frontier scout, Congressman; killed at the Alamo
Engraved by Thomas B. Welch from a painting by S. S. Osgood

RICHARD CROKER (*right*)
["Boss Croker"]
(1841–1922)
Leader of Tammany Hall for sixteen years
Photograph by Pach Brothers

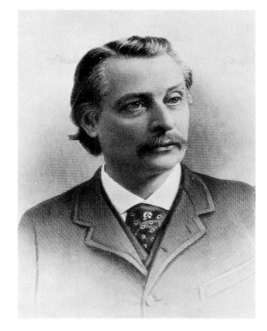

JANE CROLY (*left*)
[Jennie June; nee Jane Cunningham]
(1829–1901)
Journalist, feminist

GEORGE CROMPTON (*right*)
(1829–1886)
Inventor, developed weaving-loom improvements
Engraving by F. T. Stuart

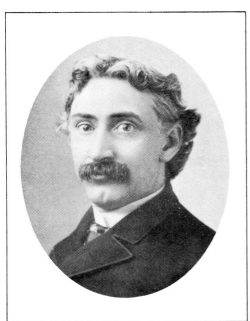

WILLIAM NELSON CROMWELL
(*left*)
(1854–1948)
Lawyer, counsel in transfer of ownership
of Panama Canal

GEORGE CROOK (*right*)
(1829–1890)
Union general in Civil War; leader in Indian Wars
Courtesy Library of Congress, Brady-Handy Collection

JASPAR FRANCIS CROPSEY (*left*)
(1823–1900)
Landscape painter, architect

ENOCH CROSBY (*right*)
(1750–1835)
Patriot spy in American Revolution

FANNY CROSBY *(left)*
[Frances Jane Crosby]
(1820–1915)
Hymn writer, teacher of the blind

HENRIETTA CROSMAN *(right)*
[Mrs. Maurice Campbell]
(1870–1944)
Actress

FREDERICK NICHOLLS CROUCH
(left)
(1808–1896)
Composer, wrote "Kathleen Mavourneen"

BENJAMIN WILLIAMS
CROWNINSHIELD *(right)*
(1772–1851)
Banker, merchant, Congressman, Secretary
of the Navy under Madison and Monroe
Engraving by John C. Buttre Co.

GEORGE CROWNINSHIELD *(left)*
(1766–1817)
Merchant, pioneer yachtsman

JACOB CROWNINSHIELD *(right)*
(1770–1808)
Schooner captain, merchant, Congressman
Painting by Robert Hinkley

MICHAEL CUDAHY (*left*)
(1841–1910)
Meat packer
Engraving by E. G. Williams & Bro.

GEORGE WASHINGTON CULLUM
(*right*)
(1809–1892)
Military engineer, historian

GEORGE DAVID CUMMINS (*left*)
(1822–1876)
Clergyman, organized Reformed Episcopal
Church
Engraving by John C. Buttre

NATHANIEL CURRIER (*right*)
(1813–1888)
Lithographer, partner in Currier and Ives
Courtesy Free Library of Philadelphia

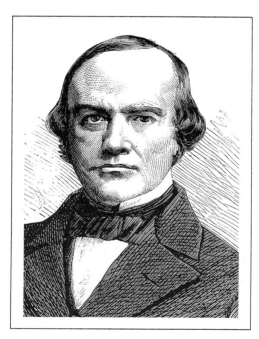

JEREMIAH CURTIN (*left*)
(1835–1906)
Folklorist, linguist, ethnologist
*Courtesy Bureau of American Ethnology, Smithsonian
Institution*

BENJAMIN ROBBINS CURTIS (*right*)
(1809–1874)
Associate justice, U.S. Supreme Court

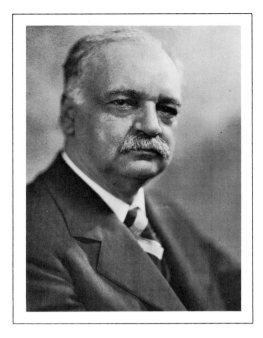 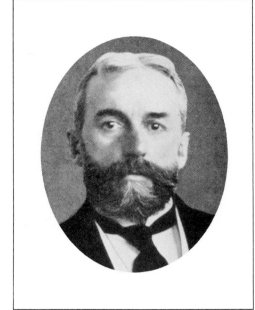

CHARLES CURTIS *(left)*
(1860–1936)
Congressman, U.S. Senator; Vice-President
of U.S., 1929–1933
Courtesy Kansas State Historical Society

**CYRUS HERMANN KOTZSCHMAR
CURTIS** *(right)*
(1850–1933)
Publisher, founded Curtis Publishing Co.

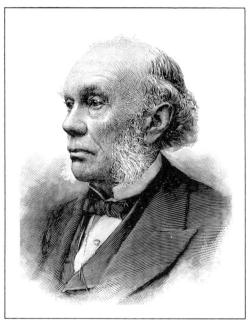

GEORGE TICKNOR CURTIS *(left)*
(1812–1894)
Lawyer, historian

GEORGE WILLIAM CURTIS *(right)*
(1824–1892)
Editor of *Harper's Weekly* and "The Easy
Chair" in *Harper's Magazine*
Engraving by Timothy Cole

CALEB CUSHING *(left)*
(1800–1879)
Lawyer, Congressman, diplomat; Attorney
General under Pierce

WILLIAM CUSHING *(right)*
(1732–1810)
Associate justice, U.S. Supreme Court
*Painting attributed to James Sharples, Sr. or Ellen
Sharples*

 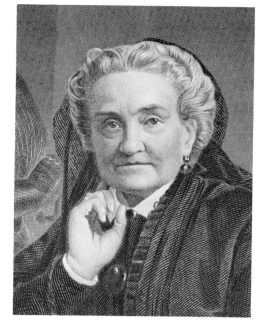

WILLIAM BARKER CUSHING (*left*)
(1842–1874)
Union naval officer, torpedoed Confederate
ram *Albemarle*

CHARLOTTE SAUNDERS CUSHMAN
(*right*)
(1816–1876)
Actress
After a painting by Alonzo Chappel

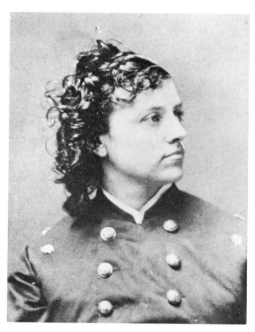

PAULINE CUSHMAN (*left*)
(1835–1893)
Actress, Union spy in Civil War
Courtesy New-York Historical Society

ARTHUR ROBERTSON CUSHNY
(*right*)
(1866–1926)
Physiologist, pharmacologist, educator
Courtesy New York Academy of Medicine

 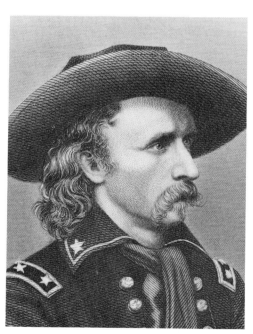

ELIZABETH BACON CUSTER (*left*)
(c. 1844–1933)
Wife of George Armstrong Custer; writer
Courtesy New-York Historical Society

GEORGE ARMSTRONG CUSTER
(*right*)
(1839–1876)
Army officer, killed with all his men in
battle of Little Big Horn

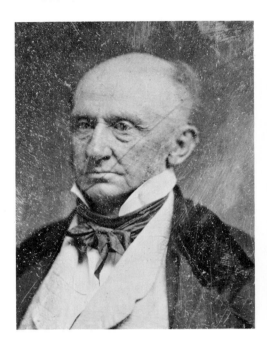

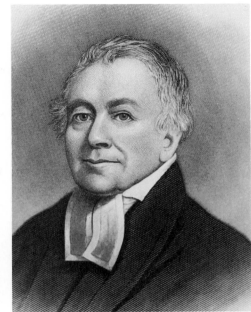

GEORGE WASHINGTON PARKE CUSTIS (*left*)
(1781–1857)
Playwright
Daguerreotype by Mathew Brady. Courtesy Library of Congress

MANASSEH CUTLER (*right*)
(1742–1823)
Congregational clergyman, botanist, colonizer of Ohio
Courtesy Ohio University

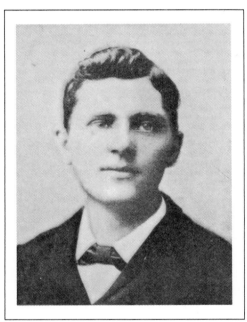

LEON F. CZOLGOSZ
(1873–1901)
Assassin of President McKinley

CHARLES WILLIAM DABNEY (*left*)
(1855–1945)
Educator; president, University of Tennessee and University of Cincinnati
Courtesy University of Cincinnati

JAMES RICHARD DACRES (*right*)
(1788–1853)
British naval officer in War of 1812

JOHN ADOLPHUS BERNARD DAHLGREN (*left*)
(1809–1870)
Naval ordnance officer, developed Dahlgren gun
Courtesy National Archives, Brady Collection

RICHARD DALE (*right*)
(1756–1826)
Revolutionary naval officer, served on *Bon Homme Richard* under John Paul Jones
Engraved by Richard W. Dodson from a drawing by James B. Longacre after a painting by Joseph Wood

CAROLINE DALL (*left*)
[nee Caroline Wells Healey]
(1822–1912)
Writer, advocate of women's rights

WILLIAM HEALEY DALL (*right*)
(1845–1927)
Paleontologist, naturalist
Courtesy Smithsonian Institution

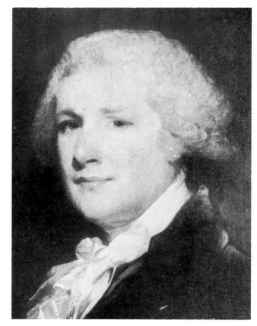
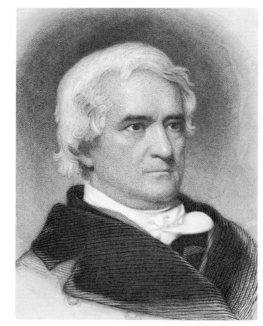

ALEXANDER JAMES DALLAS (*left*)
(1759–1817)
Secretary of the Treasury under Madison;
first editor, Supreme Court reports
Painting by Gilbert Stuart

GEORGE MIFFLIN DALLAS (*right*)
(1792–1864)
Vice-President of U.S., 1845–1849
Engraving by Thomas B. Welch

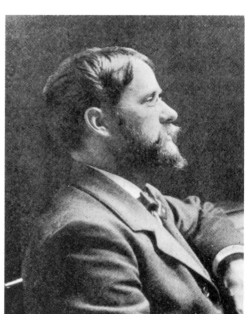

CYRUS EDWIN DALLIN (*left*)
(1861–1944)
Sculptor

EMMET DALTON (*right*)
(1871–1937)
Western outlaw
Courtesy Mercaldo Archives

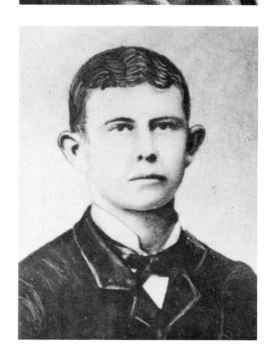
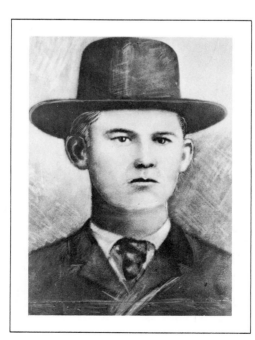

GRATTAN DALTON (*left*)
(1861–1892)
Western outlaw
Courtesy Mercaldo Archives

ROBERT DALTON (*right*)
(c. 1870–1892)
Western outlaw
Courtesy Mercaldo Archives

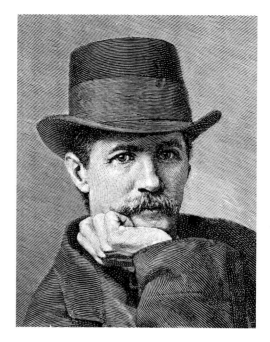

AUGUSTIN DALY (*left*)
[John Augustin Daly]
(1838–1899)
Playwright, producer, director
From a photograph by Napoleon Sarony

MARCUS DALY (*right*)
(1841–1900)
Capitalist, developed Anaconda copper
mines

FRANK HEINO DAMROSCH (*left*)
(1859–1937)
Conductor of choral societies

LEOPOLD DAMROSCH (*right*)
(1832–1885)
Conductor, composer, violinist

WALTER JOHANNES DAMROSCH
(*left*)
(1862–1950)
Composer, musical director, educator

CHARLES ANDERSON DANA (*right*)
(1819–1897)
Newspaper editor, owner of *New York Sun*

EDWARD SALISBURY DANA (*left*)
(1849–1935)
Mineralogist, educator
Photograph by Pach Brothers

JAMES DWIGHT DANA (*right*)
(1813–1895)
Geologist, mineralogist, educator

JOHN COTTON DANA (*left*)
(1856–1929)
Librarian, a founder of Newark Museum
Courtesy Public Library, Newark, New Jersey

RICHARD DANA (*right*)
(1700–1772)
Lawyer, leader of Colonial cause prior to
Revolution
Painting by John Singleton Copley

RICHARD HENRY DANA (*left*)
(1787–1879)
Poet, essayist

RICHARD HENRY DANA (*right*)
(1815–1882)
Writer, lawyer, author of *Two Years Before
the Mast*

PETER VIVIAN DANIEL *(left)*
(1784–1860)
Associate justice, U.S. Supreme Court
Engraving by Max Rosenthal. Courtesy Virginia State Library

LORENZO DA PONTE *(right)*
[Emanuele Conegliano]
(1749–1838)
Mozart's librettist; first professor of Italian in the U.S., at Columbia College

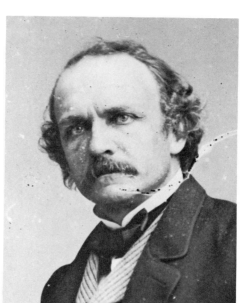
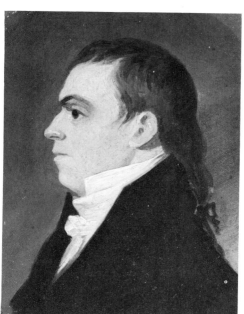

FELIX OCTAVIUS CARR DARLEY
(left)
(1822–1888)
Book and magazine illustrator
Courtesy Library of Congress, Brady-Handy Collection

WILLIAM DARLINGTON *(right)*
(1782–1863)
Botanist
Painting by Jacob Eichholtz. Courtesy New-York Historical Society

CLARENCE SEWARD DARROW
(left)
(1857–1938)
Lawyer
Courtesy Chicago Historical Society

EDWARD LOOMIS DAVENPORT
(right)
(1815–1877)
Actor
Courtesy Library of Congress, Brady-Handy Collection

FANNY LILY GYPSY DAVENPORT
(*left*)
(1850–1898)
Actress

HOMER CALVIN DAVENPORT
(*right*)
(1867–1912)
Political cartoonist
Courtesy "New York Journal-American"

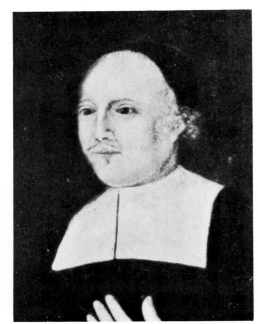

IRA ERASTUS DAVENPORT (*left*)
(1839–1911)
Spiritualist, medium

JOHN DAVENPORT (*right*)
(1597–1670)
Colonial clergyman, founded colony of New Haven
Painting attributed to John Foster

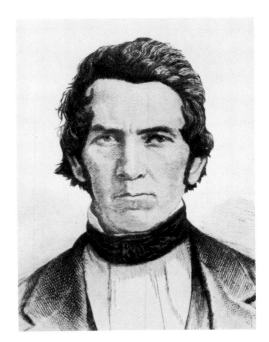

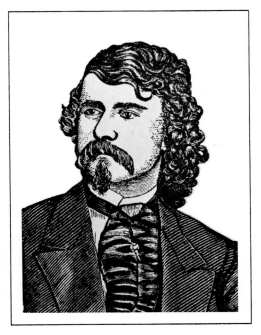

THOMAS DAVENPORT (*left*)
(1802–1857)
Inventor of the electric motor, designed and patented prototype of electric trolley car

WILLIAM HENRY HARRISON DAVENPORT (*right*)
(1841–1877)
Spiritualist, medium

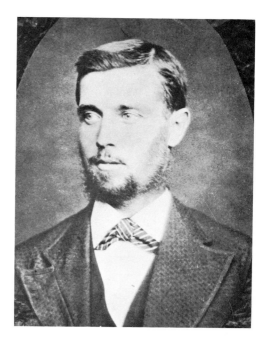

JOHN DAVEY (*left*)
(1846–1923)
Pioneer tree surgeon
Courtesy Kent Free Library

THOMAS DAVIDSON (*right*)
(1840–1900)
Philosopher, teacher, historian of education

ARTHUR BOWEN DAVIES (*left*)
(1862–1928)
Painter
Courtesy Peter A. Juley & Son

SAMUEL DAVIES (*right*)
(1723–1761)
Presbyterian clergyman; president, College
of New Jersey (Princeton)
Painting by James Massalon

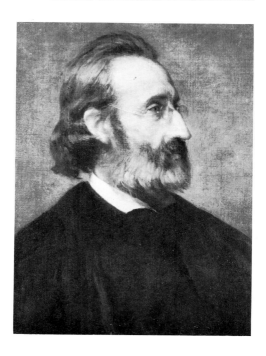
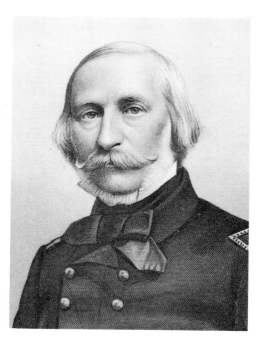

ANDREW JACKSON DAVIS (*left*)
(1826–1910)
Hypnotist, mystic, writer
*Painting by Thomas Le Clear. Courtesy New-York
Historical Society*

CHARLES HENRY DAVIS (*right*)
(1807–1877)
Union naval officer in Civil War
Engraving by John C. Buttre

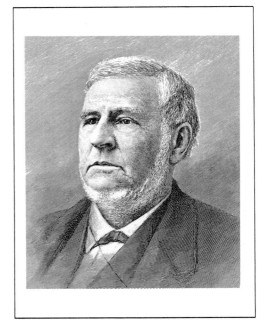

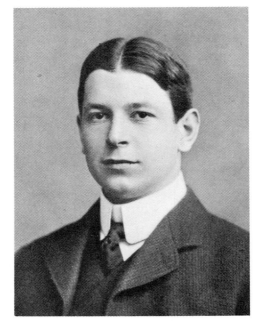

DAVID DAVIS (*left*)
(1815–1886)
Associate justice, U.S. Supreme Court; U.S.
Senator; Lincoln's campaign manager, 1860

DWIGHT FILLEY DAVIS (*right*)
(1879–1945)
Secretary of War under Coolidge; donor of
Davis Cup in tennis

EDWIN HAMILTON DAVIS (*left*)
(1811–1888)
Physician, writer, archaeologist of Missis-
sippi Valley

GEORGE DAVIS (*right*)
(1820–1896)
Confederate Attorney General
Courtesy Wilmington Public Library

GEORGE WHITEFIELD DAVIS
(*left*)
(1839–1918)
Army officer, engineer

HENRY WINTER DAVIS (*right*)
(1817–1865)
Congressman, leading Radical politician
during Civil War
Engraving by Frederick Halpin

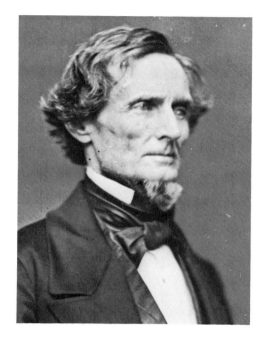

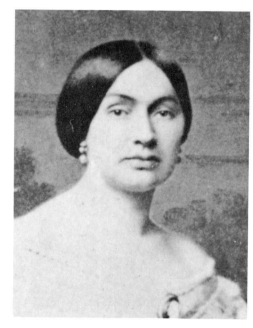

JEFFERSON DAVIS (*left*)
(1808–1889)
President of the Confederacy
Courtesy National Archives, Brady Collection

Mrs. JEFFERSON DAVIS (*right*)
[nee Varina Howell]
(1826–1906)
First lady of the Confederacy
Courtesy Confederate Museum

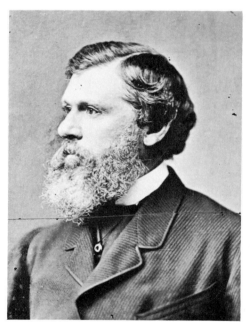

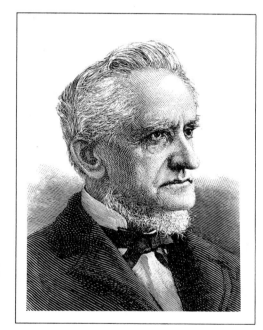

JOHN CHANDLER BANCROFT
DAVIS (*left*)
(1822–1907)
Jurist, diplomat, lawyer, editor of Supreme
Court reports
Courtesy Library of Congress, Brady-Handy Collection

NATHAN SMITH DAVIS (*right*)
(1817–1904)
Medical educator; a founder of American
Medical Association and of Northwestern
University

NOAH DAVIS (*left*)
(1818–1902)
Jurist, presided at Tweed Ring trial
Engraving by George E. Perine

RICHARD HARDING DAVIS (*right*)
(1864–1916)
Reporter, war correspondent, short-story
writer, novelist, playwright
Photograph by Napoleon Sarony

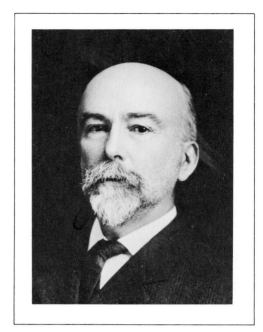

WILLIAM MORRIS DAVIS *(left)*
(1850–1934)
Geologist, physical geographer
Courtesy Harvard University Archives

CHARLES GATES DAWES *(right)*
(1865–1951)
Lawyer, financier, politician, diplomat;
Vice-President of U.S., 1925–1929
Courtesy Chicago Historical Society

HENRY LAURENS DAWES *(left)*
(1816–1903)
Congressman, U.S. Senator

WILLIAM DAWES *(right)*
(1745–1799)
Patriot, rode with Paul Revere to Concord,
April 18, 1775
Courtesy New-York Historical Society

BENJAMIN HENRY DAY *(left)*
(1810–1889)
Journalist, founded *New York Sun*, first suc-
cessful penny daily
Courtesy Free Library of Philadelphia

JAMES ROSCOE DAY *(right)*
(1845–1923)
Methodist clergyman, chancellor of Syracuse
University

JEREMIAH DAY (*left*)
(1773–1867)
Educator, president of Yale University
Engraving by John Sartain. Courtesy Burndy Library

WILLIAM RUFUS DAY (*right*)
(1849–1923)
Associate justice, U.S. Supreme Court; Secretary of State under McKinley; lawyer, diplomat
Courtesy Library of Congress

JONATHAN DAYTON (*left*)
(1760–1824)
Signer of the Constitution, U.S. Senator, Speaker of the House; eponym of Dayton, Ohio

WILLIAM LEWIS DAYTON (*right*)
(1807–1864)
Lawyer, diplomat, U.S. Senator
Engraved by John C. Buttre from a photograph by Mathew Brady

DEADWOOD DICK (*left*)
[Richard W. Clarke]
(1845–1930)
English-born frontiersman
Courtesy Mercaldo Archives

BASHFORD DEAN (*right*)
(1867–1928)
Ichthyologist, armor expert
Courtesy New-York Historical Society

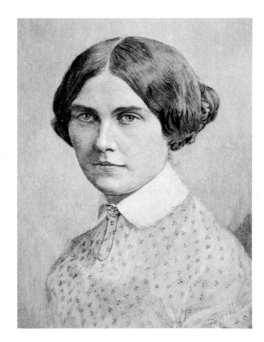
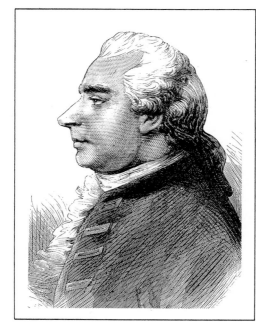

JULIA DEAN (*left*)
(1830–1868)
Actress
Engraving by R. G. Tietze

SILAS DEANE (*right*)
(1737–1789)
First foreign emissary of American Colonies;
member of Continental Congress

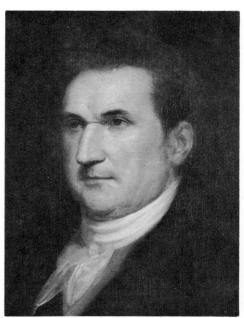
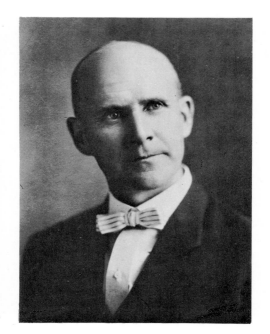

HENRY DEARBORN (*left*)
(1751–1829)
Army officer in Revolution and War of
1812; Secretary of War under Jefferson
Painting by Charles Willson Peale. Courtesy Independence National Historical Park

EUGENE VICTOR DEBS (*right*)
(1855–1926)
Socialist leader
Courtesy Tamiment Institute Library

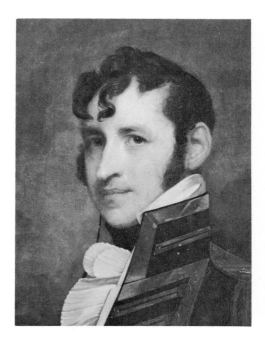
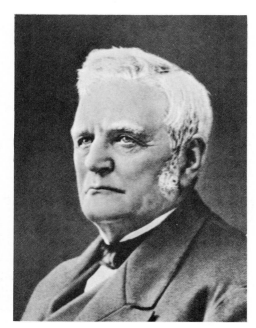

STEPHEN DECATUR (*left*)
(1779–1820)
Naval officer
Painting by Gilbert Stuart. Courtesy Independence National Historical Park

JOHN DEERE (*right*)
(1804–1886)
Plow manufacturer
Courtesy Deere and Co.

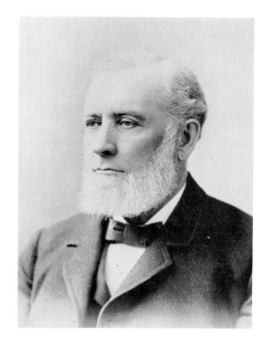

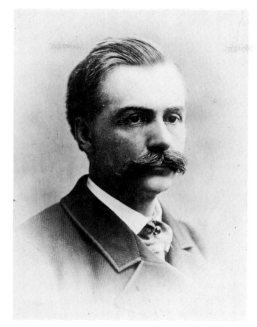

WILLIAM DEERING (*left*)
(1826–1913)
Harvester manufacturer

JOHN WILLIAM DE FOREST
(*right*)
(1826–1906)
Novelist
Courtesy Meserve Collection

CHARLES DE GARMO (*left*)
(1849–1934)
Educator, president of Swarthmore College
Courtesy Cornell University

REGINALD DE KOVEN (*right*)
[Henry Louis Reginald De Koven]
(1859–1920)
Composer, music critic

EDWARD DELAFIELD (*left*)
(1794–1875)
Ophthalmologist, surgeon
Courtesy Dr. Maynard C. Wheeler

FRANCIS DELAFIELD (*right*)
(1841–1915)
Pathologist, educator

MARGARET DELAND (*left*)
[nee Margaretta Wade Campbell]
(1857–1945)
Novelist

LORD DELAWARE (*right*)
[Baron Thomas West De La Warr]
(1577–1618)
First governor of Virginia colony
Courtesy Virginia State Library

DANIEL DE LEON (*left*)
(1852–1914)
Socialist leader, editor

LORENZO DELMONICO (*right*)
(1813–1881)
New York restaurateur

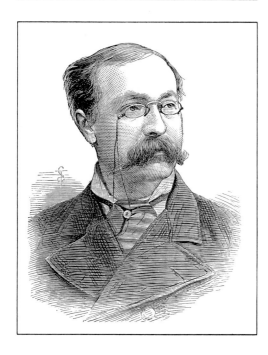

GEORGE WASHINGTON DE LONG
(*left*)
(1844–1881)
Naval officer, arctic explorer

JOSEPH DENNIE (*right*)
(1768–1812)
Essayist, editor

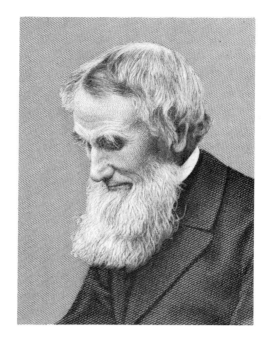

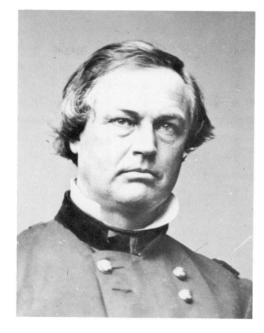

AARON LUFKIN DENNISON (*left*)
(1812–1895)
Watch manufacturer
Engraving by J. A. J. Wilcox

JAMES WILLIAM DENVER (*right*)
(1817–1892)
Congressman, Governor of Kansas Territory; eponym of Denver, Colorado
Courtesy Library of Congress, Brady Collection

WASHINGTON CHARLES DePAUW
(*left*)
(1822–1887)
Glass manufacturer, philanthropist, benefactor of DePauw University

CHAUNCEY MITCHELL DEPEW
(*right*)
(1834–1928)
U.S. Senator, lawyer, president of New York Central Railroad

ABRAHAM De PEYSTER (*left*)
(c. 1657–1728)
Merchant, public official, mayor of New Amsterdam

ELIAS HASKET DERBY (*right*)
(1739–1799)
Salem merchant, shipowner
Engraving by John C. Buttre. Courtesy Harvard University Archives

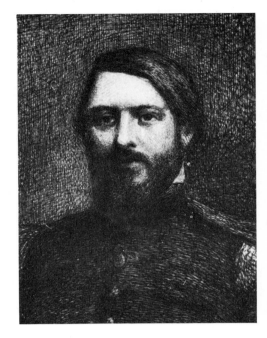

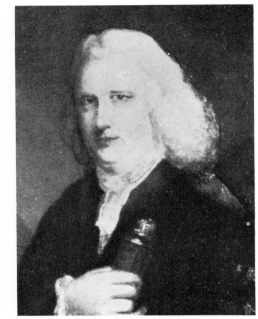

GEORGE HORATIO DERBY *(left)*
[Squibob; John Phoenix]
(1823–1861)
Humorist

RICHARD DERBY *(right)*
(1712–1783)
Salem merchant, shipowner; supplied ship
Quero for Revolutionary cause
*Painted by J. Alden Weir from a painting by Henry
Sargent*

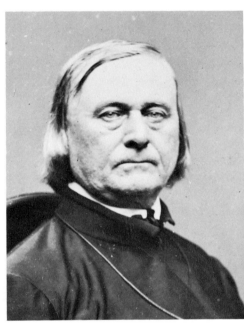

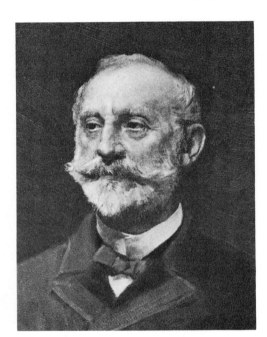

PIERRE JEAN De SMET *(left)*
[Blackrobe]
(1801–1873)
Jesuit missionary to Indians
Courtesy Library of Congress, Brady-Handy Collection

CHARLES DEVENS *(right)*
(1820–1891)
Union general in Civil War; Attorney
General under Hayes
After a painting by Frederick P. Vinton

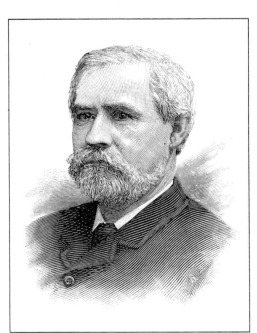

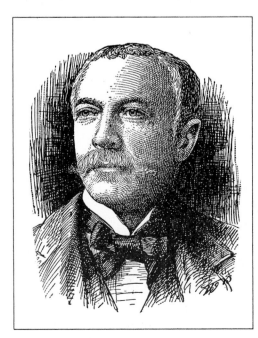

THEODORE LOW De VINNE *(left)*
(1828–1914)
Printer, typographer, authority on history
of printing; a founder of Grolier Club

CHARLES MELVILLE DEWEY *(right)*
(1849–1937)
Painter

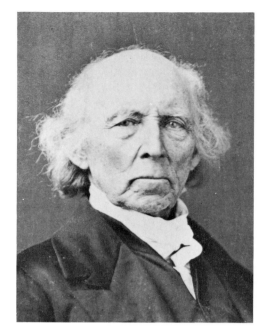

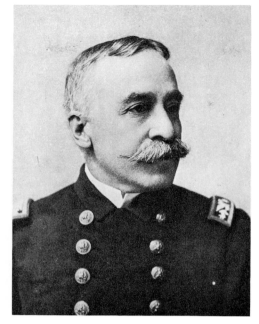

CHESTER DEWEY (*left*)
(1784–1867)
Congregational clergyman, educator, botanist, geologist
Courtesy University of Rochester

GEORGE DEWEY (*right*)
(1837–1917)
Naval officer in Spanish-American War, destroyed Spanish squadron at Manila Bay

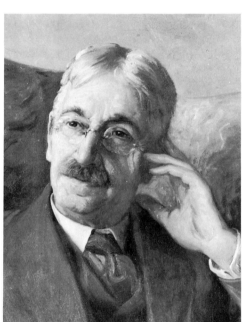

JOHN DEWEY (*left*)
(1859–1952)
Philosopher, educator
Painting by Edwin B. Child. Courtesy Columbiana Collection, Columbia University

MELVIL DEWEY (*right*)
[Melvil Louis Kossuth Dewey]
(1851–1931)
Librarian, developed Dewey decimal classification system

THOMAS WILMER DEWING (*left*)
(1851–1938)
Painter

ELSIE DE WOLFE (*right*)
[Elsie de Wolfe Mendl]
(1865–1950)
Actress, interior designer
Photograph by Napoleon Sarony

TIMOTHY DEXTER (*left*)
["Lord Timothy Dexter"]
(1747–1806)
Eccentric merchant, Newburyport, Mass.

MICHEL HARRY DE YOUNG (*right*)
(1849–1925)
Newspaper editor, founder of *San Francisco Chronicle*

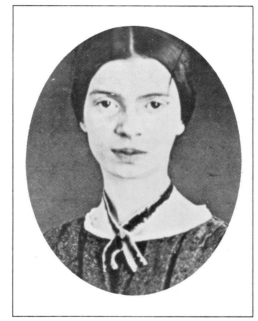

ANNA ELIZABETH DICKINSON
(*left*)
(1842–1932)
Abolitionist, actress, reformer
Engraving by George E. Perine & Co.

EMILY DICKINSON (*right*)
[Emily Elizabeth Dickinson]
(1830–1886)
Poet

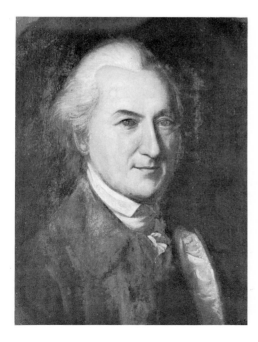
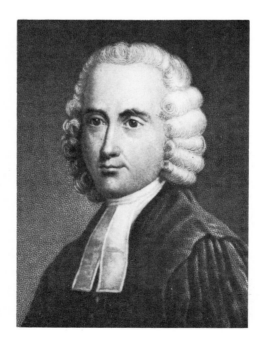

JOHN DICKINSON (*left*)
(1732–1808)
Political leader in Colonial Philadelphia, delegate to Constitutional Convention
Painting by Charles Willson Peale. Courtesy Independence National Historical Park

JONATHAN DICKINSON (*right*)
(1688–1747)
Presbyterian clergyman, educator; first president, College of New Jersey (Princeton)
Courtesy Princeton University Archives

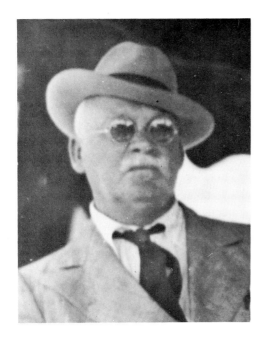
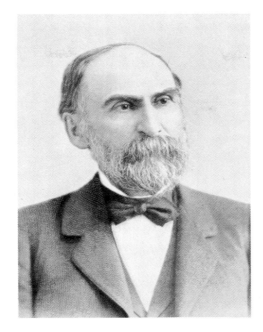

CHARLES BANCROFT DILLINGHAM
(*left*)
(1868–1934)
Theatrical manager, producer
Courtesy Harvard Theatre Collection

NELSON DINGLEY (*right*)
(1832–1899)
Congressman, Governor of Maine, editor

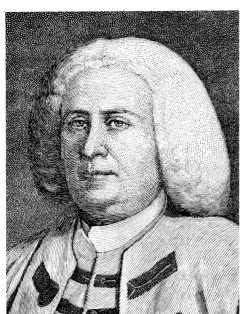
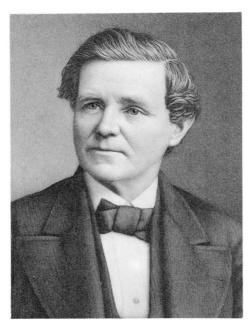

ROBERT DINWIDDIE (*left*)
(1693–1770)
Lieutenant Governor of Colonial Virginia

HENRY DISSTON (*right*)
(1819–1878)
Saw and hardware manufacturer
Engraving by Samuel Sartain

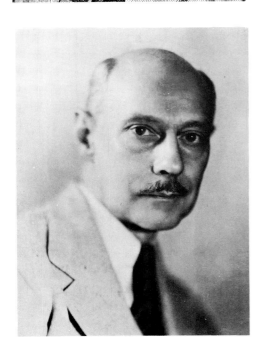
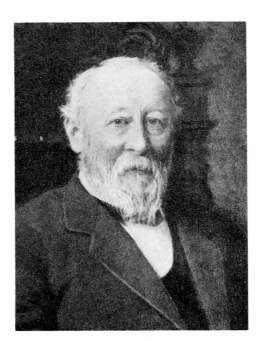

RAYMOND LEE DITMARS (*left*)
(1876–1942)
Naturalist, authority on reptiles

OLIVER DITSON (*right*)
(1811–1888)
Music publisher

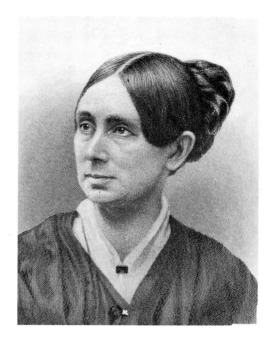

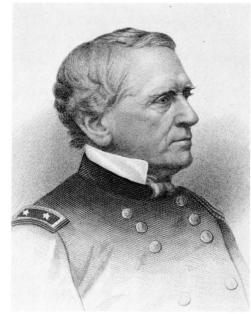

DOROTHEA LYNDE DIX *(left)*
(1802–1887)
Reformer, humanitarian

JOHN ADAMS DIX *(right)*
(1798–1879)
U.S. Senator, Secretary of the Treasury under Buchanan, Governor of New York; Union general in Civil War
Engraving by Alexander H. Ritchie

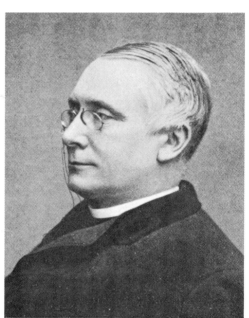

MORGAN DIX *(left)*
(1827–1908)
Protestant Episcopal clergyman

THOMAS DIXON *(right)*
(1864–1946)
Baptist clergyman, novelist; wrote *The Clansman*, basis for *Birth of a Nation*

GEORGE WASHINGTON DOANE
(left)
(1799–1859)
Protestant Episcopal bishop
Engraving by W. H. Jackman

WILLIAM CROSWELL DOANE
(right)
(1832–1913)
Protestant Episcopal bishop

LEW DOCKSTADER (*left*)
[George Alfred Clapp]
(1856–1924)
Vaudevillian, minstrel actor
Courtesy Museum of the City of New York

GRENVILLE MELLEN DODGE
(*right*)
(1831–1916)
Army officer, Congressman, railroad engineer
Engraving by Alexander H. Ritchie

MARY ABIGAIL DODGE (*left*)
[Gail Hamilton]
(1833–1896)
Essayist

MARY MAPES DODGE (*right*)
[nee Mary Elizabeth Mapes]
(1831–1905)
Author of children's books, editor of *St. Nicholas Magazine*

WILLIAM EARL DODGE (*left*)
(1805–1883)
Merchant, reformer; organized Young Men's Christian Association
From a photograph by Napoleon Sarony

NATHAN HASKELL DOLE (*right*)
(1852–1935)
Editor, writer, poet, translator
Courtesy Margaret Dole McCall

SANFORD BALLARD DOLE (*left*)
(1844–1926)
Hawaiian political leader; first governor,
Territory of Hawaii; U.S. district judge

ROBERT DOLLAR (*right*)
(1844–1932)
Shipping magnate

ANDREW JACKSON DONELSON
(*left*)
(1799–1871)
Diplomat, politician; adopted son and
aide of Andrew Jackson
After an ambrotype by Mathew Brady

MRS. ANDREW JACKSON DONELSON
(*right*)
[nee Emily Tennessee Donelson]
(1807–1836)
White House hostess for Andrew Jackson;
niece of Mrs. Jackson, married Jackson's
adopted son
*Painting by Ralph E. Earl. Courtesy White House
Collection*

ALEXANDER WILLIAM DONIPHAN
(*left*)
(1808–1887)
Army officer in Mexican War; lawyer,
politician
Engraving by H. B. Hall & Sons

IGNATIUS DONNELLY (*right*)
(1831–1901)
Reform politician, orator, writer

ROBERT OGDEN DOREMUS (*left*)
(1824–1906)
Chemist

THOMAS WILSON DORR (*right*)
(1805–1854)
Rhode Island reform politician, leader of "Dorr's Rebellion"

MARION DORSET (*left*)
(1872–1935)
Biochemist
Courtesy U.S. Department of Agriculture

JOHN RANDOLPH DOS PASSOS
(*right*)
(1844–1917)
Corporation lawyer

ABNER DOUBLEDAY (*left*)
(1819–1893)
Union general in Civil War; erroneously credited with invention of baseball
Engraved by John C. Buttre from a photograph by Mathew Brady

FRANK NELSON DOUBLEDAY
(*right*)
(1862–1934)
Book publisher
Photograph by Pach Brothers. Courtesy Doubleday & Co., Inc.

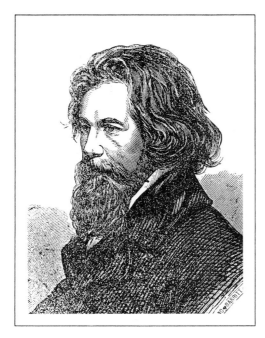

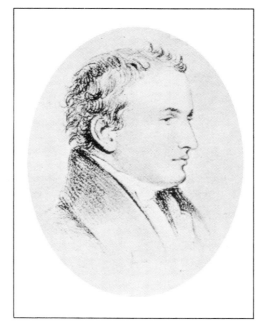

THOMAS DOUGHTY (*left*)
(1793–1856)
Landscape painter
Courtesy Free Library of Philadelphia

DAVID DOUGLAS (*right*)
(1798–1834)
Scottish botanist in U.S., discovered the Douglas fir tree
Courtesy "American Forests"

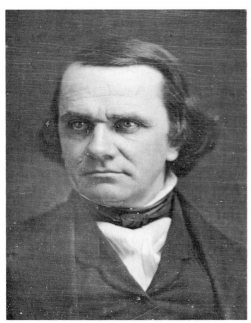

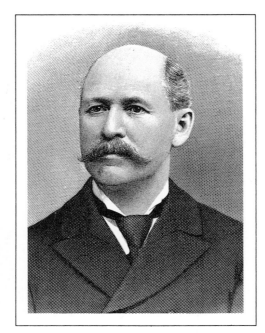

STEPHEN ARNOLD DOUGLAS
(*left*)
(1813–1861)
Political leader, orator, U.S. Senator; Lincoln's political opponent; called "The Little Giant"
Daguerreotype by Mathew Brady. Courtesy Library of Congress

WILLIAM LEWIS DOUGLAS (*right*)
(1845–1924)
Shoe manufacturer, politician, Governor of Massachusetts

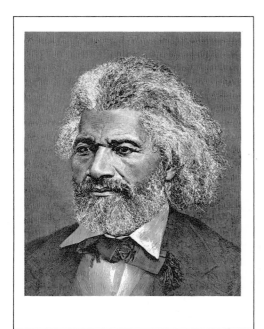

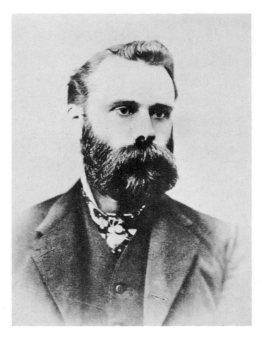

FREDERICK DOUGLASS (*left*)
[Frederick Augustus Washington Bailey]
(*c.* 1817–1895)
Abolitionist, lecturer, journalist

CHARLES H. DOW (*right*)
(1851–1902)
Financial statistician, founded Dow-Jones averages and *Wall Street Journal*
Courtesy Prof. George W. Bishop, Jr., Ph.D., The University of Tennessee, author of "Charles H. Dow and the Dow Theory"

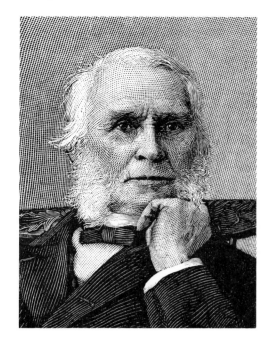

NEAL DOW (*left*)
(1804–1897)
Prohibitionist

CHARLES FERDINAND DOWD
(*right*)
(1825–1904)
Educator, reputed originator of standard
time zones

ANDREW JACKSON DOWNING
(*left*)
(1815–1852)
Horticulturist, landscape gardener, architect

MAJOR JACK DOWNING (*right*)
[Seba Smith]
(1792–1868)
Political satirist, journalist, editor
Engraving by John C. Buttre. Courtesy New-York Historical Society

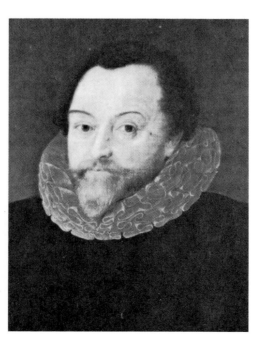

DANIEL DRAKE (*left*)
(1785–1852)
Physician, educator, scientist
Engraving by Alexander H. Ritchie

SIR FRANCIS DRAKE (*right*)
(*c.* 1540–1596)
Navigator, explorer

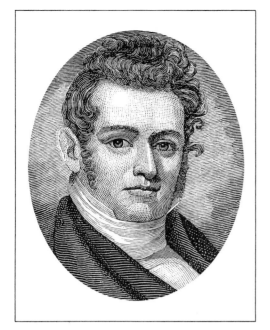

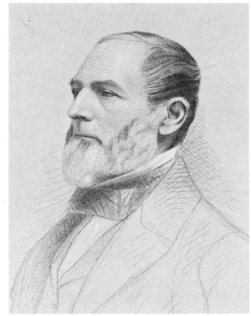

JOSEPH RODMAN DRAKE *(left)*
(1795–1820)
Poet

SAMUEL GARDNER DRAKE *(right)*
(1798–1875)
Bookseller, bibliophile, historian

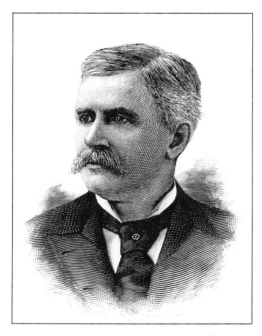

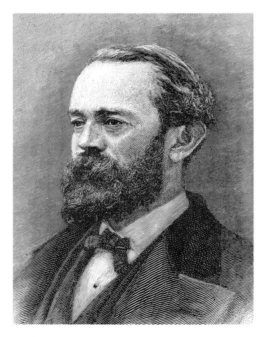

ANDREW SLOAN DRAPER *(left)*
(1848–1913)
Lawyer, educator; president, University of Illinois

HENRY DRAPER *(right)*
(1837–1882)
Astronomer, pioneer in astronomical photography

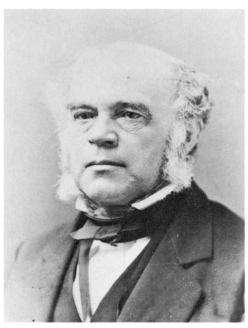

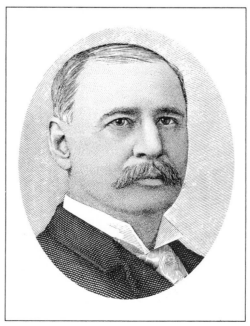

JOHN WILLIAM DRAPER *(left)*
(1811–1882)
Chemist, historian, pioneer in photography and spectrum analysis
Courtesy New-York Historical Society

WILLIAM FRANKLIN DRAPER *(right)*
(1842–1910)
Textile manufacturer, inventor, Congressman, diplomat

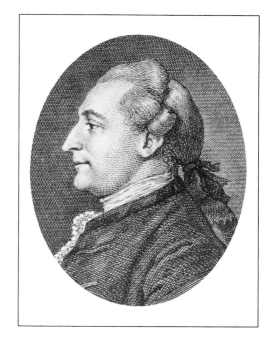

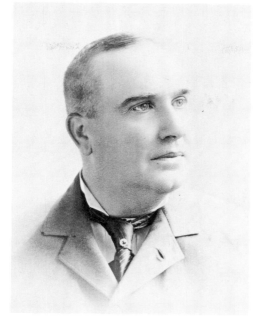

WILLIAM HENRY DRAYTON (*left*)
(1742–1779)
Revolutionary leader in South Carolina, jurist
Courtesy South Caroliniana Library, University of South Carolina

PAUL DRESSER (*right*)
[Paul Dreiser]
(1857–1911)
Song writer
Courtesy Walter Hampden Memorial Library at The Players, New York

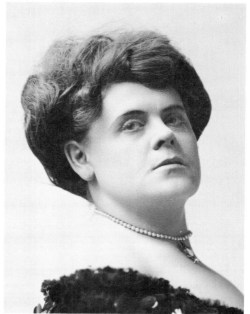

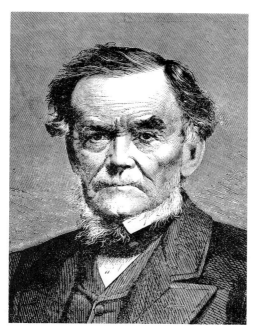

MARIE DRESSLER (*left*)
[Leila Koerber]
(1873–1934)
Actress
Courtesy New-York Historical Society

DANIEL DREW (*right*)
(1797–1879)
Financier, speculator; founded Drew Theological Seminary
After a photograph by Mathew Brady

JOHN DREW (*left*)
(1827–1862)
Actor

JOHN DREW (*right*)
(1853–1927)
Actor
Courtesy Walter Hampden Memorial Library at The Players, New York

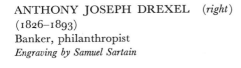

LOUISA LANE DREW *(left)*
(1820–1897)
Actress, wife of John Drew (1827–1862)

ANTHONY JOSEPH DREXEL *(right)*
(1826–1893)
Banker, philanthropist
Engraving by Samuel Sartain

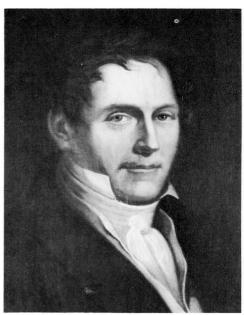

FRANCIS MARTIN DREXEL *(left)*
(1792–1863)
Banker, founded Drexel & Co., Philadelphia
Self-portrait. Courtesy Drexel & Co.

MOSES AARON DROPSIE *(right)*
(1821–1905)
Lawyer, civic leader, educator; founded
Dropsie College
Courtesy Dropsie College

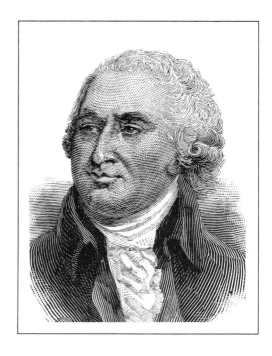

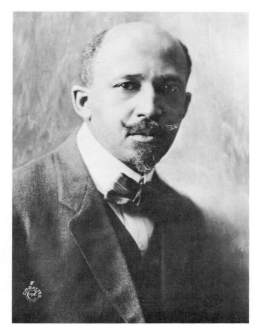

JAMES DUANE *(left)*
(1733–1797)
Revolutionary leader, mayor of New York,
Federal judge

WILLIAM EDWARD BURGHARDT
Du BOIS *(right)*
(1868–1963)
Educator, writer, editor; described life and
history of the American Negro
Courtesy Library of Congress

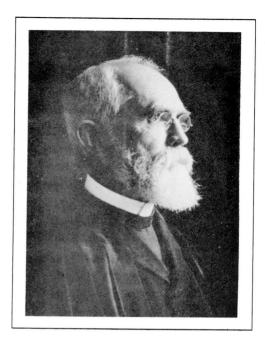

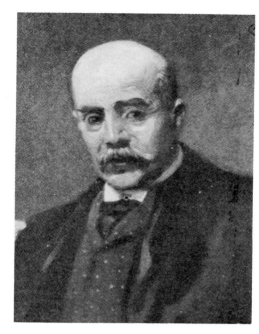

WILLIAM PORCHER Du BOSE (*left*)
(1836–1918)
Protestant Episcopal theologian

PAUL BELLONI Du CHAILLU (*right*)
(1835–1903)
Explorer, writer
Painting by James Carroll Beckwith

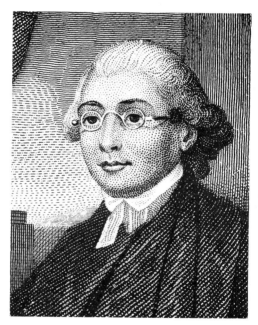

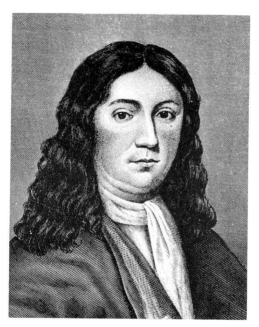

JACOB DUCHÉ (*left*)
(1738–1798)
Anglican clergyman, Loyalist in American
Revolution

JOSEPH DUDLEY (*right*)
(1647–1720)
Governor of Colonial Massachusetts

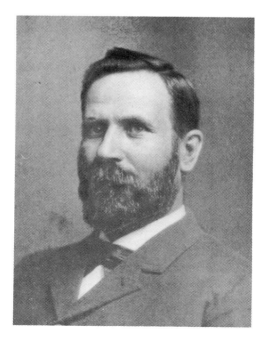

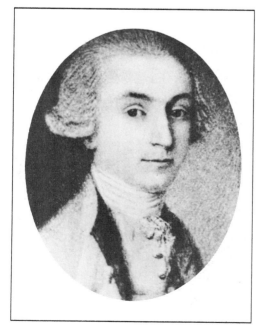

PLIMMON HENRY DUDLEY (*left*)
(1843–1924)
Railroad engineer, developed modern track
design

WILLIAM DUER (*right*)
(1747–1799)
Financier, speculator, member of Con-
tinental Congress, signer of Articles of Con-
federation
Courtesy New-York Historical Society

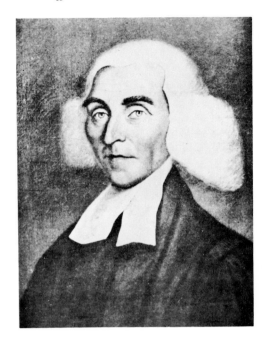

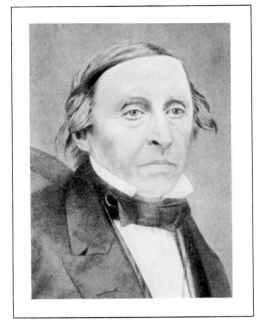

GEORGE DUFFIELD *(left)*
(1732–1790)
Presbyterian clergyman, supported Revolution

GEORGE DUFFIELD *(right)*
(1794–1868)
Presbyterian clergyman, writer
Courtesy First Presbyterian Church, Detroit, Michigan

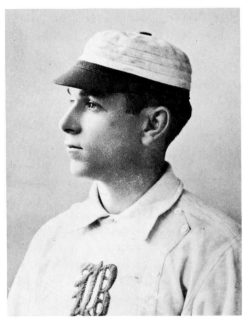

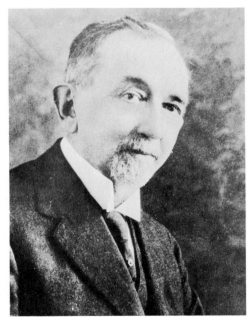

HUGH DUFFY *(left)*
(1866–1954)
Baseball outfielder, member of Baseball Hall of Fame
Courtesy National Baseball Hall of Fame

BENJAMIN NEWTON DUKE *(right)*
(1855–1929)
Cigarette manufacturer, philanthropist
Courtesy Duke University

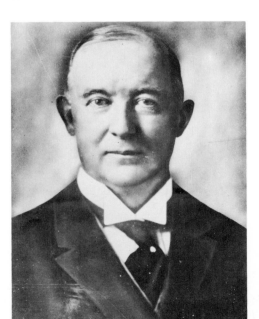

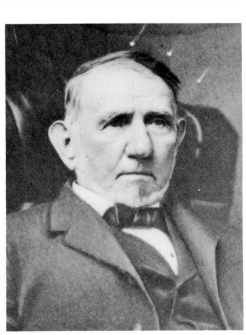

JAMES BUCHANAN DUKE *(left)*
(1856–1925)
Cigarette manufacturer, philanthropist, benefactor of Duke University
Courtesy American Tobacco Co.

WASHINGTON DUKE *(right)*
(1820–1905)
Cigarette manufacturer, father of Benjamin and James Duke
Courtesy Duke University

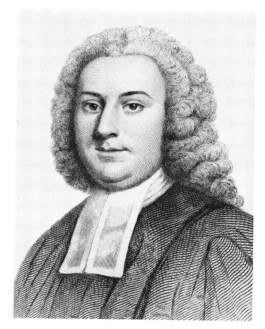
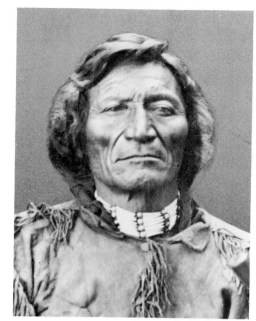

DANIEL DULANY (*left*)
(1722–1797)
Lawyer, Colonial political figure, opposed Stamp Act and Revolution
Engraving by William G. Armstrong

DULL KNIFE (*right*)
(*d.* 1879)
Cheyenne Indian chief
Photograph by William Henry Jackson. Courtesy Bureau of American Ethnology, Smithsonian Institution

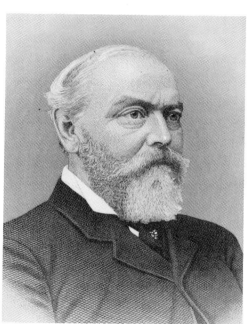

ROBERT GRAHAM DUN (*left*)
(1826–1900)
Developed credit rating system, now Dun & Bradstreet, Inc.
Engraving by George E. Perine

CHARLES FRANKLIN DUNBAR (*right*)
(1830–1900)
Economist, editor; first professor of political economy at Harvard University

PAUL LAURENCE DUNBAR (*left*)
(1872–1906)
Poet
Courtesy Ohio Historical Society

ISADORA DUNCAN (*right*)
(1878–1927)
Dancer
Photograph by Arnold Genthe

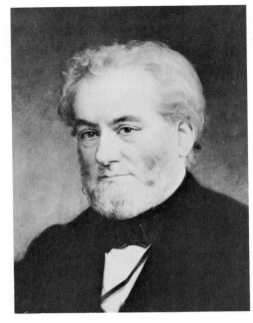

JAMES DUNCAN (*left*)
(1857–1928)
Labor leader; vice-president, American
Federation of Labor

ROBLEY DUNGLISON (*right*)
(1798–1869)
Physician, physiologist, educator, medical
writer
*Painting by Samuel B. Waugh. Courtesy Jefferson
Medical College*

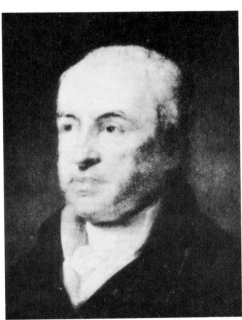
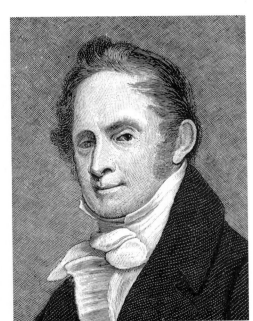

JOHN DUNLAP (*left*)
(1747–1812)
Printer, published *Pennsylvania Packet*, first
daily newspaper in U.S.

WILLIAM DUNLAP (*right*)
(1766–1839)
Playwright, painter, historian; a founder of
National Academy of Design

**JOHN MURRAY, 4th Earl of
DUNMORE** (*left*)
(1732–1809)
Governor of Virginia prior to Revolution
Engraving by Charles B. Hall

FINLEY PETER DUNNE (*right*)
(1867–1936)
Humorist, journalist, creator of "Mr.
Dooley"
Caricature by Spy. Courtesy Philip Dunne

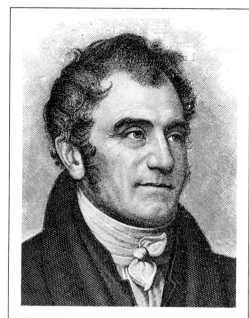

PETER STEPHEN Du PONCEAU
(*left*)
[Pierre Étienne Du Ponceau]
(1760–1844)
Lawyer, philologist, writer

ELEUTHÈRE IRÉNÉE DU PONT
(*right*)
(1771–1834)
Manufacturer, founded E.I. du Pont de
Nemours & Co.

HENRY DU PONT (*left*)
(1812–1889)
Manufacturer of explosives; president of
E.I. du Pont de Nemours & Co.

HENRY ALGERNON DU PONT (*right*)
(1838–1926)
Army officer, U.S. Senator, partner in
E.I. du Pont de Nemours & Co.

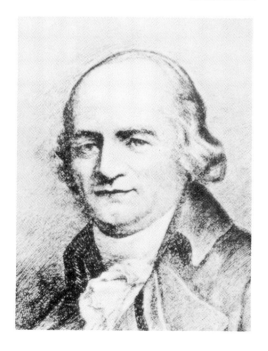
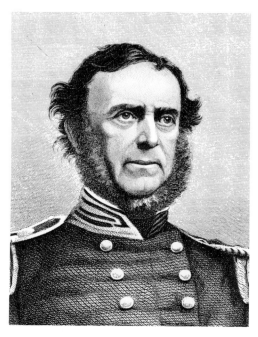

PIERRE SAMUEL DU PONT DE
NEMOURS (*left*)
(1739–1817)
French economist, printer; father of E. I.
and Victor Marie du Pont
Courtesy E.I. du Pont de Nemours & Co., Inc.

SAMUEL FRANCIS DU PONT (*right*)
(1803–1865)
Naval officer
Engraving by H. W. Smith

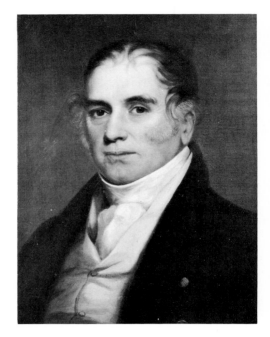

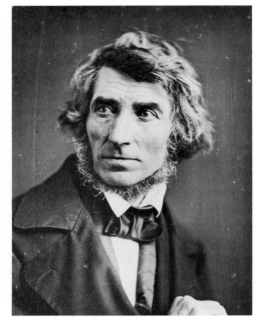

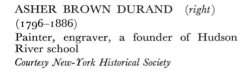

VICTOR MARIE ᴅᴜ PONT *(left)*
(1767–1827)
Diplomat, industrialist
Courtesy E.I. du Pont de Nemours & Co., Inc.

ASHER BROWN DURAND *(right)*
(1796–1886)
Painter, engraver, a founder of Hudson
River school
Courtesy New-York Historical Society

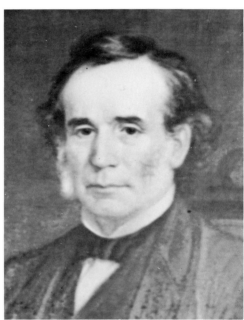

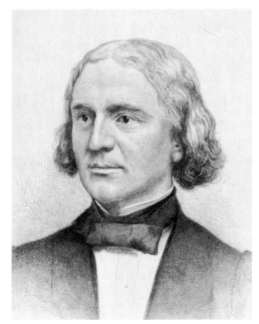

HENRY DURANT *(left)*
(1802–1875)
Congregational clergyman; first president,
University of California
Courtesy University of California

HENRY FOWLE DURANT *(right)*
[Henry Welles Smith]
(1822–1881)
Lawyer, revivalist, founder of Wellesley
College

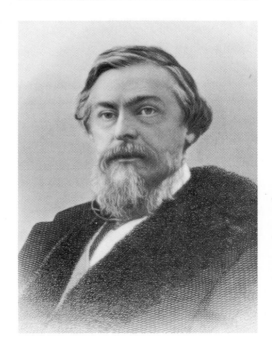

THOMAS CLARK DURANT *(left)*
(1820–1885)
Founder of Crédit Mobilier; prime mover in
building Union Pacific Railroad
Engraving by Charles B. Hall

WILLIAM CRAPO DURANT *(right)*
(1861–1947)
Pioneer automobile manufacturer
Courtesy Automobile Manufacturers Association, Inc.

CHARLES EDGAR DURYEA (*left*)
(1861–1938)
Pioneer automobile manufacturer
Courtesy Automobile Manufacturers Association, Inc.

J. FRANK DURYEA (*right*)
(1869–1967)
Pioneer automobile developer, racer
Courtesy Automobile Manufacturers Association, Inc.

CLARENCE EDWARD DUTTON
(*left*)
(1841–1912)
Geologist, writer
Courtesy Library of Congress

EDWARD PAYSON DUTTON (*right*)
(1831–1923)
Book publisher

FRANK DUVENECK (*left*)
[Frank Decker]
(1848–1919)
Painter, etcher, sculptor, teacher
Courtesy Peter A. Juley & Son

EVERT AUGUSTUS DUYCKINCK
(*right*)
(1816–1878)
Editor, biographer

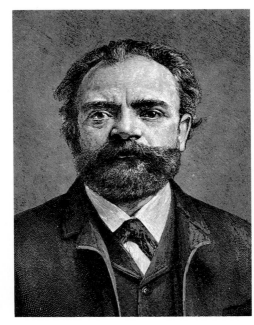

GEORGE LONG DUYCKINCK *(left)*
(1823–1863)
Editor, biographer
Engraving by Charles Burt

ANTON DVOŘÁK *(right)*
(1841–1904)
Czech composer; director, National Conservatory of Music, New York
Engraving by Thomas Johnson

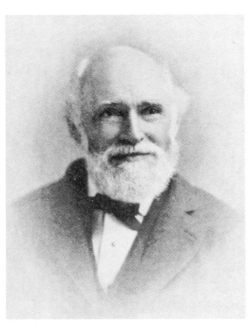

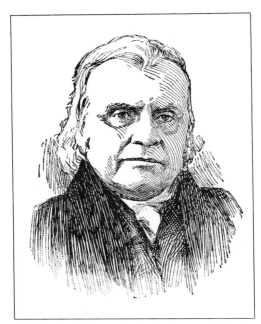

JOHN SULLIVAN DWIGHT *(left)*
(1813–1893)
Music critic

THEODORE DWIGHT *(right)*
(1764–1846)
Lawyer, orator, essayist; one of "Hartford Wits"

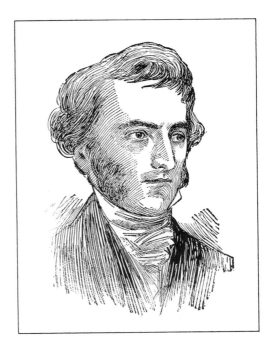

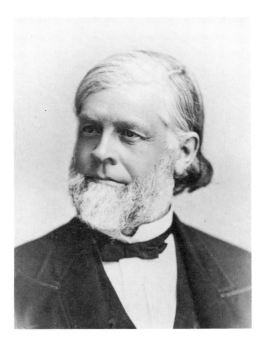

THEODORE DWIGHT *(left)*
(1796–1866)
Writer, editor, educator

THEODORE WILLIAM DWIGHT
(right)
(1822–1892)
Educator, lawyer
Courtesy Cornell University

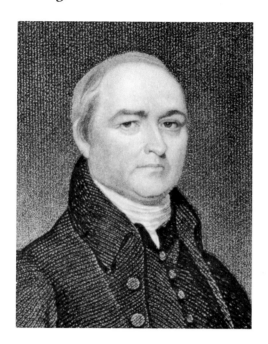

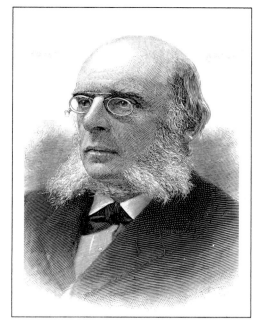

TIMOTHY DWIGHT (*left*)
(1752–1817)
Congregational clergyman, theologian, educator; president of Yale College
Engraved by J. B. Forrest from a painting by John Trumbull

TIMOTHY DWIGHT (*right*)
(1828–1916)
Congregational clergyman, president of Yale University

ISADORE DYER
(1865–1920)
Dermatologist, leprologist

JAMES BUCHANAN EADS (*left*)
(1820–1887)
Bridge designer, hydraulic engineer; designed Eads Bridge, St. Louis
Engraving by Alexander H. Ritchie

THOMAS EAKINS (*right*)
(1844–1916)
Painter, sculptor
Self-portrait

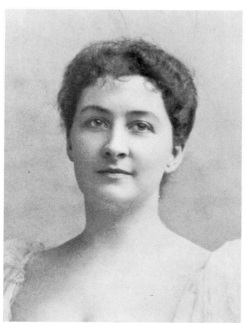

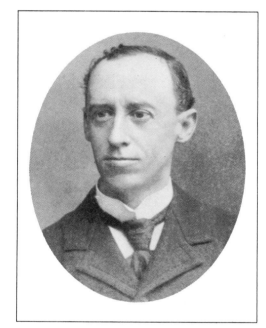

EMMA EAMES (*left*)
(1865–1952)
Operatic soprano

WILBERFORCE EAMES (*right*)
(1855–1937)
Librarian, bibliographer

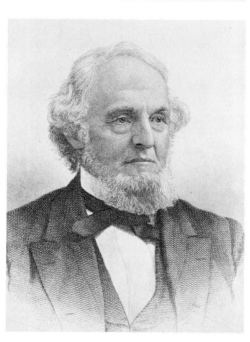

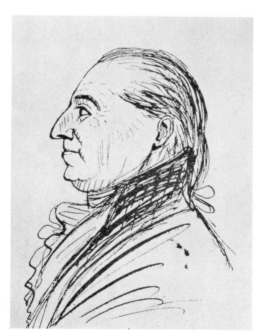

PLINY EARLE (*left*)
(1762–1832)
Inventor, textile-machinery manufacturer

RALPH EARLE (*right*)
[Ralph Earl]
(1751–1801)
Portrait painter

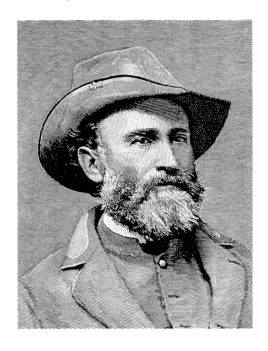

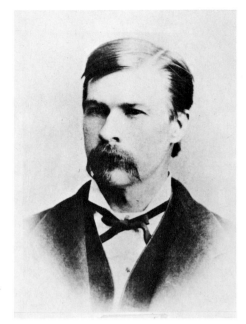

JUBAL ANDERSON EARLY (*left*)
(1816–1894)
Confederate general

MORGAN EARP (*right*)
(1851–1882)
Western lawman
Courtesy Mercaldo Archives

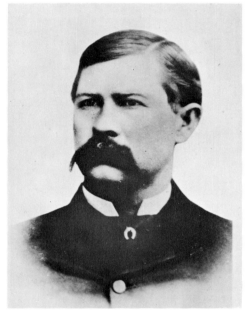

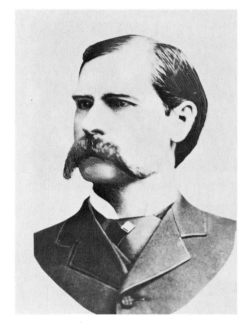

VIRGIL EARP (*left*)
(1843–1906)
Western lawman
Courtesy Mercaldo Archives

WYATT EARP (*right*)
[Wyatt Berry Stapp Earp]
(1848–1929)
Western lawman
Courtesy Mercaldo Archives

CHARLES ALEXANDER EASTMAN
(*left*)
[Ohiyesa]
(1858–1939)
Physician, writer; ministered to American
Indians, wrote of their lives

CHARLES GAMAGE EASTMAN
(*right*)
(1816–1860)
Journalist, poet
Engraving by Capewell & Kimmel

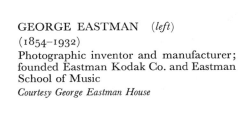

GEORGE EASTMAN (*left*)
(1854–1932)
Photographic inventor and manufacturer;
founded Eastman Kodak Co. and Eastman
School of Music
Courtesy George Eastman House

JOHN ROBIE EASTMAN (*right*)
(1836–1913)
Astronomer
Courtesy Library of Congress, Brady-Handy Collection

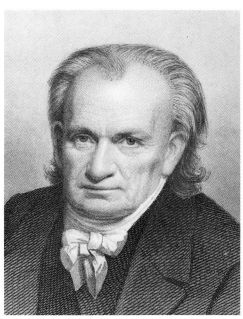
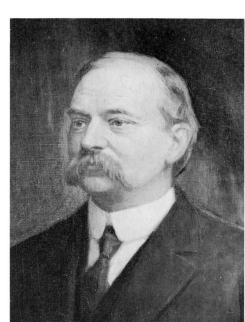

AMOS EATON (*left*)
(1776–1842)
Botanist, educator
Engraving by Alexander H. Ritchie

DANIEL CADY EATON (*right*)
(1834–1895)
Botanist
Courtesy Yale University

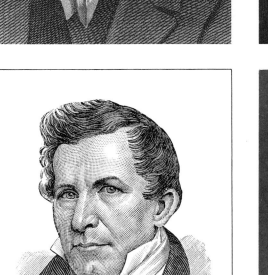

JOHN HENRY EATON (*left*)
(1790–1856)
U.S. Senator, Secretary of War under Jackson

MARGARET EATON (*right*)
[Mrs. John Henry Eaton; nee Peggy O'Neale,
Peggy O'Neill]
(1796–1879)
Center of controversy during Jackson Administration
Courtesy Library of Congress, Brady-Handy Collection

WILLIAM EATON (*left*)
(1764–1811)
Army officer, diplomat
Engraving by C. B. J. F. de Saint-Mémin

CLARENCE EDDY (*right*)
(1851–1937)
Organist, composer

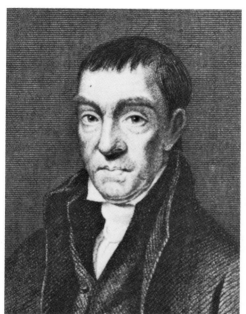

MARY BAKER EDDY (*left*)
[nee Mary Morse Baker]
(1821–1910)
Founder of the Christian Science Church;
writer
*Courtesy First Church of Christ Scientist, Boston,
Massachusetts*

THOMAS EDDY (*right*)
(1758–1827)
Prison reformer
*Engraved by Illman & Pilbrow from a painting by
William Dunlap. Courtesy New-York Historical
Society*

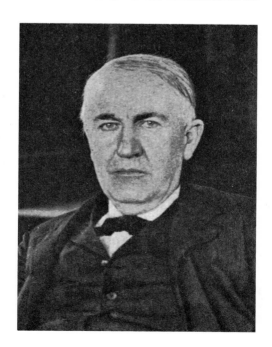

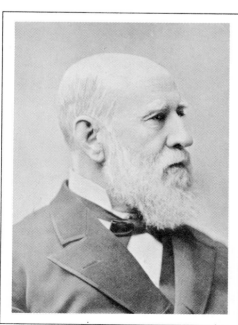

THOMAS ALVA EDISON (*left*)
(1847–1931)
Inventor

GEORGE FRANKLIN EDMUNDS
(*right*)
(1828–1919)
Lawyer, U.S. Senator

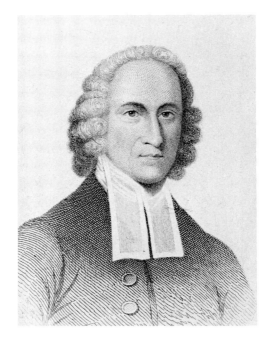

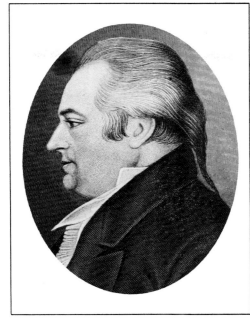

JONATHAN EDWARDS *(left)*
(1703–1758)
Congregational clergyman, theologian, philosopher

NINIAN EDWARDS *(right)*
(1775–1833)
U.S. Senator, Governor of Illinois

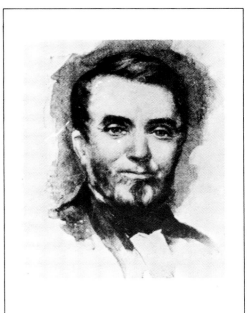

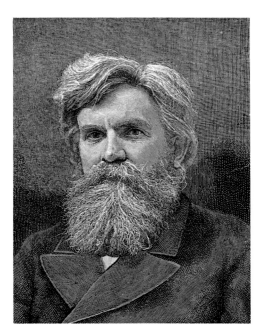

NINIAN WIRT EDWARDS *(left)*
(1809–1889)
Illinois politician, educator
Courtesy Illinois State Historical Society

EDWARD EGGLESTON *(right)*
(1837–1902)
Novelist, journalist, historian

GEORGE CARY EGGLESTON *(left)*
(1839–1911)
Journalist, writer

THOMAS EGLESTON *(right)*
(1832–1900)
Mineralogist, metallurgist

LEOPOLD EIDLITZ (*left*)
(1823–1908)
Architect

DAVID EINHORN (*right*)
(1809–1879)
Rabbi, theologian, leader of reform Judaism
Courtesy Jewish Encyclopedic Handbooks, Inc.

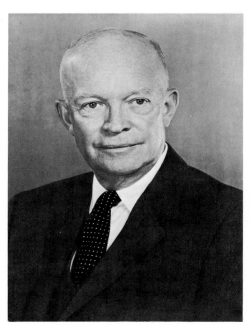
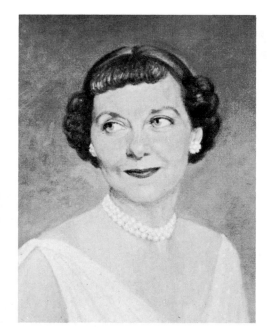

DWIGHT DAVID EISENHOWER
(*left*)
(1890–)
President of the United States, 1953–1961
Courtesy Library of Congress

Mrs. DWIGHT DAVID EISENHOWER
(*right*)
[nee Mamie Geneva Doud]
(1896–)
First lady, 1953–1961
*Painting by Thomas E. Stephens. Courtesy White
House Collection*

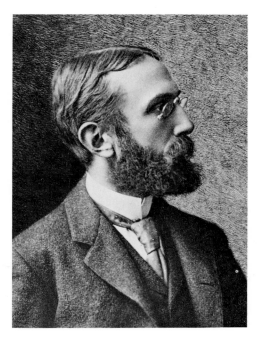
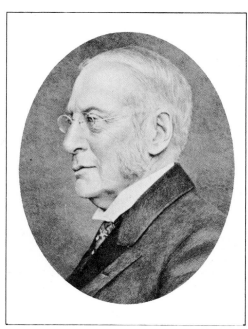

CHARLES ELIOT (*left*)
(1859–1897)
Landscape architect

CHARLES WILLIAM ELIOT (*right*)
(1834–1926)
President of Harvard University; editor of
"Harvard Classics"

JOHN ELIOT *(left)*
(1604–1690)
Missionary to the Indians; translator, writer

ELIZABETH I *(right)*
[Elizabeth Tudor; The Virgin Queen]
(1533–1603)
Queen of England and Ireland; aided
American colonization

WILLIAM LUKENS ELKINS *(left)*
(1832–1903)
Industrialist, pioneer in oil refining

WILLIAM ELLERY *(right)*
(1727–1820)
Signer of Declaration of Independence
*Painted by Samuel B. Waugh from a painting by
John Trumbull. Courtesy Independence National
Historical Park*

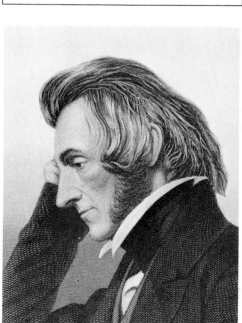
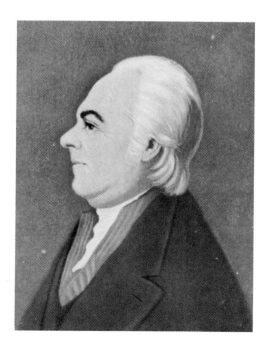

CHARLES ELLET *(left)*
(1810–1862)
Civil engineer, pioneer builder of suspension
bridges

ANDREW ELLICOTT *(right)*
(1754–1820)
Surveyor

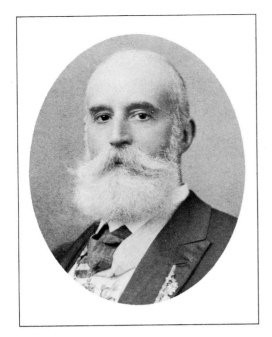

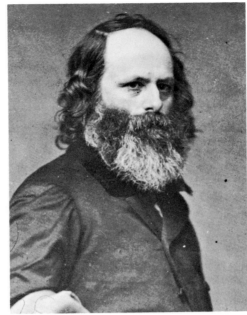

DANIEL GIRAUD ELLIOT (*left*)
(1835–1915)
Zoologist
Courtesy Chicago Natural History Museum

CHARLES LORING ELLIOTT (*right*)
(1812–1868)
Portrait painter
Courtesy Library of Congress, Brady-Handy Collection

JESSE DUNCAN ELLIOTT (*left*)
(1782–1845)
Naval officer in War of 1812

MAXINE ELLIOTT (*right*)
[Jessie Carolyn Dermot]
(1871–1940)
Actress

EDWARD SYLVESTER ELLIS (*left*)
(1840–1916)
Writer of dime novels, popular histories

JOB BICKNELL ELLIS (*right*)
(1829–1905)
Botanist, mycologist
Courtesy New York Botanical Garden

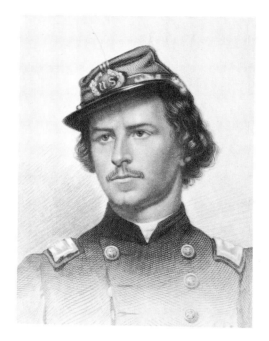

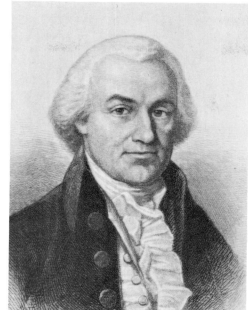

ELMER EPHRAIM ELLSWORTH (*left*)
(1837–1861)
Union officer, early casualty in Civil War
Engraving by John A. O'Neill

OLIVER ELLSWORTH (*right*)
(1745–1807)
Lawyer; member of Continental Congress,
delegate to Constitutional Convention, U.S.
Senator; Chief Justice of U.S., 1796–1799
Engraving by Albert Rosenthal

RICHARD THEODORE ELY (*left*)
(1854–1943)
Economist

PHILIP EMBURY (*right*)
(1728–1773)
Methodist preacher, organized first Meth-
odist society in America

RALPH WALDO EMERSON (*left*)
(1803–1882)
Essayist, poet, Transcendentalist, lecturer
Engraving by J. A. J. Wilcox

THOMAS ADDIS EMMET (*right*)
(1828–1919)
Gynecologist

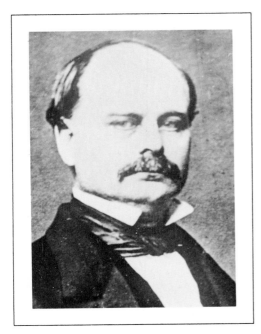

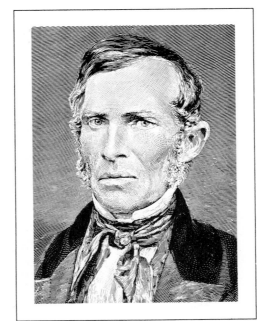

DANIEL DECATUR EMMETT (*left*)
(1815–1904)
Song writer; organized first minstrel groups, composed "Dixie"
Courtesy Meserve Collection

EBENEZER EMMONS (*right*)
(1799–1863)
Geologist, physician, teacher

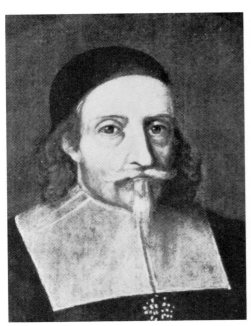

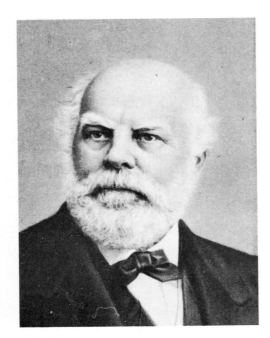

JOHN ENDECOTT (*left*)
[John Endicott]
(*c.* 1589–1665)
Governor of Colonial Massachusetts

GEORGE ENGELMANN (*right*)
(1809–1884)
Botanist, meteorologist, physician

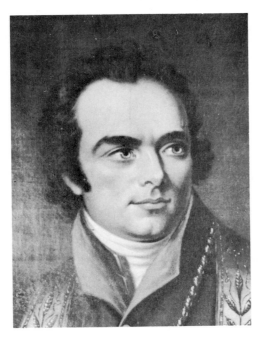

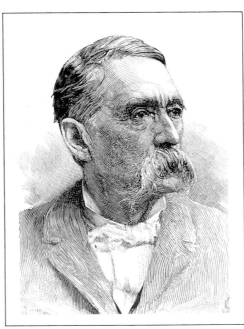

JOHN ENGLAND (*left*)
(1786–1842)
Roman Catholic bishop
Courtesy "Catholic Banner"

THOMAS DUNN ENGLISH (*right*)
(1819–1902)
Editor, poet, physician; author of song "Ben Bolt"
Engraving by R. G. Tietze

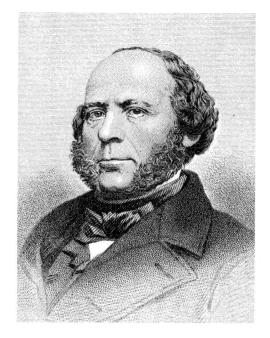

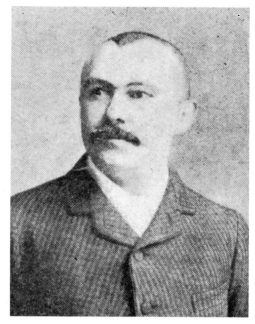

JOHN ERICSSON (*left*)
(1803–1889)
Engineer, inventor; designed the *Monitor*
Engraving by Samuel Hollyer

ABRAHAM LINCOLN ERLANGER
(*right*)
(1860–1930)
Theatrical producer, booking agent

LARS PAUL ESBJÖRN (*left*)
(1808–1870)
Clergyman, founded Swedish Lutheran
Church in U.S.
Courtesy Augustana College

JAMES POLLARD ESPY (*right*)
(1785–1860)
Meteorologist, originated convectional theory
of storms

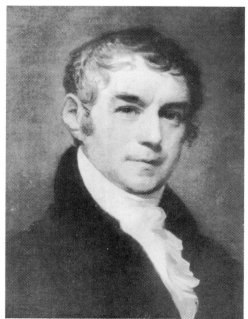

Comte CHARLES HECTOR d'ESTAING
(*left*)
[Jean Baptiste Charles Hector, Comte
d'Estaing]
(1729–1794)
Commander of French naval forces in
American Revolution
Engraving by H. B. Hall's Sons

WILLIAM EUSTIS (*right*)
(1753–1825)
Congressman, diplomat, Secretary of War
under Jefferson and Madison; Governor of
Massachusetts
Painting by Gilbert Stuart

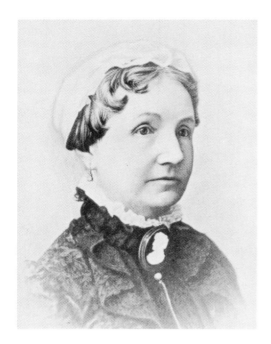

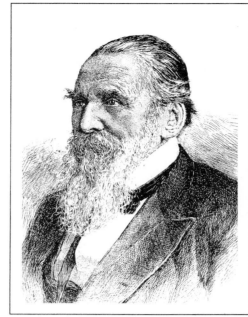

AUGUSTA JANE EVANS (*left*)
[Mrs. Lorenzo Madison Wilson]
(1835–1909)
Novelist, author of *St. Elmo*

JOHN EVANS (*right*)
(1814–1897)
Physician, reformer, railroad promoter; a
founder of Northwestern University and the
University of Denver

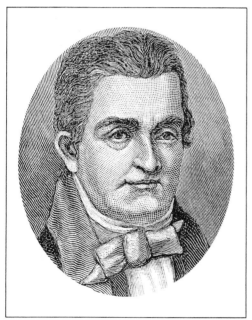

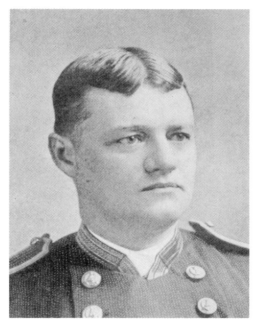

OLIVER EVANS (*left*)
(1755–1819)
Pioneer steam-engine builder

ROBLEY DUNGLISON EVANS (*right*)
["Fighting Bob" Evans]
(1846–1912)
Naval officer

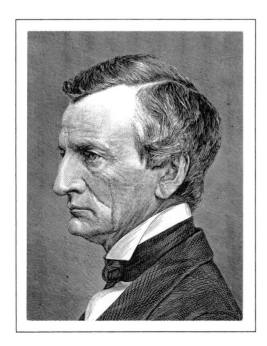

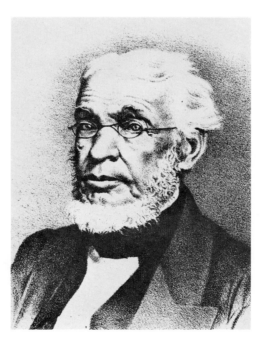

WILLIAM MAXWELL EVARTS
(*left*)
(1818–1901)
Lawyer, U.S. Senator, Attorney General
under Andrew Johnson, Secretary of State
under Hayes

PAUL FITZSIMONS EVE (*right*)
(1806–1877)
Surgeon
Courtesy Medical College of Georgia

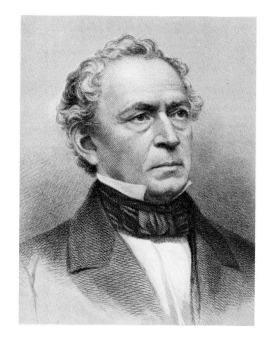

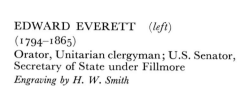

EDWARD EVERETT (*left*)
(1794–1865)
Orator, Unitarian clergyman; U.S. Senator,
Secretary of State under Fillmore
Engraving by H. W. Smith

BARTON WARREN EVERMANN
(*right*)
(1853–1932)
Ichthyologist
Courtesy California Academy of Sciences

BENJAMIN STODDERT EWELL
(*left*)
(1810–1894)
Confederate officer, educator; president,
College of William and Mary
Courtesy College of William and Mary

RICHARD STODDERT EWELL
(*right*)
(1817–1872)
Confederate general
Courtesy Library of Congress, Brady Collection

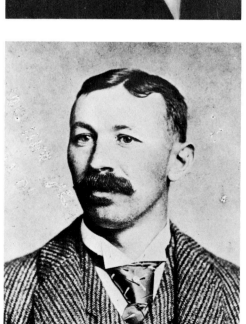

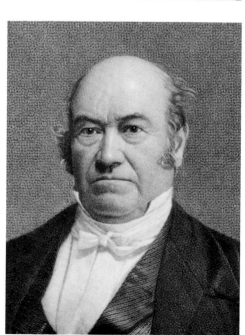

BUCK EWING (*left*)
[William Ewing]
(1859–1906)
Baseball catcher, member of Baseball Hall
of Fame
Courtesy National Baseball Hall of Fame

THOMAS EWING (*right*)
(1789–1871)
Secretary of the Treasury under B. Harrison
and Tyler; first Secretary of the Interior
(1849); U.S. Senator
*Engraved by Alexander H. Ritchie from a daguerreo-
type by Mathew Brady*

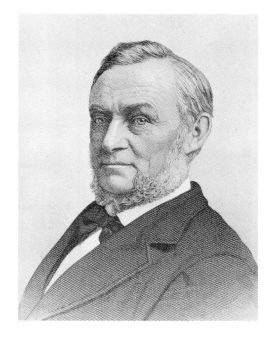

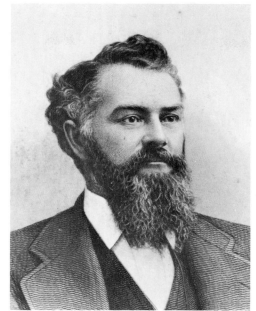

JOHN EBERHARD FABER (*left*)
(1822–1879)
Pencil manufacturer, founded Eberhard Faber, Inc.
Engraving by George E. Perine

JAMES GRAHAM FAIR (*right*)
(1831–1894)
U.S. Senator, mined vast wealth from Comstock lode
Engraving by J. A. J. Wilcox

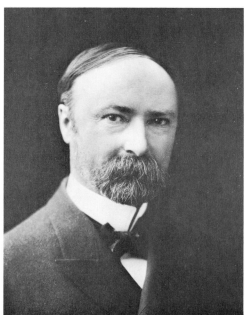

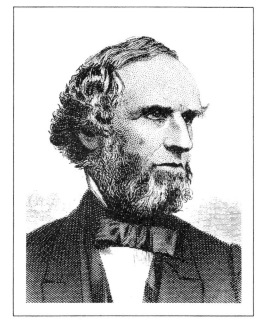

CHARLES WARREN FAIRBANKS
(*left*)
(1852–1918)
Vice-President of U.S., 1905–1909
Courtesy Library of Congress

THADDEUS FAIRBANKS (*right*)
(1796–1886)
Inventor, developed and manufactured platform scale

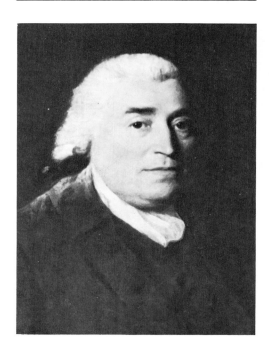

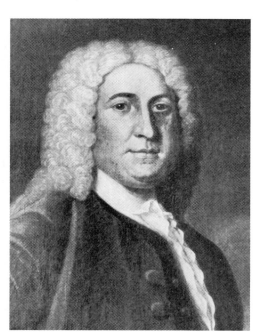

Lord THOMAS FAIRFAX (*left*)
(1693–1781)
Virginia landholder, proprietor of the Northern Neck
Painting by Sir Joshua Reynolds. Courtesy Alexandria-Washington Lodge No. 22

PETER FANEUIL (*right*)
(1700–1743)
Boston merchant, donated Faneuil Hall
Painting by John Smibert

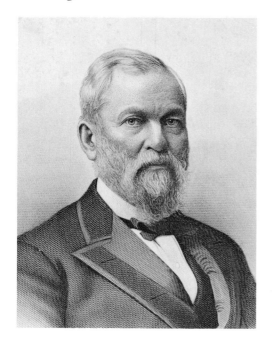
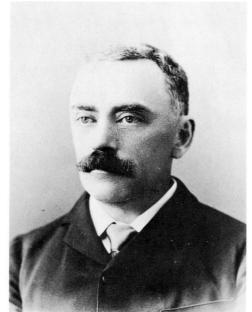

WILLIAM GEORGE FARGO (*left*)
(1818–1881)
Partner in Wells, Fargo and Co.; founded
American Express Co.
Engraving by E. G. Williams & Bro.

WILLIAM GILSON FARLOW (*right*)
(1844–1919)
Botanist
Courtesy New York Botanical Garden

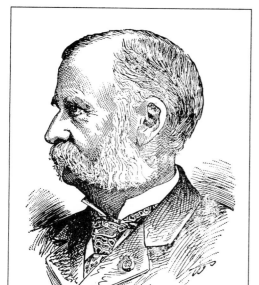

ELBERT ELI FARMAN (*left*)
(1831–1911)
Diplomat, Egyptologist, jurist, lawyer

FANNIE FARMER (*right*)
[Fannie Merritt Farmer]
(1857–1915)
Editor, *Boston Cooking School Cook Book*
Courtesy Little, Brown and Co.

MOSES GERRISH FARMER (*left*)
(1820–1893)
Inventor, pioneer electrician

DAVID GLASGOW FARRAGUT
(*right*)
(1801–1870)
Union naval officer in Civil War; hero of
battle of Mobile Bay

GERALDINE FARRAR (*left*)
(1882–1967)
Operatic soprano

WILLIAM HERBERT PERRY
FAUNCE (*right*)
(1859–1930)
Baptist clergyman, president of Brown University

WILLIAM ALFRED FAVERSHAM
(*left*)
(1868–1940)
Actor, theatrical producer

EDGAR FAWCETT (*right*)
(1847–1904)
Novelist, playwright

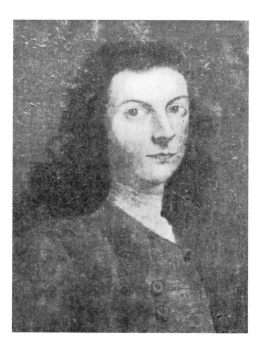

CHARLES ALBERT FECHTER (*left*)
(1824–1879)
Actor

ROBERT FEKE (*right*)
(*c.* 1705–*c.* 1750)
Portrait painter
Self-portrait

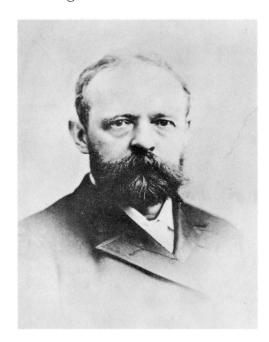

CHRISTIAN FENGER *(left)*
(1840–1902)
Pioneer pathologist, surgeon
Courtesy New York Academy of Medicine

HARRY FENN *(right)*
(1838–1911)
Painter; illustrator for *Picturesque America*

ERNEST FRANCISCO FENOLLOSA
(left)
(1853–1908)
Orientalist, art historian
Courtesy Mrs. Erwin S. Whatley

REUBEN EATON FENTON *(right)*
(1819–1885)
Governor of New York, U.S. Senator; in-
volved in Erie Railroad scandal
Engraving by H. B. Hall & Co.

EDWARD DOMINIC FENWICK
(left)
(1768–1832)
Roman Catholic bishop
Courtesy "Catholic Telegraph"

FERDINAND V *(right)*
[Ferdinand the Catholic]
(1452–1516)
King of Castile (and Aragon), aided Colum-
bus

WILLIAM JASON FERGUSON　(*left*)
(1844–1930)
Actor, reputed to be only witness of Lincoln's assassination

FANNY FERN　(*right*)
[Sara Parton, nee Sara Payson Willis]
(1811–1872)
Writer, author of children's books
Painting by Edward Dalton Marchant. Courtesy Frick Art Reference Library

CHARLES HENRY FERNALD　(*left*)
(1838–1921)
Entomologist
Courtesy University of Massachusetts

WILLIAM FERREL　(*right*)
(1817–1891)
Meteorologist

GEORGE WASHINGTON GALE FERRIS　(*left*)
(1859–1896)
Engineer, designed and built Ferris wheel
Courtesy Carnegie Library of Pittsburgh

REGINALD AUBREY FESSENDEN
(*right*)
(1866–1932)
Electrical engineer, pioneer in wireless communication

THOMAS GREEN FESSENDEN
(*left*)
(1771–1837)
Satirist, poet, journalist

WILLIAM PITT FESSENDEN
(*right*)
(1806–1869)
U.S. Senator, Secretary of the Treasury under Lincoln

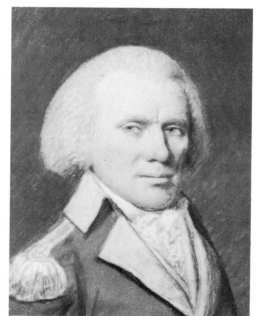

WILLIAM JUDD FETTERMAN
(*left*)
(c. 1833–1866)
Army officer, massacred with his troops by Indians under Red Cloud
Courtesy Mercaldo Archives

WILLIAM FEW (*right*)
(1748–1828)
Member of Continental Congress, signer of Constitution; U.S. Senator
Painting attributed to James Sharples, Sr. Courtesy Independence National Historical Park

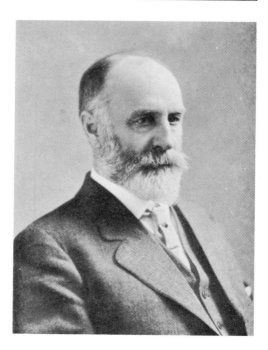

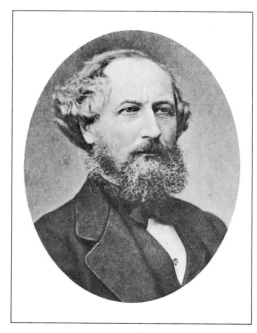

JESSE WALTER FEWKES (*left*)
(1850–1930)
Ethnologist, archaeologist

CYRUS WEST FIELD (*right*)
(1819–1892)
Financier, promoted Atlantic Cable

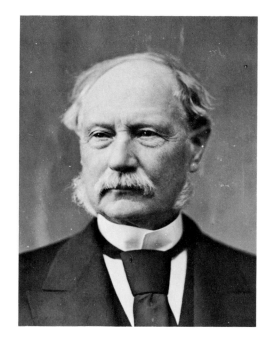

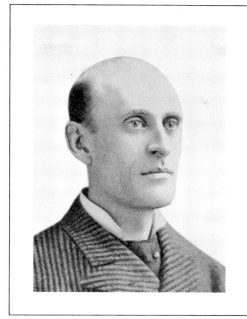

DAVID DUDLEY FIELD (*left*)
(1805–1894)
Lawyer, law reformer
Courtesy Library of Congress, Brady-Handy Collection

EUGENE FIELD (*right*)
(1850–1895)
Journalist, poet, humorist

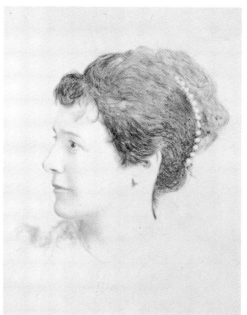

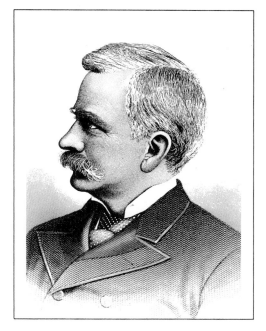

KATE FIELD (*left*)
[Mary Katherine Keemle Field]
(1838–1896)
Journalist, writer, lecturer, actress

MARSHALL FIELD (*right*)
(1834–1906)
Merchant, philanthropist

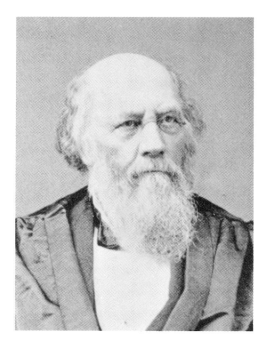

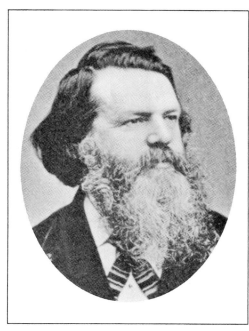

STEPHEN JOHNSON FIELD (*left*)
(1816–1899)
Associate justice, U.S. Supreme Court

JAMES THOMAS FIELDS (*right*)
(1817–1881)
Publisher, writer, editor of *Atlantic Monthly*

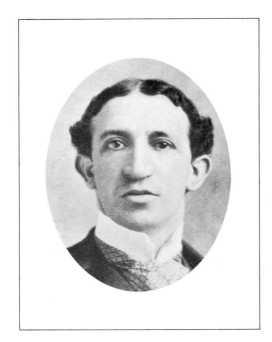

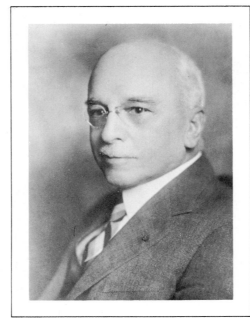

LEWIS MAURICE FIELDS (*left*)
(1867–1941)
Theater owner, manager, member of Weber and Fields comedy team

EDWARD ALBERT FILENE (*right*)
(1860–1937)
Merchant, reformer, philanthropist
Courtesy Wm. Filene's Sons Co.

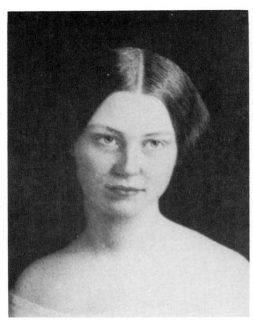

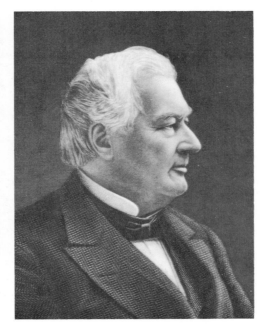

MARY ABIGAIL FILLMORE (*left*)
(1832–1854)
Daughter of Millard Fillmore; White House hostess, 1850–1853
Courtesy Buffalo and Erie County Historical Society

MILLARD FILLMORE (*right*).
(1800–1874)
President of the United States, 1850–1853
Engraving by Henry B. Hall, Jr.

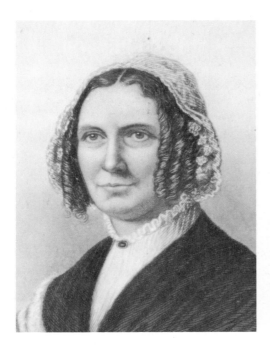

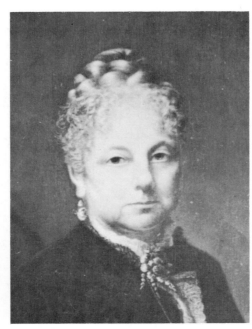

MRS. MILLARD FILLMORE (*left*)
[nee Abigail Powers]
(1798–1853)
First lady, 1850–1853

MRS. MILLARD FILLMORE (*right*)
[Mrs. Caroline McIntosh; nee Caroline Carmichael]
(1813–1881)
Second wife of Millard Fillmore; married after he left White House
Courtesy Buffalo and Erie County Historical Society

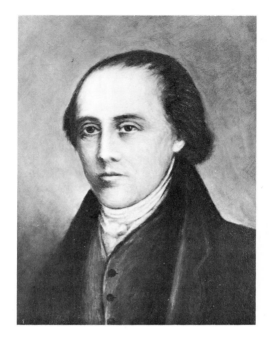

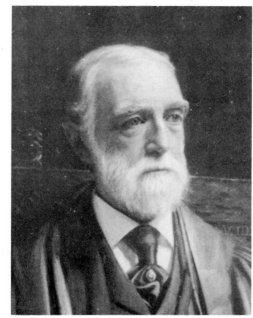

JOHN FILSON (*left*)
(*c.* 1747–1788)
Explorer, Kentucky historian
Courtesy Filson Club

FRANCIS MILES FINCH (*right*)
(1827–1907)
Lawyer, jurist, educator, poet
Courtesy Cornell University

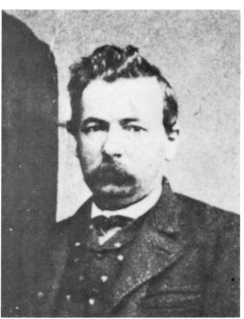

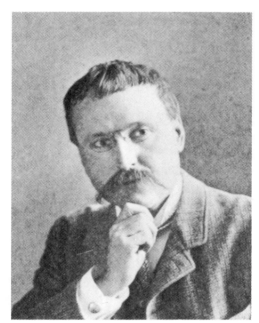

JONATHAN C. FINCHER (*left*)
(*fl.* 1863–1866)
Machinist, edited labor journal
Courtesy Tamiment Institute Library

HENRY THEOPHILUS FINCK (*right*)
(1854–1926)
Music critic, writer

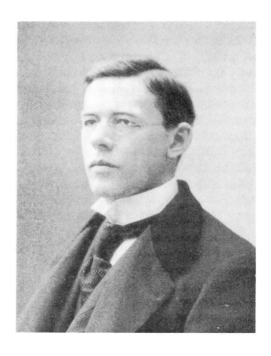

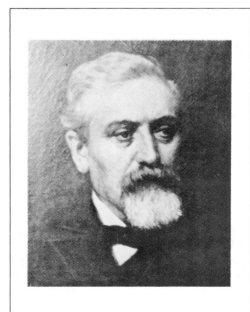

HENRY BURCHARD FINE (*left*)
(1858–1928)
Mathematician

ALBERT FINK (*right*)
(1827–1897)
Civil engineer, statistician, railroad developer
Painting by Benoni Irwin. Courtesy Filson Club

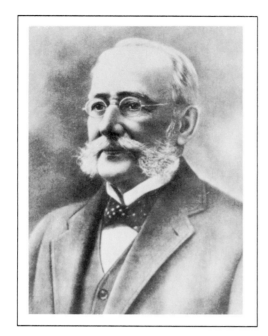

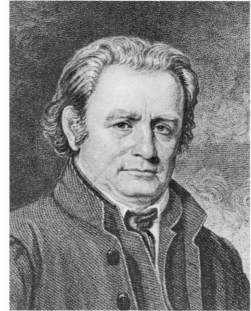

CARLOS JUAN FINLAY (*left*)
(1833–1915)
Physician, developed mosquito theory of yellow-fever transmission
Courtesy New York Academy of Medicine

JAMES BRADLEY FINLEY (*right*)
(1781–1856)
Methodist preacher in early West
Engraving by E. Mackenzie. Courtesy New-York Historical Society

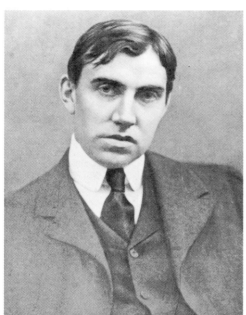

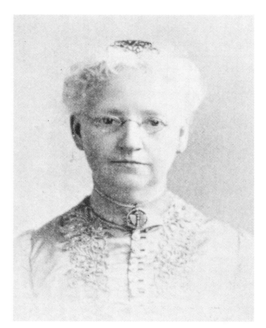

JOHN HUSTON FINLEY (*left*)
(1863–1940)
Educator, editor, writer; president, College of the City of New York

MARTHA FARQUHARSON FINLEY
(*right*)
[Martha Farquharson]
(1828–1909)
Novelist; author of children's books, including *Elsie Dinsmore* series

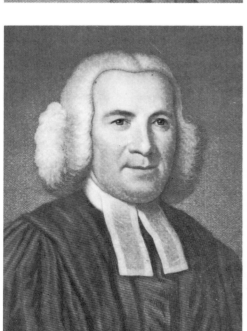

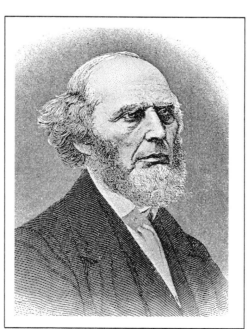

SAMUEL FINLEY (*left*)
(1715–1766)
Presbyterian clergyman; president, College of New Jersey (Princeton)
Courtesy Princeton University Archives

CHARLES GRANDISON FINNEY
(*right*)
(1792–1875)
Evangelist; president, Oberlin College

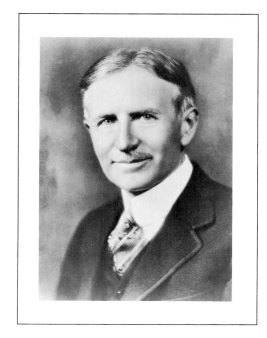

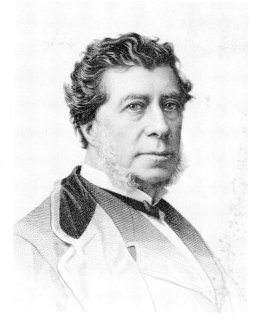

HARVEY SAMUEL FIRESTONE
(*left*)
(1868–1938)
Rubber manufacturer
Courtesy Firestone Tire and Rubber Co.

HAMILTON FISH (*right*)
(1808–1893)
Secretary of State under Grant, U.S. Senator, Governor of New York
Engraving by Alexander H. Ritchie

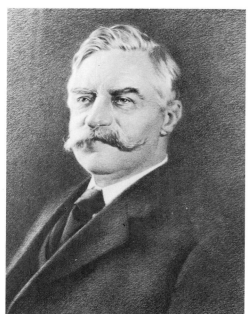

STUYVESANT FISH (*left*)
(1851–1923)
Railroad industrialist, banker
Courtesy Illinois Central Railroad

Mrs. STUYVESANT FISH (*right*)
[nee Marian Graves Anthon]
(1855–1915)
New York society leader

CLARA FISHER (*left*)
[Clara Fisher Maeder]
(1811–1898)
Actress

GEORGE PARK FISHER (*right*)
(1827–1909)
Congregational clergyman, theologian, church historian
Courtesy Yale University

IRVING FISHER (*left*)
(1867–1947)
Economist, educator
Courtesy Yale University

CLINTON BOWEN FISK (*right*)
(1828–1890)
Pioneer in Negro education, founded Fisk
University

JIM FISK (*left*)
[James Fisk]
(1834–1872)
Capitalist
From a photograph by Mathew Brady

WILBUR FISK (*right*)
(1792–1839)
Methodist clergyman; first president, Wes-
leyan University
Engraving by E. Mackenzie

BRADLEY ALLEN FISKE (*left*)
(1854–1942)
Naval officer, inventor
Courtesy U.S. Department of Defense

HARRISON GREY FISKE (*right*)
(1861–1942)
Playwright, theatrical manager, director

JOHN FISKE (*left*)
[Edmund Fisk Green]
(1842–1901)
Historian, philosopher, lecturer

MINNIE MADDERN FISKE (*right*)
[nee Marie Augusta Davey]
(1865–1932)
Actress

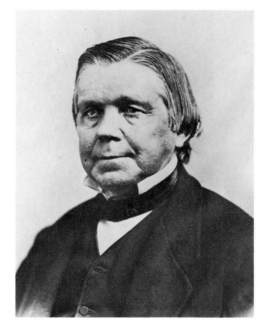

STEPHEN RYDER FISKE (*left*)
(1840–1916)
Journalist, drama critic, theatrical manager, playwright

ASA FITCH (*right*)
(1809–1879)
Entomologist
Courtesy New York State Museum and Science Service

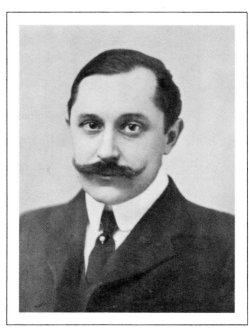

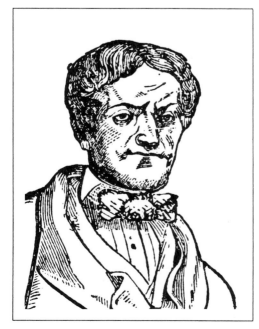

CLYDE FITCH (*left*)
[William Clyde Fitch]
(1865–1909)
Playwright

JOHN FITCH (*right*)
(1743–1798)
Inventor, pioneer in development of the steamboat
Courtesy Smithsonian Institution

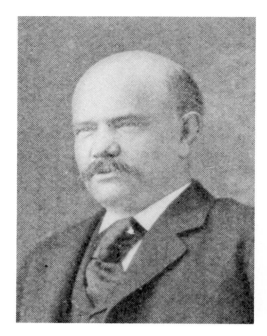

REGINALD HEBER FITZ (*left*)
(1843–1913)
Pathologist, educator; diagnosed appendicitis
and proposed its surgical cure

JOHN FRANCIS FITZGERALD (*right*)
["Honey Fitz"]
(1863–1950)
Congressman, mayor of Boston; grandfather
of John F. Kennedy

GEORGE FITZHUGH (*left*)
(1806–1881)
Lawyer, sociologist, defended Southern slave
system before Civil War
Courtesy Professor Harvey Wish

WILLIAM FITZHUGH (*right*)
(1651–1701)
Lawyer, planter
Painting by Gustavus Hesselius

**ROBERT PROMETHEUS
FITZSIMMONS** (*left*)
(1862–1917)
Boxing champion

ERNEST FLAGG (*right*)
(1857–1947)
Architect

HENRY MORRISON FLAGLER
(*left*)
(1830–1913)
Capitalist; pioneer developer of Florida
"Gold Coast"
Courtesy New-York Historical Society

CHARLES LOUIS FLEISCHMANN
(*right*)
(1834–1897)
Yeast manufacturer
Courtesy Standard Brands, Inc.

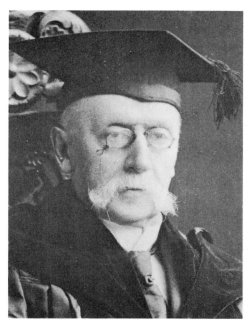

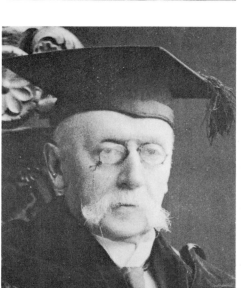

ALICE CUNNINGHAM FLETCHER
(*left*)
(1838–1923)
Ethnologist, authority on American Indian
music

ROBERT FLETCHER (*right*)
(1823–1912)
Medical bibliographer, historian
*Courtesy Welch Medical Library, Johns Hopkins
University*

SIMON FLEXNER (*left*)
(1863–1946)
Pathologist, bacteriologist
Courtesy James Thomas Flexner

AUSTIN FLINT (*right*)
(1812–1886)
Pathologist, pioneer in study of chest dis-
eases; a founder of Bellevue Hospital Medi-
cal College
After a photograph by Napoleon Sarony

AUSTIN FLINT (*left*)
(1836–1915)
Physiologist, educator; a founder of Bellevue Hospital Medical College

WILLIAM JERMYN FLORENCE (*right*)
[Bernard Conlin]
(1831–1891)
Actor, playwright

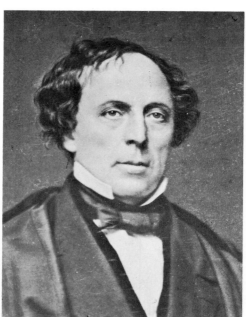
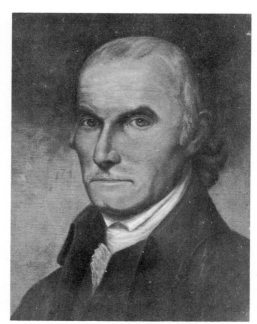

JOHN BUCHANAN FLOYD (*left*)
(1806–1863)
Governor of Virginia, Secretary of War under Buchanan; Confederate general
Courtesy Library of Congress, Brady-Handy Collection

WILLIAM FLOYD (*right*)
(1734–1821)
Member of Continental Congress, signer of Declaration of Independence
Painted by Edward L. Henry from a painting by Ralph Earle. Courtesy Independence National Historical Park

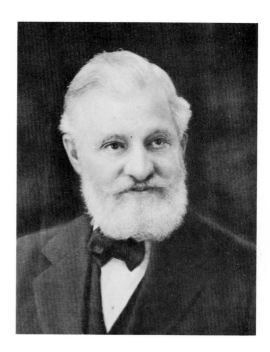
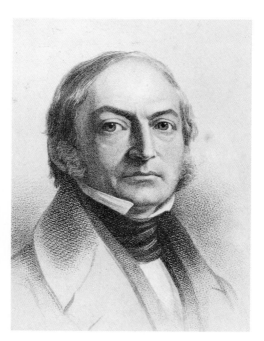

HENRY CLAY FOLGER (*left*)
(1857–1930)
Oil magnate, philanthropist, donated Folger Shakespeare Library

CHARLES FOLLEN (*right*)
(1796–1840)
Unitarian preacher, abolitionist; first professor of German literature at Harvard
Engraving by H. W. Smith. Courtesy Harvard University Archives

CHARLES FOLSOM *(left)*
(1794–1872)
Librarian, publisher, editor, educator

ANDREW HULL FOOTE *(right)*
(1806–1863)
Naval officer
Engraving by John A. O'Neill

ARTHUR WILLIAM FOOTE *(left)*
(1853–1937)
Composer, organist

HENRY STUART FOOTE *(right)*
(1804–1880)
U.S. Senator, Governor of Mississippi, Confederate Congressman
Courtesy National Archives, Brady Collection

MARY FOOTE *(left)*
[nee Mary Anna Hallock]
(1847–1938)
Novelist, illustrator; portrayed Far West

JOSEPH BENSON FORAKER *(right)*
(1846–1917)
Governor of Ohio, U.S. Senator

JOHN MURRAY FORBES *(left)*
(1813–1898)
Railroad financier
Courtesy Chicago, Burlington & Quincy Railroad

ROBERT BENNET FORBES *(right)*
(1804–1889)
Shipowner, merchant in Far East

STEPHEN ALFRED FORBES *(left)*
(1844–1930)
Entomologist

BOB FORD *(right)*
[Robert Newton Ford]
(1862–1892)
Western outlaw, shot Jesse James

HENRY FORD *(left)*
(1863–1947)
Automobile manufacturer
Courtesy Automobile Manufacturers Association, Inc.

JOHN THOMSON FORD *(right)*
(1829–1894)
Manager of Ford's Theater, Washington,
D.C., site of Lincoln's assassination

PAUL LEICESTER FORD (*left*)
(1865–1902)
Historian, novelist, bibliophile, editor

WORTHINGTON CHAUNCEY FORD
(*right*)
(1858–1941)
Statistician, economist, historian, editor

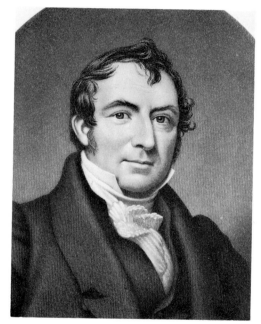

FRANK FORESTER (*left*)
[Henry William Herbert]
(1807–1858)
Writer on field sports; classicist, editor,
translator

JOSHUA FORMAN (*right*)
(1777–1848)
Lawyer; early promoter of Erie Canal
Engraving by Samuel Sartain

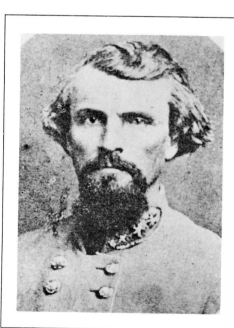

EDWIN FORREST (*left*)
(1806–1872)
Actor
*Daguerreotype by Mathew Brady. Courtesy Library
of Congress*

NATHAN BEDFORD FORREST
(*right*)
(1821–1877)
Confederate general
Courtesy Library of Congress

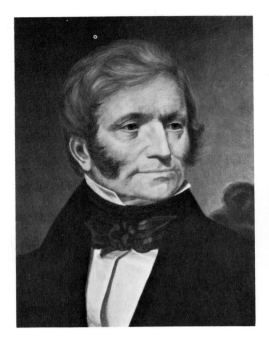

JOHN FORSYTH (*left*)

(1780–1841)

U.S. Senator, Governor of Georgia, Secretary of State under Jackson and Van Buren

Painting by Freeman Thorpe. Courtesy U.S. Department of State

CHARLES AUSTIN FOSDICK (*right*)

[Harry Castlemon]

(1842–1915)

Writer of juvenile books; author of the *Gunboat* series, the *Rocky Mountain* series

JOHN WATSON FOSTER (*left*)

(1836–1917)

Lawyer, diplomat, writer; Secretary of State under Cleveland

Painting by Henry Floyd. Courtesy U.S. Department of State

STEPHEN COLLINS FOSTER (*right*)

(1826–1864)

Song writer

STEPHEN SYMONDS FOSTER (*left*)

(1809–1881)

Abolitionist, reformer

WILLIAM DUDLEY FOULKE (*right*)

(1848–1935)

Lawyer, writer, advocate of civil service reform

GUSTAVUS VASA FOX (*left*)
(1821–1883)
Assistant Secretary of the Navy under Lincoln, supervised Union naval successes in Civil War

IMRO FOX (*right*)
(1852–1910)
Magician
Courtesy Milbourne Christopher Collection

JOHN WILLIAM FOX (*left*)
(1863–1919)
Novelist, portrayed the Cumberlands; wrote *Trail of the Lonesome Pine*

KATE FOX (*right*)
[Catherine Fox; Catherine Fox Jencken]
(1839–1892)
Medium

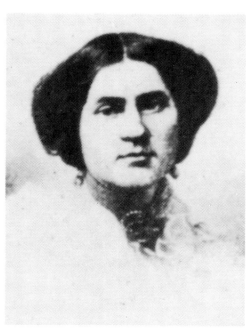

LEAH FOX (*left*)
[Ann Leah Fox; Leah Fox Fish; Leah Fox Underhill]
(1814–1891)
Medium

MARGARET FOX (*right*)
[Margaret Fox Kane]
(1833–1893)
Medium

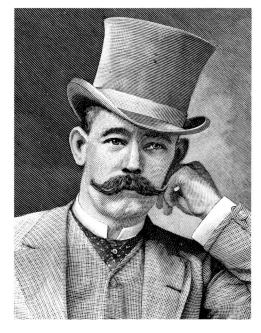

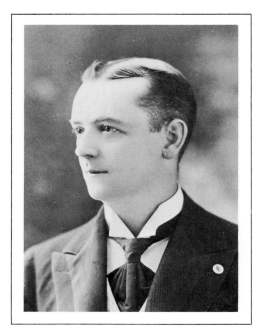

RICHARD KYLE FOX (*left*)
(1846–1922)
Owner of *National Police Gazette;* pioneer in
modern journalism

EDDIE FOY (*right*)
[Edwin Fitzgerald]
(1856–1928)
Comedian
*Courtesy Walter Hampden Memorial Library at The
Players, New York*

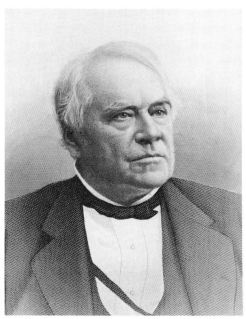

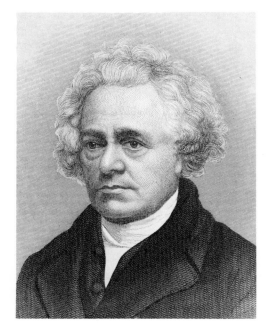

JAMES BICHENO FRANCIS (*left*)
(1815–1892)
Hydraulic engineer, pioneer in turbine
design
Engraving by Alexander H. Ritchie

JOHN WAKEFIELD FRANCIS (*right*)
(1789–1861)
Obstetrician, educator; founded New York
Academy of Medicine
Engraving by George E. Perine

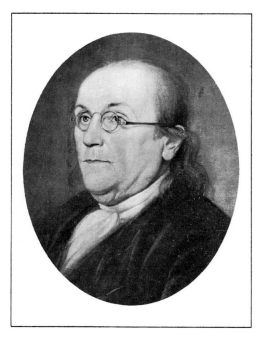

KUNO FRANCKE (*left*)
(1855–1930)
German-born historian, philologist, poet;
taught history of German culture at Har-
vard University

BENJAMIN FRANKLIN (*right*)
(1706–1790)
Printer, publisher, statesman, philosopher,
inventor
Painting by Charles Willson Peale

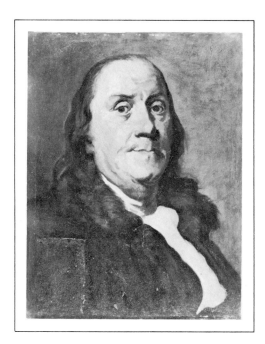

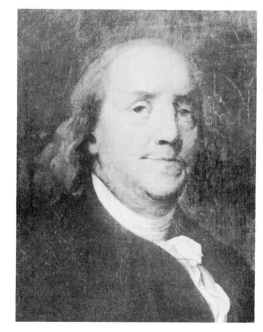

BENJAMIN FRANKLIN *(left)*
(see above)
Painting by Joseph Siffred Duplessis. Courtesy Independence National Historical Park

BENJAMIN FRANKLIN *(right)*
(see above)
Painting by Jean Baptiste Greuze

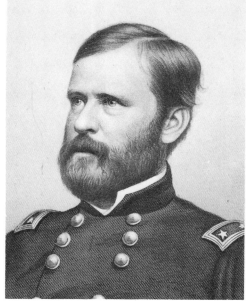

M*RS.* **BENJAMIN FRANKLIN** *(left)*
[nee Deborah Read]
(c. 1705–1774)
Wife of Colonial statesman
Painting by Benjamin Wilson after an unknown artist. Courtesy American Philosophical Society

WILLIAM BUEL FRANKLIN *(right)*
(1823–1903)
Union general in Civil War
Engraved by John C. Buttre from a photograph by Mathew Brady

HERMAN FRASCH *(left)*
(c. 1851–1914)
Chemist, inventor; developed methods of oil refining, sulphur mining
Courtesy New-York Historical Society

JOHN FRAZEE *(right)*
(1790–1852)
Stonecutter, sculptor
Painting by Henry Colton Shumway. Courtesy Pennsylvania Academy of Fine Arts

PERSIFOR FRAZER (*left*)
(1844–1909)
Geologist, chemist, graphologist

HAROLD FREDERIC (*right*)
(1856–1898)
Novelist, journalist

PAULINE FREDERICK (*left*)
[Pauline Libby]
(1885–1938)
Actress

JAMES FREEMAN (*right*)
(1759–1835)
First Unitarian clergyman in U.S.
After a painting by Gilbert Stuart

MARY WILKINS FREEMAN (*left*)
[nee Mary Eleanor Wilkins]
(1852–1930)
Short-story writer, novelist

CHARLES LANG FREER (*right*)
(1856–1919)
Industrialist, art collector; donated Freer
Gallery of Art, Washington, D.C.
*Painting by James McNeill Whistler. Courtesy Freer
Gallery of Art*

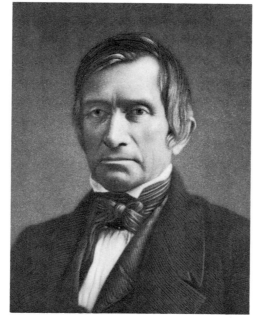

FREDERICK THEODORE FRELINGHUYSEN (*left*)
(1817–1885)
U.S. Senator, Secretary of State under Arthur
After a photograph by Mathew Brady

THEODORE FRELINGHUYSEN (*right*)
(1787–1862)
U.S. Senator, educator, lawyer
Engraving by T. Doney

JESSIE FRÉMONT (*left*)
[nee Jessie Benton]
(1824–1902)
Wife of John Charles Frémont; writer, social figure

JOHN CHARLES FRÉMONT (*right*)
(1813–1890)
Western explorer, army officer; first Republican presidential candidate (1856)
Engraving by John C. Buttre

OLIVE FREMSTAD (*left*)
[Anna Olivia Fremstad]
(*c.* 1872–1951)
Operatic soprano

ALICE FRENCH (*right*)
[Octave Thanet]
(1850–1934)
Short-story writer

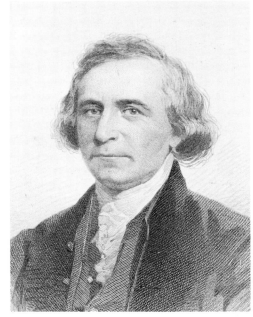

DANIEL CHESTER FRENCH (*left*)
(1850–1931)
Sculptor, designed statue for Lincoln Memorial, Washington, D.C.

PHILIP MORIN FRENEAU (*right*)
(1752–1832)
Poet, editor, mariner; known as "Poet of the American Revolution"
Engraving by Frederick Halpin

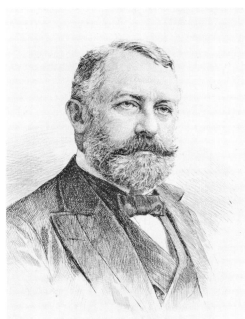

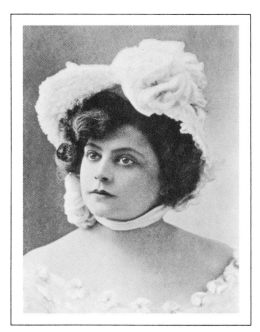

HENRY CLAY FRICK (*left*)
(1849–1919)
Steel industrialist, capitalist, art collector; founded Frick Collection, New York

TRIXIE FRIGANZA (*right*)
[Delia O'Callahan]
(1870–1955)
Actress, singer
Courtesy Museum of the City of New York

BARBARA FRITCHIE (*left*)
[Barbara Frietchie; nee Barbara Hauer]
(1766–1862)
Reputed Civil War heroine, subject of Whittier's poem, "Barbara Frietchie"
After a photograph by Mathew Brady

JOHN FRITZ (*right*)
(1822–1913)
Engineer, pioneer in iron and steel manufacture
Courtesy Lehigh University

SIR MARTIN FROBISHER (*left*)
(*c.* 1535–1594)
English navigator, sought Northwest Passage
Painting by Cornelis Ketel

CHARLES FROHMAN (*right*)
(1860–1915)
Theater manager, developed star system
Courtesy Museum of the City of New York

DANIEL FROHMAN (*left*)
(1851–1940)
Theater manager

ARTHUR BURDETT FROST (*right*)
(1851–1928)
Illustrator, humorist

OCTAVIUS BROOKS
FROTHINGHAM (*left*)
(1822–1895)
Liberal clergyman, theologian, biographer
Engraving by H. W. Smith

WILLIAM HENRY FRY (*right*)
(1815–1864)
Composer, music critic, journalist

GEORGE FULLER (*left*)
(1822–1884)
Painter

LOIE FULLER (*right*)
(1862–1928)
Dancer, noted for serpentine dance
Courtesy Walter Hampden Memorial Library at The Players, New York

MARGARET FULLER (*left*)
[Marchioness Ossoli, nee Sarah Margaret Fuller]
(1810–1850)
Transcendentalist critic, feminist, journalist

MELVILLE WESTON FULLER
(*right*)
(1833–1910)
Chief Justice of U.S., 1893–1910

ROBERT FULTON (*left*)
(1765–1815)
Engineer, inventor, pioneer in steamboat design, painter
Painting by Charles Willson Peale. Courtesy Independence National Historical Park

ISAAC KAUFFMAN FUNK (*right*)
(1839–1912)
Editor, publisher, clergyman; partner in Funk & Wagnalls Co.

FREDERICK FUNSTON (*left*)
(1865–1917)
Army officer in Spanish-American War;
botanist, explorer

HORACE HOWARD FURNESS
(*right*)
(1833–1912)
Shakespearean scholar, edited New Vario-
rum Edition of Shakespeare's plays

WILLIAM HENRY FURNESS (*left*)
(1802–1896)
Unitarian clergyman, abolitionist, writer,
translator

ANDREW FURUSETH (*right*)
[Anders Andreassen]
(1854–1938)
Labor leader; president, International Sea-
men's Union of America

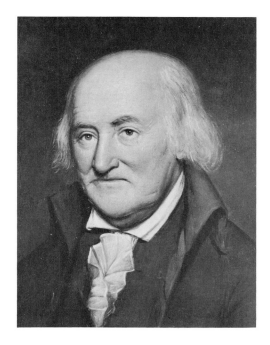

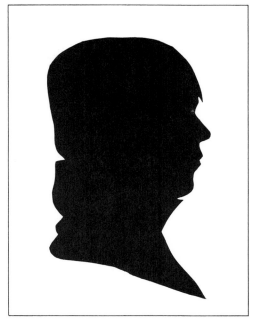

CHRISTOPHER GADSDEN (*left*)
(1724–1805)
Revolutionary general, member of Continental Congress
Painting by Rembrandt Peale. Courtesy Independence National Historical Park

JAMES GADSDEN (*right*)
(1788–1858)
Diplomat, railroad developer, negotiated Gadsden Purchase with Mexico
Courtesy Yale University

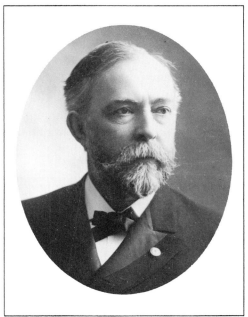

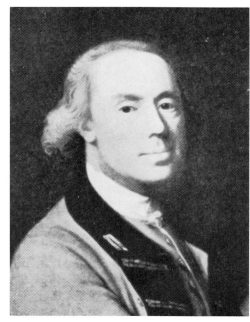

SIMON HENRY GAGE (*left*)
(1851–1944)
Biologist
Courtesy Cornell University

THOMAS GAGE (*right*)
(1721–1787)
Commander of British forces in North America prior to Revolution; last royal governor of Massachusetts
Painting by John Singleton Copley

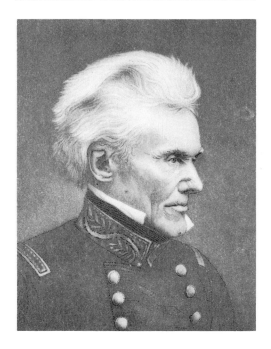

EDMUND PENDLETON GAINES
(*left*)
(1777–1849)
Army officer in War of 1812 and Mexican War
Engraving by T. Doney

MYRA GAINES (*right*)
[Mrs. Myra Whitney, nee Myra Clark]
(1805–1885)
Wife of Edmund Pendleton Gaines; gained notoriety by contesting father's will
After a photograph by Mathew Brady

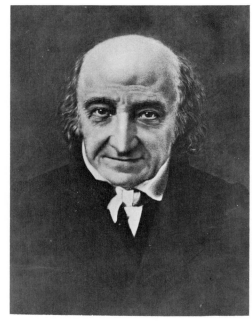

GALL *(left)*
[Pizi]
(c. 1840–1894)
Sioux chief in battle of Little Big Horn;
later, judge of Court of Indian Offenses

ALBERT GALLATIN *(right)*
[Abraham Alfonse Albert Gallatin]
(1761–1849)
Diplomat, financier, Secretary of the Trea-
sury under Jefferson and Madison
Courtesy National Archives, Brady Collection

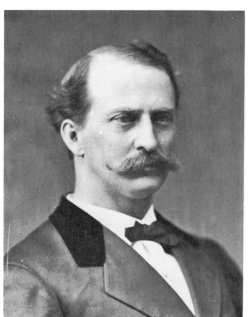

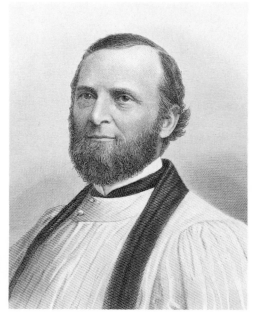

EDWARD MINER GALLAUDET
(left)
(1837–1917)
Educator of deaf-mutes
Courtesy Library of Congress, Brady-Handy Collection

THOMAS GALLAUDET *(right)*
(1822–1902)
Protestant Episcopal clergyman, established
church for deaf-mutes

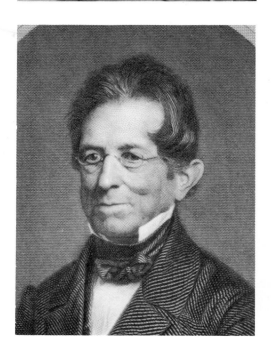

THOMAS HOPKINS GALLAUDET
(left)
(1787–1851)
Pioneer in educating deaf-mutes

JOSEPH GALLOWAY *(right)*
(c. 1731–1803)
Colonial legislator, Loyalist in American
Revolution

BERNARDO DE GÁLVEZ *(left)*
(c. 1746–1786)
Spanish army officer, governor of Louisiana
during American Revolution

HENRY GANNETT *(right)*
(1846–1914)
Geographer, statistician
Courtesy U.S. Geological Survey

JOE GANS *(left)*
(1874–1910)
Lightweight boxing champion
Courtesy Mercaldo Archives

PETER GANSEVOORT *(right)*
(1749–1812)
Revolutionary army officer
Painting by Gilbert Stuart

MARY GARDEN *(left)*
(1874–1967)
Operatic soprano

ALEXANDER GARDNER *(right)*
(1821–1882)
Photographer
Courtesy Acacia Mutual Life Insurance Co.

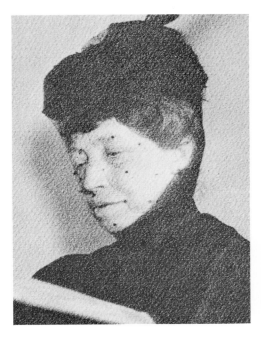

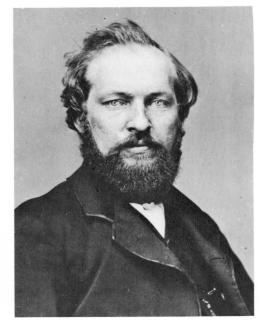

ISABELLA STEWART GARDNER
(*left*)
[nee Isabella Stewart]
(1840–1924)
Boston society leader, art collector; founded
Gardner Museum, Fenway Court
Courtesy Isabella Stewart Gardner Museum

JAMES ABRAM GARFIELD (*right*)
(1831–1881)
President of the United States, 1881
Courtesy National Archives, Brady Collection

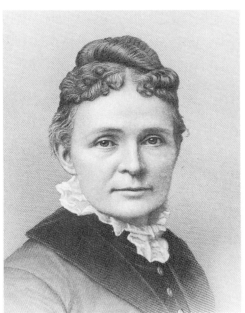

Mrs. JAMES ABRAM GARFIELD
(*left*)
[nee Lucretia Rudolph]
(1832–1918)
First lady, 1881
Engraving by Samuel Sartain

AUGUSTUS HILL GARLAND (*right*)
(1832–1899)
U.S. Senator, Governor of Louisiana, Attorney General under Cleveland
Courtesy Library of Congress, Brady Collection

HAMLIN GARLAND (*left*)
[Hannibal Hamlin Garland]
(1860–1940)
Novelist, short-story writer

JOHN NANCE GARNER (*right*)
(1868–1967)
Vice-President of U.S., 1933–1941
Courtesy Garner Memorial Museum

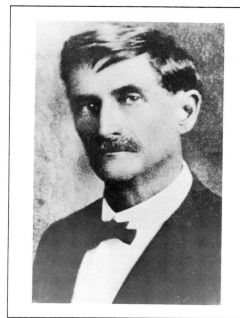

JAMES EDMUND GARRETSON
(*left*)
(1828–1895)
Dentist, pioneer in oral surgery

PAT GARRETT (*right*)
[Patrick Floyd Garrett]
(1850–1908)
Western lawman, shot Billy the Kid
Courtesy Mercaldo Archives

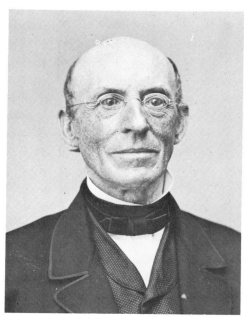

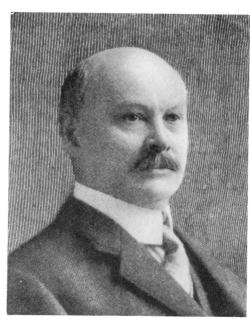

WILLIAM LLOYD GARRISON (*left*)
(1805–1879)
Abolitionist, lecturer, reformer
Courtesy Library of Congress, Brady-Handy Collection

ELBERT HENRY GARY (*right*)
(1846–1927)
Corporation lawyer, industrialist; organized
U.S. Steel Corp.

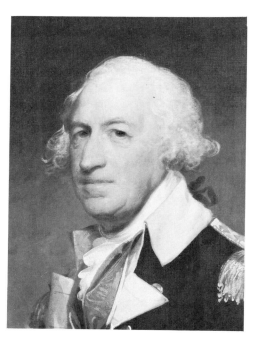

HORATIO GATES (*left*)
(*c.* 1729–1806)
Revolutionary general
Painting by Gilbert Stuart

JOHN WARNE GATES (*right*)
["Bet-you-a-million" Gates]
(1855–1911)
Speculator, promoter, early leader in wire
manufacturing

RICHARD JORDAN GATLING (*left*)
(1818–1903)
Inventor, developed rapid-fire Gatling gun

ALBERT SAMUEL GATSCHET (*right*)
(1832–1907)
Philologist, ethnologist; early student of American Indian languages
Courtesy Bureau of American Ethnology, Smithsonian Institution

SYDNEY HOWARD GAY (*left*)
(1814–1888)
Journalist, historian, abolitionist

CHARLES ÉTIENNE ARTHUR GAYARRÉ (*right*)
(1805–1895)
Historian

CHARLES MILLS GAYLEY (*left*)
(1858–1932)
Educator, literary critic

WILLIAM JAY GAYNOR (*right*)
(1849–1913)
Lawyer, jurist, mayor of New York

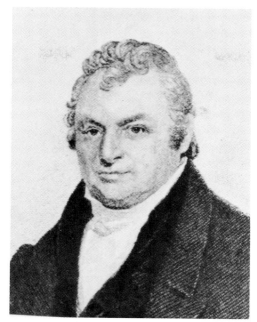

JOHN WHITE GEARY (*left*)
(1819–1873)
First mayor of San Francisco; Governor of
Kansas Territory and Pennsylvania

JAMES GEDDES (*right*)
(1763–1838)
Civil engineer, leader in construction of
Erie Canal
Courtesy Buffalo and Erie County Historical Society

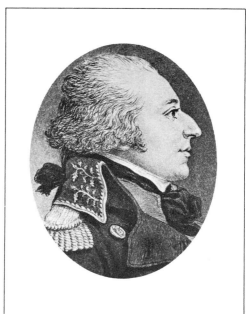

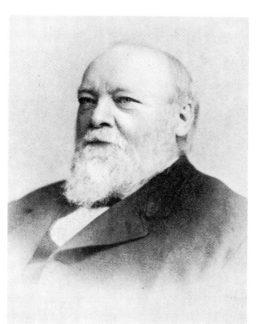

EDMOND CHARLES ÉDOUARD
GENÊT (*left*)
[Citizen Genêt]
(1763–1834)
First French minister to U. S.; center of
controversy in American politics

FREDERICK AUGUSTUS GENTH
(*right*)
[Friedrich August Ludwig Karl Wilhelm
Genth]
(1820–1893)
Analytical chemist, mineralogist

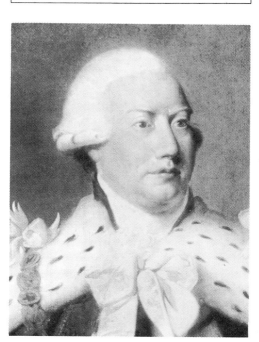

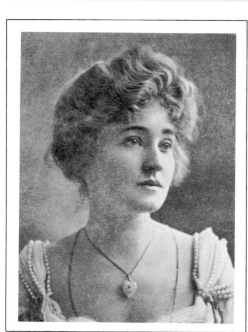

GEORGE III (*left*)
(1738–1820)
British monarch during American Rev-
olution

GRACE GEORGE (*right*)
(1879-)
Actress

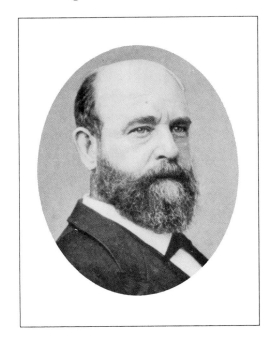

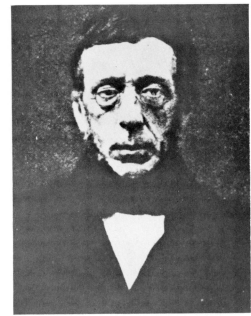

HENRY GEORGE *(left)*
(1839–1897)
Economist, reformer, journalist; started single-tax movement

WILLIAM WOOD GERHARD *(right)*
(1809–1872)
Physician, pathologist
Courtesy New York Academy of Medicine

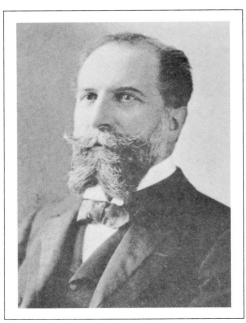

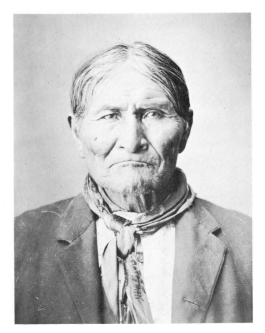

WILHELM GERICKE *(left)*
(1845–1925)
Conductor, led Boston Symphony Orchestra

GERONIMO *(right)*
[Goyathlay]
(1829–1909)
Apache warrior
Courtesy Mercaldo Archives

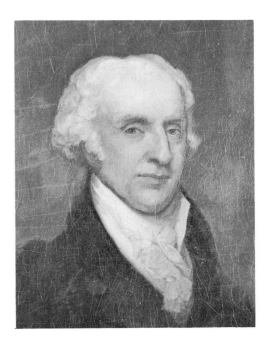

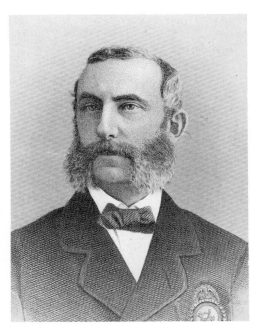

ELBRIDGE GERRY *(left)*
(1744–1814)
Signer of Declaration of Independence, delegate to Constitutional Convention, Governor of Massachusetts; Vice-President of U.S., 1813–1814; known for "gerrymander"
Painting by James Bogle. Courtesy Independence National Historical Park

ELBRIDGE THOMAS GERRY *(right)*
(1837–1927)
Lawyer, philanthropist
Engraving by George E. Perine

PIERRE GIBAULT (*left*)
(1737–1804)
Catholic missionary in Illinois country; aided George Rogers Clark during American Revolution
Courtesy Illinois State Historical Library

JAMES CARDINAL GIBBONS (*right*)
(1834–1921)
Roman Catholic archbishop of Baltimore; second American cardinal

THOMAS GIBBONS (*left*)
(1757–1826)
Lawyer, steamboat operator; plaintiff in *Gibbons v. Ogden*

JOSIAH WILLARD GIBBS (*right*)
(1839–1903)
Physicist, mathematician; pioneer in thermodynamics and physical chemistry
Courtesy Burndy Library

OLIVER WOLCOTT GIBBS (*left*)
(1822–1908)
Chemist, teacher, editor

CHARLES DANA GIBSON (*right*)
(1867–1944)
Magazine illustrator, creator of the "Gibson girl"
Courtesy Peter A. Juley & Son

JOHN BANNISTER GIBSON (*left*)
(1780–1853)
Jurist; chief justice of Pennsylvania

FRANKLIN HENRY GIDDINGS
(*right*)
(1855–1931)
Sociologist, educator

JOSHUA REED GIDDINGS (*left*)
(1795–1864)
Abolitionist Congressman
Engraving by H. B. Hall & Sons

SANFORD ROBINSON GIFFORD
(*right*)
(1823–1880)
Landscape painter, member of Hudson River
school

ANNE GILBERT (*left*)
[nee Anne Hartley]
(1821–1904)
Character actress

CASS GILBERT (*right*)
(1859–1934)
Architect, designed Woolworth Building,
U.S. Supreme Court Building

GROVE KARL GILBERT (*left*)
(1843–1918)
Geologist
Courtesy U.S. Geological Survey

JOHN GIBBS GILBERT (*right*)
(1810–1889)
Comic actor
Courtesy Library of Congress, Brady-Handy Collection

LINDA GILBERT (*left*)
(1847–1895)
Reformer, philanthropist; founded Prisoner's Aid Society

RUFUS HENRY GILBERT (*right*)
(1832–1885)
Surgeon, inventor; built New York City's first elevated railroad

RICHARD WATSON GILDER (*left*)
(1844–1909)
Editor, poet, reformer, biographer

BASIL LANNEAU GILDERSLEEVE
(*right*)
(1831–1924)
Philologist, classicist, teacher

THEODORE NICHOLAS GILL (*left*)
(1837–1914)
Zoologist, taxonomist, ichthyologist

KING CAMP GILLETTE (*right*)
(1855–1932)
Inventor of safety razor; founded Gillette Safety Razor Co.

WILLIAM HOOKER GILLETTE
(*left*)
(1855–1937)
Actor, playwright; portrayed Sherlock Holmes

ARTHUR GILMAN (*right*)
(1837–1909)
Educator, historian, editor; founded Radcliffe College
Courtesy Radcliffe College

CHARLOTTE GILMAN (*left*)
[Charlotte Stetson, nee Charlotte Perkins]
(1860–1935)
Writer, lecturer, reformer

DANIEL COIT GILMAN (*right*)
(1831–1908)
Educator; planned the Sheffield Scientific School at Yale University; first president, Johns Hopkins University
Courtesy Johns Hopkins University

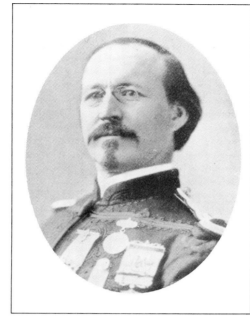

NICHOLAS GILMAN (*left*)
(1755–1814)
Signer of Constitution; Congressman, U.S. Senator
Painting by Albert Rosenthal. Courtesy Independence National Historical Park

PATRICK SARSFIELD GILMORE (*right*)
[Louis Lambert]
(1829–1892)
Bandmaster, composed "When Johnny Comes Marching Home Again"
Photograph by Napoleon Sarony

CHARLES GIMBEL (*left*)
(1861–1932)
Merchant, executive in Gimbel Brothers
Courtesy Gimbel Brothers

ELLIS A. GIMBEL (*right*)
(1865–1950)
Merchant, executive in Gimbel Brothers
Courtesy Gimbel Brothers

ISAAC GIMBEL (*left*)
(1856–1931)
Merchant, president of Gimbel Brothers
Photograph by Pirie MacDonald. Courtesy Gimbel Brothers

JACOB GIMBEL (*right*)
(1850–1922)
Merchant, helped found New York branch of Gimbel Brothers
Courtesy Gimbel Brothers

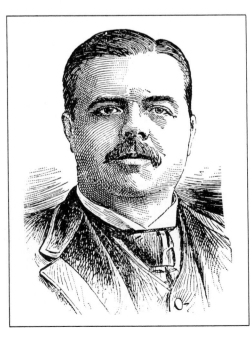

EDWIN GINN *(left)*
(1838–1914)
Book publisher
Courtesy Ginn & Co.

STEPHEN GIRARD *(right)*
(1750–1831)
Merchant, banker, philanthropist; founded .
Girard College

WILLIAM JAMES GLACKENS *(left)*
(1870–1938)
Painter, member of the "Ashcan school"
Courtesy Peter A. Juley & Son

WASHINGTON GLADDEN *(right)*
[Solomon Washington Gladden]
(1836–1918)
Congregational clergyman, adherent of the
"social gospel"
Courtesy First Congregational Church, Columbus, Ohio

ELLEN GLASGOW *(left)*
[Ellen Anderson Gholson Glasgow]
(1874–1945)
Novelist
Courtesy Doubleday & Co.

CHARLES JASPER GLIDDEN *(right)*
(1857–1927)
Pioneer in telephone communications sys-
tems

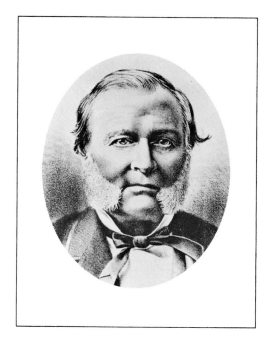

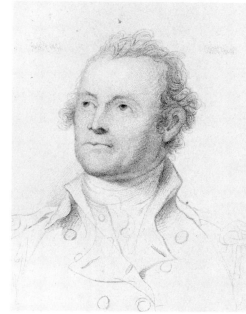

JOSEPH FARWELL GLIDDEN (*left*)
(1813–1906)
Inventor, developed barbed wire
Courtesy Smithsonian Institution

JOHN GLOVER (*right*)
(1732–1797)
Revolutionary army officer; transported Washington's army across Delaware
Engraved by Henry B. Hall from a drawing by John Trumbull

TOWNEND GLOVER (*left*)
(1813–1883)
Entomologist
Courtesy U.S. Department of Agriculture

LOUIS ANTOINE GODEY (*right*)
(1804–1878)
Publisher, originated the *Lady's Book*

EDWIN LAWRENCE GODKIN (*left*)
(1831–1902)
Journalist, publisher; a founder of *The Nation*; editor, *New York Evening Post*

LEOPOLD GODOWSKY (*right*)
(1870–1938)
Russian pianist, composer, teacher; director, Chicago Conservatory of Music

PARKE GODWIN (*left*)
(1816–1904)
Journalist, editor, writer

GEORGE WASHINGTON GOETHALS
(*right*)
(1858–1928)
Military engineer, completed Panama Canal
construction
Courtesy Burndy Library

ABRAHAM GOLDFADEN (*left*)
(1840–1908)
Playwright, founded the Yiddish Theater
Courtesy Jewish Encyclopedic Handbooks, Inc.

HORACE GOLDIN (*right*)
[Hyman Goldstein]
(1873–1939)
Magician
Courtesy Milbourne Christopher Collection

EMMA GOLDMAN (*left*)
(1869–1940)
Anarchist, reformer, writer, editor
Courtesy University of Michigan

LOUIS MALESHERBES
GOLDSBOROUGH (*right*)
(1805–1877)
Union naval officer in Civil War
Engraving by John C. Buttre

SAMUEL GOMPERS (*left*)
(1850–1924)
Labor leader; a founder and first president,
American Federation of Labor

GEORGE LINCOLN GOODALE
(*right*)
(1839–1923)
Botanist, educator
Courtesy Harvard University Archives

GEORGE BROWN GOODE (*left*)
(1851–1896)
Ichthyologist

BERTRAM GROSVENOR GOODHUE
(*right*)
(1869–1924)
Architect, designed West Point chapel

THOMAS WAKEFIELD GOODSPEED
(*left*)
(1842–1927)
Baptist clergyman, a founder of University of
Chicago
Courtesy University of Chicago

NAT GOODWIN (*right*)
[Nathaniel Carll Goodwin]
(1857–1919)
Actor

WILLIAM WATSON GOODWIN
(*left*)
(1831–1912)
Greek scholar, educator
Courtesy Harvard University Archives

CHARLES GOODYEAR (*right*)
(1800–1860)
Inventor, devised process for vulcanizing rubber
Engraving by W. G. Jackman

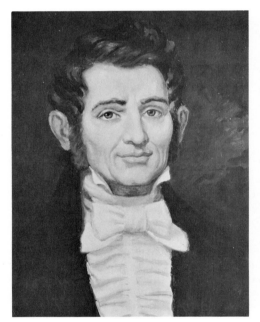
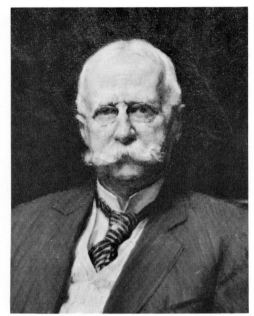

CHARLES GOODYEAR (*left*)
(1833–1896)
Industrialist, pioneer in shoemaking machinery
Courtesy Goodyear Tire and Rubber Co.

WILLIAM HENRY GOODYEAR
(*right*)
(1846–1923)
Archaeologist, architectural historian
Courtesy Brooklyn Museum

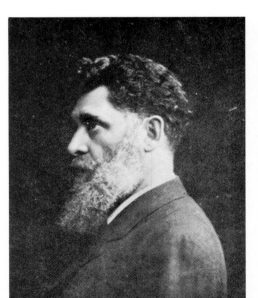

JACOB GORDIN (*left*)
(1853–1909)
Yiddish playwright
Courtesy Jewish Encyclopedic Handbooks, Inc.

GEORGE ANGIER GORDON (*right*)
(1853–1929)
Congregational clergyman, theologian
Courtesy Old South Church, Boston, Massachusetts

JOHN BROWN GORDON (*left*)
(1832–1904)
Confederate general, U.S. Senator, Governor of Georgia
After a photograph by Mathew Brady

WILLIAM CRAWFORD GORGAS
(*right*)
(1854–1920)
Sanitary engineer, Surgeon General; supervised yellow-fever control in Havana and Panama Canal Zone
Courtesy Library of Congress

NATHANIEL GORHAM (*left*)
(1738–1796)
Member of Continental Congress, signer of Constitution
Painting attributed to James Sharples, Sr.

ARTHUR PUE GORMAN (*right*)
(1839–1906)
U.S. Senator
Courtesy Library of Congress, Brady-Handy Collection

FRANK ALVIN GOTCH (*left*)
(b.1878)
Champion wrestler
Courtesy "The Ring" Magazine

LOUIS MOREAU GOTTSCHALK
(*right*)
(1829–1869)
Pianist, composer
Courtesy Eric Schaal

JOHN FRANKLIN GOUCHER (*left*)
(1845–1922)
Methodist clergyman; benefactor and second president, Goucher College
Courtesy Goucher College

FREDERIC WILLIAM GOUDY
(*right*)
(1865–1947)
Printer, type designer
Courtesy Peter A. Juley & Son

JOHN BARTHOLOMEW GOUGH
(*left*)
(1817–1886)
Temperance lecturer, writer

BENJAMIN APTHORP GOULD
(*right*)
(1824–1896)
Astronomer, founded *Astronomical Journal*

GEORGE JAY GOULD (*left*)
(1864–1923)
Railroad industrialist
Photograph by Pach Brothers

GEORGE MILBRY GOULD (*right*)
(1848–1922)
Ophthalmologist, medical writer; helped develop bifocal lens
Courtesy Jefferson Medical College

JAY GOULD (*left*)
[Jason Gould]
(1836–1892)
Capitalist

WILLIAM RUSSELL GRACE (*right*)
(1832–1904)
Merchant, shipowner, founder of Grace
Lines; reform mayor of New York

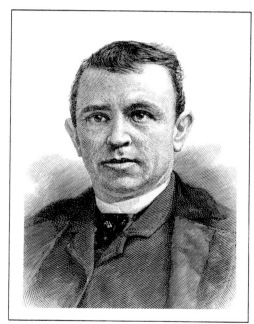

ARCHIBALD GRACIE (*left*)
(1832–1864)
Confederate general
Courtesy Library of Congress

HENRY WOODFIN GRADY (*right*)
(1850–1889)
Editor of *Atlanta Constitution*; orator

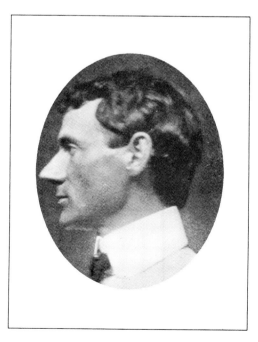

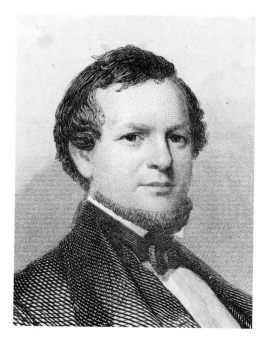

CHARLES GRAFLY (*left*)
(1862–1929)
Sculptor

GEORGE REX GRAHAM (*right*)
(1813–1894)
Editor, publisher; founded and edited *Graham's Magazine*
Engraved by William G. Armstrong after a painting by Thomas Buchanan Read

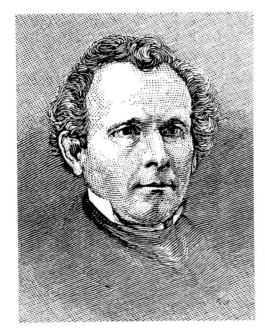
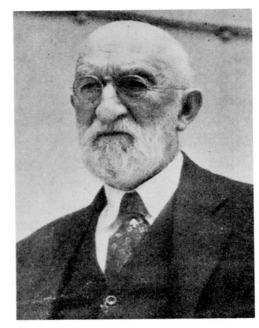

SYLVESTER GRAHAM (*left*)
(1794–1851)
Food cultist, advocated use of unbolted
(graham) flour

HEBER JEDEDIAH GRANT (*right*)
(1856–1945)
Mormon leader

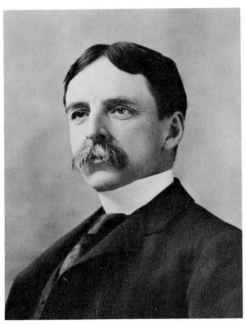
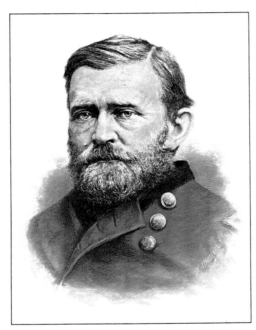

ROBERT GRANT (*left*)
(1852–1940)
Novelist, jurist
Courtesy Library of Congress

ULYSSES SIMPSON GRANT (*right*)
(1822–1885)
President of the United States, 1869–1877

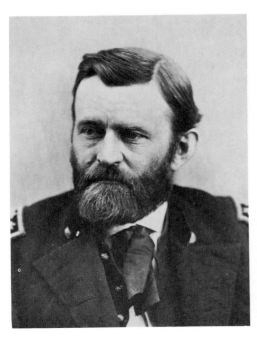

ULYSSES SIMPSON GRANT (*left*)
(*see above*)
*Photograph by Alexander Gardner. Courtesy Peter A.
Juley & Son*

MRS. ULYSSES SIMPSON GRANT
(*right*)
[nee Julia Dent]
(1826–1902)
First lady, 1869–1877
Courtesy Library of Congress

WILLIAM WEST GRANT (*left*)
(1846–1934)
Surgeon, performed first appendectomy in
U.S. and Europe

JOHN GRASS (*right*)
(1837–1918)
Blackfoot Sioux chief
Courtesy Mercaldo Archives

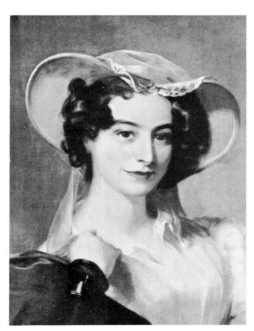

Comte FRANÇOIS JOSEPH PAUL de
GRASSE (*left*)
[Marquis de Grasse-Tilly]
(1722–1788)
French naval commander, blockaded Corn-
wallis at Yorktown

REBECCA GRATZ (*right*)
(1781–1869)
Philadelphia philanthropist, reputed model
for Rebecca in Scott's *Ivanhoe*
Painting by Thomas Sully

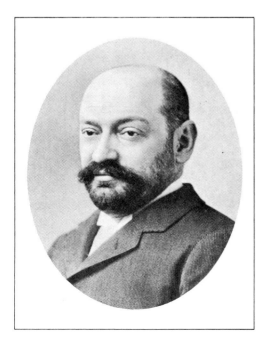

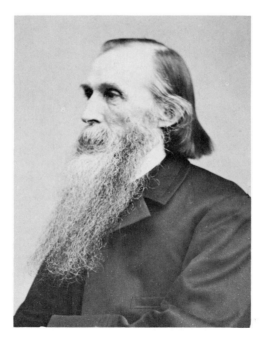

MAURICE GRAU (*left*)
(1849–1907)
Operatic manager

ASA GRAY (*right*)
(1810–1888)
Botanist, writer, educator
Courtesy Library of Congress, Brady-Handy Collection

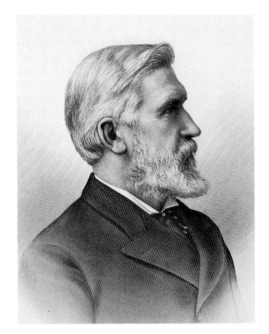

ELISHA GRAY (*left*)
(1835–1901)
Inventor, rivaled Bell in development of telephone

HENRY PETERS GRAY (*right*)
(1819–1877)
Painter

HORACE GRAY (*left*)
(1828–1902)
Lawyer, chief justice of Massachusetts; associate justice, U.S. Supreme Court

JOHN CHIPMAN GRAY (*right*)
(1839–1915)
Lawyer, legal writer, educator

ROBERT GRAY (*left*)
(1755–1806)
Shipmaster, discovered Columbia River

HORACE GREELEY (*right*)
(1811–1872)
Politician; publisher, founder, and editor of the *New York Tribune*

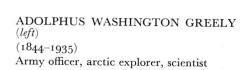

ADOLPHUS WASHINGTON GREELY
(left)
(1844–1935)
Army officer, arctic explorer, scientist

ANNA KATHARINE GREEN *(right)*
[Mrs. Charles Rohlfs]
(1846–1935)
Mystery-story writer

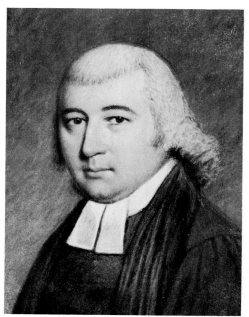

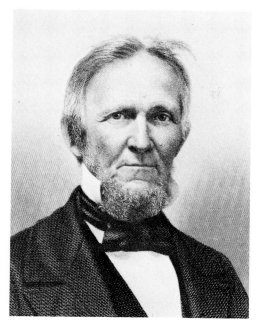

ASHBEL GREEN *(left)*
(1762–1848)
Presbyterian clergyman, editor; president,
College of New Jersey (Princeton)
*Painting attributed to James Sharples, Sr. Courtesy
Independence National Historical Park*

BERIAH GREEN *(right)*
(1795–1874)
Congregational clergyman, educator, aboli-
tionist
Engraving by Alexander H. Ritchie

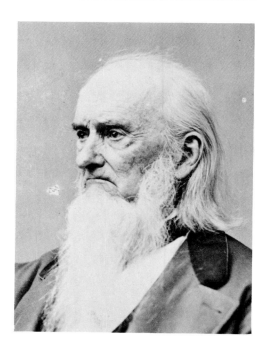

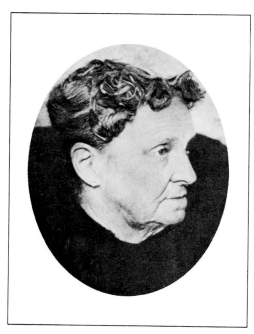

DUFF GREEN *(left)*
(1791–1875)
Publisher, editor, politician
Courtesy Library of Congress, Brady-Handy Collection

HETTY GREEN *(right)*
[nee Henrietta Howland Robinson]
(1834–1916)
Capitalist

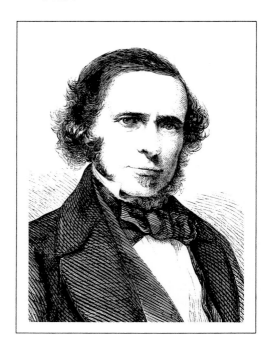

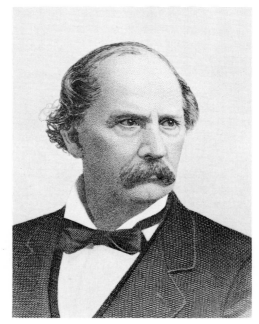

HORACE GREEN (*left*)
(1802–1866)
Physician, pioneer specialist in throat diseases

NORVIN GREEN (*right*)
(1818–1893)
Financier, leader in establishment of Western Union Telegraph Co.
Engraving by George E. Perine

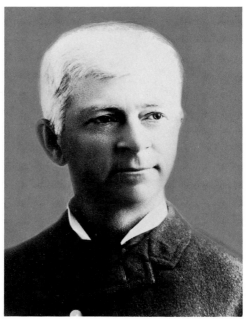

EDWARD LEE GREENE (*left*)
(1843–1915)
Botanist
Courtesy New York Botanical Garden

FRANCIS VINTON GREENE (*right*)
(1850–1921)
Army officer, engineer, historian

NATHANAEL GREENE (*left*)
(1742–1786)
Revolutionary general
Engraved by J. B. Forrest from a painting by John Trumbull

SAMUEL DANA GREENE (*right*)
(1840–1884)
Naval commander; executive officer of the *Monitor*

SIMON GREENLEAF *(left)*
(1783–1853)
Lawyer, educator
Courtesy Library of Congress

HORATIO GREENOUGH *(right)*
(1805–1852)
Sculptor

JAMES BRADSTREET GREENOUGH
(left)
(1833–1901)
Philologist
Courtesy Harvard University

GRACE GREENWOOD *(right)*
[Sara Jane Lippincott]
(1823–1904)
Essayist, poet

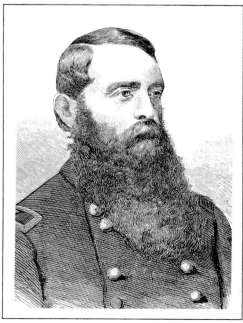

JOHN GREENWOOD *(left)*
(1760–1819)
Dental pioneer; a dentist to George Washington

DAVID McMURTRIE GREGG *(right)*
(1833–1916)
Union general of cavalry in Civil War
After a photograph by Mathew Brady

WILLIAM GREGG (*left*)
(1800–1867)
Cotton manufacturer, promoted industrialization of South
Courtesy South Caroliniana Library, University of South Carolina

GEORGE GRENVILLE (*right*)
(1712–1770)
English prime minister, presided over enactment of Stamp Act, 1765
Engraved by James Watson after a painting by William Hoare. Courtesy British Museum

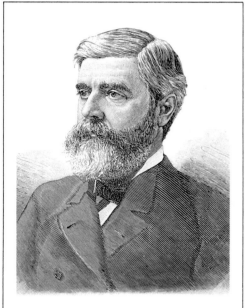

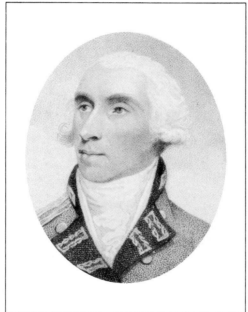

WALTER QUINTIN GRESHAM
(*left*)
(1832–1895)
Postmaster General and Secretary of the Treasury under Arthur; Secretary of State under Cleveland

CHARLES GREY, 1st Earl GREY
(*right*)
(1729–1807)
British general in American Revolution

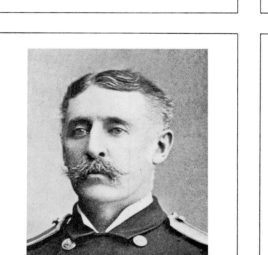

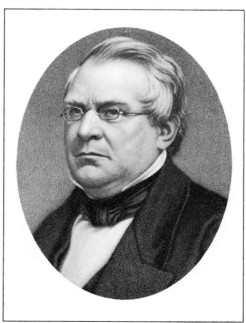

CHARLES VERNON GRIDLEY
(*left*)
(1844–1898)
Naval officer, battle of Manila Bay ("You may fire when you are ready, Gridley")

ROBERT COOPER GRIER (*right*)
(1794–1870)
Associate justice, U.S. Supreme Court
Engraving by H. S. Sadd

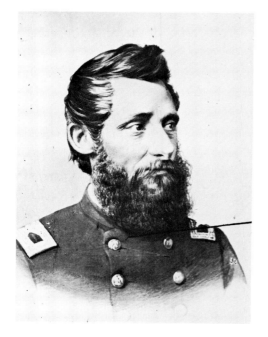

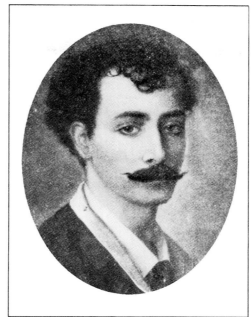

BENJAMIN HENRY GRIERSON
(*left*)
(1826–1911)
Union general in Civil War
Courtesy Library of Congress, Brady Collection

FRANCIS GRIERSON (*right*)
[Benjamin Henry Jesse Francis Shepard]
(1848–1927)
Writer, pianist, singer

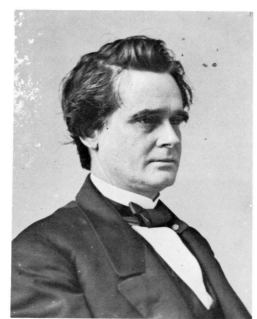

CLARK CALVIN GRIFFITH (*left*)
(1869–1955)
Baseball pitcher, executive; member of Baseball Hall of Fame
Courtesy National Baseball Hall of Fame

JAMES WILSON GRIMES (*right*)
(1816–1872)
Governor of Iowa, U.S. Senator; cast decisive vote in Andrew Johnson's impeachment trial
Courtesy Library of Congress, Brady-Handy Collection

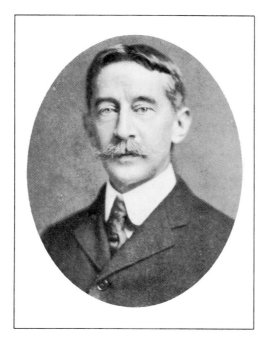

SARAH MOORE GRIMKÉ (*left*)
(1792–1873)
Abolitionist, feminist

GEORGE BIRD GRINNELL (*right*)
(1849–1938)
Ethnologist, naturalist, writer; edited *Forest and Stream*; influenced founding of Glacier National Park
Courtesy National Park Service, Glacier National Park

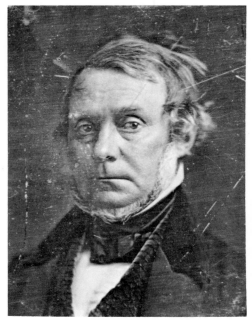

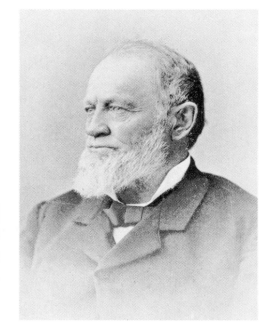

HENRY GRINNELL (*left*)
(1799–1874)
Merchant, financed early arctic exploration
Daguerreotype by Mathew Brady. Courtesy Library of Congress

JOSIAH BUSHNELL GRINNELL
(*right*)
(1821–1891)
Congregational clergyman; advised by Greeley to "go west," founded Grinnell, Iowa, and Grinnell College

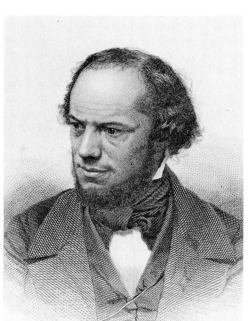

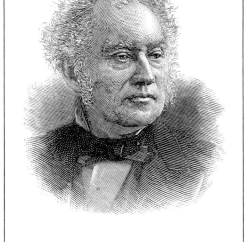

RUFUS WILMOT GRISWOLD (*left*)
(1815–1857)
Anthologist, journalist, editor
Engraving by Capewell & Kimmel

SAMUEL DAVID GROSS (*right*)
(1805–1884)
Surgeon, pathologist, teacher, writer

PETER STENGER GROSSCUP (*left*)
(1852–1921)
Federal judge

GALUSHA AARON GROW (*right*)
(1822–1907)
Congressman; Speaker of the House during special session at start of Civil War; pioneer in homestead legislation

FELIX GRUNDY (*left*)
(1777–1840)
U.S. Senator, Attorney General under Van Buren
Engraving by Thomas B. Welch

JAMES McCLURG GUFFEY (*right*)
(1839–1930)
Pioneer oil producer

DANIEL GUGGENHEIM (*left*)
(1856–1930)
Industrialist, philanthropist

MEYER GUGGENHEIM (*right*)
(1828–1905)
Merchant, capitalist; developed mining and smelting properties

SOLOMON R. GUGGENHEIM (*left*)
(1861–1949)
Capitalist, donated New York City's Guggenheim Museum
Courtesy Solomon R. Guggenheim Foundation

LOUISE IMOGEN GUINEY (*right*)
(1861–1920)
Poet, essayist

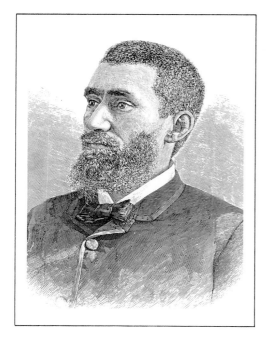

CHARLES J. GUITEAU *(left)*
(c. 1840–1882)
Assassin of President Garfield

FRANCIS BARTON GUMMERE
(right)
*(*1855–1919*)*
Philologist, critic, educator; authority on ballads
Courtesy Haverford College

FRANK WAKELEY GUNSAULUS
(left)
*(*1856–1921*)*
Congregational clergyman, writer; a founder of Illinois Institute of Technology
Courtesy Illinois Institute of Technology

GEORGE GUNTON *(right)*
*(*1845–1919*)*
Economic reformer

JAMES GUTHRIE *(left)*
*(*1792–1869*)*
Financier, Secretary of the Treasury under Pierce, U.S. Senator; founded University of Louisville
Engraving by Henry B. Hall

WILLIAM DAMERON GUTHRIE
(right)
*(*1859–1935*)*
Lawyer, scholar, educator

ARNOLD HENRY GUYOT
(1807–1884)
Physical geographer, geologist

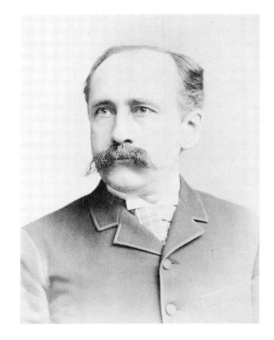

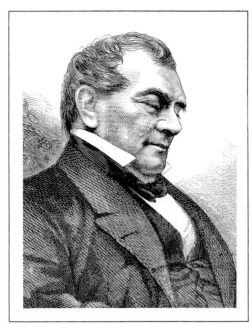

JOHN HABBERTON (*left*)
(1842–1921)
Journalist, novelist; wrote *Helen's Babies*

JAMES HENRY HACKETT (*right*)
(1800–1871)
Character actor

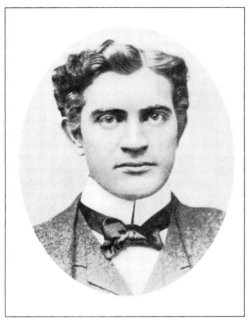

JAMES KETELTAS HACKETT (*left*)
(1869–1926)
Actor; son of James Henry Hackett

ARTHUR TWINING HADLEY (*right*)
(1856–1930)
Political economist, educator; president of
Yale University

JAMES HADLEY (*left*)
(1821–1872)
Philologist

JAMES BEN ALI HAGGIN (*right*)
(1827–1914)
Lawyer, mining financier, rancher and
farmer

ARNOLD HAGUE (*left*)
(1840–1917)
Government geologist in Western U.S.;
supervised survey of Yellowstone National
Park

CHARLES COOLIDGE HAIGHT
(*right*)
(1841–1917)
Architect

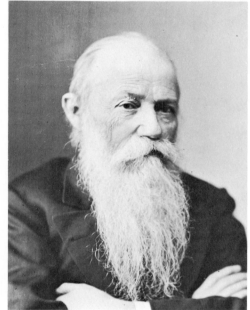

WILLIAM NICHOLAS HAILMANN
(*left*)
(1836–1920)
Educator; leader of kindergarten movement
in U.S.
Courtesy Chicago Historical Society

SAMUEL STEMAN HALDEMAN
(*right*)
(1812–1880)
Philologist, naturalist, educator
Courtesy Library of Congress, Brady-Handy Collection

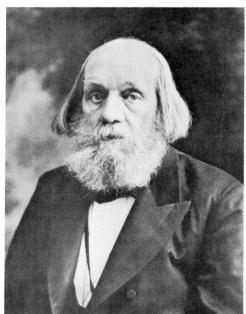

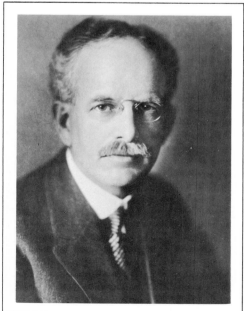

EDWARD EVERETT HALE (*left*)
(1822–1909)
Writer, editor, Unitarian clergyman, hu-
manitarian

GEORGE ELLERY HALE (*right*)
(1868–1938)
Astronomer, guided founding of Yerkes,
Mt. Wilson, and Palomar Observatories
Courtesy University of Chicago

IRVING HALE (*left*)
(1862–1930)
Army officer, founded Veterans of Foreign
Wars

JOHN PARKER HALE (*right*)
(1806–1873)
U.S. Senator, Congressman, diplomat; abo-
litionist
Engraving by John C. Buttre

NATHAN HALE (*left*)
(1784–1863)
Publisher, editor; nephew of Nathan Hale
(1755–1776)

PHILIP HALE (*right*)
(1854–1934)
Music critic
Courtesy Library of Congress

SARAH HALE (*left*)
[nee Sarah Josepha Buell]
(1788–1879)
Writer, reformer; edited *Ladies' Magazine*
and *Godey's Lady's Book*
Engraving by John C. Buttre

ABRAHAM OAKEY HALL (*right*)
(1826–1898)
Mayor of New York, involved in Tweed
Ring scandal

ASAPH HALL (*left*)
(1829–1907)
Astronomer, discovered satellites of Mars

CHARLES CUTHBERT HALL (*right*)
(1852–1908)
Presbyterian clergyman, theologian; president, Union Theological Seminary

CHARLES FRANCIS HALL (*left*)
(1821–1871)
Arctic explorer
Daguerreotype by Mathew Brady. Courtesy Library of Congress

CHARLES MARTIN HALL (*right*)
(1863–1914)
Chemist, manufacturer; invented process for smelting aluminum
Courtesy Oberlin College

EDWIN HERBERT HALL (*left*)
(1855–1938)
Physicist, educator

FITZEDWARD HALL (*right*)
(1825–1901)
Philologist

GRANVILLE STANLEY HALL (*left*)
(1844–1924)
Psychologist, educational philosopher; president of Clark University; founded *American Journal of Psychology*

JAMES HALL (*right*)
(1793–1868)
Jurist, journalist, frontier historian

JAMES HALL (*left*)
(1811–1898)
Geologist, paleontologist
Courtesy Illinois State Historical Library

LYMAN HALL (*right*)
(1724–1790)
Revolutionary leader, Governor of Georgia; signer of Declaration of Independence

SAMUEL READ HALL (*left*)
(1795–1877)
Educator, leader in teacher training
Engraving by George E. Perine. Courtesy Smithsonian Institution

LEWIS HALLAM (*right*)
(c. 1740–1808)
Actor, theatrical producer
Courtesy Harvard University Theatre Collection

FITZ-GREENE HALLECK (*left*)
(1790–1867)
Poet
Engraved by John Cheney from a painting by Charles Loring Elliott

HENRY WAGER HALLECK (*right*)
(1815–1872)
Union general in Civil War
Engraving by Alexander H. Ritchie

ANDREW SMITH HALLIDIE (*left*)
[Andrew Smith]
(1836–1900)
Engineer, inventor, wire manufacturer; developed San Francisco cable-car system
Courtesy Lick Observatory

CHARLES HALLOCK (*right*)
(1834–1917)
Journalist, naturalist, conservationist; founded and edited *Forest and Stream*

MURAT HALSTEAD (*left*)
(1829–1908)
Newspaper editor, publisher

GEORGE BRUCE HALSTED (*right*)
(1853–1922)
Mathematician, translator, educator
Courtesy University of Texas

WILLIAM STEWART HALSTED
(*left*)
(1852–1922)
Surgeon
Courtesy Johns Hopkins University

ALEXANDER HAMILTON (*right*)
(1712–1756)
Physician, wrote on life and opinion in the
Colonies

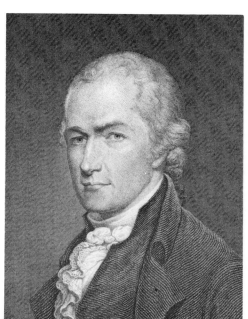

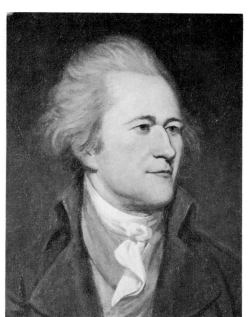

ALEXANDER HAMILTON (*left*)
(1757–1804)
First U.S. Secretary of the Treasury (1789–
1795); signer of Constitution, principal
author of *The Federalist*
*Engraved by J. F. E. Prud'homme from a painting by
Archibald Robertson*

ALEXANDER HAMILTON (*right*)
(*see above*)
*Painting by Charles Willson Peale. Courtesy Inde-
pendence National Historical Park*

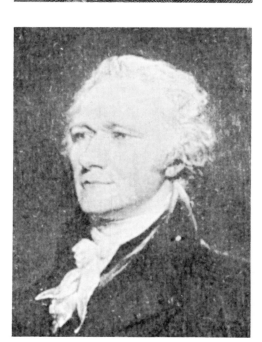

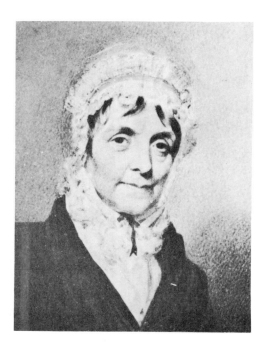

ALEXANDER HAMILTON (*left*)
(*see above*)
Painting by John Trumbull

MRS. ALEXANDER HAMILTON
(*right*)
[nee Elizabeth Schuyler]
(1757–1854)
New York society leader
Painting by Henry Inman

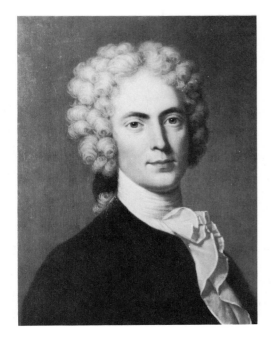

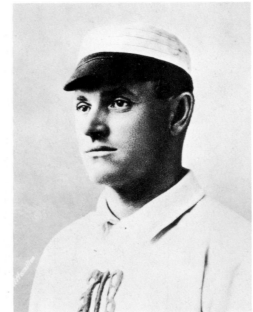

ANDREW HAMILTON (*left*)
(c. 1676–1741)
Lawyer, defended John Peter Zenger
Painting by Adolf U. Wertmüller

BILLY HAMILTON (*right*)
[William Robert Hamilton]
(1866–1940)
Baseball outfielder, member of Baseball
Hall of Fame
Courtesy National Baseball Hall of Fame

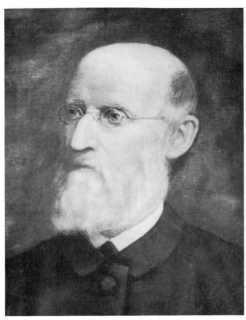

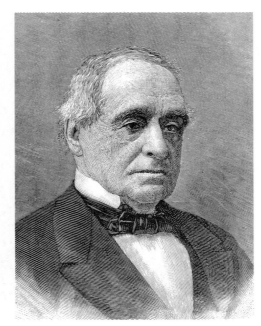

CYRUS HAMLIN (*left*)
(1811–1900)
Congregational missionary, educator; found-
ed Robert College, Constantinople
Courtesy Middlebury College

HANNIBAL HAMLIN (*right*)
(1809–1891)
Congressman, U.S. Senator, Governor of
Maine; Vice-President of U.S., 1861–1865

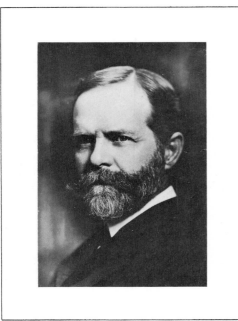

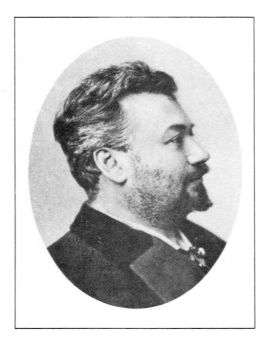

WILLIAM JOSEPH HAMMER (*left*)
(1858–1934)
Electrical engineer, assistant to Edison; in-
ventor of electric signs, radium luminous
materials; built first electrical central sta-
tion; originated radium therapy
Courtesy Mrs. Mabel H. Assheton

OSCAR HAMMERSTEIN (*right*)
(c. 1847–1919)
Theater owner, theatrical producer, com-
poser of operettas

JAMES BARTLETT HAMMOND
(left)
(1839–1913)
Typewriter inventor and manufacturer; journalist

JAMES HENRY HAMMOND *(right)*
(1807–1864)
Governor of South Carolina, U.S. Senator; advocated slavery and secession
Courtesy South Caroliniana Library, University of South Carolina

JOHN HAYS HAMMOND *(left)*
(1855–1936)
Mining engineer
Photograph by Pirie MacDonald. Courtesy New-York Historical Society

WILLIAM ALEXANDER HAMMOND
(right)
(1828–1900)
U.S. Surgeon General during Civil War; neurologist, educator
Courtesy National Archives, Brady Collection

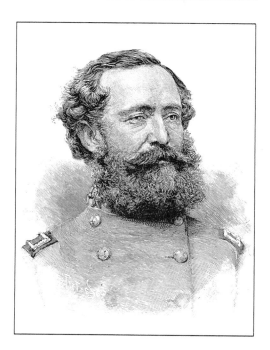

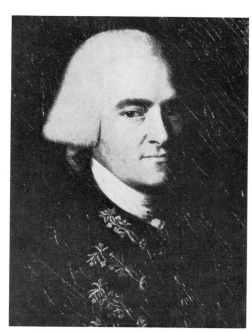

WADE HAMPTON *(left)*
(1818–1902)
Confederate general, Governor of South Carolina, U.S. Senator

JOHN HANCOCK *(right)*
(1737–1793)
Signer of Declaration of Independence; president of Continental Congress; first governor of Massachusetts
Painting by John Singleton Copley

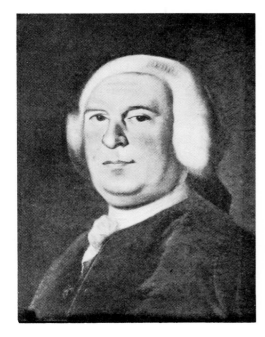

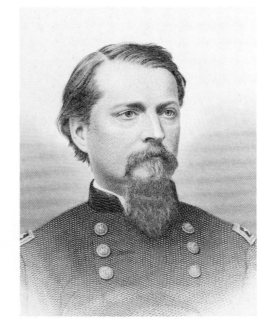

THOMAS HANCOCK (*left*)
(1703–1764)
Boston merchant, uncle of John Hancock

WINFIELD SCOTT HANCOCK (*right*)
(1824–1886)
Union general in Civil War, presidential
candidate
Engraving by Robert Whitechurch

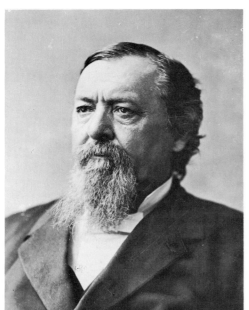

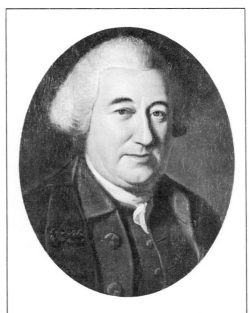

MARK HANNA (*left*)
[Marcus Alonzo Hanna]
(1837–1904)
Industrialist, Republican political leader,
U.S. Senator
Courtesy Library of Congress, Brady-Handy Collection

JOHN HANSON (*right*)
(1721–1783)
Revolutionary leader, first president of
Congress under Articles of Confederation
*Painting by Charles Willson Peale. Courtesy Inde-
pendence National Historical Park*

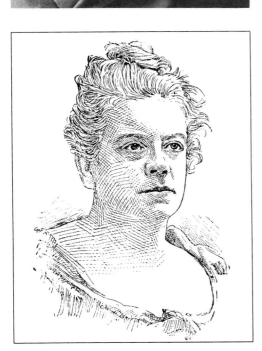

ISABEL FLORENCE HAPGOOD
(*left*)
(1850–1928)
Journalist, translated Russian novels into
English

WILLIAM NATHANIEL HARBEN
(*right*)
(1858–1919)
Novelist
Photograph by Pach Brothers

WILLIAM JOSEPH HARDEE (*left*)
(1815–1873)
Confederate general

HENRY JANEWAY HARDENBERGH
(*right*)
(1847–1918)
Architect, designed Plaza Hotel and Dakota
Apartments, New York City

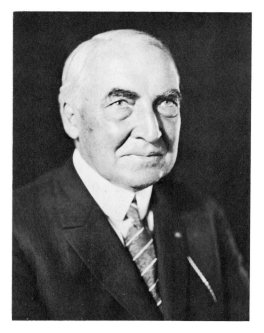

CHESTER HARDING (*left*)
(1792–1866)
Portrait painter
Engraved by H. W. Smith from a self-portrait

WARREN GAMALIEL HARDING
(*right*)
(1865–1923)
President of the United States, 1921–1923
Courtesy Library of Congress

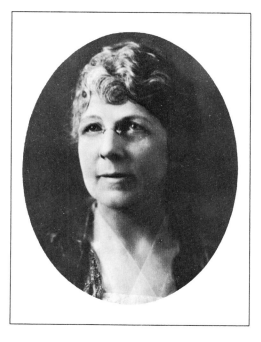

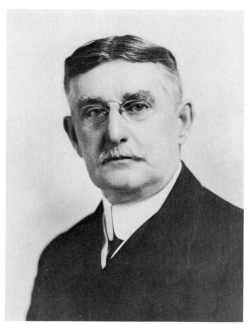

Mrs. WARREN G. HARDING (*left*)
[nee Florence Kling]
(1860–1924)
First lady, 1921–1923
Courtesy Harding Home and Museum

ARTHUR SHERBURNE HARDY
(*right*)
(1847–1930)
Mathematician, novelist, diplomat
Courtesy Dartmouth College

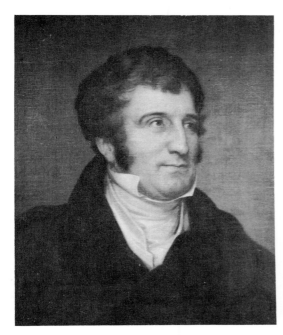

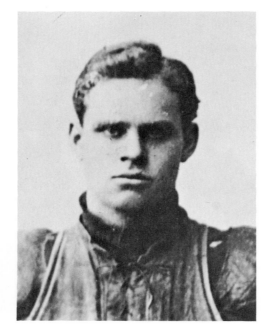

ROBERT HARE (*left*)
(1781–1858)
Chemist, inventor, educator
*Painting by Rembrandt Peale. Courtesy Independence
National Historical Park*

THOMAS TRUXTON HARE (*right*)
(1878–1956)
University of Pennsylvania football player
Courtesy University of Pennsylvania

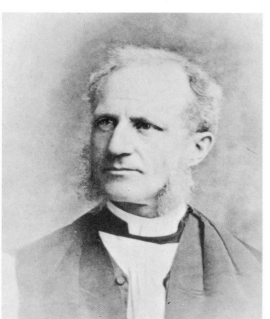

WILLIAM HOBART HARE (*left*)
(1838–1909)
Protestant Episcopal clergyman, missionary
to Sioux Indians

THOMAS HARIOT (*right*)
[Thomas Harriot; Harriott]
(1560–1621)
English mathematician; wrote of year in
Virginia as colonist under Raleigh

ALBERT HARKNESS (*left*)
(1822–1907)
Educator, classical scholar
Courtesy Albert Harkness

STEPHEN VANDENBURG
HARKNESS (*right*)
(1818–1888)
Industrialist, developed large oil holdings
Courtesy Western Reserve Historical Society

Mrs. STEPHEN VANDENBURG HARKNESS (*left*)
[nee Anna M. Richardson]
(*c.* 1838–1926)
Philanthropist; donated Harkness Memorial Quadrangle, Yale University
Painting by Albert Herter. Courtesy Yale University Art Gallery, Gift of Edward S. Harkness

WILLIAM HARKNESS (*right*)
(1837–1903)
Astronomer

JAMES HARLAN (*left*)
(1820–1899)
U.S. Senator, Secretary of the Interior under Andrew Johnson
Engraving by John C. Buttre

JOHN MARSHALL HARLAN (*right*)
(1833–1911)
Associate justice, U.S. Supreme Court

MARION HARLAND (*left*)
[Mary Terhune, nee Mary Virginia Hawes]
(1830–1922)
Novelist, pioneer home economist

VIRGINIA HARNED (*right*)
(*c.* 1868–1946)
Actress

WILLIAM M. HARNETT *(left)*
(1848–1892)
Still-life painter

FLETCHER HARPER *(right)*
(1806–1877)
Publisher, originated *Harper's Weekly* and
Harper's Bazaar
Engraving by Frederick Halpin

JAMES HARPER *(left)*
(1795–1869)
Printer, publisher, originated *Harper's Month-
ly*; reform mayor of New York
Engraving by Frederick Halpin

JOHN HARPER *(right)*
(1797–1875)
Publisher; co-founder, Harper and Brothers

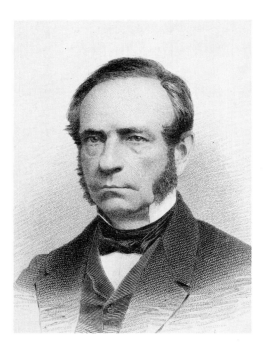

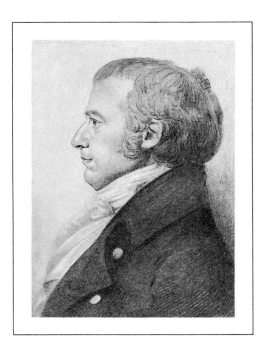

JOSEPH WESLEY HARPER *(left)*
(1801–1870)
Publisher, one of four Harper brothers

ROBERT GOODLOE HARPER *(right)*
(1765–1825)
Lawyer, Congressman, U.S. Senator; Fed-
eralist leader

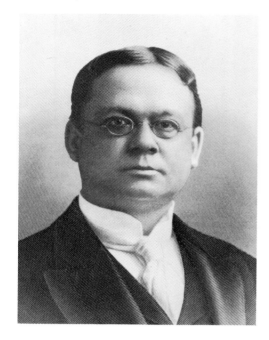

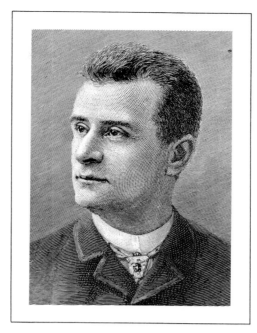

WILLIAM RAINEY HARPER　(*left*)
(1856–1906)
Hebraic scholar, educator; first president,
University of Chicago

EDWARD HARRIGAN　(*right*)
(1845–1911)
Playwright, actor; member of Harrigan and
Hart vaudeville team

EDWARD HENRY HARRIMAN
(*left*)
(1848–1909)
Railroad magnate, financier

CHAPIN AARON HARRIS　(*right*)
(1806–1860)
Dentist, leader in establishing institutions of
professional dentistry in U.S.

JOEL CHANDLER HARRIS　(*left*)
(1848–1908)
Journalist, writer; author of " Uncle Remus "
tales

THADDEUS WILLIAM HARRIS
(*right*)
(1795–1856)
Entomologist, librarian
Courtesy Harvard University Archives

THOMAS LAKE HARRIS (*left*)
(1823–1906)
Spiritualist, poet

TOWNSEND HARRIS (*right*)
(1804–1878)
Diplomat, first U.S. minister to Japan; helped establish the College of the City of New York
Courtesy Library of Congress, Brady-Handy Collection

WILLIAM TORREY HARRIS (*left*)
(1835–1909)
Hegelian philosopher, educator, editor

BENJAMIN HARRISON (*right*)
(*c.* 1726–1791)
Governor of Virginia; member of Continental Congress; signer of Declaration of Independence
Painted by James Reid Lambdin from a painting by John Trumbull. Courtesy Independence National Historical Park

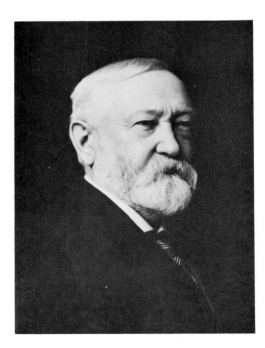

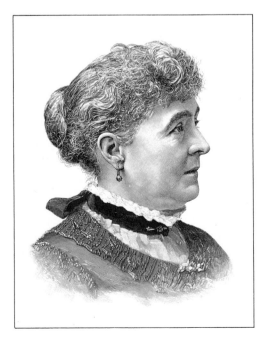

BENJAMIN HARRISON (*left*)
(1833–1901)
President of the United States, 1889–1893
Courtesy Benjamin H. Walker

Mrs. BENJAMIN HARRISON (*right*)
[nee Caroline Lavinia Scott]
(1832–1892)
First lady, 1889–1892

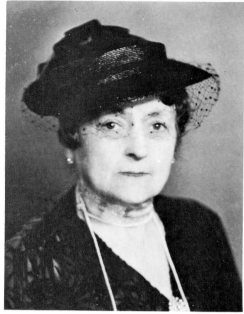

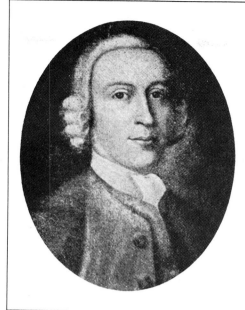

Mrs. BENJAMIN HARRISON (*left*)
[nee Mary Scott Lord]
(1858–1948)
Second wife of Benjamin Harrison, married
in 1896
Courtesy Benjamin H. Walker and Josephine U. Herrick

PETER HARRISON (*right*)
(1716–1775)
Architect
After a painting attributed to Nathaniel Smibert

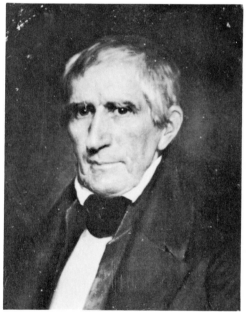

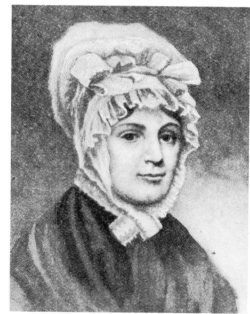

WILLIAM HENRY HARRISON
(*left*)
(1773–1841)
President of the United States, 1841
Photograph by Southworth and Hawes. Courtesy Metropolitan Museum of Art, Stokes-Hawes Collection

Mrs. WILLIAM HENRY HARRISON
(*right*)
[nee Anna Symmes]
(1775–1864)
First lady, 1841

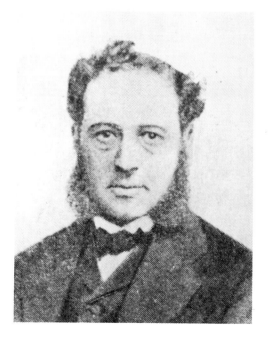

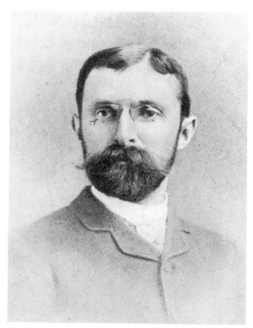

HENRY HARRISSE (*left*)
(1829–1910)
Historian

ALBERT BUSHNELL HART (*right*)
(1854–1943)
Historian, editor, educator

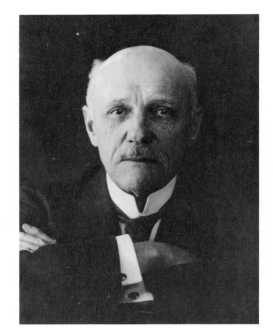

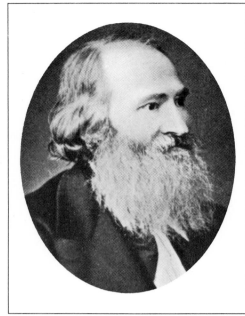

JAMES MORGAN HART *(left)*
(1839–1916)
Philologist, educator
Courtesy Cornell University

JOEL TANNER HART *(right)*
(1810–1877)
Sculptor

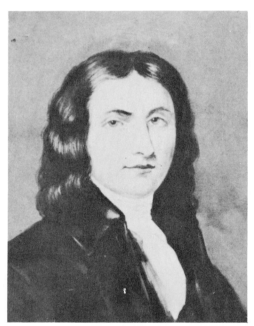

JOHN HART *(left)*
(c. 1711–1779)
Member of Continental Congress, signer
of Declaration of Independence
Courtesy New Jersey Historical Society

TONY HART *(right)*
[Anthony Cannon]
(1855–1891)
Comedian; member of Harrigan and Hart
vaudeville team

WILLIAM S. HART *(left)*
(1872–1946)
Actor
Courtesy Newhall-Saugus Chamber of Commerce

BRET HARTE *(right)*
[Francis Brett Harte]
(1836–1902)
Short-story writer, novelist, poet

GEORGE H. HARTFORD (*left*)
(1833–1917)
Merchant, founded A & P Co.
Courtesy A & P Food Stores

GEORGE L. HARTFORD (*right*)
(1865–1957)
Merchant; chairman, A & P Co.
Courtesy A & P Food Stores

JOHN A. HARTFORD (*left*)
(1872–1951)
Merchant, A & P Co.
Courtesy A & P Food Stores

JAMES HARTNESS (*right*)
(1861–1934)
Mechanical engineer, tool designer; Governor of Vermont

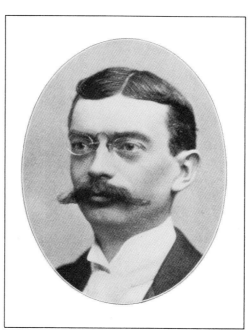

CHARLES T. HARVEY (*left*)
(1829–1912)
Entrepreneur, designed and built first elevated railroad
Engraving by E. G. Williams & Bro. Courtesy New-York Historical Society

GEORGE BRINTON McCLELLAN
HARVEY (*right*)
(1864–1928)
Publisher, editor, political leader, diplomat

WILLIAM HOPE HARVEY (*left*)
["Coin" Harvey]
(1851–1936)
Economic reformer, advocate of bimetallism
Courtesy Arkansas History Commission

CHILDE HASSAM (*right*)
[Frederick Childe Hassam]
(1859–1935)
Painter, etcher
Courtesy Peter A. Juley & Son

FERDINAND RUDOLPH HASSLER
(*left*)
(1770–1843)
Geodetic surveyor, mathematician; organized U.S. Coast Survey
Lithograph by Charles Fenderich. Courtesy Library of Congress

THOMAS HASTINGS (*right*)
(1784–1872)
Hymn writer, compiler of hymnals; wrote music for "Rock of Ages"

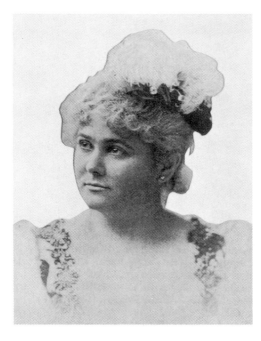

THOMAS HASTINGS (*left*)
(1860–1929)
Architect; co-designer, New York Public Library

MINNIE HAUK (*right*)
(c. 1852–1929)
Operatic soprano

HERMAN HAUPT (*left*)
(1817–1905)
Bridge and railroad engineer, chief engineer
of Hoosac Tunnel in Massachusetts
Courtesy National Archives, Brady Collection

ROBERT HAVELL (*right*)
(1793–1878)
Etcher, engraver, painter; principal en-
graver of elephant edition, Audubon's *Birds
of America*
Courtesy New-York Historical Society

HENRY OSBORNE HAVEMEYER
(*left*)
(1847–1907)
Sugar refiner

**WILLIAM FREDERICK
HAVEMEYER** (*right*)
(1804–1874)
Sugar refiner, banker, mayor of New York
Courtesy New-York Historical Society

GILBERT HAVEN (*left*)
(1821–1880)
Methodist Episcopal bishop, abolitionist,
reformer, editor

JOHN HAVILAND (*right*)
(1792–1852)
Architect, originated radial design for
prisons
*Painting by John Neagle. Courtesy Metropolitan
Museum of Art, Alfred N. Punnett Fund*

JOSIAH JOHNSON HAWES (*left*)
(*c.* 1808–1901)
Photographer, partner in Southworth and
Hawes
*Courtesy Metropolitan Museum of Art, Stokes-Hawes
Collection*

Sɪʀ JOHN HAWKINS (*right*)
(1532–1595)
English naval officer; second to Drake on
expedition to West Indies

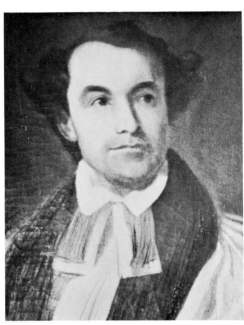

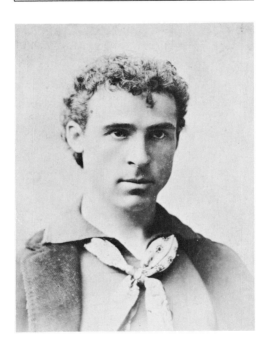

FRANCIS LISTER HAWKS (*left*)
(1798–1866)
Protestant Episcopal clergyman, historian,
editor; first president, Louisiana University
(Tulane)
Courtesy Tulane University

JOSEPH HAWORTH (*right*)
(*c.* 1855–1903)
Actor
Courtesy Museum of the City of New York

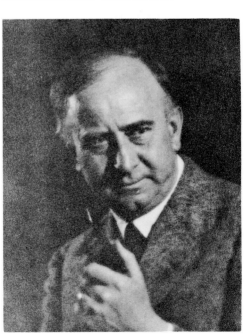

CHARLES WEBSTER HAWTHORNE
(*left*)
(1872–1930)
Painter; founded Cape Cod School of Art
Courtesy Joseph Hawthorne

JULIAN HAWTHORNE (*right*)
(1846–1934)
Novelist, writer; son of Nathaniel Haw-
thorne

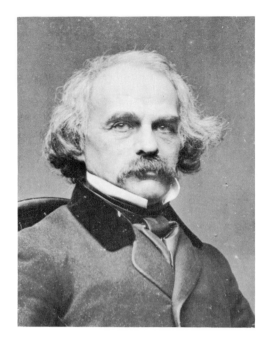

NATHANIEL HAWTHORNE (*left*)
(1804–1864)
Novelist, short-story writer
Courtesy National Archives, Brady Collection

SOPHIA PEABODY HAWTHORNE
(*right*)
(1810–1871)
Youngest of Peabody sisters of Salem; wife
of Nathaniel Hawthorne

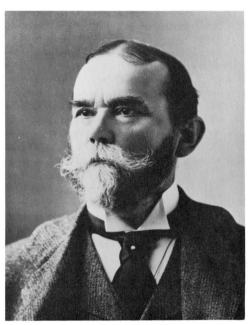
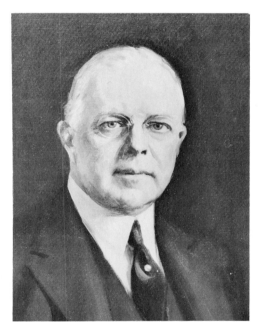

JOHN MILTON HAY (*left*)
(1838–1905)
Diplomat, lawyer, Secretary of State under
McKinley and T. Roosevelt; poet; biog-
rapher of Lincoln
Courtesy Brown University Library, John Hay Collection

CHARLES HAYDEN (*right*)
(1870–1937)
Financier, philanthropist; benefactor of
Hayden Planetarium, New York
*Painting by Wilbur Fiske Noyes. Courtesy American
Museum of Natural History*

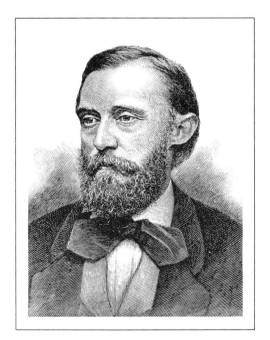
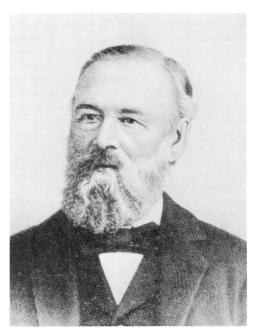

FERDINAND VANDIVEER HAYDEN
(*left*)
(1829–1887)
Geologist, explored Western U.S.; instru-
mental in founding Yellowstone National
Park

HIRAM WASHINGTON HAYDEN
(*right*)
(1820–1904)
Inventor, manufacturer of brassware

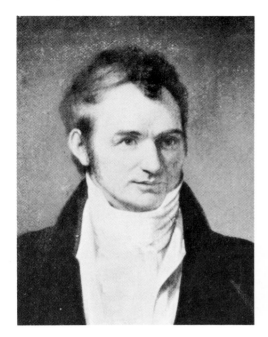

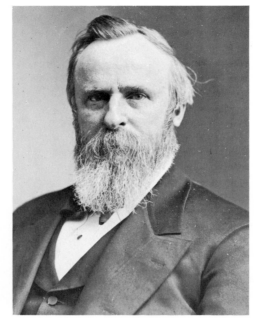

HORACE H. HAYDEN (*left*)
(1769–1844)
Dentist; first president, Baltimore College
of Dental Surgery, world's first dental college

RUTHERFORD BIRCHARD HAYES
(*right*)
(1822–1893)
President of the United States, 1877–1881
Courtesy Library of Congress, Brady-Handy Collection

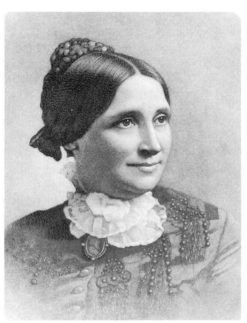

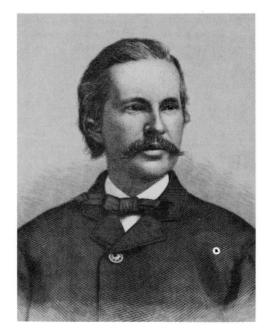

Mrs. RUTHERFORD B. HAYES
(*left*)
[nee Lucy Ware Webb]
(1831–1889)
First lady, 1877–1881
Engraving by John Sartain

PAUL HAMILTON HAYNE (*right*)
(1830–1886)
Poet
Engraving by J. J. Cade

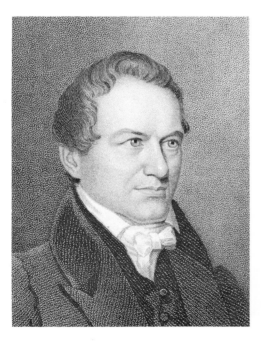

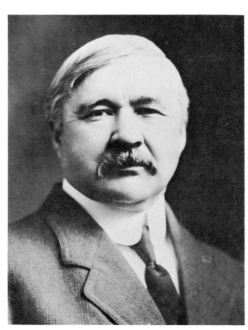

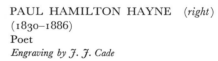

ROBERT YOUNG HAYNE (*left*)
(1791–1839)
U.S. Senator, Governor of South Carolina;
advocate of nullification; opponent of
Webster in great debates of 1830–1832
*Engraved by J. B. Forrest from a drawing by James
B. Longacre*

ELWOOD HAYNES (*right*)
(1857–1925)
Automobile pioneer, inventor; patented
stainless steel
Courtesy Automobile Manufacturers Association, Inc.

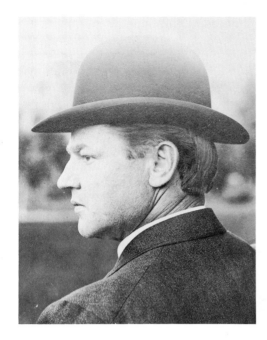

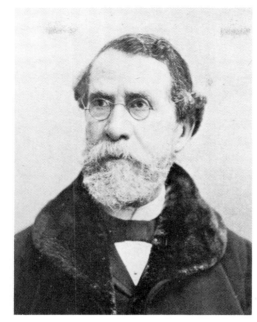

WILLIAM DUDLEY HAYWOOD
(*left*)
["Big Bill" Haywood]
(1869–1928)
Labor organizer, founder of the Industrial
Workers of the World
Courtesy Library of Congress

GEORGE PETER ALEXANDER
HEALY (*right*)
(1813–1894)
Portrait painter

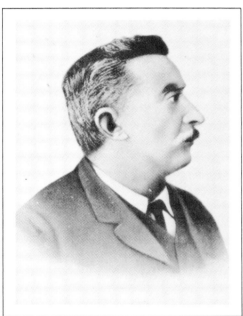

LAFCADIO HEARN (*left*)
[Patricio Lafcadio Tessima Carlos Hearn]
(1850–1904)
Journalist, translator, novelist, student of
Japanese culture

GEORGE HEARST (*right*)
(1820–1891)
Mine owner, publisher, U.S. Senator
Courtesy William Randolph Hearst, Jr.

Mrs. GEORGE HEARST (*left*)
[nee Phoebe Apperson]
(1842–1919)
Philanthropist
Courtesy William Randolph Hearst, Jr.

WILLIAM RANDOLPH HEARST
(*right*)
(1863–1951)
Newspaper publisher, capitalist
Courtesy William Randolph Hearst, Jr.

DANIEL COLLAMORE HEATH
(*left*)
(1843–1908)
Book publisher
Courtesy D. C. Heath & Co.

THOMAS KURTON HEATH (*right*)
(1853–1938)
Partner in McIntyre and Heath, blackface
comedy team
Courtesy Museum of the City of New York

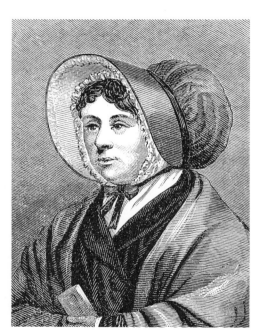

WILLIAM HEATH (*left*)
(1737–1814)
Revolutionary army officer

BARBARA HECK (*right*)
[nee Barbara Ruckle]
(1734–1804)
Organized first Methodist society in New
York City

ISAAC THOMAS HECKER (*left*)
(1819–1888)
Roman Catholic priest, founded Paulist
Fathers and the *Catholic World*
Painting by G. P. A. Healy. Courtesy Paulist Communications

FREDERIC HENRY HEDGE (*right*)
(1805–1890)
Unitarian clergyman, Transcendentalist;
translated German literature
Courtesy Harvard University Archives

EARLE RAYMOND HEDRICK (*left*)
(1876–1943)
Mathematician
Courtesy University of Missouri

JOHN CARMEL HEENAN (*right*)
(1835–1873)
Prize fighter

PUDGE HEFFELFINGER (*left*)
[William W. Heffelfinger]
(1867–1954)
Yale University football star
Courtesy Yale University

ANGELO HEILPRIN (*right*)
(1853–1907)
Geologist, paleontologist, explorer
Courtesy Geographical Society of Philadelphia

MICHAEL HEILPRIN (*left*)
(1823–1888)
Encyclopedia editor, journalist

SAMUEL PETER HEINTZELMAN
(*right*)
(1805–1880)
Union general in Civil War
Engraving by H. W. Smith

HENRY JOHN HEINZ *(left)*
(1844–1919)
Food packager; founded H. J. Heinz Co.

FREDERICK AUGUSTUS HEINZE
(right)
(1869–1914)
Copper magnate, banker

LUDVIG HEKTOEN *(left)*
(1863–1951)
Pathologist, bacteriologist, educator
Courtesy University of Chicago

ANNA HELD *(right)*
(c. 1873–1918)
Comedienne, singer, wife of Florenz Ziegfeld
Courtesy New-York Historical Society

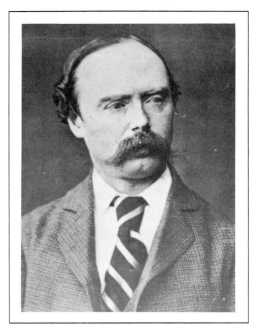

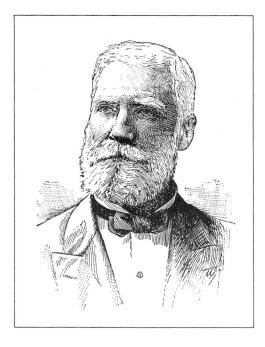

ROBERT HELLER *(left)*
[William Henry Palmer]
(1826–1878)
Magician, pianist, humorist
Courtesy Milbourne Christopher Collection

HINTON ROWAN HELPER *(right)*
(1829–1909)
Writer, opponent both of slavery and of Negro equality

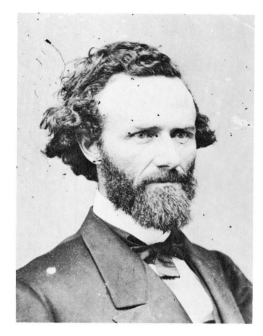

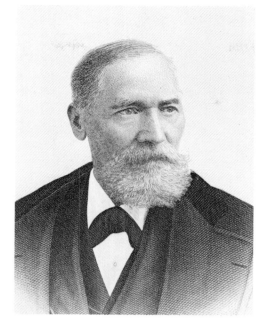

JOHN BROOKS HENDERSON (*left*)
(1826–1913)
U.S. Senator, proposed Thirteenth Amend-
ment to Constitution
Courtesy Library of Congress, Brady-Handy Collection

PETER HENDERSON (*right*)
(1822–1890)
Horticultural experimenter and writer, seed
merchant
Engraving by George E. Perine

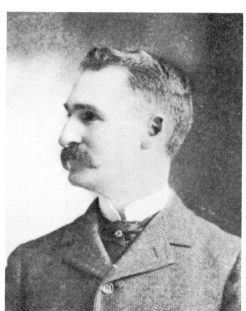

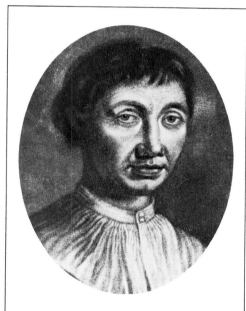

WILLIAM JAMES HENDERSON
(*left*)
(1855–1937)
Music critic, writer

HENDRICK (*right*)
[Tiyanoga]
(*c.* 1680–1755)
Mohawk leader; supported the English
against the French
*Engraving by John Faber. Courtesy Prints Division,
New York Public Library*

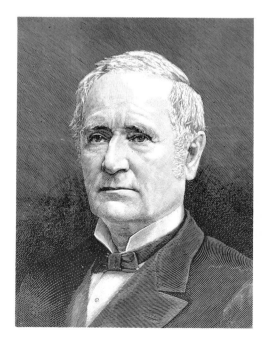

THOMAS ANDREWS HENDRICKS
(*left*)
(1819–1885)
Congressman, U.S. Senator; Vice-President
of U.S., 1885

ROBERT HENRI (*right*)
(1865–1929)
Painter, one of "The Eight"
Courtesy Peter A. Juley & Son

JOSEPH HENRY (*left*)
(1797–1878)
Physicist, pioneer in electromagnetism; first director of Smithsonian Institution
Engraving by George R. Hall

O. HENRY (*right*)
[William Sydney Porter]
(1862–1910)
Short-story writer

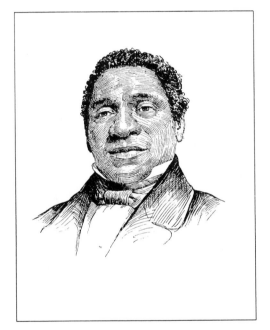

PATRICK HENRY (*left*)
(1736–1799)
Revolutionary leader, member of Continental Congress, Governor of Virginia
Painting by Thomas Sully. Courtesy Colonial Williamsburg

JOSIAH HENSON (*right*)
(1789–1883)
Escaped slave, Methodist preacher; reputed model for Uncle Tom in *Uncle Tom's Cabin*

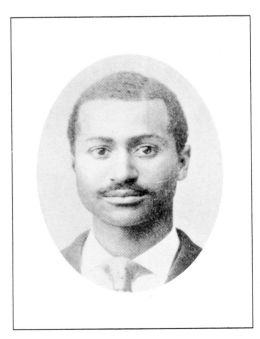

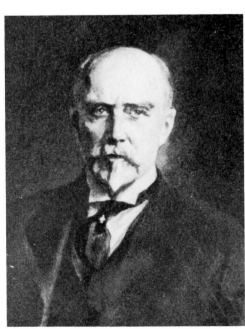

MATTHEW HENSON (*left*)
(1866–1955)
Explorer, member of Peary expedition to North Pole

ALONZO BARTON HEPBURN (*right*)
(1846–1922)
Banker, authority on currency, philanthropist

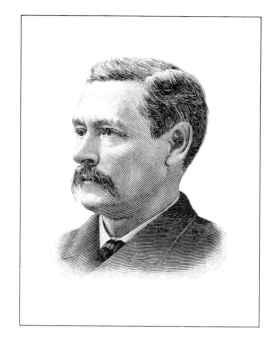

WILLIAM PETERS HEPBURN (*left*)
(1833–1916)
Congressman, author of Hepburn Act; joint author, Pure Food and Drug Act

HENRY L. HERBERT (*right*)
(1845–1921)
Sportsman

VICTOR HERBERT (*left*)
(1859–1924)
Operetta composer

OLIVER BROOKE HERFORD (*right*)
(1863–1935)
Author of whimsy and light verse; illustrator

CONSTANTINE HERING (*left*)
(1800–1880)
Physician; father of homeopathy in America; founded Hahnemann Medical College of Philadelphia

NICHOLAS HERKIMER (*right*)
(1728–1777)
Revolutionary general, mortally wounded attempting to relieve Fort Schuyler

WILLIAM HENRY HERNDON (*left*)
(1818–1891)
Law partner and biographer of Abraham
Lincoln
Courtesy Meserve Collection

JAMES A. HERNE (*right*)
[James Ahern]
(1839–1901)
Actor, playwright

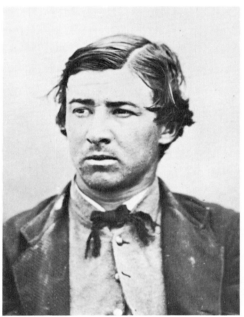

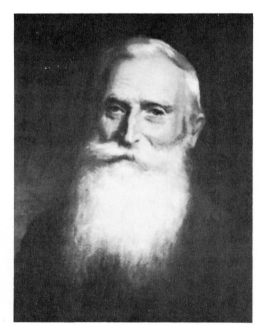

DAVID E. HEROLD (*left*)
(*c.* 1846–1865)
Conspired with John Wilkes Booth in
assassination of Lincoln
*Photograph by Alexander Gardner. Courtesy New-
York Historical Society*

JAMES BROWN HERRESHOFF
(*right*)
(1834–1930)
Inventor; developed improvements for row-
boats, sailboats, and steamboats
Painting by Lazar Raditz. Courtesy Norman Herreshoff

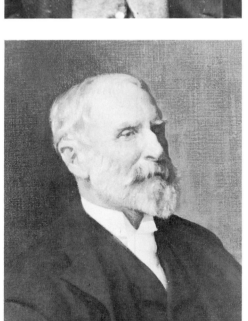

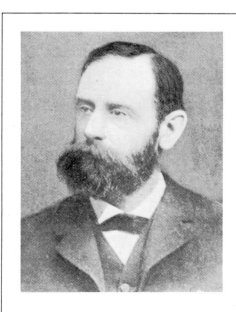

JOHN BROWN HERRESHOFF (*left*)
(1841–1915)
Shipbuilder, co-founder of Herreshoff Man-
ufacturing Co.
Courtesy Louise H. DeWolf

**NATHANAEL GREENE
HERRESHOFF** (*right*)
(1848–1938)
Ship designer and builder

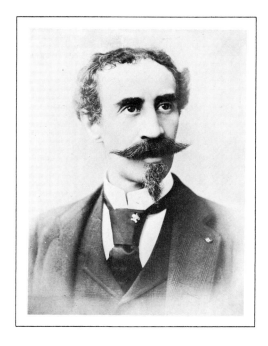

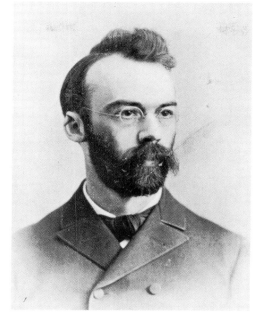

ALEXANDER HERRMANN (*left*)
[Chevalier Alexander Hermann; Hermann the Great]
(1844–1896)
Magician
Courtesy Milbourne Christopher Collection

GEORGE DAVIS HERRON (*right*)
(1862–1925)
Congregational clergyman, Socialist, reformer

MILTON SNAVELY HERSHEY (*left*)
(1857–1945)
Chocolate manufacturer
Courtesy Hershey Chocolate Corp.

CHRISTIAN HERTER (*right*)
(1840–1883)
Designer, interior decorator

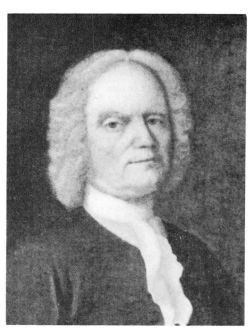

GUSTAV HERTER (*left*)
(1830–1898)
Interior designer

GUSTAVUS HESSELIUS (*right*)
(1682–1755)
Portrait painter, organ builder
Self-portrait

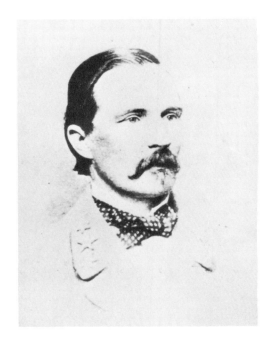

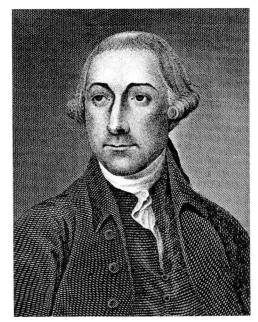

HENRY HETH (*left*)
(1825–1899)
Confederate general
Courtesy Confederate Museum

JOSEPH HEWES (*right*)
(1730–1779)
Member of Continental Congress, signer of
Declaration of Independence
*Engraved by F. Kearny after a drawing by J. B.
Longacre*

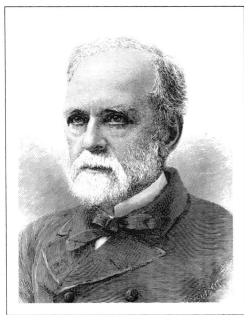

ABRAM STEVENS HEWITT (*left*)
(1822–1903)
Iron and steel manufacturer, philanthropist;
Congressman, mayor of New York

PETER COOPER HEWITT (*right*)
(1861–1921)
Electrical engineer; inventor of mercury-
vapor lamp, leader in development of vac-
uum tube

THOMAS HEYWARD (*left*)
(1746–1809)
Member of Continental Congress, signer of
Declaration of Independence
*Painted by Charles Fraser from a painting by Jeremiah
Theus. Courtesy Independence National Historical
Park*

JOHN GRIER HIBBEN (*right*)
(1861–1933)
Philosopher, Presbyterian clergyman; pres-
ident of Princeton University

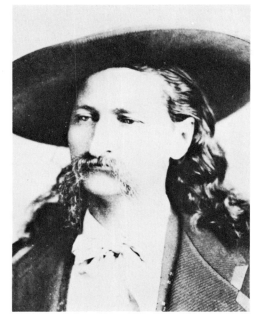

LAURENS PERSEUS HICKOK (*left*)
(1798–1888)
Philosopher, Presbyterian clergyman
Courtesy Schaffer Library, Union College

WILD BILL HICKOK (*right*)
[James Butler Hickok]
(1837–1876)
Law officer, U.S. marshal in the West
Courtesy Mercaldo Archives

EDWARD HICKS (*left*)
(1780–1849)
Painter
Painting by Thomas Hicks

ELIAS HICKS (*right*)
(1748–1830)
Liberal Quaker minister, leader of separation in Society of Friends

THOMAS HOLLIDAY HICKS (*left*)
(1798–1865)
Governor of Maryland, U.S. Senator; helped forestall Maryland secession
Courtesy Enoch Pratt Free Library

HENRY LEE HIGGINSON (*right*)
(1834–1919)
Banker, founded Boston Symphony Orchestra
Courtesy Boston Symphony Orchestra

THOMAS WENTWORTH HIGGINSON (*left*)
[Thomas Wentworth Storrow Higginson]
(1823–1911)
Writer, biographer; Unitarian clergyman, abolitionist, reformer
Engraving by Charles B. Hall

AMBROSE POWELL HILL (*right*)
(1825–1865)
Confederate general, led initial combat at Gettysburg
Engraving by Alexander H. Ritchie

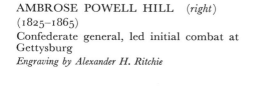

DANIEL HARVEY HILL (*left*)
(1821–1889)
Confederate general; president, University of Arkansas
Courtesy Library of Congress

DAVID JAYNE HILL (*right*)
(1850–1932)
Historian, diplomat; president of Bucknell College and University of Rochester

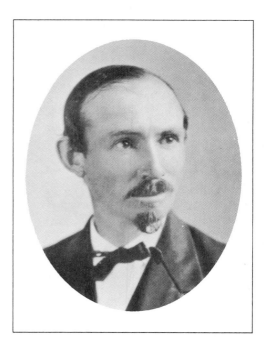

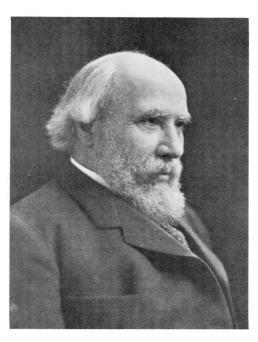

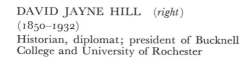

GEORGE WILLIAM HILL (*left*)
(1838–1914)
Mathematical astronomer
Courtesy Smithsonian Institution

JAMES JEROME HILL (*right*)
(1838–1916)
Railroad promoter, financier
Photograph by Pach Brothers

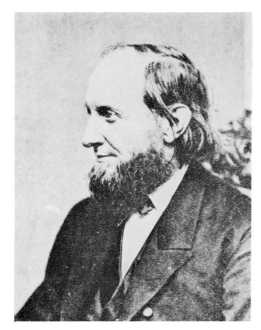

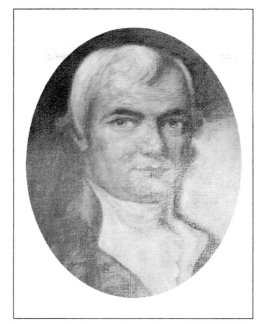

THOMAS HILL (*left*)
(1818–1891)
Unitarian clergyman, mathematician; president of Antioch College and Harvard University
Courtesy Antioch College

MICHAEL HILLEGAS (*right*)
(1729–1804)
Financier, first Treasurer of the U.S. (1777–1789)
Painting by A. Margaretta Archambault. Courtesy Independence National Historical Park

JOHN K. HILLERS (*left*)
(1843–1925)
Photographer
Courtesy U.S. Geological Survey

NEWELL DWIGHT HILLIS (*right*)
(1858–1929)
Clergyman, reformer, lecturer, writer

MORRIS HILLQUIT (*left*)
(1869–1933)
Socialist leader
Courtesy Tamiment Institute Library

HERMAN VOLRATH HILPRECHT
(*right*)
(1859–1925)
Assyriologist

FRANK A. HINKEY *(left)*
(1871–1925)
Yale University football star

EMIL GUSTAV HIRSCH *(right)*
(1851–1923)
Rabbi, biblical scholar, editor

CHARLES HENRY HITCHCOCK
(left)
(1836–1919)
Geologist, educator
Courtesy Dartmouth College

EDWARD HITCHCOCK *(right)*
(1793–1864)
Geologist, educator, president of Amherst
College; Congregational clergyman
Courtesy Amherst College

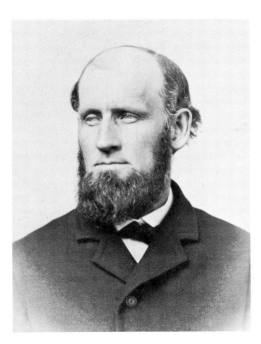

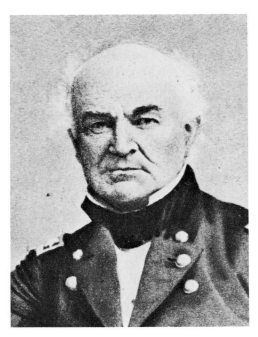

EDWARD HITCHCOCK *(left)*
(1828–1911)
Educator; at Amherst, first professor of
physical education in U.S.
Courtesy Amherst College

ETHAN ALLEN HITCHCOCK *(right)*
(1798–1870)
Union general in Civil War, writer

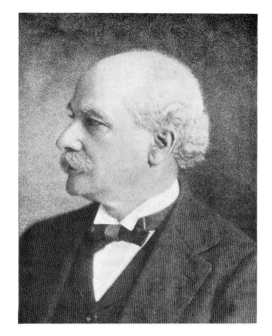

ETHAN ALLEN HITCHCOCK (*left*)
(1835–1909)
Secretary of the Interior under McKinley
and T. Roosevelt; first U.S. ambassador to
Russia

LAMBERT HITCHCOCK (*right*)
(1795–1852)
Furniture designer, manufacturer
Courtesy Hitchcock Chair Co.

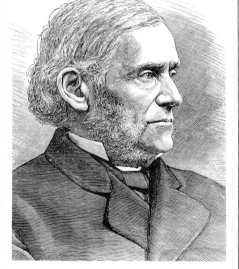

RAYMOND HITCHCOCK (*left*)
(1865–1929)
Comic actor

ROSWELL DWIGHT HITCHCOCK
(*right*)
(1817–1887)
Congregational clergyman, theologian, educator

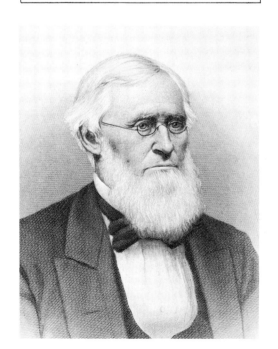

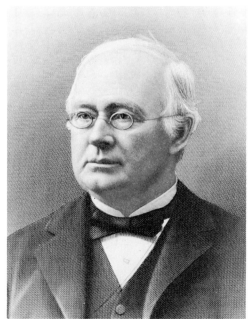

EBENEZER ROCKWOOD HOAR
(*left*)
(1816–1895)
Attorney General under Grant; Congressman, jurist
Engraving by J. A. J. Wilcox

GEORGE FRISBIE HOAR (*right*)
(1826–1904)
U.S. Senator, Congressman
Engraving by Alexander H. Ritchie

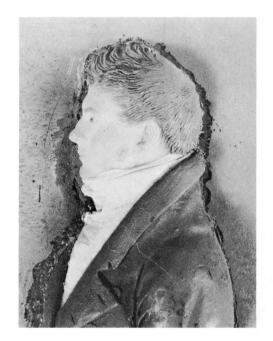

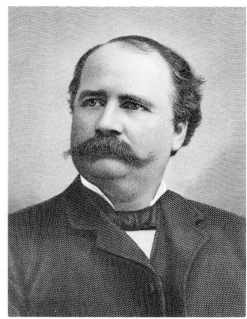

JAMES HOBAN (*left*)
(*c.* 1762–1831)
Architect, designed the White House
Courtesy Smithsonian Institution

GARRET AUGUSTUS HOBART
(*right*)
(1844–1899)
Vice-President of U.S., 1897–1899
Engraving by H. B. Hall's Sons

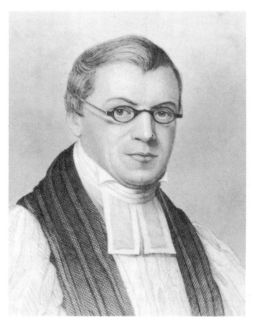

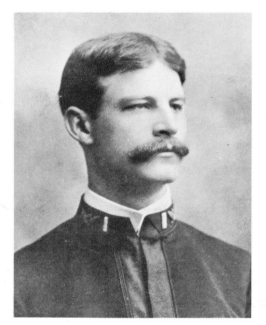

JOHN HENRY HOBART (*left*)
(1775–1830)
Protestant Episcopal bishop
Engraving by John C. Buttre

RICHMOND PEARSON HOBSON
(*right*)
(1870–1937)
Naval officer, Spanish-American War hero

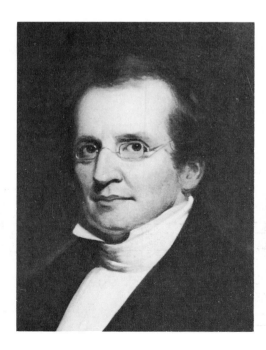

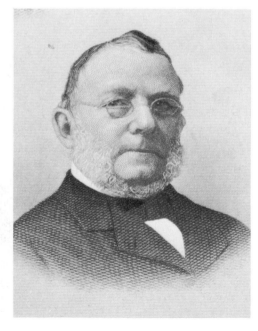

CHARLES HODGE (*left*)
(1797–1878)
Presbyterian theologian, educator
Courtesy Princeton Theological Seminary

PETER SMITH HOE (*right*)
(1821–1902)
Printer
Engraving by George E. Perine

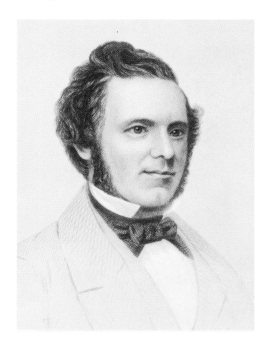

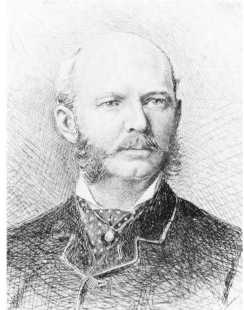

RICHARD MARCH HOE *(left)*
(1812–1886)
Printing-press designer, manufacturer; invented rotary and web presses
Courtesy Graduate School of Business, Harvard University

ROBERT HOE *(right)*
(1839–1909)
Printing-press manufacturer; developed rotary-color and newspaper presses
Courtesy Graduate School of Business, Harvard University

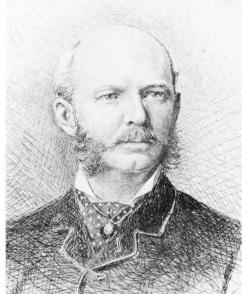

CHARLES FENNO HOFFMAN *(left)*
(1806–1884)
Journalist, editor, poet
Engraved by Alexander L. Dick from a painting by Henry Inman

JOSEF HOFMANN *(right)*
(1876–1957)
Polish pianist in U.S.; director, Curtis Institute of Music

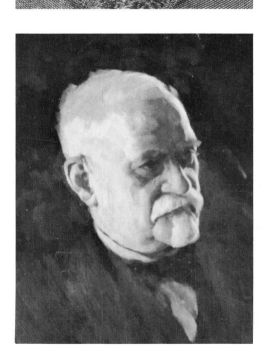

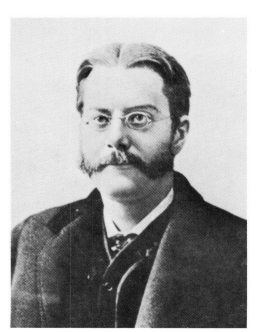

WILLIAM HOLABIRD *(left)*
(1854–1923)
Chicago architect, pioneer in use of skeleton steel construction for skyscrapers
Painting by William P. Welsh. Courtesy Chicago Historical Society

EDWARD SINGLETON HOLDEN
(right)
(1846–1914)
Astronomer, librarian, educator; first director, Lick Observatory

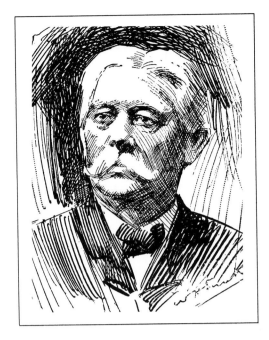

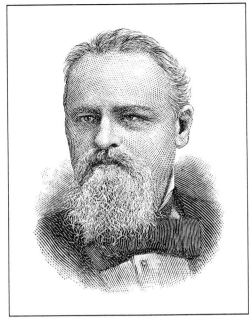

JOSEPH BASSETT HOLDER *(left)*
(1824–1888)
Naturalist, physician

BEN HOLLADAY *(right)*
(1819–1887)
Entrepreneur; organized stagecoach, steamship, and railroad lines to Western U.S.

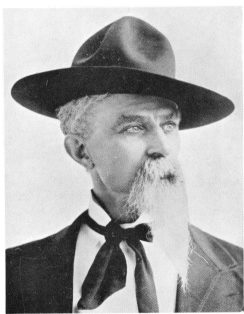

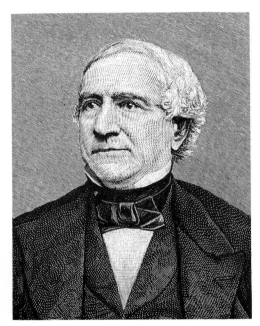

EDMUND MILTON HOLLAND
(left)
(1848–1913)
Actor

GEORGE HOLLAND *(right)*
(1791–1870)
Comic actor

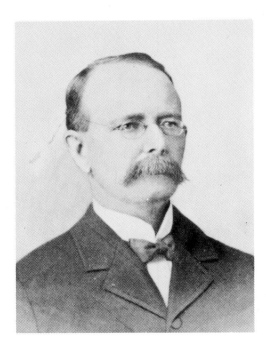

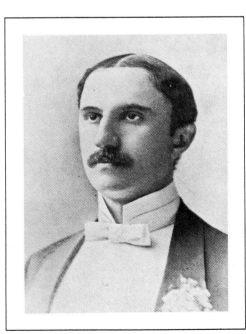

JOHN PHILIP HOLLAND *(left)*
(1840–1914)
Pioneer developer of modern submarine; founded Electric Boat Company
Courtesy Paterson Museum

JOSEPH JEFFERSON HOLLAND
(right)
(1860–1926)
Actor

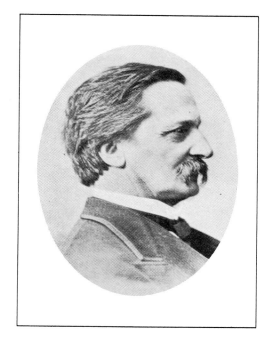

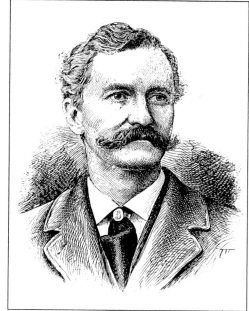

JOSIAH GILBERT HOLLAND (*left*)
[Timothy Titcomb]
(1819–1881)
Editor, writer, lecturer; a founder and editor of *Scribner's Monthly*

ALEXANDER LYMAN HOLLEY
(*right*)
(1832–1882)
Mechanical engineer, metallurgist, journalist; introduced Bessemer steel process into U.S.

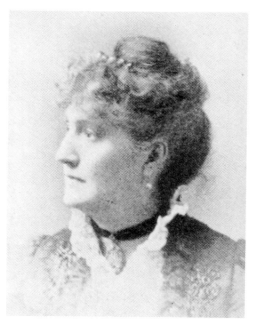

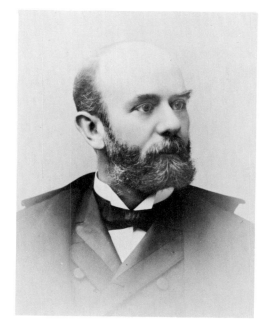

MARIETTA HOLLEY (*left*)
(1836–1926)
Novelist, humorist; wrote Samantha books under pseudonym of "Josiah Allen's Wife"

CHARLES ARTHUR HOLLICK
(*right*)
(1857–1933)
Geologist, botanist
Courtesy New York Botanical Garden

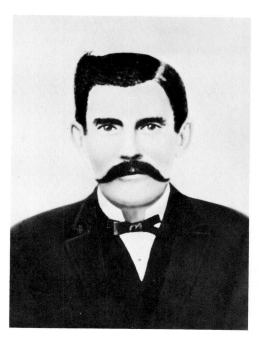

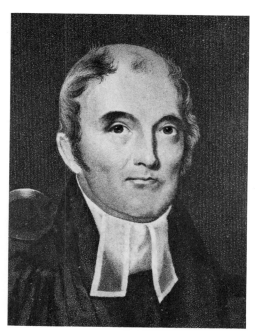

DOC HOLLIDAY (*left*)
[Dr. John H. Holliday]
(1850–1885)
Western gunman, aided Wyatt Earp in battle of O.K. Corral
Courtesy Mercaldo Archives

ABIEL HOLMES (*right*)
(1763–1837)
Congregational clergyman, historian; father of Oliver Wendell Holmes
Courtesy First Congregational Church, Cambridge, Massachusetts

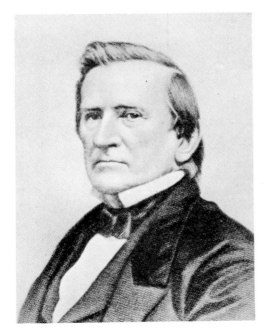
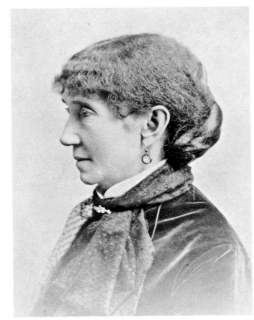

ISRAEL HOLMES (*left*)
(1800–1874)
Manufacturer of brass goods

MARY JANE HOLMES (*right*)
[nee Mary Jane Hawes]
(1825–1907)
Novelist

OLIVER WENDELL HOLMES (*left*)
(1809–1894)
Poet, essayist, novelist, physician, educator

OLIVER WENDELL HOLMES (*right*)
(1841–1935)
Associate justice, U.S. Supreme Court;
lawyer, educator, writer
Courtesy Library of Congress

WILLIAM HENRY HOLMES (*left*)
(1846–1933)
Archaeologist, anthropologist, scientific il-
lustrator; director, National Gallery of Art

HERMANN EDUARD ᴠᴏɴ **HOLST**
(*right*)
(1841–1904)
Historian

HENRY HOLT *(left)*
(1840–1926)
Book publisher; editor, writer

JOSEPH HOLT *(right)*
(1807–1894)
Jurist, prosecuted Booth conspirators; Post-master General and Secretary of War under Buchanan
Courtesy Library of Congress

LUTHER EMMETT HOLT *(left)*
(1855–1924)
Pediatrician, educator, writer

DANIEL DUNGLAS HOME *(right)*
(1833–1886)
Spiritualist, medium

LOUISE HOMER *(left)*
[nee Louise Dilworth Beatty]
(1871–1947)
Operatic contralto, wife of Sidney Homer

SIDNEY HOMER *(right)*
(1864–1953)
Composer
Courtesy Sidney Homer, Jr.

WINSLOW HOMER (*left*)
(1836–1910)
Painter
Courtesy Peter A. Juley & Son

PHILIP HONE (*right*)
(1780–1851)
Auctioneer, politician, mayor of New York;
noted for diary describing life of period
Engraving by John Rogers

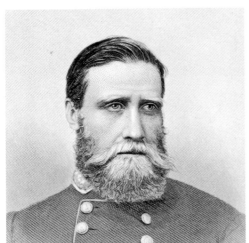

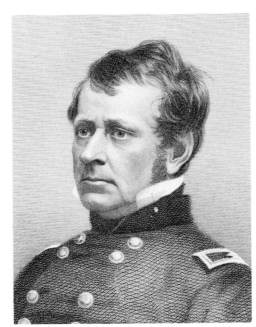

JOHN BELL HOOD (*left*)
(1831–1879)
Confederate general
Engraving by Henry B. Hall, Jr.

JOSEPH HOOKER (*right*)
(1814–1879)
Union general in Civil War
Engraving by H. W. Smith

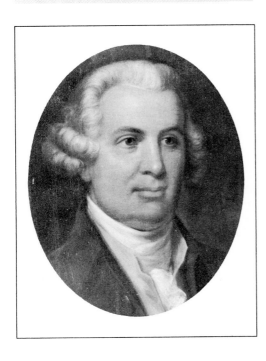

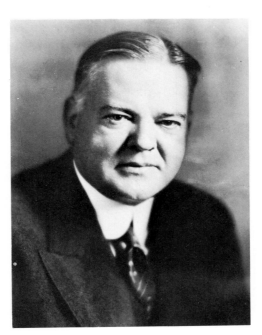

WILLIAM HOOPER (*left*)
(1742–1790)
Revolutionary leader, signer of Declaration
of Independence
*Painted by James Reid Lambdin from a painting by
John Trumbull. Courtesy Independence National
Historical Park*

HERBERT CLARK HOOVER (*right*)
(1874–1964)
President of the United States, 1929–1933
Courtesy Library of Congress

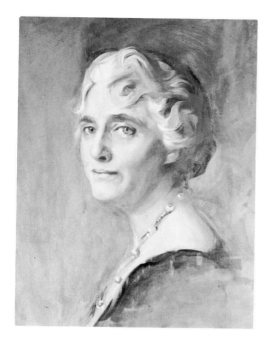
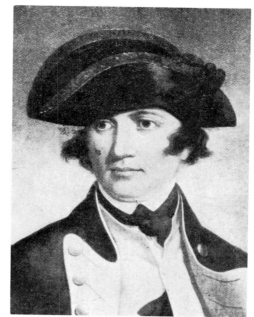

Mrs. HERBERT C. HOOVER (*left*)
[nee Lou Henry]
(1875–1944)
First lady, 1929–1933
Courtesy White House Collection

ESEK HOPKINS (*right*)
(1718–1802)
First commander-in-chief, Continental navy
Painting by Martin J. Heade

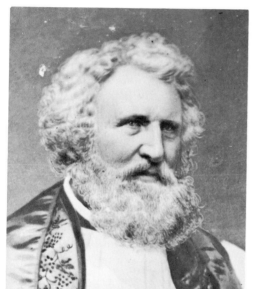
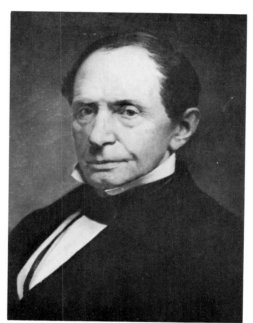

JOHN HENRY HOPKINS (*left*)
(1792–1868)
Protestant Episcopal bishop, writer
Courtesy Library of Congress, Brady-Handy Collection

JOHNS HOPKINS (*right*)
(1795–1873)
Merchant, banker, investor; founded Johns
Hopkins University, Johns Hopkins Hospital
Courtesy Johns Hopkins University

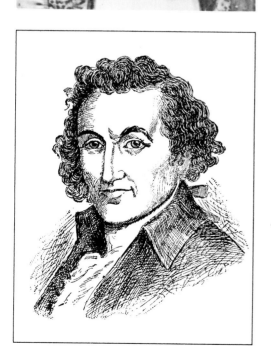
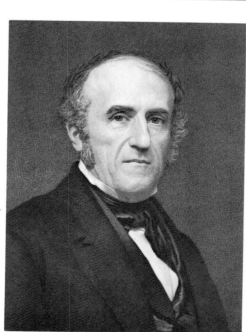

LEMUEL HOPKINS (*left*)
(1750–1801)
Physician, poet, one of "Hartford Wits"

MARK HOPKINS (*right*)
(1802–1887)
Educator, physician, Congregational theo-
logian; president of Williams College
Engraving by John Sartain

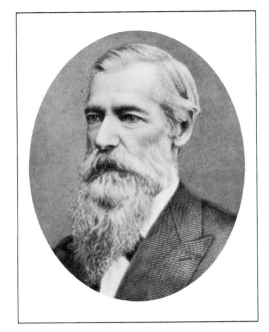

MARK HOPKINS *(left)*
(1813–1878)
Financier, promoter of Central Pacific and
Southern Pacific Railroads
Engraving by J. A. J. Wilcox

SAMUEL HOPKINS *(right)*
(1721–1803)
Congregational clergyman, theologian
Engraving by H. W. Smith

STEPHEN HOPKINS *(left)*
(1707–1785)
Governor of Colonial Rhode Island, signer
of Declaration of Independence
*Painted by James Reid Lambdin from a painting by
John Trumbull. Courtesy Independence National His-
torical Park*

FRANCIS HOPKINSON *(right)*
(1737–1791)
Revolutionary patriot, poet, pamphleteer,
composer; probable designer of American
flag in its original form
Self-portrait. Courtesy Maryland Historical Society

JOSEPH HOPKINSON *(left)*
(1770–1842)
Jurist, Congressman, lawyer; author of
"Hail, Columbia"
Painting by Gilbert Stuart

DeWOLF HOPPER *(right)*
[William D'Wolf Hopper]
(1858–1935)
Musical-comedy actor

EDNA WALLACE HOPPER (*left*)
[Mrs. Albert O. Brown, nee Edna Wallace]
(1874–1959)
Actress

WILLIAM HORLICK (*right*)
(1846–1936)
Food manufacturer, developed malted milk;
philanthropist

GEORGE HENRY HORN (*left*)
(1840–1897)
Entomologist, obstetrician
Courtesy Peabody Museum, Harvard University

WILLIAM TEMPLE HORNADAY
(*right*)
(1854–1937)
Wildlife conservationist, taxidermist; first
director of Bronx Zoo, New York
Courtesy New York Zoological Society

LOUIS J. HOROWITZ (*left*)
(1875–1956)
Construction magnate

EBEN NORTON HORSFORD (*right*)
(1818–1893)
Chemist, educator
Engraving by Alexander H. Ritchie

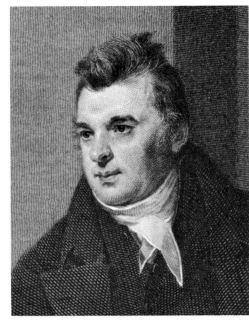

JAMES MADISON HORTON *(left)*
(1835–1914)
Ice cream manufacturer

DAVID HOSACK *(right)*
(1769–1835)
Physician, botanist, educator; a founder of
New-York Historical Society
*Engraved by Asher B. Durand from a painting by
Thomas Sully*

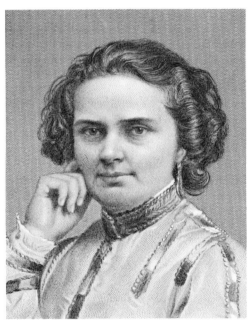

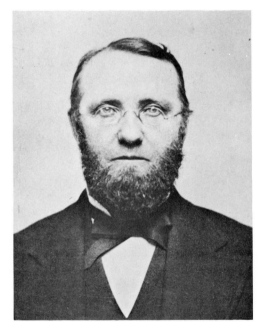

HARRIET GOODHUE HOSMER
(left)
(1830–1908)
Sculptor

JAMES KENDALL HOSMER *(right)*
(1834–1927)
Historian, biographer, educator, librarian
Courtesy Washington University

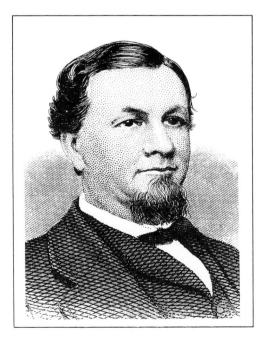

BENJAMIN BERKELEY HOTCHKISS
(left)
(1826–1885)
Ordnance developer, manufacturer; de-
signed Hotchkiss machine gun and magazine
rifle

HARRY HOUDINI *(right)*
[Ehrich Weiss]
(1874–1926)
Magician, writer

GEORGE WASHINGTON HOUGH
(left)
(1836–1909)
Astronomer, inventor
Courtesy Northwestern University

AMORY HOUGHTON *(right)*
(1837–1909)
Glass manufacturer, founded Corning Glass
Works
Courtesy Corning Glass Works

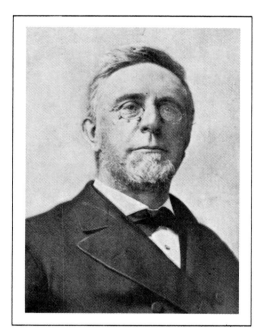

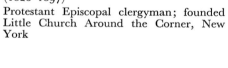

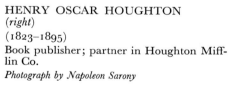

GEORGE HENDRIC HOUGHTON
(left)
(1820–1897)
Protestant Episcopal clergyman; founded
Little Church Around the Corner, New
York

HENRY OSCAR HOUGHTON
(right)
(1823–1895)
Book publisher; partner in Houghton Mifflin Co.
Photograph by Napoleon Sarony

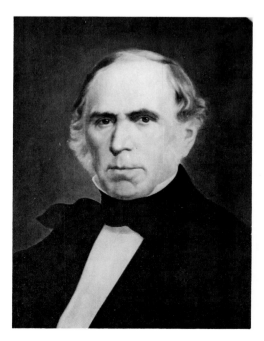

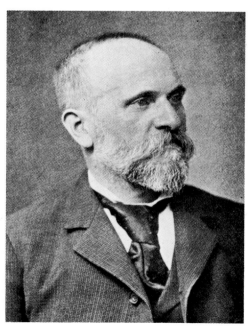

SAMUEL HOUSTON *(left)*
(1793–1863)
Leader of Texas independence; first president, Texas Republic; U.S. Senator, Governor of Texas
Painting by Edward Schnabel. Courtesy Gregory's Old Master Gallery

THOMAS HOVENDEN *(right)*
(1840–1895)
Painter

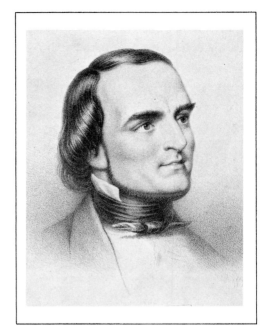

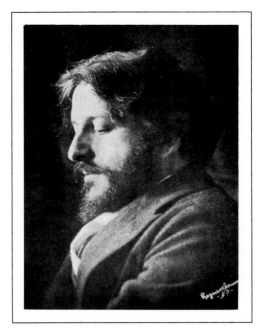

CHARLES MASON HOVEY (*left*)
(1810–1887)
Horticultural experimenter, editor

RICHARD HOVEY (*right*)
(1864–1900)
Poet

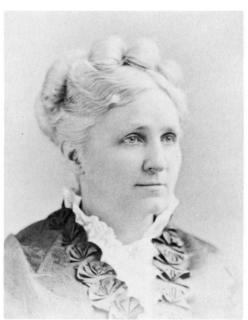

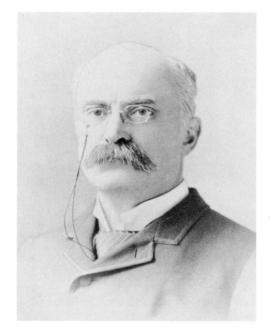

ADA LYDIA HOWARD (*left*)
(1829–1907)
Educator; first president, Wellesley College
Photograph by Pach Brothers. Courtesy Wellesley College

BRONSON CROCKER HOWARD
(*right*)
(1842–1908)
Playwright

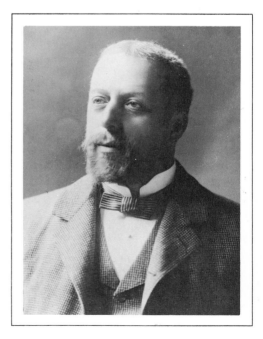

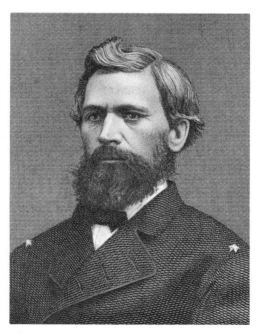

LELAND OSSIAN HOWARD (*left*)
(1857–1950)
Entomologist
Courtesy Cornell University

OLIVER OTIS HOWARD (*right*)
(1830–1909)
Union general in Civil War; a founder and
first president of Howard University
Engraving by Robert Whitechurch

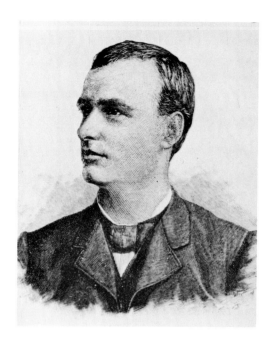

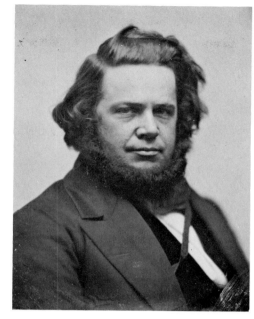

EDGAR WATSON HOWE (*left*)
(1853–1937)
Newspaper editor, writer; author of *The Story of a Country Town*

ELIAS HOWE (*right*)
(1819–1867)
Inventor of the sewing machine
Photograph by Southworth and Hawes. Courtesy Metropolitan Museum of Art, Stokes-Hawes Collection

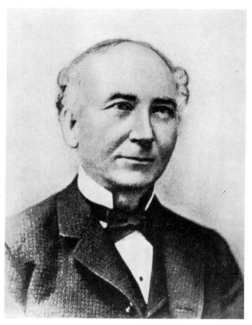

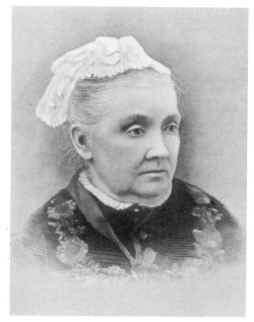

FREDERICK WEBSTER HOWE
(*left*)
(1822–1891)
Machine tool designer, manufacturer

JULIA WARD HOWE (*right*)
[nee Julia Ward]
(1819–1910)
Abolitionist, reformer, writer; author of "The Battle Hymn of the Republic"

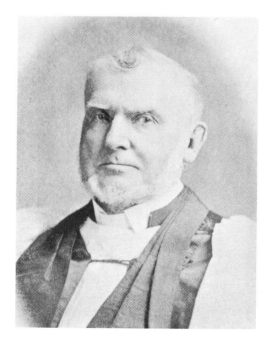

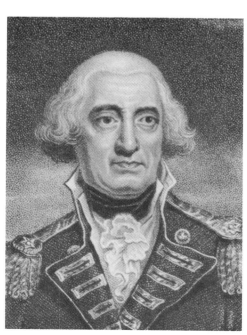

MARK ANTHONY DeWOLFE HOWE
(*left*)
(1808–1895)
Protestant Episcopal bishop

RICHARD HOWE, EARL HOWE
(*right*)
(1726–1799)
English naval officer during American Revolution

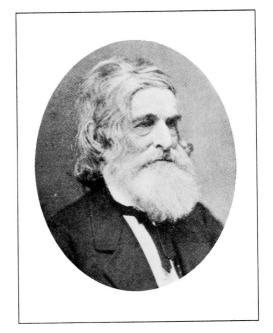
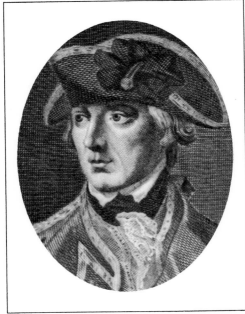

SAMUEL GRIDLEY HOWE *(left)*
(1801–1876)
Humanitarian; pioneer in educating the
blind, deaf, and retarded

Sɪʀ **WILLIAM HOWE**, 5ᴛʜ Vɪsᴄᴏᴜɴᴛ
HOWE *(right)*
(1729–1814)
British general during American Revolution

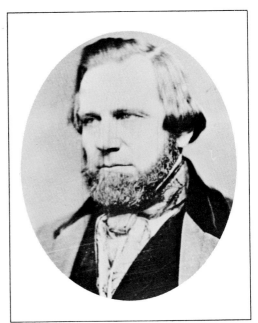
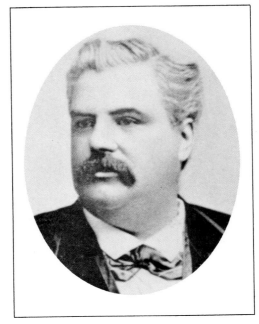

WILLIAM HOWE *(left)*
(1803–1852)
Bridge designer, builder
*Courtesy Smithsonian Institution and Worcester Poly-
technic Institute*

WILLIAM FREDERICK HOWE
(right)
(1828–1902)
Criminal lawyer

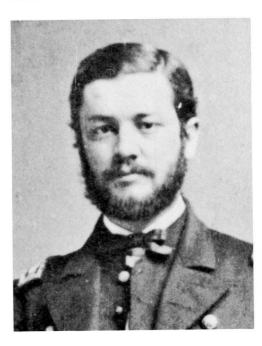
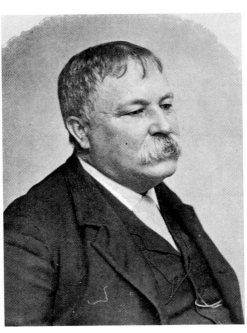

JOHN ADAMS HOWELL *(left)*
(1840–1918)
Naval officer, inventor; improved naval
ordnance
Courtesy U.S. Department of Defense

WILLIAM DEAN HOWELLS *(right)*
(1837–1920)
Novelist, critic, editor of *The Atlantic Monthly*

GEORGE HOLMES HOWISON
(*left*)
(1834–1916)
Philosopher, educator
Courtesy University of California

VINNIE REAM HOXIE (*right*)
[nee Vinnie Ream]
(1847–1914)
Portrait sculptor

CHARLES HALE HOYT (*left*)
(1860–1900)
Playwright, journalist

JOHN WESLEY HOYT (*right*)
(1831–1912)
Educator, governor of Wyoming Territory
Courtesy University of Wyoming

ELBERT GREEN HUBBARD (*left*)
(1856–1915)
Writer, publisher, lecturer; wrote *A Message to Garcia*

GARDINER GREENE HUBBARD
(*right*)
(1822–1897)
Lawyer; business manager, Bell Telephone; founded National Geographic Society

HENRY NORMAN HUDSON (*left*)
(1814–1886)
Shakespearean scholar, editor; Episcopal clergyman

JOSEPH LOWTHIAN HUDSON
(*right*)
(1846–1912)
Detroit merchant
Courtesy J. L. Hudson Co.

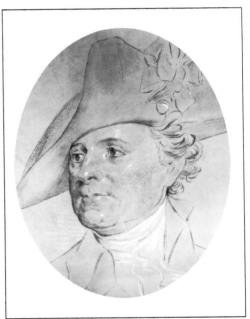

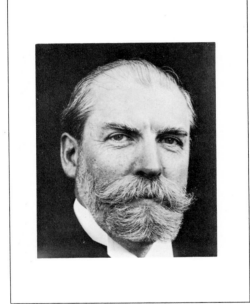

ISAAC HUGER (*left*)
(1743–1797)
Revolutionary general
Painted by Albert Rosenthal from a painting by John Trumbull. Courtesy Independence National Historical Park

CHARLES EVANS HUGHES (*right*)
(1862–1948)
Chief Justice of U.S., 1930–1941; lawyer, political leader, Governor of New York, Secretary of State under Harding and Coolidge
Courtesy Library of Congress

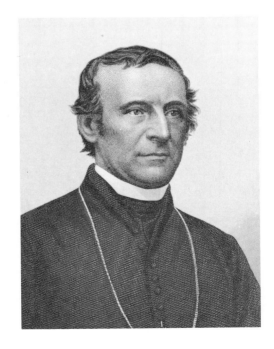

JOHN JOSEPH HUGHES (*left*)
(1797–1864)
Roman Catholic prelate, first archbishop of New York
Engraving by George E. Perine

ROBERT BALL HUGHES (*right*)
(1806–1868)
Sculptor
Courtesy Boston Athenæum

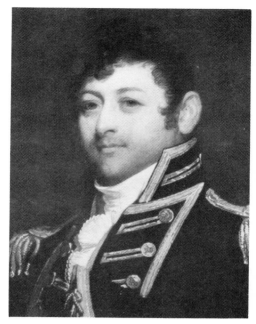

ISAAC HULL (*left*)
(1773–1843)
Naval officer; commanded the *Constitution*
in War of 1812
Painting by Gilbert Stuart

WILLIAM HULL (*right*)
(1753–1825)
Army officer; first governor of Michigan
Territory
*Engraved by F. T. Stuart from a painting by Gilbert
Stuart*

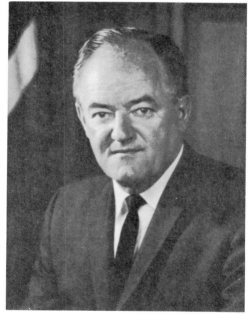

ABRAHAM HENRY HUMMEL (*left*)
(1850–1926)
Criminal lawyer

HUBERT HORATIO HUMPHREY
(*right*)
(1911–)
Vice-President of U.S., 1965–
Courtesy Kurt Jafay

ANDREW ATKINSON HUMPHREYS
(*left*)
(1810–1883)
Union general in Civil War; Chief of
Engineers, U.S. Army

DAVID HUMPHREYS (*right*)
(1752–1818)
Revolutionary officer, diplomat, poet; one of
"Hartford Wits"
Painting by Gilbert Stuart

JAMES GIBBONS HUNEKER (*left*)
(1857–1921)
Writer, music and drama critic
Courtesy Museum of the City of New York

HENRY JACKSON HUNT (*right*)
(1819–1889)
Union artillery officer in Civil War, broke
Pickett's charge at Gettysburg
Courtesy Library of Congress, Brady Collection

RICHARD MORRIS HUNT (*left*)
(1827–1895)
Architect; designed main section of Metropolitan Museum of Art, New York

THOMAS STERRY HUNT (*right*)
(1826–1892)
Chemist, mineralogist, geologist

WALTER HUNT (*left*)
(1796–1859)
Inventor; designed lock-stitch sewing machine
Courtesy Clarence P. Hornung Collection

WARD HUNT (*right*)
(1810–1886)
Associate justice, U.S. Supreme Court
Engraving by H. B. Hall & Sons

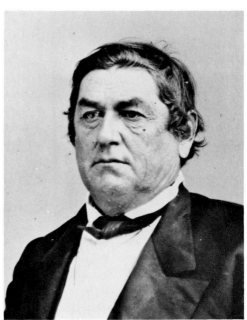

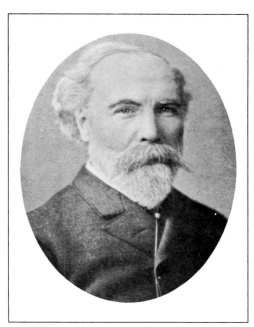

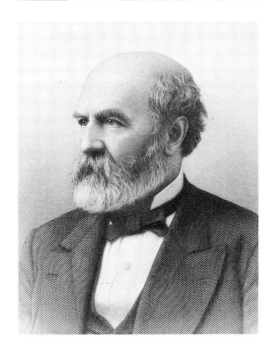

WILLIAM MORRIS HUNT *(left)*
(1824–1879)
Painter

DAVID HUNTER *(right)*
(1802–1886)
Union general in Civil War
Engraving by John C. Buttre

ROBERT MERCER TALIAFERRO
HUNTER *(left)*
(1809–1887)
Congressman, U.S. Senator; Confederate
Secretary of State
Courtesy National Archives, Brady Collection

THOMAS HUNTER *(right)*
(1831–1915)
Educator, reformer; founded Hunter College, New York

COLLIS POTTER HUNTINGTON
(left)
(1821–1900)
Railroad magnate; constructed Central
Pacific and Southern Pacific railroads
Engraving by Samuel Sartain

DANIEL HUNTINGTON *(right)*
(1816–1906)
Painter

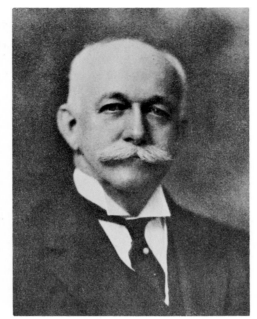

FREDERIC DAN HUNTINGTON
(*left*)
(1819–1904)
Protestant Episcopal bishop
Courtesy Andover-Harvard Theological Library

HENRY EDWARDS HUNTINGTON
(*right*)
(1850–1927)
Railroad executive; founded Huntington
Library and Art Gallery, San Marino,
California
Courtesy New-York Historical Society

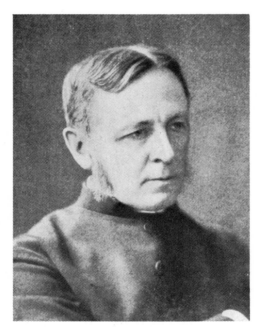

SAMUEL HUNTINGTON (*left*)
(1731–1796)
President of Continental Congress; signer
of Declaration of Independence
Engraving by John C. Buttre

WILLIAM REED HUNTINGTON
(*right*)
(1838–1909)
Protestant Episcopal clergyman

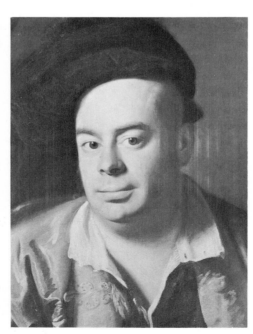

HENRY MILLS HURD (*left*)
(1843–1927)
Psychiatrist, educator
Courtesy New York Academy of Medicine

NATHANIEL HURD (*right*)
(1730–1777)
Engraver, silversmith
*Painting by John Singleton Copley. Courtesy Cleveland
Museum of Art, John Huntington Collection*

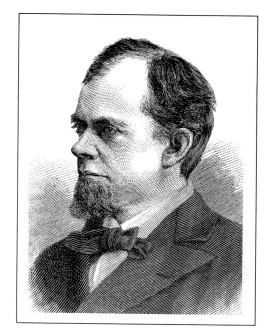

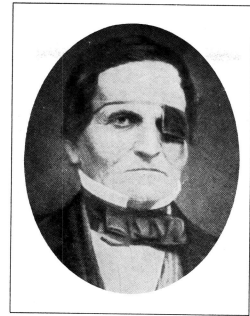

JOHN FLETCHER HURST (*left*)
(1834–1903)
Methodist bishop; president, Drew Theological Seminary

OBED HUSSEY (*right*)
(1792–1860)
Inventor of the reaper; competed with Cyrus McCormick for farm-machinery market

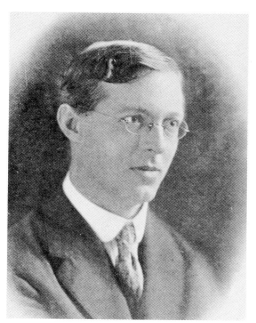

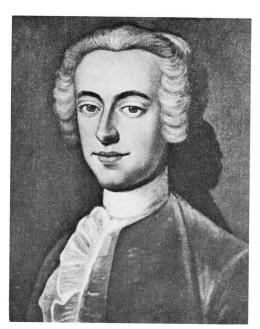

ERNEST HUTCHESON (*left*)
(1871–1951)
Australian pianist, composer; president, Juilliard School of Music

THOMAS HUTCHINSON (*right*)
(1711–1780)
Royal governor of Massachusetts, supported prerogatives of British Parliament

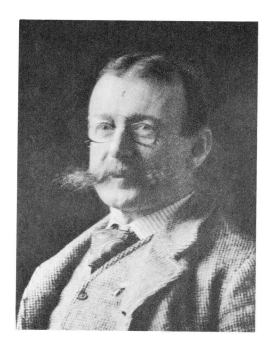

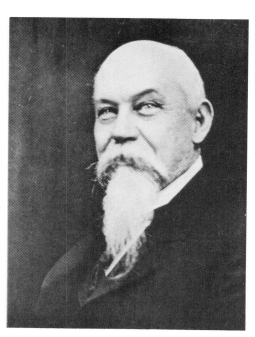

LAURENCE HUTTON (*left*)
(1843–1904)
Essayist, editor; literary editor of *Harper's Magazine*
Courtesy Walter Hampden Memorial Library at The Players, New York

ALPHEUS HYATT (*right*)
(1838–1902)
Zoologist, paleontologist

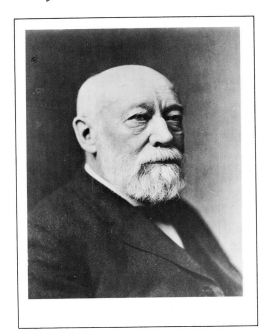

JOHN WESLEY HYATT (*left*)
(1837–1920)
Inventor, developed celluloid
Courtesy Smithsonian Institution

HENRY BALDWIN HYDE (*right*)
(1834–1899)
Insurance executive; founded Equitable Life
Assurance Society of U.S.

WILLIAM DeWITT HYDE
(1858–1917)
Congregational clergyman; president, Bow-
doin College

PIERRE LE MOYNE, Sieur D'IBERVILLE *(left)*
(1661–1706)
French-Canadian explorer, founded French colonies at Biloxi and Mobile

MARGARET ILLINGTON *(right)*
(1879–1934)
Actress

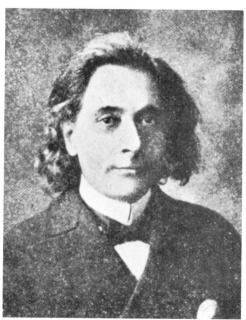

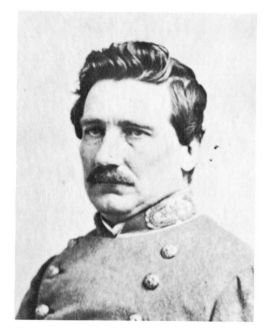

NAPHTALI HERZ IMBER *(left)*
(1856–1909)
Vagabond Hebrew poet

JOHN DANIEL IMBODEN *(right)*
(1823–1895)
Confederate army officer
Courtesy Confederate Museum

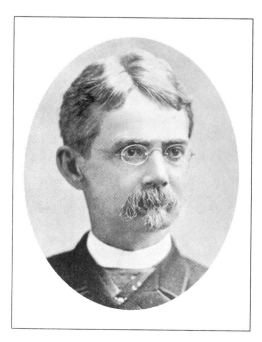

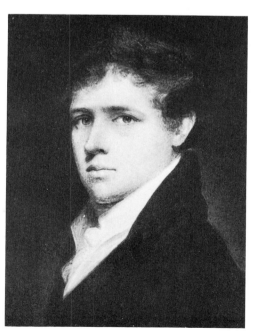

JOHN JAMES INGALLS *(left)*
(1833–1900)
U.S. Senator, lawyer

CHARLES JARED INGERSOLL *(right)*
(1782–1862)
Congressman, politician, writer

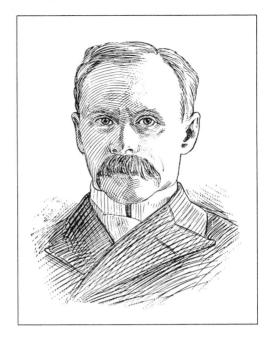

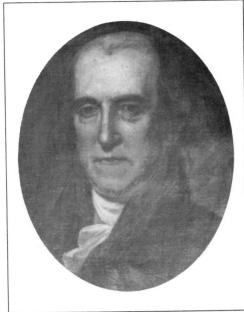

ERNEST INGERSOLL (*left*)
(1852–1946)
Naturalist, editor, journalist

JARED INGERSOLL (*right*)
(1749–1822)
Lawyer, jurist; member of Continental Congress, delegate to Constitutional Convention

Painted by George C. Lambdin from a painting by Charles Willson Peale. Courtesy Independence National Historical Park

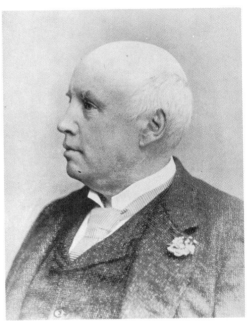

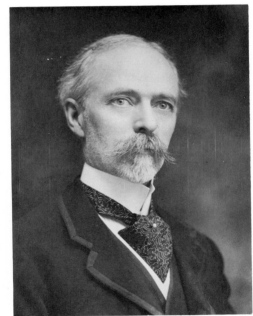

ROBERT GREEN INGERSOLL (*left*)
(1833–1899)
Agnostic lecturer; politician, lawyer

ROBERT HAWLEY INGERSOLL
(*right*)
(1859–1928)
Watch manufacturer; produced the dollar watch

Courtesy Pach Brothers

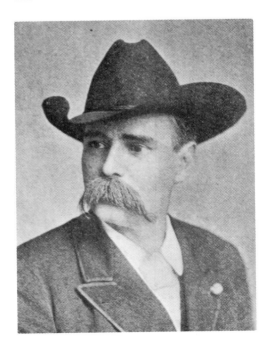

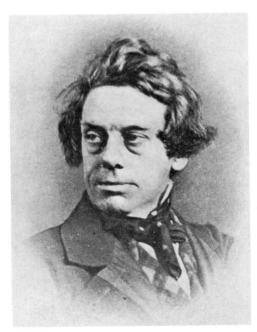

PRENTISS INGRAHAM (*left*)
(1843–1904)
Writer of dime novels; playwright, essayist

HENRY INMAN (*right*)
(1801–1846)
Portrait and genre painter

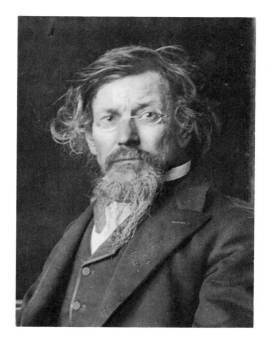

GEORGE INNESS *(left)*
(1825–1894)
Landscape painter
Courtesy Peter A. Juley & Son

SAMUEL INSULL *(right)*
(1859–1938)
Public-utilities promoter
Courtesy Chicago Historical Society

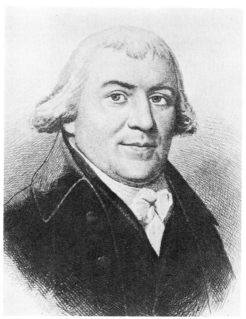

JAMES IREDELL *(left)*
(1751–1799)
Associate justice, U.S. Supreme Court; early
advocate of judicial review
*Engraving by Albert Rosenthal. Courtesy Library of
Congress*

JOHN IRELAND *(right)*
(1838–1918)
Roman Catholic archbishop; a founder of
Catholic University of America

Sɪʀ HENRY IRVING *(left)*
[John Henry Brodribb]
(1838–1905)
English actor, toured U.S. eight times

ISABEL IRVING *(right)*
(1871–1944)
Actress

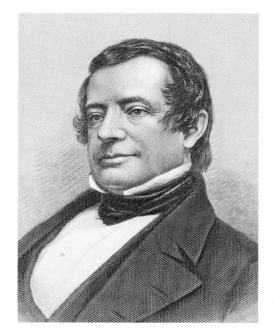

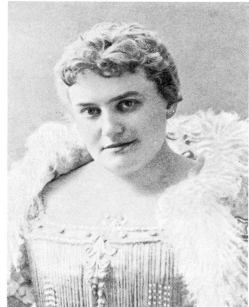

WASHINGTON IRVING (*left*)
(1783–1859)
Essayist, short-story writer, historian, humorist
Engraving by Samuel Hollyer

MAY IRWIN (*right*)
[Ada Campbell]
(1862–1938)
Comedienne, music-hall performer; among first to sing ragtime for white audiences

SAMUEL MYER ISAACS (*left*)
(1804–1878)
Rabbi, editor; a founder of Mt. Sinai Hospital, New York

ISABEL I (*right*)
[Isabella the Catholic]
(1451–1504)
Queen of Castile, supported Columbus on his explorations

BENJAMIN FRANKLIN ISHERWOOD
(*left*)
(1822–1915)
Naval engineer, pioneer in steam-engine design
Courtesy U.S. Department of Defense

CHARLES EDWARD IVES (*right*)
(1874–1954)
Composer

FREDERIC EUGENE IVES (*left*)
(1856–1937)
Inventor, developed halftone photoengraving process

JAMES MERRITT IVES (*right*)
(1824–1895)
Lithographer, partner in Currier and Ives
Courtesy Free Library of Philadelphia

RALPH IZARD
(*c.* 1742–1804)
U.S. Senator, diplomat, member of Continental Congress
From a drawing by Charles Deas. Courtesy South Caroliniana Library, University of South Carolina

CAPTAIN JACK (*left*)
[Kintpuash; Kientpoos]
(*c.* 1837–1873)
Indian leader in Modoc War
Courtesy Mercaldo Archives

ABRAHAM VALENTINE WILLIAMS
JACKSON (*right*)
(1862–1937)
Philologist, educator; specialized in Indo-
Iranian languages
Courtesy Columbiana Collection, Columbia University

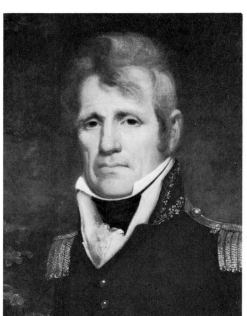

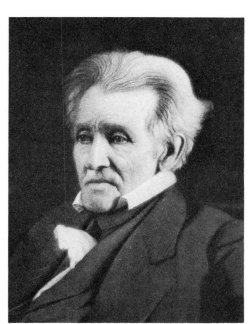

ANDREW JACKSON (*left*)
(1767–1845)
President of the United States, 1829–1837
*Painting by John Wesley Jarvis. Courtesy Metropolitan
Museum of Art, Dick Fund*

ANDREW JACKSON (*right*)
(*see above*)

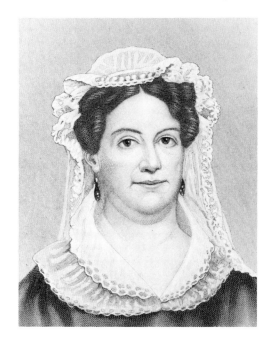

Mrs. ANDREW JACKSON (*left*)
[Mrs. Rachel Robards, nee Rachel
Donelson]
(1767–1828)
Controversial figure in campaign of 1828,
died before husband took office
Engraving by John C. Buttre

Mrs. ANDREW JACKSON, Jr. (*right*)
[Sarah Yorke Jackson]
(1805–1888)
Andrew Jackson's daughter-in-law and
White House hostess
*Painting by Ralph E. Earl. Courtesy Ladies' Hermit-
age Association*

CHARLES THOMAS JACKSON
(*left*)
(1805–1880)
Geologist; claimed invention of telegraph, discovery of guncotton and surgical anaesthesia
Courtesy Burndy Library

HELEN HUNT JACKSON (*right*)
[nee Helen Maria Fiske]
(1830–1885)
Novelist, poet, journalist, reformer

HOWELL EDMUNDS JACKSON
(*left*)
(1832–1895)
Associate justice, U.S. Supreme Court; U.S. Senator

JAMES JACKSON (*right*)
(1777–1867)
Physician, pioneer in vaccination; a founder of Massachusetts General Hospital
Courtesy Massachusetts General Hospital

PATRICK TRACY JACKSON (*left*)
(1780–1847)
Pioneer textile manufacturer
Engraved by John Cheney from a painting by G. P. A. Healy

SAMUEL MACAULEY JACKSON
(*right*)
(1851–1912)
Presbyterian clergyman, church historian, editor

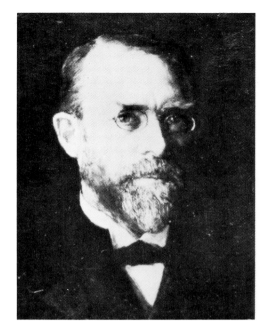

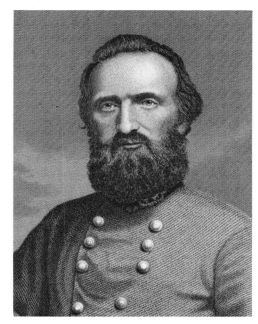

SHELDON JACKSON　(*left*)
(1834–1909)
Presbyterian missionary, introduced domesticated reindeer into Alaska
Painting by Harold T. Macdonald

STONEWALL JACKSON　(*right*)
[Thomas Jonathan Jackson]
(1824–1863)
Confederate general

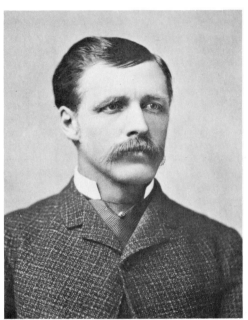

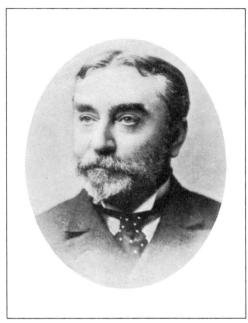

WILLIAM HENRY JACKSON　(*left*)
(1843–1942)
Photographer
Courtesy U.S. Geological Survey

ABRAHAM JACOBI　(*right*)
(1830–1919)
Physician, pioneer in study of childhood diseases

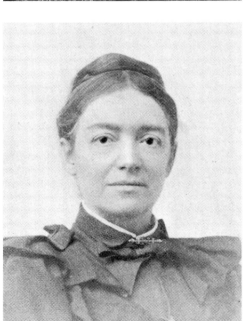

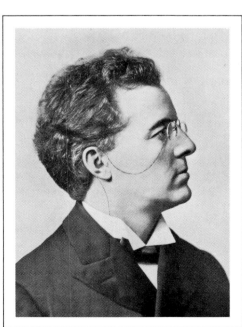

MARY JACOBI　(*left*)
[Mrs. Abraham Jacobi, nee Mary Corinna Putnam]
(1842–1906)
Physician, pioneer in women's medical education

EDMUND JANES JAMES　(*right*)
(1855–1925)
Economist, educator; founded American Academy of Political and Social Science

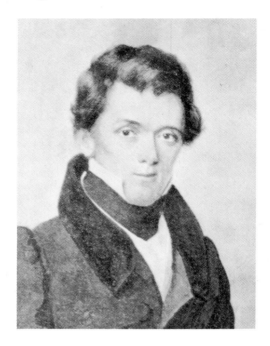

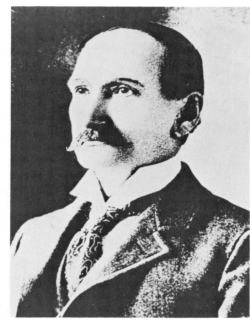

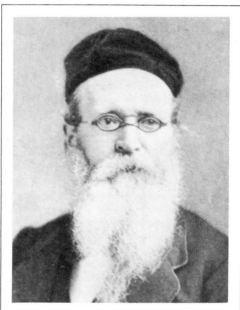

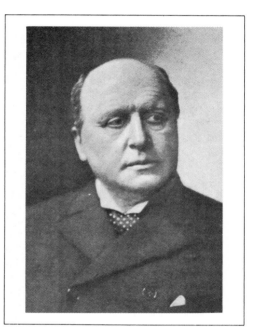

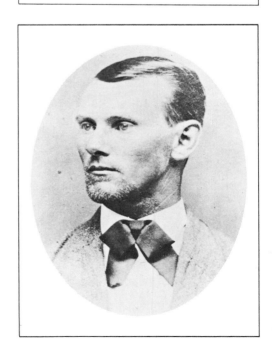

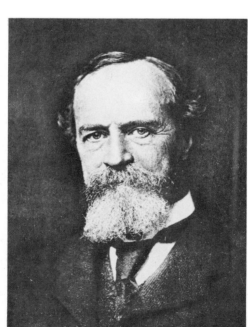

EDWIN JAMES (*left*)
(1797–1861)
Frontier surgeon, explorer, naturalist

FRANK JAMES (*right*)
[Alexander Franklin James]
(*c.* 1844–1915)
Western outlaw
Courtesy Mercaldo Archives

HENRY JAMES (*left*)
(1811–1882)
Religious and social philosopher; father of
William and Henry James

HENRY JAMES (*right*)
(1843–1916)
Novelist, short-story writer, critic

JESSE JAMES (*left*)
[Jesse Woodson James]
(1847–1882)
Western outlaw
Courtesy Mercaldo Archives

WILLIAM JAMES (*right*)
(1842–1910)
Philosopher, psychologist

JOHN FRANKLIN JAMESON (*left*)
(1859–1937)
Historian, educator, editor; leading figure in
study of American history
Courtesy American Philosophical Society

ELSIE JANIS (*right*)
[Elsie Janis Bierbower]
(1889–1956)
Actress

THOMAS ALLIBONE JANVIER
(*left*)
(1849–1913)
Journalist, writer

DEMING JARVES (*right*)
(1790–1869)
Pioneer glass manufacturer
Courtesy Sandwich Historical Society

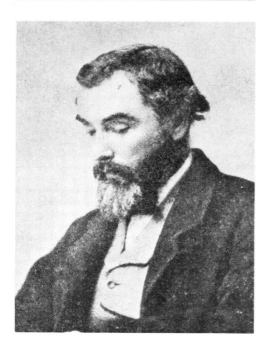

JAMES JACKSON JARVES (*left*)
(1818–1888)
Art critic and collector
*From " The Two Lives of James Jackson Jarves" by
Francis Steegmuller. Copyright 1951 by Yale Univer-
sity Press. Reprinted by permission of the author*

JOHN WESLEY JARVIS (*right*)
(1781–1839)
Portrait painter
*Painting by Bass Otis. Courtesy New-York Historical
Society*

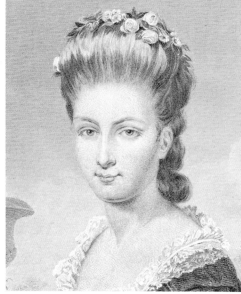

JOHN JAY (*left*)
(1745–1829)
Diplomat, statesman; co-author, *The Federalist*; first Chief Justice of U.S., 1790–1795
Painting by Gilbert Stuart

MRS. JOHN JAY (*right*)
[nee Sarah Van Brugh Livingston]
(1757–1802)
New York society leader
After a painting by Alonzo Chappel

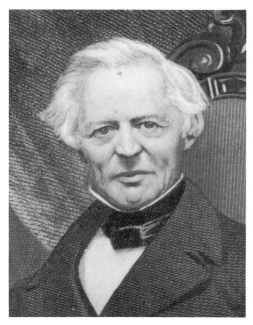

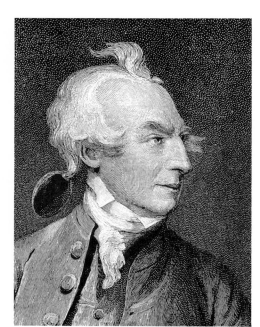

WILLIAM JAY (*left*)
(1789–1858)
Lawyer, jurist, abolitionist
Engraving by George E. Perine from a painting by H. A. Wenzler

JOSEPH JEFFERSON (*right*)
(1774–1832)
Comic actor

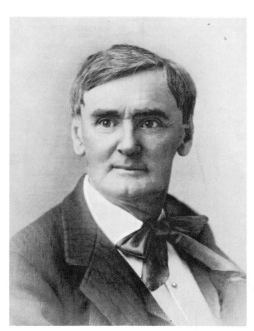

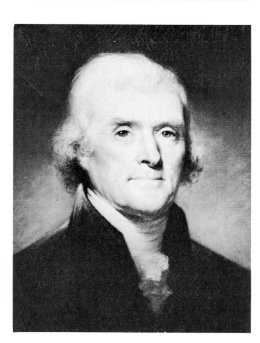

JOSEPH JEFFERSON (*left*)
(1829–1905)
Actor

THOMAS JEFFERSON (*right*)
(1743–1826)
President of the United States, 1801–1809
Painting by Rembrandt Peale. Courtesy Princeton University

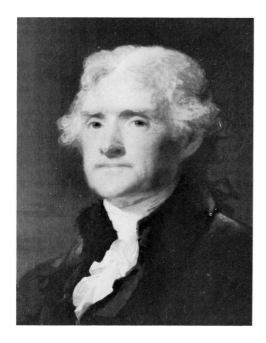

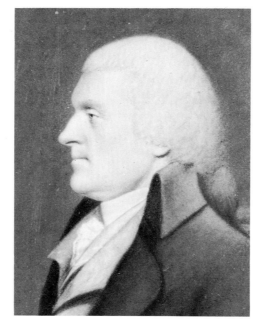

THOMAS JEFFERSON (*left*)
(*see above*)
Painting by Gilbert Stuart. Courtesy Bowdoin College Museum of Art

THOMAS JEFFERSON (*right*)
(*see above*)
Painting attributed to James Sharples, Sr. Courtesy Independence National Historical Park

JAMES J. JEFFRIES (*left*)
(1875–1953)
Heavyweight boxing champion
Courtesy Mercaldo Archives

DANIEL of St. THOMAS JENIFER
(*right*)
(1723–1790)
Maryland Revolutionary leader, signer of Constitution
Engraved by Albert Rosenthal from a painting by John Trumbull. Courtesy Enoch Pratt Free Library

WILLIAM Le BARON JENNEY
(*left*)
(1832–1907)
Chicago architect, pioneer in skeleton construction of tall buildings
Courtesy Chicago Historical Society

HUGHIE JENNINGS (*right*)
[Hugh Ambrose Jennings]
(1869–1928)
Baseball infielder, member of Baseball Hall of Fame
Courtesy National Baseball Hall of Fame

CHAUNCEY JEROME (*left*)
(1793–1868)
Clock manufacturer, inventor

JENNIE JEROME (*right*)
[Lady Randolph Spencer Churchill; Mrs. George Cornwallis-West]
(1854–1921)
New York society figure, mother of Sir Winston Churchill

LEONARD W. JEROME (*left*)
(1818–1891)
New York financier, grandfather of Sir Winston Churchill

WILLIAM TRAVERS JEROME
(*right*)
(1859–1934)
New York County District Attorney; prosecutor, Thaw-White murder case

JOHN BLOOMFIELD JERVIS (*left*)
(1795–1885)
Civil engineer, pioneer in railroad and canal design
Courtesy Jervis Library

MILO PARKER JEWETT (*right*)
(1808–1882)
Educator, first president of Vassar College
Courtesy Vassar College

SARAH ORNE JEWETT (*left*)
(1849–1909)
Short-story writer, essayist

Saint ISAAC JOGUES (*right*)
(1607–1646)
French Jesuit missionary to Indians in Canada and northern New York

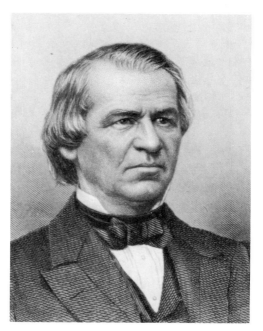

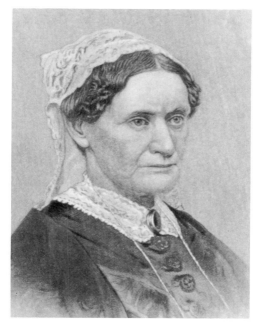

ANDREW JOHNSON (*left*)
(1808–1875)
President of the United States, 1865–1869
Engraving by Alexander H. Ritchie

Mrs. ANDREW JOHNSON (*right*)
[nee Eliza McCardle]
(1810–1876)
First lady, 1865–1869
Engraving by John C. Buttre

BAN JOHNSON (*left*)
[Byron Bancroft Johnson]
(1864–1931)
Baseball executive; founded American League, originated World Series
Courtesy National Baseball Hall of Fame

CLIFTON JOHNSON (*right*)
(1865–1940)
Writer, illustrator
Courtesy Roger Johnson

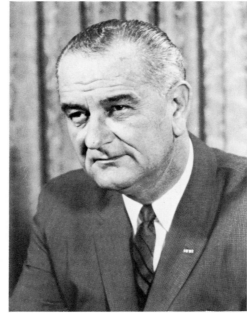

EASTMAN JOHNSON (*left*)
[Jonathan Eastman Johnson]
(1824–1906)
Portrait and genre painter

LYNDON BAINES JOHNSON (*right*)
(1908–)
President of the United States, 1963–
Courtesy Library of Congress

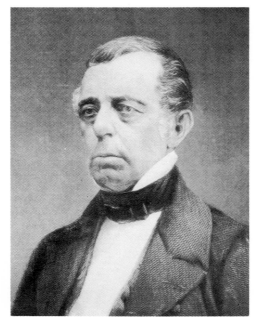

Mrs. LYNDON BAINES JOHNSON
(*left*)
[Lady Bird Johnson, nee Claudia Taylor]
(1912–)
First lady, 1963–
Courtesy S. M. Schonbrunn

REVERDY JOHNSON (*right*)
(1796–1876)
U.S. Senator, diplomat; Attorney General
under Taylor; defense counsel, *Dred Scott* v.
Sanford
Engraving by Alfred Jones

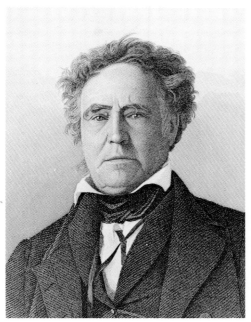

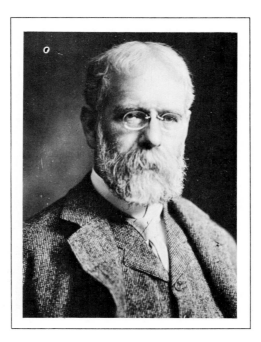

RICHARD MENTOR JOHNSON
(*left*)
(1780–1850)
U.S. Senator, Congressman; Vice-President
of U.S., 1837–1841

ROBERT UNDERWOOD JOHNSON
(*right*)
(1853–1937)
Poet, conservationist, diplomat; editor of
Century Magazine
Courtesy American Academy of Arts and Letters

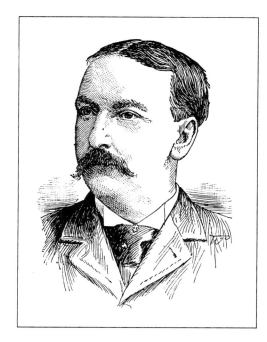

ROSSITER JOHNSON *(left)*
(1840–1931)
Editor, writer

SAMUEL JOHNSON *(right)*
(1696–1772)
Anglican clergyman, philosopher; first president of King's College, New York (later Columbia)

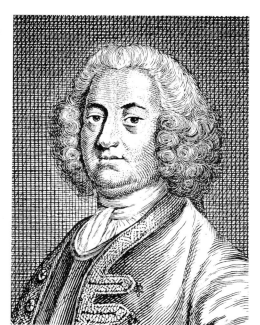

SAMUEL WILLIAM JOHNSON
(left)
(1830–1909)
Pioneer soil chemist, educator
Courtesy Connecticut Agricultural Experiment Station

Sir WILLIAM JOHNSON *(right)*
(1715–1774)
British superintendent of Indian affairs in Colonies

WILLIAM JOHNSON *(left)*
(1771–1834)
Associate justice, U.S. Supreme Court
Engraved by Albert Rosenthal from a painting by John Wesley Jarvis

WILLIAM SAMUEL JOHNSON
(right)
(1727–1819)
Signer of Constitution, U.S. Senator, jurist; first president of Columbia College
Painting by Samuel L. Waldo after Gilbert Stuart. Courtesy Columbiana Collection, Columbia University

ALBERT SIDNEY JOHNSTON (*left*)
(1803–1862)
Confederate general

ANNIE JOHNSTON (*right*)
[nee Annie Fellows]
(1863–1931)
Writer of juvenile books, author of *The Little Colonel*

JOSEPH EGGLESTON JOHNSTON
(*left*)
(1807–1891)
Confederate general, U.S. Congressman
Engraving by Alexander H. Ritchie

MARY JOHNSTON (*right*)
(1870–1936)
Novelist, author of historical romances

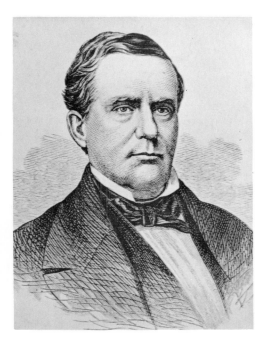

RICHARD MALCOLM JOHNSTON
(*left*)
(1822–1898)
Novelist, wrote local-color stories about the South
Engraving by R. G. Tietze

ANSON JONES (*right*)
(1798–1858)
Texas political leader, last president of Texas Republic
Courtesy Texas State Library

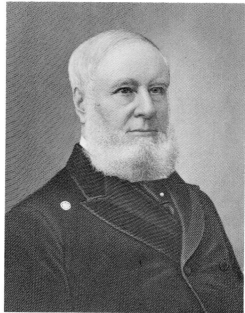

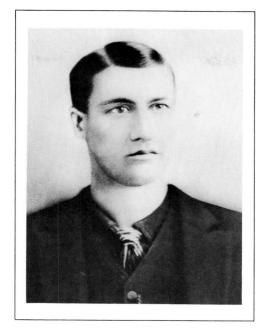

BENJAMIN FRANKLIN JONES
(*left*)
(1824–1903)
Industrialist, founded Jones & Laughlin
Steel Co.
Engraving by H. B. Hall's Sons

CASEY JONES (*right*)
[John Luther Jones]
(1864–1900)
Railroad engineer aboard the "Cannonball
Express"
Courtesy Illinois Central Railroad

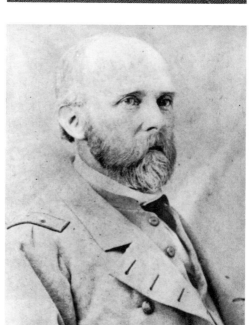

CATESBY AP ROGER JONES (*left*)
(1821–1877)
Confederate naval officer; commanded *Mer-
rimac* against *Monitor*
Courtesy U.S. Department of Defense

GEORGE JONES (*right*)
(1811–1891)
Co-founder and publisher, *The New York
Times*; fought Tweed Ring
Courtesy Earle P. Hubbard

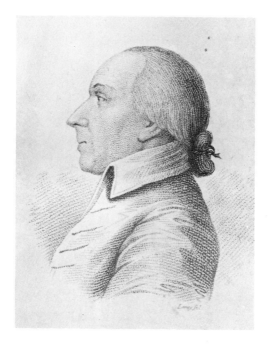

JACOB JONES (*left*)
(1768–1850)
Naval officer, War of 1812

JOHN JONES (*right*)
(1729–1791)
Surgeon, wrote first surgical textbook in
American Colonies
Courtesy College of Physicians of Philadelphia

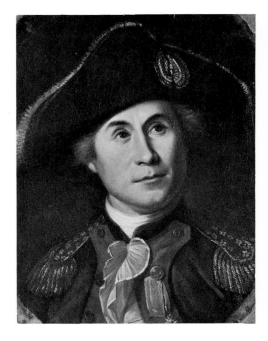

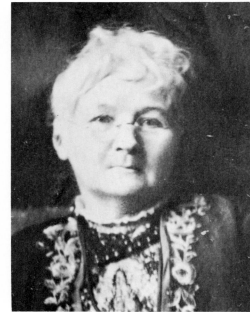

JOHN PAUL JONES *(left)*
[John Paul]
(1747–1792)
Naval officer in Revolutionary War
Painting by Charles Willson Peale. Courtesy Independence National Historical Park

MARY JONES *(right)*
["Mother Jones," nee Mary Harris]
(1830–1930)
Labor agitator and organizer
Courtesy Tamiment Institute Library

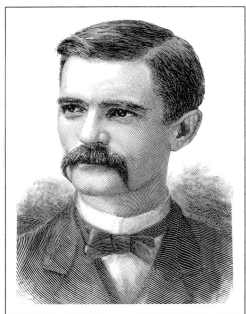

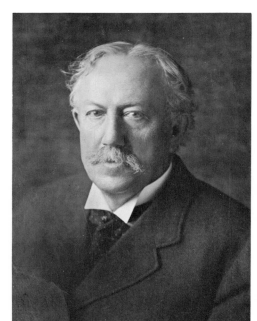

SAMUEL PORTER JONES *(left)*
(1847–1906)
Evangelist

DAVID STARR JORDAN *(right)*
(1851–1931)
Botanist, zoologist, educator; first president, Stanford University
Courtesy Stanford University Libraries

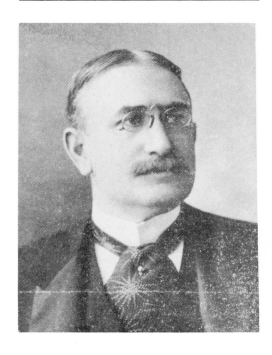

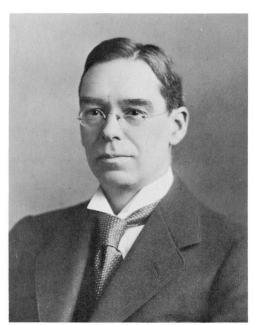

EBEN DYER JORDAN *(left)*
(1857–1916)
Boston merchant, music patron
Courtesy New England Conservatory of Music

EDWIN OAKES JORDAN *(right)*
(1866–1936)
Bacteriologist, educator, pioneer public-health investigator
Courtesy University of Chicago

RAFAEL JOSEFFY (*left*)
(1852–1915)
Pianist, educator, music editor

CHIEF JOSEPH (*right*)
[Hinmaton-Yalaktit]
(*c.* 1840–1904)
Nez Percé Indian chief

MATTHEW HARRIS JOUETT (*left*)
(1787–1827)
Portrait painter
Self-portrait

HENRY BOURNE JOY (*right*)
(1864–1936)
Automobile manufacturer, founded Packard
Motor Car Co.
Courtesy Automobile Manufacturers Association, Inc.

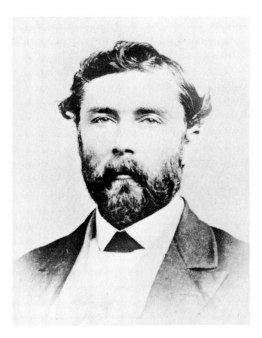

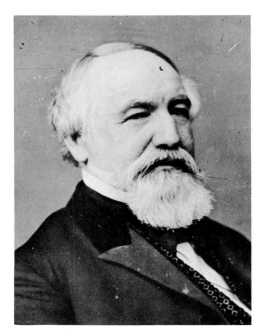

THEODORE DEHONE JUDAH
(*left*)
(1826–1863)
Railroad financier, promoted construction of
Central Pacific Railroad
Courtesy California Historical Society

NORMAN BUEL JUDD (*right*)
(1815–1878)
Congressman, lawyer, diplomat, railroad
organizer; managed Lincoln's campaign for
nomination, 1860
Courtesy National Archives, Brady Collection

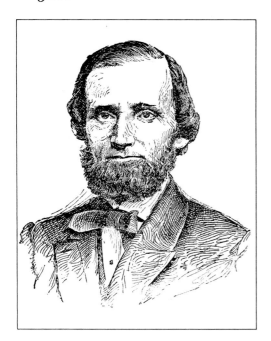

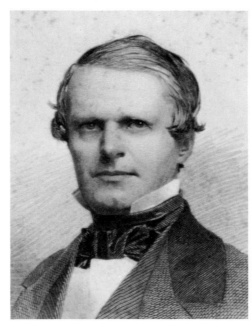

ORANGE JUDD (*left*)
(1822–1892)
Agricultural editor and publisher

SYLVESTER JUDD (*right*)
(1813–1853)
Unitarian clergyman; writer
Engraving by Frederick Halpin

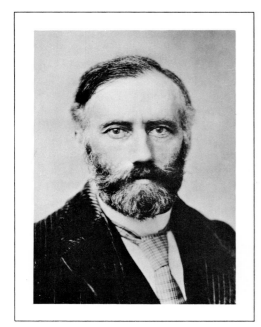

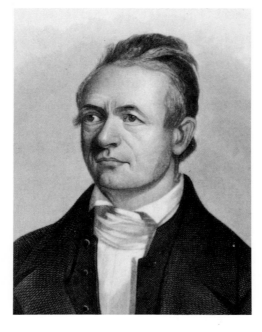

WILLIAM QUAN JUDGE (*left*)
(1851–1896)
Lawyer, theosophical leader
Courtesy United Lodge of Theosophists

ADONIRAM JUDSON (*right*)
(1788–1850)
Baptist missionary in Burma
Engraving by John C. Buttre

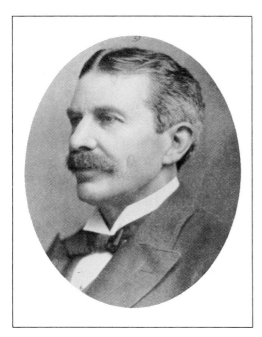

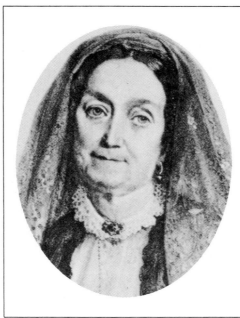

AUGUSTUS D. JUILLIARD (*left*)
(1836–1919)
Manufacturer, banker; founded Juilliard
School of Music, New York

MME STEPHEN JUMEL (*right*)
[nee Eliza Brown; Betsey Bowen]
(1769–1865)
Controversial New York society figure; later
married Aaron Burr
Courtesy Jumel Mansion

JOSEPH JUNEAU (*left*)
(1826–1899)
Alaska pioneer
Courtesy Alaska Historical Library and Museum

SOLOMON LAURENT JUNEAU
(*right*)
(1793–1856)
Fur trader; founder and first mayor of Milwaukee

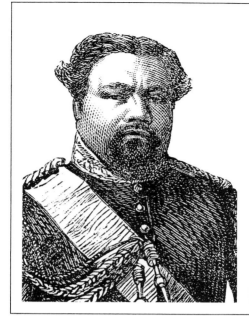

JOHANN KALB (*left*)
[Baron de Kalb]
(1721–1780)
Revolutionary general
Painting by Charles Willson Peale. Courtesy Independence National Historical Park

KAMEHAMEHA V (*right*)
[Lot Kamehameha]
(1830–1877)
King of the Hawaiian Islands

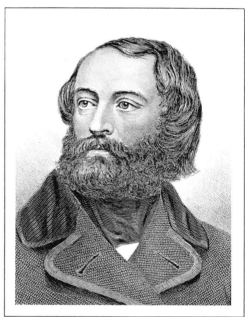

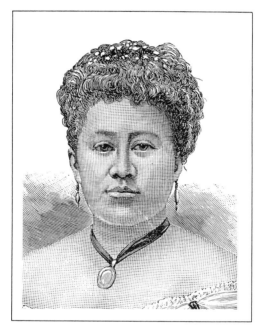

ELISHA KENT KANE (*left*)
(1820–1857)
Arctic explorer, physician
Engraved by Thomas Phillibrowne from a photograph by Mathew Brady

KAPIOLANI (*right*)
(1834–1899)
Queen of Hawaii

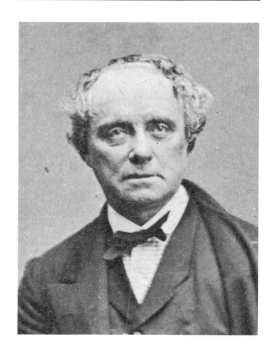

CHARLES JOHN KEAN (*left*)
(1811–1868)
English actor, toured U.S.

ELLEN TREE KEAN (*right*)
[Mrs. Charles Kean]
(1805–1880)
English actress, toured U.S.

DENIS KEARNEY (*left*)
(1847–1907)
Labor leader

PHILIP KEARNY (*right*)
(1814–1862)
Union general in Civil War
Engraving by John C. Buttre

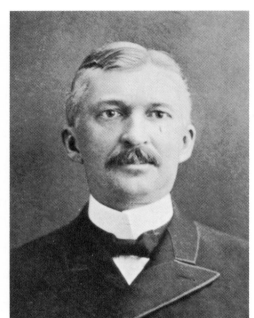

STEPHEN WATTS KEARNY (*left*)
(1794–1848)
Army officer in Mexican War
Engraving by Thomas B. Welch

JAMES EDWARD KEELER (*right*)
(1857–1900)
Astronomer, specialist in spectroscopy

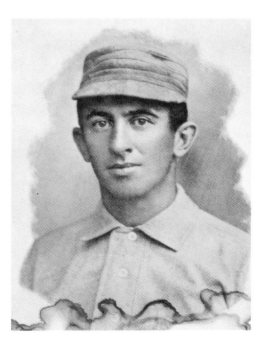

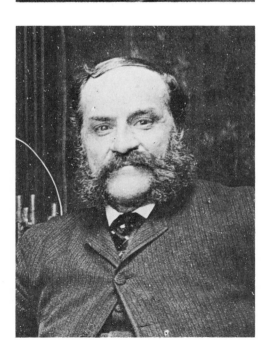

WEE WILLIE KEELER (*left*)
[William Henry Keeler]
(1872–1923)
Baseball outfielder, member of Baseball Hall of Fame
Courtesy National Baseball Hall of Fame

JOHN ERNST WORRELL KEELY
(*right*)
(1827–1898)
Fraudulent inventor
Courtesy Smithsonian Institution

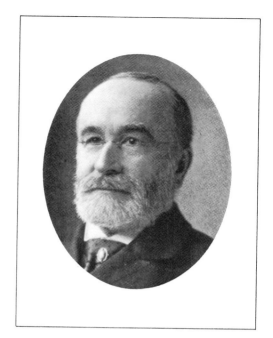

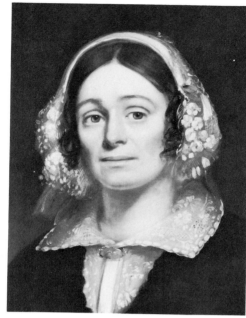

WILLIAM WILLIAMS KEEN (*left*)
(1837–1932)
Surgeon

LAURA KEENE (*right*)
(1826–1873)
English actress, popular in U.S.
Painting by William Henry Powell. Courtesy New-York Historical Society

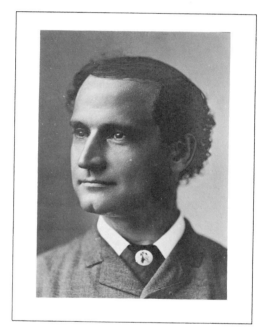

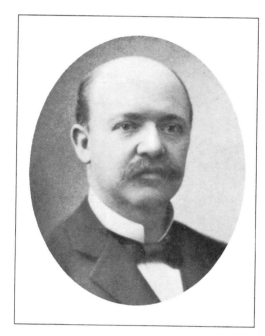

THOMAS WALLACE KEENE (*left*)
[Thomas R. Eagleson]
(1840–1898)
Actor
Photograph by Napoleon Sarony

BENJAMIN FRANKLIN KEITH
(*right*)
(1846–1914)
Theater owner, theatrical manager

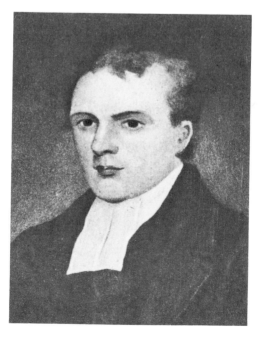

GEORGE KEITH (*left*)
(c. 1638–1716)
Anglican missionary, founded "Christian Quakers"
Courtesy Free Library of Philadelphia

WILLIAM KEITH (*right*)
(1839–1911)
Painter, engraver
Courtesy Oakland Municipal Art Museum

HARRY KELLAR (*left*)
(1849–1922)
Magician

HELEN ADAMS KELLER (*right*)
(1880–1968)
Blind and deaf writer and lecturer

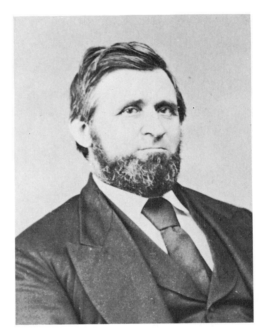

ABBY KELLEY (*left*)
[Abigail Kelley Foster]
(1810–1887)
Abolitionist, advocate of woman's rights

OLIVER HUDSON KELLEY (*right*)
(1826–1913)
Agricultural organizer, founded National Grange
Courtesy National Grange

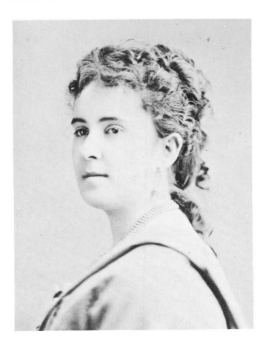

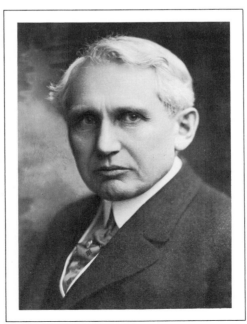

CLARA LOUISE KELLOGG (*left*)
(1842–1916)
Operatic soprano, early promoter of opera in English translation

FRANK BILLINGS KELLOGG (*right*)
(1856–1937)
U.S. Senator, diplomat, Secretary of State under Coolidge; Nobel Peace Laureate
Courtesy Library of Congress

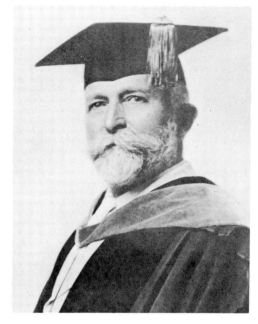

JOHN HARVEY KELLOGG (*left*)
(1852–1943)
Surgeon, nutritionist
Courtesy New York Academy of Medicine

HOWARD ATWOOD KELLY (*right*)
(1858–1943)
Surgeon, gynecologist, educator; co-founder,
National Radium Institute
Courtesy New York Academy of Medicine

JAMES EDWARD KELLY (*left*)
(1855–1933)
Sculptor, known as "the sculptor of American history"

MICHAEL JOSEPH KELLY (*right*)
["King" Kelly]
(1857–1894)
Baseball player; hero of song, "Slide, Kelly, Slide!"; member of Baseball Hall of Fame
Courtesy National Baseball Hall of Fame

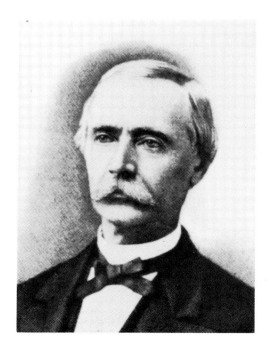

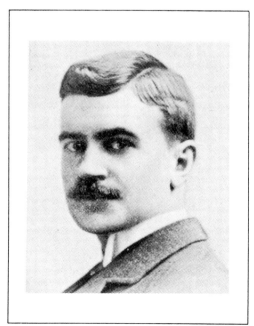

WILLIAM KELLY (*left*)
(1811–1888)
Inventor, original developer of Bessemer steelmaking process
Courtesy American Iron and Steel Institute

EDWARD WINDSOR KEMBLE
(*right*)
(1861–1933)
Illustrator, cartoonist

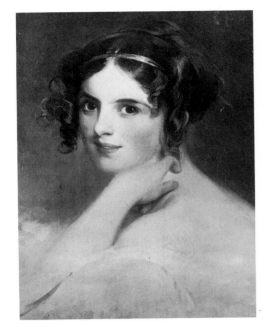

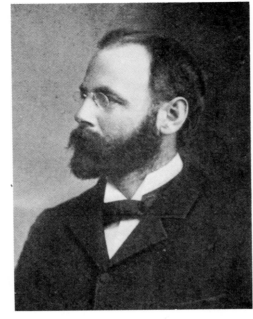

FANNY KEMBLE (*left*)
[Frances Anne Kemble]
(1809–1893)
English actress, writer; popular in U.S.
Painting by Thomas Sully. Courtesy Pennsylvania Academy of Fine Arts

JAMES FURMAN KEMP (*right*)
(1859–1926)
Geologist

JACKSON KEMPER (*left*)
(1789–1870)
First Protestant Episcopal missionary bishop, presided over western settlements from 1834

AMOS KENDALL (*right*)
(1789–1869)
Journalist, Postmaster General under Jackson; member of "Kitchen Cabinet"

GEORGE WILKINS KENDALL (*left*)
(1809–1867)
Journalist, founded *New Orleans Picayune*
Courtesy Times-Picayune Publishing Corporation

GEORGE KENNAN (*right*)
(1845–1924)
Journalist, foreign correspondent

JOHN FITZGERALD KENNEDY
(*left*)
(1917–1963)
President of the United States, 1961–1963
Courtesy The White House

MRS. JOHN FITZGERALD KENNEDY
(*right*)
[nee Jacqueline Lee Bouvier]
(1929–)
First lady, 1961–1963

JOHN PENDLETON KENNEDY (*left*)
["Mark Littleton"]
(1795–1870)
Novelist; Congressman, Secretary of the
Navy under Fillmore
Engraving by Henry B. Hall

FRANCIS PATRICK KENRICK
(*right*)
(1796–1863)
Roman Catholic prelate, archbishop of Baltimore

JOHN FREDERICK KENSETT (*left*)
(1816–1872)
Landscape painter, member of Hudson
River school

JAMES KENT (*right*)
(1763–1847)
Jurist, legal scholar
*Engraved by Asher B. Durand from a painting by
Frederick R. Spencer*

SIMON KENTON (*left*)
(1755–1836)
Frontiersman, Indian fighter
Engraved by Richard W. Dodson from a painting by L. W. Morgan

KEOKUK (*right*)
[Kiyo′ Kaga]
(c. 1780–1848)
Sauk Indian chief; eponym of Keokuk, Iowa
Courtesy Bureau of American Ethnology, Smithsonian Institution

FREDERICK KEPPEL (*left*)
(1845–1912)
Art dealer, critic

JOSEPH KEPPLER (*right*)
(1838–1894)
Cartoonist, founded and edited *Puck*

FRANCIS SCOTT KEY (*left*)
(1779–1843)
Lawyer, author of "The Star-Spangled Banner"

PHILIP BARTON KEY (*right*)
(1818–1859)
Son of Francis Scott Key, killed by Daniel Edgar Sickles

HUGH JUDSON KILPATRICK (*left*)
(1836–1881)
Union general in Civil War; commanded
Sherman's cavalry
Engraving by John C. Buttre

JAKE KILRAIN (*right*)
[John Joseph Killion]
(1859–1937)
Heavyweight boxer, lost to John L. Sullivan
in last bare-knuckle championship fight
Courtesy Woody Gelman

HEBER CHASE KIMBALL (*left*)
(1801–1868)
Mormon leader
Courtesy Church of Jesus Christ of Latter-Day Saints

CHARLES KING (*right*)
(1789–1867)
Merchant, editor; president of Columbia
College

CHARLES KING (*left*)
(1844–1933)
Army officer, novelist, military historian

CHARLES BRADY KING (*right*)
(1868–1957)
Pioneer automobile manufacturer; designed,
built, and drove first car in Detroit
Courtesy Automobile Manufacturers Association

CLARENCE KING (*left*)
(1842–1901)
Geologist, mining engineer; first director,
U.S. Geological Survey
Courtesy U.S. Geological Survey

RICHARD KING (*right*)
(1825–1885)
Cattleman, founded "King Ranch"
Courtesy Texas State Library

RUFUS KING (*left*)
(1755–1827)
Signer of Constitution, U.S. Senator, minis-
ter to Great Britain
Painting by Gilbert Stuart

RUFUS KING (*right*)
(1814–1876)
Union general in Civil War, editor, diplomat

THOMAS STARR KING (*left*)
(1824–1864)
Unitarian clergyman
Engraving by John C. Buttre

WILLIAM RUFUS DEVANE KING
(*right*)
(1786–1853)
U.S. Senator, diplomat; Vice-President of
U.S., 1853

THOMAS KINGSFORD (*left*)
(1799–1869)
Manufacturer, developed cornstarch

NORMAN WILLIAM KINGSLEY
(*right*)
(1829–1913)
Dentist, oral surgeon, educator; helped found New York College of Dentistry

EDMUND KIRBY-SMITH (*left*)
(1824–1893)
Confederate general; mathematician, educator
Engraving by John A. O'Neill

CAROLINE MATILDA KIRKLAND
(*right*)
["Mrs. Mary Clavers"; nee Caroline Matilda Stansbury]
(1801–1864)
Writer, author of frontier stories

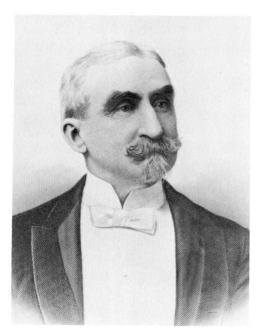

JOHN THORNTON KIRKLAND
(*left*)
(1770–1840)
Educator, liberal clergyman, president of Harvard College
Painting by Gilbert Stuart

JOSEPH KIRKLAND (*right*)
(1830–1894)
Novelist, journalist, lawyer
Courtesy Chicago Historical Society

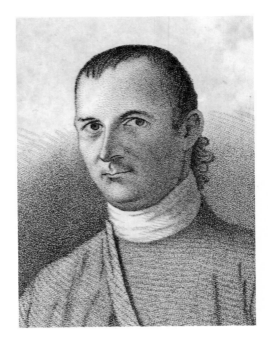

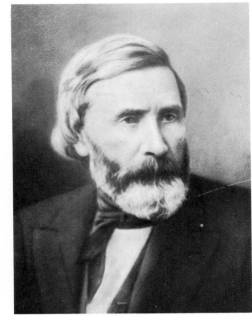

SAMUEL KIRKLAND　(*left*)
[Samuel Kirtland]
(1741–1808)
Missionary to Oneida and Seneca Indians;
founded Hamilton College
Engraving by D. C. Hinman

JAMES PUGH KIRKWOOD　(*right*)
(1807–1877)
Civil engineer
Courtesy James Kip Finch

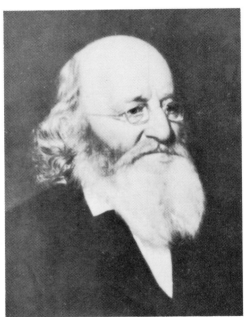

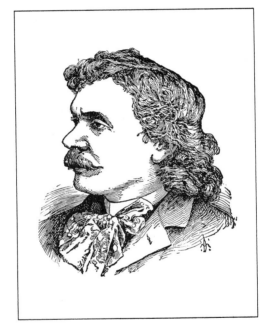

JARED POTTER KIRTLAND　(*left*)
(1793–1877)
Physician, zoologist, ornithologist
Courtesy Cleveland Natural Science Museum

HENRY HUDSON KITSON　(*right*)
(1865–1947)
Sculptor; designed Minute Man statue,
Lexington, Massachusetts

GEORGE LYMAN KITTREDGE
(*left*)
(1860–1941)
Philologist, writer; Professor of English,
Harvard University
Courtesy Harvard University Archives

MARC KLAW　(*right*)
(1858–1936)
Theatrical manager
Courtesy Museum of the City of New York

VALENTINE WILHELM LUDWIG
KNABE (*left*)
(1803–1864)
Piano manufacturer
Courtesy Aeolian Corporation

EDWARD COLLINGS KNIGHT (*right*)
(1813–1892)
Financier, sugar refiner; developed Knight
Sleeping Car, forerunner of Pullman Cars

JONATHAN KNIGHT (*left*)
(1787–1858)
Civil engineer; chief engineer, Baltimore &
Ohio Railroad
Courtesy James Kip Finch

HENRY KNOX (*right*)
(1750–1806)
Revolutionary general, Secretary of War
under Washington
Painting by Gilbert Stuart

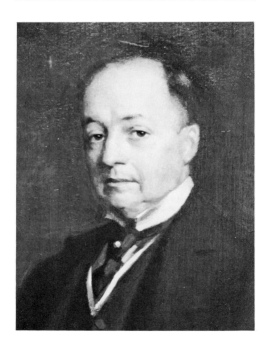

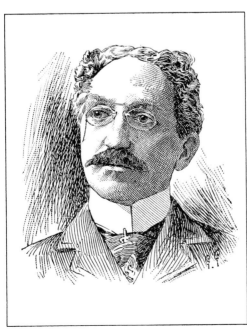

PHILANDER CHASE KNOX (*left*)
(1853–1921)
U.S. Senator, Attorney General under
McKinley and Roosevelt, Secretary of State
under Taft; initiated "dollar diplomacy"
*Painting by Alphonse Jongers. Courtesy U.S. Depart-
ment of State*

GUSTAV KOBBÉ (*right*)
(1857–1918)
Music critic, writer; authority on Wagner

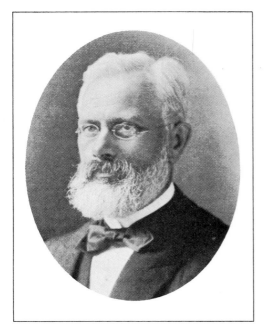

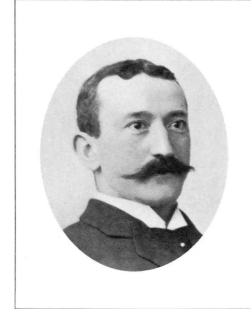

KAUFMANN KOHLER (*left*)
(1843–1926)
Rabbi, educator; leader of reform Judaism

CARL KOLLER (*right*)
(1857–1944)
Ophthalmologist, introduced cocaine as local anesthetic in eye surgery

THADDEUS KOSCIUSKO (*left*)
[Tadeusz Andrzej Bonawentura Kościuszko]
(1746–1817)
Polish patriot, general in Continental Army

LOUIS KOSSUTH (*right*)
[Lajos Kossuth]
(1802–1894)
Hungarian patriot, toured U.S. during exile

JOSEPH KRAUSKOPF (*left*)
(1858–1923)
Rabbi, leader of reform Judaism

CHARLES PORTERFIELD KRAUTH
(*right*)
(1823–1883)
Lutheran clergyman, leader of conservative Lutheranism
Painting by L. L. Williams. Courtesy University of Pennsylvania

HENRY EDWARD KREHBIEL (*left*)
(1854–1923)
Music critic, editor, writer

BERNARD HENRY KROGER (*right*)
(1860–1938)
Merchant, founded grocery chain
Courtesy Kroger Co.

ABRAHAM KUHN (*left*)
(1819–1892)
Investment banker, partner in Kuhn, Loeb
& Co.

GEORGE FREDERICK KUNZ (*right*)
(1856–1932)
Mineralogist, gem expert

GEORGE TRUMBULL LADD *(left)*
(1842–1921)
Psychologist, philosopher, theologian
Courtesy Yale University

CHRISTINE LADD-FRANKLIN *(right)*
(1847–1930)
Psychologist, logician; developed important
theory of color vision
Courtesy Columbiana Collection, Columbia University

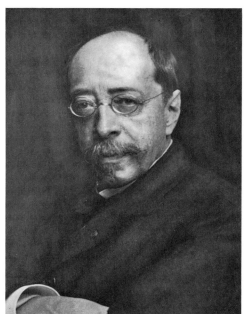

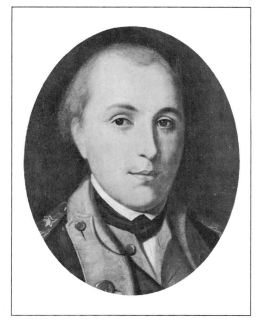

JOHN LA FARGE *(left)*
(1835–1910)
Painter, muralist, designed stained-glass
windows
Courtesy Peter A. Juley & Son

MARQUIS DE LAFAYETTE *(right)*
[Marie Joseph Paul Yves Roch Gilbert du
Motier]
(1757–1834)
French patriot, general in Continental Army
*Painting by Charles Willson Peale. Courtesy Inde-
pendence National Historical Park*

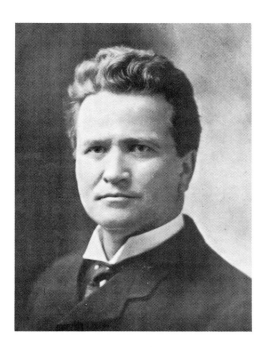

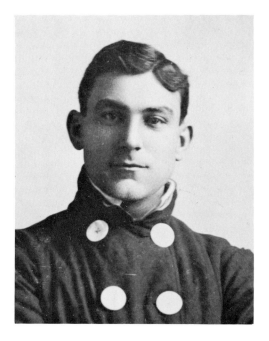

ROBERT MARION LA FOLLETTE
(left)
(1855–1925)
Governor of Wisconsin, U.S. Senator; leader
of Progressive party

NAPOLEON LAJOIE *(right)*
[Larry Lajoie]
(1875–1959)
Baseball infielder, member of Baseball Hall
of Fame
Courtesy National Baseball Hall of Fame

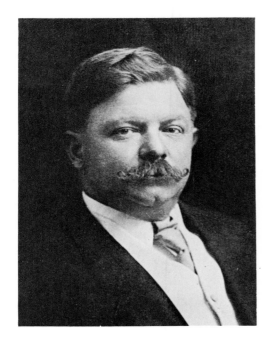

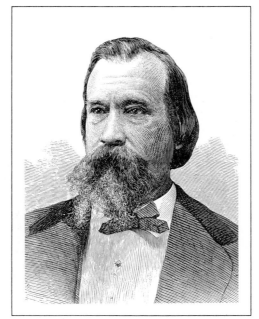

SIMON LAKE (*left*)
(1866–1945)
Marine inventor, built first submarine to
operate successfully in open sea
Courtesy Free Library of Philadelphia

**LUCIUS QUINTUS CINCINNATUS
LAMAR** (*right*)
(1825–1893)
U.S. Senator, Secretary of the Interior
under Cleveland; associate justice, U.S.
Supreme Court

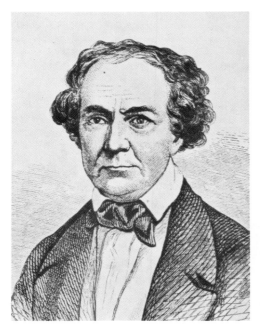

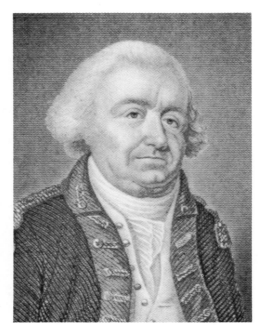

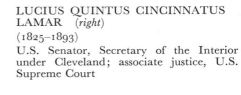

MIRABEAU BUONAPARTE LAMAR
(*left*)
(1798–1859)
Texas pioneer; second president, Republic
of Texas
Courtesy Texas State Library

JOHN LAMB (*right*)
(1735–1800)
Revolutionary patriot
Engraving by Joseph N. Gimbrede

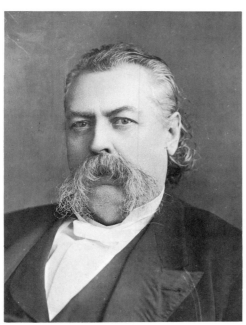

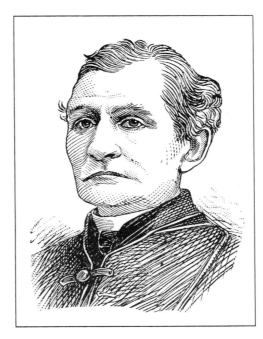

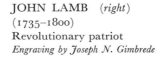

WARD HILL LAMON (*left*)
(1828–1893)
Law partner and bodyguard of Abraham
Lincoln
Courtesy Library of Congress, Brady-Handy Collection

JOHN BAPTIST LAMY (*right*)
[Jean Baptiste l'Amy]
(1814–1888)
Roman Catholic prelate, model for Willa
Cather's *Death Comes for the Archbishop*

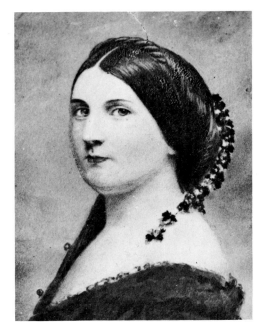

HARRIET REBECCA LANE (*left*)
[Mrs. Henry Elliott Johnston]
(1833–1903)
Niece of James Buchanan; White House hostess, 1857–1861
Courtesy Library of Congress, Brady-Handy Collection

JAMES HENRY LANE (*right*)
(1814–1866)
Kansas politician, leader of Free-State party
Courtesy National Archives, Brady Collection

JOSEPH LANE (*left*)
(1801–1881)
Governor of Oregon Territory, Congressman, U.S. Senator
Engraving by John C. Buttre

BENJAMIN JOHNSON LANG (*right*)
(1837–1909)
Pianist, composer, conductor

HENRY ROSEMAN LANG (*left*)
(1853–1934)
Philologist, educator
Photograph by Pach Brothers

CHRISTOPHER COLUMBUS LANGDELL (*right*)
(1826–1906)
Jurist, educator; developed "case system" of teaching law

JOHN LANGDON *(left)*
(1741–1819)
Member of Continental Congress, signer of the Constitution, Governor of New Hampshire; first president pro tempore, U.S. Senate
Engraving by Samuel Sartain

SAMUEL PIERPONT LANGLEY
(right)
(1834–1906)
Astronomer, pioneer in solar-radiation research and aircraft construction

JOHN MERCER LANGSTON *(left)*
(1829–1897)
Lawyer, educator, diplomat; dean of Howard University
Courtesy Library of Congress, Brady-Handy Collection

LILY LANGTRY *(right)*
[nee Emily Charlotte Le Breton]
(1852–1929)
English actress, known as "The Jersey Lily"; toured U.S.

SIDNEY LANIER *(left)*
(1842–1881)
Poet, musician, critic
Engraving by H. B. Hall's Sons

CHARLES LANMAN *(right)*
(1819–1895)
Writer, painter, traveler

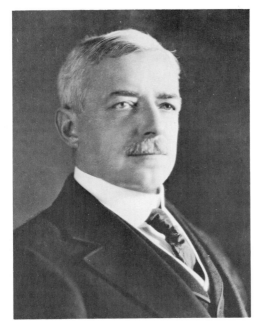

CHARLES ROCKWELL LANMAN
(*left*)
(1850–1941)
Orientalist, educator

ROBERT LANSING (*right*)
(1864–1928)
Lawyer, Secretary of State under Wilson
Courtesy Library of Congress

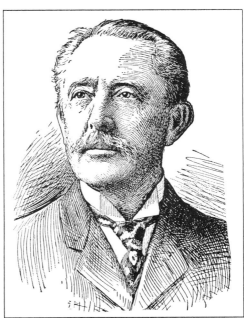

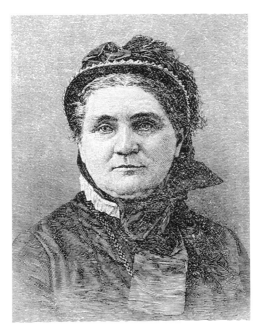

TOLBERT LANSTON (*left*)
(1844–1913)
Inventor, perfected and manufactured mono-
type

LUCY LARCOM (*right*)
(1824–1893)
Writer, editor, teacher

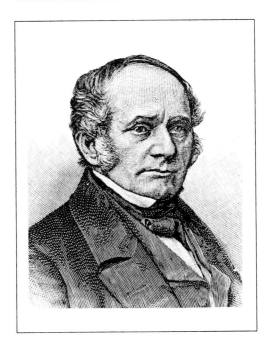

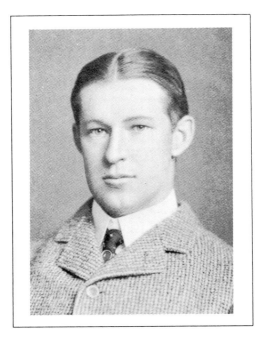

THOMAS OLIVER LARKIN (*left*)
(1802–1858)
Merchant; diplomatic agent in California,
aided acquisition by U.S.

WILLIAM AUGUSTUS LARNED
(*right*)
(1872–1926)
Lawn tennis champion

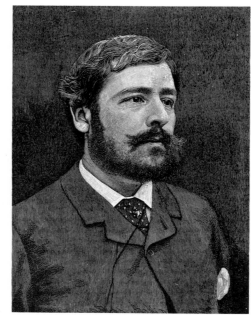

ROBERT CAVELIER, Sieur de La SALLE (*left*)
(1643–1687)
French explorer in North America, descended the Mississippi

GEORGE PARSONS LATHROP (*right*)
(1851–1898)
Journalist, writer

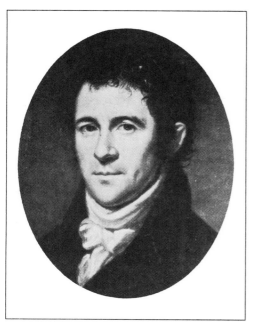

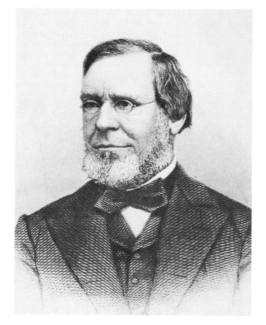

BENJAMIN HENRY LATROBE (*left*)
(1764–1820)
Architect, engineer; supervised reconstruction of U.S. Capitol following War of 1812
Painting by Charles Willson Peale

BENJAMIN HENRY LATROBE (*right*)
(1806–1878)
Railroad engineer
Engraving by Henry B. Hall. Courtesy Smithsonian Institution

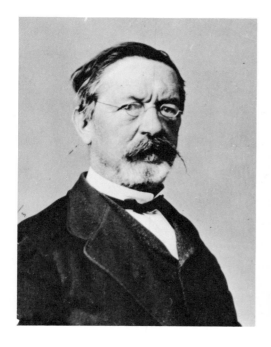

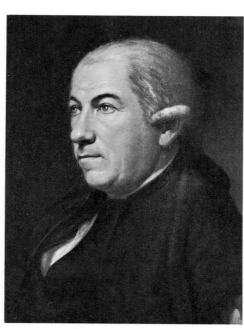

JOHN HAZLEHURST BONEVAL LATROBE (*left*)
(1803–1891)
Lawyer, inventor, art patron
Courtesy National Archives, Brady Collection

HENRY LAURENS (*right*)
(1724–1792)
Revolutionary patriot, merchant; president of Continental Congress
Painting by Charles Willson Peale. Courtesy Independence National Historical Park

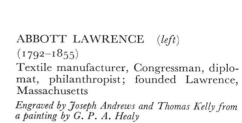

ABBOTT LAWRENCE (*left*)
(1792–1855)
Textile manufacturer, Congressman, diplomat, philanthropist; founded Lawrence, Massachusetts

Engraved by Joseph Andrews and Thomas Kelly from a painting by G. P. A. Healy

AMOS LAWRENCE (*right*)
(1786–1852)
Textile merchant and manufacturer; philanthropist

Engraved by Joseph Andrews from a painting by Chester Harding

JAMES LAWRENCE (*left*)
(1781–1813)
Naval officer, War of 1812; said, "Don't give up the ship"
Painting by Gilbert Stuart

RICHARD SMITH LAWRENCE
(*right*)
(1817–1892)
Toolmaker, inventor, gunsmith

WILLIAM LAWRENCE (*left*)
(1783–1848)
Textile merchant and manufacturer, philanthropist
Engraving by H. W. Smith

WILLIAM LAWRENCE (*right*)
(1850–1941)
Protestant Episcopal bishop, writer

SAMUEL SPAHR LAWS (*left*)
(1824–1921)
Presbyterian clergyman, lawyer; president,
University of Missouri; invented stock-
market ticker
Engraving by H. B. Hall & Sons

VICTOR FREEMONT LAWSON
(*right*)
(1850–1925)
Journalist, published *Chicago Daily News*

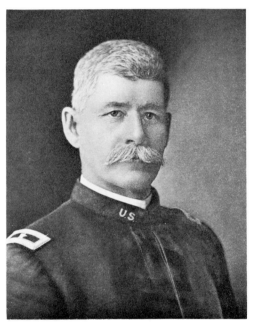
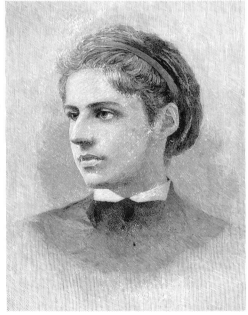

HENRY WARE LAWTON (*left*)
(1843–1899)
Army officer, pursued and captured Geron-
imo

EMMA LAZARUS (*right*)
(1849–1887)
Poet, essayist, author of Statue of Liberty
sonnet

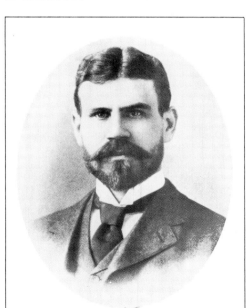
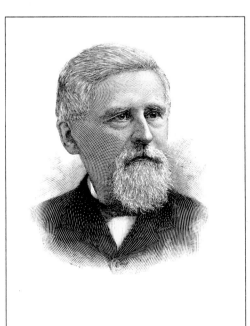

JESSE WILLIAM LAZEAR (*left*)
(1866–1900)
Physician, member of Reed Yellow Fever
Commission
Courtesy New York Academy of Medicine

HENRY CHARLES LEA (*right*)
(1825–1909)
Historian, book publisher

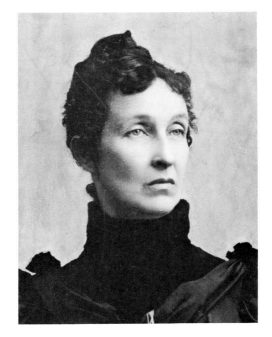

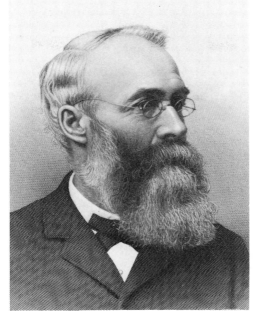

MARY ELIZABETH LEASE (*left*)
[Mrs. Charles L. Lease, nee Mary Elizabeth
Clyens]
(1853–1933)
Social reformer, lecturer, writer

ERASMUS DARWIN LEAVITT (*right*)
(1836–1916)
Mechanical engineer
Engraving by Alexander H. Ritchie

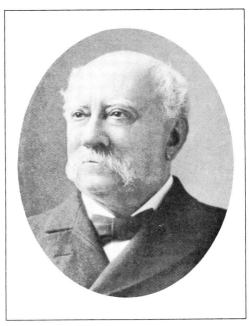

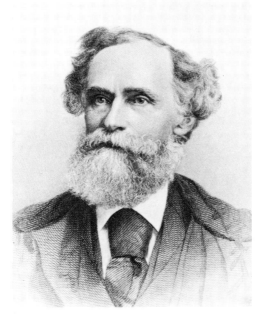

NAPOLÉON EUGÈNE HENRY
CHARLES Le BRUN (*left*)
(1821–1901)
Architect; designed Metropolitan Life tower,
New York

JOHN Le CONTE (*right*)
(1818–1891)
Physicist; president, University of California
Engraving by J.A.J. Wilcox

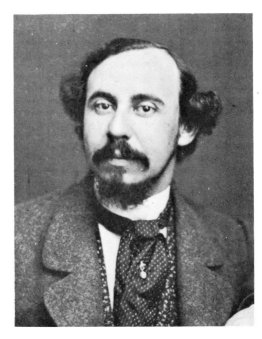

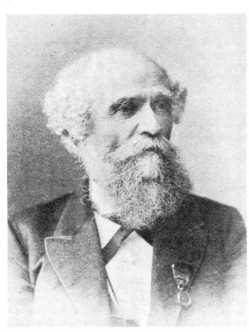

JOHN LAWRENCE Le CONTE
(*left*)
(1825–1883)
Entomologist, physician
Courtesy Smithsonian Institution

JOSEPH Le CONTE (*right*)
(1823–1901)
Geologist, educator

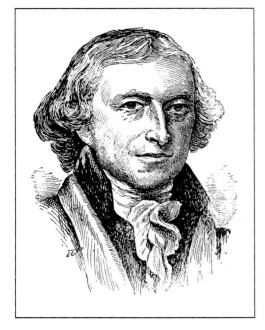

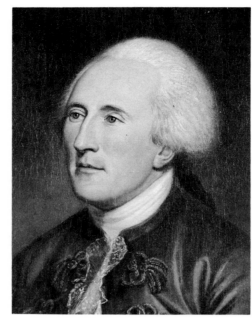

JOHN LEDYARD (*left*)
(1751–1789)
Explorer, writer

ARTHUR LEE (*right*)
(1740–1792)
Diplomat, member of Continental Congress; opposed adoption of Constitution
Painting by Charles Willson Peale. Courtesy Independence National Historical Park

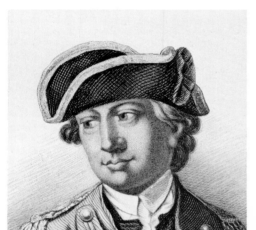

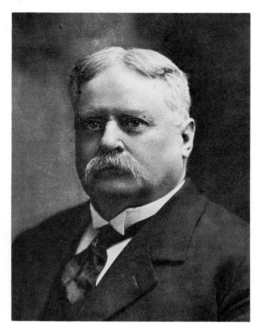

CHARLES LEE (*left*)
(1731–1782)
Revolutionary general; court-martialed, dismissed from service
Engraving by George R. Hall

FITZHUGH LEE (*right*)
(1835–1905)
Confederate cavalry commander; major general, Spanish-American War

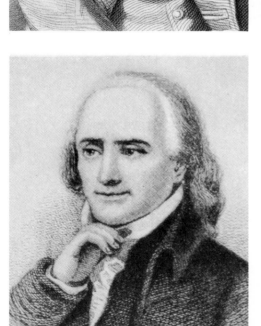

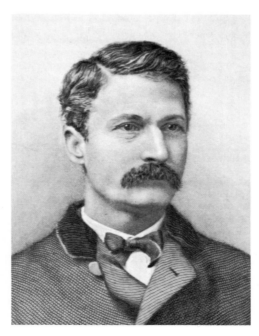

FRANCIS LIGHTFOOT LEE (*left*)
(1734–1797)
Revolutionary patriot, signer of Declaration of Independence

GEORGE WASHINGTON CUSTIS LEE (*right*)
(1832–1913)
Confederate general; president, Washington and Lee University
Engraving by J. J. Cade

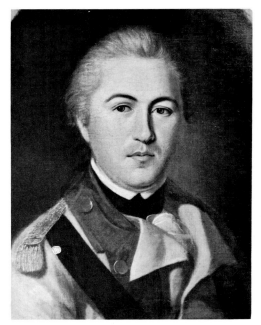

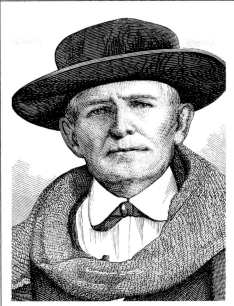

HENRY LEE (*left*)
[Light-Horse Harry Lee]
(1756–1818)
Revolutionary cavalry commander, legislator; suppressed Whisky Rebellion; eulogized Washington as "first in war, first in peace . . ."
Painting by Charles Willson Peale. Courtesy Independence National Historical Park

JOHN DOYLE LEE (*right*)
(1812–1877)
Mormon elder, leader in Mountain Meadows Massacre

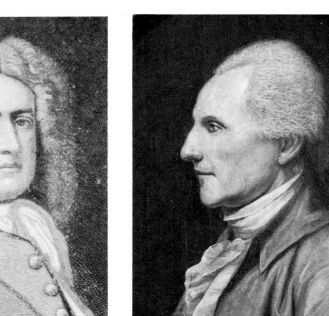

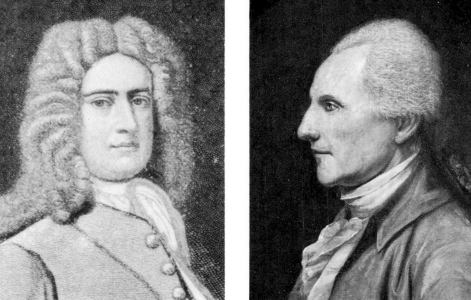

RICHARD LEE (*left*)
(*d.* 1664)
Early Virginia settler, progenitor of Lee family

RICHARD HENRY LEE (*right*)
(1732–1794)
Revolutionary patriot, legislator; signer of Declaration of Independence
Painting by Charles Willson Peale. Courtesy Independence National Historical Park

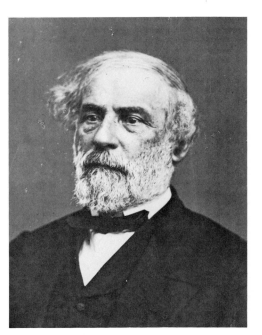

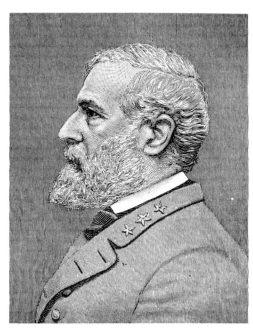

ROBERT EDWARD LEE (*left*)
(1807–1870)
Commander, Confederate armies
Courtesy Library of Congress, Brady-Handy Collection

ROBERT EDWARD LEE (*right*)
(*see above*)

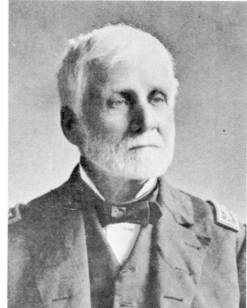

MRS. ROBERT EDWARD LEE (*left*)
[nee Mary Anne Randolph Custis]
(1808–1873)
Virginia society figure, great-granddaughter
of Martha Washington

SAMUEL PHILLIPS LEE (*right*)
(1812–1897)
Union naval officer in Civil War

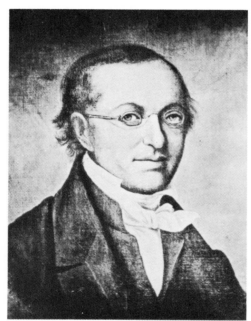

WILLIAM HENRY FITZHUGH LEE
(*left*)
["Rooney" Lee]
(1837–1891)
Confederate officer; U.S. Congressman
Engraving by H. W. Smith

ISAAC LEESER (*right*)
(1806–1868)
Rabbi, editor, writer; founded Maimonides
College
Courtesy Free Library of Philadelphia

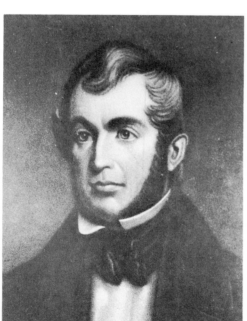

HUGH SWINTON LEGARÉ (*left*)
(c. 1797–1843)
Lawyer, diplomat, Congressman; Attorney
General under Tyler
Engraving by T. Doney. Courtesy South Carolina Historical Society

FRANCIS H. LEGGETT (*right*)
(1840–1909)
Wholesale grocer, food packer

WILLIAM LEGGETT (*left*)
(1801–1839)
Journalist, editor
Engraved by Alfred Sealey from a painting by
Thomas S. Cummings

EMANUEL LEHMAN (*right*)
(1827–1909)
Entrepreneur, financier

MAYER LEHMAN (*left*)
(1830–1897)
Entrepreneur, financier

LILLI LEHMANN (*right*)
(1848–1929)
German dramatic coloratura soprano, sang
at Metropolitan Opera House

JOSEPH LEIDY (*left*)
(1823–1891)
Naturalist, paleontologist, physician

NATE LEIPZIG (*right*)
[Nathan Leipziger]
(1873–1939)
Magician, sleight-of-hand artist
Courtesy Milbourne Christopher Collection

LEVI ZEIGLER LEITER (*left*)
(1834–1904)
Chicago dry-goods merchant, financier
Courtesy Chicago Historical Society

CHARLES GODFREY LELAND (*right*)
(1824–1903)
Journalist, humorist; wrote *Hans Breitmann's Ballads*

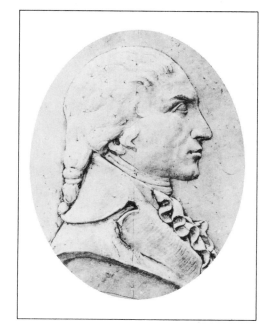

HENRY MARTYN LELAND (*left*)
(1843–1932)
Pioneer automobile manufacturer, founded Cadillac Motor Car Co.
Courtesy Clarence P. Hornung Collection

PIERRE CHARLES L'ENFANT (*right*)
(1754–1825)
Revolutionary soldier, engineer; planned city of Washington, D.C.

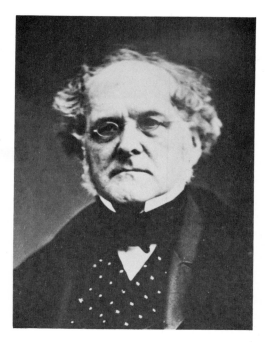

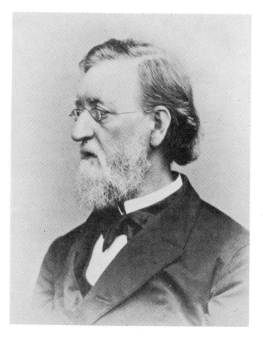

JAMES LENOX (*left*)
(1800–1880)
Book collector, merchant, philanthropist; founded Lenox Library, New York City

PETER LESLEY (*right*)
[J. P. Lesley]
(1819–1903)
Geologist

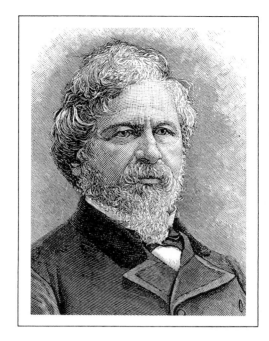

FRANK LESLIE (*left*)
[Henry Carter]
(1821–1880)
Magazine publisher, journalist, illustrator

MIRIAM FLORENCE LESLIE (*right*)
[Mrs. Frank Leslie, nee Miriam Florence Follin]
(*c.* 1836–1914)
Magazine publisher, writer; successor to Frank Leslie

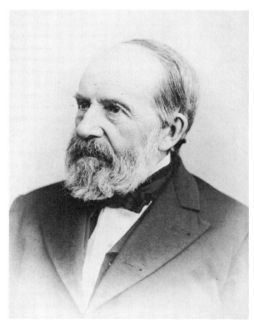

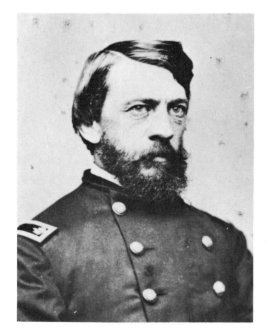

LEO LESQUEREUX (*left*)
(1806–1889)
Paleobotanist, authority on Appalachian coal field
Courtesy Ohio Historical Society Library

JONATHAN LETTERMAN (*right*)
(1824–1872)
Military surgeon, revolutionized care of wounded
Courtesy New-York Historical Society

EMANUEL LEUTZE (*left*)
(1816–1868)
Historical painter, known for "Washington Crossing the Delaware"

JOHN LEVERETT (*right*)
(1616–1679)
Governor of Colonial Massachusetts
Engraving by Denison Kimberly

URIAH PHILLIPS LEVY *(left)*
(1792–1862)
Naval officer, instrumental in abolishing flogging; purchased Monticello as a public shrine

EXUM PERCIVAL LEWIS *(right)*
(1863–1926)
Physicist, spectroscopist, educator
Courtesy Franklin Institute

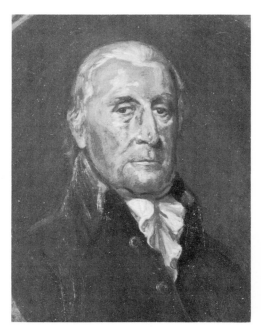

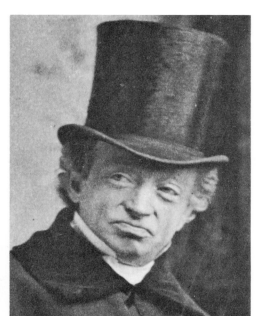

FRANCIS LEWIS *(left)*
(1713–1802)
Merchant, signer of Declaration of Independence
Painting by Albert Rosenthal. Courtesy Independence National Historical Park

JAMES LEWIS *(right)*
[James Lewis Deming]
(1837–1896)
Actor
Photograph by Napoleon Sarony

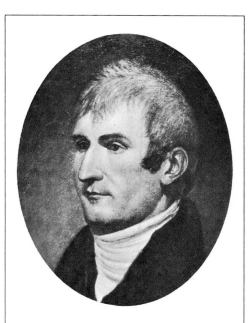

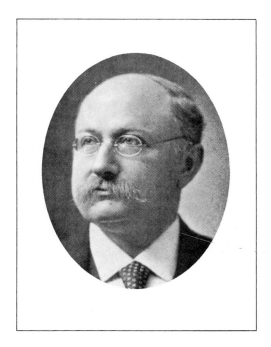

MERIWETHER LEWIS *(left)*
(1774–1809)
Explored American Northwest with William Clark
Painting by Charles Willson Peale

ADOLPH LEWISOHN *(right)*
(1849–1938)
Capitalist, philanthropist; donor of Lewisohn Stadium, New York City

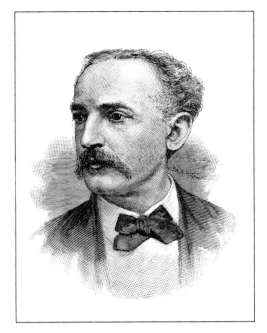

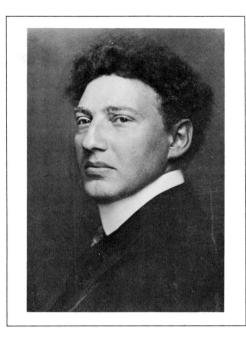

FREDERICK LEYPOLDT (*left*)
(1835–1884)
Publisher, cataloguer, bibliographer; founded *Library Journal*

JOSEF LHÉVINNE (*right*)
(1874–1944)
Russian pianist, performed and taught in U.S.
Courtesy Walter Hampden Memorial Library at The Players, New York

EDWARD DRUMMOND LIBBEY
(*left*)
(1854–1925)
Glass manufacturer, art patron
Courtesy Libbey-Owens-Ford Glass Co.

LAURA JEAN LIBBEY (*right*)
(1862–1924)
Popular novelist

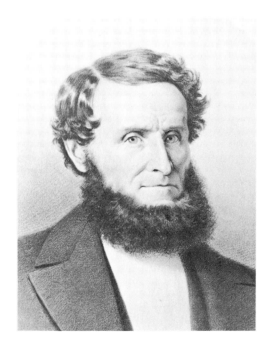

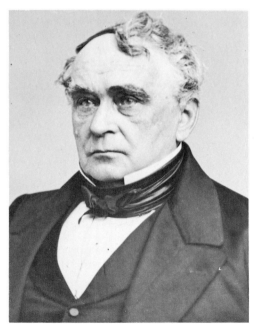

JAMES LICK (*left*)
(1796–1876)
Financier, philanthropist; endowed Lick Observatory
Courtesy Lick Observatory

FRANCIS LIEBER (*right*)
(1800–1872)
Political scientist, educator, writer
Courtesy Library of Congress, Brady-Handy Collection

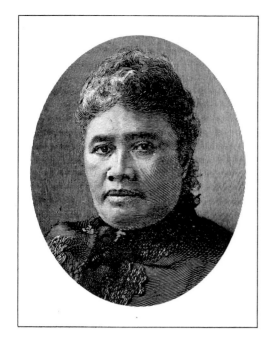

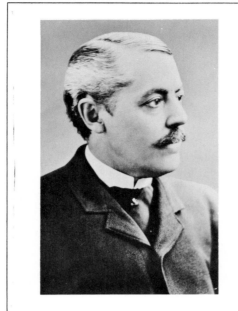

**LYDIA KAMEHAMEHA
LILIUOKALANI** (*left*)
(1838–1917)
Queen of Hawaiian Islands, wrote "Aloha
Oe"

ELI LILLY (*right*)
(1838–1898)
Drug manufacturer
Courtesy Eli Lilly and Co.

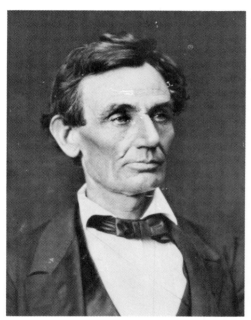

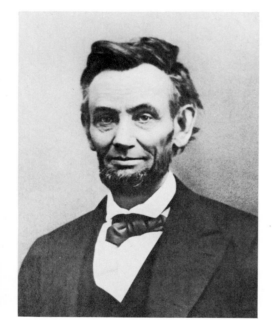

ABRAHAM LINCOLN (*left*)
(1809–1865)
President of the United States, 1861–1865
Photograph by Alexander Hesler

ABRAHAM LINCOLN (*right*)
(*see above*)
*Photograph by Alexander Gardner. Courtesy New-York
Historical Society*

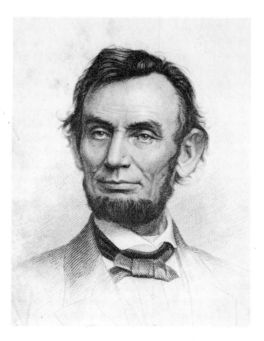

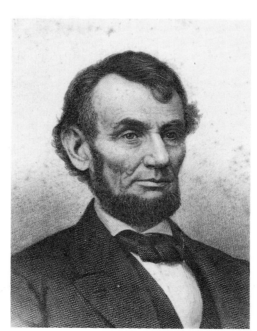

ABRAHAM LINCOLN (*left*)
(*see above*)
*Engraved by John C. Buttre from a photograph by
Mathew Brady*

ABRAHAM LINCOLN (*right*)
(*see above*)
Engraving by H. B. Hall's Sons

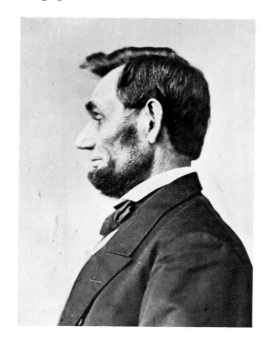

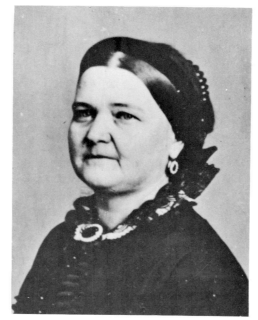

ABRAHAM LINCOLN (*left*)
(*see above*)
Courtesy New-York Historical Society

Mrs. ABRAHAM LINCOLN (*right*)
[nee Mary Todd]
(1818–1882)
First lady, 1861–1865
Courtesy New-York Historical Society

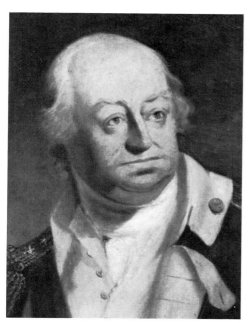

BENJAMIN LINCOLN (*left*)
(1733–1810)
Revolutionary general, suppressed Shays'
Rebellion
Painting by Henry Sargent

LEVI LINCOLN (*right*)
(1749–1820)
Massachusetts political leader, Attorney
General under Jefferson
After a painting by William S. Lincoln

LEVI LINCOLN (*left*)
(1782–1868)
Governor of Massachusetts, Congressman
Engraving by W. H. Forbes

ROBERT TODD LINCOLN (*right*)
(1843–1926)
Lawyer, Secretary of War under Garfield
and Arthur, diplomat, businessman; son of
Abraham Lincoln

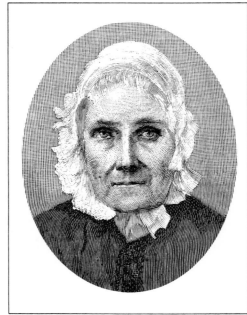

THOMAS LINCOLN (*left*)
(1778–1851)
Father of Abraham Lincoln

Mrs. THOMAS LINCOLN (*right*)
[Sarah Johnston, nee Sarah Bush]
(*c.* 1785–1869)
Stepmother of Abraham Lincoln

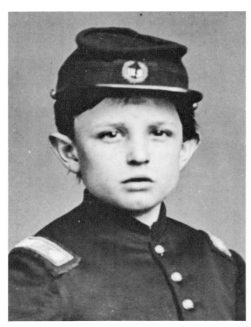

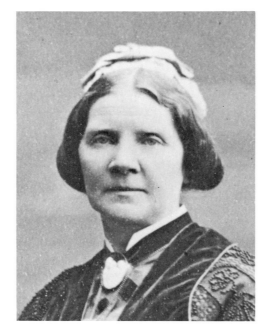

THOMAS LINCOLN (*left*)
["Tad" Lincoln]
(1853–1871)
Youngest son of Abraham Lincoln
Courtesy National Archives, Brady Collection

JENNY LIND (*right*)
[Mme Jennie Lind-Goldschmidt; nee
Johanna Maria Lind]
(1820–1887)
Coloratura soprano, "the Swedish Nightin-
gale"; toured U.S. with Barnum
Courtesy New-York Historical Society

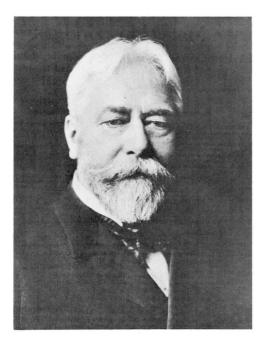

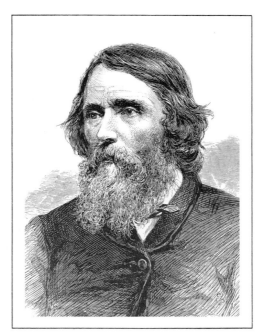

GUSTAV LINDENTHAL (*left*)
(1850–1935)
Railroad and bridge engineer; designed
Queensboro and Hell Gate bridges, New
York City
Courtesy Smithsonian Institution

WILLIAM JAMES LINTON (*right*)
(1812–1897)
Wood engraver, printer, writer, reformer

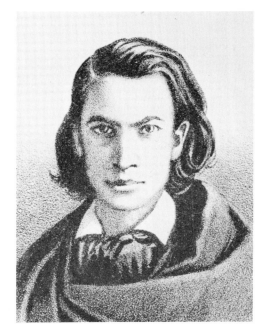

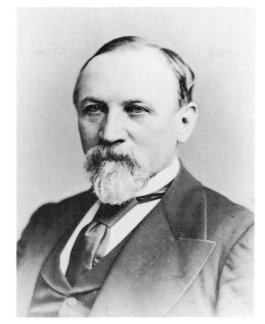

GEORGE LIPPARD (*left*)
(1822–1854)
Novelist, journalist, founded Brotherhood of the Union fraternal order

JOSHUA BALLINGER LIPPINCOTT
(*right*)
(1813–1886)
Book and magazine publisher
Courtesy New-York Historical Society

GEORGE FRIEDRICH LIST (*left*)
(1789–1846)
German political economist in U.S., advocated national system and protection

CHARLES COFFIN LITTLE (*right*)
(1799–1869)
Book publisher; established Little, Brown and Co.
Courtesy Little, Brown and Co.

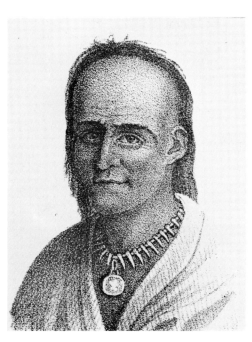

LITTLE CROW V (*left*)
[Chetan-wakan-mani]
(*c.* 1803–1863)
Sioux Indian chief
Courtesy New-York Historical Society

LITTLE TURTLE (*right*)
[Michikinikwa]
(*c.* 1752–1812)
Miami Indian chief
After a painting attributed to Gilbert Stuart. Courtesy Bureau of American Ethnology, Smithsonian Institution

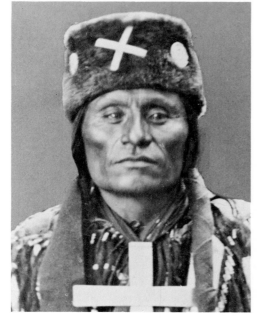

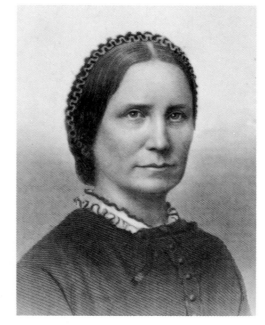

LITTLE WOLF (*left*)
(*fl.* 1830–1860)
Cheyenne Indian chief
*Photograph by William Henry Jackson. Courtesy
Bureau of American Ethnology, Smithsonian Institution*

MARY ASHTON LIVERMORE
(*right*)
[nee Mary Ashton Rice]
(*c.* 1820–1905)
Social reformer, suffragette, editor
Engraving by Alexander H. Ritchie

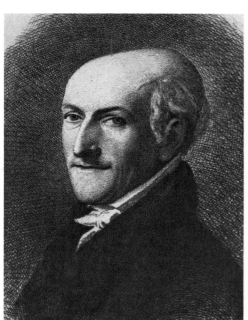

BROCKHOLST LIVINGSTON (*left*)
[Henry Brockholst Livingston]
(1757–1823)
Revolutionary officer, lawyer; associate justice, U.S. Supreme Court
Engraving by Albert Rosenthal

EDWARD LIVINGSTON (*right*)
(1764–1836)
U.S. Senator, Congressman, diplomat; Secretary of State under Jackson
Engraved by E. Wellmore from a drawing by James B. Longacre

JOHN HENRY LIVINGSTON (*left*)
(1746–1825)
Dutch Reformed clergyman; educator
Courtesy Rutgers University

PHILIP LIVINGSTON (*right*)
(1716–1778)
Signer of Declaration of Independence, advocated founding King's College (Columbia University)
Engraving by James B. Longacre

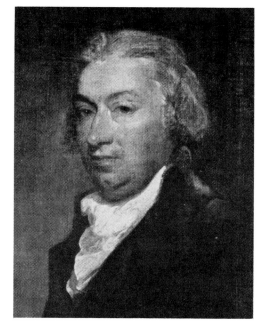

ROBERT LIVINGSTON (*left*)
(1654–1728)
Colonial political leader; established Livingston Manor, New York

ROBERT R. LIVINGSTON (*right*)
[Chancellor Livingston]
(1746–1813)
Revolutionary leader, diplomat, jurist; helped draft Declaration of Independence; aided Fulton in building steamboat
Painting by Gilbert Stuart

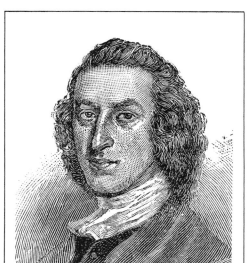

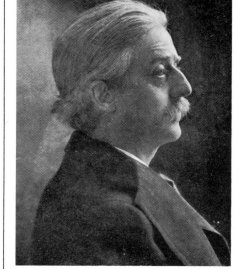

WILLIAM LIVINGSTON (*left*)
(1723–1790)
Governor of New Jersey, member of Continental Congress, signer of Constitution

HENRY DEMAREST LLOYD (*right*)
(1847–1903)
Journalist, writer, Socialist; first of the muckrakers

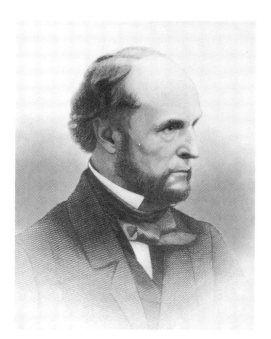

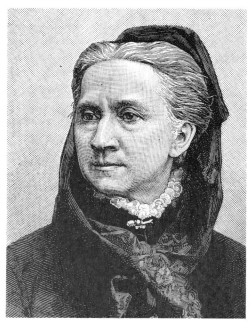

RICHARD ADAMS LOCKE (*left*)
(1800–1871)
Journalist, perpetrated the "Moon Hoax"
Engraving by Augustus Robin

BELVA ANN LOCKWOOD (*right*)
[nee Belva Ann Bennett]
(1830–1917)
Lawyer; first woman admitted to practice before U.S. Supreme Court, first woman candidate for President

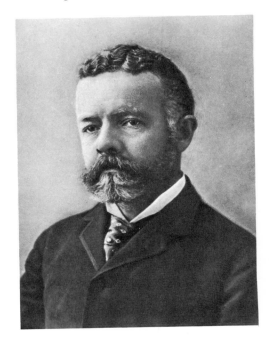

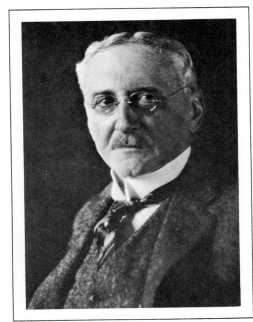

HENRY CABOT LODGE (*left*)
(1850–1924)
U.S. Senator, Congressman, writer; opposed
Covenant of League of Nations

JACQUES LOEB (*right*)
(1859–1924)
Physiologist
Courtesy "Journal of General Physiology"

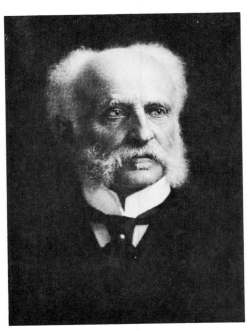

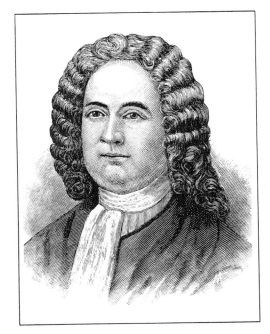

SOLOMON LOEB (*left*)
(1829–1903)
Investment banker, partner in Kuhn, Loeb
& Co.

JAMES LOGAN (*right*)
(1674–1751)
Colonial politician, Pennsylvania jurist,
botanist; bequeathed library to Philadelphia

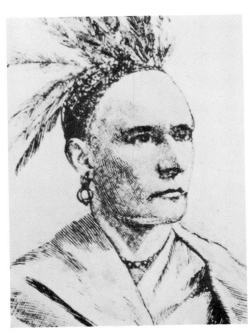

JAMES LOGAN (*left*)
[John Logan; Tahgahjute]
(*c.* 1725–1780)
Mingo Indian chief

JOHN ALEXANDER LOGAN (*right*)
(1826–1886)
Union general in Civil War, U.S. Senator,
Congressman
Engraving by H. B. Hall's Sons

STEPHEN TRIGG LOGAN (*left*)
(1800–1880)
Jurist, Lincoln's law partner in Springfield
Courtesy Illinois State Historical Library

JACK LONDON (*right*)
[John Griffith London]
(1876–1916)
Novelist, short-story writer
Courtesy Library of Congress

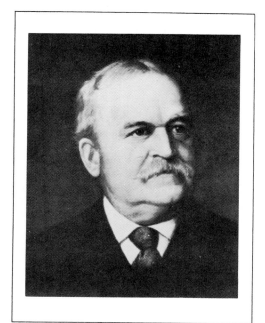

CRAWFORD WILLIAMSON LONG
(*left*)
(1815–1878)
Surgeon, anesthetist; reputed first to use anesthetic for surgery
After a painting by Francis Bicknell Carpenter

JOHN DAVIS LONG (*right*)
(1838–1915)
Governor of Massachusetts, Congressman, Secretary of the Navy under McKinley and Roosevelt; translator, writer

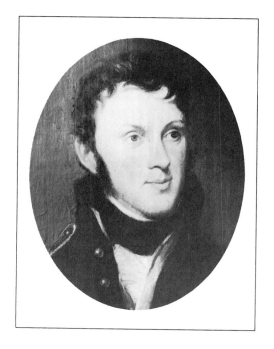

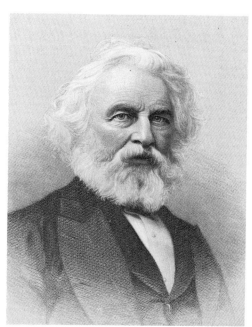

STEPHEN HARRIMAN LONG (*left*)
(1784–1864)
Explorer, engineer, army officer; discovered Long's Peak, Colorado
Courtesy Library of Congress

HENRY WADSWORTH LONGFELLOW (*right*)
(1807–1882)
Poet, translator
Engraving by H. B. Hall & Sons

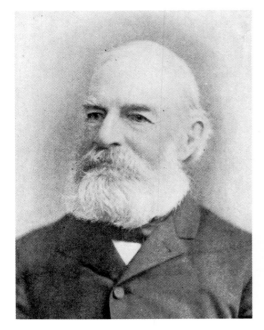

SAMUEL LONGFELLOW (*left*)
(1819–1892)
Unitarian clergyman, hymn writer, biographer

AUGUSTUS BALDWIN
LONGSTREET (*right*)
(1790–1870)
Methodist Episcopal clergyman, educator, writer of humorous sketches
Engraving by John C. Buttre

JAMES LONGSTREET (*left*)
(1821–1904)
Confederate general

ALICE ROOSEVELT LONGWORTH
(*right*)
[Mrs. Nicholas Longworth, nee Alice Lee Roosevelt]
(1884–)
Washington society leader; daughter of Theodore Roosevelt, married in White House

NICHOLAS LONGWORTH (*left*)
(1782–1863)
Horticulturist, lawyer, art patron; "father of American grape culture"

NICHOLAS LONGWORTH (*right*)
(1869–1931)
Speaker of the House of Representatives, married Alice Roosevelt in the White House

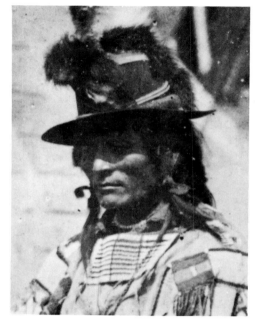

LOOKING GLASS (*left*)
(*d.* 1877)
Nez Percé Indian chief
Photograph by William Henry Jackson. Courtesy Bureau of American Ethnology, Smithsonian Institution

ELIAS LOOMIS (*right*)
(1811–1889)
Mathematician, astronomer, educator

PIERRE LORILLARD (*left*)
(1833–1901)
Tobacco merchant, sportsman; founded Tuxedo Park, New York

GEORGE CLAUDE LORIMER (*right*)
(1838–1904)
Baptist clergyman, writer

GEORGE BAILEY LORING (*left*)
(1817–1891)
Physician, agricultural leader; Commissioner of Agriculture under Garfield and Arthur

BENSON JOHN LOSSING (*right*)
(1813–1891)
Journalist, wood engraver, popular historian
Engraving by George E. Perine

DANIEL LOTHROP (*left*)
(1831–1892)
Book publisher

THOMAS RAYNESFORD
LOUNSBURY (*right*)
(1838–1915)
Philologist, critic, educator

ELIJAH PARISH LOVEJOY (*left*)
(1802–1837)
Abolitionist, journalist; known as "the
Martyr Abolitionist"
Courtesy Illinois State Historical Library

OWEN LOVEJOY (*right*)
(1811–1864)
Abolitionist, clergyman, Congressman; early
supporter of Lincoln

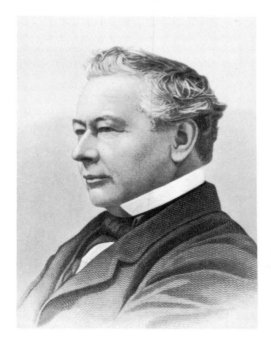

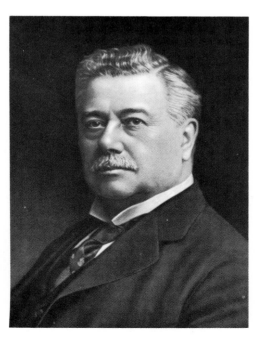

ABIEL ABBOT LOW (*left*)
(1811–1893)
Merchant, prospered in Far Eastern trade
Engraving by George E. Perine

SETH LOW (*right*)
(1850–1916)
Merchant, mayor of Brooklyn and of New
York, president of Columbia University
Engraving by E. G. Williams & Bro.

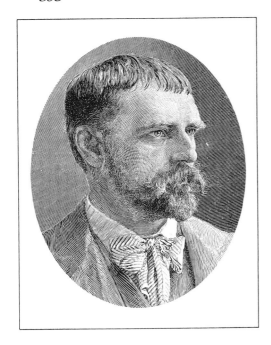

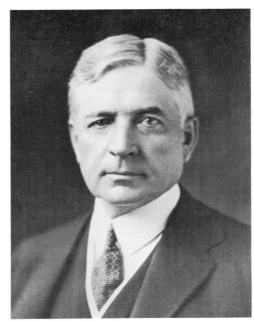

WILL HICOK LOW (*left*)
(1853–1932)
Painter, muralist, writer

FRANK ORREN LOWDEN (*right*)
(1861–1943)
Lawyer, Congressman, Governor of Illinois
Courtesy Chicago Historical Society

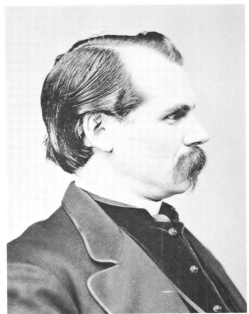

**THADDEUS SOBIESKI
COULINCOURT LOWE** (*left*)
(1832–1913)
Inventor, balloonist; reputed first to manu-
facture artificial ice in U.S.
Courtesy Library of Congress, Brady-Handy Collection

ABBOTT LAWRENCE LOWELL
(*right*)
(1856–1943)
Political scientist, educator; president of
Harvard University
Courtesy Harvard University Archives

FRANCIS CABOT LOWELL (*left*)
(1775–1817)
Textile industrialist; eponym of Lowell,
Massachusetts
Courtesy Mrs. Harriet Ropes Cabot

JAMES RUSSELL LOWELL (*right*)
(1819–1891)
Poet, essayist, educator, diplomat

JOHN LOWELL (*left*)
(1769–1840)
Lawyer, political leader, pamphleteer
Painting by Gilbert Stuart

JOHN LOWELL (*right*)
(1799–1836)
Textile merchant, endowed Lowell Institute
Painting by G. P. A. Healy. Courtesy Ralph Lowell

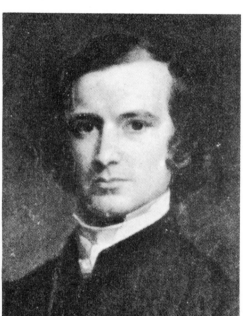

PERCIVAL LOWELL (*left*)
(1855–1916)
Astronomer, writer; predicted discovery of planet Pluto
Courtesy Lowell Observatory

ROBERT TRAILL SPENCE LOWELL (*right*)
(1816–1891)
Protestant Episcopal clergyman, novelist, poet
Courtesy Robert Lowell

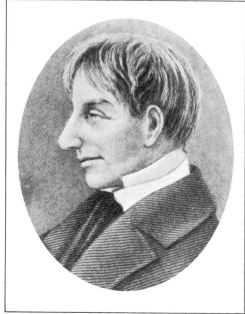

WILLIAM LOWNDES (*left*)
(1782–1822)
Political leader, Congressman
Courtesy South Caroliniana Library, University of South Carolina

SAM LOYD (*right*)
[Samuel Loyd]
(1841–1911)
Creator of puzzles

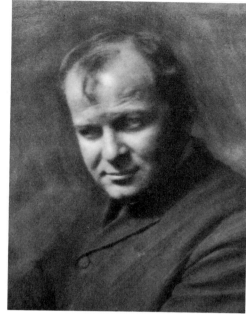

STEPHEN BLEECKER LUCE (*left*)
(1827–1917)
Naval officer, writer; founder and first president, Naval War College

GEORGE BENJAMIN LUKS (*right*)
(1867–1933)
Painter, member of "The Eight"; newspaper illustrator, cartoonist
Courtesy Peter A. Juley & Son

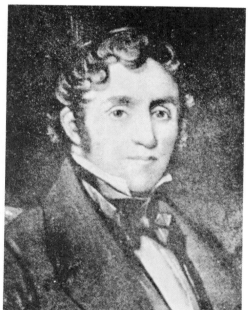

CHARLES FLETCHER LUMMIS
(*left*)
(1859–1928)
Writer, editor; pioneer in study of Southwest
Courtesy Southwest Museum

BENJAMIN LUNDY (*right*)
(1789–1839)
Abolitionist, journalist
Painting by Anson Dickinson

GRAHAM LUSK (*left*)
(1866–1932)
Physiologist, nutritionist
Courtesy Cornell University Medical College

WILLIAM THOMPSON LUSK (*right*)
(1838–1897)
Obstetrician, wrote *Science and Art of Midwifery*

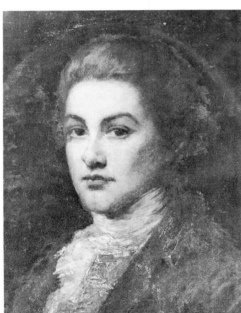
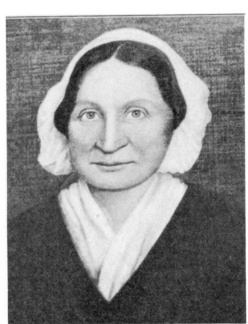

SIDNEY LUSKA (*left*)
[Henry Harland]
(1861–1905)
Novelist, edited *The Yellow Book*

BENJAMIN SMITH LYMAN (*right*)
(1835–1920)
Geologist, mining engineer

THOMAS LYNCH (*left*)
(1749–1779)
Planter, signer of Declaration of Independence
Painting by Anna Lea. Courtesy Independence National Historical Park

MARY LYON (*right*)
(1797–1849)
Educator, founded Mount Holyoke College

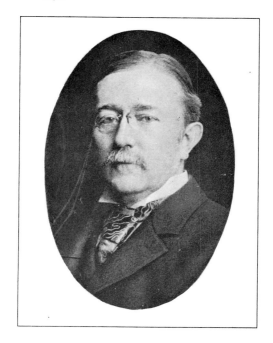

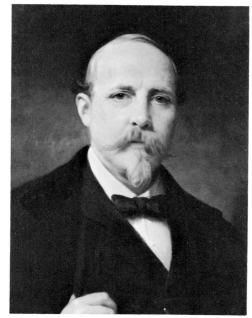

HAMILTON WRIGHT MABIE *(left)*
(1845–1916)
Editor, critic, lawyer

WARD McALLISTER *(right)*
[Samuel Ward McAllister]
(1827–1895)
New York society leader, established the "Four Hundred"
Painting by Adolphe Yvon. Courtesy New-York Historical Society

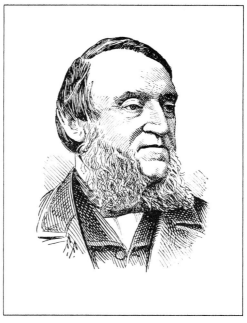

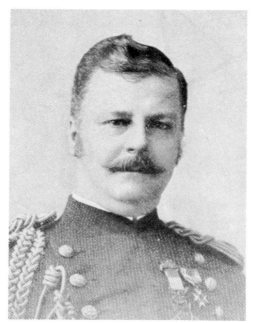

WILLIAM JARVIS McALPINE *(left)*
(1812–1890)
Civil engineer, pioneer in caisson design; consulting engineer for Eads Bridge, St. Louis

ARTHUR MacARTHUR *(right)*
(1845–1912)
Army officer, father of General Douglas MacArthur

JACK McAULIFFE *(left)*
(1866–1937)
Lightweight boxing champion, retired undefeated

CHARLES McBURNEY *(right)*
(1845–1913)
Surgeon, educator; pioneer in treating appendicitis

GEORGE BRINTON McCLELLAN
(*left*)
(1826–1885)
Union general in Civil War
Courtesy New-York Historical Society

GEORGE BRINTON McCLELLAN
(*right*)
(1865–1940)
Tammany leader, Congressman, mayor of
New York, educator

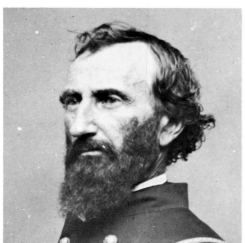

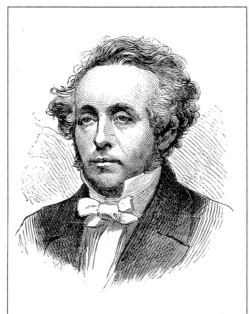

JOHN ALEXANDER McCLERNAND
(*left*)
(1812–1900)
Lawyer, journalist, Congressman; Union
general in Civil War
Courtesy Library of Congress, Brady Collection

JOHN M'CLINTOCK (*right*)
(1814–1870)
Methodist Episcopal clergyman, editor;
first president, Drew Theological Seminary

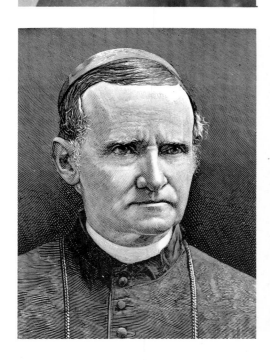

JOHN McCLOSKEY (*left*)
(1810–1885)
Roman Catholic prelate, first American
Cardinal

SAMUEL SIDNEY McCLURE (*right*)
(1857–1949)
Publisher and editor, *McClure's Magazine*
Photograph by Arnold Genthe

ALEXANDER CALDWELL
McCLURG (*left*)
(1832–1901)
Bookseller, publisher

JOHN McCOMB (*right*)
(1763–1853)
Architect, designed New York City Hall
Painting by Samuel Lovett Waldo. Courtesy New-York Historical Society

CYRUS HALL McCORMICK (*left*)
(1809–1884)
Inventor, manufacturer; invented the reaper

JOHN B. McCORMICK (*right*)
(1834–1924)
Inventor, developed most widely used hydraulic turbine engine
Courtesy Smithsonian Institution and Margery McC. Stephenson

ROBERT McCORMICK (*left*)
(1780–1846)
Inventor of agricultural machinery, father of Cyrus McCormick

JAMES McCOSH (*right*)
(1811–1894)
Scottish clergyman, philosopher; president of Princeton College
Engraving by George E. Perine

CHARLES "KID" McCOY (*left*)
[Norman Selby]
(1873–1941)
Middleweight boxer

HENRY MITCHELL MacCRACKEN
(*right*)
(1840–1918)
Presbyterian clergyman, chancellor of New
York University
Courtesy New York University

HUGH McCULLOCH (*left*)
(1808–1895)
Secretary of the Treasury under Lincoln,
Johnson, and Arthur
Courtesy National Archives, Brady Collection

JOHN McCULLOUGH (*right*)
(1832–1885)
Actor

GEORGE BARR McCUTCHEON
(*left*)
(1866–1928)
Novelist, author of *Graustark* and *Brewster's
Millions*

CHARLES BLAIR MACDONALD
(*right*)
(1856–1928)
Early leader of American golf, built first
eighteen-hole course in U.S.
Courtesy National Golf Links of America

THOMAS MACDONOUGH (*left*)
(1783–1825)
Naval officer, defeated British at Plattsburg,
War of 1812
Engraved by J. B. Forrest from a painting by John Wesley Jarvis

EDWARD ALEXANDER
MacDOWELL (*right*)
(1861–1908)
Composer, pianist
Courtesy Library of Congress

EPHRAIM McDOWELL (*left*)
(1771–1830)
Physician, pioneer in abdominal surgery
Painting by William Davenport. Courtesy Department of the History of Medicine, University of Kansas Medical Center

IRVIN McDOWELL (*right*)
(1818–1885)
Union general in Civil War, commander at
first battle of Bull Run

GEORGE McDUFFIE (*left*)
(c. 1790–1851)
Congressman, U.S. Senator, Governor of
South Carolina
Courtesy Library of Congress, Brady-Handy Collection

Mrs. JOHN E. McELROY (*right*)
[nee Mary Arthur]
(1842–1917)
Sister of Chester A. Arthur; White House
hostess, 1881–1885

JOSEPH JEROME McGINNITY (*left*)
["Iron Man" McGinnity]
(1871–1929)
Baseball pitcher, member of Baseball Hall of Fame
Courtesy National Baseball Hall of Fame

EDWARD McGLYNN (*right*)
(1837–1900)
Roman Catholic priest, supported Henry George and single tax

JOHN JOSEPH McGRAW (*left*)
(1873–1934)
Baseball infielder, manager; member of Baseball Hall of Fame
Courtesy National Baseball Hall of Fame

WILLIAM HOLMES McGUFFEY
(*right*)
(1800–1873)
Educator, president of Ohio University; compiled *Eclectic Readers*
Courtesy Ohio University

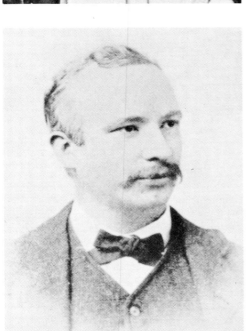

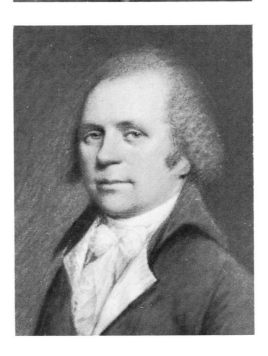

PETER JAMES McGUIRE (*left*)
(1852–1906)
Labor leader, "the father of Labor Day"
Courtesy Tamiment Institute Library

JAMES McHENRY (*right*)
(1753–1816)
Revolutionary soldier, secretary to Washington; signer of Constitution; Secretary of War under Washington and John Adams
Painting attributed to James Sharples, Sr. Courtesy Independence National Historical Park

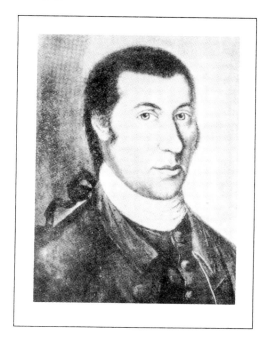

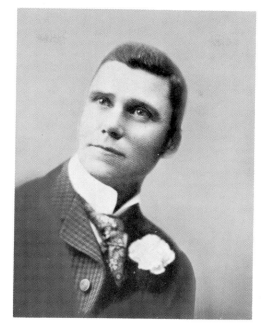

SAMUEL McINTIRE (*left*)
(1757–1811)
Salem architect, wood sculptor
Painting attributed to Benjamin Blyth

JAMES McINTYRE (*right*)
(1857–1937)
Partner in blackface comedy team, McIntyre and Heath
Courtesy Museum of the City of New York

CONNIE MACK (*left*)
[Cornelius Alexander McGillicuddy]
(1862–1956)
Baseball catcher, manager, club owner; member of Baseball Hall of Fame
Courtesy National Baseball Hall of Fame

CLARENCE HUNGERFORD MACKAY (*right*)
(1874–1938)
Financier, sportsman, philanthropist

DONALD McKAY (*left*)
(1810–1880)
Clipper ship designer, builder
Daguerreotype by Southworth and Hawes. Courtesy Metropolitan Museum of Art, Stokes-Hawes Collection

GORDON McKAY (*right*)
(1821–1903)
Shoe manufacturer, developed shoemaking machinery

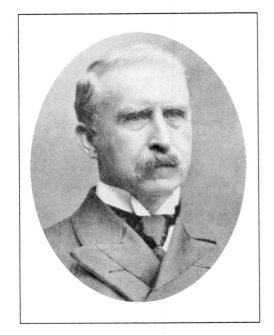

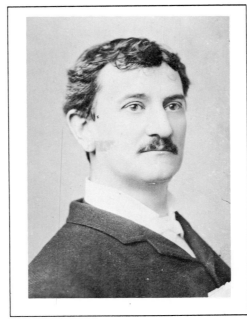

JOHN WILLIAM MACKAY (*left*)
(1831–1902)
Mining magnate, financier

STEELE MacKAYE (*right*)
[James Morrison Steele MacKaye]
(1842–1894)
Actor, playwright, theater owner
Courtesy Museum of the City of New York

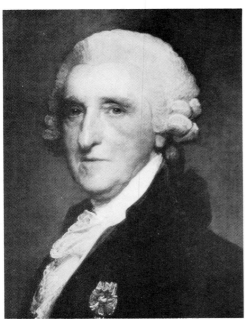

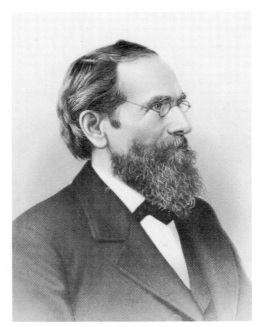

THOMAS McKEAN (*left*)
(1734–1817)
Jurist, signer of the Declaration of Independence, president of Continental Congress, Governor of Pennsylvania
Painting by Gilbert Stuart

THOMAS MacKELLAR (*right*)
(1812–1899)
Printer, type manufacturer, poet
Engraving by Alexander H. Ritchie

St. CLAIR McKELWAY (*left*)
(1845–1915)
Journalist, edited *Brooklyn Daily Eagle*

WILLIAM McKENDREE (*right*)
(1757–1835)
Methodist Episcopal clergyman, first American-born Methodist bishop
Courtesy University of Kentucky

JOSEPH McKENNA (*left*)
(1843–1926)
Associate justice, U.S. Supreme Court; Attorney General under McKinley; Congressman

SIR ALEXANDER MACKENZIE
(*right*)
(1764–1820)
Scottish explorer in American Northwest
After a painting by Sir Thomas Lawrence

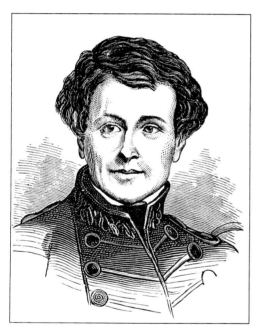

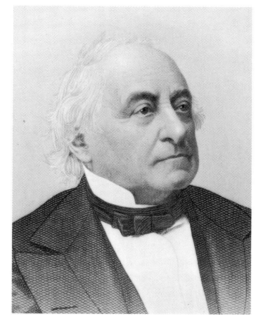

ALEXANDER SLIDELL MACKENZIE
(*left*)
[Alexander Slidell]
(1803–1848)
Naval officer, writer; executed three men at sea for plans to mutiny

JOHN McKESSON (*right*)
(1806–1893)
Drug manufacturer, partner in McKesson & Robbins
Engraving by George E. Perine

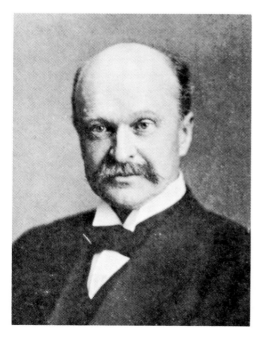

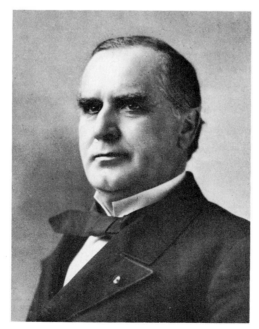

CHARLES FOLLEN McKIM (*left*)
(1847–1909)
Architect; partner in McKim, Mead, and White

WILLIAM McKINLEY (*right*)
(1843–1901)
President of the United States, 1897–1901

Mrs. WILLIAM McKINLEY (*left*)
[nee Ida Saxton]
(1847–1907)
First lady, 1897–1901

LOUIS McLANE (*right*)
(1786–1857)
Secretary of the Treasury and Secretary of State under Jackson; Congressman, U.S. Senator, diplomat
Painting by Robert Hinckley. Courtesy U.S. Department of State

LAFAYETTE McLAWS (*left*)
(1821–1897)
Confederate general

JOHN MACLEAN (*right*)
(1771–1814)
Chemist, educator; at College of New Jersey (Princeton), first American professor of chemistry in non-medical college
Courtesy Princeton University Archives

JOHN McLEAN (*left*)
(1785–1861)
Congressman, Postmaster General under Monroe and J. Q. Adams; associate justice, U.S. Supreme Court
Engraving by Henry B. Hall

JOHN McLOUGHLIN (*right*)
(1784–1857)
Agent for Hudson's Bay Company on Columbia River
Painting by William Cogswell. Courtesy McLoughlin House National Historic Site

WILLIAM MACLURE (*left*)
(1763–1840)
Geologist, promoted science and education
Engraved by P. S. Duval from a painting by Thomas Sully

JOHN BACH McMASTER (*right*)
(1852–1932)
Historian, educator

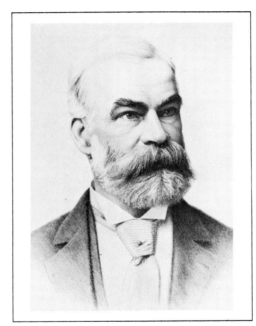

FREDERICK WILLIAM
MacMONNIES (*left*)
(1863–1937)
Sculptor
Courtesy American Academy of Arts and Letters

ANDREW McNALLY (*right*)
(1836–1904)
Map designer, manufacturer; partner in
Rand McNally & Co.
Courtesy Rand McNally & Co.

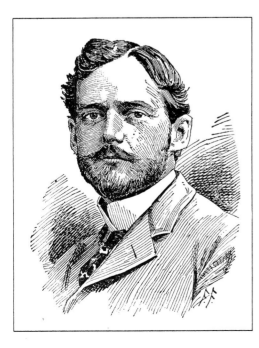

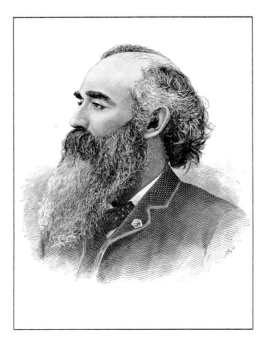

HERMON ATKINS MacNEIL (*left*)
(1866–1947)
Sculptor

GEORGE EDWIN McNEILL (*right*)
(1837–1906)
Labor leader, a founder of American
Federation of Labor

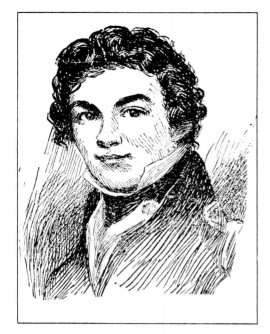

WILLIAM GIBBS McNEILL (*left*)
(1801–1853)
Civil engineer

ALEXANDER MACOMB (*right*)
(1782–1841)
Commanding general, U.S. army, 1828–
1841
Engraved by James B. Longacre from a painting by Thomas Sully

NATHANIEL MACON (*left*)
(1758–1837)
Congressman, Speaker of the House; U.S.
Senator
Courtesy North Carolina State Department of Archives and History

JAMES BIRDSEYE McPHERSON
(*right*)
(1828–1864)
Union general in Civil War

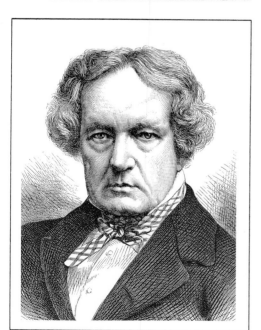

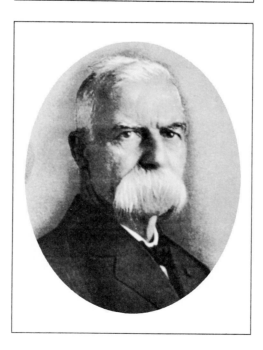

WILLIAM CHARLES MACREADY
(*left*)
(1793–1873)
English actor in U.S.; rivalry with Edwin
Forrest caused riots in New York

JOHN McTAMMANY (*right*)
(1845–1915)
Inventor; developed player piano and early
voting machine
Courtesy New-York Historical Society

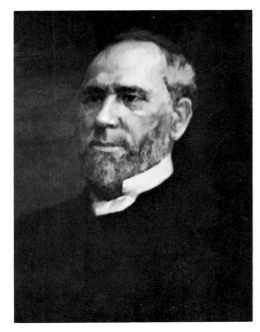

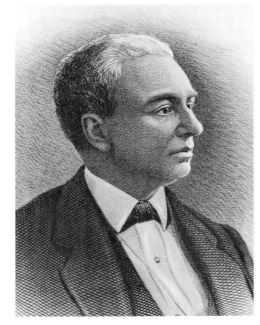

HOLLAND NIMMONS McTYEIRE (*left*)
(1824–1889)
Methodist Episcopal bishop, founded Vanderbilt University
Courtesy Vanderbilt University

JAMES HUBERT McVICKER (*right*)
(1822–1896)
Actor, theatrical manager
Courtesy Chicago Historical Society

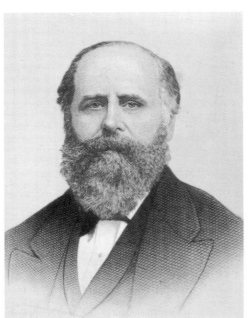

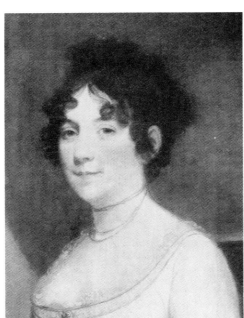

ROWLAND HUSSEY MACY (*left*)
(1822–1877)
New York merchant, founder of R. H. Macy & Co.
Engraving by George E. Perine

DOLLY MADISON (*right*)
[Dolley Madison; Mrs. James Madison, nee Dorothea Payne]
(1768–1849)
Washington social leader; first lady, 1809–1817
Painting by Gilbert Stuart

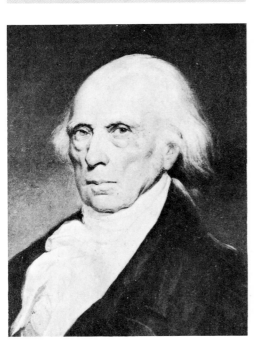

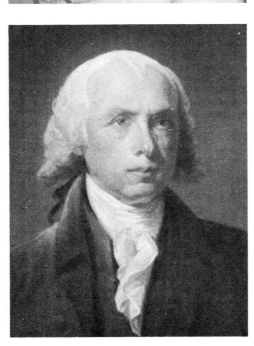

JAMES MADISON (*left*)
(1751–1836)
President of the United States, 1809–1817
Painting by Asher B. Durand

JAMES MADISON (*right*)
(*see above*)
Painting by Gilbert Stuart

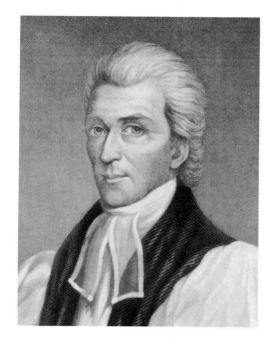

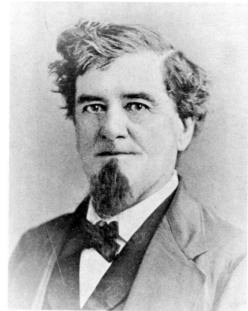

JAMES MADISON (*left*)
(1749–1812)
Protestant Episcopal bishop; president, College of William and Mary

JOHN NEWLAND MAFFITT (*right*)
(1819–1886)
Confederate naval officer, blockade runner
Courtesy U.S. Department of Defense

JOHN BANKHEAD MAGRUDER
(*left*)
(1810–1871)
Confederate general

JULIA MAGRUDER (*right*)
(1854–1907)
Popular novelist, short-story writer

ALFRED THAYER MAHAN (*left*)
(1840–1914)
Naval officer, historian, strategist
Courtesy U.S. Department of Defense

DENNIS HART MAHAN (*right*)
(1802–1871)
Military engineer, educator

CHARLES MAJOR (*left*)
(1856–1913)
Historical novelist, wrote *When Knighthood Was in Flower*

EDWARD GREENE MALBONE
(*right*)
(1777–1807)
Portrait painter, miniaturist
Self-portrait

MAX MALINI (*left*)
[Max Katz]
(1875–1942)
Magician, showman
Courtesy Milbourne Christopher Collection

FRANKLIN PAINE MALL (*right*)
(1862–1917)
Anatomist, embryologist, educator

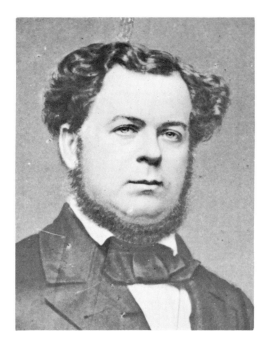
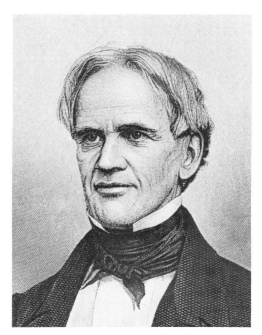

STEPHEN RUSSELL MALLORY
(*left*)
(c. 1813–1873)
Confederate Secretary of the Navy
Courtesy Library of Congress, Brady-Handy Collection

HORACE MANN (*right*)
(1796–1859)
Educator; reformed public school organization and teaching in U.S.

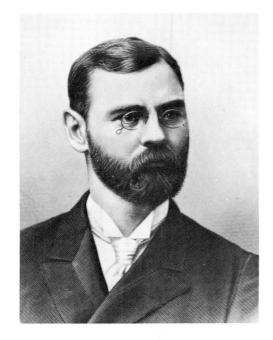

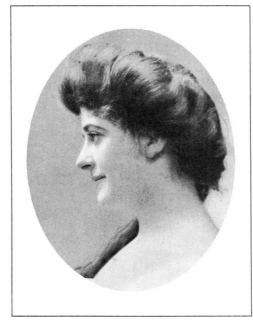

JAMES ROBERT MANN (*left*)
(1856–1922)
Lawyer, Congressman; sponsor of Mann
Act barring "white slavery"
Courtesy Chicago Historical Society

MARY MANNERING (*right*)
[Florence Friend]
(1876–1953)
Actress

JAMES MANNING (*left*)
(1738–1791)
Baptist clergyman, educator; a founder and
first president of Brown University

JOSIE MANSFIELD (*right*)
[Helen Josephine Mansfield]
(*b.* 1848)
Mistress of Jim Fisk, reason for his murder

RICHARD MANSFIELD (*left*)
(1854–1907)
Actor

FRANCIS ANDREW MARCH (*right*)
(1825–1911)
Philologist, pioneer in historical study of
English language

RANDOLPH BARNES MARCY (*left*)
(1812–1887)
Army officer
Courtesy Library of Congress, Brady-Handy Collection

WILLIAM LEARNED MARCY (*right*)
(1786–1857)
Governor of New York, Secretary of War
under Polk, Secretary of State under Pierce;
coined phrase, "spoils system"
Engraving by John C. Buttre

MAX MARETZEK (*left*)
(1821–1897)
Operatic producer, conductor, composer

FRANCIS MARION (*right*)
(*c.* 1732–1795)
Revolutionary commander; "The Swamp
Fox"

EDWIN MARKHAM (*left*)
[Charles Edward Anson Markham]
(1852–1940)
Poet, wrote "The Man with the Hoe"
Courtesy Library of Congress

JULIA MARLOWE (*right*)
[Sarah Frances Frost]
(1866–1950)
Actress

GEORGE PERKINS MARSH (*left*)
(1801–1882)
Lawyer, Congressman, diplomat; philologist
Engraving by Henry B. Hall, Jr.

JAMES MARSH (*right*)
(1794–1842)
Philosopher, educator; president, University of Vermont
Courtesy University of Vermont

OTHNIEL CHARLES MARSH (*left*)
(1831–1899)
Paleontologist

JAMES WILSON MARSHALL (*right*)
(1810–1885)
Pioneer, discovered gold near Sutter's Fort, California, 1848
Courtesy Mercaldo Archives

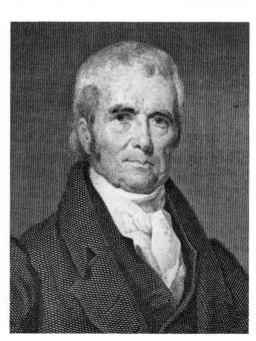

JOHN MARSHALL (*left*)
(1755–1835)
Chief Justice of U.S., 1801–1835; diplomat, Congressman, Secretary of State under John Adams
Painting by Rembrandt Peale. Courtesy Virginia Museum of Fine Arts, The Glasgow Fund

JOHN MARSHALL (*right*)
(*see above*)
Engraved by Asher B. Durand from a painting by Henry Inman

LOUIS MARSHALL *(left)*
(1856–1929)
Constitutional lawyer, Zionist leader, philanthropist

THOMAS RILEY MARSHALL *(right)*
(1854–1925)
Governor of Indiana; Vice-President of U.S., 1913–1921
Painting by Wayman Adams, Courtesy Indiana Historical Society Library

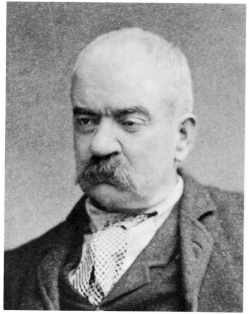

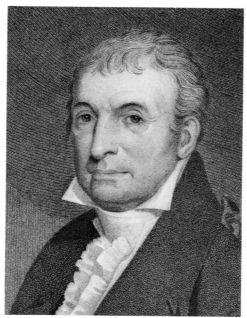

HOMER DODGE MARTIN *(left)*
(1836–1897)
Landscape painter
Courtesy Peter A. Juley & Son

LUTHER MARTIN *(right)*
(c. 1748–1826)
Lawyer, jurist, member of Continental Congress, delegate to Constitutional Convention; proposed supremacy clause of Constitution
Engraving by William A. Wilmer

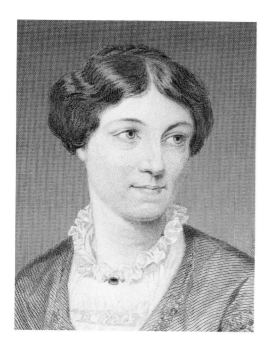

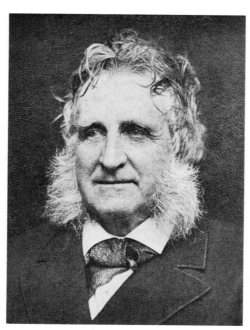

HARRIET MARTINEAU *(left)*
(1802–1876)
English novelist, economist; wrote on life in U.S.
After a painting by Alonzo Chappel

IK MARVEL *(right)*
[Donald Grant Mitchell]
(1822–1908)
Essayist, novelist, agriculturist

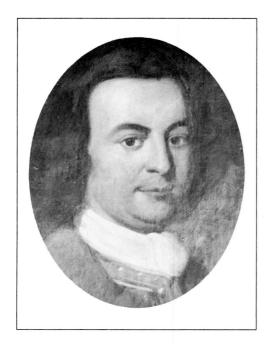

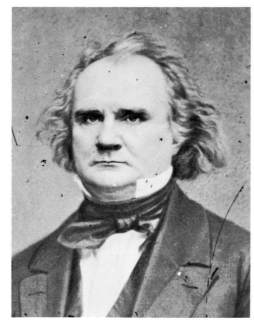

GEORGE MASON (*left*)
(1725–1792)
Revolutionary leader, author of Virginia Declaration of Rights, delegate to Constitutional Convention
After a painting by John Hesselius. Courtesy Independence National Historical Park

JAMES MURRAY MASON (*right*)
(1798–1871)
Congressman, U.S. Senator; Confederate diplomat
Courtesy Library of Congress, Brady-Handy Collection

LOWELL MASON (*left*)
(1792–1872)
Musician, hymn writer, educator; wrote "Nearer, My God, to Thee"

OTIS TUFTON MASON (*right*)
(1838–1908)
Anthropologist, ethnologist
Courtesy Smithsonian Institution

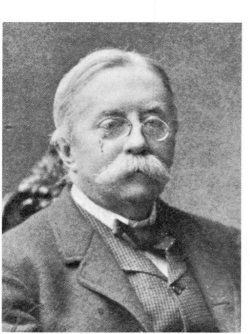

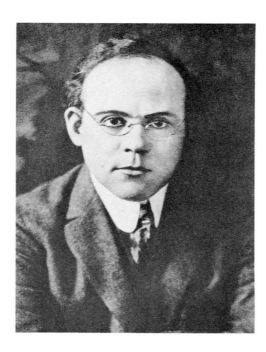

WILLIAM MASON (*left*)
(1829–1908)
Pianist, music teacher, composer

EDGAR LEE MASTERS (*right*)
(1869–1950)
Poet
Courtesy American Academy of Arts and Letters

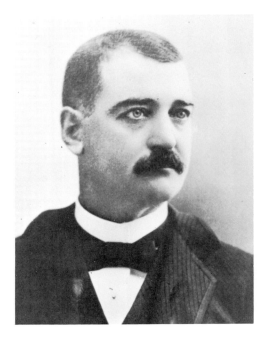

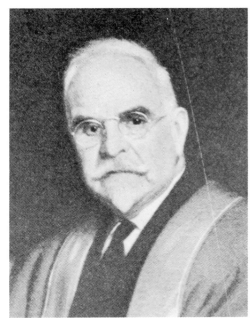

BAT MASTERSON (*left*)
[William Barclay Masterson]
(1853–1921)
Frontier marshal, gambler; sports writer for
New York Morning Telegraph
Courtesy Mercaldo Archives

RUDOLPH MATAS (*right*)
(1860–1957)
Surgeon

COTTON MATHER (*left*)
(1663–1728)
Congregational clergyman, Puritan zealot,
writer; investigated witchcraft
Painting by Peter Pelham

INCREASE MATHER (*right*)
(1639–1723)
Congregational clergyman, Massachusetts
colony leader; president of Harvard College
Painting by Jan Van Der Spriett

RICHARD MATHER (*left*)
(1596–1669)
Congregational clergyman, early leader of
Massachusetts colony
Woodcut by John Foster

CHRISTY MATHEWSON (*right*)
[Christopher Mathewson]
(1880–1925)
Baseball pitcher, charter member of Baseball
Hall of Fame
Courtesy National Baseball Hall of Fame

BRANDER MATTHEWS (*left*)
[James Brander Matthews]
(1852–1929)
Critic of drama and literature; first pro-
fessor of dramatic literature in university in
U.S.

STANLEY MATTHEWS (*right*)
[Thomas Stanley Matthews]
(1824–1889)
Lawyer, jurist, U.S. Senator; associate jus-
tice, U.S. Supreme Court

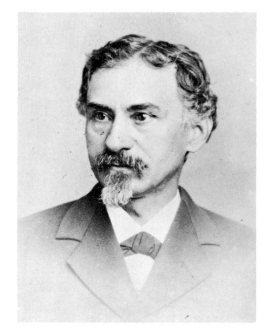

VICTOR MAUREL (*left*)
(1848–1923)
French operatic baritone, voice teacher in
New York

LOUIS MAURER (*right*)
(1832–1932)
Painter, lithographer
Courtesy New-York Historical Society

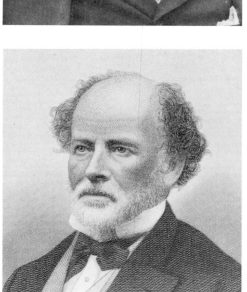
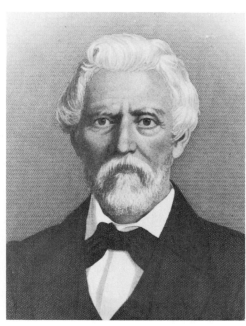

MATTHEW FONTAINE MAURY
(*left*)
(1806–1873)
Oceanographer, naval officer
Engraving by George E. Perine

SAMUEL AUGUSTUS MAVERICK
(*right*)
(1803–1870)
Texas pioneer, cattleman; basis for term
"maverick"
*Engraving by R. Dudensing. Courtesy Texas State
Library*

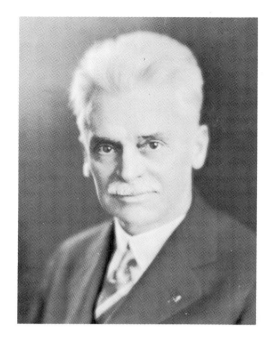

HIRAM PERCY MAXIM (*left*)
(1869–1936)
Automobile pioneer, writer; invented silencer for firearms
Courtesy Clarence P. Hornung Collection

Sɪʀ **HIRAM STEVENS MAXIM**
(*right*)
(1840–1916)
Inventor, developed Maxim machine gun

HUDSON MAXIM (*left*)
[Isaac Weston Maxim, Jr.]
(1853–1927)
Inventor, developed explosives

ALFRED MARSHALL MAYER (*right*)
(1836–1897)
Physicist, authority on acoustics

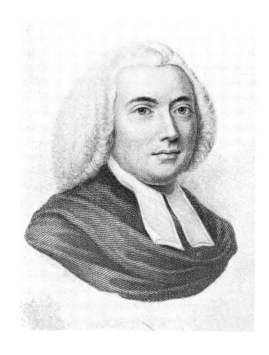
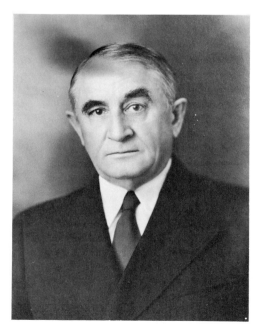

JONATHAN MAYHEW (*left*)
(1720–1766)
Liberal clergyman, leader in Colonial Boston

CHARLES HORACE MAYO (*right*)
(1865–1939)
Physician; co-founder, Mayo Clinic, Rochester, Minnesota
Courtesy Mayo Clinic

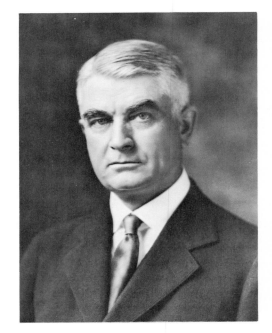

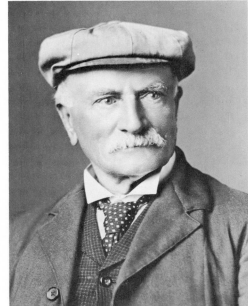

WILLIAM JAMES MAYO *(left)*
(1861–1939)
Physician; co-founder, Mayo Clinic, Rochester, Minnesota
Courtesy Mayo Clinic

WILLIAM WORRALL MAYO *(right)*
(1819–1911)
Frontier physician, surgeon; father of Charles and William Mayo
Courtesy Mayo Clinic

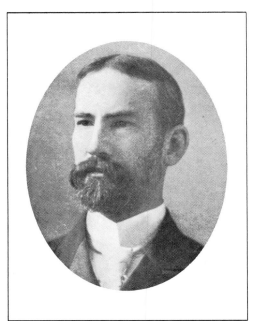

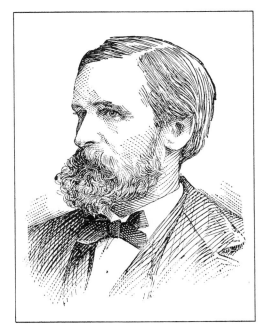

RICHMOND MAYO-SMITH *(left)*
(1854–1901)
Statistician, economist

LARKIN GOLDSMITH MEAD *(right)*
(1835–1910)
Sculptor

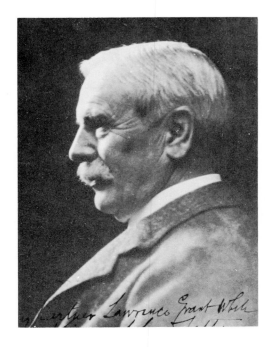

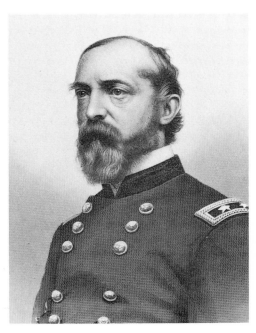

WILLIAM RUTHERFORD MEAD
(left)
(1846–1928)
Architect; partner in McKim, Mead, and White
Courtesy Steinman, Cain & White

GEORGE GORDON MEADE *(right)*
(1815–1872)
Union general in Civil War; defeated Lee at Gettysburg
Engraved by John C. Buttre from a photograph by Mathew Brady

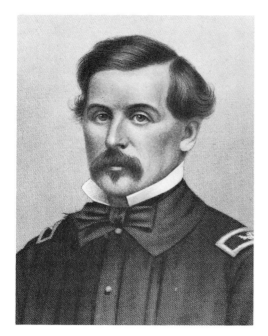

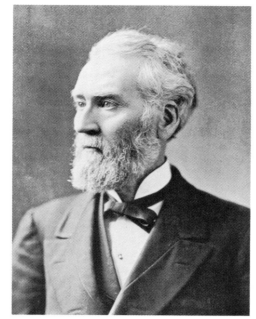

THOMAS FRANCIS MEAGHER
(left)
(1823–1867)
Lawyer, Irish leader in New York City; acting governor, Montana Territory
Engraved by John C. Buttre from a photograph by Mathew Brady

JOSEPH MEDILL *(right)*
(1823–1899)
Publisher of *Chicago Tribune*; a founder of Republican Party

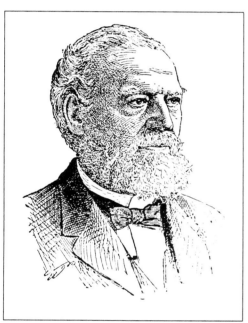

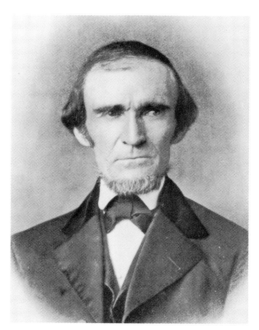

THOMAS MEEHAN *(left)*
(1826–1901)
Horticulturist, agricultural journalist

FIELDING BRADFORD MEEK *(right)*
(1817–1876)
Paleontologist
Courtesy Peabody Museum, Harvard University

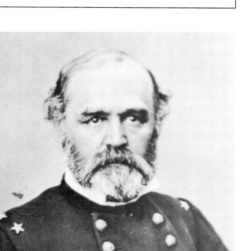

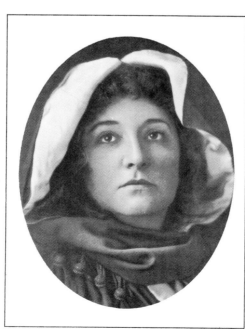

MONTGOMERY CUNNINGHAM MEIGS *(left)*
(1816–1892)
Military engineer, quartermaster general of Union army
Courtesy National Archives, Brady Collection

MME NELLIE MELBA *(right)*
[Helen Porter Mitchell]
(1861–1931)
Australian operatic soprano, popular in U.S.

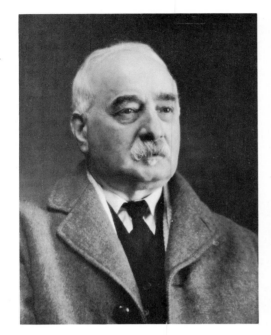

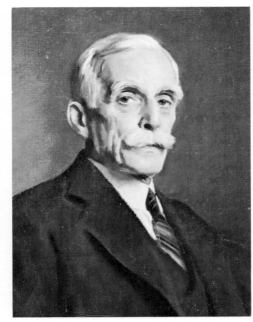

GARI MELCHERS (*left*)
[Julius Gari Melchers]
(1860–1932)
Painter
Courtesy Peter A. Juley & Son

ANDREW WILLIAM MELLON (*right*)
(1855–1937)
Financier, diplomat; Secretary of the
Treasury under Harding, Coolidge, and
Hoover; founder, National Gallery of Art
*Painting by Oswald Birley. Courtesy National Gallery
of Art. Gift of Ailsa Mellon Bruce*

SAMUEL JAMES MELTZER (*left*)
(1851–1920)
Physiologist
Courtesy New York Academy of Medicine

GEORGE WALLACE MELVILLE
(*right*)
(1841–1912)
Naval engineer, arctic explorer

HERMAN MELVILLE (*left*)
(1819–1891)
Novelist, poet
*Painting by Joseph Oriel Eaton. Courtesy Houghton
Library, Harvard University*

CHRISTOPHER GUSTAVUS
MEMMINGER (*right*)
(1803–1888)
Confederate Secretary of the Treasury;
South Carolina political leader
Courtesy New-York Historical Society

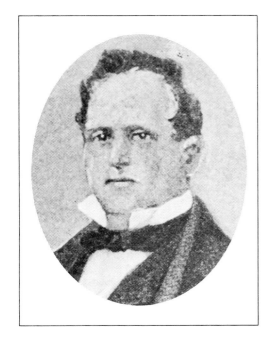

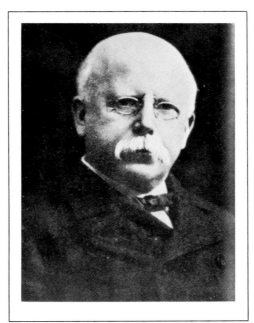

MICHEL BRANAMOUR MENARD
(*left*)
(1805–1856)
Frontier trader; founded Galveston, Texas
Courtesy Texas State Library

THOMAS CORWIN MENDENHALL
(*right*)
(1841–1924)
Physicist, educator

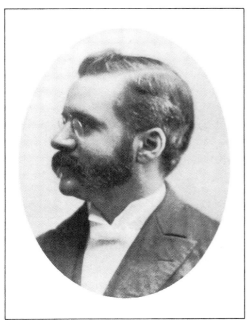

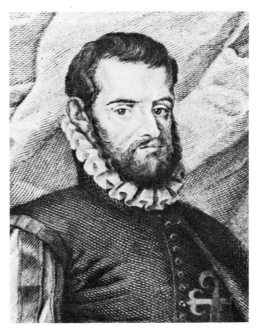

FREDERIC DE SOLA MENDES
(*left*)
(1850–1927)
Rabbi, editor, translator

PEDRO MENÉNDEZ DE AVILÉS
(*right*)
(1519–1574)
Spanish explorer, established Spanish rule
in Florida, founded St. Augustine

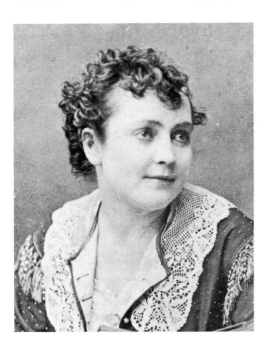

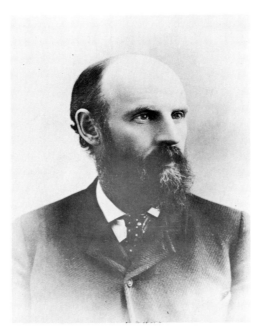

ADAH ISAACS MENKEN (*left*)
[nee Adah Bertha (Theodore?)]
(c. 1835–1868)
Actress, poet
*Courtesy Walter Hampden Memorial Library at The
Players, New York*

ASA MERCER (*right*)
[Asa Shinn Mercer]
(1839–1917)
Pioneer in State of Washington
Courtesy Washington State Historical Society

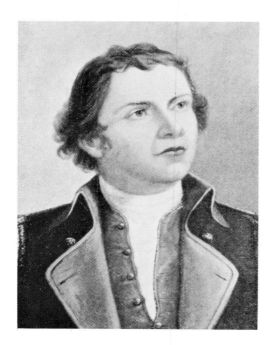
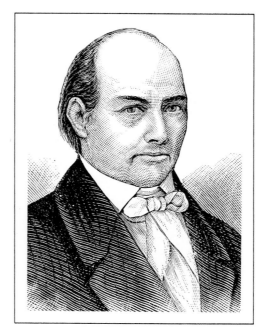

HUGH MERCER *(left)*
(*c.* 1725–1777)
Revolutionary general, aided Washington at Princeton

JESSE MERCER *(right)*
(1769–1841)
Baptist clergyman, founded Mercer University

OTTMAR MERGENTHALER *(left)*
(1854–1899)
Inventor of the linotype

CHARLES MERRIAM *(right)*
(1806–1887)
Printer, publisher of Merriam-Webster Dictionary
Courtesy G. & C. Merriam Co., publishers of the Merriam-Webster Dictionary

CLINTON HART MERRIAM *(left)*
(1855–1942)
Naturalist, ethnologist, physician

GEORGE MERRIAM *(right)*
(1803–1880)
Printer, publisher of Merriam-Webster Dictionary
Courtesy G. & C. Merriam Co., publishers of the Merriam-Webster Dictionary

GEORGE PERKINS MERRILL (*left*)
(1854–1929)
Geologist; curator, U.S. National Museum;
authority on meteorites

STUART FITZRANDOLPH MERRILL
(*right*)
(1863–1915)
Poet, affiliated with French Symbolists
Drawing by Albert Sterner

ALFRED MERRITT (*left*)
(1847–1926)
Mining prospector, railroad president; ex-
plored Mesabi Range
Courtesy St. Louis County Historical Society

ANNA MERRITT (*right*)
[nee Anna Lea]
(1844–1930)
Painter, etcher

CASSIUS CLAY MERRITT (*left*)
(1851–1894)
Mining prospector, explored Mesabi Range
Courtesy St. Louis County Historical Society

ISRAEL JOHN MERRITT (*right*)
(1829–1911)
Pioneer in marine salvage methods; founded
Merritt, Chapman & Scott

LEONIDAS MERRITT (*left*)
(1844–1926)
Mining prospector, discovered Mesabi iron
ore deposits
Courtesy St. Louis County Historical Society

WESLEY MERRITT (*right*)
(1834–1910)
Army officer; commanded first Philippine
Expedition, 1898; captured Manila

ADOLF MEYER (*left*)
(1866–1950)
Psychiatrist, educator
Courtesy New York Academy of Medicine

FRANÇOIS ANDRÉ MICHAUX
(*right*)
(1770–1855)
French horticulturist, studied trees of U.S.
Courtesy Muséum National d'Histoire Naturelle

ALBERT ABRAHAM MICHELSON
(*left*)
(1852–1931)
Physicist, determined speed of light; Nobel
Laureate

ARTHUR MIDDLETON (*right*)
(1742–1787)
Lawyer, Revolutionary leader, signer of
Declaration of Independence
Painted by Philip Wharton from a painting by Benjamin West. Courtesy Independence National Historical Park

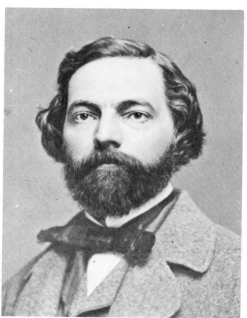

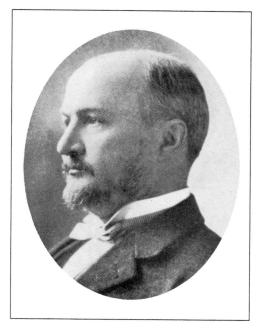

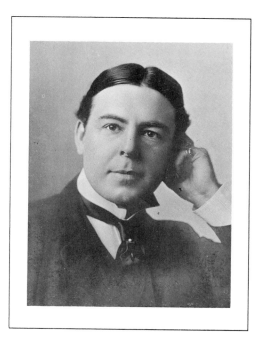

THOMAS MIFFLIN (*left*)
(1744–1800)
Revolutionary general, signer of Constitution, Governor of Pennsylvania
Engraved by E. Wellmore from a painting by Gilbert Stuart

NELSON APPLETON MILES (*right*)
(1839–1925)
Commander-in-chief, U.S. army, during Spanish-American War

WILLIAM PORCHER MILES (*left*)
(1822–1899)
Congressman, educator; first president, University of South Carolina
Courtesy Library of Congress, Brady-Handy Collection

CHARLES RANSOM MILLER (*right*)
(1849–1922)
Journalist; editor-in-chief, *The New York Times*

HENRY JOHN MILLER (*left*)
(1860–1926)
Actor, theater owner and manager

JOAQUIN MILLER (*right*)
[Cincinnatus Hiner Miller]
(1839–1913)
Poet, journalist

LEWIS MILLER (*left*)
(1829–1899)
Inventor, manufacturer of farm implements;
co-founder, Chautauqua movement

OLIVE THORNE MILLER (*right*)
[Mrs. Harriet Miller, nee Harriet Mann]
(1831–1918)
Ornithologist, author of books for children

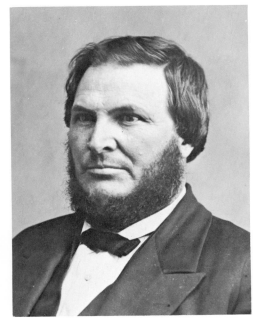

SAMUEL MILLER (*left*)
(1769–1850)
Presbyterian clergyman, educator; a found-
er of New-York Historical Society
*Painting by John Neagle. Courtesy Princeton Theologi-
cal Seminary*

SAMUEL FREEMAN MILLER (*right*)
(1816–1890)
Associate justice, U.S. Supreme Court
Courtesy Library of Congress, Brady-Handy Collection

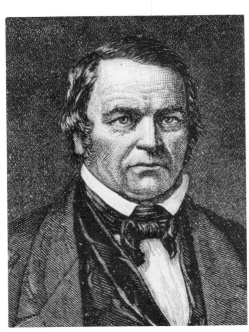

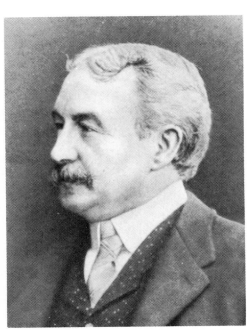

WILLIAM MILLER (*left*)
(1782–1849)
Adventist, founder of Adventist Church

FRANCIS DAVIS MILLET (*right*)
(1846–1912)
Painter, journalist; lost on the *Titanic*

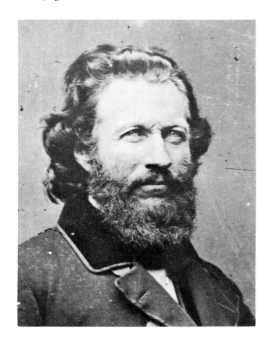

CLARK MILLS (*left*)
(1810–1883)
Sculptor
Courtesy National Archives, Brady Collection

DARIUS OGDEN MILLS (*right*)
(1825–1910)
Merchant, banker, philanthropist; established hotels for poor
Engraved by Alexander H. Ritchie from a photograph by Napoleon Sarony

ROBERT MILLS (*left*)
(1781–1855)
Architect, designed Washington Monument

MARTIN MILMORE (*right*)
(1844–1883)
Sculptor

CHARLES SEDGWICK MINOT
(*left*)
(1852–1914)
Physiologist, embryologist, educator

PETER MINUIT (*right*)
[Peter Minnewit]
(1580–1638)
Dutch colonist, director general of New Netherland; purchased Manhattan Island from Indians
Courtesy Library of Congress

ELISHA MITCHELL (*left*)
(1793–1857)
Geologist, botanist, educator

JOHN MITCHELL (*right*)
(1870–1919)
Labor leader; president, United Mine Workers of America

JOHN AMES MITCHELL (*left*)
(1845–1918)
Illustrator, magazine publisher, novelist; founded and published original *Life*

JOHN KEARSLEY MITCHELL (*right*)
(1793–1858)
Physician, chemist, educator
Courtesy Jefferson Medical College

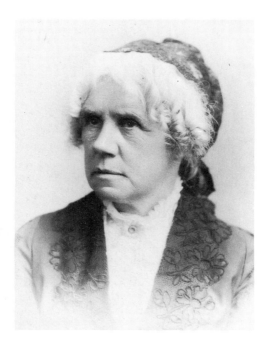

MAGGIE MITCHELL (*left*)
[Margaret Julia Mitchell]
(1837–1918)
Actress
Courtesy New-York Historical Society

MARIA MITCHELL (*right*)
(1818–1889)
Astronomer, educator; first woman elected to American Academy of Arts and Sciences
Courtesy Lick Observatory

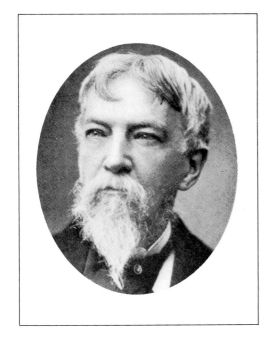
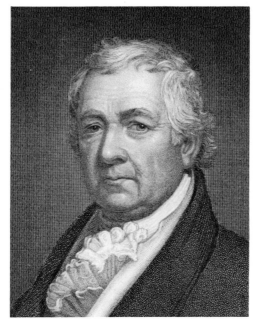

SILAS WEIR MITCHELL (*left*)
(1829–1914)
Physician, medical researcher, poet, novelist

SAMUEL LATHAM MITCHILL
(*right*)
(1764–1831)
Physician, educator, writer; U.S. Senator, Congressman
Engraved by Gimber and Dick from a painting by Henry Inman

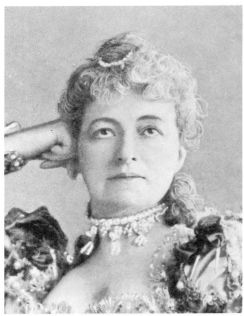

HELENA MODJESKA (*left*)
[Helena Modrzejewska, nee Helena Opid]
(1840–1909)
Polish-American actress

RALPH MODJESKI (*right*)
[Ralph Modrzejewski]
(1861–1940)
Bridge engineer
Courtesy Smithsonian Institution and Modjeski & Masters

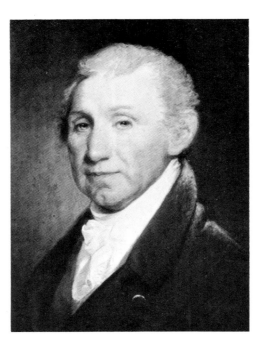

HARRIET STONE MONROE (*left*)
(1860–1936)
Poet, editor; founded and edited *Poetry: A Magazine of Verse*

JAMES MONROE (*right*)
(1758–1831)
President of the United States, 1817–1825
Painting by Gilbert Stuart

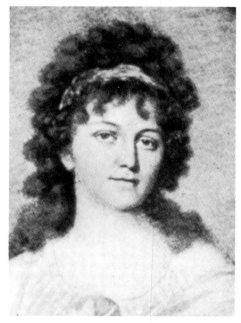

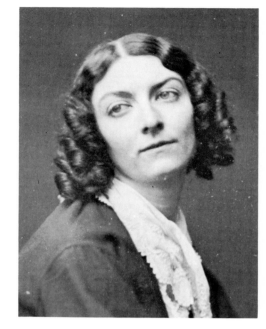

Mrs. JAMES MONROE (*left*)
[nee Eliza Kortright; Elizabeth Kortright]
(1768–1830)
First lady, 1817–1825
After a miniature by Sené

LOLA MONTEZ (*right*)
[Marie Dolores Eliza Rosanna Gilbert]
(*c.* 1818–1861)
English adventuress, dancer; settled in U.S.
Photograph by Southworth and Hawes. Courtesy Metropolitan Museum of Art, Stokes-Hawes Collection

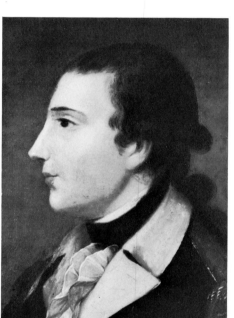

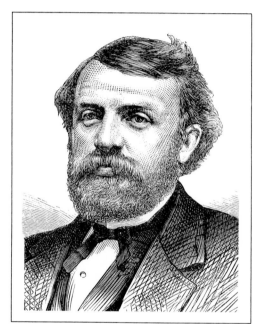

RICHARD MONTGOMERY (*left*)
(1738–1775)
Revolutionary general, took Montreal from the British
Painting by Charles Willson Peale. Courtesy Independence National Historical Park

DWIGHT LYMAN MOODY (*right*)
(1837–1899)
Evangelist

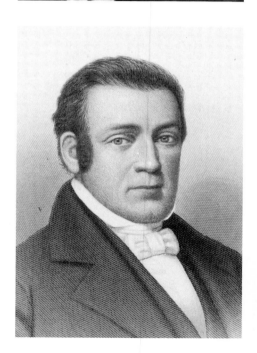

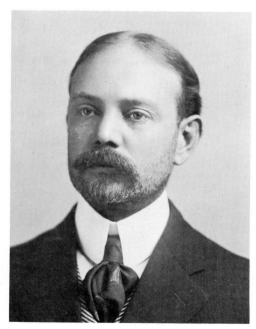

PAUL MOODY (*left*)
(1779–1831)
Inventor, developed improvements in cotton milling
Engraving by Alexander H. Ritchie

WILLIAM VAUGHN MOODY (*right*)
(1869–1910)
Playwright, poet, educator
Courtesy Walter Hampden Memorial Library at The Players, New York

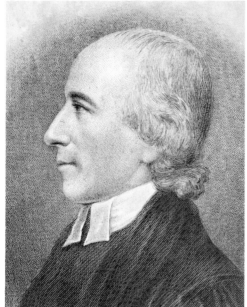

BENJAMIN MOORE (*left*)
(1748–1816)
Protestant Episcopal clergyman, president of Columbia College

CLEMENT CLARKE MOORE (*right*)
(1779–1863)
Hebraic scholar, poet; wrote "'Twas the night before Christmas . . ."

ELIAKIM HASTINGS MOORE (*left*)
(1862–1932)
Mathematician, educator
Courtesy Clarence P. Hornung Collection

GEORGE THOMAS MOORE (*right*)
(1871–1956)
Botanist, algologist

JOHN BASSETT MOORE (*left*)
(1860–1947)
Jurist, writer; professor of international law, Columbia University

JULIA A. MOORE (*right*)
(1847–1920)
Poet, the "Sweet Singer of Michigan"

VERANUS ALVA MOORE (*left*)
(1859–1931)
Pathologist, microbiologist
Courtesy Cornell University

SABATO MORAIS (*right*)
(1823–1897)
Rabbi; founder and president, Jewish
Theological Seminary of America

EDWARD MORAN (*left*)
(1829–1901)
Marine painter

THOMAS MORAN (*right*)
(1837–1926)
Landscape painter, illustrator

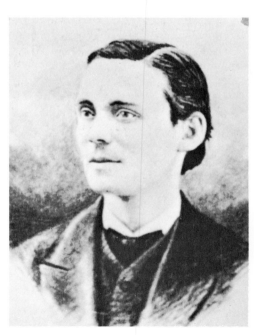

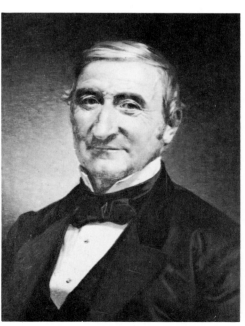

HENRY LYMAN MOREHOUSE
(*left*)
(1834–1917)
Baptist clergyman, home missionary, edu-
cator
Courtesy Library of Congress

CHARLES MORGAN (*right*)
(1795–1878)
Shipping magnate
Courtesy New-York Historical Society

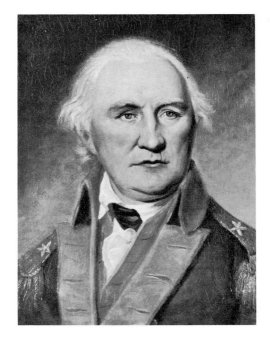

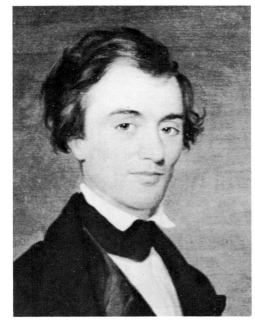

DANIEL MORGAN (*left*)
(1736–1802)
Revolutionary general, suppressed Whisky
Rebellion
Painting by Charles Willson Peale. Courtesy Independence National Historical Park

EDWIN BARBER MORGAN (*right*)
(1806–1881)
Merchant, first president of Wells, Fargo &
Co.; Congressman, philanthropist
Courtesy Wells College

JOHN MORGAN (*left*)
(1735–1789)
Chief physician, Continental Army; founded
University of Pennsylvania Medical College
Courtesy University of Pennsylvania Medical College

JOHN HUNT MORGAN (*right*)
(1825–1864)
Confederate cavalry commander, raider
Courtesy Library of Congress, Brady Collection

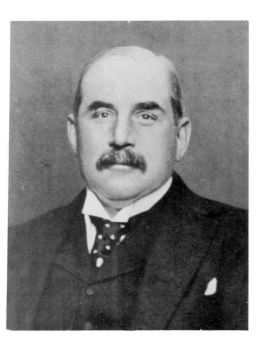

J. P. MORGAN (*left*)
[John Pierpont Morgan]
(1837–1913)
Financier, art collector
Courtesy Library of Congress

JOHN PIERPONT MORGAN (*right*)
(1867–1943)
Financier

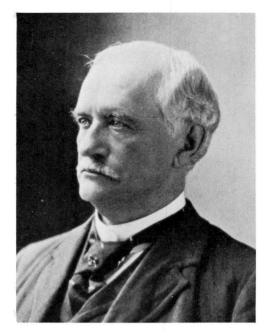

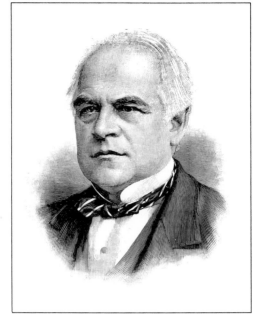

JOHN TYLER MORGAN *(left)*
(1824–1907)
Confederate general, U.S. Senator; promoted Nicaraguan canal

JUNIUS SPENCER MORGAN *(right)*
(1813–1890)
Banker, financier; father of J. P. Morgan

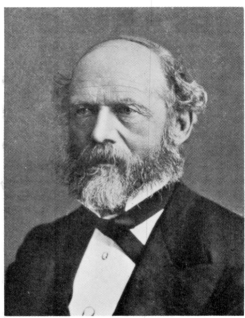

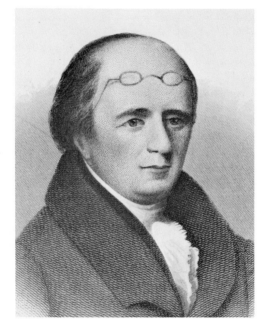

LEWIS HENRY MORGAN *(left)*
(1818–1881)
Ethnologist, known as "father of American anthropology"

WILLIAM MORGAN *(right)*
(*c.* 1774–*c.* 1826)
Freemason, disappeared while purportedly writing book exposing Masonic ritual
Engraving by J. A. J. Wilcox

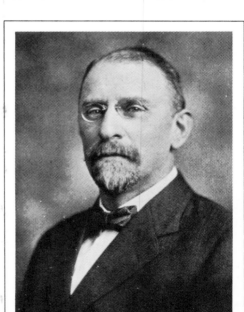

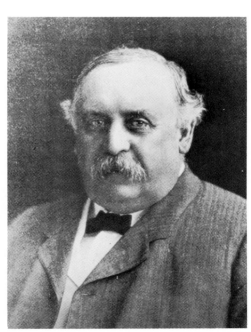

HENRY MORGENTHAU *(left)*
(1856–1946)
Lawyer, businessman, diplomat

GEORGE SHATTUCK MORISON
(right)
(1824–1903)
Bridge engineer
Courtesy Smithsonian Institution and James Kip Finch

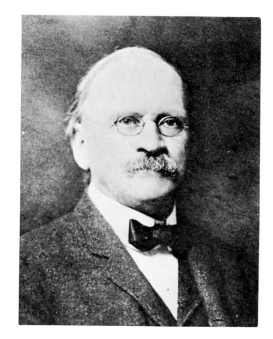

EDWARD WILLIAMS MORLEY
(left)
(1838–1923)
Chemist, physicist, educator
Courtesy Western Reserve University

PAUL CHARLES MORPHY *(right)*
(1837–1884)
Chess master

JUSTIN SMITH MORRILL *(left)*
(1810–1898)
Congressman, U.S. Senator; sponsor of
Morrill Land-Grant College Act

CLARA MORRIS *(right)*
[Clara Morrison; Clara La Montagne]
(1848–1925)
Actress

GEORGE POPE MORRIS *(left)*
(1802–1864)
Journalist, editor, poet; wrote "Woodman,
Spare That Tree"
Courtesy Library of Congress, Brady-Handy Collection

GEORGE SYLVESTER MORRIS
(right)
(1840–1889)
Philosopher, educator
Courtesy University of Michigan

GOUVERNEUR MORRIS (*left*)
(1752–1816)
Revolutionary political leader in New York and Pennsylvania; draftsman and signer of the Constitution; diplomat, diarist, U.S. Senator
Engraving by W. G. Jackman

LEWIS MORRIS (*right*)
(1726–1798)
Signer of Declaration of Independence
Painted by Charles Noel Flagg from a painting by John Trumbull. Courtesy Independence National Historical Park

NELSON MORRIS (*left*)
(1838–1907)
Meat packer, cattle breeder and trader

ROBERT MORRIS (*right*)
(1734–1806)
Financier of American Revolution; signer of Declaration of Independence, Articles of Confederation, and Constitution; U.S. Senator
Painting by Gilbert Stuart

JOHN MORRISSEY (*left*)
(1831–1878)
Prizefighter, gambler, U.S. Congressman
Engraving by George E. Perine

EDWARD SYLVESTER MORSE (*right*)
(1838–1925)
Zoologist, authority on Japanese culture

JEDIDIAH MORSE (*left*)
(1761–1826)
Congregational clergyman, "father of American geography"

SAMUEL FINLEY BREESE MORSE (*right*)
(1791–1872)
Inventor of electric telegraph and Morse code; painter; first president, National Academy of Design

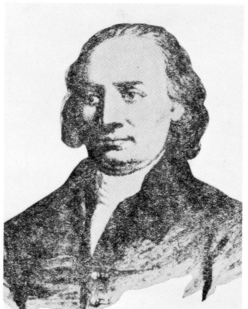

HENRY MORTON (*left*)
(1836–1902)
Scientist, educator; first president, Stevens Institute of Technology
Courtesy Stevens Institute of Technology

JOHN MORTON (*right*)
(*c.* 1724–1777)
Signer of Declaration of Independence
Courtesy Delaware County Historical Society

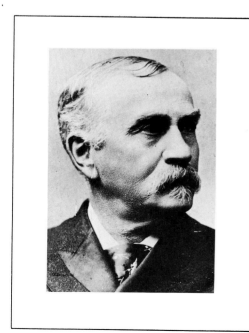

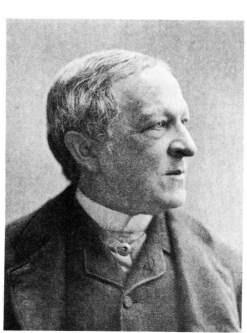

JULIUS STERLING MORTON (*left*)
(1832–1902)
Nebraska political leader, Secretary of Agriculture under Cleveland, sponsor of Arbor Day
Courtesy U.S. Department of Agriculture

LEVI PARSONS MORTON (*right*)
(1824–1920)
Banker, diplomat, Governor of New York; Vice-President of U.S., 1889–1893

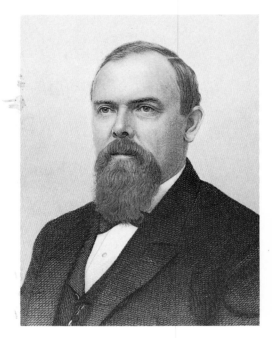
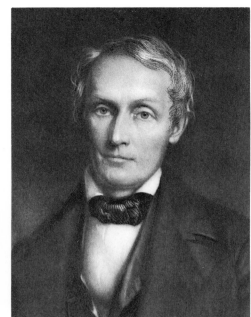

OLIVER PERRY MORTON (*left*)
[Oliver Hazard Perry Throck Morton]
(1823–1877)
Civil War Governor of Indiana, U.S. Senator
Engraving by John C. Buttre

SAMUEL GEORGE MORTON (*right*)
(1799–1851)
Physician, naturalist, anthropologist

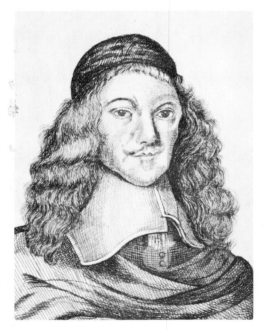
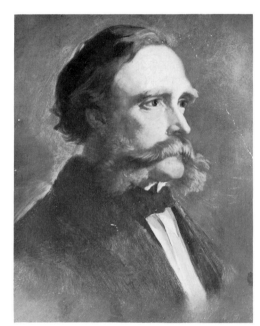

THOMAS MORTON (*left*)
(*c.* 1575–1646)
English adventurer in American colonies
Courtesy British Museum

WILLIAM THOMAS GREEN MORTON (*right*)
(1819–1868)
Dentist, pioneer in use of surgical anesthesia
Painting by Christian Schussele. Courtesy Massachusetts General Hospital

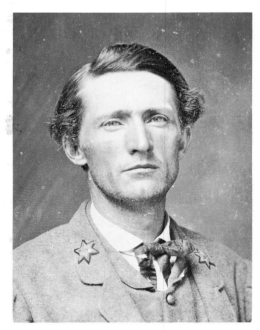
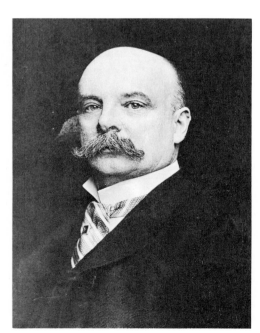

JOHN SINGLETON MOSBY (*left*)
(1833–1916)
Confederate ranger, lawyer
Courtesy Library of Congress, Brady-Handy Collection

THOMAS BIRD MOSHER (*right*)
(1852–1923)
Publisher
Courtesy Library of Congress

JOHANN JOSEPH MOST (*left*)
(1846–1906)
Anarchist

JOHN LOTHROP MOTLEY (*right*)
(1814–1877)
Historian, diplomat; authority on history of
the Netherlands
Engraving by John Sartain

JAMES MOTT (*left*)
(1788–1868)
Abolitionist, reformer

LUCRETIA MOTT (*right*)
[nee Lucretia Coffin]
(1793–1880)
Quaker preacher, abolitionist, feminist
Engraving by George E. Perine

VALENTINE MOTT (*left*)
(1785–1865)
Physician, surgeon, educator
Courtesy Library of Congress, Brady-Handy Collection

LOUISE CHANDLER MOULTON
(*right*)
[nee Ellen Louise Chandler]
(1835–1908)
Poet, writer of children's books

RICHARD GREEN MOULTON (*left*)
(1849–1924)
Critic, educator; edited *The Modern Reader's Bible*

WILLIAM MOULTRIE (*right*)
(1730–1805)
Revolutionary general, Governor of South Carolina
Engraved by Alexander H. Ritchie from a painting by John Trumbull

WILLIAM SIDNEY MOUNT (*left*)
(1807–1868)
Portrait and genre painter
Painting by Francis B. Carpenter. Courtesy New-York Historical Society

ANNA MOWATT (*right*)
[nee Anna Cora Ogden]
(1819–1870)
Writer, actress
Engraving by John C. Buttre

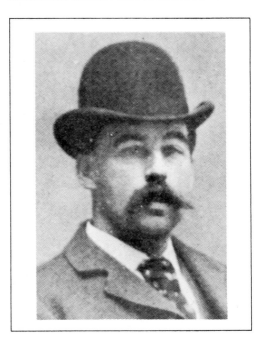

SAMUEL A. MUDD (*left*)
(1833–1883)
Physician, attended John Wilkes Booth during his flight
Courtesy Meserve Collection

HERMAN WEBSTER MUDGETT
(*right*)
[H. H. Holmes]
(1861–1896)
Murderer, confidence man; called "Criminal of the Century"

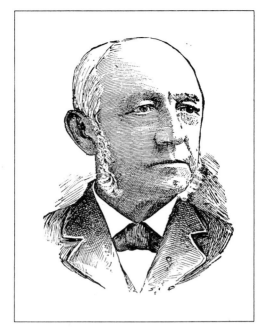

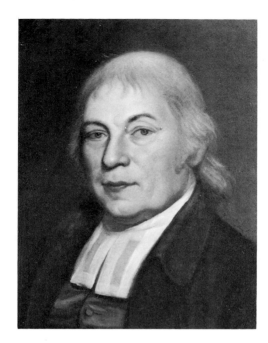

FREDERICK AUGUSTUS
MUHLENBERG (*left*)
(1818–1901)
Lutheran clergyman, classicist; first president, Muhlenberg College

GOTTHILF HENRY ERNEST
MUHLENBERG (*right*)
(1753–1815)
Lutheran clergyman, botanist
Painting by Charles Willson Peale. Courtesy Independence National Historical Park

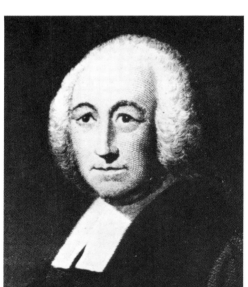

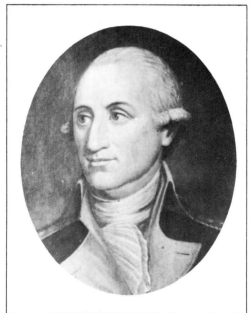

HENRY MELCHIOR MÜHLENBERG
(*left*)
[Heinrich Melchior Mühlenberg]
(1711–1787)
Lutheran clergyman, leader in founding American Lutheranism
Engraved by James W. Steel from a painting by Charles Willson Peale

JOHN PETER GABRIEL
MUHLENBERG (*right*)
(1746–1807)
Lutheran clergyman, Revolutionary general; Congressman, U.S. Senator
Painting by Gustav Behne. Courtesy Independence National Historical Park

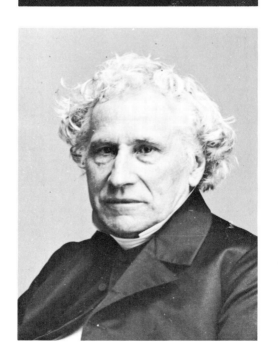

WILLIAM AUGUSTUS
MUHLENBERG (*left*)
(1796–1877)
Protestant Episcopal clergyman, hymn writer; founded St. Luke's Hospital, New York
Courtesy Library of Congress, Brady-Handy Collection

JOHN MUIR (*right*)
(1838–1914)
Naturalist, conservationist, writer
Courtesy Sierra Club

WILLIAM MULDOON (*left*)
(1852–1933)
Wrestler, physical culturist, devised the
medicine ball
After a photograph by Napoleon Sarony

ORSON DESAIX MUNN (*right*)
(1824–1907)
Editor and publisher of *Scientific American*
Engraving by George E. Perine

GEORGE MUNRO (*left*)
(1825–1896)
Publisher of dime novels and Seaside
Library reprints; philanthropist
Courtesy Dalhousie University

CHARLES EDWARD MUNROE
(*right*)
(1849–1938)
Chemist, explosives expert, educator; in-
vented smokeless powder

ALBERT HENRY MUNSELL (*left*)
(1858–1918)
Portrait painter, invented instruments for
color measurement

FRANK ANDREW MUNSEY (*right*)
(1854–1925)
Newspaper and magazine publisher; pub-
lished *Argosy*, *Munsey's*, and *New York Her-
ald*, *Sun*, and *Telegram*

HUGO MÜNSTERBERG *(left)*
(1863–1916)
Psychologist, educator
Photograph by Pach Brothers

JAMES EDWARD MURDOCH *(right)*
(1811–1893)
Actor, lecturer, elocutionist

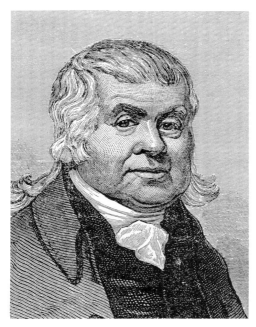

JOHN BENJAMIN MURPHY *(left)*
(1857–1916)
Surgeon, educator

JOHN MURRAY *(right)*
(1741–1815)
Universalist clergyman, founder of Universalism in America

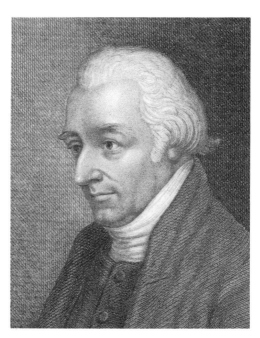

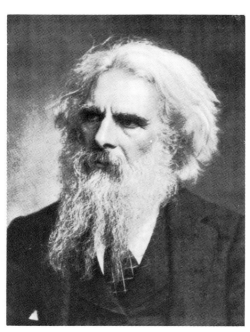

LINDLEY MURRAY *(left)*
(1745–1826)
Writer, authority on English grammar
Engraved by Stephen H. Gimber from a painting by Westoby

EADWEARD MUYBRIDGE *(right)*
[Edward James Muggeridge]
(1830–1904)
Pioneer in photography of motion

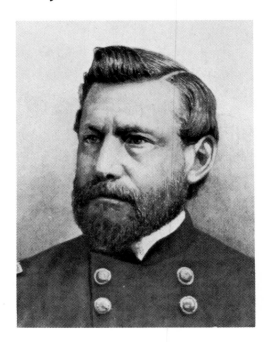

ALBERT JAMES MYER
(1829–1880)
Army officer, organized and commanded
Signal Corps; founded U.S. Weather Bureau

JAMES NAISMITH (*left*)
(1861–1939)
Inventor of basketball, pioneer in physical education
Courtesy Naismith Memorial Basketball Hall of Fame, Inc.

PETROLEUM V. NASBY (*right*)
[David Ross Locke]
(1833–1888)
Political satirist, journalist, wrote *The Nasby Letters*

CHARLES WILLIAM NASH (*left*)
(1864–1948)
Automobile manufacturer
Courtesy Detroit Public Library, Automotive History Collection

THOMAS NAST (*right*)
(1840–1902)
Political cartoonist, attacked Tweed Ring

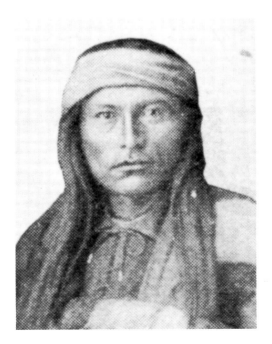

NATCHEZ (*left*)
(*born, c.* 1858)
Apache Indian, son of Cochise; ally of Geronimo

CARRY NATION (*right*)
[nee Carry Amelia Moore]
(1846–1911)
Temperance agitator, social reformer
Courtesy Kansas State Historical Society

JOHN NEAGLE (*left*)
(1796–1865)
Portrait painter

JOHN NEAL (*right*)
(1793–1876)
Novelist, essayist, editor

JOSEPH CLAY NEAL (*left*)
(1807–1847)
Humorist, journalist
Engraved by Thomas B. Welch after a miniature by
J. Tooley, Jr.

FRANCIS JOSEPH NICHOLAS NEEF
(*right*)
(1770–1854)
Educator, disciple of Pestalozzi
Courtesy New Harmony Workingmen's Institute

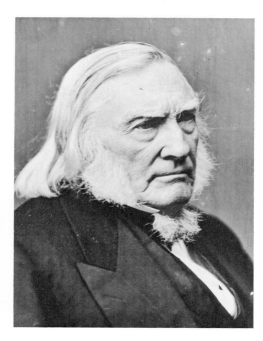

JOHN ULRIC NEF (*left*)
(1862–1915)
Chemist, educator
Courtesy University of Chicago

SAMUEL NELSON (*right*)
(1792–1873)
Jurist; associate justice, U.S. Supreme Court
Courtesy National Archives, Brady Collection

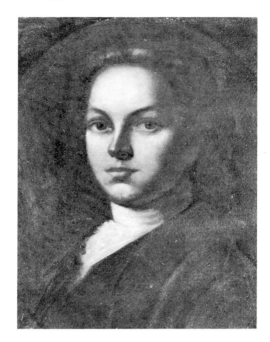

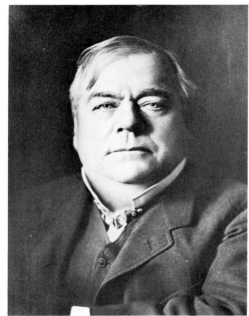

THOMAS NELSON (*left*)
(1738–1789)
Revolutionary patriot, signer of Declaration of Independence; Governor of Virginia
Painted by William Ludlow Sheppard from a painting by Mason Chamberlin. Courtesy Independence National Historical Park

WILLIAM ROCKHILL NELSON
(*right*)
(1841–1915)
Journalist, art patron; founder and editor, *Kansas City Evening Star*
Photograph by Pirie MacDonald. Courtesy "Kansas City Star"

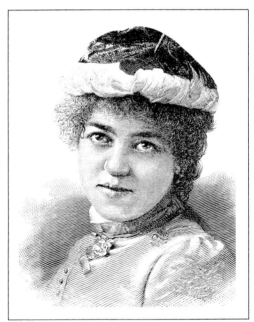

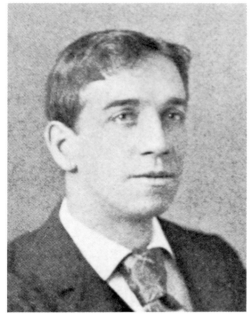

EMMA NEVADA (*left*)
[Emma Wixom]
(1862–1940)
Operatic soprano
After a photograph by Napoleon Sarony

ETHELBERT WOODBRIDGE NEVIN
(*right*)
(1862–1901)
Composer

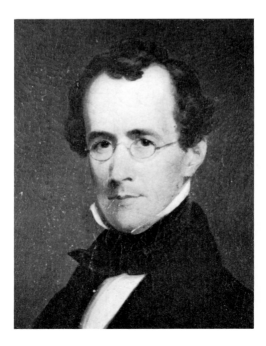

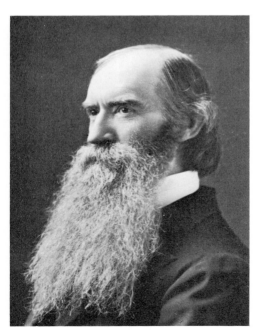

JOHN WILLIAMSON NEVIN (*left*)
(1803–1886)
Theologian; president, Franklin and Marshall College
Painting by Jacob Eichholtz. Courtesy John Nevin Sayre

JOHN STRONG NEWBERRY (*right*)
(1822–1892)
Geologist, paleontologist

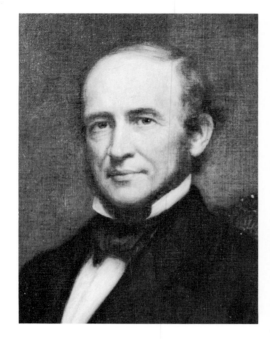

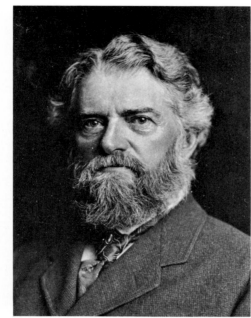

WALTER LOOMIS NEWBERRY
(*left*)
(1804–1868)
Merchant, banker; endowed Newberry
Library, Chicago
Painting by G. P. A. Healy. Courtesy Newberry Library

SIMON NEWCOMB (*right*)
(1835–1909)
Astronomer, educator, writer
Courtesy Harvard University Archives

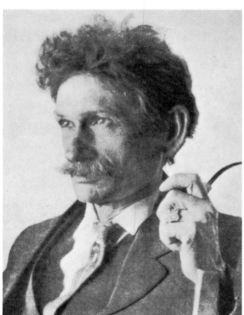

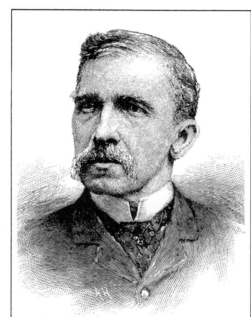

PETER SHEAF HERSEY NEWELL
(*left*)
(1862–1924)
Cartoonist, illustrator; writer of juvenile
books
Courtesy Meserve Collection

ROBERT HENRY NEWELL (*right*)
[Orpheus C. Kerr]
(1836–1901)
Humorist, journalist

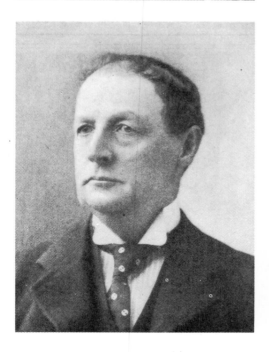

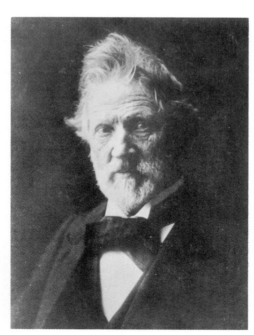

FRANCIS GRIFFITH NEWLANDS
(*left*)
(1848–1917)
Congressman, U.S. Senator

ROBERT LOFTIN NEWMAN (*right*)
(1827–1912)
Painter

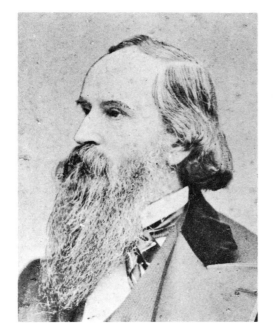

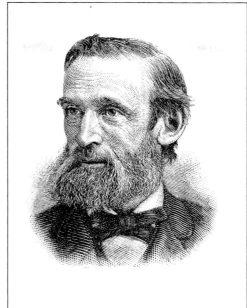

HENRY JOTHAM NEWTON (*left*)
(1823–1895)
Inventor, manufacturer, pioneer in dry-plate photographic process; theosophist
Courtesy Theosophical Society

HUBERT ANSON NEWTON (*right*)
(1830–1896)
Mathematician

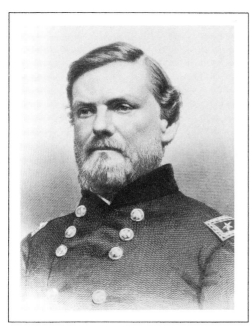

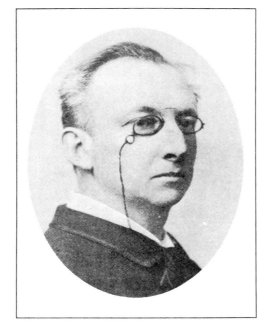

JOHN NEWTON (*left*)
(1823–1895)
Union general in Civil War, military engineer
Engraving by Alexander H. Ritchie

RICHARD HEBER NEWTON (*right*)
(1840–1914)
Protestant Episcopal clergyman

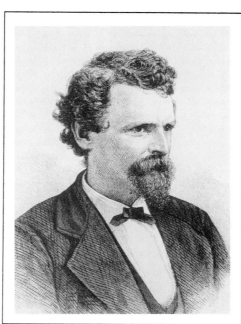

WILLIAM NIBLO (*left*)
(1789–1878)
Theater manager; proprietor of Niblo's Garden, New York City
Courtesy Museum of the City of New York

FRANCIS REDDING TILLOU NICHOLLS (*right*)
(1834–1912)
Confederate general, lawyer; governor and chief justice of Louisiana

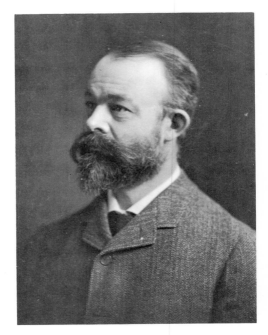

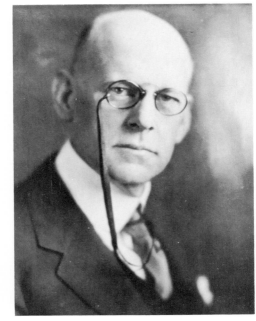

EDWARD LEAMINGTON NICHOLS
(*left*)
(1854–1937)
Physicist, educator; founded and edited
Physical Review, first U.S. journal of physics
Courtesy Cornell University

ERNEST FOX NICHOLS (*right*)
(1869–1924)
Physicist, educator; devised radiometer for
measuring planetary heat
Courtesy Columbiana Collection, Columbia University

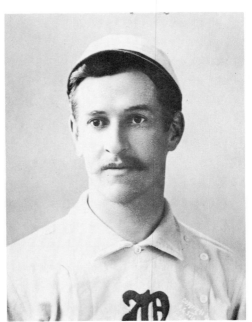

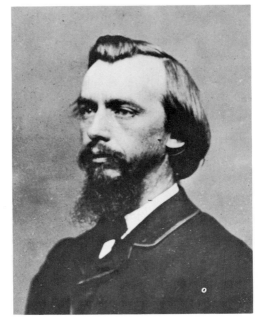

KID NICHOLS (*left*)
[Charles Arthur Nichols]
(1869–1953)
Baseball pitcher, member of Baseball Hall
of Fame
Courtesy National Baseball Hall of Fame

JOHN GEORGE NICOLAY (*right*)
(1832–1901)
Private secretary and biographer of Lincoln;
diplomat, marshal of U.S. Supreme Court
Courtesy New-York Historical Society

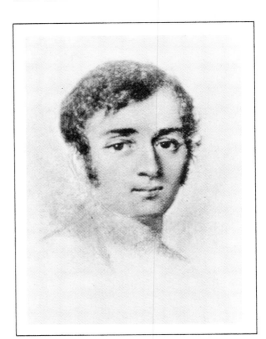

JOSEPH NICOLAS NICOLLET
(*left*)
(1786–1843)
French mathematician, explored upper
Mississippi and Missouri Rivers

CHARLES HENRY NIEHAUS (*right*)
(1855–1935)
Sculptor

ARTHUR NIKISCH (*left*)
(1855–1922)
Hungarian composer, conducted Boston Symphony Orchestra

CHRISTINE NILSSON (*right*)
(1843–1921)
Swedish soprano, sang Marguerite in *Faust* at opening of Metropolitan Opera House
Courtesy New-York Historical Society

CHARLES NISBET (*left*)
(1736–1804)
Presbyterian clergyman, educator; first president of Dickinson College
Courtesy Dickinson College

RICHARD MILHOUS NIXON (*right*)
(1913–)
Vice-President of U.S., 1953–1961

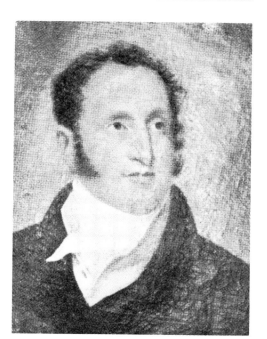

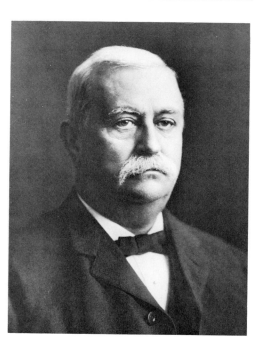

MORDECAI MANUEL NOAH (*left*)
(1785–1851)
Journalist, playwright, lawyer, diplomat
Painting by John Wesley Jarvis

ALFRED NOBLE (*right*)
(1844–1914)
Civil engineer
Courtesy Smithsonian Institution

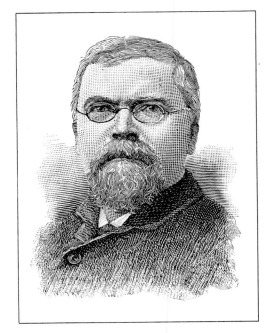

CHARLES NORDHOFF (*left*)
(1830–1901)
Journalist, writer

LILLIAN NORDICA (*right*)
[Lillian Norton]
(1859–1914)
Operatic soprano

FRANK NORRIS (*left*)
[Benjamin Franklin Norris, Jr.]
(1870–1902)
Novelist, author of *McTeague*
Courtesy Doubleday & Co.

ISAAC NORRIS (*right*)
(1701–1766)
Philadelphia merchant; suggested inscription for Liberty Bell

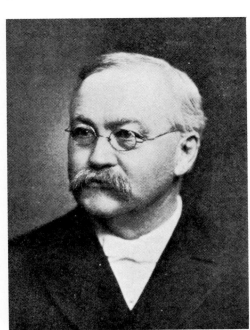

SIMEON NORTH (*left*)
(1765–1852)
Arms manufacturer

CYRUS NORTHROP (*right*)
(1834–1922)
Educator; president, University of Minnesota

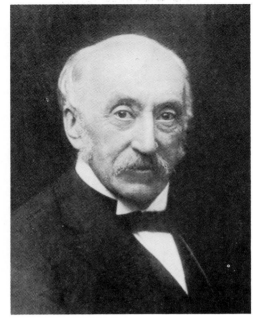

ANDREWS NORTON (*left*)
(1786–1853)
Biblical scholar, educator
Courtesy Harvard University Archives

CHARLES ELIOT NORTON (*right*)
(1827–1908)
Editor, writer, educator; a founder of *The Nation*
Courtesy American Academy of Arts and Letters

ELIPHALET NOTT (*left*)
(1773–1866)
Presbyterian clergyman, inventor, president of Union College

FREDERICK GEORGE NOVY (*right*)
(1864–1957)
Bacteriologist
Courtesy University of Michigan

JOHN HUMPHREY NOYES (*left*)
(1811–1886)
Reformer, founder of the Oneida Community
Courtesy Oneida Ltd.

GEORGE HENRY FALKINER NUTTALL (*right*)
(1862–1937)
Bacteriologist, leader in public health research, editor
Courtesy New York Academy of Medicine

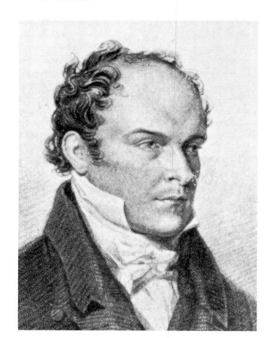

THOMAS NUTTALL (*left*)
(1786–1859)
Botanist, ornithologist

EDGAR WILSON NYE (*right*)
[Bill Nye]
(1850–1896)
Humorist, journalist, lecturer

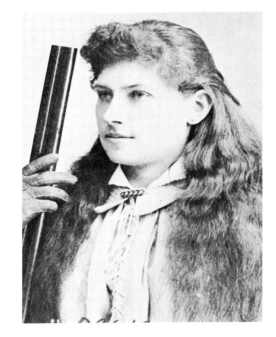

ANNIE OAKLEY (*left*)
[Phoebe Anne Oakley Mozee]
(1860–1926)
Marksman, circus performer
Courtesy Mercaldo Archives

FITZ-JAMES O'BRIEN (*right*)
(*c.* 1828–1862)
Short-story writer, poet, journalist

ADOLPH SIMON OCHS (*left*)
(1858–1935)
Publisher of *The New York Times* and *The Chattanooga Times*
Photograph by Pirie MacDonald.

LEONARD OCHTMAN (*right*)
(1854–1934)
Landscape painter
Painting by Dorothy Ochtman. Courtesy of the artist

CHARLES O'CONOR (*left*)
[Charles O'Connor]
(1804–1884)
Lawyer

AARON OGDEN (*right*)
(1756–1839)
U.S. Senator, Governor of New Jersey; steamship operator, prosecuted *Gibbons v. Ogden*
Engraving by John W. Orr

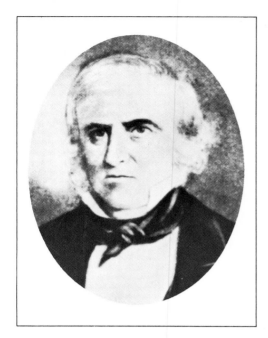

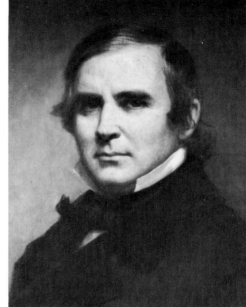

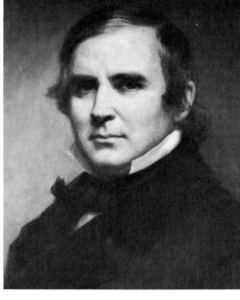

PETER SKENE OGDEN (*left*)
(1794–1854)
Fur trader, explorer; eponym of Ogden, Utah
Courtesy Utah State Historical Society

WILLIAM BUTLER OGDEN (*right*)
(1805–1877)
Railroad promoter; first mayor of Chicago; first president, Union Pacific Railroad
Painting by G. P. A. Healy. Courtesy Chicago Historical Society

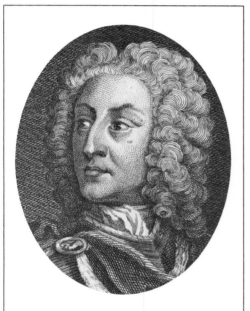

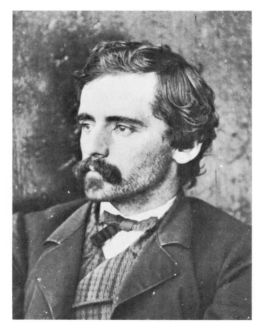

JAMES EDWARD OGLETHORPE (*left*)
(1696–1785)
British philanthropist, founder of Georgia
Engraving by Simon François Ravenet

MICHAEL O'LAUGHLIN (*right*)
(c. 1838–1867)
Conspirator in Lincoln assassination plot, died during ensuing imprisonment
Photograph by Alexander Gardner. Courtesy New-York Historical Society

CHAUNCEY OLCOTT (*left*)
[Chancellor John Olcott]
(1860–1932)
Singer, actor, song writer; wrote "Mother Machree," "My Wild Irish Rose"

HENRY STEEL OLCOTT (*right*)
(1832–1907)
Theosophist, social reformer; co-founder and first president, Theosophical Society
Courtesy Theosophical Society

BARNEY OLDFIELD (*left*)
(1878–1946)
Professional bicycle and automobile racer
Courtesy Automobile Manufacturers Association, Inc.

RANSOM ELI OLDS (*right*)
(1864–1950)
Automobile manufacturer
Courtesy Clarence P. Hornung Collection

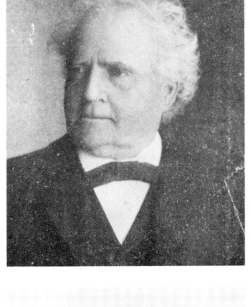

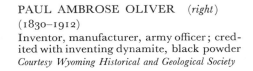

JAMES OLIVER (*left*)
(1823–1908)
Industrialist, inventor; manufactured hard-faced plows

PAUL AMBROSE OLIVER (*right*)
(1830–1912)
Inventor, manufacturer, army officer; credited with inventing dynamite, black powder
Courtesy Wyoming Historical and Geological Society

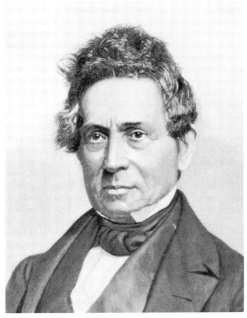

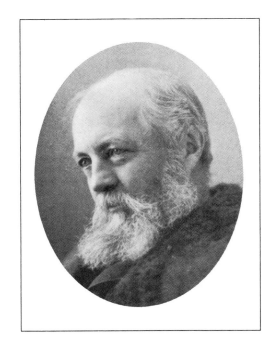

DENISON OLMSTED (*left*)
(1791–1859)
Physicist, astronomer, mathematician

FREDERICK LAW OLMSTED (*right*)
(1822–1903)
Landscape architect; designed Central Park, New York, and Prospect Park, Brooklyn

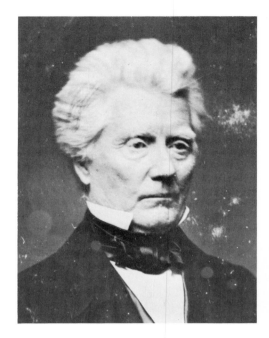

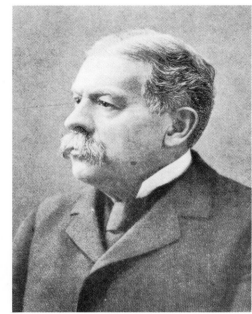

JESSE OLNEY (*left*)
(1798–1872)
Textbook writer, educator
Courtesy Stratford Historical Society

RICHARD OLNEY (*right*)
(1835–1917)
Attorney General and Secretary of State
under Cleveland

BENJAMIN TREDWELL
ONDERDONK (*left*)
(1791–1861)
Protestant Episcopal bishop, educator

HENRY USTICK ONDERDONK
(*right*)
(1789–1858)
Protestant Episcopal bishop, theologian

JAMES O'NEILL (*left*)
(1849–1920)
Actor, father of Eugene O'Neill

FREDERICK BURR OPPER (*right*)
(1857–1937)
Cartoonist, illustrator; created *Happy Hooligan*, *Alphonse and Gaston*

OLIVER OPTIC (*left*)
[William Taylor Adams]
(1822–1897)
Teacher, editor, writer of children's books

EDWARD OTHO CRESAP ORD
(*right*)
(1818–1883)
Union general in Civil War
Engraving by John A. O'Neill

GEORGE ORD (*left*)
(1781–1866)
Naturalist, philologist; completed Wilson's
Ornithology
Painted by T. Henry Smith from a painting by John Neagle

JAMES HENRY O'ROURKE (*right*)
(1852–1919)
Baseball player, member of Baseball Hall of Fame
Courtesy National Baseball Hall of Fame

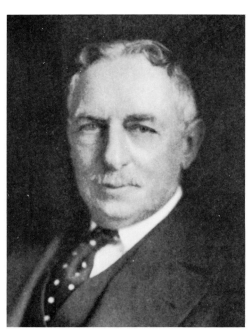

EDWARD FRANCIS BAXTER ORTON (*left*)
(1829–1899)
Geologist; first president, Ohio State University
Courtesy Ohio State University

HENRY FAIRFIELD OSBORN (*right*)
(1857–1935)
Paleontologist, writer, educator, museum administrator

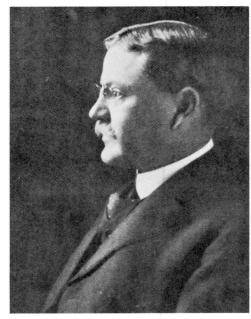
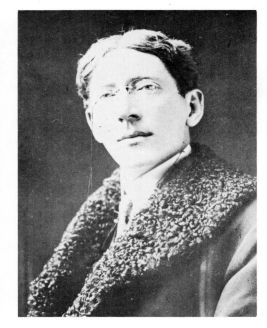

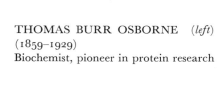

THOMAS BURR OSBORNE *(left)*
(1859–1929)
Biochemist, pioneer in protein research

LLOYD OSBOURNE *(right)*
(1868–1947)
Writer; stepson and collaborator of Robert
Louis Stevenson
Courtesy Huntly House Museum

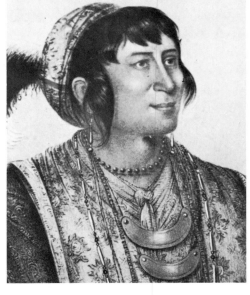
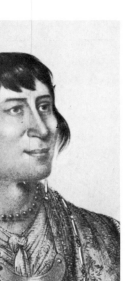
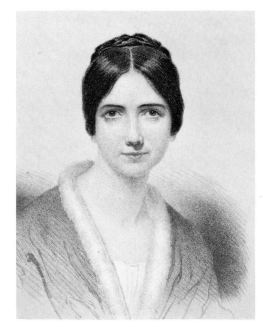

OSCEOLA *(left)*
[Asi Yahola]
(c. 1800–1838)
Seminole Indian leader
Lithograph by George Catlin. Courtesy New-York Historical Society

FRANCES SARGENT OSGOOD
(right)
[nee Frances Sargent Locke]
(1811–1850)
Poet
Engraved by John Rogers from a painting by S. S. Osgood

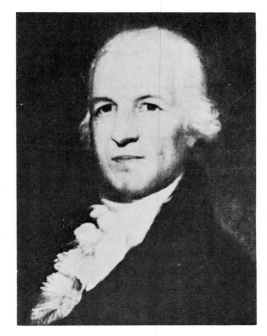

SAMUEL OSGOOD *(left)*
(1748–1813)
Revolutionary leader, Postmaster General
under Washington
Painting by John Trumbull

WILLIAM FOGG OSGOOD *(right)*
(1864–1943)
Mathematician, educator
Courtesy Mrs. Celeste Phelps Osgood

Sir WILLIAM OSLER (*left*)
(1849–1919)
Canadian-born physician, educator, taught in U.S. for twenty-one years
Painting by Thomas C. Corner. Courtesy Johns Hopkins University

BASS OTIS (*right*)
(1784–1861)
Portrait painter, engraver; made first lithograph in U.S.
Self-portrait

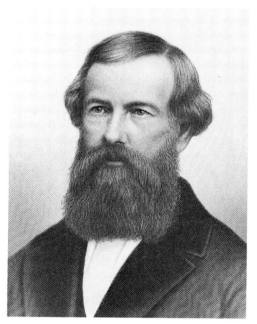
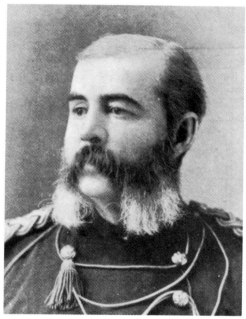

ELISHA GRAVES OTIS (*left*)
(1811–1861)
Manufacturer, developed first elevator to incorporate safety devices
Engraving by H. B. Hall's Sons

ELWELL STEPHEN OTIS (*right*)
(1838–1909)
Army officer, military governor of Philippines; quelled Philippine insurrection, 1899–1900

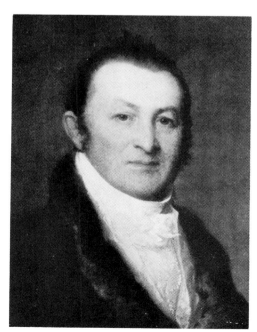

HARRISON GRAY OTIS (*left*)
(1765–1848)
U.S. Senator, mayor of Boston
Painting by Gilbert Stuart

HARRISON GRAY OTIS (*right*)
(1837–1917)
Journalist, army officer

JAMES OTIS *(left)*
(1725–1783)
Revolutionary agitator, politician, political writer

Engraved by W. G. Jackman after a painting by John Singleton Copley

PHILIP WILLIAM OTTERBEIN *(right)*
(1726–1813)
German Reformed clergyman, a founder of the United Brethren in Christ

Courtesy Enoch Pratt Free Library

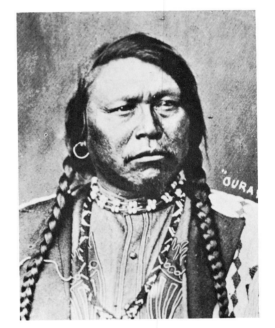

OURAY *(left)*
(c. 1833–1880)
Ute Indian chief

Courtesy Mercaldo Archives

OUTACITY *(right)*
(fl. 1756–1777)
Cherokee Indian chief

Engraving by John W. Orr

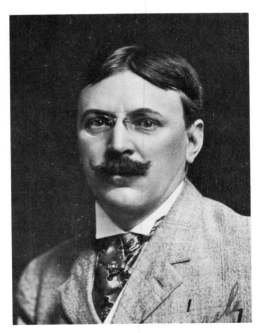

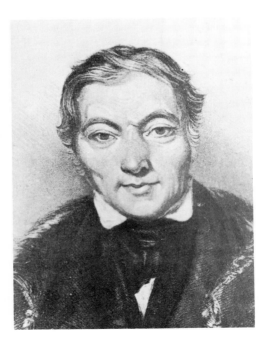

RICHARD FELTON OUTCAULT *(left)*
(1863–1928)
Cartoonist; originated *Buster Brown, Yellow Kid* comic strips

ROBERT OWEN *(right)*
(1771–1858)
Welsh socialist; founded utopian society at New Harmony, Indiana

Courtesy Don Blair, New Harmony Workingmen's Institute

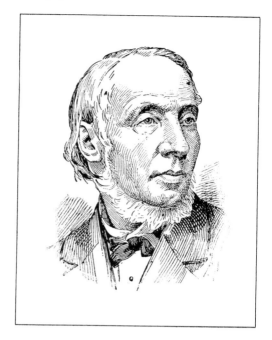

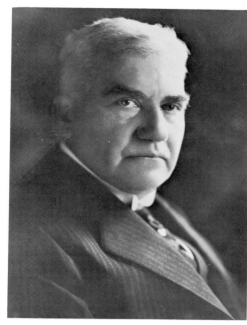

ROBERT DALE OWEN *(left)*
(1801–1877)
Social reformer at New Harmony, Indiana;
writer, editor, Congressman, diplomat

MICHAEL JOSEPH OWENS *(right)*
(1859–1923)
Glass manufacturer, inventor
Courtesy Libbey-Owens-Ford Glass Co.

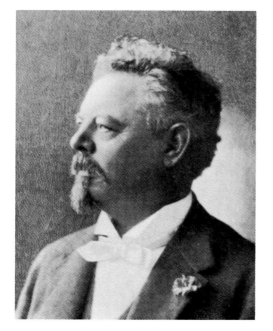
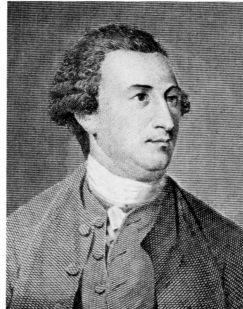

FREDERICK PABST (*left*)
(1836–1904)
Brewer, businessman

WILLIAM PACA (*right*)
(1740–1799)
Revolutionary leader, signer of Declaration
of Independence; Governor of Maryland
Engraved by P. Maverick from a drawing by James B.
Longacre after a painting by John Singleton Copley

ALPHEUS SPRING PACKARD (*left*)
(1839–1905)
Entomologist, educator, editor

JAMES WARD PACKARD (*right*)
(1863–1928)
Automobile designer and builder; inventor,
engineer
Courtesy Automobile Manufacturers Association, Inc.

SILAS SADLER PACKARD (*left*)
(1826–1898)
Pioneer in business education

ASA PACKER (*right*)
(1805–1879)
Financier, Congressman; built Lehigh Val-
ley Railroad; endowed Lehigh University

IGNACE PADEREWSKI (*left*)
(1860–1941)
Polish pianist, diplomat

DAVID PERKINS PAGE (*right*)
(1810–1848)
Educator

THOMAS NELSON PAGE (*left*)
(1853–1922)
Novelist, diplomat

WALTER HINES PAGE (*right*)
[Nicholas Worth]
(1855–1918)
Journalist, diplomat, editor, publisher, novelist

WILLIAM PAGE (*left*)
(1811–1885)
Portrait painter
Photograph by Mathew Brady

ALBERT BIGELOW PAINE (*right*)
(1861–1937)
Writer, editor; literary executor and biographer of Mark Twain

JOHN KNOWLES PAINE (*left*)
(1839–1906)
Composer, organist; first professor of music in university in U.S.

ROBERT TREAT PAINE (*right*)
(1731–1814)
Jurist, political leader; signer of Declaration of Independence
Painted by Richard M. Staigg from a painting by Edward Savage. Courtesy Independence National Historical Park

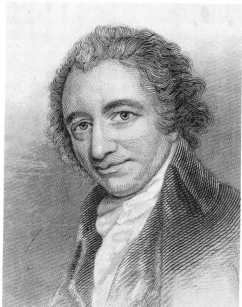

ROBERT TREAT PAINE (*left*)
(1773–1811)
Poet, satirist

THOMAS PAINE (*right*)
(1737–1809)
Revolutionary agitator, pamphleteer, philosopher; author of *The Age of Reason*
Engraved by Illman & Sons after a painting by George Romney

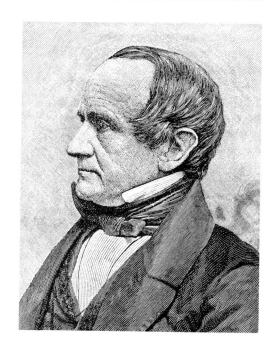

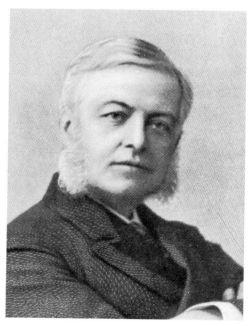

JOHN GORHAM PALFREY (*left*)
(1796–1881)
Unitarian clergyman, historian, Congressman, editor

ALBERT MARSHMAN PALMER
(*right*)
(1838–1905)
Theater manager

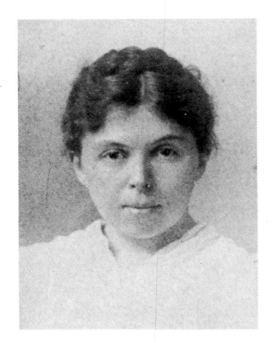

ALICE FREEMAN PALMER (*left*)
[nee Alice Elvira Freeman]
(1855–1902)
Educator, president of Wellesley College

AUSTIN NORMAN PALMER (*right*)
(1857–1927)
Penman, educator; developed Palmer hand-
writing method
Courtesy William C. Henning

DANIEL DAVID PALMER (*left*)
(1845–1913)
Founder of chiropractic
Courtesy Chiropractic Institute of New York

EDWARD PALMER (*right*)
(1831–1911)
Botanist, botanical collector
Courtesy Smithsonian Institution

ERASTUS DOW PALMER (*left*)
(1817–1904)
Sculptor

GEORGE HERBERT PALMER (*right*)
(1842–1933)
Philosopher, educator

JOHN McAULEY PALMER (*left*)
(1817–1900)
Union general in Civil War, U.S. Senator, Governor of Illinois

NATHANIEL BROWN PALMER
(*right*)
(1799–1877)
Sea captain, South Sea explorer; discovered Antarctic Continent
Painting by Samuel L. Waldo. Courtesy Frick Art Reference Library

POTTER PALMER (*left*)
(1826–1902)
Chicago merchant, financier; built Palmer House, Chicago

Mrs. POTTER PALMER (*right*)
[nee Bertha Honoré]
(1849–1918)
Chicago society leader, philanthropist

TIMOTHY PALMER (*left*)
(1751–1821)
Bridge engineer
Courtesy Smithsonian Institution and George B. Pease Collection

EDWARDS AMASA PARK (*right*)
(1808–1900)
Congregational clergyman, theologian, editor
Daguerreotype by Mathew Brady. Courtesy Library of Congress

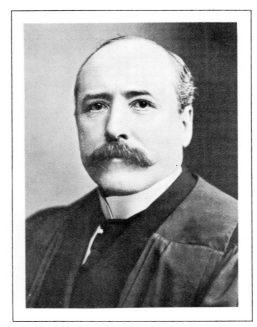

WILLIAM HALLOCK PARK *(left)*
(1863–1939)
Bacteriologist, serologist
Courtesy New York City Department of Health

ALTON BROOKS PARKER *(right)*
(1852–1926)
Lawyer, jurist, Democratic political leader

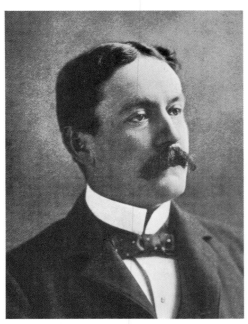

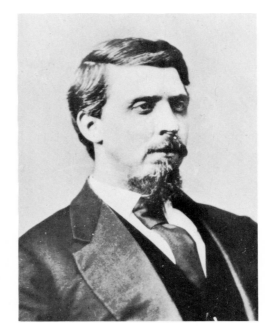

HORATIO WILLIAM PARKER *(left)*
(1863–1919)
Composer, educator, organist

ISAAC CHARLES PARKER *(right)*
(1838–1896)
Western jurist, lawyer, Congressman; called
"The Hanging Judge," reputedly sentenced
162 men to death
Courtesy Mercaldo Archives

SAMUEL PARKER *(left)*
(1779–1866)
Congregational clergyman; explorer and
missionary in Oregon Territory

THEODORE PARKER *(right)*
(1810–1860)
Unitarian clergyman, theologian, aboli-
tionist, reformer

WILLARD PARKER (*left*)
(1800–1884)
Surgeon, educator; pioneer in surgery for appendicitis

CHARLES HENRY PARKHURST
(*right*)
(1842–1933)
Presbyterian clergyman, reformer; denounced vice and corruption in New York City

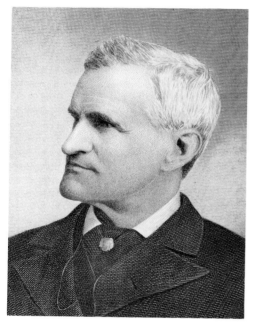
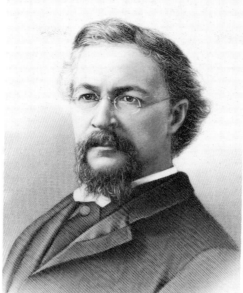

FRANCIS PARKMAN (*left*)
(1823–1893)
Historian
Engraving by H. B. Hall's Sons

GEORGE PARKMAN (*right*)
(1790–1849)
Boston physician, murdered by Professor John White Webster of Harvard

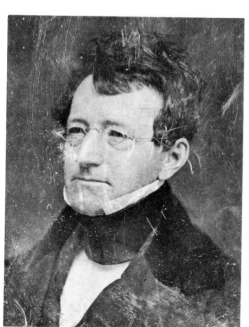

PETER PARLEY (*left*)
[Samuel Griswold Goodrich]
(1793–1860)
Publisher, editor; author of children's books
Daguerreotype by Mathew Brady. Courtesy Library of Congress

CHARLES CHRISTOPHER PARRY
(*right*)
(1823–1890)
Botanist
Engraving by E. G. Williams & Bro. Courtesy New York Academy of Medicine

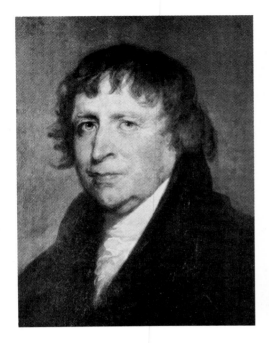

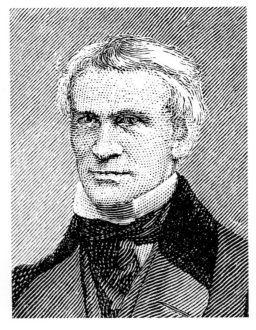

THEOPHILUS PARSONS (*left*)
(1750–1813)
Lawyer, jurist
Painting by Gilbert Stuart

THOMAS WILLIAM PARSONS
(*right*)
(1819–1892)
Poet, translator of Dante

WILLIAM BARCLAY PARSONS
(*left*)
(1859–1932)
Civil engineer, supervised construction of
first New York subway

JAMES PARTON (*right*)
(1822–1891)
Biographer, journalist

WILLIAM ORDWAY PARTRIDGE
(*left*)
(1861–1930)
Sculptor

TONY PASTOR (*right*)
[Antonio Pastor]
(1837–1908)
Theater manager, actor
Photograph by Napoleon Sarony

WILLIAM PATERSON (*left*)
(1745–1806)
Signer of the Constitution; U.S. Senator,
Governor of New Jersey; associate justice,
U.S. Supreme Court
Painting attributed to James Sharples, Sr.

GILBERT PATTEN (*right*)
[Burt L. Standish]
(1866–1945)
Writer, author of Frank Merriwell stories

SIMON NELSON PATTEN (*left*)
(1852–1922)
Economist, educator
Courtesy University of Pennsylvania

Mrs. DAVID T. PATTERSON (*right*)
[nee Martha Johnson]
(1828–1901)
Daughter of Andrew Johnson; White House
hostess

JOHN HENRY PATTERSON (*left*)
(1844–1922)
Cash register manufacturer
Courtesy National Cash Register Co.

ADELINA PATTI (*right*)
[Adela Juana Maria Patti]
(1843–1919)
Italian operatic soprano, popular in U.S.

FRANCIS LANDEY PATTON (*left*)
(1843–1932)
Presbyterian clergyman, theologian, educator; president, Princeton University
Photograph by Pach Brothers. Courtesy Princeton University Archives

JOHN PAUL (*right*)
[Charles Henry Webb]
(1834–1905)
Journalist, humorist; founded the *Californian*

HIRAM PAULDING (*left*)
(1797–1878)
Naval officer
Courtesy Library of Congress, Brady Collection

JAMES KIRKE PAULDING (*right*)
(1778–1860)
Novelist, poet; Secretary of the Navy under Van Buren

PAWNEE BILL (*left*)
[Gordon William Lillie]
(1860–1942)
Showman, rancher
Courtesy New-York Historical Society

WILLIAM McGREGOR PAXTON
(*right*)
(1869–1941)
Portrait painter
Courtesy Peter A. Juley & Son

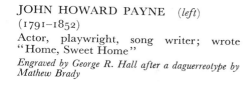

JOHN HOWARD PAYNE (*left*)
(1791–1852)
Actor, playwright, song writer; wrote
"Home, Sweet Home"
*Engraved by George R. Hall after a daguerreotype by
Mathew Brady*

LEWIS PAYNE (*right*)
[Lewis Thornton Powell]
(1845–1865)
Conspirator; hanged for part in Lincoln
assassination plot
*Photograph by Alexander Gardner. Courtesy New-York
Historical Society*

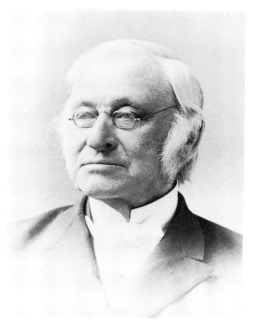

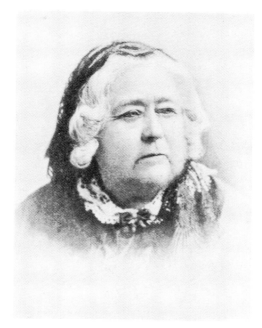

ANDREW PRESTON PEABODY
(*left*)
(1811–1893)
Unitarian clergyman, writer, educator;
published and edited *North American Review*
Courtesy New-York Historical Society

ELIZABETH PALMER PEABODY
(*right*)
(1804–1894)
Educator, writer

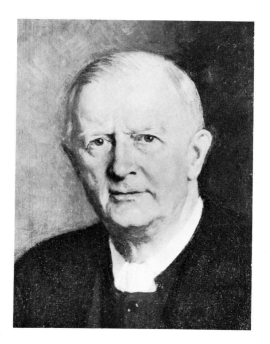

ENDICOTT PEABODY (*left*)
(1857–1944)
Protestant Episcopal clergyman; a founder
and first headmaster of Groton School
Painting by Ellen Emmet Rand. Courtesy Groton School

GEORGE PEABODY (*right*)
(1795–1869)
Merchant, financier, philanthropist; en-
dowed Peabody Institute, Baltimore

GEORGE FOSTER PEABODY (*left*)
(1852–1938)
Investment banker, philanthropist; promoted Southern education

JOSEPH PEABODY (*right*)
(1757–1844)
Salem shipping magnate

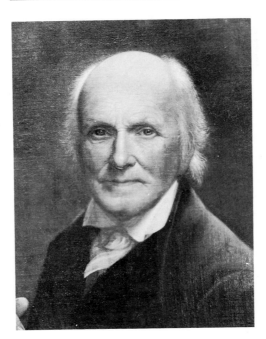

MARY TYLER PEABODY (*left*)
[Mrs. Horace Mann]
(1806–1887)
Educator, writer

CHARLES WILLSON PEALE (*right*)
(1741–1827)
Portrait painter, naturalist
Self-portrait. Courtesy Pennsylvania Academy of the Fine Arts

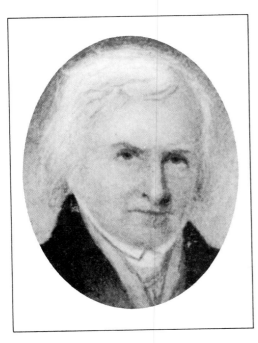

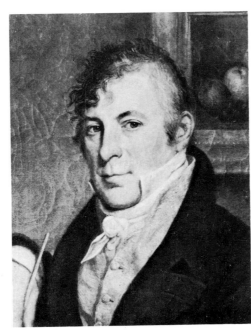

JAMES PEALE (*left*)
(1749–1831)
Portrait painter, miniaturist
Self-portrait

RAPHAEL PEALE (*right*)
(1774–1825)
Painter
Painting by Charles Willson Peale. Courtesy Smithsonian Institution

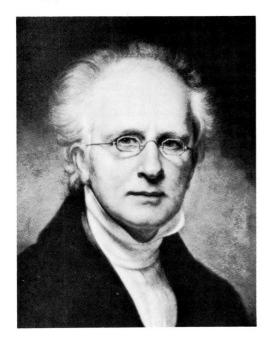

REMBRANDT PEALE　(*left*)
(1778–1860)
Painter
Self-portrait

TITIAN RAMSAY PEALE　(*right*)
(1799–1885)
Painter, naturalist
Self-portrait

RICHARD PEARSON　(*left*)
(1731–1806)
English naval officer, commanded *Serapis* against *Bon Homme Richard*
Painting by Gilbert Stuart

ROBERT EDWIN PEARY　(*right*)
(1856–1920)
Arctic explorer, naval officer; first to reach North Pole
Courtesy Burndy Library

Mrs. **ROBERT EDWIN PEARY**　(*left*)
[nee Josephine Diebitsch]
(1863–1955)
Accompanied husband on explorations; gave birth farther north than any other white woman

ELIA WILKINSON PEATTIE　(*right*)
(1862–1935)
Journalist, editor, critic, writer

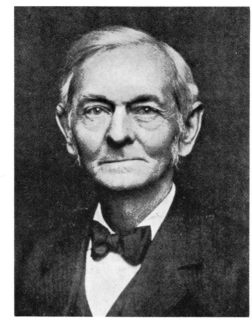

ANNIE SMITH PECK (*left*)
(1850–1935)
Mountain climber, lecturer, writer

CHARLES HORTON PECK (*right*)
(1833–1917)
Mycologist, pioneer in study of fungi

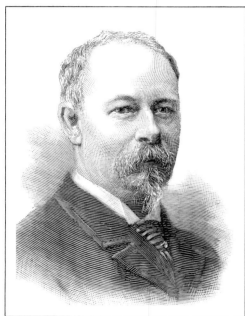

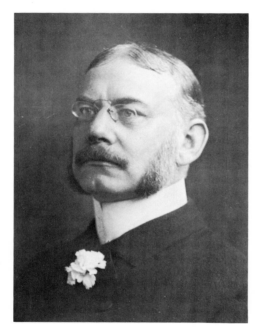

GEORGE WILBUR PECK (*left*)
(1840–1916)
Journalist, humorist, wrote *Peck's Bad Boy*
series; Governor of Wisconsin

HARRY THURSTON PECK (*right*)
(1856–1914)
Classical scholar, editor, educator, critic
Courtesy Columbiana Collection, Columbia University

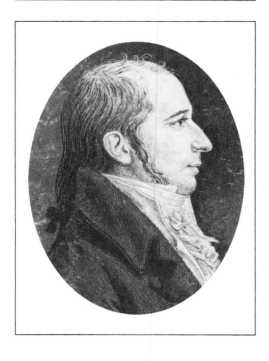

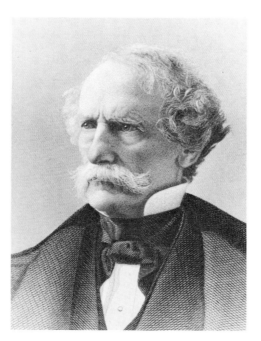

WILLIAM DANDRIDGE PECK (*left*)
(1763–1822)
Entomologist, educator
Engraving by G. L. Chrétien. Courtesy Harvard University Archives

RUFUS WHEELER PECKHAM (*right*)
(1838–1909)
Lawyer, jurist; associate justice, U.S.
Supreme Court
Engraved by John C. Buttre from a photograph by Napoleon Sarony

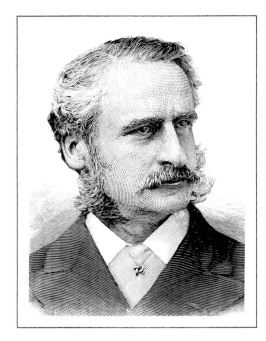

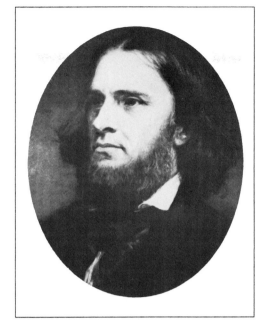

WHEELER HAZARD PECKHAM
(*left*)
(1833–1905)
Lawyer, prosecuted Tweed Ring
After a photograph by Napoleon Sarony

BENJAMIN PEIRCE (*right*)
(1809–1880)
Mathematician, astronomer, educator
Courtesy McMaster University

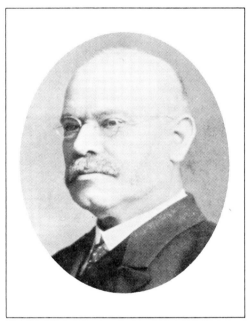

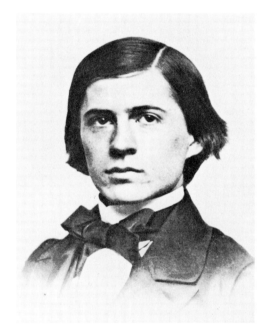

BENJAMIN OSGOOD PEIRCE (*left*)
(1854–1914)
Mathematician, physicist, educator
Courtesy Harvard University Archives

CHARLES SANDERS PEIRCE (*right*)
(1839–1914)
Philosopher, logician, mathematician
Courtesy Harvard University Archives

CYRUS PEIRCE (*left*)
(1790–1860)
Educator, Congregational clergyman
Engraving by H. W. Smith. Courtesy Free Library of Philadelphia

JOHN CLIFFORD PEMBERTON
(*right*)
(1814–1881)
Confederate general, led defense of Vicksburg
Courtesy Library of Congress

EDMUND PENDLETON (*left*)
(1721–1803)
Revolutionary leader, jurist

GEORGE HUNT PENDLETON (*right*)
(1825–1889)
U.S. Senator, Congressman, diplomat
Engraving by W. G. Jackman

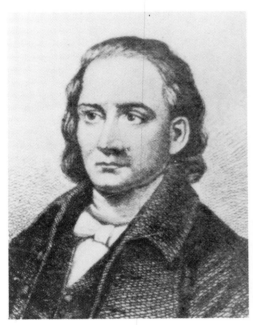

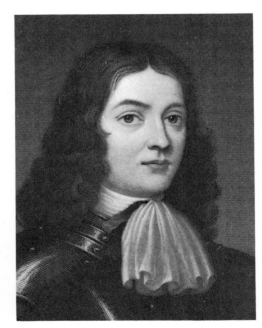

JOHN PENN (*left*)
(*c.* 1740–1788)
Signer of Declaration of Independence
Courtesy University of North Carolina

WILLIAM PENN (*right*)
(1644–1718)
English Quaker leader, proprietor of Pennsylvania
Engraved by John Sartain from a painting attributed to Sir Peter Lely

JOSEPH PENNELL (*left*)
(1857–1926)
Graphic artist, writer
Photograph by Pirie MacDonald. Courtesy New-York Historical Society

BOIES PENROSE (*right*)
(1860–1921)
Pennsylvania Republican leader, U.S. Senator

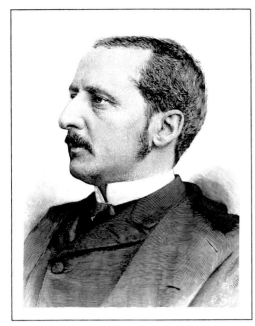

WILLIAM PEPPER (*left*)
(1843–1898)
Physician, philanthropist; provost of University of Pennsylvania

Sɪʀ **WILLIAM PEPPERRELL** (*right*)
[Sir William Pepperell]
(1696–1759)
Merchant, army officer, leader in Colonial New England; first native American created a baronet
Painting by John Smibert

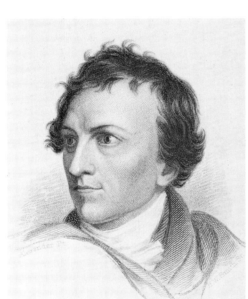

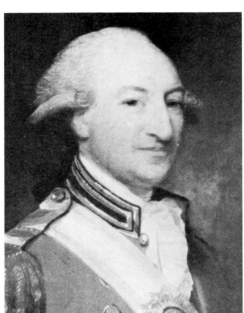

JAMES GATES PERCIVAL (*left*)
(1795–1856)
Poet, geologist
Engraved by H. W. Smith from a painting by Francis Alexander

Sɪʀ **HUGH PERCY**, 2ɴᴅ Dᴜᴋᴇ ᴏғ NORTHUMBERLAND (*right*)
(1742–1817)
British general in American Revolution
Painting by Gilbert Stuart

GEORGE WALBRIDGE PERKINS
(*left*)
(1862–1920)
Financier, insurance executive, civic leader

JACOB PERKINS (*right*)
(1766–1849)
Inventor, bank-note manufacturer
Lithograph by John Pendleton from a painting by Thomas Edwards

THOMAS HANDASYD PERKINS
(*left*)
(1764–1854)
Boston merchant, political leader, philanthropist
Engraved by H. W. Smith after a painting by Gambardella

BLISS PERRY (*right*)
(1860–1954)
Editor, educator, critic, writer

MATTHEW CALBRAITH PERRY
(*left*)
(1794–1858)
Naval officer, opened Japan to West
Courtesy New-York Historical Society

OLIVER HAZARD PERRY (*right*)
(1785–1819)
Naval officer, War of 1812
Painting by Gilbert Stuart

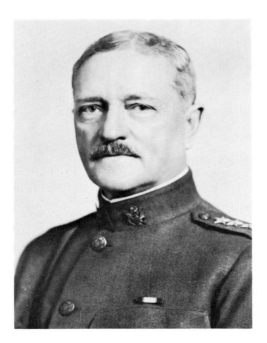

WILLIAM STEVENS PERRY (*left*)
(1832–1898)
Protestant Episcopal clergyman, church historian

JOHN JOSEPH PERSHING (*right*)
["Black Jack" Pershing]
(1860–1948)
General, army chief of staff; commanded American Expeditionary Force, World War I
Courtesy Library of Congress

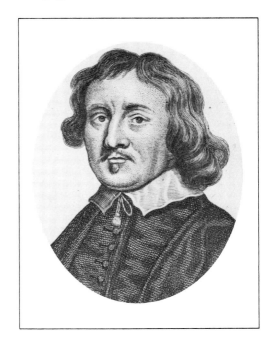

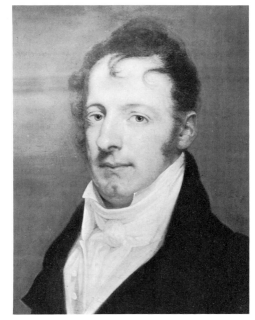

HUGH PETER (*left*)

[Hugh Peters]

(1598–1660)

English clergyman active in Massachusetts Bay Colony

RICHARD PETERS (*right*)

(1744–1828)

Jurist, member of Continental Congress, agriculturist

Painting by Rembrandt Peale. Courtesy Pennsylvania Academy of Fine Arts

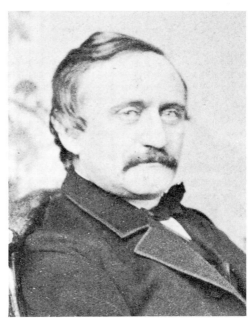

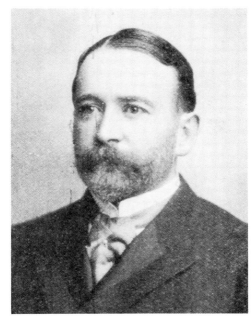

CHARLES JACOBS PETERSON (*left*)

(1819–1887)

Magazine publisher; edited *Peterson's Magazine*

JAMES DUVAL PHELAN (*right*)

(1861–1930)

U.S. Senator, banker; reform mayor of San Francisco

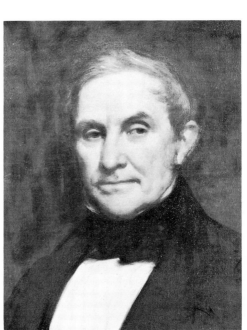

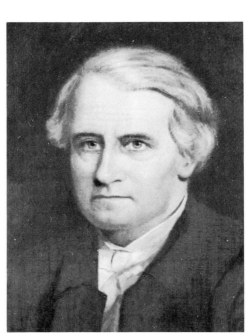

ANSON GREENE PHELPS (*left*)

(1781–1853)

Entrepreneur, philanthropist; founded Phelps, Dodge & Co.

Painting by Waldo and Jewett. Courtesy New-York Historical Society

AUSTIN PHELPS (*right*)

(1820–1890)

Congregational clergyman, educator

Courtesy Andover Newton Theological School

ELIZABETH STUART PHELPS (*left*)
["H. Trusta"; nee Elizabeth Stuart]
(1815–1852)
Popular novelist, author of religious tales
Engraved by H. W. Smith after a painting by Francis Alexander

JOHN WOODWARD PHILIP (*right*)
(1840–1900)
Naval officer; commanded the *Texas* at Santiago Bay

JOHN PHILLIPS (*left*)
(1719–1795)
Merchant, civic leader; founded Phillips Exeter Academy
Painting by Joseph Stewart. Courtesy The Connecticut Historical Society and Phillips Exeter Academy

SAMUEL PHILLIPS (*right*)
(1752–1802)
Political leader, merchant; founded Phillips Andover Academy

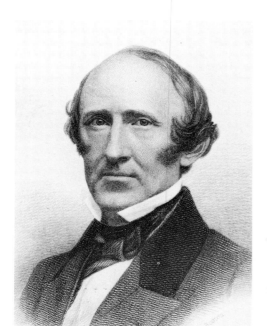

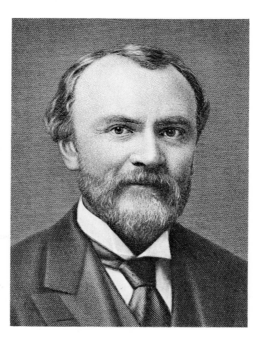

WENDELL PHILLIPS (*left*)
(1811–1884)
Abolitionist, reformer, lawyer
Engraving by H. W. Smith

HENRY PHIPPS (*right*)
(1839–1930)
Steel industrialist, philanthropist
Courtesy Library of Congress

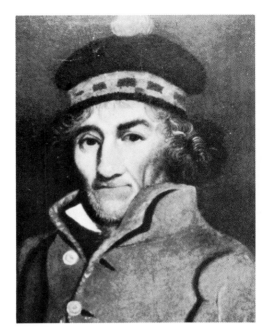
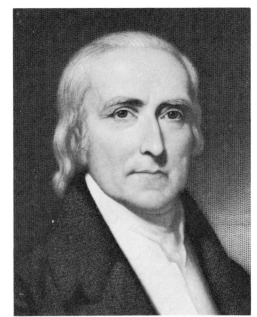

DUNCAN PHYFE *(left)*
(1768–1854)
Furniture maker

PHILIP SYNG PHYSICK *(right)*
(1768–1837)
Pioneer surgeon, known as "father of American surgery"
Engraved by Samuel Sartain after a painting by Henry Inman

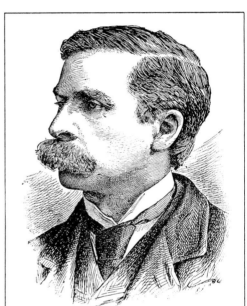

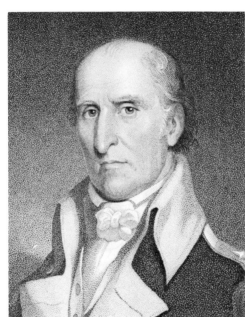

JOHN JAMES PIATT *(left)*
(1835–1917)
Poet, journalist, diplomat

ANDREW PICKENS *(right)*
(1739–1817)
Revolutionary general, Congressman
Engraved by James B. Longacre after a painting by Thomas Sully

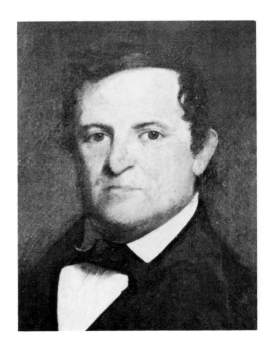
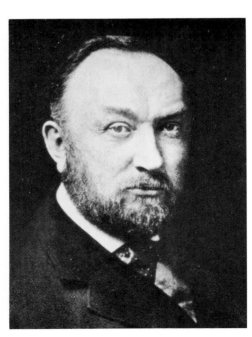

FRANCIS WILKINSON PICKENS
(left)
(1805–1869)
Secessionist leader, Congressman, diplomat; Governor of South Carolina
Courtesy South Caroliniana Library, University of South Carolina

EDWARD CHARLES PICKERING
(right)
(1846–1919)
Astronomer, physicist; director of Harvard Observatory

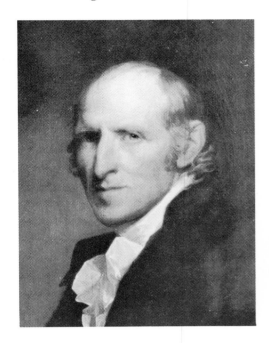

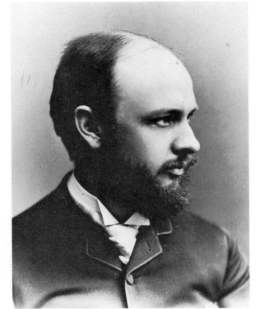

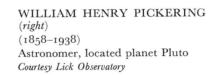

TIMOTHY PICKERING (*left*)
(1745–1829)
Revolutionary officer, politician; Secretary
of War under Washington, Secretary of
State under Washington and Adams; Con-
gressman, U.S. Senator
Painting by Gilbert Stuart

WILLIAM HENRY PICKERING
(*right*)
(1858–1938)
Astronomer, located planet Pluto
Courtesy Lick Observatory

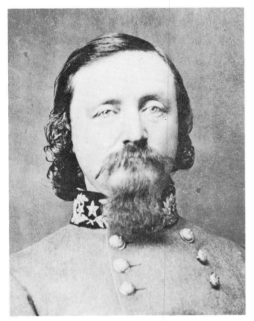

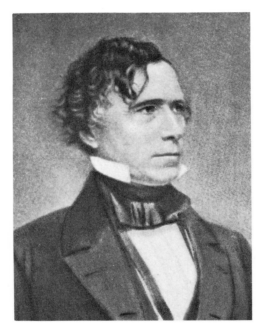

GEORGE EDWARD PICKETT (*left*)
(1825–1875)
Confederate general; repulsed in decisive
charge at Gettysburg
Courtesy Library of Congress, Brady Collection

FRANKLIN PIERCE (*right*)
(1804–1869)
President of the United States, 1853–1857

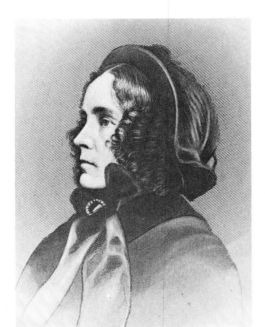

Mrs. FRANKLIN PIERCE (*left*)
[nee Jane Means Appleton]
(1806–1863)
First lady, 1853–1857
*Engraving by John C. Buttre. Courtesy Library of
Congress*

S. S. PIERCE (*right*)
[Samuel Stillman Pierce]
(1807–1880)
Boston merchant
Engraving by J. A. J. Wilcox

JAMES PIERPONT (*left*)
(1660–1714)
Congregational clergyman, a founder of Yale College
Courtesy Yale University

JOHN PIERPONT (*right*)
(1785–1866)
Unitarian clergyman, poet
Courtesy National Archives, Brady Collection

ALBERT PIKE (*left*)
(1809–1891)
Lawyer, writer, Confederate official
Courtesy National Archives, Brady Collection

ZEBULON MONTGOMERY PIKE
(*right*)
(1779–1813)
Army officer, Western explorer; discovered Pikes Peak
Painting by Charles Willson Peale. Courtesy Independence National Historical Park

GIDEON JOHNSON PILLOW (*left*)
(1806–1878)
Army officer in Mexican War; Confederate general
Engraving by H. S. Sadd

CHARLES ALFRED PILLSBURY
(*right*)
(1842–1899)
Flour milling magnate

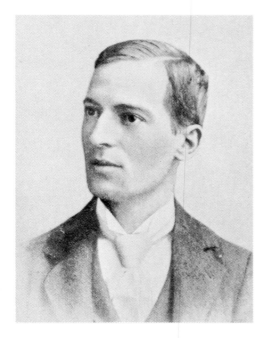

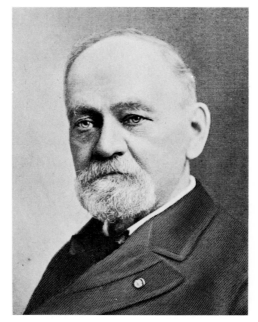

HARRY NELSON PILLSBURY (*left*)
(1872–1906)
Chess master

JOHN SARGENT PILLSBURY (*right*)
(1828–1901)
Flour miller, philanthropist; Governor of
Minnesota
Courtesy Pillsbury Co.

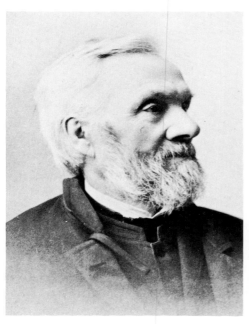

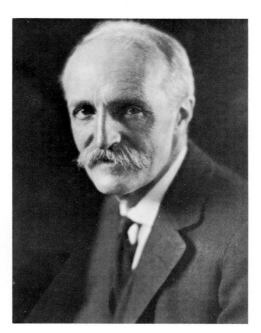

PARKER PILLSBURY (*left*)
(1809–1898)
Abolitionist preacher, reformer
Courtesy New Hampshire Historical Society

GIFFORD PINCHOT (*right*)
(1865–1946)
Conservationist, forester, writer; Governor
of Pennsylvania
Courtesy Library of Congress

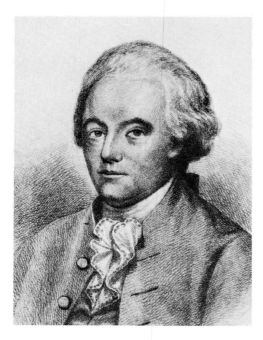

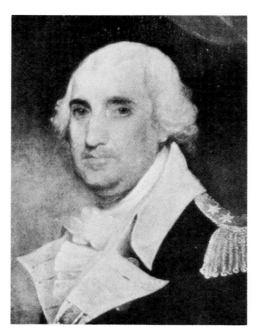

CHARLES PINCKNEY (*left*)
(1757–1824)
U.S. Senator, diplomat; author of "Pinck-
ney draft" of federal Constitution, signer of
Constitution
*Engraving by Albert Rosenthal. Courtesy South Caro-
liniana Library, University of South Carolina*

CHARLES COTESWORTH
PINCKNEY (*right*)
(1746–1825)
Revolutionary general, lawyer, diplomat;
signer of the Constitution; involved in XYZ
Affair
Painting by Gilbert Stuart

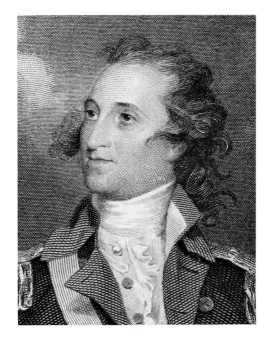

THOMAS PINCKNEY (*left*)
(1750–1828)
Revolutionary officer, diplomat; Governor
of South Carolina
*Engraved by William G. Armstrong from a painting
by John Trumbull*

ALLAN PINKERTON (*right*)
(1819–1884)
Detective

LYDIA PINKHAM (*left*)
[nee Lydia Estes]
(1819–1883)
Patent-medicine manufacturer, reformer
Courtesy The Lydia E. Pinkham Medicine Company

WILLIAM PINKNEY (*right*)
(1764–1822)
Lawyer, diplomat, U.S. Senator, Attorney
General under Madison; helped secure
Missouri Compromise
Engraving by W. G. Jackman

JOHN THOMAS PIRIE (*left*)
(1827–1913)
Chicago merchant, a founder of Carson
Pirie Scott & Co.

BENN PITMAN (*right*)
[Benjamin Pitman]
(1822–1910)
Brother of Sir Isaac Pitman, introduced
Pitman shorthand method to U.S.

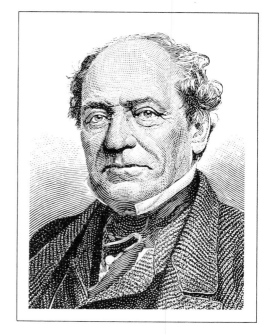

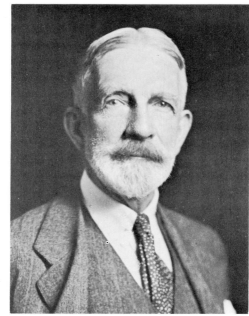

HENRY PLACIDE (*left*)
(1799–1870)
Comedian, character actor

CHARLES ADAMS PLATT (*right*)
(1861–1933)
Architect, painter, etcher
Courtesy American Academy of Arts and Letters

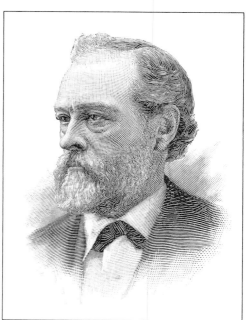

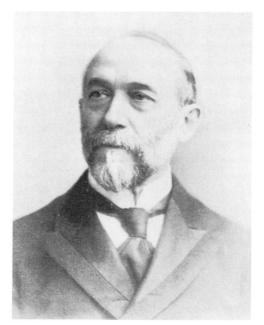

ORVILLE HITCHCOCK PLATT
(*left*)
(1827–1905)
U.S. Senator; author of Platt Amendment
maintaining U.S. rights in Cuba

THOMAS COLLIER PLATT (*right*)
(1833–1910)
Republican political boss in New York;
U.S. Senator, Congressman

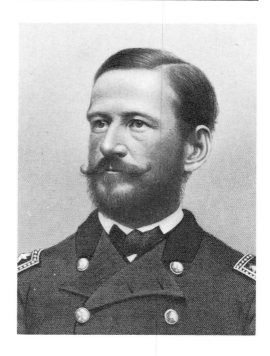

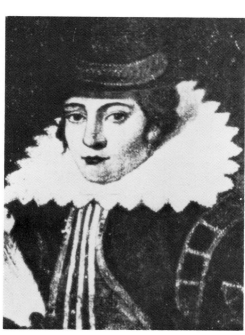

ALFRED PLEASONTON (*left*)
(1824–1897)
Union general in Civil War
*Engraved by John C. Buttre from a photograph by
Mathew Brady*

POCAHONTAS (*right*)
[Matoaka]
(c. 1595–1617)
Indian maiden, daughter of Powhatan; said
to have saved John Smith; married John
Rolfe

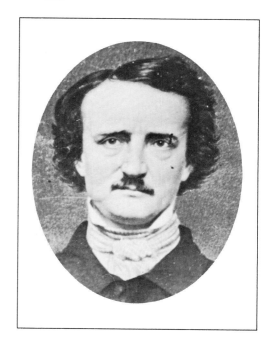
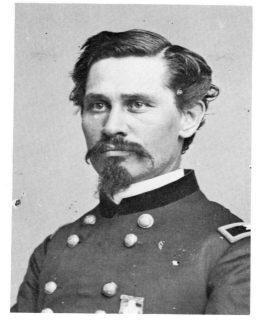

EDGAR ALLAN POE (*left*)
(1809–1849)
Poet, critic, short-story writer
Courtesy National Archives, Brady Collection

ORLANDO METCALFE POE (*right*)
(1832–1895)
Union general in Civil War; engineer;
supervised lock construction, Sault Ste.
Marie
Courtesy Library of Congress, Brady-Handy Collection

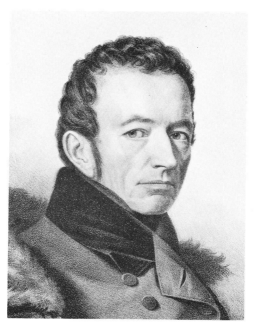
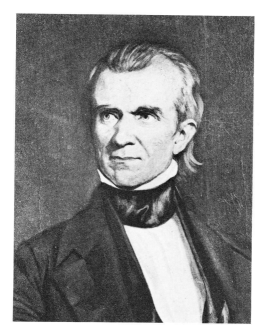

JOEL ROBERTS POINSETT (*left*)
(1779–1851)
Diplomat, Congressman, Secretary of War
under Van Buren; developed the Poinsettia
*Lithograph by Charles Fenderich. Courtesy Library of
Congress*

JAMES KNOX POLK (*right*)
(1795–1849)
President of the United States, 1845–1849
Painting by G. P. A. Healy

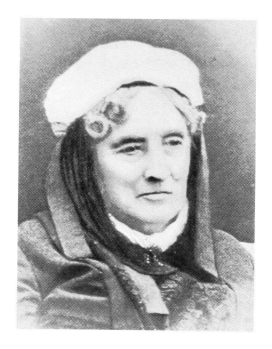
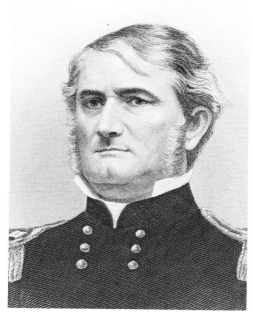

Mrs. JAMES KNOX POLK (*left*)
[nee Sarah Childress]
(1803–1891)
First lady, 1845–1849

LEONIDAS POLK (*right*)
(1806–1864)
Protestant Episcopal bishop; Confederate
general; founded University of the South
After a photograph by Mathew Brady

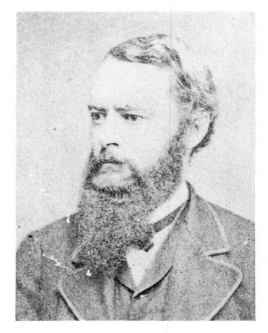

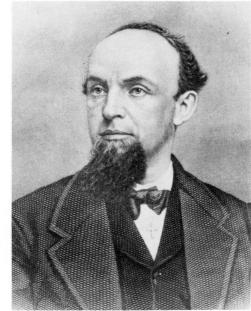

EDWARD ALFRED POLLARD (*left*)
(1831–1872)
Journalist, historian
Courtesy Virginia State Library

BRICK POMEROY (*right*)
[Marcus Mills Pomeroy]
(1833–1896)
Journalist, publicist
Engraving by W. G. Jackman

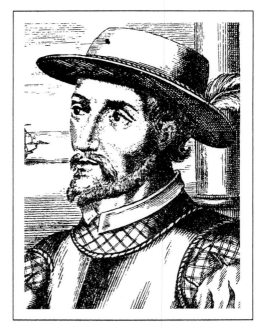

JUAN PONCE DE LEÓN (*left*)
(*c.* 1460–1521)
Spanish explorer, discovered Florida

JAMES BURTON POND (*right*)
(1838–1903)
Promoter, managed lecture tours through-
out U.S.

WILLIAM FREDERICK POOLE
(*left*)
(1821–1894)
Librarian, historian; compiled *Poole's Index
to Periodical Literature*

HENRY VARNUM POOR (*right*)
(1812–1905)
Railroad economist, editor; founded Poor &
Co. (later Standard & Poor's Corp.)

BENJAMIN PERLEY POORE (*left*)
(1820–1887)
Journalist, writer

HENRY RANKIN POORE (*right*)
(1859–1940)
Painter

ALBERT AUGUSTUS POPE (*left*)
(1843–1909)
Pioneer bicycle and automobile manufacturer; early advocate of improved roads

JOHN POPE (*right*)
(1822–1892)
Union general in Civil War
After an ambrotype by Mathew Brady

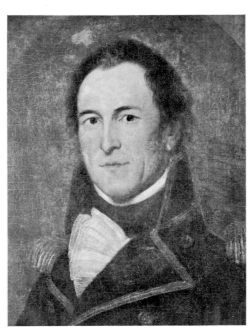

CHARLES TALBOT PORTER (*left*)
(1826–1910)
Mechanical engineer, pioneer in development of high-speed engines
Courtesy Smithsonian Institution

DAVID PORTER (*right*)
(1780–1843)
Naval officer
Painting by Charles Willson Peale. Courtesy Independence National Historical Park

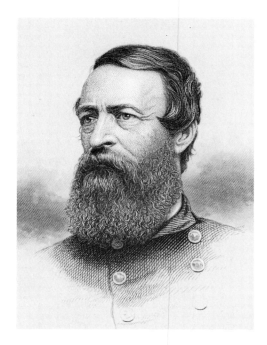

DAVID DIXON PORTER (*left*)
(1813–1891)
Admiral, U.S. Navy; commanded Mississippi Squadron in Civil War

FITZ-JOHN PORTER (*right*)
(1822–1901)
Union general in Civil War; New York police and fire commissioner

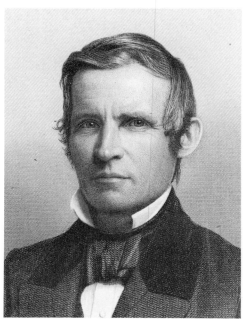

NOAH PORTER (*left*)
(1811–1892)
Philosopher, scholar; president, Yale University; editor, *Webster's International Dictionary*
Engraving by Alexander H. Ritchie

THOMAS CONRAD PORTER (*right*)
(1822–1901)
Botanist, educator
Courtesy New York Botanical Garden

CHARLES WILLIAM POST (*left*)
(1854–1914)
Breakfast-food manufacturer; developed Postum
Courtesy Mrs. Marjorie Post May

GEORGE BROWNE POST (*right*)
(1837–1913)
Architect, designed New York Stock Exchange

ALONZO POTTER (*left*)
(1800–1865)
Protestant Episcopal bishop, educator
Engraving by H. W. Smith

EDWARD CLARK POTTER (*right*)
(1857–1923)
Sculptor
Courtesy Mrs. Henry B. Selden

ELIPHALET NOTT POTTER (*left*)
(1836–1901)
Protestant Episcopal clergyman, educator

HENRY CODMAN POTTER (*right*)
(1835–1908)
Protestant Episcopal bishop, initiated work on Cathedral of St. John the Divine, New York

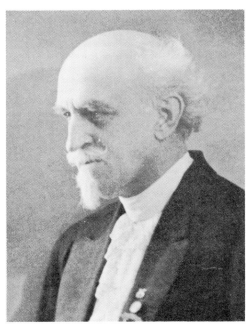

TERENCE VINCENT POWDERLY (*left*)
(1849–1924)
Labor leader, headed Knights of Labor

FREDERICK EUGENE POWELL (*right*)
(1856–1938)
Magician
Courtesy Milbourne Christopher Collection

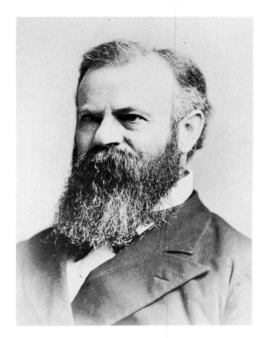

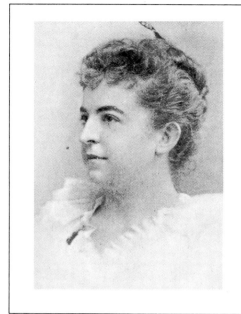

JOHN WESLEY POWELL (*left*)
(1834–1902)
Geologist, ethnologist; explored and wrote
of canyons of the Colorado; headed U.S.
Geological Survey
Courtesy New-York Historical Society

MAUD POWELL (*right*)
(1868–1920)
Concert violinist

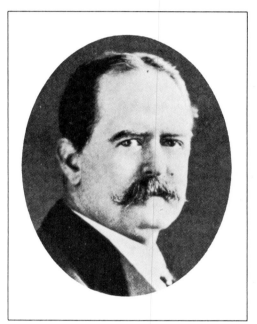

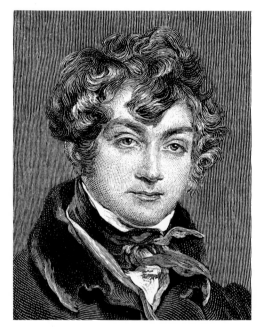

WILLIAM HENRY POWELL (*left*)
(1823–1879)
Painter, noted for historical scenes and por-
traits

TYRONE POWER (*right*)
[William Grattan Tyrone Power]
(1797–1841)
Irish comedian, toured U.S.

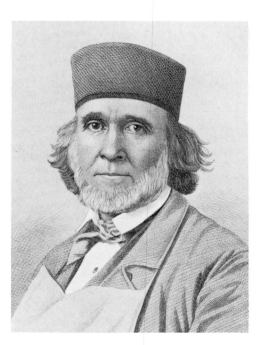

HIRAM POWERS (*left*)
(1805–1873)
Sculptor
Engraving by Perine and Giles

JAMES T. POWERS (*right*)
(1862–1943)
Comic actor, played in light opera

LOUIS PRANG (*left*)
(1824–1909)
Lithographer, published art books and reproductions

BELA LYON PRATT (*right*)
(1867–1917)
Sculptor

CHARLES PRATT (*left*)
(1830–1891)
Oil-refining magnate, philanthropist; founded Pratt Institute
Courtesy Pratt Institute

ENOCH PRATT (*right*)
(1808–1896)
Financier, philanthropist
Courtesy Enoch Pratt Free Library

FRANCIS ASHBURY PRATT (*left*)
(1827–1902)
Machine-tool and arms manufacturer, inventor; co-founder, Pratt & Whitney Co.
Courtesy Pratt & Whitney Co., Inc.

MATTHEW PRATT (*right*)
(1734–1805)
Portrait painter
Self-portrait

ORSON PRATT (*left*)
(1811–1881)
Apostle of the Mormon Church
Courtesy Utah State Historical Society

PARLEY PARKER PRATT (*right*)
(1807–1857)
Apostle of the Mormon Church
Courtesy Utah State Historical Society

RICHARD HENRY PRATT (*left*)
(1840–1924)
Army officer; founded Indian school at
Carlisle, Pennsylvania

THOMAS WILLIS PRATT (*right*)
(1812–1875)
Bridge and railroad engineer; inventor
Courtesy Smithsonian Institution

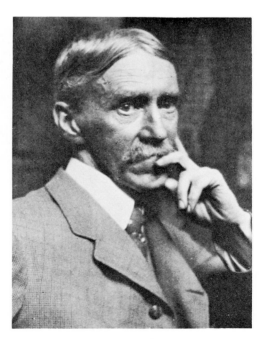

EDWARD PREBLE (*left*)
(1761–1807)
Naval officer
Engraving by T. Kelly

MAURICE BRAZIL PRENDERGAST
(*right*)
(1861–1924)
Painter
Courtesy Oliver Baker Associates

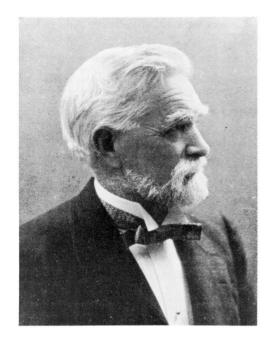

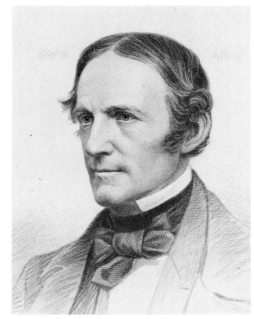

ALBERT BENJAMIN PRESCOTT
(*left*)
(1832–1905)
Chemist, pharmacist, educator
Courtesy University of Michigan

WILLIAM HICKLING PRESCOTT
(*right*)
(1796–1859)
Historian, wrote *History of the Conquest of Mexico*
Engraving by H. W. Smith

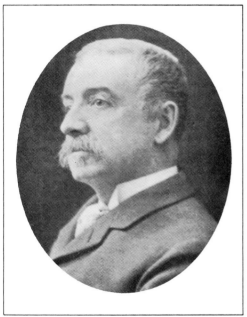

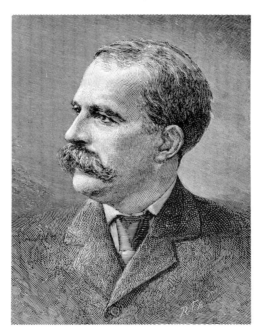

BRUCE PRICE (*left*)
(1845–1903)
Architect; designed Château Frontenac, Quebec

THOMAS RANDOLPH PRICE (*right*)
(1839–1903)
Philologist, educator

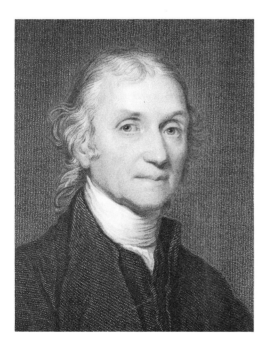

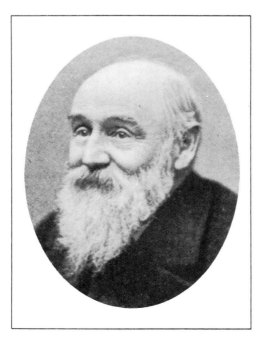

JOSEPH PRIESTLEY (*left*)
(1733–1804)
English clergyman, scientist in U.S.; influenced American Unitarianism
Engraving by W. Holl after a painting by Gilbert Stuart

WILLIAM COWPER PRIME (*right*)
(1825–1905)
Writer, editor, art historian and collector

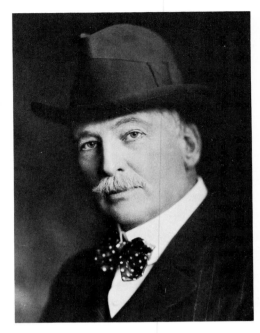
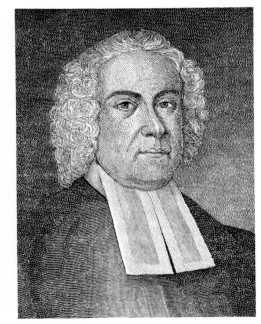

MORTON PRINCE (*left*)
(1854–1929)
Neurologist, psychologist; founded *Journal of Abnormal Psychology*
Courtesy National Library of Medicine

THOMAS PRINCE (*right*)
(1687–1758)
Congregational clergyman, historian, biblio-phile

CYRUS GUERNSEY PRINGLE (*left*)
(1838–1911)
Horticulturist, botanist, botanical collector
Courtesy New York Botanical Garden

WILLIAM COOPER PROCTER
(*right*)
(1862–1934)
Soap manufacturer, philanthropist; president of Procter & Gamble
Courtesy Procter & Gamble Co.

FREDERICK FRANCIS PROCTOR
(*left*)
(*c.* 1851–1929)
Theater owner, manager

SAMUEL PROVOOST (*right*)
[Samuel Provost]
(*c.* 1742–1815)
First Protestant Episcopal bishop of New York; chaplain of Continental Congress

THEOPHIL MITCHELL PRUDDEN
(*left*)
(1849–1924)
Pathologist, bacteriologist, educator

EVAN PUGH (*right*)
(1828–1864)
Chemist; first president, Agriculture College
of Pennsylvania (Pennsylvania State Uni-
versity)
Courtesy Pennsylvania State University

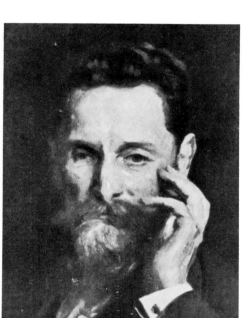

CASIMIR PULASKI (*left*)
(*c.* 1748–1779)
Polish officer in American Revolution; mor-
tally wounded in siege of Savannah

JOSEPH PULITZER (*right*)
(1847–1911)
Newspaper publisher; founded school of
journalism, Columbia University
*Painting by John Singer Sargent. Courtesy Columbiana
Collection, Columbia University*

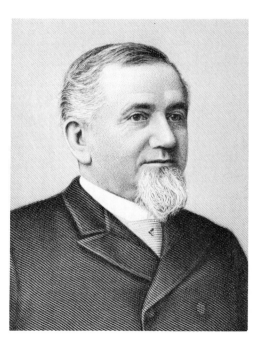

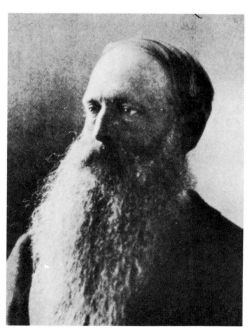

GEORGE MORTIMER PULLMAN
(*left*)
(1831–1897)
Developer and manufacturer of railroad
sleeping car
Engraving by W. T. Bather

RAPHAEL PUMPELLY (*right*)
(1837–1923)
Geologist, mining engineer

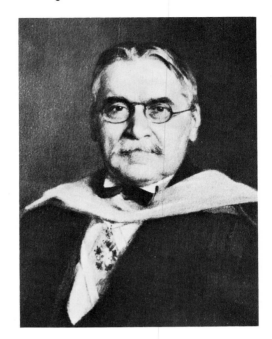

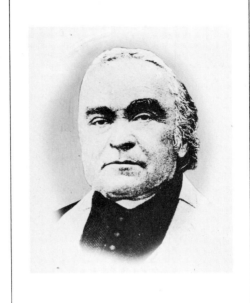

MICHAEL IDVORSKY PUPIN (*left*)
(1858–1935)
Physicist, inventor, educator
Courtesy Columbiana Collection, Columbia University

JOHN BAPTIST PURCELL (*right*)
(1800–1883)
Catholic archbishop of Cincinnati
Courtesy "Catholic Telegraph"

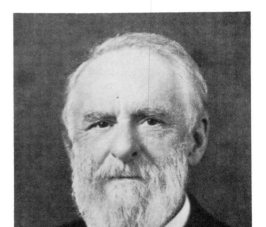

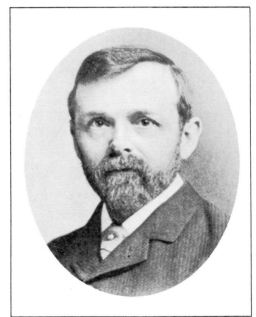

FREDERIC WARD PUTNAM (*left*)
(1839–1915)
Anthropologist, archaeologist, museum curator, educator

GEORGE HAVEN PUTNAM (*right*)
(1844–1930)
Publisher, writer, civic leader; advocate of copyright reform

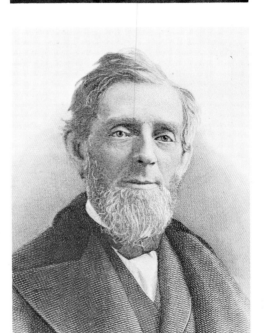

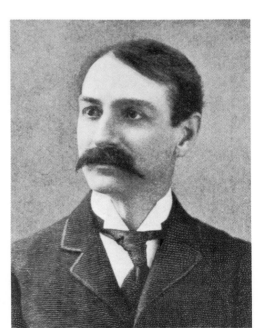

GEORGE PALMER PUTNAM (*left*)
(1814–1872)
Publisher, founded G. P. Putnam & Sons
Engraving by J. A. J. Wilcox

HERBERT PUTNAM (*right*)
(1861–1955)
Librarian of Congress for forty years

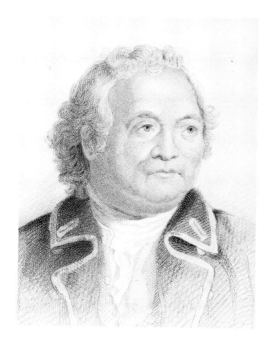

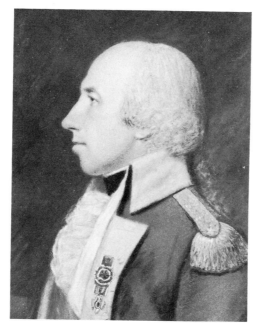

ISRAEL PUTNAM　　(*left*)
(1718–1790)
Revolutionary general
Engraving by Henry B. Hall after a painting by
John Trumbull

RUFUS PUTNAM　　(*right*)
(1738–1824)
Revolutionary general, helped settle North-
west Territory
Painting attributed to James Sharples, Sr. Courtesy
Independence National Historical Park

HOWARD PYLE
(1853–1911)
Illustrator, writer, teacher
Courtesy Peter A. Juley & Son

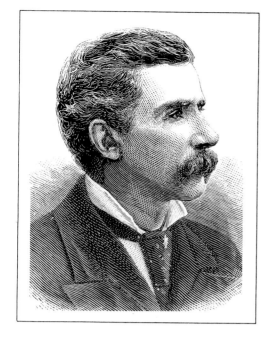

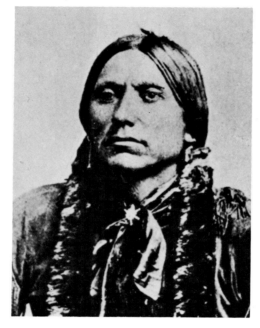

M. QUAD (*left*)
[Charles Bertrand Lewis]
(1842–1924)
Humorist, journalist, journeyman printer

QUANAH (*right*)
[Quanah Parker]
(*c.* 1845–1911)
Comanche Indian chief
Courtesy Mercaldo Archives

WILLIAM CLARKE QUANTRILL
(*left*)
(1837–1865)
Confederate guerrilla commander; led raid
on Lawrence, Kansas
Courtesy Smithsonian Institution

MATTHEW STANLEY QUAY (*right*)
(1833–1904)
Pennsylvania political boss, U.S. Senator

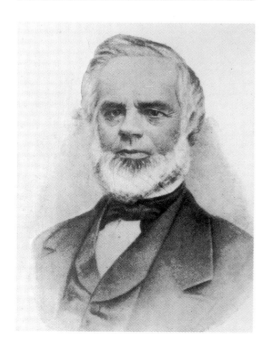

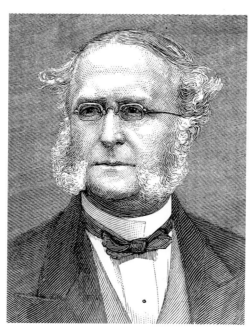

PHINEAS PARKHURST QUIMBY
(*left*)
(1802–1866)
Mental healer, consulted by Mary Baker
Eddy

EDMUND QUINCY (*right*)
(1808–1877)
Abolitionist, editor, writer

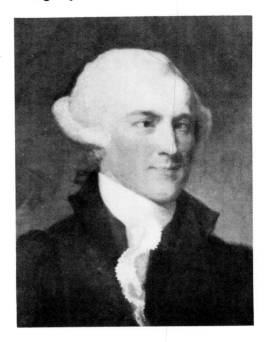

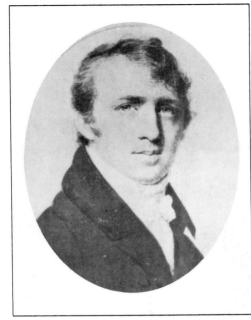

JOSIAH QUINCY (*left*)
(1744–1775)
Revolutionary patriot, lawyer, pamphleteer
Painting by Gilbert Stuart

JOSIAH QUINCY (*right*)
(1772–1864)
U.S. Congressman, mayor of Boston; president, Harvard University

CHARLES TODD QUINTARD (*left*)
(1824–1898)
Episcopal bishop, physician; helped found University of the South
Courtesy University of the South

GEORGE WILLIAM QUINTARD
(*right*)
(1822–1913)
Marine engine manufacturer
Engraved by John C. Buttre after a photograph by Mathew Brady

JOHN ANTHONY QUITMAN
(1798–1858)
Governor of Mississippi, army officer and administrator in Mexican War
Engraving by John C. Buttre

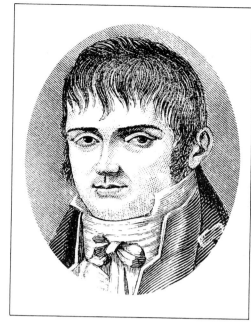

CHARLES G. RADBOURNE (*left*)
["Old Hoss" Radbourne]
(1853–1897)
Baseball pitcher, member of Baseball Hall of Fame

CONSTANTINE SAMUEL RAFINESQUE (*right*)
[Constantine Samuel Rafinesque-Schmaltz]
(1783–1840)
Botanist, ichthyologist, writer

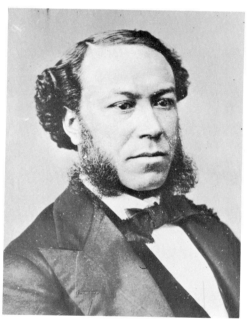

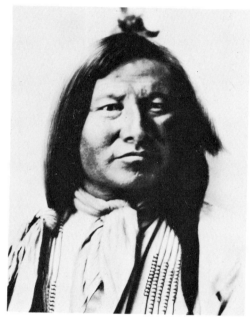

JOSEPH HAYNE RAINEY (*left*)
(1832–1887)
Representative from South Carolina, first Negro Congressman
Courtesy National Archives, Brady Collection

RAIN-IN-THE-FACE (*right*)
(*c.* 1843–1905)
Sioux Indian chief, leader at battle of Little Big Horn
Courtesy Mercaldo Archives

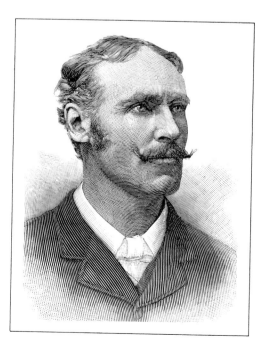

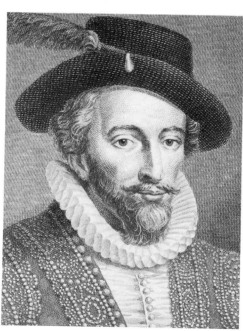

WILLIAM STEPHEN RAINSFORD (*left*)
(1850–1933)
Protestant Episcopal clergyman, explorer

Sir WALTER RALEIGH (*right*)
[Sir Walter Ralegh]
(*c.* 1552–1618)
English courtier, sent expeditions to explore east coast of North America
Engraved by Charles Pye after a painting by Sir Antonio More

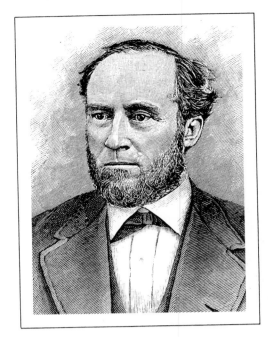

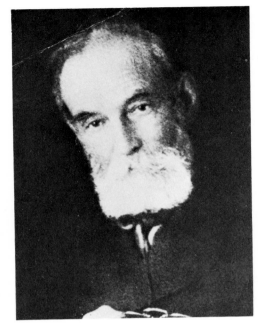

WILLIAM CHAPMAN RALSTON
(*left*)
(1826–1875)
California banker, promoter

WILLIAM H. RAND (*right*)
(1828–1915)
Mapmaker, partner in Rand McNally & Co.
Courtesy Rand McNally & Co.

JAMES RYDER RANDALL (*left*)
(1839–1908)
Journalist, poet; wrote "Maryland, My
Maryland"
Courtesy Enoch Pratt Free Library

EDMUND RANDOLPH (*right*)
[Edmund Jenings Randolph]
(1753–1813)
First Attorney General; Secretary of State
under Washington; Governor of Virginia
Courtesy Virginia State Library

GEORGE WYTHE RANDOLPH
(*left*)
(1818–1867)
Confederate general, Confederate Secretary
of War; lawyer
Courtesy Library of Congress, Brady Collection

JOHN RANDOLPH (*right*)
[John Randolph of Roanoke]
(1773–1833)
U.S. Senator, Congressman, diplomat, ora-
tor
Painting by Chester Harding

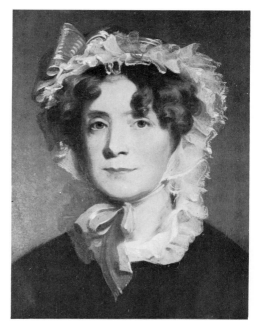

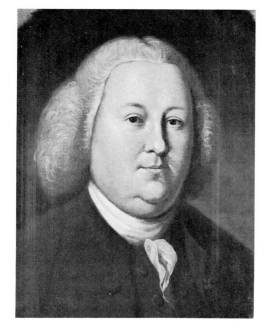

MARTHA RANDOLPH (*left*)

[Mrs. Thomas Mann Randolph, nee Martha Jefferson]

(1772–1836)

Daughter of Thomas Jefferson; served as his White House hostess

Painting by Thomas Sully. Courtesy Peter A. Juley & Son

PEYTON RANDOLPH (*right*)

(*c.* 1721–1775)

Virginia political leader; first president, Continental Congress

Painting by Charles Willson Peale. Courtesy Independence National Historical Park

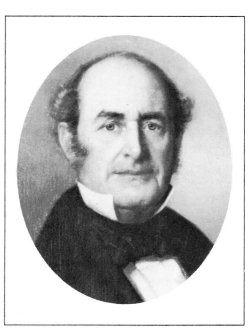

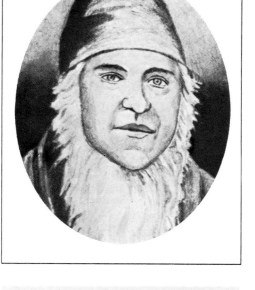

THOMAS JEFFERSON RANDOLPH (*left*)

(1792–1875)

Financier; grandson of Thomas Jefferson and executor of his estate

Painting by Guillaume. Courtesy J. Randolph Kean and the Thomas Jefferson Memorial Foundation

GEORGE RAPP (*right*)

[Johann Georg Rapp]

(1757–1847)

Religious leader, founded the communistic Harmony Society

Courtesy Pennsylvania Historical and Museum Commission

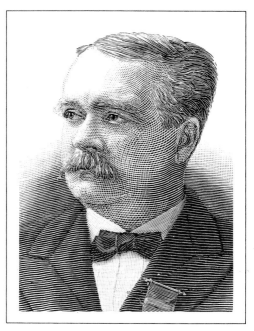

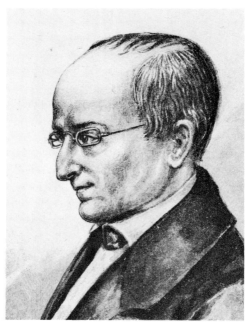

JUSTUS HENRY RATHBONE (*left*)

(1839–1889)

Founder of the Knights of Pythias

FREDERICK AUGUSTUS RAUCH (*right*)

(1806–1841)

Theologian; first president of Marshall College (now Franklin and Marshall)

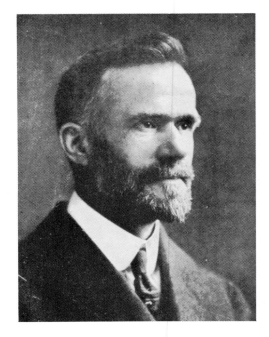

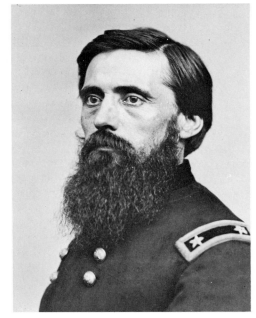

WALTER RAUSCHENBUSCH (*left*)
(1861–1918)
Baptist clergyman, theologian; advocate of
"social gospel"
Courtesy American Baptist Historical Society

JOHN AARON RAWLINS (*right*)
(1831–1869)
Union general and aide to Grant in Civil
War; Secretary of War under Grant
Courtesy National Archives, Brady Collection

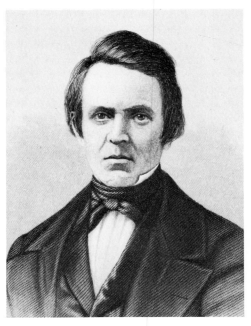

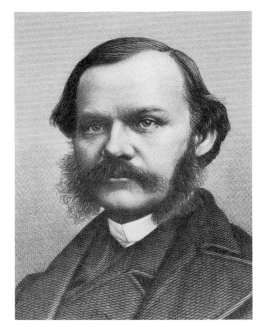

JOSEPH RAY (*left*)
(1807–1865)
Educator, wrote arithmetic textbooks

HENRY JARVIS RAYMOND (*right*)
(1820–1869)
Editor, politician; co-founder of *The New
York Times*; a founder of the Republican
party
*Engraved by George E. Perine after a photograph by
Mathew Brady*

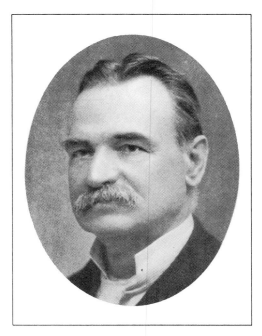

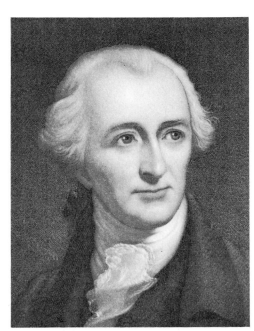

ALFRED JAMES REACH (*left*)
(1840–1928)
Baseball player, sporting-goods manufac-
turer

GEORGE READ (*right*)
(1733–1798)
Signer of Declaration of Independence and
Constitution; jurist, U.S. Senator
*Engraved by Samuel Sartain after a painting by Robert
Edge Pine*

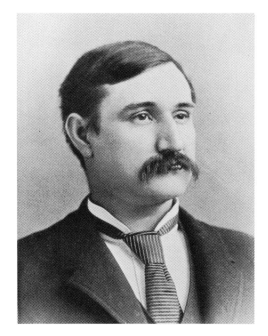

OPIE POPE READ *(left)*
(1852–1939)
Humorist, novelist, journalist, lecturer

THOMAS BUCHANAN READ *(right)*
(1822–1872)
Poet, painter

JOHN HENNINGER REAGAN *(left)*
(1818–1905)
U.S. Senator, Congressman; Confederate
Postmaster General
Courtesy Library of Congress, Brady-Handy Collection

RED CLOUD *(right)*
(1822–1909)
Oglala Indian chief
Courtesy Mercaldo Archives

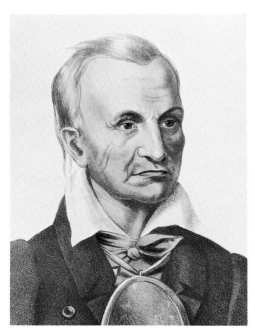

WILLIAM C. REDFIELD *(left)*
(1789–1857)
Pioneer meteorologist; first president of
American Association for Advancement of
Science
Engraving by Alexander H. Ritchie

RED JACKET *(right)*
[Sagoyewatha]
(c. 1758–1830)
Seneca Indian chief
*Courtesy Bureau of American Ethnology, Smithsonian
Institution*

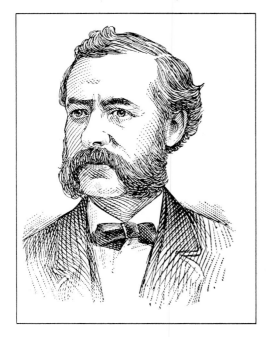

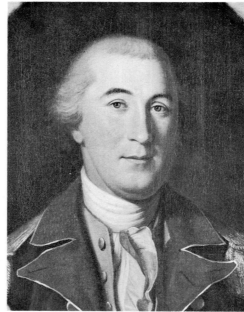

JAMES REDPATH (*left*)
(1833–1891)
Journalist, editor, abolitionist; established lecture bureau

JOSEPH REED (*right*)
(1741–1785)
Revolutionary officer, Pennsylvania political leader, member of Continental Congress
Painting by Charles Willson Peale. Courtesy Independence National Historical Park

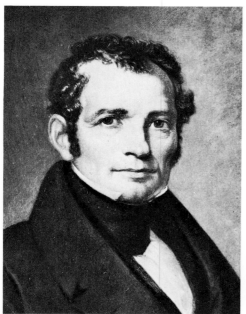

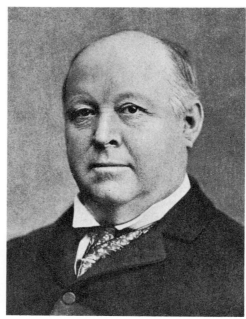

LUMAN REED (*left*)
(1787–1836)
Merchant, art patron and collector
Painting by Asher B. Durand

THOMAS BRACKETT REED (*right*)
(1839–1902)
U.S. Congressman, lawyer; Speaker of the House of Representatives

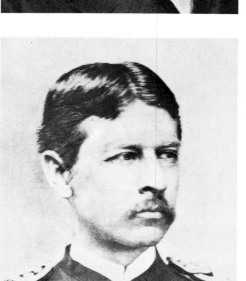

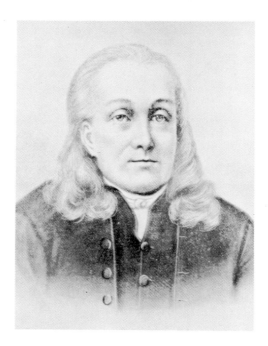

WALTER REED (*left*)
(1851–1902)
Army surgeon, bacteriologist; pioneer in yellow-fever and typhoid research
Courtesy New York Academy of Medicine

TAPPING REEVE (*right*)
(1744–1823)
Lawyer, educator, jurist; established Litchfield Law School
Painting by George Catlin. Courtesy Litchfield County Historical Society

ADA REHAN (*left*)
[Ada Crehan]
(1860–1916)
Actress

JOHN REID (*right*)
(1840–1916)
Leader in development of golf in U.S.
Painting by Frank Fowler. Courtesy U.S. Golf Association

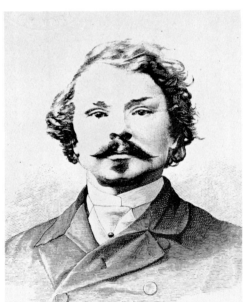

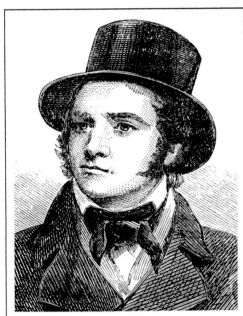

MAYNE REID (*left*)
[Thomas Mayne Reid]
(1818–1883)
Novelist, journalist, writer of juvenile books

SAMUEL CHESTER REID (*right*)
(1783–1861)
Naval officer, War of 1812; designed U.S. flag in its present form

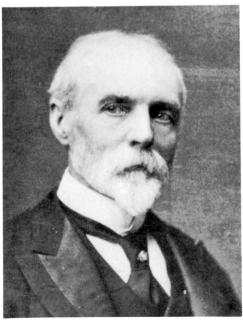

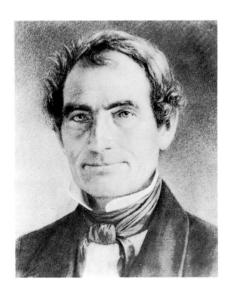

WHITELAW REID (*left*)
(1837–1912)
Newspaper correspondent, editor, publisher; diplomat

ELIPHALET REMINGTON (*right*)
(1793–1861)
Firearms and farm-equipment manufacturer; marketed Remington pistol
Courtesy Remington Arms Co.

FREDERIC REMINGTON (*left*)
(1861–1909)
Painter, sculptor, illustrator, writer

PHILO REMINGTON (*right*)
(1816–1889)
Manufacturer of firearms, sewing machines,
typewriters, and farm equipment
Courtesy Remington Rand Corporation

IRA REMSEN (*left*)
(1846–1927)
Chemist, educator; president of Johns Hop-
kins University

MARCUS A. RENO (*right*)
(1835–1889)
Army officer, commanded auxiliary force
while Custer fought at Little Big Horn

JAMES RENWICK (*left*)
(1792–1863)
Physical scientist, educator
*Painting by John H. Ehninger. Courtesy James Kip
Finch and Columbia University*

JAMES RENWICK (*right*)
(1818–1895)
Architect, designed Smithsonian Institution
and St. Patrick's Cathedral, New York
Engraving by George E. Perine

AGNES REPPLIER (*left*)
(1855–1950)
Essayist, biographer

ÉDOUARD DE RESZKE (*right*)
(1855–1917)
Polish operatic basso, popular in U.S.

JEAN DE RESZKE (*left*)
[Jan Mieczislaw de Reszke]
(1850–1925)
Polish operatic tenor, popular in U.S.

HIRAM RHOADES REVELS (*right*)
(1822–1901)
U.S. Senator, Methodist clergyman, educator; first Negro Senator
Courtesy Library of Congress, Brady Collection

PAUL REVERE (*left*)
(1735–1818)
Revolutionary patriot, silversmith, engraver
Painting by Gilbert Stuart

EDWIN REYNOLDS (*right*)
(1831–1909)
Mechanical engineer, inventor
Courtesy Smithsonian Institution

ROBERT BARNWELL RHETT (*left*)
[Robert Barnwell Smith]
(1800–1876)
South Carolina politician, secessionist; U.S. Senator, Congressman
Courtesy Library of Congress, Brady-Handy Collection

JAMES FORD RHODES (*right*)
(1848–1927)
Historian

DAN RICE (*left*)
(1823–1900)
Circus clown

THOMAS DARTMOUTH RICE (*right*)
(1808–1860)
Minstrel-show pioneer

ELLEN H. RICHARDS (*left*)
[nee Ellen Henrietta Swallow]
(1842–1911)
Home economist, chemist, educator

LAURA E. RICHARDS (*right*)
[nee Laura Elizabeth Howe]
(1850–1943)
Writer of children's books and biographies; author of *Captain January*

THEODORE WILLIAM RICHARDS
(*left*)
(1868–1928)
Chemist, educator, Nobel Laureate

EDMUND RICHARDSON (*right*)
(1818–1886)
Cotton grower, manufacturer; largest cotton planter in world

HENRY HOBSON RICHARDSON
(*left*)
(1838–1886)
Architect, predecessor of Sullivan and Wright

TEX RICKARD (*right*)
[George Lewis Rickard]
(1871–1929)
Boxing promoter
Courtesy Madison Square Garden and "The Ring" Magazine

HOWARD TAYLOR RICKETTS
(*left*)
(1871–1910)
Pathologist, immunologist, identified *Rickettsia* microorganism
Courtesy University of Chicago

ROBERT RIDGWAY (*right*)
(1850–1929)
Ornithologist, curator of birds at Smithsonian Institution
Courtesy Smithsonian Institution

JOHN CLARK RIDPATH (*left*)
(1840–1900)
Educator, author of popular histories

SIDNEY RIGDON (*right*)
(1793–1876)
Early Mormon leader, separated from Utah branch

JACOB AUGUST RIIS (*left*)
(1849–1914)
Journalist, writer, photographer; exposed slum conditions in New York City
Courtesy Library of Congress

CHARLES VALENTINE RILEY (*right*)
(1843–1895)
Entomologist

JAMES WHITCOMB RILEY (*left*)
(1849–1916)
Hoosier poet

WILLIAM RIMMER (*right*)
(1816–1879)
Sculptor, painter, physician, anatomist, art teacher

WILLIAM HENRY RINEHART *(left)*
(1825–1874)
Sculptor

BLANCHE RING *(right)*
(1871–1961)
Actress

ALBERT C. RINGLING *(left)*
(1852–1916)
Circus owner
Courtesy John and Mabel Ringling Museum

ALFRED T. RINGLING *(right)*
(1861–1919)
Circus owner
Courtesy John and Mabel Ringling Museum

CHARLES RINGLING *(left)*
(1863–1926)
Circus owner
Courtesy John and Mabel Ringling Museum

JOHN RINGLING *(right)*
(1866–1936)
Circus owner
Courtesy John and Mabel Ringling Museum

OTTO RINGLING (*left*)
(1858–1911)
Circus owner
Courtesy John and Mabel Ringling Museum

GEORGE RIPLEY (*right*)
(1802–1880)
Transcendentalist critic; organizer and president of Brook Farm

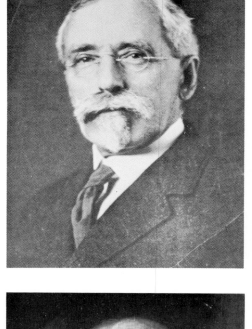

WILLIAM ZEBINA RIPLEY (*left*)
(1867–1941)
Economist, ethnologist

THOMAS RITCHIE (*right*)
(1778–1854)
Newspaper publisher, editor; Virginia political leader
Engraved by J. B. Forrest after a painting by Thomas Sully, Jr.

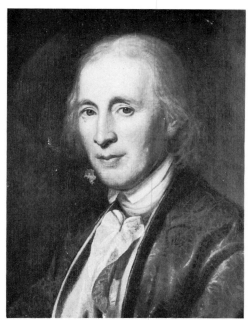

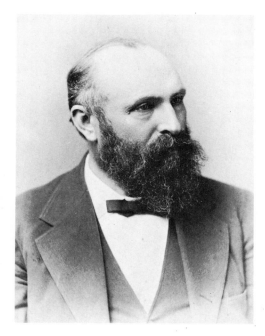

DAVID RITTENHOUSE (*left*)
(1732–1796)
Astronomer, mathematician, instrument maker; first director, U.S. Mint
Painting by Charles Willson Peale. Courtesy Independence National Historical Park

FRÉDÉRIC LOUIS RITTER (*right*)
(1834–1891)
Composer, conductor, music historian, educator
Courtesy Vassar College

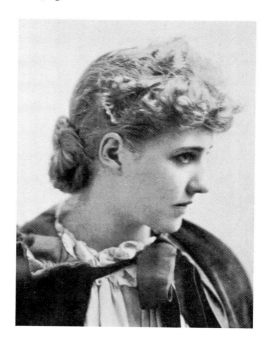

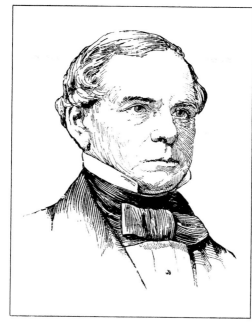

AMÉLIE RIVES *(left)*
[Princess Troubetzkoy]
(1863–1945)
Novelist, playwright

WILLIAM CABELL RIVES *(right)*
(1793–1868)
Virginia political leader, diplomat, lawyer

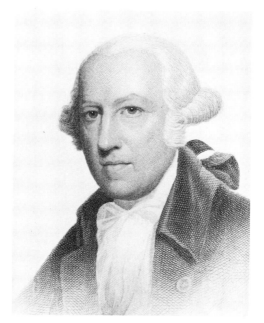

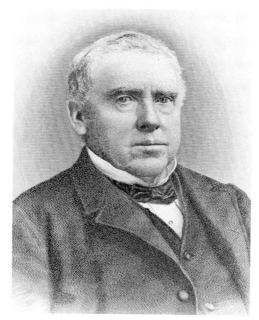

JAMES RIVINGTON *(left)*
(1724–1802)
Bookseller, newspaper publisher ; reputed
American spy during the Revolution
*Engraved by Alexander H. Ritchie after a painting by
Gilbert Stuart*

JOHN ROACH *(right)*
[John Roche]
(1813–1887)
Pioneer builder of iron ships

DANIEL COCK ROBBINS *(left)*
(1815–1888)
Drug manufacturer, partner in McKesson
& Robbins
Engraving by Alexander H. Ritchie

HENRY MARTYN ROBERT *(right)*
(1837–1923)
Military engineer, parliamentarian; wrote
Robert's Rules of Order
Courtesy National Archives, Brady Collection

ARCHIBALD ROBERTSON (*left*)
(1765–1835)
Painter of miniatures

JAMES ROBERTSON (*right*)
(1742–1814)
Frontier leader, Indian agent

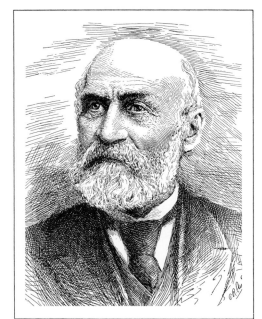

BENJAMIN LINCOLN ROBINSON
(*left*)
(1864–1935)
Botanist, educator, editor

CHARLES ROBINSON (*right*)
(1818–1894)
Pioneer, leader of Free-State movement;
first governor of state of Kansas

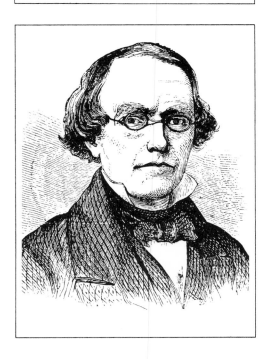

EDWARD ROBINSON (*left*)
(1794–1863)
Philologist, biblical scholar

EDWIN ARLINGTON ROBINSON
(*right*)
(1869–1935)
Poet

*Photograph by Pirie MacDonald. Courtesy American
Academy of Arts and Letters*

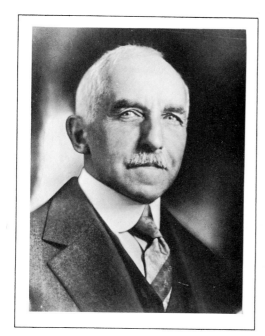

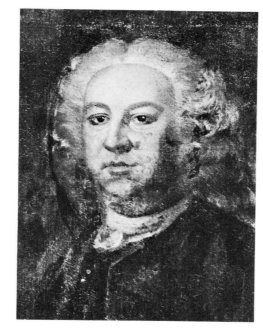

JAMES HARVEY ROBINSON (*left*)
(1863–1936)
Historian, educator, a founder of New School for Social Research
Courtesy Columbiana Collection, Columbia University

JOHN ROBINSON (*right*)
(*c.* 1576–1625)
English clergyman, organized Pilgrims' emigration to America
Courtesy Library of Congress

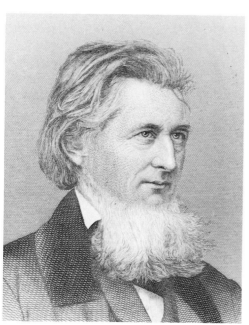

SOLON ROBINSON (*left*)
(1803–1880)
Pioneer, agriculturist, writer; described early rural life in U.S.
Engraving by John C. Buttre

THEODORE ROBINSON (*right*)
(1852–1896)
Impressionist painter
Courtesy Peter A. Juley & Son

WILBERT ROBINSON (*left*)
[Uncle Robbie]
(1864–1934)
Baseball catcher and manager, member of Baseball Hall of Fame
Courtesy National Baseball Hall of Fame

ELEANOR ELSIE ROBSON (*right*)
[Mrs. August Belmont]
(1879-)
Actress; philanthropist, opera patron

MAY ROBSON (*left*)
[Mary Robison]
(1865–1942)
Actress
Courtesy New-York Historical Society

STUART ROBSON (*right*)
[Henry Robson Stuart]
(1836–1903)
Actor

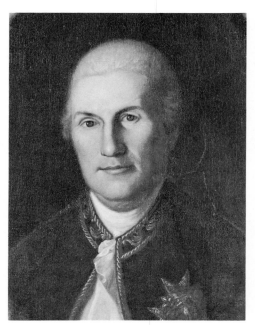
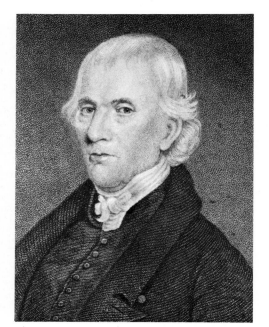

JEAN BAPTISTE DONATIEN DE
VIMEUR, Comte DE ROCHAMBEAU
(*left*)
(1725–1807)
French nobleman, commanded French forces
in American Revolution
Painting by Charles Willson Peale. Courtesy Independence National Historical Park

NATHANIEL ROCHESTER (*right*)
(1752–1831)
Banker, pioneer in western New York;
founded city of Rochester
Engraving by E. Mackenzie

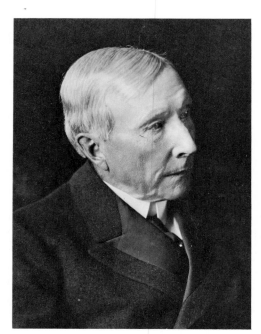
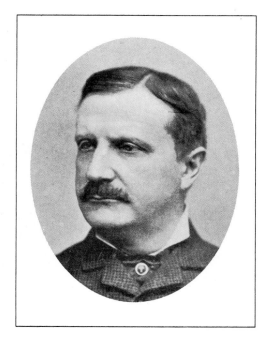

JOHN DAVISON ROCKEFELLER
(*left*)
(1839–1937)
Oil magnate, capitalist, philanthropist
Courtesy Library of Congress

WILLIAM ROCKEFELLER (*right*)
(1841–1922)
Financier

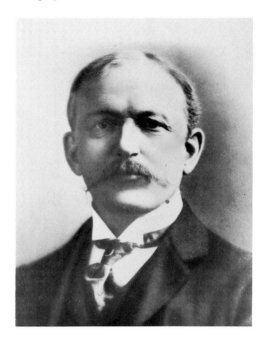

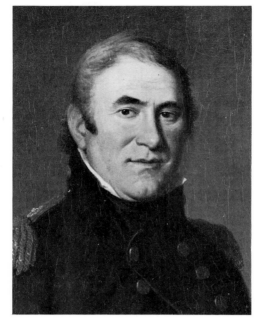

WILLIAM WOODVILLE ROCKHILL
(*left*)
(1845–1914)
Orientalist, diplomat; influenced open-door
policy toward China
Courtesy National Archives

JOHN RODGERS (*right*)
(1773–1838)
Naval officer, War of 1812
Painting by Charles Willson Peale. Courtesy Independence National Historical Park

JOHN RODGERS (*left*)
(1812–1882)
Union naval officer in Civil War
Engraving by Alexander H. Ritchie

THOMAS JACKSON RODMAN
(*right*)
(1815–1871)
Army officer, ordnance developer and manufacturer

EDWARD PAYSON ROE (*left*)
(1838–1888)
Novelist, horticulturist, Presbyterian clergyman

JOHN AUGUSTUS ROEBLING (*right*)
(1806–1869)
Civil engineer, designed Brooklyn Bridge

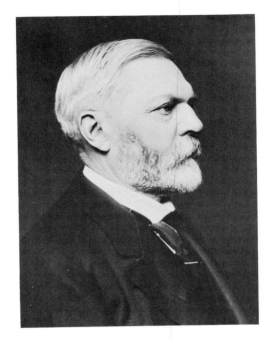

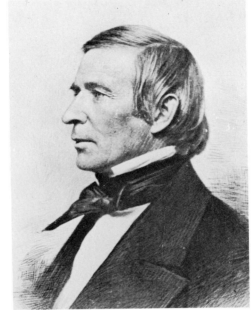

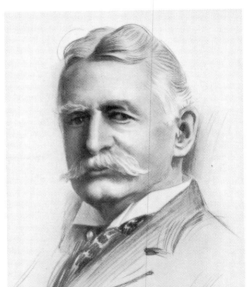

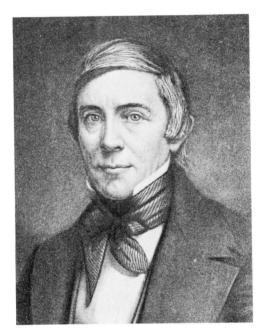

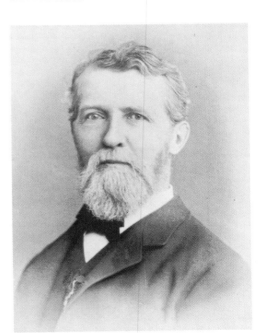

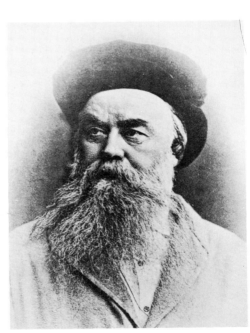

WASHINGTON AUGUSTUS
ROEBLING (*left*)
(1837–1926)
Civil engineer, supervised construction of
Brooklyn Bridge
Courtesy John A. Roebling's Sons Corporation

HENRY DARWIN ROGERS (*right*)
(1808–1866)
Geologist, educator
Courtesy University of Glasgow

HENRY HUTTLESTON ROGERS
(*left*)
[Henry Huddleston Rogers]
(1840–1909)
Oil magnate, originated pipe-line trans-
portation

JAMES BLYTHE ROGERS (*right*)
(1802–1852)
Chemist, educator
Courtesy Virginia State Library

JOHN ROGERS (*left*)
(1829–1904)
Sculptor; designed popular Rogers groups
of genre sculpture

RANDOLPH ROGERS (*right*)
(1825–1892)
Sculptor; created Columbus doors to rotunda
of Capitol, Washington, D.C.
*Courtesy Michigan Historical Collections, University of
Michigan*

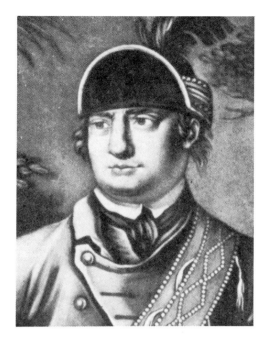

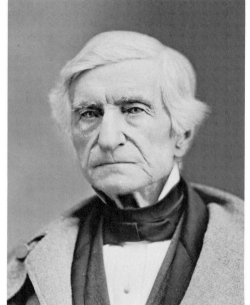

ROBERT ROGERS (*left*)
(1731–1795)
Frontier soldier; captain of ranger company, French and Indian Wars; British officer, Revolutionary War

WILLIAM BARTON ROGERS (*right*)
(1804–1882)
Geologist; founder and first president, Massachusetts Institute of Technology
Courtesy Library of Congress, Brady-Handy Collection

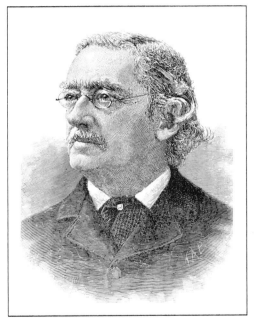

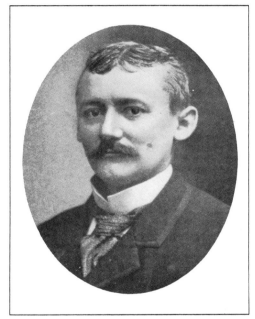

WILLIAM JAMES ROLFE (*left*)
(1827–1910)
Educator, editor, critic, Shakespearean scholar

HENRY ROMEIKE (*right*)
(1855–1903)
Entrepreneur, originated press-clipping service

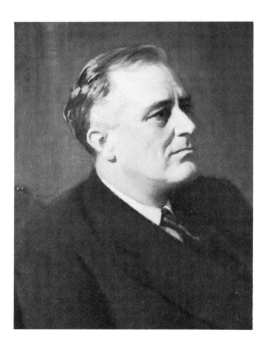

ELEANOR ROOSEVELT (*left*)
[Anna Eleanor Roosevelt]
(1884–1962)
First lady, 1933–1945; humanitarian
Courtesy Library of Congress

FRANKLIN DELANO ROOSEVELT
(*right*)
(1882–1945)
President of the United States, 1933–1945
Painting by Frank O. Salisbury. Courtesy Franklin D. Roosevelt Library

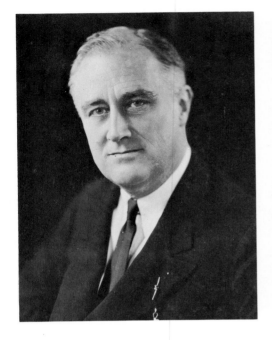
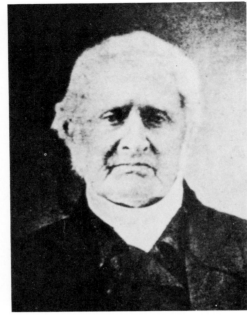

FRANKLIN DELANO ROOSEVELT (*left*)
(*see above*)
Courtesy Library of Congress

NICHOLAS I. ROOSEVELT (*right*)
(1767–1854)
Pioneer steamboat designer, manufacturer
Courtesy Nicholas G. Roosevelt

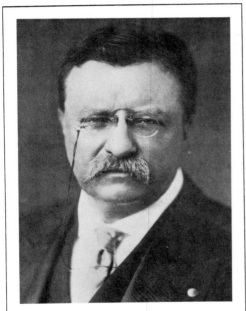
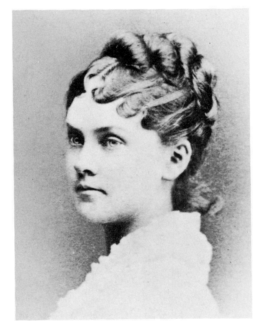

THEODORE ROOSEVELT (*left*)
(1858–1919)
President of the United States, 1901–1909

Mrs. THEODORE ROOSEVELT
(*right*)
[nee Alice Hathaway Lee]
(1861–1884)
First wife of Theodore Roosevelt
Courtesy Theodore Roosevelt Association

Mrs. THEODORE ROOSEVELT
(*left*)
[nee Edith Kermit Carow]
(1861–1948)
First lady, 1901–1909

ELIHU ROOT (*right*)
(1845–1937)
Lawyer, diplomat, Secretary of War under McKinley and Roosevelt, Secretary of State under Roosevelt; Nobel Peace Laureate

GEORGE FREDERICK ROOT (*left*)
(1820–1895)
Music educator, composer

JOHN WELLBORN ROOT (*right*)
(1850–1891)
Chicago architect, designed Monadnock
Building

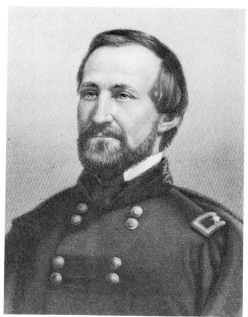
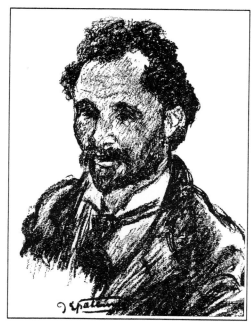

WILLIAM STARKE ROSECRANS
(*left*)
(1819–1898)
Union general in Civil War
Engraving by John A. O'Neill

MORRIS ROSENFELD (*right*)
(1862–1923)
Yiddish poet in New York
Drawing by Jacob Epstein

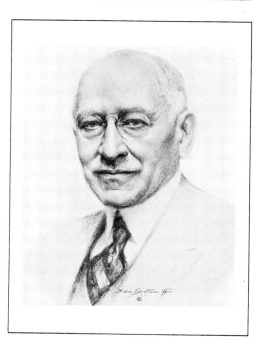
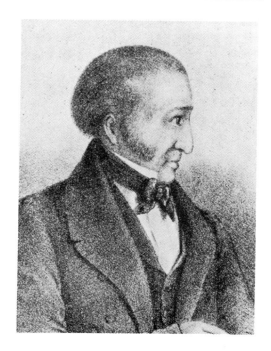

JULIUS ROSENWALD (*left*)
(1862–1932)
Merchant, philanthropist; president of
Sears, Roebuck & Co.
Courtesy Sears, Roebuck & Co.

ALEXANDER ROSS (*right*)
(1783–1856)
Scottish-Canadian pioneer in Oregon

CHARLIE ROSS (*left*)
(*b.c.* 1870)
Kidnapped child, abducted in 1874 and never returned

EDMUND GIBSON ROSS (*right*)
(1826–1907)
U.S. Senator, journalist; voted for acquittal in Johnson impeachment trial
Courtesy Library of Congress, Brady-Handy Collection

GEORGE ROSS (*left*)
(1730–1779)
Lawyer, jurist, signer of Declaration of Independence
Painted by Philip F. Wharton from a painting by Benjamin West. Courtesy Independence National Historical Park

Sɪʀ JOHN ROSS (*right*)
(1777–1856)
Scottish arctic explorer, sought Northwest Passage

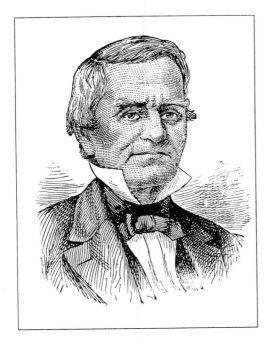

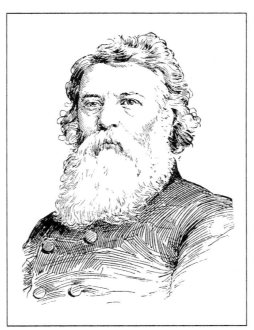

JOHN ROSS (*left*)
[Cooweescoowe; or Kooweskowe]
(1790–1866)
Cherokee Indian chief

THOMAS PRICHARD ROSSITER
(*right*)
(1818–1871)
Painter

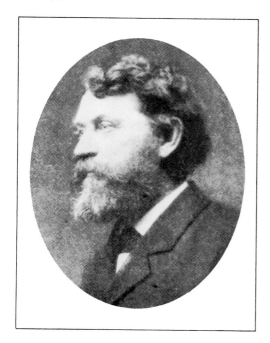

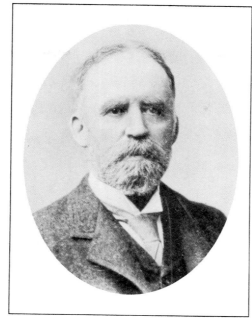

JOSEPH TRIMBLE ROTHROCK
(*left*)
(1839–1922)
Botanist, conservationist, physician, educator
Courtesy New York Academy of Medicine

GEORGE PRESBURY ROWELL
(*right*)
(1838–1908)
Advertising agent, published *Printers' Ink*

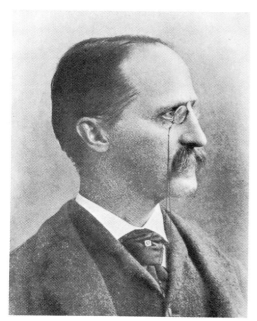

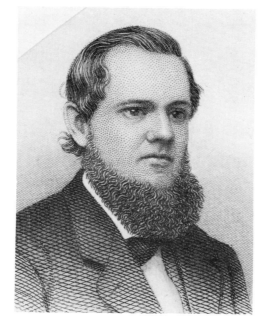

HENRY AUGUSTUS ROWLAND
(*left*)
(1848–1901)
Physicist, educator, authority on solar spectrum

THOMAS FITCH ROWLAND (*right*)
(1831–1907)
Iron and steel manufacturer, constructed the *Monitor*

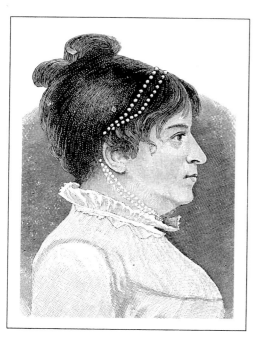

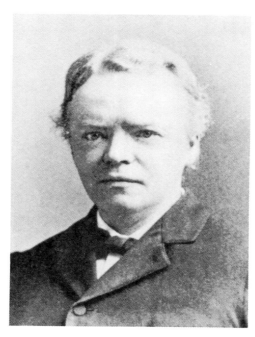

SUSANNA ROWSON (*left*)
[nee Susanna Haswell]
(1762–1824)
Novelist, playwright, actress, educator

JOSIAH ROYCE (*right*)
(1855–1916)
Philosopher, writer, educator

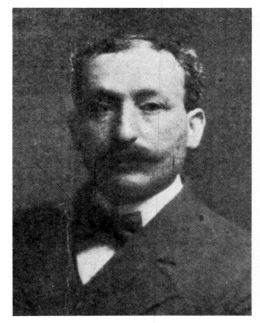

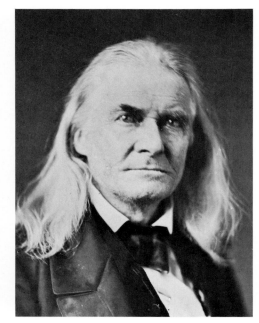

ABRAHAM RUEF (*left*)
(1864–1936)
San Francisco political boss

EDMUND RUFFIN (*right*)
(1794–1865)
Agriculturist, publisher; fired first shot against Fort Sumter
Courtesy Library of Congress, Brady-Handy Collection

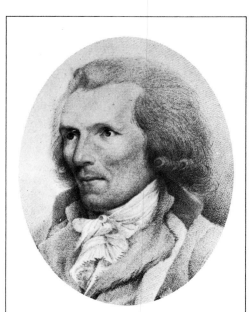

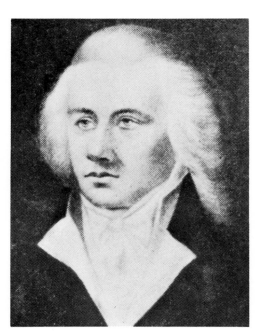

Count RUMFORD (*left*)
[Benjamin Thompson]
(1753–1814)
Physicist, scientific organizer
Courtesy Eric Schaal

JAMES RUMSEY (*right*)
(1743–1792)
Inventor, pioneer steamboat developer
Courtesy West Virginia Department of Archives and History

JOHN DANIEL RUNKLE (*left*)
(1822–1902)
Mathematician, educator; president, Massachusetts Institute of Technology
Courtesy Massachusetts Institute of Technology

JACOB RUPPERT (*right*)
(1842–1915)
New York brewer

BENJAMIN RUSH (*left*)
(*c.* 1745–1813)
Physician, chemist, natural philosopher; signer of Declaration of Independence
Engraved by Richard W. Dodson after a painting by Thomas Sully

RICHARD RUSH (*right*)
(1780–1859)
Diplomat, Attorney General under Madison, Secretary of State under Monroe, Secretary of the Treasury under J. Q. Adams

WILLIAM RUSH (*left*)
(1756–1833)
Wood sculptor, known for ship figureheads
Painting by Rembrandt Peale or Charles Willson Peale. Courtesy Independence National Historical Park

ANNIE RUSSELL (*right*)
(1864–1936)
Actress
Photograph by Napoleon Sarony

CHARLES EDWARD RUSSELL (*left*)
(1860–1941)
Journalist, writer, Socialist leader
Courtesy Tamiment Institute Library

CHARLES MARION RUSSELL (*right*)
(1865–1926)
Cowboy artist
Courtesy Mercaldo Archives

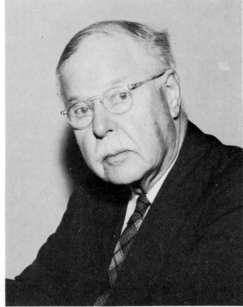

CHARLES TAZE RUSSELL (*left*)
[Pastor Russell]
(1852–1916)
Religious leader, founded Jehovah's Witnesses
Courtesy Watchtower Bible and Tract Society

HARRY LUMAN RUSSELL (*right*)
(1866–1954)
Agricultural bacteriologist, educator; developed cheese-processing methods; conducted anti-tuberculosis research
Courtesy College of Agriculture, University of Wisconsin

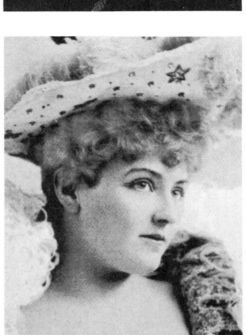

ISRAEL COOK RUSSELL (*left*)
(1852–1906)
Geologist, geographer

LILLIAN RUSSELL (*right*)
[Helen Louise Leonard]
(1861–1922)
Actress, singer; starred in comic-opera roles
Photograph by Napoleon Sarony

SOL SMITH RUSSELL (*left*)
(1848–1902)
Actor
Courtesy Museum of the City of New York

WILLIAM HEPBURN RUSSELL (*right*)
(1812–1872)
Founder of the Pony Express

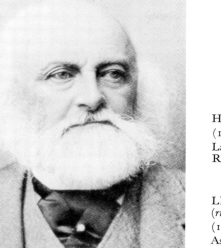

HENRY RUTGERS (*left*)
(1745–1830)
Landholder, philanthropist; benefactor of
Rutgers University

LEWIS MORRIS RUTHERFURD
(*right*)
(1816–1892)
Astronomer, physicist, pioneer in astro-
nomical photography
Courtesy Columbiana Collection, Columbia University

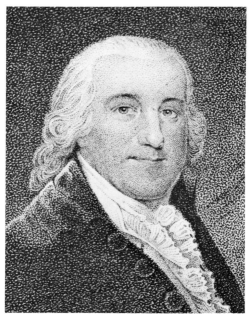

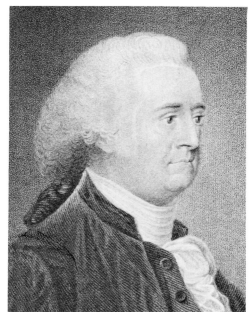

EDWARD RUTLEDGE (*left*)
(1749–1800)
Signer of Declaration of Independence,
Governor of South Carolina
*Engraved by James B. Longacre from a painting by
Ralph Earl. Courtesy South Caroliniana Library,
University of South Carolina*

JOHN RUTLEDGE (*right*)
(1739–1800)
Revolutionary leader, lawyer, jurist; signer
of Constitution; Chief Justice of U.S., 1795
*Engraved by G. F. Storm from a drawing by James
Herring after a painting by John Trumbull*

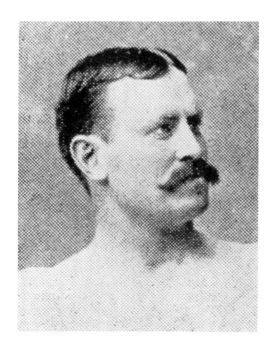

PADDY RYAN (*left*)
(1853–1901)
Heavyweight prize fighter

PATRICK JOHN RYAN (*right*)
(1831–1911)
Roman Catholic prelate, archbishop of
Philadelphia

THOMAS FORTUNE RYAN (*left*)
(1851–1928)
Financier, speculator

ALBERT PINKHAM RYDER (*right*)
(1847–1917)
Painter

JOSEPH SABIN *(left)*
(1821–1881)
Bookseller, bibliographer; compiled *Biblio-
theca Americana*

**WALLACE CLEMENT WARE
SABINE** *(right)*
(1868–1919)
Physicist, educator, pioneer in acoustics

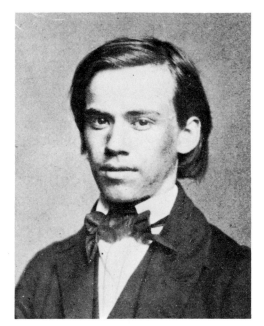

SAMUEL PHILIP SADTLER *(left)*
(1847–1923)
Chemist, educator
Courtesy Philadelphia College of Pharmacy and Science

TRUMAN HENRY SAFFORD *(right)*
(1836–1901)
Astronomer, mathematician, educator
Courtesy Harvard University Archives

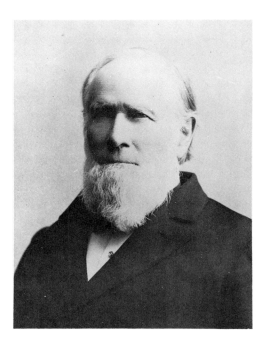

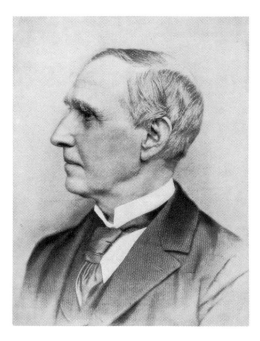

HENRY WILLIAMS SAGE *(left)*
(1814–1897)
Transportation and lumber merchant; bene-
factor of Cornell University
Courtesy Cornell University

RUSSELL SAGE *(right)*
(1816–1906)
Financier, merchant, Congressman

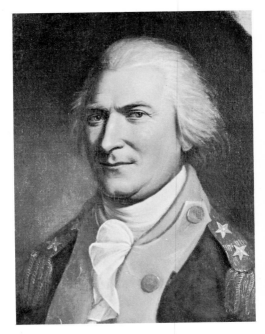

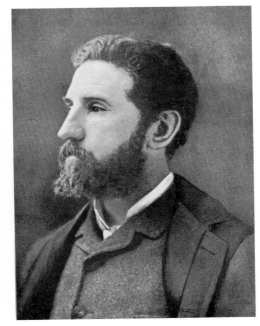

ARTHUR St. CLAIR (*left*)
(1736–1818)
Revolutionary general, first governor of Northwest Territory
Painting by Charles Willson Peale. Courtesy Independence National Historical Park

AUGUSTUS SAINT-GAUDENS (*right*)
(1848–1907)
Sculptor

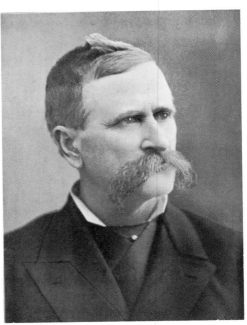

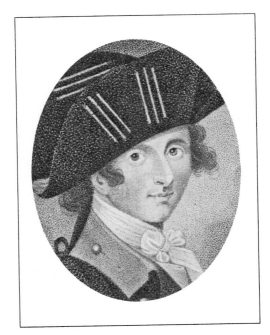

JOHN PIERCE St. JOHN (*left*)
(1833–1916)
Governor of Kansas, prohibitionist

BARRY St. LEGER (*right*)
(1737–1789)
British officer in American Revolution
Engraved by P. Roberts from a miniature by R. Cosway

ALEXIS St. MARTIN (*left*)
(*c.* 1803 –*c.* 1886)
Subject of William Beaumont's experiments on digestion
Courtesy New York Academy of Medicine

CHARLES BALTHAZAR JULIEN FEVRET DE SAINT-MÉMIN (*right*)
(1770–1852)
French portrait engraver in U.S.
Self-portrait

CHARLES SAJOUS　　(*left*)
[Charles Euchariste de Médicis-Jodoigne]
(1852–1929)
Physiologist, endocrinologist, editor, educator

Courtesy Temple University Medical Center

DANIEL ELMER SALMON　　(*right*)
(1850–1914)
Veterinarian, organized federal programs to combat animal disease

Courtesy U.S. Department of Agriculture

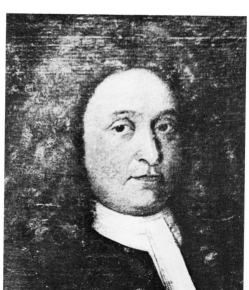

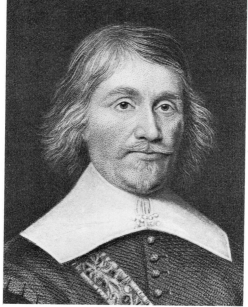

GURDON SALTONSTALL　　(*left*)
(1666–1724)
Clergyman, governor of Colonial Connecticut; a founder of Yale College

Courtesy Yale University

RICHARD SALTONSTALL　　(*right*)
(*c.* 1610–1694)
Massachusetts colonial leader

Engraved by H. W. Smith from a painting by Rembrandt

EDGAR EVERTSON SALTUS　　(*left*)
(1855–1921)
Novelist, poet, essayist

WILLIAM THOMAS SAMPSON
(*right*)
(1840–1902)
Naval officer, Spanish-American War; destroyed Spanish fleet under Cervera

SAMUEL SAMUELS (*left*)
(1823–1908)
Ship captain; made seventy-eight transatlantic voyages in packet *Dreadnought*

FRANKLIN BENJAMIN SANBORN
(*right*)
(1831–1917)
Writer, editor, abolitionist, reformer

JAMES S. SANBORN (*left*)
(1835–1903)
Merchant, organized Chase & Sanborn Co.
Courtesy Standard Brands Inc.

KATE SANBORN (*right*)
[Katherine Abbott Sanborn]
(1839–1917)
Editor, writer, teacher, lecturer

THOMAS SANDERS (*left*)
(1839–1911)
Financier, supported Bell in telephone experiments
Courtesy American Telephone & Telegraph Co.

JULIA SANDERSON (*right*)
(1887–)
Actress

EUGENE SANDOW (*left*)
(1867–1925)
Professional strong man

ROBERT CHARLES SANDS (*right*)
(1799–1832)
Writer, editor, poet
Engraved by Asher B. Durand after a painting by Robert W. Weir

GEORGE SANDYS (*left*)
(1578–1644)
Virginia colonist, poet
Courtesy Virginia State Library

MARGARET E. SANGSTER (*right*)
[nee Margaret Elizabeth Munson]
(1838–1912)
Writer of children's stories, poet; edited
Harper's Bazaar

IRA DAVID SANKEY (*left*)
(1840–1908)
Evangelist, hymn singer; assisted Dwight L.
Moody

ANTONIO LÓPEZ DE SANTA ANNA
(*right*)
[Antonio López de Santa Ana]
(*c.* 1795–1876)
Mexican general, captured the Alamo;
commanded Mexican forces against U.S.,
1846–1847
Painting by Paul L'Ouvrier. Courtesy New-York Historical Society

GEORGE SANTAYANA *(left)*
(1863–1952)
Philosopher, poet, novelist, educator

CHARLES SPRAGUE SARGENT
(right)
(1841–1927)
Dendrologist, wrote *Manual of the Trees of North America*

DUDLEY ALLEN SARGENT *(left)*
(1849–1924)
Physical-training pioneer
Courtesy Harvard University Archives

EPES SARGENT *(right)*
(1813–1880)
Journalist, playwright, editor, poet, spiritualist
Engraved by H. W. Smith after a painting by Charles Loring Elliott

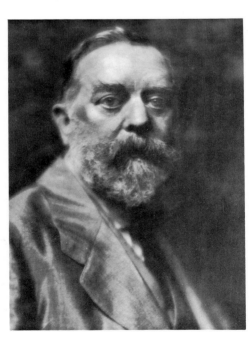

FRANK PIERCE SARGENT *(left)*
(1854–1908)
Labor leader

JOHN SINGER SARGENT *(right)*
(1856–1925)
Painter
Courtesy Peter A. Juley & Son

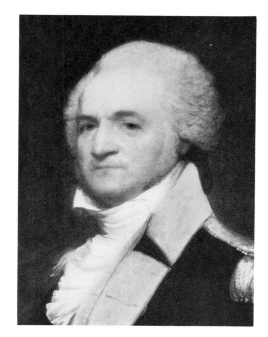

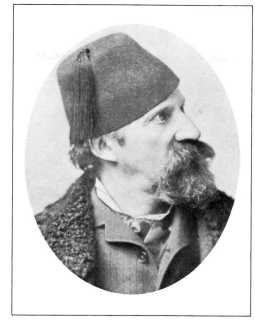

WINTHROP SARGENT (*left*)
(1753–1820)
Secretary of Northwest Territory; first governor, Mississippi Territory
Painting by Gilbert Stuart

NAPOLEON SARONY (*right*)
(c. 1821–1896)
Photographer

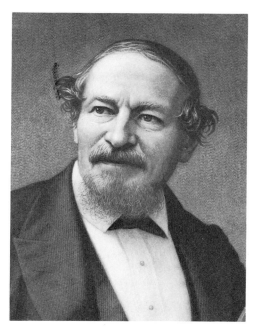

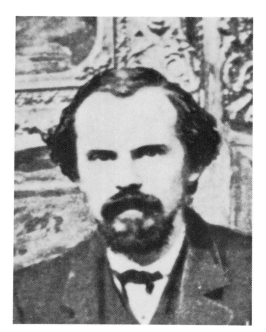

JOHN SARTAIN (*left*)
(1808–1897)
Engraver, publisher; advanced pictorial illustration in U.S. periodicals

SAMUEL SARTAIN (*right*)
(1830–1906)
Engraver
Courtesy Free Library of Philadelphia

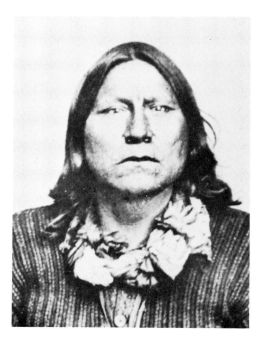

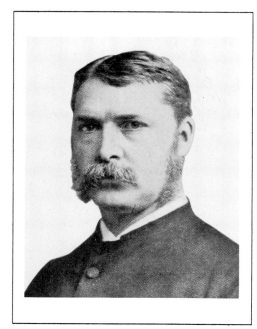

SATANTA (*left*)
(c. 1830–1878)
Kiowa Indian chief
Courtesy Mercaldo Archives

HENRY YATES SATTERLEE (*right*)
(1843–1908)
Protestant Episcopal bishop, initiated work on Washington Cathedral

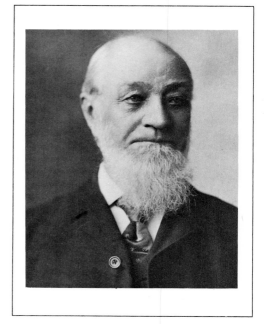

WILLIAM SAUNDERS (*left*)
(1822–1900)
Horticulturist, supervised tree planting in
Washington, D.C.
Courtesy U.S. Department of Agriculture

EDWARD SAVAGE (*right*)
(1761–1817)
Painter, engraver
Painted by Albert Rosenthal from a painting by Saint-Memin. Courtesy Independence National Historical Park

HENRY WILSON SAVAGE (*left*)
(1859–1927)
Theatrical and operatic producer
Courtesy Walter Hampden Memorial Library at The Players, New York

JOSEPH SAXTON (*right*)
(1799–1873)
Inventor, helped standardize weights and
measures throughout U.S.
Courtesy U.S. Treasury Department

THOMAS SAY (*left*)
(1787–1834)
Entomologist
Engraved by Henry Hoppner Meyer from a painting by Joseph Wood

LEWIS ALBERT SAYRE (*right*)
(1820–1900)
Orthopedic surgeon, leader in New York
medicine

JOHN MARTIN SCHAEBERLE (*left*)
(1853–1924)
Astronomer
Courtesy Library of Congress

JACOB SCHAEFER (*right*)
(*born*, 1855)
Billiard champion

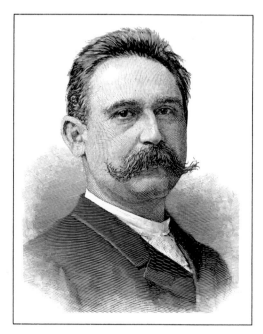

PHILIP SCHAFF (*left*)
(1819–1893)
Church historian, theologian, editor
Engraving by J. J. Cade

XAVER SCHARWENKA (*right*)
(1850–1924)
German pianist and composer in U.S.

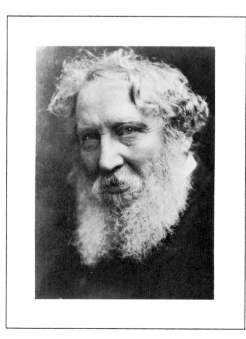

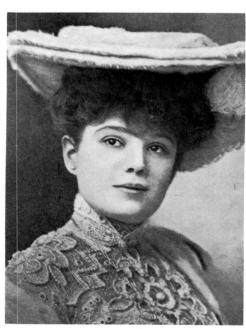

SOLOMON SCHECHTER (*left*)
(1850–1915)
Judaic scholar, editor; president, Jewish
Theological Seminary of America
Courtesy Jewish Theological Seminary of America

FRITZI SCHEFF (*right*)
(*c.* 1882–1954)
Austrian operatic soprano; popular in U.S.

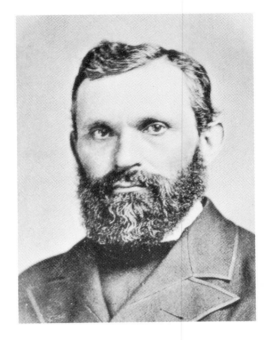

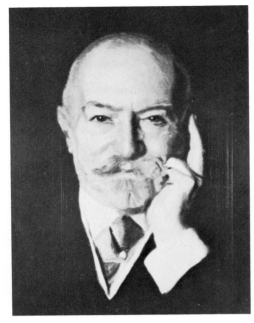

SAMUEL ISAAC JOSEPH
SCHERESCHEWSKY (*left*)
(1831–1906)
Protestant Episcopal bishop of Shanghai,
translated Bible into Chinese

JACOB HENRY SCHIFF (*right*)
(1847–1920)
Investment banker, philanthropist

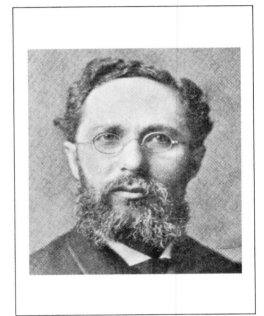

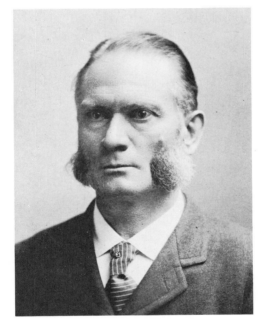

SOLOMON SCHINDLER (*left*)
(1842–1915)
Rabbi, writer; introduced reform Judaism
into New England
Courtesy Temple Israel, Boston, Massachusetts

GUSTAV SCHIRMER (*right*)
(1829–1893)
Music publisher
Courtesy G. Schirmer, Inc.

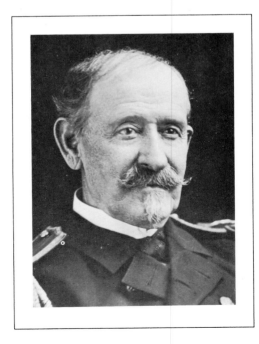

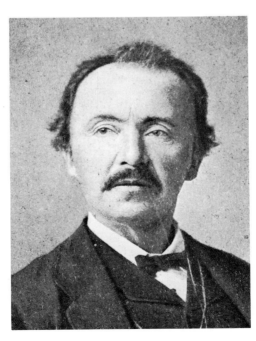

WINFIELD SCOTT SCHLEY (*left*)
(1839–1909)
Naval commander, battle of Santiago,
Spanish-American War

HEINRICH SCHLIEMANN (*right*)
(1822–1890)
German archaeologist in U.S.

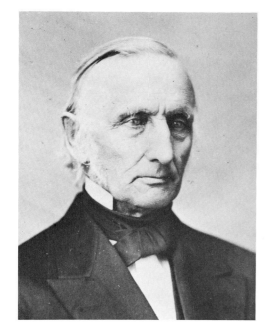

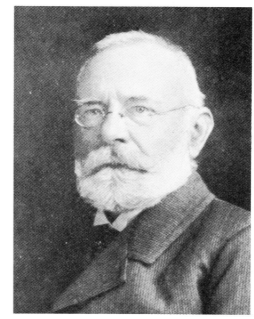

SAMUEL SIMON SCHMUCKER
(*left*)
(1799–1873)
Lutheran clergyman, theologian; president,
Pennsylvania College (now Gettysburg)

CHARLES C. SCHNEIDER (*right*)
(1843–1916)
Bridge engineer

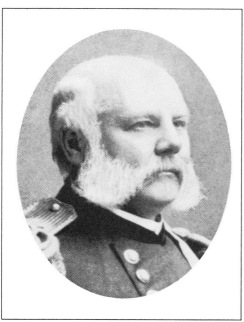

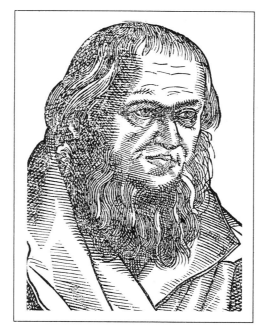

JOHN McALLISTER SCHOFIELD
(*left*)
(1831–1906)
Union general in Civil War; Secretary of
War under Andrew Johnson, Superinten-
dent of West Point

JOHANNES SCHÖNER (*right*)
(1477–1547)
German geographer; constructed first globe
bearing name "America"
After an engraving by Theodor de Bry

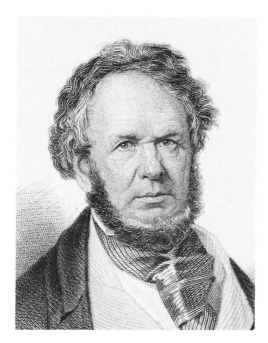

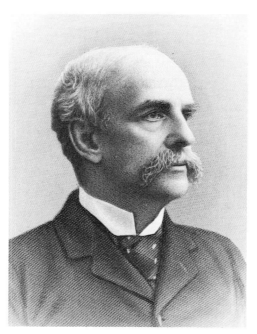

HENRY ROWE SCHOOLCRAFT
(*left*)
(1793–1864)
Ethnologist, geologist, explorer; studied
American Indians
Engraving by Wellstood and Peters

JAMES SCHOULER (*right*)
(1839–1920)
Lawyer, legal scholar, historian

ERNESTINE SCHUMANN-HEINK
(*left*)
[nee Ernestine Roessler]
(1861–1936)
Austrian operatic contralto, concert singer;
popular in U.S.

JACOB GOULD SCHURMAN (*right*)
(1854–1942)
Philosopher, diplomat; president, Cornell
University

CARL SCHURZ (*left*)
(1829–1906)
Journalist, U.S. Senator, Secretary of the
Interior under Hayes; Union general in
Civil War

MONTGOMERY SCHUYLER (*right*)
(1843–1914)
Architectural critic, journalist, editor

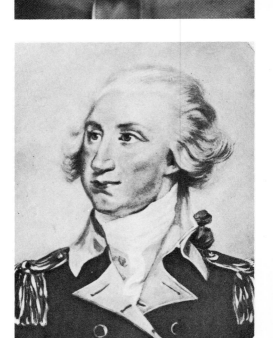

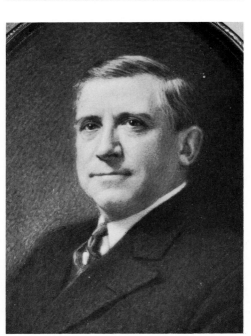

PHILIP JOHN SCHUYLER (*left*)
(1733–1804)
Revolutionary general, New York political
and social leader; U.S. Senator
Painting by John Trumbull

CHARLES MICHAEL SCHWAB
(*right*)
(1862–1939)
Steel industrialist, philanthropist; president,
U.S. Steel and Bethlehem Steel
*Painting by J. Phillip Schmand. Courtesy New-York
Historical Society*

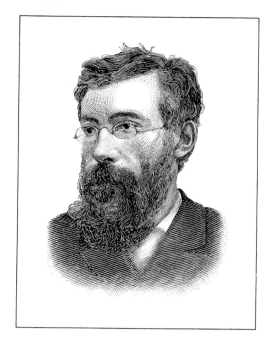

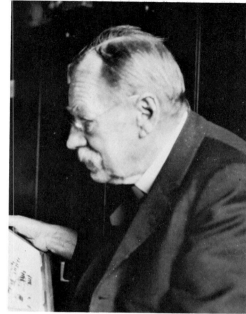

MICHAEL SCHWAB (*left*)
(1853–1898)
Anarchist, involved in the Haymarket bombing

EUGENE AMANDUS SCHWARZ (*right*)
(1844–1928)
Coleopterist, entomologist
Courtesy Franklin Institute

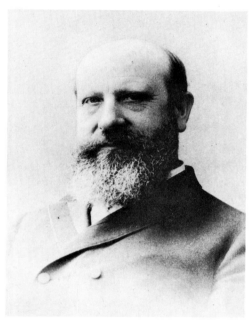

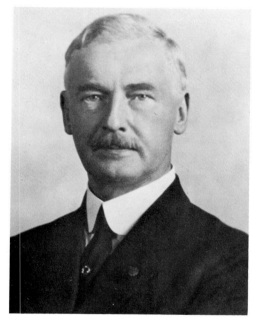

FREDERICK AUGUST OTTO SCHWARZ (*left*)
(1836–1911)
Toy merchant
Courtesy George Burke Public Relations

GEORGE EDMUND DE SCHWEINITZ (*right*)
(1858–1938)
Ophthalmologist, educator; president, American Medical Association
Courtesy New York Academy of Medicine

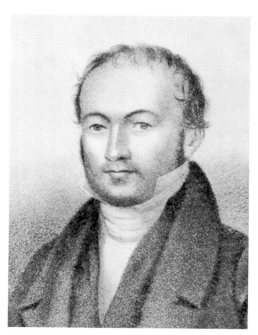

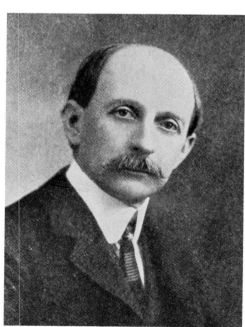

LEWIS DAVID VON SCHWEINITZ (*left*)
(1780–1834)
Botanist, mycologist; Moravian clergyman

CLINTON SCOLLARD (*right*)
(1860–1932)
Poet, writer, educator

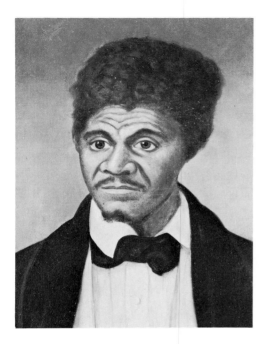

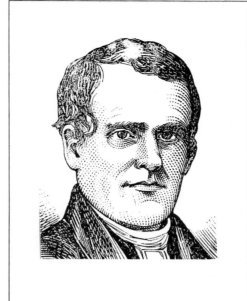

DRED SCOTT (*left*)
(*c.* 1795–1858)
Negro slave, denied freedom by Supreme
Court in *Dred Scott v. Sanford*
Courtesy New-York Historical Society

ORANGE SCOTT (*right*)
(1800–1847)
Methodist clergyman, abolitionist
Courtesy Methodist Historical Society

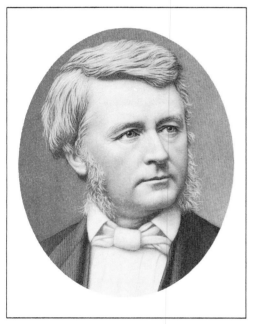

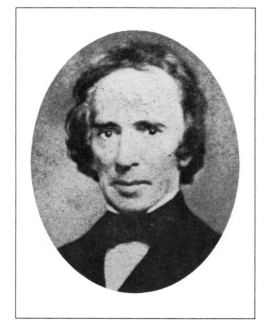

THOMAS ALEXANDER SCOTT
(*left*)
(1823–1881)
President, Pennsylvania Railroad; Union
transportation officer, Civil War
Engraving by Samuel Sartain

WALTER SCOTT (*right*)
(1796–1861)
Clergyman and evangelist of the Disciples of
Christ
Courtesy Meserve Collection

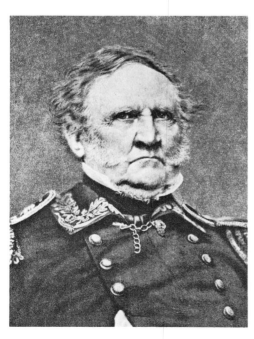

WINFIELD SCOTT (*left*)
(1786–1866)
General-in-chief, U.S. Army, 1841–1861
Photograph by Mathew Brady

ANTONIO SCOTTI (*right*)
(1866–1936)
Italian basso with Metropolitan Opera
Company

GEORGE WHITFIELD SCRANTON
(*left*)
(1811–1861)
Iron manufacturer, Congressman; founded
Scranton, Pennsylvania
Engraving by E. G. Williams & Bro. Courtesy
Lackawanna Historical Society

CHARLES SCRIBNER (*right*)
(1821–1871)
Publisher

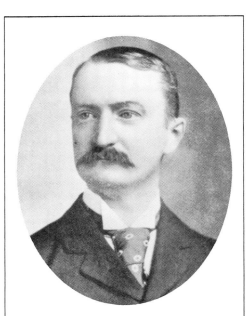

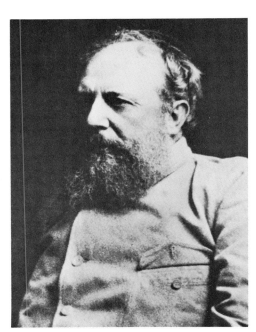

CHARLES SCRIBNER (*left*)
(1854–1930)
Publisher

EDWARD WYLLIS SCRIPPS (*right*)
(1854–1926)
Newspaper publisher, philanthropist, en-
dowed Scripps Institution of Oceanography
Courtesy Scripps-Howard Newspapers

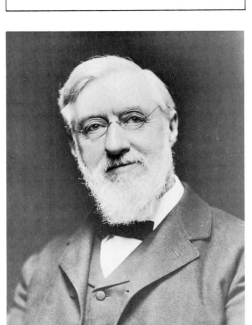

JAMES EDMUND SCRIPPS (*left*)
(1835–1906)
Newspaper publisher
Courtesy "Detroit News"

HORACE ELISHA SCUDDER (*right*)
(1838–1902)
Editor, writer

SAMUEL HUBBARD SCUDDER
(*left*)
(1837–1911)
Entomologist
Courtesy Harvard University Biological Laboratories

SAMUEL SEABURY (*right*)
(1729–1796)
Clergyman, Loyalist; first bishop of Protes-
tant Episcopal Church in America
Engraved by D. C. Hinman from a painting by
Thomas S. Duché

CHARLES SEALSFIELD (*left*)
[Karl Anton Postl]
(1793–1864)
Novelist

BARNAS SEARS (*right*)
(1802–1880)
Baptist clergyman, educator; president,
Brown University

RICHARD DUDLEY SEARS (*left*)
(c. 1861–1943)
Tennis champion

RICHARD WARREN SEARS (*right*)
(1863–1914)
Merchant; founded Sears, Roebuck & Co.
Courtesy Sears, Roebuck & Co.

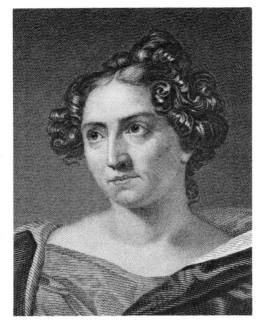

JAMES ALEXANDER SEDDON *(left)*
(1815–1880)
U.S. Congressman, Confederate Secretary of War
Engraving by H. S. Sadd

CATHARINE MARIA SEDGWICK
(right)
(1789–1867)
Novelist
After a painting by Charles C. Ingham

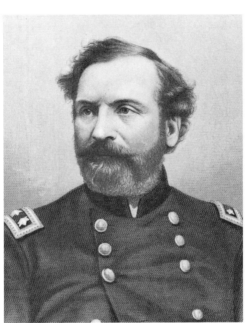
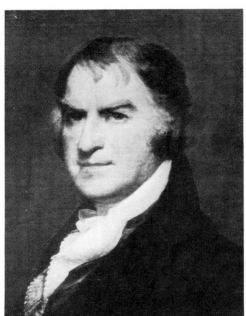

JOHN SEDGWICK *(left)*
(1813–1864)
Union general in Civil War
Engraving by John C. Buttre

THEODORE SEDGWICK *(right)*
(1746–1813)
Lawyer, jurist, U.S. Senator, Congressman
Painting by Gilbert Stuart

WILLIAM THOMPSON SEDGWICK
(left)
(1855–1921)
Biologist, sanitarian, educator
Courtesy Massachusetts Institute of Technology

JULIUS HAWLEY SEELYE *(right)*
(1824–1895)
Clergyman, educator; president of Amherst College
Courtesy Amherst College

LAURENUS CLARK SEELYE (*left*)
(1837–1924)
Clergyman, educator; first president of
Smith College
Courtesy Library of Congress

EDWARD CONSTANT SEGUIN
(*right*)
(1843–1898)
Neurologist, educator
Courtesy New York Academy of Medicine

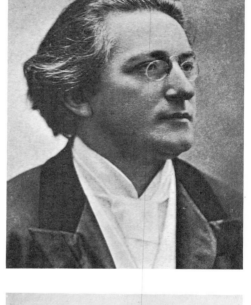

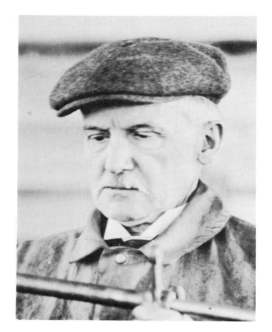

ANTON SEIDL (*left*)
(1850–1898)
Conductor, New York Philharmonic, Metro-
politan Opera; authority on German opera

GEORGE BALDWIN SELDEN (*right*)
(1846–1922)
Patent lawyer, inventor, pioneer automobile
designer
Courtesy Automobile Manufacturers Association

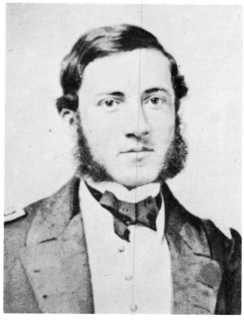

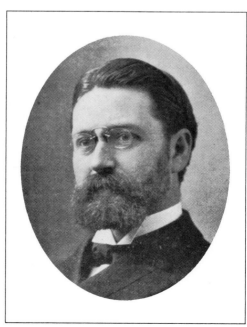

THOMAS OLIVER SELFRIDGE
(*left*)
(1836–1924)
Naval officer
Courtesy Meserve Collection

**EDWIN ROBERT ANDERSON
SELIGMAN** (*right*)
(1861–1939)
Economist, educator, reformer

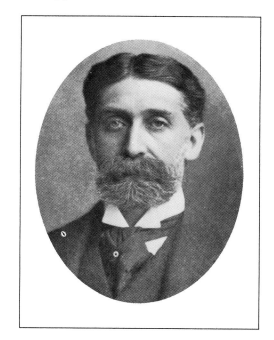

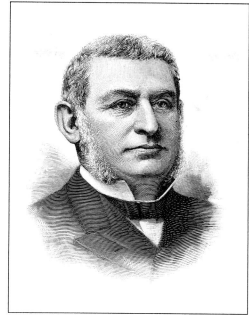

ISAAC NEWTON SELIGMAN (*left*)
(1855–1917)
Investment banker, reformer

JESSE SELIGMAN (*right*)
(1827–1894)
Merchant, banker, philanthropist

JOSEPH SELIGMAN (*left*)
(1819–1880)
Financier, reformer, philanthropist; founded
J. & W. Seligman & Co.
Courtesy New-York Historical Society

COLEMAN SELLERS (*right*)
(1827–1907)
Engineer, inventor, lecturer

WILLIAM SELLERS (*left*)
(1824–1905)
Machine-tool manufacturer, inventor; pro-
posed standard screw-thread system
Engraving by Samuel Sartain

MARCELLA SEMBRICH (*right*)
[Praxede Marcelline Kochańska]
(1858–1935)
Austrian operatic soprano; popular in U.S.

RAPHAEL SEMMES (*left*)
(1809–1877)
Confederate admiral; commanded raider
Alabama in Civil War

LETITIA TYLER SEMPLE (*right*)
[Mrs. James A. Semple]
(1821–1907)
Daughter of John Tyler; White House
hostess, 1844

NICHOLAS SENN (*left*)
(1844–1908)
Surgeon, educator, philanthropist
Courtesy New York Academy of Medicine

SEQUOYAH (*right*)
[Sequoya; George Guess]
(*c.* 1770–1843)
Half-breed, compiled Cherokee catalogue of
syllables; eponym of redwood *Sequoias*
After a painting attributed to C. B. King. Courtesy
Bureau of American Ethnology, Smithsonian Institution

JONATHAN DICKINSON SERGEANT
(*left*)
(1746–1793)
Lawyer, Revolutionary leader; member of
Continental Congress, delegate to Constitu-
tional Convention
Painted by George Caleb Bingham from a painting
by Charles Willson Peale. Courtesy Miss Elizabeth
Sergeant Abbot and the Frick Art Reference Library

JUNÍPERO SERRA (*right*)
[Miguel José Serra]
(1713–1784)
Franciscan leader, established missions along
California coast

MOTHER ELIZABETH SETON (*left*)
[nee Elizabeth Ann Bayley]
(1774–1821)
Leader of Catholic charitable and educational work; beatified 1963
Courtesy Mount St. Vincent-on-Hudson

ERNEST THOMPSON SETON (*right*)
[Ernest Seton Thompson]
(1860–1946)
Writer of nature stories; naturalist, illustrator
Courtesy Mrs. Ernest Thompson Seton

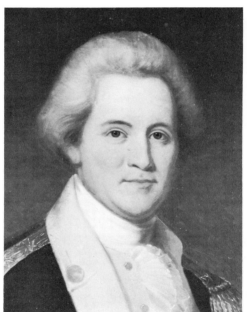

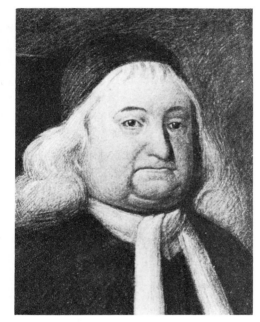

JOHN SEVIER (*left*)
(1745–1815)
Frontiersman, Revolutionary soldier; first governor of Tennessee
Courtesy Tennessee Conservation Department

SAMUEL SEWALL (*right*)
(1652–1730)
Colonial jurist; judge at Salem witchcraft trials
After a painting attributed to John Smibert

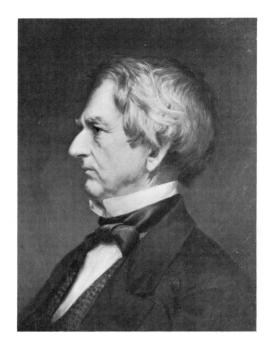

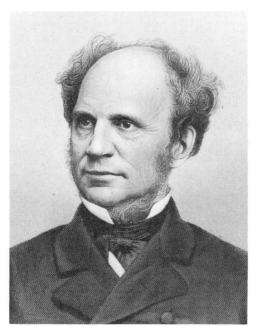

WILLIAM HENRY SEWARD (*left*)
(1801–1872)
Secretary of State under Lincoln and Andrew Johnson, U.S. Senator; negotiated purchase of Alaska
Retouched photograph by Mathew Brady. Courtesy U.S. Department of State

HORATIO SEYMOUR (*right*)
(1810–1886)
Democratic politician, Governor of New York
Engraved by John C. Buttre from a photograph by Mathew Brady

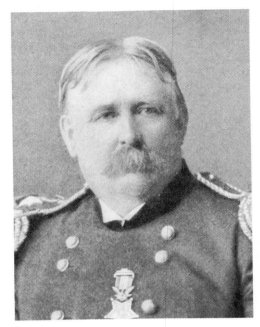

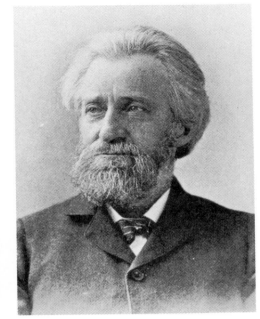

WILLIAM RUFUS SHAFTER (*left*)
(1835–1906)
Major general, Spanish-American War; captured Santiago de Cuba

NATHANIEL SOUTHGATE SHALER
(*right*)
(1841–1906)
Geologist, paleontologist, writer

EFFIE SHANNON (*left*)
(1867–1954)
Actress
Photograph by Napoleon Sarony

ISAAC SHARPLESS (*right*)
(1848–1920)
Educator, president of Haverford College
Courtesy Haverford College

GEORGE CHEYNE SHATTUCK
(*left*)
(1813–1893)
Physician, educator
Courtesy New York Academy of Medicine

ALBERT SHAW (*right*)
(1857–1947)
Editor, writer on economics

ANNA HOWARD SHAW (*left*)
(1847–1919)
Suffragette, reformer, Methodist minister, physician
Courtesy Tamiment Institute

LEMUEL SHAW (*right*)
(1781–1861)
Jurist, chief justice of Massachusetts
Photograph by Southworth and Hawes. Courtesy Metropolitan Museum of Art, Stokes-Hawes Collection

ROBERT GOULD SHAW (*left*)
(1837–1863)
Union officer, commanded first free-state Negro regiment in Civil War

JOHN DAWSON GILMARY SHEA
(*right*)
(1824–1892)
Historian, editor

THOMAS GASKELL SHEARMAN
(*left*)
(1834–1900)
Lawyer, economist, philanthropist; counsel for Jim Fisk, Jay Gould, James J. Hill

WILLIAM GREENOUGH THAYER
SHEDD (*right*)
(1820–1894)
Theologian, educator, writer
Courtesy Library of Congress, Brady-Handy Collection

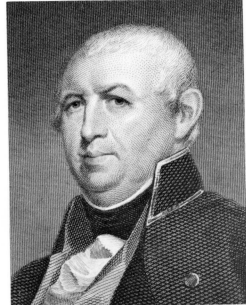

JOSEPH EARL SHEFFIELD (*left*)
(1793–1882)
Merchant, financier; endowed Sheffield
Scientific School, Yale University

ISAAC SHELBY (*right*)
(1750–1826)
Revolutionary officer, pioneer; first governor
of Kentucky
*Engraved by Asher B. Durand after a painting by
Mathew H. Jouett*

CHARLES MONROE SHELDON
(*left*)
(1857–1946)
Congregational clergyman, editor; author
of *In His Steps*

EDWARD AUSTIN SHELDON (*right*)
(1823–1897)
Educator, advocate of Pestalozzi methods

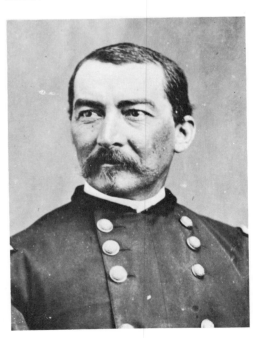

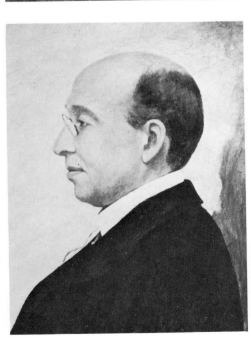

PHILIP HENRY SHERIDAN (*left*)
(1831–1888)
Union general in Civil War
Courtesy New-York Historical Society

FRANK DEMPSTER SHERMAN
(*right*)
(1860–1916)
Poet, architect
*Painting by Morgan Hart. Courtesy New-York His-
torical Society*

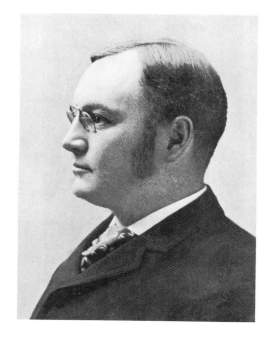

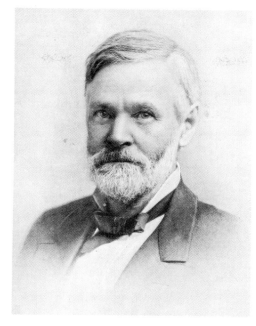

JAMES SCHOOLCRAFT SHERMAN
(*left*)
(1855–1912)
Lawyer, Congressman; Vice-President of
U.S., 1909–1912

JOHN SHERMAN (*right*)
(1823–1900)
U.S. Senator, Secretary of Treasury under
Hayes, Secretary of State under McKinley,
sponsor of Sherman Antitrust Act

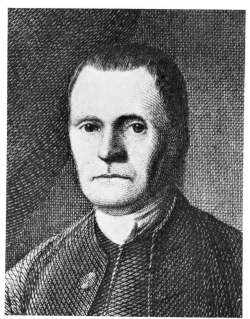

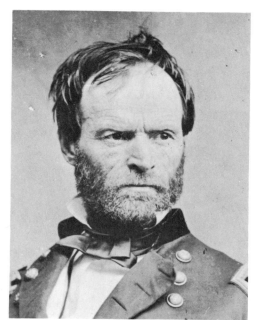

ROGER SHERMAN (*left*)
(1721–1793)
Connecticut legislator; only man to sign
Declaration of Independence, Articles of
Association, Articles of Confederation, and
the Constitution
*Engraved by Simeon S. Jocelyn from a painting by
Ralph Earle*

WILLIAM TECUMSEH SHERMAN
(*right*)
[Tecumseh Sherman]
(1820–1891)
Union general in Civil War, devastated
Georgia on march to sea
Courtesy New-York Historical Society

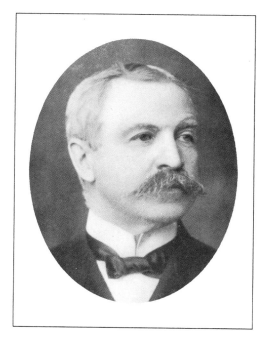

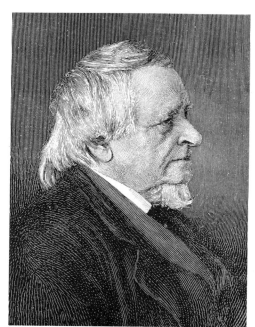

LOUIS SHERRY (*left*)
(1856–1926)
Restaurant operator

BENJAMIN PENHALLOW
SHILLABER (*right*)
(1814–1890)
Humorist, journalist, editor

GEORGE SHIRAS (*left*)
(1832–1924)
Associate justice, U.S. Supreme Court

WALTER SHIRLAW (*right*)
(1838–1909)
Painter, engraver

WILLIAM SHIRLEY (*left*)
(1694–1771)
Governor of Colonial Massachusetts; major
general, French and Indian Wars
Painting by Thomas Hudson

CHRISTOPHER LATHAM SHOLES
(*right*)
(1819–1890)
Typewriter inventor, journalist
Courtesy Smithsonian Institution

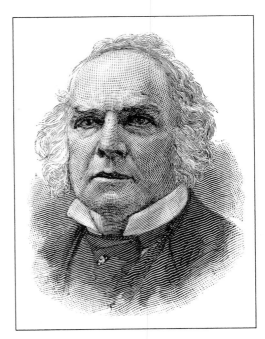

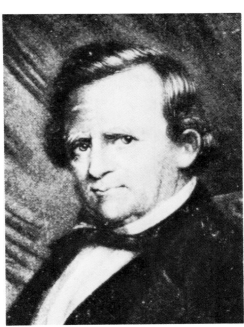

CHARLES SHORT (*left*)
(1821–1886)
Classical philologist, president of Kenyon
College
Photograph by Pach Brothers

HENRY MILLER SHREVE (*right*)
(1785–1851)
Early Mississippi River steamboat operator;
eponym of Shreveport, Louisiana

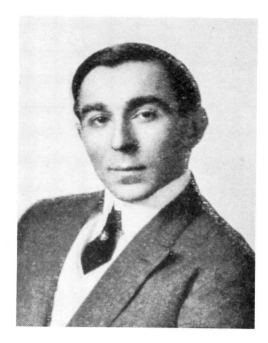

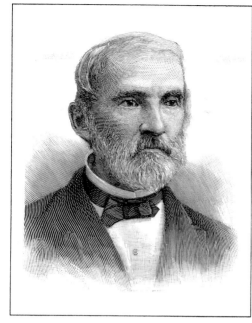

LEE SHUBERT (*left*)
(1875–1953)
Theatre manager, producer

HENRY HASTINGS SIBLEY (*right*)
(1811–1891)
Indian trader, first governor of Minnesota

HIRAM SIBLEY (*left*)
(1807–1888)
Financier, co-founder of Western Union;
benefactor of Cornell University

DANIEL EDGAR SICKLES (*right*)
(1825–1914)
Congressman, Union general, diplomat;
acquitted, on plea of temporary insanity, of
killing Philip Barton Key

MRS. DANIEL EDGAR SICKLES
(*left*)
[nee Theresa Bagioli]
(*c.*1836 –*c.* 1864)
Wife of Daniel E. Sickles, source of duel
between her husband and Philip Barton Key

MARGARET SIDNEY (*right*)
[Harriet Lothrop, nee Harriet Mulford
Stone]
(1844–1924)
Writer; author of *Five Little Peppers and How
They Grew*

FRANZ SIGEL (*left*)
(1824–1902)
Union general in Civil War; editor
Engraving by R. Dudensing

LYDIA SIGOURNEY (*right*)
[nee Lydia Howard Huntley]
(1791–1865)
Writer, poet, "the sweet singer of Hartford"
Courtesy Library of Congress, Brady-Handy Collection

CHARLES DWIGHT SIGSBEE (*left*)
(1845–1923)
Naval officer, hydrographer; commanded
the *Maine* at the time of its destruction in
Havana Harbor

EDWARD ROWLAND SILL (*right*)
(1841–1887)
Poet, educator; wrote "The Fool's Prayer"

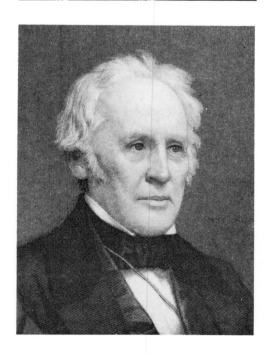

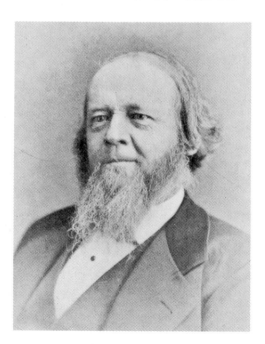

BENJAMIN SILLIMAN (*left*)
(1779–1864)
Chemist, geologist, lecturer, editor
Engraving by John Sartain. Courtesy Burndy Library

BENJAMIN SILLIMAN (*right*)
(1816–1885)
Chemist, educator, editor

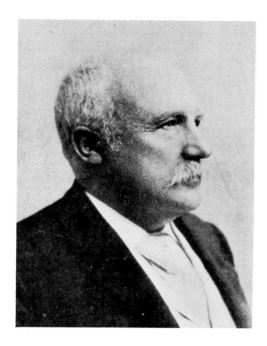

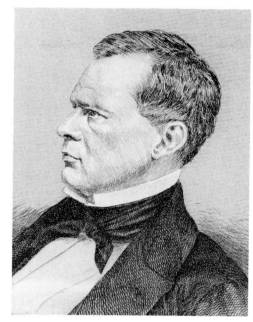

FRANKLIN SIMMONS (*left*)
(1839–1913)
Sculptor

WILLIAM GILMORE SIMMS (*right*)
(1806–1870)
Southern poet, novelist, biographer, historian

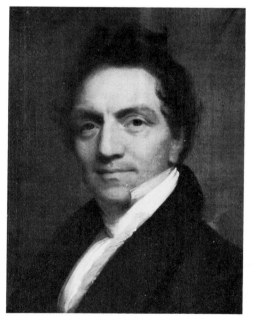

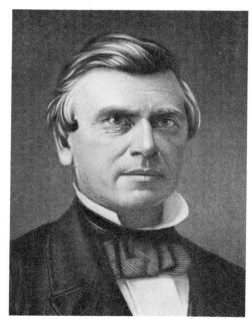

EDMUND SHAW SIMPSON (*left*)
(1784–1848)
Actor, theatrical manager
Courtesy Museum of the City of New York

MATTHEW SIMPSON (*right*)
(1811–1884)
Methodist Episcopal bishop, educator; delivered eulogy at Lincoln's burial
Engraving by F. F. Jones

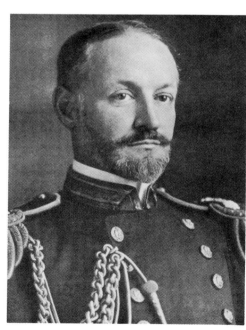

JAMES MARION SIMS (*left*)
(1813–1883)
Surgeon, pioneer gynecologist

WILLIAM SOWDEN SIMS (*right*)
(1858–1936)
Naval officer

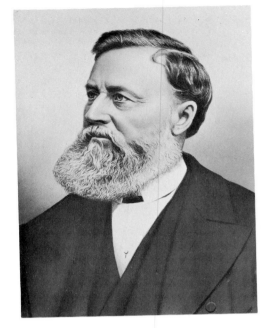

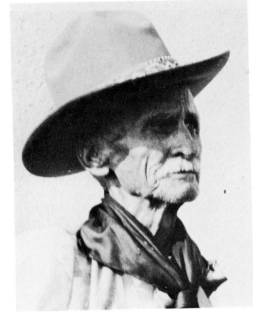

ISAAC MERRIT SINGER (*left*)
(1811–1875)
Sewing-machine inventor, manufacturer
Courtesy Singer Manufacturing Co.

CHARLES A. SIRINGO (*right*)
(1855–1928)
Cowboy, adventurer, writer
Courtesy Houghton Mifflin Co.

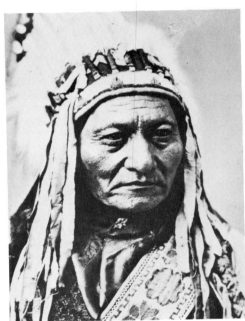

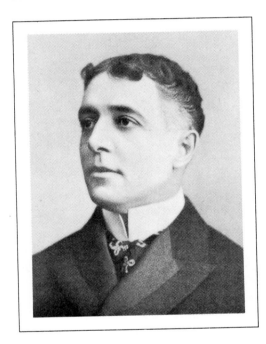

SITTING BULL (*left*)
(*c.* 1834–1890)
Sioux Indian chief
Courtesy Mercaldo Archives

OTIS SKINNER (*right*)
(1858–1942)
Actor

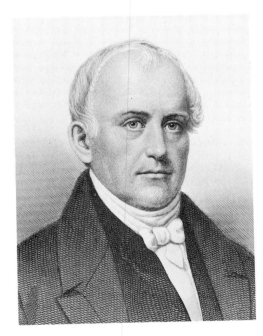

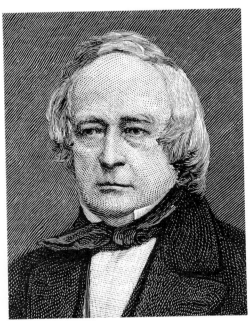

SAMUEL SLATER (*left*)
(1768–1835)
Cotton manufacturer, brought English tex-
tile-machine designs to U.S.

JOHN SLIDELL (*right*)
(1793–1871)
U.S.Senator,Congressman; appointed Con-
federate commissioner to France

JOHN SLOAN (*left*)
(1871–1951)
Painter, etcher
Courtesy Peter A. Juley & Son

TOD SLOAN (*right*)
[James Forman Sloan]
(1874–1933)
Jockey
Courtesy Mercaldo Archives

JOHN DRAKE SLOAT (*left*)
(1781–1867)
Naval officer
Courtesy U.S. Department of Defense

JOSHUA SLOCUM (*right*)
(1844–*c*.1910)
Sailor, adventurer, writer; sailed alone around the world

ALBION WOODBURY SMALL (*left*)
(1854–1926)
Sociologist, educator, editor
Courtesy University of Chicago Archives

GEORGE WASHBURN SMALLEY
(*right*)
(1833–1916)
Journalist

JOHN SMIBERT *(left)*
(1688–1751)
Painter; designed Faneuil Hall, Boston
Self-portrait

JAMES SMILLIE *(right)*
(1807–1885)
Engraver
Engraving by James D. Smillie. Courtesy Prints Division, New York Public Library

JAMES DAVID SMILLIE *(left)*
(1833–1909)
Etcher, engraver

ALEX SMITH *(right)*
(c. 1874–1930)
Golf professional, helped popularize golf in U.S.
Courtesy Woody Gelman

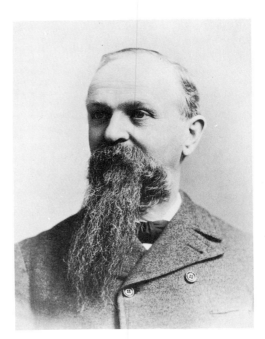

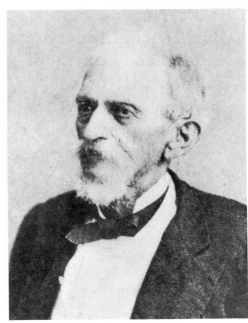

ANDREW SMITH *(left)*
(1836–1894)
Cough drop manufacturer; one of the Smith Brothers ("Mark")
Courtesy Smith Brothers

ASHBEL SMITH *(right)*
(1805–1886)
Texas political leader, diplomat; physician
Courtesy Texas State Library

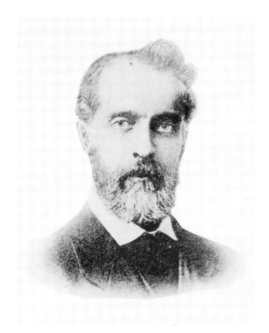

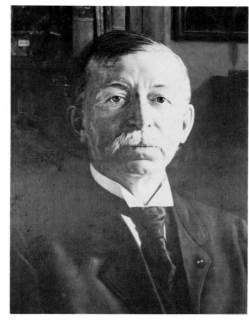

CHARLES SHALER SMITH (*left*)
(1836–1886)
Civil engineer, bridge designer
Courtesy Smithsonian Institution and the Railway and Locomotive Historical Society

EDGAR FAHS SMITH (*right*)
(1854–1928)
Chemist, educator
Painting by Conrad Frederick Haeseler. Courtesy American Philosophical Society

ELIHU HUBBARD SMITH (*left*)
(1771–1798)
Physician, poet, playwright, editor; one of "Hartford Wits"
Painting attributed to James Sharples, Sr. or Ellen Sharples

ERWIN FRINK SMITH (*right*)
(1854–1927)
Plant pathologist

FRANCIS HOPKINSON SMITH
(*left*)
(1838–1915)
Novelist, painter, construction engineer, lecturer

GERRIT SMITH (*right*)
(1797–1874)
Philanthropist, abolitionist, reformer; Congressman

HARRY BACHE SMITH (*left*)
[Henry Bach Smith]
(1860–1936)
Musical-comedy librettist
Courtesy Museum of the City of New York

HENRY BOYNTON SMITH (*right*)
(1815–1877)
Presbyterian clergyman, theologian, editor
Courtesy Library of Congress, Brady-Handy Collection

HENRY PRESERVED SMITH (*left*)
(1847–1927)
Presbyterian clergyman, educator, Biblical scholar

HOKE SMITH (*right*)
(1855–1931)
Secretary of the Interior under Cleveland, Governor of Georgia, U.S. Senator

HORACE SMITH (*left*)
(1808–1893)
Firearms inventor, manufacturer; co-founder, Smith & Wesson Co.
Courtesy Smith & Wesson Co.

HYRUM SMITH (*right*)
(1800–1844)
A founder of the Mormon Church, brother of Joseph Smith (1805–1844)
Courtesy Church of Jesus Christ of Latter-Day Saints

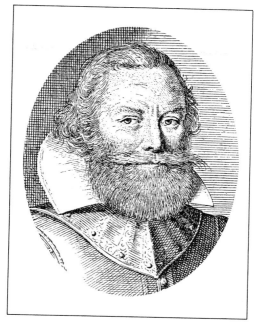

JAMES SMITH (*left*)
(*c.*1719–1806)
Lawyer, signer of Declaration of Independence

JOHN SMITH (*right*)
(1580–1631)
Leader of Virginia colonists at Jamestown

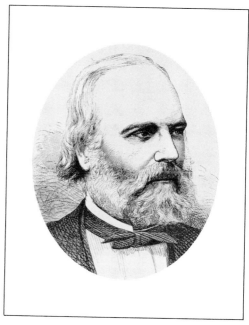

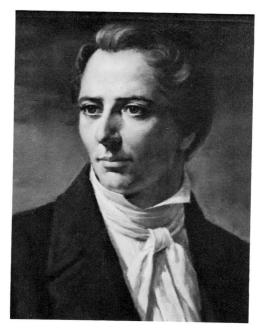

JOHN LAWRENCE SMITH (*left*)
(1818–1883)
Mineralogist, chemist, physician

JOSEPH SMITH (*right*)
(1805–1844)
Prophet and founder of the Mormon Church
Courtesy Church of Jesus Christ of Latter-Day Saints

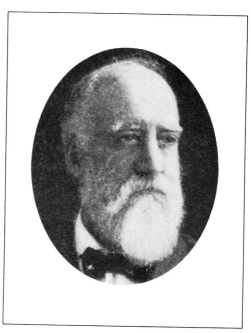

JOSEPH SMITH (*left*)
(1832–1914)
President of Mormon Church outside Utah; son of Joseph Smith (1805–1844)

JOSEPH FIELDING SMITH (*right*)
(1838–1918)
President of Utah branch of Mormon Church; nephew of Joseph Smith (1805–1844)
Courtesy Church of Jesus Christ of Latter-Day Saints

LYMAN CORNELIUS SMITH *(left)*
(1850–1910)
Typewriter manufacturer, financier, philanthropist
Engraving by H. B. Hall's Sons

MELANCTON SMITH *(right)*
[Melancthon Smith]
(1810–1893)
Naval officer
Courtesy Library of Congress, Brady Collection

NATHAN SMITH *(left)*
(1762–1829)
Physician, surgeon; pioneer in medical education at Dartmouth and Yale
Courtesy Yale University

NATHAN RYNO SMITH *(right)*
(1797–1877)
Surgeon, educator, editor

ORMOND GERALD SMITH *(left)*
(1860–1933)
Publisher of dime novels, magazines; partner in Street & Smith
Courtesy Condé Nast Publications, Inc.

ROBERT SMITH *(right)*
(1757–1842)
Secretary of the Navy and Attorney General under Jefferson, Secretary of State under Madison
Painting by Freeman Thorpe. Courtesy U.S. Department of State

ROSWELL SMITH *(left)*
[Roswell Chamberlain Smith]
(1829–1892)
Book and magazine publisher, founded The
Century Co.

SAMUEL FRANCIS SMITH *(right)*
(1808–1895)
Baptist clergyman, educator, poet; wrote
words for "America"

SAMUEL STANHOPE SMITH *(left)*
(1750–1819)
Presbyterian clergyman, president of College of New Jersey (Princeton)
Engraved by Goodman & Piggot after a painting by C. Lawrence

SOL SMITH *(right)*
[Solomon Franklin Smith]
(1801–1869)
Comic actor, theatrical manager, lawyer
Engraving by W. G. Jackman

SOPHIA SMITH *(left)*
(1796–1870)
Philanthropist, founded Smith College
Courtesy Smith College Archives

THEOBALD SMITH *(right)*
(1859–1934)
Bacteriologist, pathologist, educator
Courtesy New York Academy of Medicine

WILLIAM SMITH *(left)*
(1727–1803)
Anglican clergyman; first provost, College of Philadelphia (University of Pennsylvania)
Engraved by David Edwin from a painting by Gilbert Stuart

WILLIAM SOOY SMITH *(right)*
(1830–1916)
Bridge and railroad engineer, pioneer in use of pneumatic caissons and structural steel

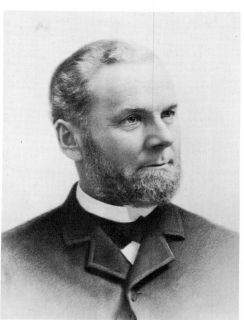

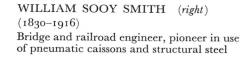

WILLIAM W. SMITH *(left)*
(1830–1913)
Cough drop manufacturer; one of the Smith Brothers ("Trade")
Courtesy Smith Brothers

JAMES SMITHSON *(right)*
[James Lewis Macie]
(1765–1829)
British chemist, gave £100,000 to U.S. to found Smithsonian Institution

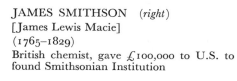

REED SMOOT *(left)*
(1862–1941)
U.S. Senator, Mormon leader; sponsor of Smoot-Hawley Tariff Act
Courtesy Church of Jesus Christ of Latter-Day Saints

HERBERT WEIR SMYTH *(right)*
(1857–1937)
Classical scholar, educator
Courtesy Harvard University Archives

JOSIAH SNELLING (*left*)
(1782–1828)
Army officer, Minnesota pioneer

EVANGELINUS APOSTOLIDES
SOPHOCLES (*right*)
(*c*.1805–1883)
Greek philologist, educator

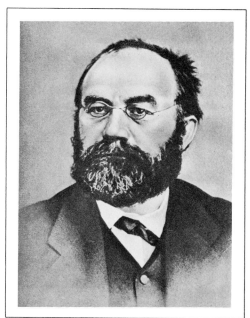

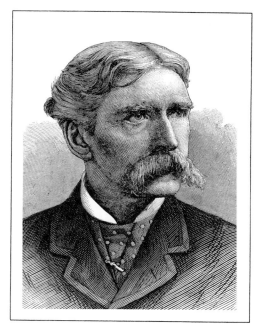

FRIEDRICH ADOLPH SORGE (*left*)
(1828–1906)
Socialist labor leader
Courtesy Tamiment Institute Library

EDWARD ASKEW SOTHERN (*right*)
(1826–1881)
Actor, theatrical producer
After a photograph by Napoleon Sarony

EDWARD HUGH SOTHERN (*left*)
(1859–1933)
Actor

PIERRE SOULÉ (*right*)
(1801–1870)
U.S. Senator, diplomat, signed Ostend
Manifesto seeking purchase of Cuba

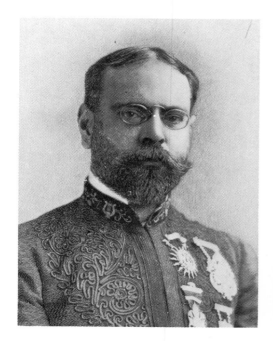

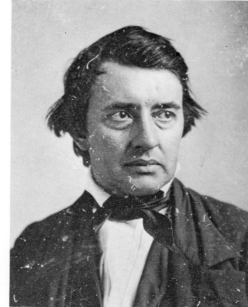

JOHN PHILIP SOUSA (*left*)
(1854–1932)
Bandmaster, composer of marches

ALBERT SANDS SOUTHWORTH
(*right*)
(1811–1894)
Photographer, partner in Southworth and Hawes
Photograph by Southworth and Hawes. Courtesy Metropolitan Museum of Art, Stokes-Hawes Collection

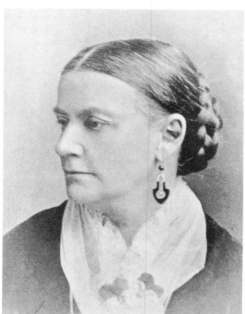

Mrs. E. D. E. N. SOUTHWORTH
(*left*)
[nee Emma Dorothy Eliza Nevitte]
(1819–1899)
Popular novelist

RICHARD DOBBS SPAIGHT (*right*)
(1758–1802)
Signer of the Constitution, Governor of North Carolina, Congressman
Painting attributed to James Sharples, Sr. Courtesy Independence National Historical Park

ALBERT GOODWILL SPALDING (*left*)
(1850–1915)
Baseball player and promoter; sporting-goods manufacturer

LYMAN SPALDING (*right*)
(1775–1821)
Physician, educator; founded U.S. Pharma-copoeia

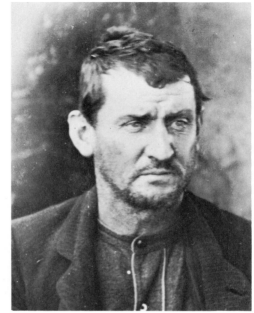

AUGUSTUS GOTTLIEB
SPANGENBERG (*left*)
(1704–1792)
Moravian bishop
Courtesy Harvey Memorial Library, Moravian College

EDWARD SPANGLER (*right*)
(*fl.* 1865–1869)
Conspirator in Lincoln assassination plot,
aided Booth's escape
*Photograph by Alexander Gardner. Courtesy New-York
Historical Society*

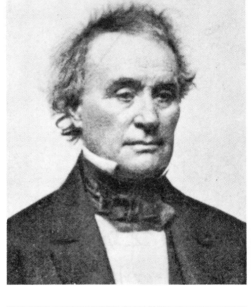

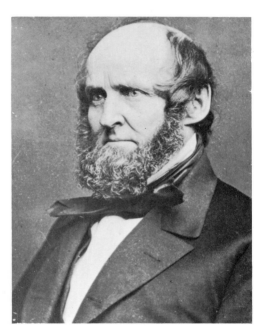

JARED SPARKS (*left*)
(1789–1866)
Historian, editor, president of Harvard
University

ELBRIDGE GERRY SPAULDING
(*right*)
(1809–1897)
Congressman, banker; sponsored bill to
issue "greenbacks" during Civil War
Courtesy National Archives, Brady Collection

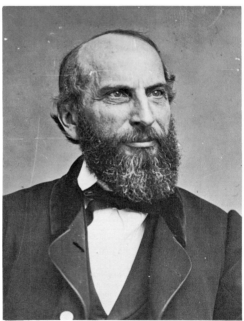

JAMES SPEED (*left*)
(1812–1887)
Attorney General under Lincoln; lawyer,
educator
Courtesy National Archives, Brady Collection

CHARLES ALBERT SPENCER (*right*)
(1813–1881)
Pioneer lens and microscope manufacturer
in U.S.

PHILIP SPENCER (*left*)
(*d.* 1842)
First U.S. naval officer hanged for mutiny

PLATT ROGERS SPENCER (*right*)
(1800–1864)
Calligrapher, founded Spencerian mode of handwriting

ELMER AMBROSE SPERRY (*left*)
(1860–1930)
Electrical-equipment inventor, manufacturer; developed adaptable gyroscope
Courtesy Sperry Rand Corporation

JAMES SPEYER (*right*)
(1861–1941)
Banker

AUGUST VINCENT THEODORE SPIES (*left*)
(1855–1887)
Anarchist, hanged for alleged part in Haymarket bombing

HARRIET PRESCOTT SPOFFORD
(*right*)
[nee Harriet Elizabeth Prescott]
(1835–1921)
Romantic novelist, poet

ALEXANDER SPOTSWOOD (*left*)
(1676–1740)
English governor of Colonial Virginia
Courtesy Virginia State Library

SPOTTED TAIL (*right*)
(c. 1833–1881)
Sioux Indian chief
Courtesy Mercaldo Archives

FRANK JULIAN SPRAGUE (*left*)
(1857–1934)
Electrical-equipment inventor, manufac-
turer; pioneer developer of electric trolleys,
electric elevators

KATE SPRAGUE (*right*)
[nee Katherine Jane Chase]
(1840–1899)
Washington social figure; daughter and
official hostess of Salmon P. Chase
Courtesy Library of Congress, Brady-Handy Collection

CLAUS SPRECKELS (*left*)
(1828–1908)
Sugar refiner, manufacturer; "the Sugar
King"

JOHN DIEDRICH SPRECKELS
(*right*)
(1853–1926)
Capitalist; benefactor of San Diego, Cali-
fornia
Courtesy New-York Historical Society

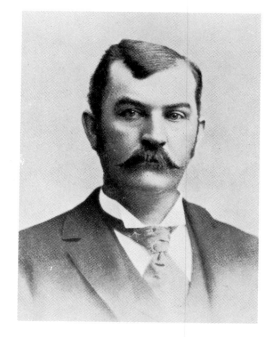

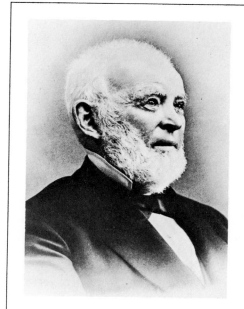

FRANK SPRINGER *(left)*
(1848–1927)
Paleontologist, archaeologist, lawyer

EDWARD ROBINSON SQUIBB *(right)*
(1819–1900)
Pharmacist, physician, chemist; founded
E. R. Squibb & Sons
Courtesy Squibb Division of Olin Mathieson Chemical Corporation

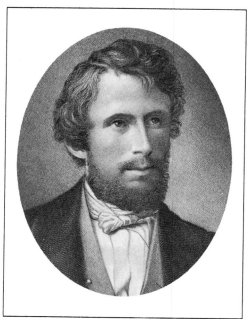

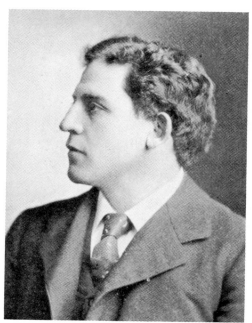

EPHRAIM GEORGE SQUIER *(left)*
(1821–1888)
Archaeologist, journalist, diplomat
Engraving by P. M. Whelpley

AMOS ALONZO STAGG *(right)*
(1862–1965)
Football player and coach

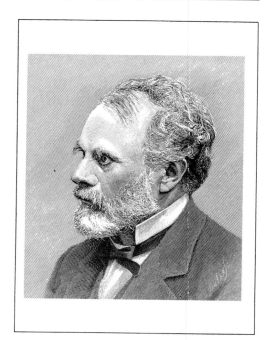

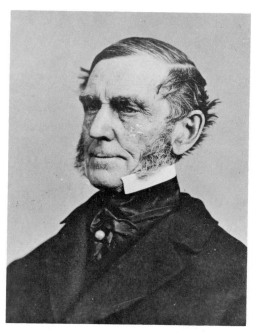

JOHANN BERNHARD STALLO
(left)
(1823–1900)
Lawyer, philosopher, classical scholar, diplomat

HENRY STANBERY *(right)*
(1803–1887)
Lawyer, Attorney General under Andrew Johnson; defended Johnson at his impeachment trial
Courtesy National Archives, Brady Collection

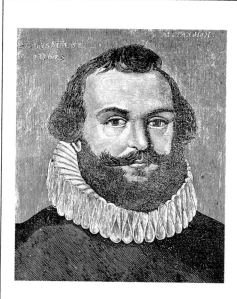

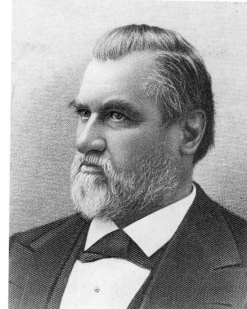

MYLES STANDISH (*left*)
(*c.* 1584–1656)
Pilgrim leader

LELAND STANFORD (*right*)
[Amasa Leland Stanford]
(1824–1893)
Railroad magnate, politician; founded Stanford University
Engraving by H. B. Hall's Sons

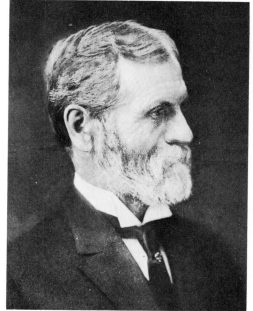

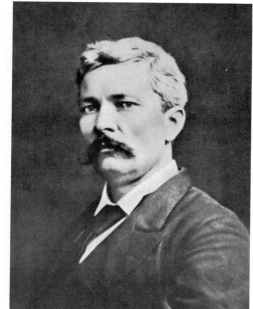

FRANCIS EDGAR STANLEY (*left*)
(1849–1918)
Inventor; developed photographic dry-plate process, "Stanley Steamer" automobile

Sɪʀ HENRY MORTON STANLEY
(*right*)
[John Rowlands]
(1841–1904)
Journalist, African explorer, found David Livingstone

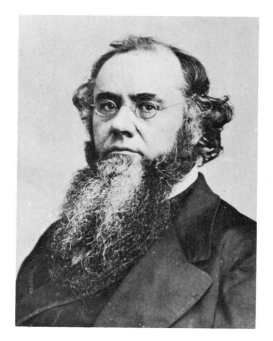

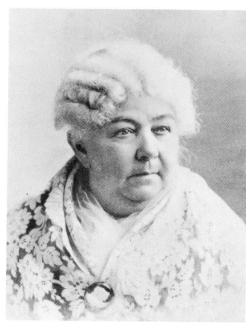

EDWIN McMASTERS STANTON
(*left*)
(1814–1869)
Secretary of War under Lincoln and Johnson; Attorney General under Buchanan
Courtesy New-York Historical Society

ELIZABETH STANTON (*right*)
[nee Elizabeth Cady]
(1815–1902)
Reformer, advocate of women's rights
Courtesy Tamiment Institute Library

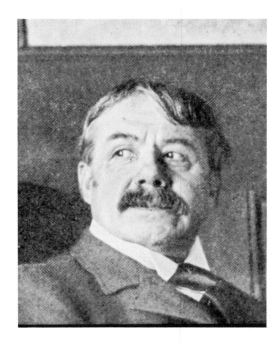

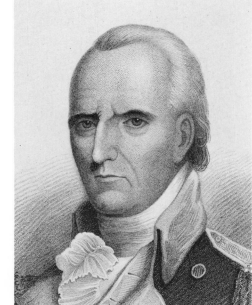

FRANK LEBBY STANTON (*left*)
(1857–1927)
Journalist, poet; author of "Mighty Lak' a Rose"

JOHN STARK (*right*)
(1728–1822)
Revolutionary general
Engraving by Alexander H. Ritchie

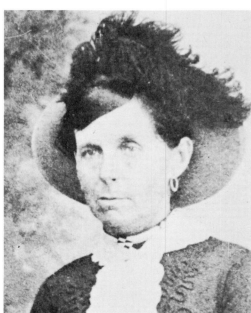

BELLE STARR (*left*)
[nee Myra Belle Shirley]
(1848–1889)
Western outlaw
Courtesy Mercaldo Archives

ELLEN GATES STARR (*right*)
(1860–1940)
Social worker, co-founder of Hull House
Courtesy Chicago Historical Society

DAVID McNEELY STAUFFER (*left*)
(1845–1913)
Civil engineer, collector of American engravings

GEORGE COLE STEBBINS (*right*)
(1846–1945)
Hymn writer, evangelist
Courtesy Library of Congress

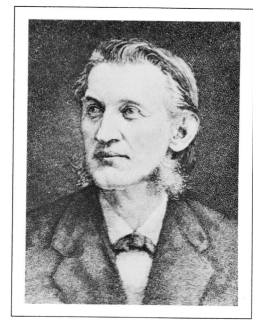

EDMUND CLARENCE STEDMAN (*left*)
(1833–1908)
Poet, anthologist; stockbroker
Engraving by Thomas Johnson

JOEL DORMAN STEELE (*right*)
(1836–1886)
Educator, textbook writer
Courtesy John A. Nietz

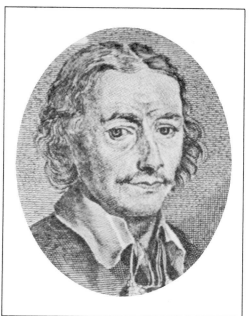

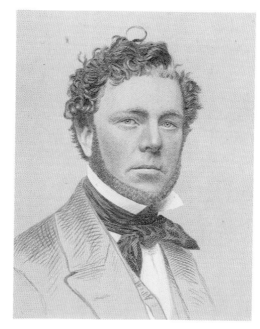

JACOB STEENDAM (*left*)
(1616– *c.* 1672)
Poet of New Amsterdam

GEORGE STEERS (*right*)
(1820–1856)
Naval architect, designed yacht *America*,
first winner of the America's Cup
Engraving by W. G. Jackman

LINCOLN STEFFENS (*left*)
[Joseph Lincoln Steffens]
(1866–1936)
Journalist, reformer, editor; exposed political corruption of large cities
Photograph by Pirie MacDonald. Courtesy New-York Historical Society

WILLIAM STEINITZ (*right*)
(1836–1900)
Chess master, world champion for twenty-eight years

CHARLES PROTEUS STEINMETZ
(*left*)
[Karl August Rudolf Steinmetz]
(1865–1923)
Electrical engineer, mathematician, inventor, educator
Courtesy General Electric Co.

CHARLES HERMAN STEINWAY
(*right*)
(1857–1919)
Piano manufacturer

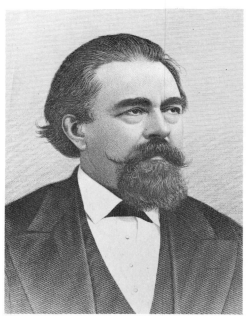

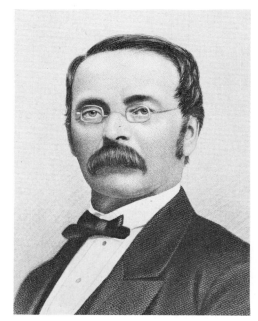

CHRISTIAN FRIEDRICH
THEODORE STEINWAY (*left*)
(1825–1889)
Piano manufacturer

HENRY ENGELHARD STEINWAY
(*right*)
[Heinrich Engelhard Steinweg]
(1797–1871)
Piano manufacturer, founded Steinway & Sons

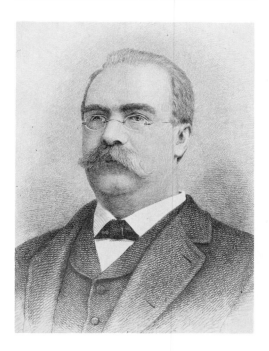

WILLIAM STEINWAY (*left*)
(1835–1896)
Piano manufacturer

ALEXANDER HAMILTON
STEPHENS (*right*)
(1812–1883)
Congressman, Governor of Georgia; Vice-President of the Confederacy
Engraving by Samuel Sartain

ANN SOPHIA STEPHENS (*left*)
[nee Ann Sophia Winterbotham]
(1813–1886)
Novelist, short-story writer, poet, editor

JOHN LLOYD STEPHENS (*right*)
(1805–1852)
Traveler, archaeologist; wrote *Incidents of Travel in Yucatan*

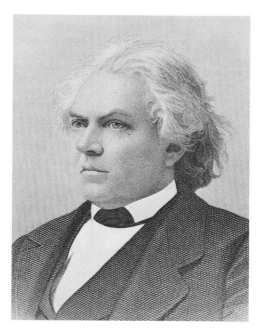

URIAH SMITH STEPHENS (*left*)
(1821–1882)
Labor leader, a founder of the Knights of Labor
Courtesy Tamiment Institute Library

JOHN STEPHENSON (*right*)
(1809–1893)
Streetcar designer, manufacturer
Engraving by George E. Perine

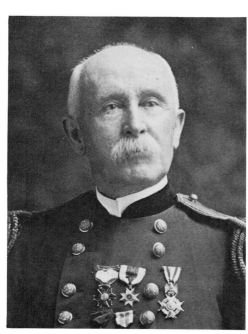

LOUIS STERN (*left*)
(1847–1922)
Dry-goods merchant, founded Stern Bros., New York

GEORGE MILLER STERNBERG
(*right*)
(1838–1915)
Bacteriologist, pioneer in study of infectious diseases
Courtesy New York Academy of Medicine

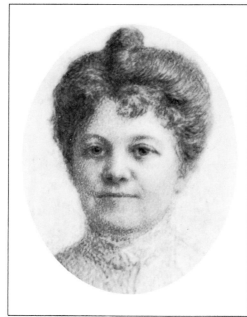

ALBERT STERNER (*left*)
(1863–1946)
Painter, etcher, lithographer

AUGUSTA STETSON (*right*)
[nee Augusta Emma Simmons]
(*c.*1842–1928)
Christian Science leader
Courtesy New-York Historical Society

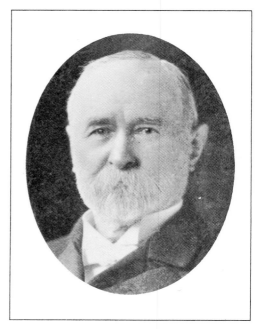

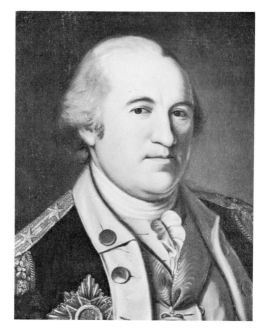

JOHN BATTERSON STETSON (*left*)
(1830–1906)
Hat manufacturer

FREDERICK WILLIAM AUGUSTUS
VON STEUBEN (*right*)
[Friedrich Wilhelm August Heinrich Ferdinand, Baron Steuben]
(1730–1794)
Prussian-American officer; inspector general, Continental Army
Painting by Charles Willson Peale. Courtesy Independence National Historical Park

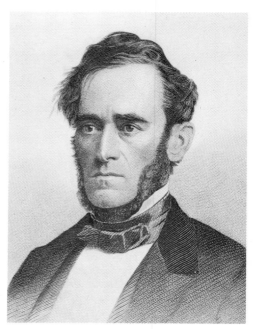

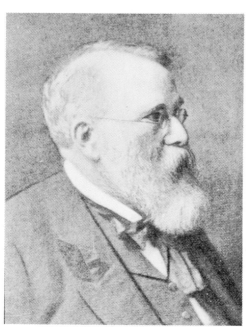

ABEL STEVENS (*left*)
(1815–1897)
Methodist Episcopal clergyman, historian
Engraving by F. E. Jones

BENJAMIN FRANKLIN STEVENS
(*right*)
(1833–1902)
Bookseller, bibliographer

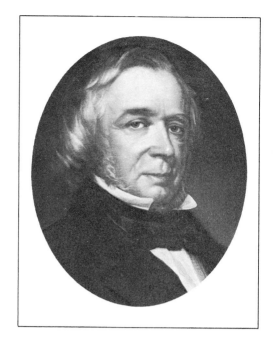

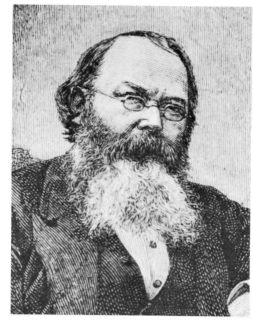

EDWIN AUGUSTUS STEVENS (*left*)
(1795–1868)
Inventor, railroad manager; founded Stevens Institute of Technology
Courtesy Stevens Institute of Technology

HENRY STEVENS (*right*)
(1819–1886)
Bookseller, bibliographer
Courtesy Library of Congress

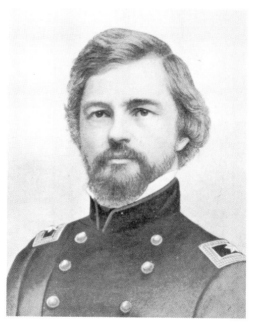

ISAAC INGALLS STEVENS (*left*)
(1818–1862)
Governor of Washington Territory, Union general in Civil War

JOHN STEVENS (*right*)
(1749–1838)
Pioneer in steam transportation; engineer, inventor
Painted by B. W. Landis from a painting by John Trumbull. Courtesy James Kip Finch and Columbia University

JOHN COX STEVENS (*left*)
(1785–1857)
Yachtsman, founded New York Yacht Club

JOHN HARRINGTON STEVENS (*right*)
(1820–1900)
Minnesota pioneer, built first dwelling in city of Minneapolis

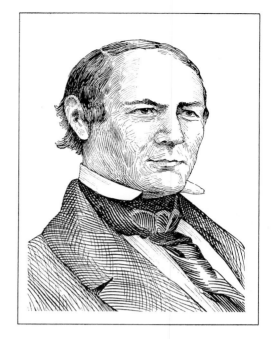

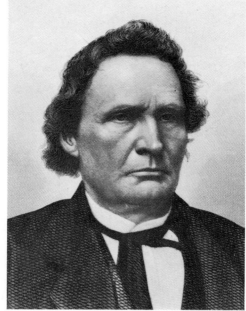

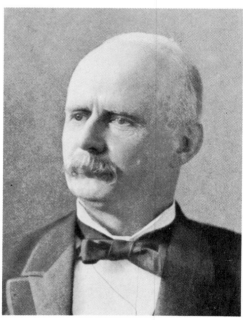

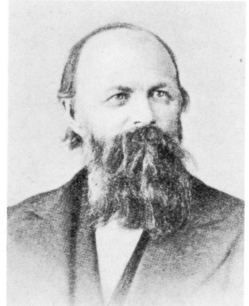

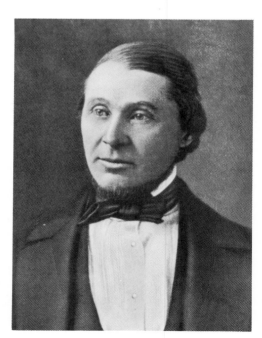

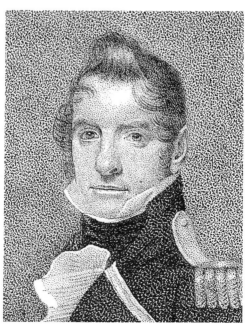

ROBERT LIVINGSTON STEVENS
(*left*)
(1787–1856)
Engineer, inventor, initiated railroad and
steamboat improvements

THADDEUS STEVENS (*right*)
(1792–1868)
Abolitionist, Congressman, lawyer; advocated harsh Reconstruction measures
Engraving by George E. Perine & Co.

ADLAI EWING STEVENSON (*left*)
(1835–1914)
Lawyer, Congressman; Vice-President of
U.S., 1893–1897
Photograph by Pach Brothers

IRA STEWARD (*right*)
(1831–1883)
Labor leader, early advocate of eight-hour
day
Courtesy Tamiment Institute Library

ALEXANDER TURNEY STEWART
(*left*)
(1803–1876)
Dry-goods merchant, investor
Engraving by W. T. Bather. Courtesy New-York Historical Society

CHARLES STEWART (*right*)
(1778–1869)
Naval officer, commanded *Constitution* in
War of 1812

HENRY WILLIAM STIEGEL (*left*)
[Heinrich Wilhelm Stiegel, "Baron von Stiegel"]
(1729–1785)
Glass manufacturer

ALFRED STIEGLITZ (*right*)
(1864–1946)
Photographer, editor, art patron
Courtesy Georgia O'Keeffe

EZRA STILES (*left*)
(1727–1795)
Congregational clergyman, educator; president of Yale College
Painting by Reuben Moulthrop

ANDREW TAYLOR STILL (*right*)
(1828–1917)
Founder of osteopathy
Courtesy American Osteopathic Association

ALFRED STILLÉ (*left*)
(1813–1900)
Pathologist; a founder and president of American Medical Association
Painting by Samuel B. Waugh. Courtesy University of Pennsylvania

JAMES STILLMAN (*right*)
(1850–1918)
Merchant, banker, capitalist

 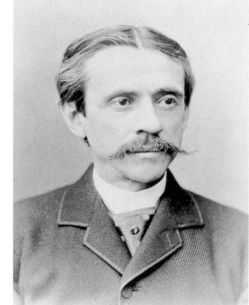

WILLIAM JAMES STILLMAN (*left*)
(1828–1901)
Painter, art critic, journalist, diplomat
Drawing by Lisa Stillman

FRANK R. STOCKTON (*right*)
[Francis Richard Stockton]
(1834–1902)
Novelist, short-story writer

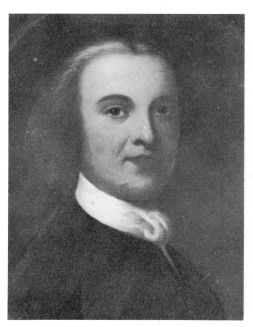 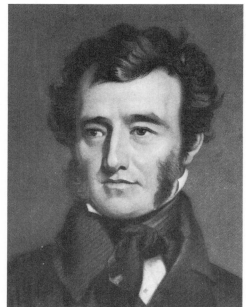

RICHARD STOCKTON (*left*)
(1730–1781)
Lawyer, jurist, signer of Declaration of Independence
Painting by George W. Connarroe. Courtesy Independence National Historical Park

ROBERT FIELD STOCKTON (*right*)
(1795–1866)
Naval officer, helped win California from Mexico; U.S. Senator
Engraved by John Sartain after a painting by Thomas Sully

CHARLES WARREN STODDARD
(*left*)
["Pip Pepperpod"]
(1843–1909)
Travel writer, journalist, poet

ELIZABETH DREW STODDARD
(*right*)
[nee Elizabeth Drew Barstow]
(1823–1902)
Novelist, poet, short-story writer

JOHN TAPPAN STODDARD　　(*left*)
(1852–1919)
Chemist, educator
Courtesy Smith College Archives

JOSHUA C. STODDARD　　(*right*)
(1814–1902)
Inventor, devised steam calliope
Courtesy Worcester Historical Society

RICHARD HENRY STODDARD
(*left*)
(1825–1903)
Literary critic, poet, editor

BENJAMIN STODDERT　　(*right*)
(1751–1813)
First Secretary of the Navy (1798–1801);
established eastern navy yards
Courtesy U.S. Department of Defense

ANSON PHELPS STOKES　　(*left*)
(1838–1913)
Financier, merchant, reformer, philan-
thropist
Courtesy New-York Historical Society

EDWARD S. STOKES　　(*right*)
(1841–1901)
Murdered Jim Fisk for his attentions to
Josie Mansfield
Courtesy Mercaldo Archives

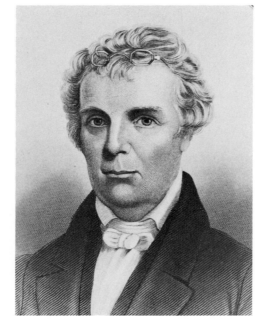

AMASA STONE (*left*)
(1818–1883)
Railroad magnate, financier, benefactor of
Western Reserve University

BARTON WARREN STONE (*right*)
(1772–1844)
Frontier evangelist, affiliated with Disciples
of Christ
Courtesy Free Library of Philadelphia

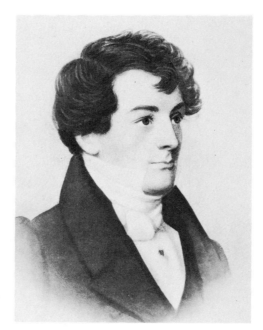

HARLAN FISKE STONE (*left*)
(1872–1946)
Lawyer, educator, Attorney General under
Coolidge; Chief Justice of U.S., 1941–
1946
Courtesy Library of Congress

JOHN AUGUSTUS STONE (*right*)
(1800–1834)
Playwright, actor
Courtesy Harvard Theatre Collection

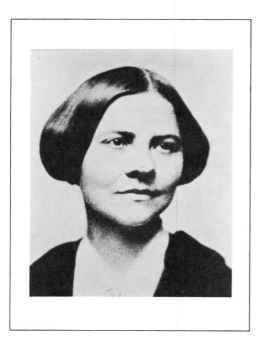

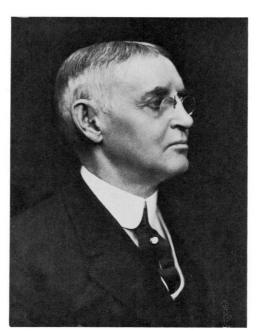

LUCY STONE (*left*)
[Mrs. Henry Brown Blackwell]
(1818–1893)
Reformer, advocate of woman's rights
Courtesy Tamiment Institute Library

MELVILLE ELIJAH STONE (*right*)
(1848–1929)
Journalist, helped establish *Chicago Daily
News* and Associated Press
Courtesy Chicago Historical Society

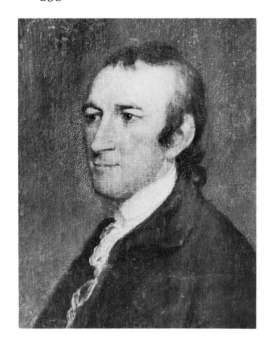

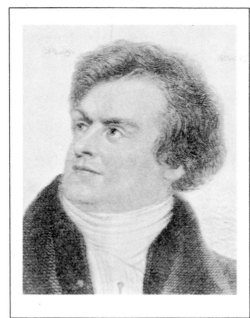

THOMAS STONE (*left*)
(1743–1787)
Lawyer, signer of Declaration of Independence
Painting by Robert Edge Pine. Courtesy Enoch Pratt Free Library

WILLIAM LEETE STONE (*right*)
(1792–1844)
Editor, writer, historian

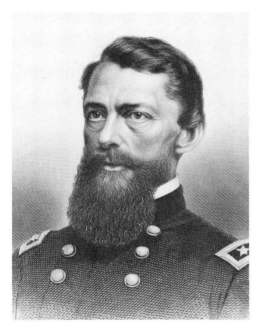

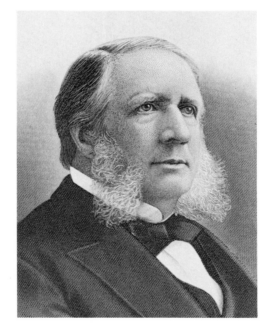

GEORGE STONEMAN (*left*)
(1822–1894)
Union general in Civil War, Governor of California
Engraving by Alexander H. Ritchie

RICHARD SALTER STORRS (*right*)
(1821–1900)
Congregational clergyman, editor, civic leader in Brooklyn
Engraving by H. B. Hall & Sons

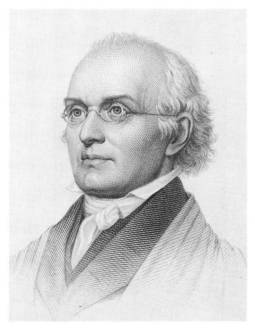

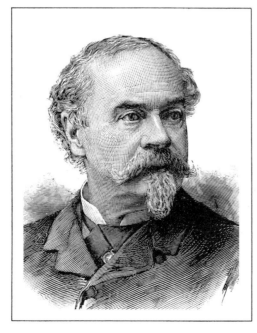

JOSEPH STORY (*left*)
(1779–1845)
Associate justice, U.S. Supreme Court; legal scholar, a founder of Harvard Law School
Engraved by J. Cheney after a drawing by William Wetmore Story

WILLIAM WETMORE STORY
(*right*)
(1819–1895)
Sculptor, poet, essayist, legal scholar

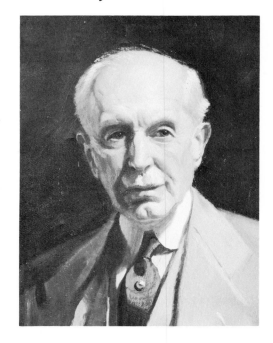

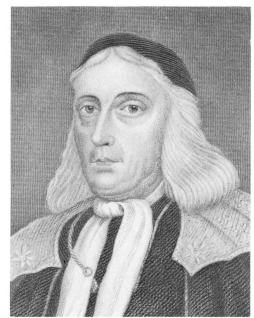

EDWARD TOWNSEND STOTESBURY (*left*)
(1849–1938)
Banker
Painting by Frank A. Salisbury. Courtesy Drexel & Co.

WILLIAM STOUGHTON (*right*)
(1631–1701)
Colonial jurist, presided at Salem witchcraft trials
Engraving by R. Babson

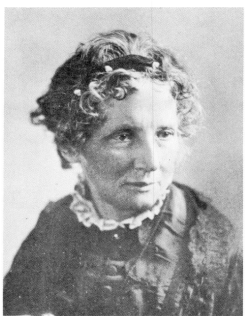

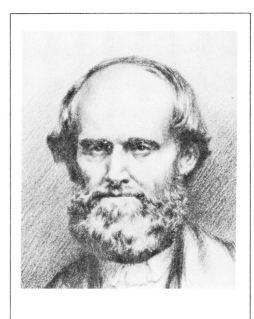

HARRIET BEECHER STOWE (*left*)
[nee Harriet Elizabeth Beecher]
(1811–1896)
Novelist, abolitionist, wrote *Uncle Tom's Cabin*

JAMES JESSE STRANG (*right*)
(1813–1856)
Mormon leader

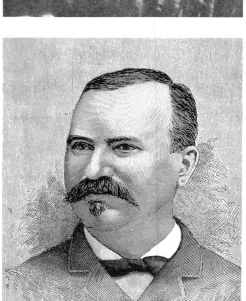

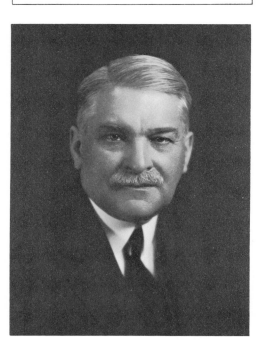

ADOLPH STRASSER (*left*)
(1844–1939)
Labor leader, associate of Samuel Gompers

SAMUEL WESLEY STRATTON (*right*)
(1861–1931)
Physicist, educator; organized U.S. Bureau of Standards; advised Massachusetts Governor on Sacco-Vanzetti appeal
Courtesy Massachusetts Institute of Technology

ISIDOR STRAUS (*left*)
(1845–1912)
Owner of R. H. Macy & Co. and Abraham and Straus, New York; Congressman, philanthropist

NATHAN STRAUS (*right*)
(1848–1931)
Department-store owner, civic leader, philanthropist

OSCAR SOLOMON STRAUS (*left*)
(1850–1926)
Lawyer, diplomat, international jurist; Secretary of Commerce and Labor under Theodore Roosevelt

LEVI STRAUSS (*right*)
(*c.* 1828–1903)
Clothing manufacturer—"Levi's"
Courtesy Levi Strauss & Co.

JUSTUS CLAYTON STRAWBRIDGE
(*left*)
(1838–1911)
Philadelphia merchant

WILLIAM STRICKLAND (*right*)
(*c.* 1787–1854)
Greek Revival architect, civil engineer, engraver
Painting by John Neagle

CHARLES LOUIS STROBEL *(left)*
(1852–1936)
Civil engineer, architectural consultant, originated standard rolled steel sections

CALEB STRONG *(right)*
(1745–1819)
Revolutionary patriot, delegate to Constitutional Convention, U.S. Senator, Governor of Massachusetts
Engraved by James B. Longacre after a painting by Gilbert Stuart

GEORGE TEMPLETON STRONG
(left)
(1820–1875)
Diarist, described mid-nineteenth century life in New York

JAMES STRONG *(right)*
(1822–1894)
Biblical scholar, educator

JOSIAH STRONG *(left)*
(1847–1916)
Social reformer, clergyman, writer
Courtesy New-York Historical Society

WILLIAM STRONG *(right)*
(1808–1895)
Jurist, Congressman; associate justice, U.S. Supreme Court
Engraving by T. Doney

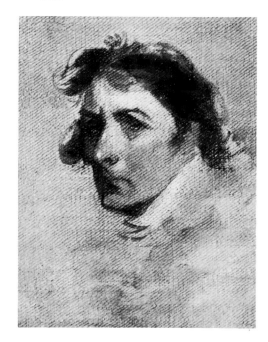

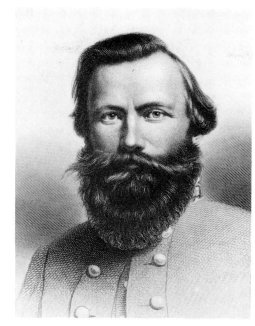

GILBERT STUART (*left*)
[Gilbert Charles Stuart]
(1755–1828)
Painter
Self-portrait

JEB STUART (*right*)
[James Ewell Brown Stuart]
(1833–1864)
Confederate general, cavalry commander
Engraving by Alexander H. Ritchie

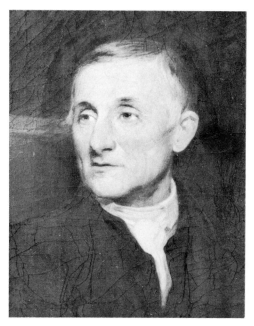

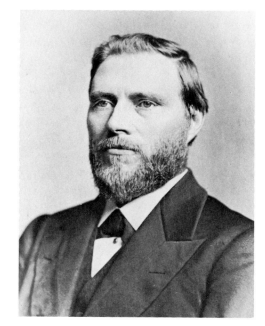

MOSES STUART (*left*)
(1780–1852)
Biblical scholar, clergyman, translator, educator
Courtesy Andover Newton Theological School

JOHN HENRY WILBRANDT STUCKENBERG (*right*)
[Johann Heinrich Willbrand Stuckenberg]
(1835–1903)
Lutheran clergyman, pioneer American sociologist
Courtesy Wittenberg University

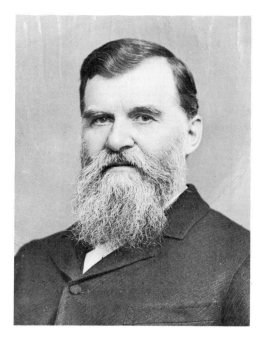

CLEMENT STUDEBAKER (*left*)
(1831–1901)
Wagon manufacturer
Courtesy Library of Congress, Brady-Handy Collection

HENRY STUDEBAKER (*right*)
(1826–1895)
Wagon manufacturer
Courtesy Studebaker Corporation

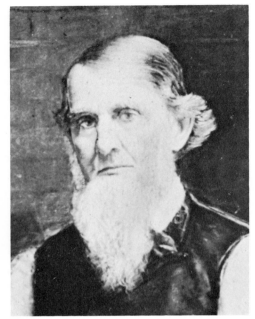

JACOB FRANKLIN STUDEBAKER
(*left*)
(1844–1887)
Wagon manufacturer
Courtesy Studebaker Corporation

JOHN STUDEBAKER (*right*)
(1799–1877)
Blacksmith and wagon manufacturer, father
of Studebaker brothers
Courtesy Studebaker Corporation

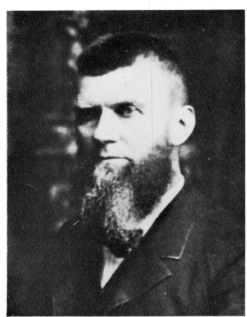

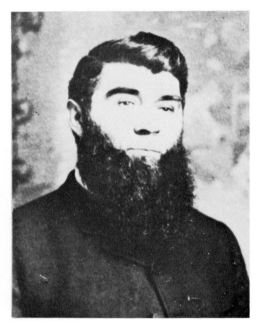

JOHN MOHLER STUDEBAKER
(*left*)
(1833–1917)
Wagon and automobile manufacturer
Courtesy Studebaker Corporation

PETER EVERST STUDEBAKER
(*right*)
(1836–1897)
Wagon manufacturer
Courtesy Studebaker Corporation

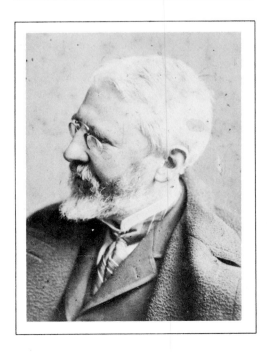

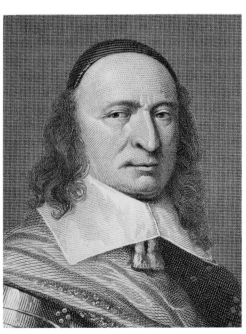

RUSSELL STURGIS (*left*)
(1836–1909)
Architect, art critic and historian

PETER STUYVESANT (*right*)
[Petrus Stuyvesant]
(1592–1672)
Dutch director-general of New Netherland
Engraving by Charles Burt

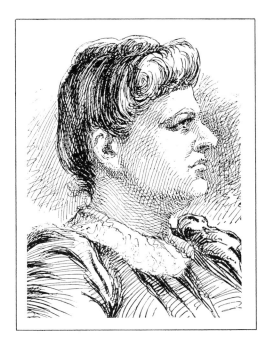

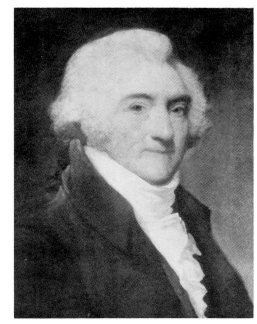

BRIDGET SULLIVAN (*left*)
(1866–1948)
Andrew Borden's maid, involved in Lizzie Borden murder case

JAMES SULLIVAN (*right*)
(1744–1808)
Political leader, Governor of Massachusetts, historian
Painting by Gilbert Stuart

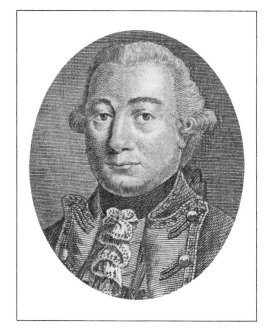

JAMES EDWARD SULLIVAN (*left*)
(1860–1914)
Sports promoter, a founder of Amateur Athletic Union of the U.S.
Courtesy Amateur Athletic Union of the U.S.

JOHN SULLIVAN (*right*)
(1740–1795)
Revolutionary general, chief executive of New Hampshire

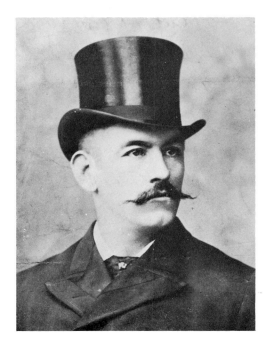

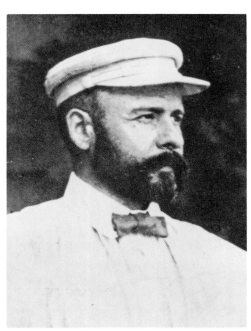

JOHN L. SULLIVAN (*left*)
[John Lawrence Sullivan]
(1858–1918)
Prize fighter, last bare-knuckle heavyweight champion
Courtesy Mercaldo Archives

LOUIS HENRI SULLIVAN (*right*)
(1856–1924)
Chicago architect, advocated functional treatment of skyscraper

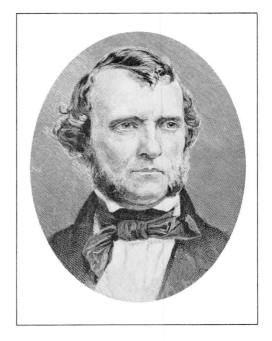

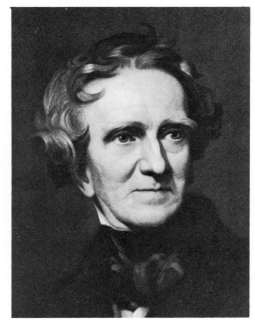

WILLIAM STARLING SULLIVANT
(*left*)
(1803–1873)
Botanist

THOMAS SULLY (*right*)
(1783–1872)
Portrait painter
Engraved by John Sartain from a self-portrait

CYRUS LINDAUER SULZBERGER
(*left*)
(1858–1932)
Merchant, philanthropist; aided settlement
of Jewish immigrants
Courtesy Library of Congress

CHARLES SUMNER (*right*)
(1811–1874)
Abolitionist, U.S. Senator, Reconstruction
leader; assaulted in Senate chamber
Engraving by George E. Perine

EDWIN VOSE SUMNER (*left*)
(1797–1863)
Union general in Civil War
Engraving by J. C. Buttre

WILLIAM GRAHAM SUMNER
(*right*)
(1840–1910)
Economist, sociologist, educator; author of
Folkways
Courtesy Yale University News Bureau

THOMAS SUMTER *(left)*
(1734–1832)
Revolutionary officer, Congressman, U.S. Senator; eponym of Fort Sumter
Painting by Rembrandt Peale. Courtesy Independence National Historical Park

BILLY SUNDAY *(right)*
[William Ashley Sunday]
(1862–1935)
Evangelist
Courtesy New-York Historical Society

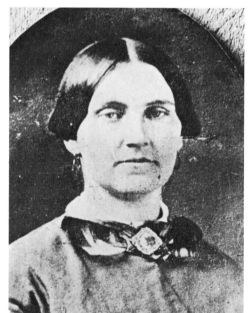

JOHN H. SURRATT *(left)*
(1844– *c.* 1916)
Son of Mary Surratt, conspirator in Lincoln assassination plot; never convicted
Courtesy Library of Congress, Brady-Handy Collection

MARY E. SURRATT *(right)*
(1820–1865)
Alleged member of Booth conspiracy, hanged after Lincoln's assassination
Courtesy New-York Historical Society

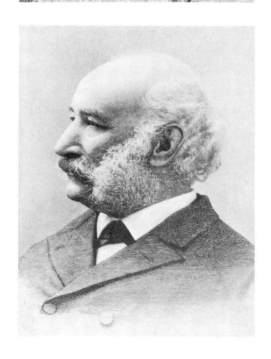

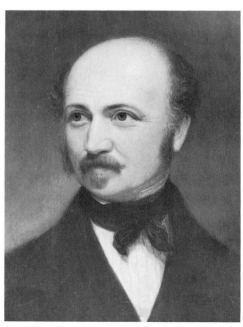

ADOLPH HEINRICH JOSEPH SUTRO *(left)*
(1830–1898)
Mine developer, planned tunnel to Comstock Lode; mayor of San Francisco

JOHN AUGUSTUS SUTTER *(right)*
[Johan August Suter]
(1803–1880)
California settler, owned site of first gold discovery, 1848
Painting by Samuel A. Osgood. Courtesy New-York Historical Society

AMBROSE SWASEY *(left)*
(1846–1937)
Manufacturer, designer of precision instruments and astronomical telescopes
Courtesy The Warner & Swasey Co.

NOAH HAYNES SWAYNE *(right)*
(1804–1884)
Associate justice, U.S. Supreme Court

GUSTAVUS FRANKLIN SWIFT
(left)
(1839–1903)
Meat packer
Courtesy Swift & Co.

JANE SWISSHELM *(right)*
[nee Jane Grey Cannon]
(1815–1884)
Abolitionist, feminist, temperance worker

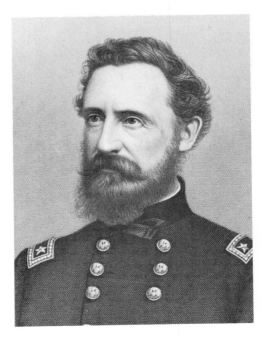

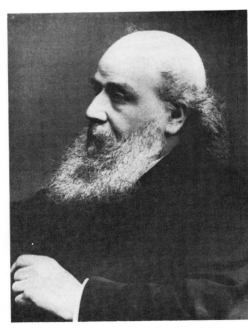

GEORGE SYKES *(left)*
(1822–1880)
Union general in Civil War
Engraving by J. C. Buttre

JAMES JOSEPH SYLVESTER *(right)*
[James Joseph]
(1814–1897)
British mathematician, influenced course of mathematical research in U.S.
Courtesy McMaster University

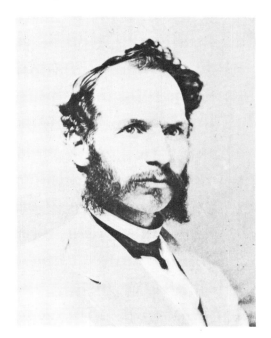

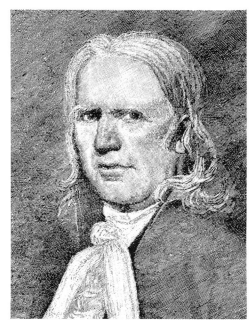

WILLIAM H. SYLVIS (*left*)
(1828–1869)
Labor leader, reformer
Courtesy Tamiment Institute Library

JOHN CLEVES SYMMES (*right*)
(1780–1829)
Army officer, advocated view that the earth
is hollow

PHILIP SYNG
(1703–1789)
Silversmith
Courtesy American Philosophical Society

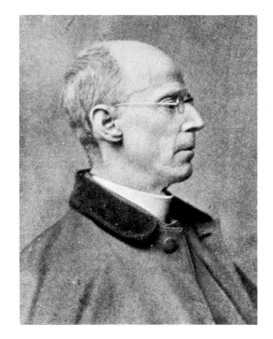

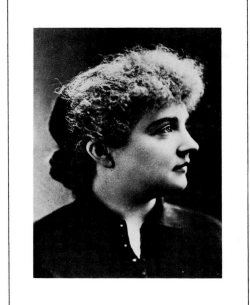

JOHN BANISTER TABB (*left*)
(1845–1909)
Roman Catholic priest, poet

BABY DOE TABOR (*right*)
[Elizabeth Bonduel McCourt Doe Tabor]
(*c.* 1862–1935)
Socialite; wife of mining-king Horace Tabor
Courtesy Mercaldo Archives

HORACE AUSTIN WARNER TABOR
(*left*)
(1830–1899)
Colorado silver-mining king, speculator;
U.S. Senator
Courtesy Library, State Historical Society of Colorado

ALPHONSO TAFT (*right*)
(1810–1891)
Lawyer, jurist, diplomat, political leader;
father of William Howard Taft

CHARLES PHELPS TAFT (*left*)
(1843–1929)
Lawyer, newspaper publisher, Cincinnati
philanthropist

LORADO ZADOC TAFT (*right*)
(1860–1936)
Sculptor

WILLIAM HOWARD TAFT (*left*)
(1857–1930)
President of the United States, 1909–1913;
Chief Justice of the United States, 1921–
1930
Courtesy Library of Congress

Mrs. WILLIAM HOWARD TAFT
(*right*)
[nee Helen Herron]
(1861–1943)
First lady, 1909–1913

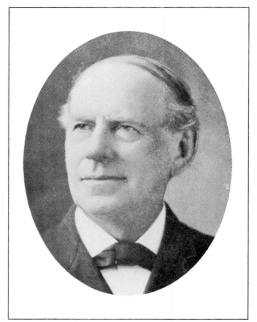

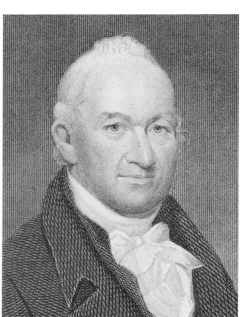

MABEL TALIAFERRO (*left*)
(1887–
Actress

BENJAMIN TALLMADGE (*right*)
(1754–1835)
Revolutionary officer, Congressman
*Engraved by George Parker from a painting by Ezra
Ames*

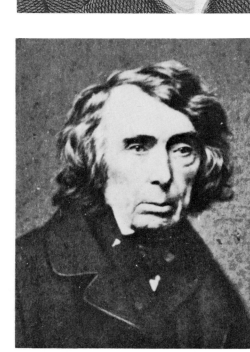

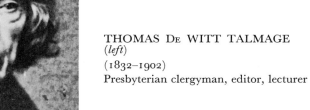

THOMAS De WITT TALMAGE
(*left*)
(1832–1902)
Presbyterian clergyman, editor, lecturer

ROGER BROOKE TANEY (*right*)
(1777–1864)
Chief Justice of U.S., 1836–1864; Attorney
General and Secretary of the Treasury
under Jackson
Courtesy Library of Congress

JOHN TANNER (*left*)
[Shaw-Shaw-Wabe-Na-Se; The Falcon]
(*c.* 1780–1847)
Frontiersman, captured as a youth and
reared by Shawnee Indians
*Engraved by T. Illman from a painting by Henry
Inman*

ARTHUR TAPPAN (*right*)
(1786–1865)
Abolitionist, silk merchant, philanthropist
Courtesy Oberlin College

BENJAMIN TAPPAN (*left*)
(1773–1857)
U.S. Senator, lawyer, jurist
*Engraved by Philip H. Reason from a painting by
Washington Blanchard*

LEWIS TAPPAN (*right*)
(1788–1873)
Abolitionist, silk merchant, philanthropist
Engraving by George R. Hall

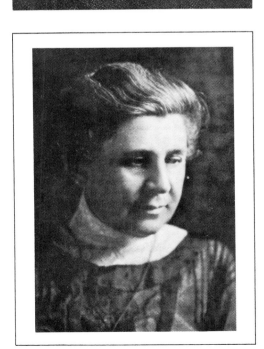

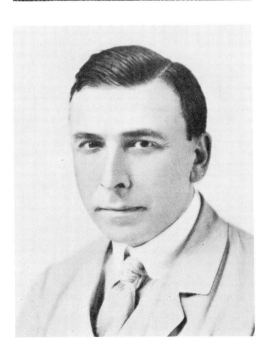

IDA MINERVA TARBELL (*left*)
(1857–1944)
Reformer, writer; early muckraker

BOOTH TARKINGTON (*right*)
[Newton Booth Tarkington]
(1869–1946)
Novelist

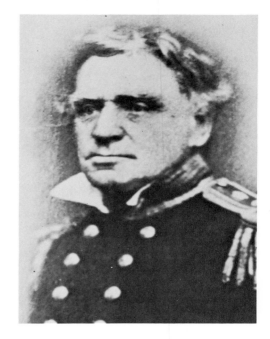

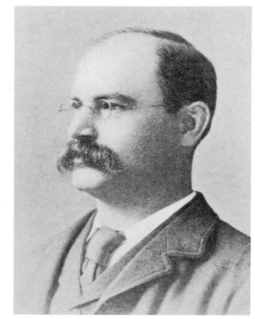

JOSIAH TATTNALL (*left*)
(1795–1871)
U.S. naval officer; captain in Confederate navy
Courtesy Library of Congress, Brady-Handy Collection

FRANK WILLIAM TAUSSIG (*right*)
(1859–1940)
Economist, educator

BAYARD TAYLOR (*left*)
[James Bayard Taylor]
(1825–1878)
Traveler, travel writer, translator, poet

EDWARD THOMPSON TAYLOR
(*right*)
(1793–1871)
Methodist clergyman, seamen's chaplain; basis for Father Mapple in *Moby Dick*

FREDERICK WINSLOW TAYLOR
(*left*)
(1856–1915)
Engineer, inventor, efficiency expert

GEORGE TAYLOR (*right*)
(1716–1781)
Signer of Declaration of Independence
Engraving by Henry B. Hall

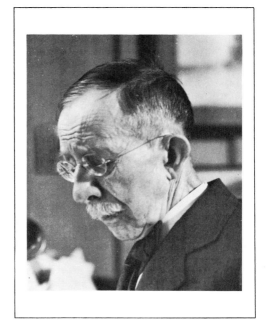

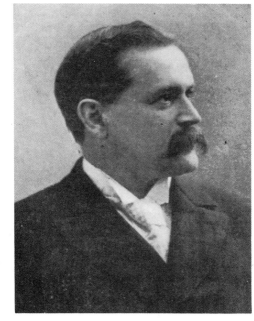

GRAHAM TAYLOR (*left*)
(1851–1938)
Social worker, sociologist, clergyman
Photograph by Helen Balfour Morrison. Courtesy Lea D. Taylor

JAMES MONROE TAYLOR (*right*)
(1848–1916)
Baptist clergyman, president of Vassar College

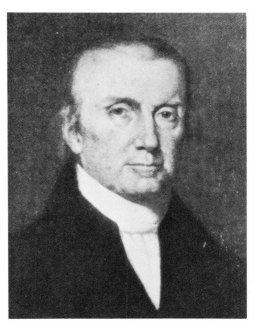

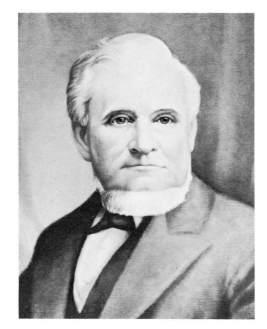

JOHN TAYLOR (*left*)
[John Taylor of Caroline]
(*c.* 1753–1824)
Virginia politician, U.S. Senator, political commentator, agriculturist
Courtesy Virginia State Library

JOHN TAYLOR (*right*)
(1808–1887)
Mormon leader
Courtesy Church of Jesus Christ of Latter-Day Saints

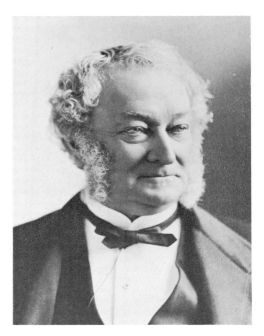

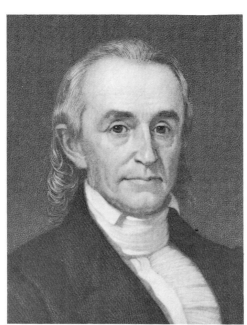

MOSES TAYLOR (*left*)
(1806–1882)
Banker; financed development and completion of Atlantic Cable
Courtesy New-York Historical Society

NATHANIEL WILLIAM TAYLOR
(*right*)
(1786–1858)
Congregational clergyman, theologian, educator
Engraved by John Sartain from a painting by George A. Baker

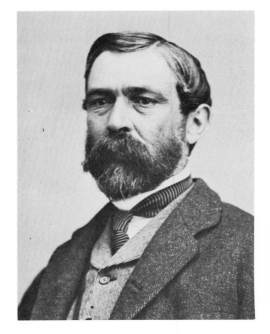
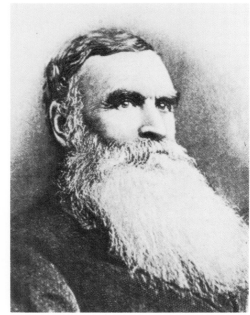

RICHARD TAYLOR (*left*)
(1826–1879)
Confederate general; son of Zachary Taylor
Courtesy Library of Congress, Brady-Handy Collection

WILLIAM TAYLOR (*right*)
(1821–1902)
Methodist Episcopal missionary bishop
Courtesy Board of Missions, Methodist Church

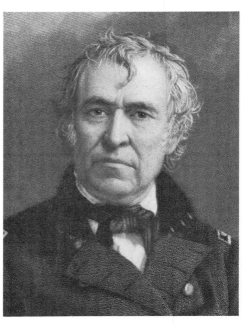
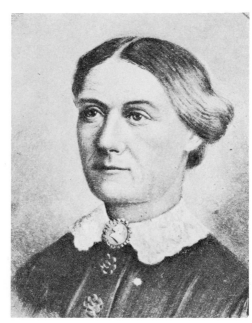

ZACHARY TAYLOR (*left*)
(1784–1850)
President of the United States, 1849–1850
Engraving by Alexander H. Ritchie

Mrs. ZACHARY TAYLOR (*right*)
[nee Margaret Mackall Smith]
(1787–1852)
First lady, 1849–1850

TECUMSEH (*left*)
[Tikamthi; Tecumtha]
(1768–1813)
Shawnee Indian chief
Courtesy Bureau of American Ethnology, Smithsonian Institution

GILBERT TENNENT (*right*)
(1703–1764)
Presbyterian evangelist, a leader of the Great Awakening

WILLIAM TENNENT (*left*)
(1673–1745)
Presbyterian clergyman, built "Log College" for ministerial candidates

TENSKWATAWA (*right*)
[Lalawethika; Elskwatawa: "The Shawnee Prophet"]
(1768–1837)
Shawnee mystic, twin brother of Tecumseh; defeated at Tippecanoe
Painting by George Catlin. Courtesy Bureau of American Ethnology, Smithsonian Institution

ALFRED HOWE TERRY (*left*)
(1827–1890)
Union general in Civil War
Courtesy National Archives, Brady Collection

ELI TERRY (*right*)
(1772–1852)
Clock manufacturer
Engraving by Samuel Sartain

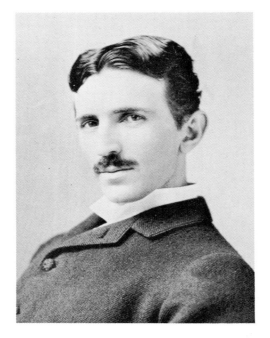

ELLEN ALICIA TERRY (*left*)
[Ellen Alice Terry]
(1847–1928)
English actress popular in U.S.
Courtesy Walter Hampden Memorial Library at The Players, New York

NIKOLA TESLA (*right*)
(1857–1943)
Electrical engineer, inventor

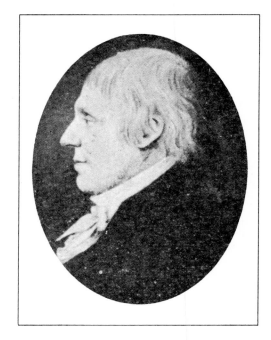
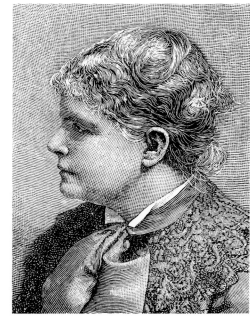

JAMES THACHER (*left*)
(1754–1844)
Physician, historian, medical writer
Courtesy Henry R. Viets, M.D.

CELIA THAXTER (*right*)
[nee Celia Laighton]
(1835–1894)
Poet

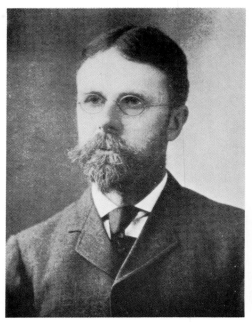

ROLAND THAXTER (*left*)
(1858–1932)
Botanist, educator

ABBOTT HANDERSON THAYER
(*right*)
(1849–1921)
Painter
Courtesy Peter A. Juley & Son

ALEXANDER WHEELOCK THAYER
(*left*)
(1817–1897)
Beethoven scholar and biographer

ELI THAYER (*right*)
(1819–1899)
Educator, Congressman; promoted free-
state emigration to West
Courtesy Library of Congress, Brady-Handy Collection

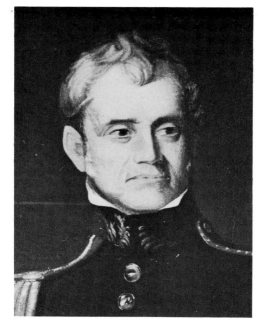

JAMES BRADLEY THAYER *(left)*
(1831–1902)
Lawyer, educator, scholar; early advocate
of judicial self-restraint
Courtesy Harvard University Archives

SYLVANUS THAYER *(right)*
(1785–1872)
Engineer; superintendent of West Point;
"Father of the Military Academy"
*Painting by Julian Alden Weir. U. S. Army Photo-
graph, courtesy U. S. Military Academy*

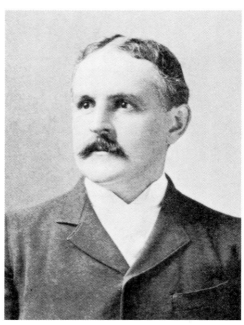

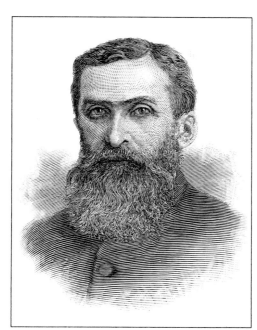

WILLIAM ROSCOE THAYER *(left)*
(1859–1923)
Historian, biographer

JAMES MILLS THOBURN *(right)*
(1836–1922)
Methodist Episcopal missionary in India,
Burma, and Far East

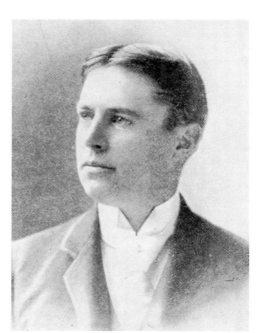

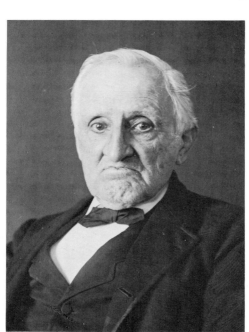

AUGUSTUS THOMAS *(left)*
(1857–1934)
Playwright

CYRUS THOMAS *(right)*
(1825–1910)
Ethnologist, archaeologist, entomologist
*Courtesy Bureau of American Ethnology, Smithsonian
Institution*

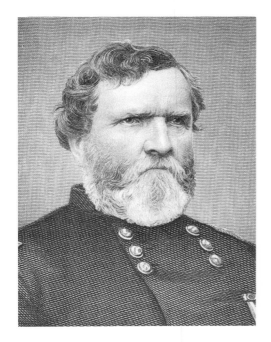

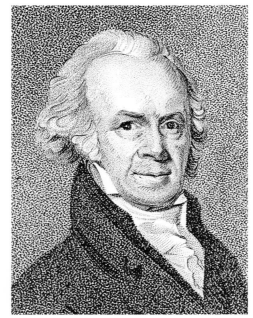

GEORGE HENRY THOMAS (*left*)
(1816–1870)
Union general in Civil War: "The Rock of Chickamauga"
Engraving by H. B. Hall Jr.

ISAIAH THOMAS (*right*)
(1749–1831)
Printer, journalist, publisher; wrote *History of Printing in America*
Engraved by J. R. Smith from a painting by Henry Williams

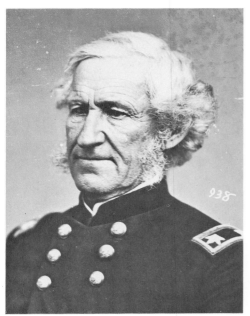

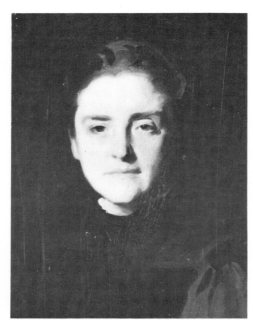

LORENZO THOMAS (*left*)
(1804–1875)
Union general in Civil War; central figure in Johnson impeachment
Courtesy Library of Congress, Brady-Handy Collection

MARTHA CAREY THOMAS (*right*)
[M. Carey Thomas]
(1857–1935)
Educator, president of Bryn Mawr College
Painting by John Singer Sargent. Courtesy Office of Public Information, Bryn Mawr College

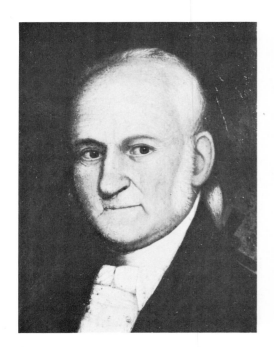

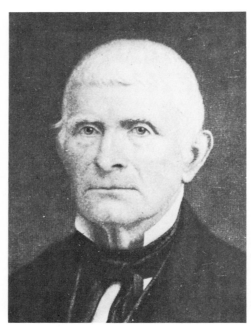

ROBERT BAILEY THOMAS (*left*)
(1766–1846)
Founder, editor, and publisher of *The Farmer's Almanack*
Painting by Zedekiah Belknap. Courtesy American Antiquarian Society

SETH THOMAS (*right*)
(1785–1859)
Clock manufacturer
Courtesy Seth Thomas Clock Company

THEODORE THOMAS *(left)*
[Christian Friedrich Theodore Thomas]
(1835–1905)
Violinist, conductor; led New York Philharmonic and Chicago Symphony Orchestras

BORIS THOMASHEFSKY *(right)*
(1864–1939)
Actor, producer, playwright; founded the Yiddish theater in U.S.
Courtesy Museum of the City of New York

DANIEL PIERCE THOMPSON *(left)*
(1795–1868)
Lawyer; wrote historical novels

DENMAN THOMPSON *(right)*
[Henry Denman Thompson]
(1833–1911)
Actor, playwright

J. WALTER THOMPSON *(left)*
[James Walter Thompson]
(1847–1928)
Pioneer advertising executive

JOHN THOMPSON *(right)*
(1802–1891)
Founder of First National and Chase National Banks, New York
Engraving by George E. Perine

MAURICE THOMPSON (*left*)
[James Maurice Thompson]
(1844–1901)
Indiana poet, writer, lawyer

SMITH THOMPSON (*right*)
(1768–1843)
Associate justice, U.S. Supreme Court;
Secretary of the Navy under Monroe
Engraving by Albert Rosenthal

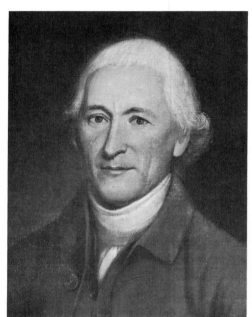

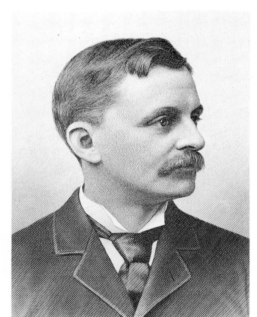

CHARLES THOMSON (*left*)
(1729–1824)
Merchant, Revolutionary patriot; per-
manent secretary, Continental Congress
*Painting by Charles Willson Peale. Courtesy Independ-
ence National Historical Park*

ELIHU THOMSON (*right*)
(1853–1937)
Inventor, electrical pioneer

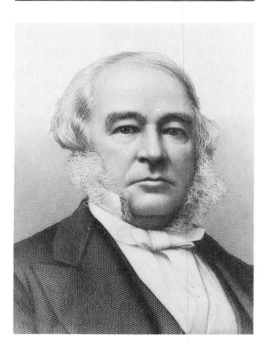

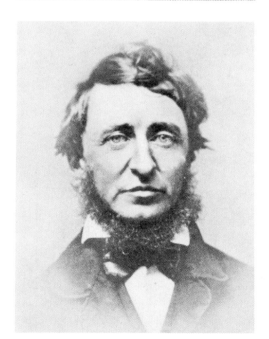

JOHN EDGAR THOMSON (*left*)
(1808–1874)
Railroad engineer, president of Pennsyl-
vania Railroad
Engraving by Samuel Sartain

HENRY DAVID THOREAU (*right*)
[David Henry Thoreau]
(1817–1862)
Transcendentalist essayist, poet, naturalist

MATTHEW THORNTON (*left*)
(*c.* 1714–1803)
Physician, signer of Declaration of Independence
Engraving by Henry B. Hall

WILLIAM THORNTON (*right*)
(1759–1828)
Architect, submitted original designs for Capitol, Washington, D.C.
Painting by Gilbert Stuart

GENERAL TOM THUMB (*left*)
[Charles Sherwood Stratton]
(1838–1883)
Barnum's famed midget
Courtesy New-York Historical Society

MRS. TOM THUMB (*right*)
[Mrs. Charles Sherwood Stratton; Lavinia Warren, nee Mercy Lavinia Warren Bumpus]
(1841–1919)
Barnum midget, wife of General Tom Thumb
Courtesy Museum of the City of New York

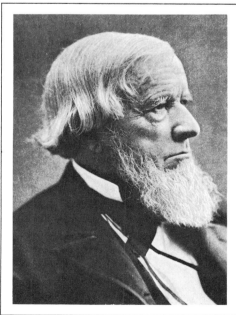

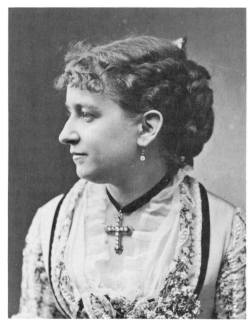

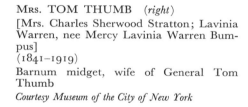

ALLEN GRANBERRY THURMAN
(*left*)
(1813–1895)
Lawyer, jurist, Congressman, U.S. Senator

EMMA CECILIA THURSBY (*right*)
(1845–1931)
Concert soprano, voice teacher
Courtesy Library of Congress, Brady-Handy Collection

HOWARD THURSTON (*left*)
(1869–1936)
Magician
Courtesy Milbourne Christopher Collection

ROBERT HENRY THURSTON (*right*)
(1839–1903)
Mechanical engineer, educator, writer

REUBEN GOLD THWAITES (*left*)
(1853–1913)
Historian, librarian, editor
Courtesy State Historical Society of Wisconsin

CHARLES FRANKLIN THWING
(*right*)
(1853–1937)
Educator, president of Western Reserve
University

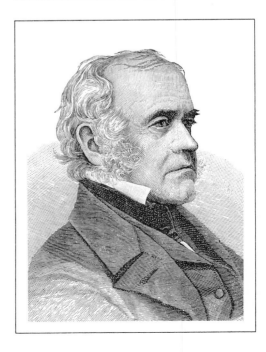

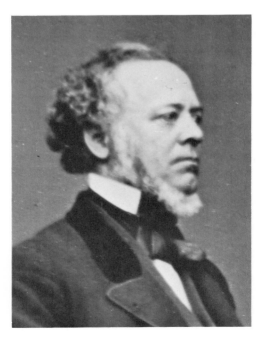

GEORGE TICKNOR (*left*)
(1791–1871)
Educator, historian; a founder of Boston
Public Library

WILLIAM DAVIS TICKNOR (*right*)
(1810–1864)
Book publisher
Courtesy National Archives, Brady Collection

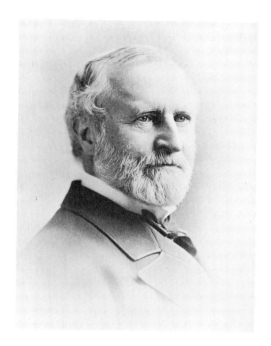

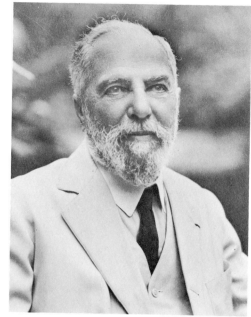

CHARLES LEWIS TIFFANY (*left*)
(1812–1902)
Jeweler, founded Tiffany & Co.
Courtesy Tiffany & Co.

LOUIS COMFORT TIFFANY (*right*)
(1848–1933)
Designer and manufacturer of colored-glass
products, "Tiffany glass"
Courtesy Tiffany & Co.

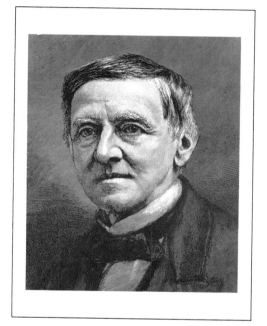

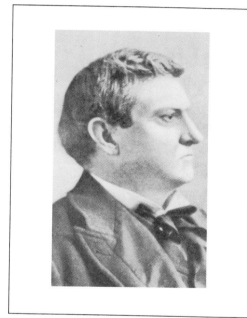

SAMUEL JONES TILDEN (*left*)
(1814–1886)
Governor of New York, defeated for Presi-
dent in disputed election of 1876

BENJAMIN RYAN TILLMAN (*right*)
["Pitchfork Ben" Tillman]
(1847–1918)
Governor of South Carolina, U.S. Senator,
farm leader, segregationist

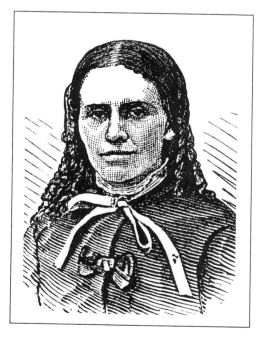

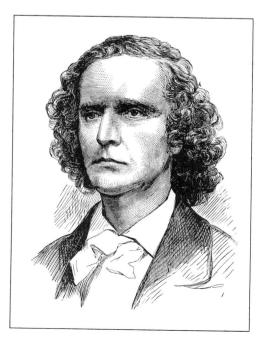

ELIZABETH TILTON (*left*)
[nee Elizabeth Richards]
(1834–1897)
Wife of Theodore Tilton, alleged mistress of
Henry Ward Beecher, central figure in
Tilton-Beecher scandal

THEODORE TILTON (*right*)
(1835–1907)
Journalist, editor; sued Henry Ward Beecher
in adultery scandal

GEORGE CORNELIUS TILYOU
(*left*)
(1862–1914)
Founder and operator of Steeplechase Park,
Coney Island
Courtesy Steeplechase Amusement Park

HENRY TIMKEN (*right*)
(1831–1909)
Carriage manufacturer; invented tapered
roller bearing
Courtesy Timken Roller Bearing Company

HENRY TIMROD (*left*)
(1828–1867)
"Poet laureate of the Confederacy"
*Courtesy South Caroliniana Library, University of
South Carolina*

KATHERINE TINGLEY (*right*)
[nee Katherine Augusta Westcott]
(1847–1929)
Theosophical leader
Courtesy Theosophical University Press

EDWARD BRADFORD TITCHENER
(*left*)
(1867–1927)
Experimental psychologist, educator, lec-
turer
Courtesy Cornell University

ALEXIS DE TOCQUEVILLE (*right*)
[Alexis Charles Henri Maurice Clérel de
Tocqueville]
(1805–1859)
French political analyst, author of *Democ-
racy in America*

DAVID PECK TODD (*left*)
(1855–1939)
Astronomer, educator
Courtesy Millicent Todd Bingham

MABEL LOOMIS TODD (*right*)
(1856–1932)
Writer; first editor of Emily Dickinson's poetry
Courtesy Millicent Todd Bingham

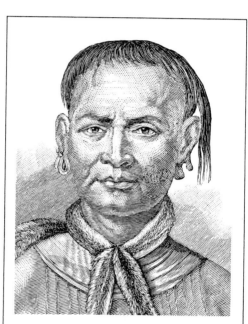

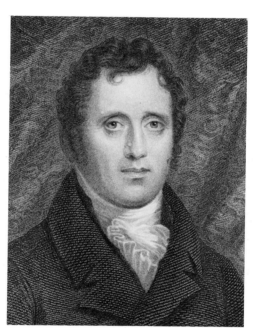

TOMOCHICHI (*left*)
(c. 1650–1739)
Creek Indian chief, befriended Oglethorpe at Savannah

DANIEL D. TOMPKINS (*right*)
(1774–1825)
Governor of New York; Vice-President of U.S., 1817–1825
Engraved from a painting by John Wesley Jarvis

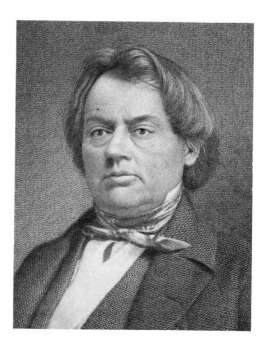

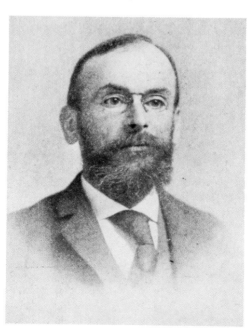

ROBERT TOOMBS (*left*)
[Robert Augustus Toombs]
(1810–1885)
U.S. Senator; Confederate Secretary of State, general
Engraved by P. M. Whelpley from a daguerreotype by Mathew Brady

BRADFORD TORREY (*right*)
(1843–1912)
Naturalist, ornithologist; editor of Thoreau's *Journal*

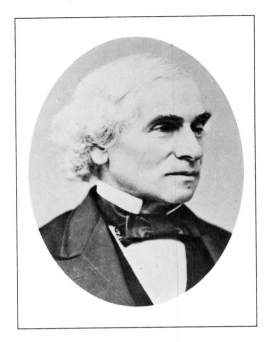

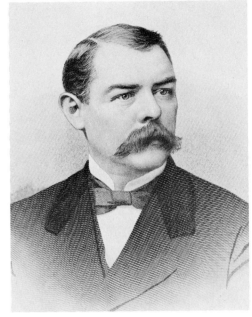

JOHN TORREY (*left*)
(1796–1873)
Botanist, chemist, physician, educator
Courtesy Burndy Library

ALBION WINEGAR TOURGÉE
(*right*)
(1838–1905)
Reconstruction lawyer, novelist; branded a carpetbagger
Engraving by Emily Sartain

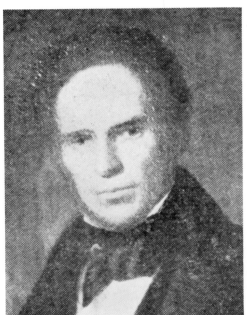

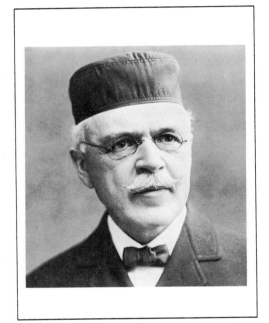

ITHIEL TOWN (*left*)
(1784–1844)
Architect

HENRY ROBINSON TOWNE (*right*)
(1844–1924)
Engineer, partner in Yale and Towne Manufacturing Co.
Courtesy Yale & Towne, Inc.

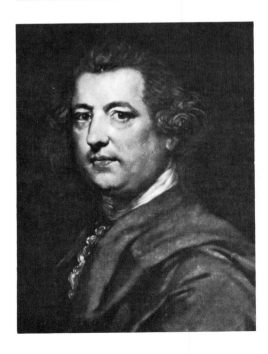

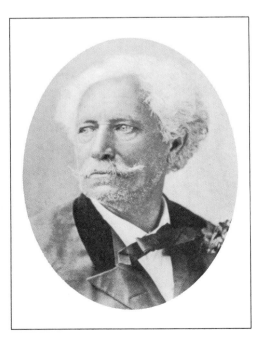

CHARLES TOWNSHEND (*left*)
(1725–1767)
English political leader; introduced tea tax that provoked Boston Tea Party
After a painting by Sir Joshua Reynolds. Courtesy British Museum

GEORGE FRANCIS TRAIN (*right*)
(1829–1904)
Entrepreneur, writer, noted eccentric

WALTER JOHN TRAVIS (*left*)
(1862–1927)
Amateur golf champion

WILLIAM BARRET TRAVIS (*right*)
(1809–1836)
Texas patriot, commander of Texas troops
at Alamo

DANIEL TREADWELL (*left*)
(1791–1872)
Inventor, educator; manufacturer of power
press

GEORGE ALFRED TRENHOLM
(*right*)
(1807–1876)
Cotton broker, financier, Confederate Sec-
retary of the Treasury
Courtesy New-York Historical Society

RICHARD F. TREVELLICK (*left*)
(1830–1895)
Labor leader

FRANCES TROLLOPE (*right*)
[nee Frances Milton]
(1780–1863)
Mother of Anthony Trollope, wrote criti-
cally of *Domestic Manners of the Americans*
Engraved by W. Holl from a drawing by Lucy Adams

JOHN TROWBRIDGE (*left*)
(1843–1923)
Physicist, writer, educator

JOHN TOWNSEND TROWBRIDGE
(*right*)
[Paul Creyton]
(1827–1916)
Writer of boys' books, novels, plays, and
poetry

EDWARD LIVINGSTON TRUDEAU
(*left*)
(1848–1915)
Physician, pioneer in tuberculosis research
Courtesy New York Academy of Medicine

HARRY S. TRUMAN (*right*)
(1884–)
President of the United States, 1945–1953
Courtesy Harry S. Truman Library

Mrs. HARRY S. TRUMAN (*left*)
[Bess Truman, nee Elizabeth Virginia Wallace]
(1885–)
First lady, 1945–1953
Courtesy Harry S. Truman Library

HENRY CLAY TRUMBULL (*right*)
(1830–1903)
Clergyman, influential in Sunday school
movement

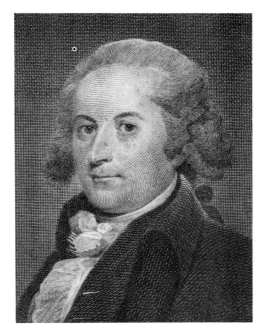

JOHN TRUMBULL (*left*)
(1750–1831)
Poet, essayist, jurist; a leader of "Hartford Wits"
After a painting by John Trumbull

JOHN TRUMBULL (*right*)
(1756–1843)
Painter of portraits, Revolutionary War scenes
Engraved by Asher B. Durand from a painting by Waldo & Jewett

JONATHAN TRUMBULL (*left*)
["Brother Jonathan"; Jonathan Trumble]
(1710–1785)
Revolutionary leader, merchant, jurist; Governor of Colonial Connecticut
Engraved by E. Mackenzie from a painting by John Trumbull

LYMAN TRUMBULL (*right*)
(1813–1896)
U.S. Senator, Congressman, lawyer, jurist
Engraving by George E. Perine

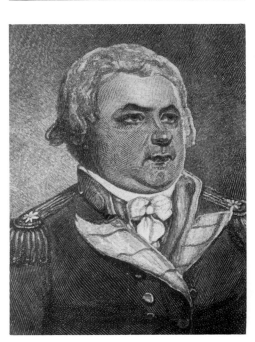

THOMAS TRUXTUN (*left*)
[Thomas Truxton]
(1755–1822)
Naval officer
After a painting by Archibald Robertson

DWIGHT WILLIAM TRYON (*right*)
(1849–1925)
Landscape painter

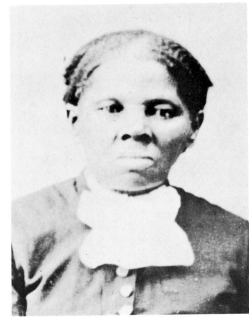

OSCAR TSCHIRKY (*left*)
[Oscar of the Waldorf]
(1866–1950)
Maître d'hôtel, Waldorf-Astoria Hotel
Courtesy Cornell University

HARRIET TUBMAN (*right*)
[nee Harriet Ross]
(*c.* 1821–1913)
Escaped slave, abolitionist, Negro leader
Courtesy Library of Congress

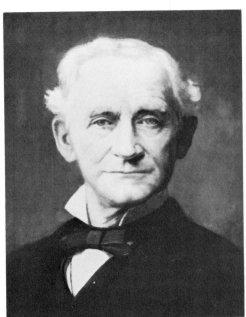

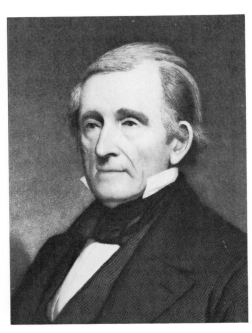

AMOS TUCK (*left*)
(1810–1879)
Lawyer, Congressman
Courtesy Dartmouth College

GEORGE TUCKER (*right*)
(1775–1861)
Political economist, educator, lawyer, Congressman
Courtesy New-York Historical Society

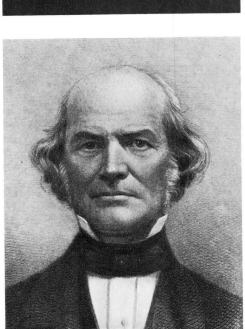

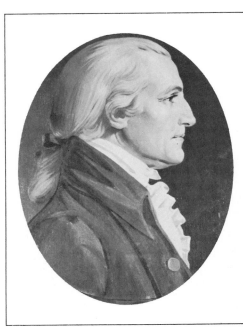

LUTHER TUCKER (*left*)
(1802–1873)
Journalist, agriculturist; founded *Country Gentleman*

St. GEORGE TUCKER (*right*)
(1752–1827)
Virginia jurist, lawyer
Painted by Bethuel Moore from an engraving by St. Memin. Courtesy William and Mary College

WILLIAM JEWETT TUCKER (*left*)
(1839–1926)
Congregational clergyman, educator; president of Dartmouth College

EDWARD TUCKERMAN (*right*)
(1817–1886)
Botanist, lichenologist, educator
Courtesy New York Botanical Garden

HENRY THEODORE TUCKERMAN
(*left*)
(1813–1871)
Essayist, biographer, critic, poet
Engraving by Capewell & Kimmel

FREDERIC TUDOR (*right*)
(1783–1864)
Entrepreneur, the "Ice King"; shipped ice to Southern latitudes
Courtesy Graduate School of Business, Harvard University

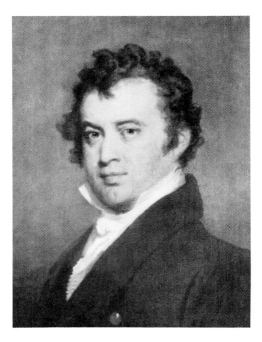

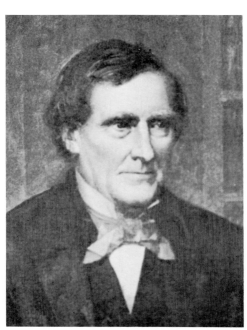

WILLIAM TUDOR (*left*)
(1779–1830)
Editor, essayist; founder and first editor, *North American Review*
Painting by Gilbert Stuart

PAUL TULANE (*right*)
(1801–1887)
New Orleans merchant, benefactor of Tulane University
Courtesy Tulane University

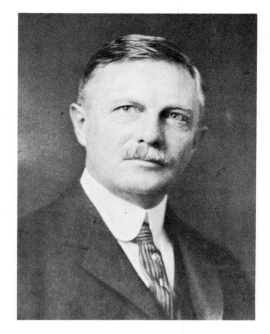

FREDERICK JACKSON TURNER
(left)
(1861–1932)
Historian, educator; originated frontier interpretation of American history
Courtesy University of Wisconsin

JOHN HENRY TWACHTMAN *(right)*
(1853–1902)
Painter
Courtesy Peter A. Juley & Son

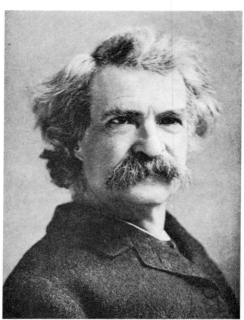

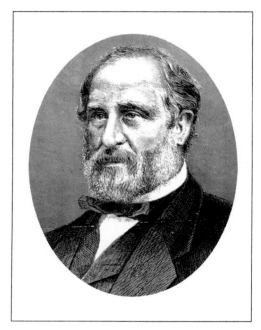

MARK TWAIN *(left)*
[Samuel Langhorne Clemens]
(1835–1910)
Novelist, humorist, lecturer

WILLIAM MARCY TWEED *(right)*
[Boss Tweed]
(1823–1878)
Politician, Congressman; leader of Tammany Hall, New York
After a photograph by Mathew Brady

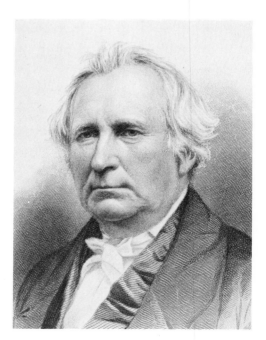

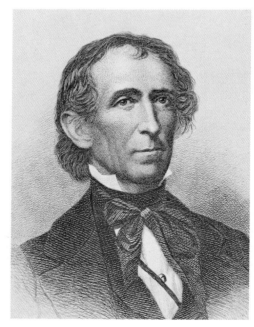

BENNET TYLER *(left)*
(1783–1858)
Theologian, clergyman, president of Dartmouth College
Engraved by H. Wright Smith from a daguerreotype by Southworth & Hawes

JOHN TYLER *(right)*
(1790–1862)
President of the United States, 1841–1845
Engraving by Henry B. Hall, Jr.

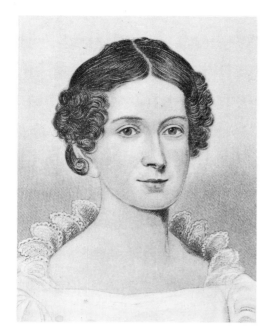

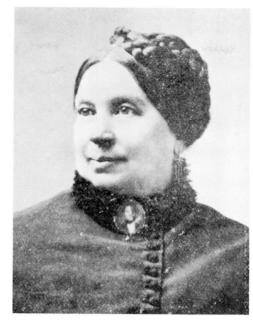

MRS. JOHN TYLER (*left*)
[nee Letitia Christian]
(1790–1842)
First lady, 1841–1842
Engraving by J. C. Buttre

MRS. JOHN TYLER (*right*)
[nee Julia Gardiner]
(1820–1889)
First lady, 1844–1845
Courtesy Virginia State Library

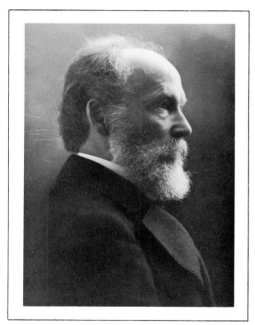

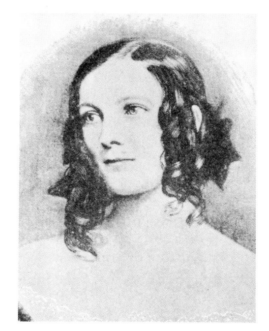

MOSES COIT TYLER (*left*)
(1835–1900)
Historian, educator, clergyman; authority
on Colonial literature; first professor of
American history in U.S.
Courtesy Cornell University

PRISCILLA TYLER (*right*)
[Mrs. Robert Tyler, nee Elizabeth Priscilla
Cooper]
(1819–1896)
Daughter-in-law of John Tyler; White
House hostess, 1841–1844

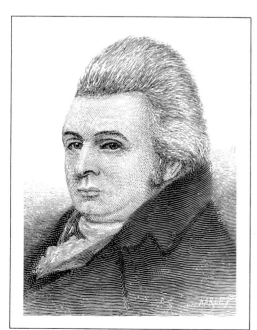

ROYALL TYLER
(1757–1826)
Playwright, jurist; wrote *The Contrast*, first
comedy by native American

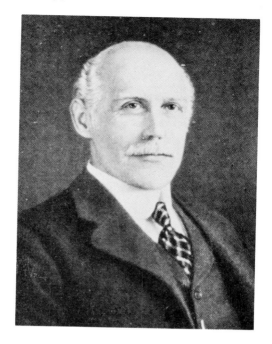

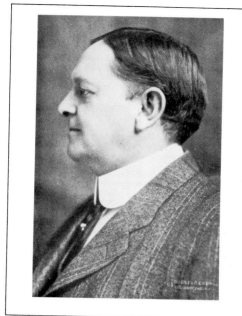

JOHN THOMAS UNDERWOOD
(left)
(c. 1857–1937)
Typewriter manufacturer
Courtesy Underwood Corporation

OSCAR WILDER UNDERWOOD
(right)
(1862–1929)
U.S. Senator, Congressman, lawyer

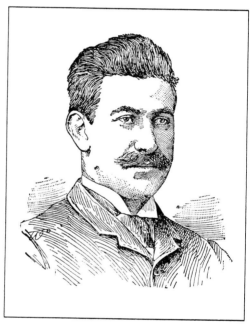

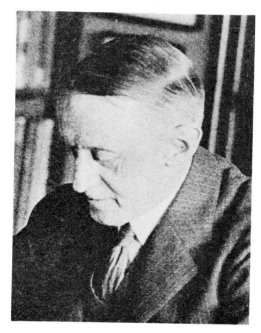

SAMUEL UNTERMYER *(left)*
(1858–1940)
Lawyer

DANIEL BERKELEY UPDIKE *(right)*
(1860–1941)
Printer, publisher

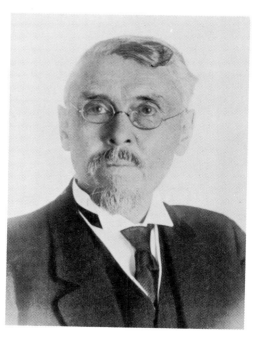

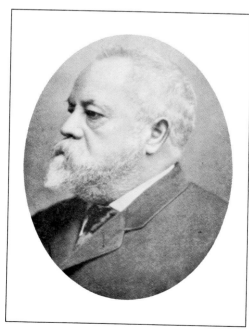

WARREN UPHAM *(left)*
(1850–1934)
Archaeologist, geologist; studied glaciers

RICHARD MICHELL UPJOHN
(right)
(1828–1903)
Architect

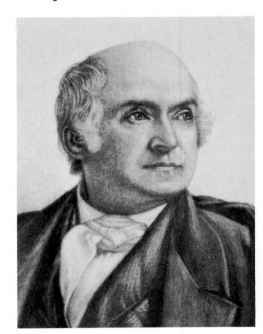 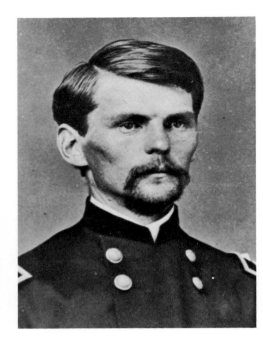

ABEL PARKER UPSHUR (*left*)
(1791–1844)
Secretary of the Navy and Secretary of State under Tyler

EMORY UPTON (*right*)
(1839–1881)
Union general in Civil War; military analyst and historian
Courtesy National Archives, Brady Collection

ALFRED VAIL (*left*)
(1807–1859)
Partner of Morse in development of telegraph
Courtesy Smithsonian Institution

THEODORE NEWTON VAIL (*right*)
(1845–1920)
Telephone executive, organized American Telephone & Telegraph Co.

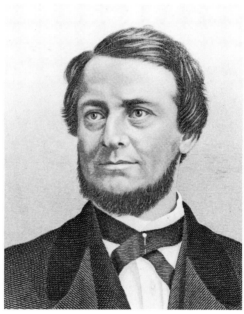

DAVID THOMAS VALENTINE
(*left*)
(1801–1869)
Pioneer compiler of New York City historical records
Engraved by John Rogers from a painting by C. Jarvis

CLEMENT LAIRD VALLANDIGHAM
(*right*)
(1820–1871)
Congressman, leader of "Copperheads" during Civil War
Engraving by W. G. Jackman

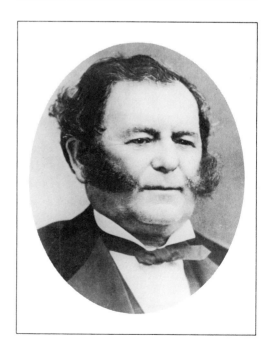

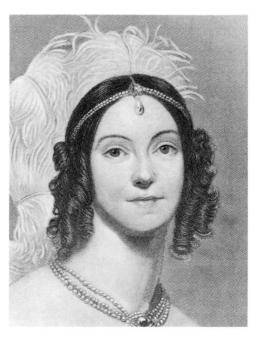

MARIANO GUADALUPE VALLEJO
(*left*)
(1808–1890)
Leader in settlement and development of California
Courtesy California Historical Society

ANGELICA VAN BUREN (*right*)
[Mrs. Abram Van Buren, nee Angelica Singleton]
(1816–1878)
Daughter-in-law of Martin Van Buren; White House hostess
Engraving by J. C. Buttre

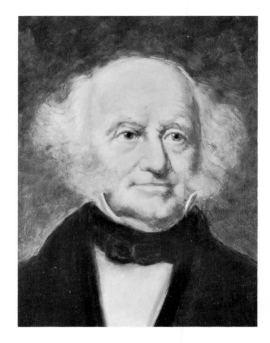

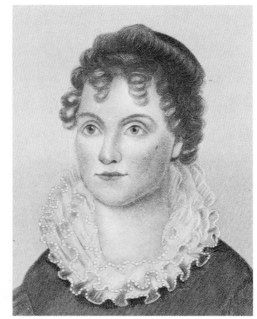

MARTIN VAN BUREN *(left)*
(1782–1862)
President of the United States, 1837–1841
*Painted by Eliphalet Fraser Andrews after a painting
by G. P. A. Healy. Courtesy U.S. Department of State*

MRS. MARTIN VAN BUREN *(right)*
[nee Hannah Hoes]
(1783–1819)
Wife of Martin Van Buren, died before his
term of office
Engraving by J. C. Buttre

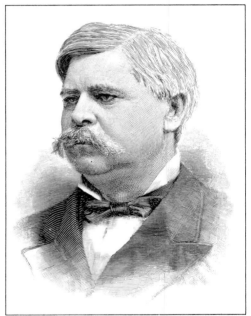

ZEBULON BAIRD VANCE *(left)*
(1830–1894)
Governor of North Carolina during Civil
War; U.S. Senator

OLOFF STEVENSZEN VAN
CORTLANDT *(right)*
(1600–1684)
Merchant, leading citizen of New Amster-
dam
Courtesy New-York Historical Society

PHILIP VAN CORTLANDT *(left)*
(1749–1831)
Revolutionary officer, Congressman
*Painting attributed to James Sharples, Sr. Courtesy
Independence National Historical Park*

CONSUELO VANDERBILT *(right)*
[Duchess of Marlborough; Mrs. Jacques
Balsam]
(1877–1964)
Socialite

CORNELIUS VANDERBILT (*left*)
["Commodore" Vanderbilt]
(1794–1877)
Capitalist, steamship and railroad owner; consolidated New York Central system
Engraving by Alexander H. Ritchie

CORNELIUS VANDERBILT (*right*)
(1843–1899)
Railroad executive, financier, philanthropist

FREDERICK WILLIAM VANDERBILT (*left*)
(1856–1938)
Railroad executive, yachtsman

GEORGE WASHINGTON VANDERBILT (*right*)
(1862–1914)
Agriculturist, philanthropist, pioneer in scientific forestry

WILLIAM HENRY VANDERBILT (*left*)
(1821–1885)
Railroad administrator, capitalist, philanthropist
Engraving by Alexander H. Ritchie

WILLIAM KISSAM VANDERBILT (*right*)
(1849–1920)
Railroad executive, yachtsman, philanthropist

JOHN VANDERLYN (*left*)
(1775–1852)
Painter
Self-portrait

HENRY van DYKE (*right*)
(1852–1933)
Presbyterian clergyman, writer, educator, diplomat

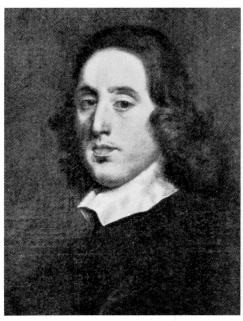
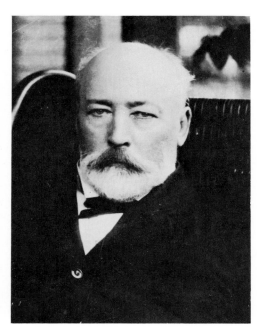

Sir HENRY VANE (*left*)
[Sir Harry Vane]
(1613–1662)
Governor of Massachusetts Colony
Painting by Sir Peter Lely

Sir WILLIAM CORNELIUS Van HORNE (*right*)
(1843–1915)
Railroad developer, built Canadian Pacific Railway
Courtesy Canadian Pacific Railway

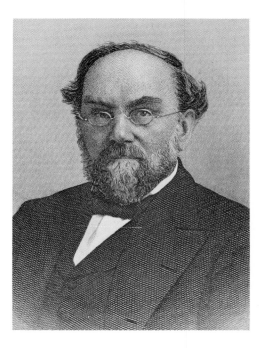
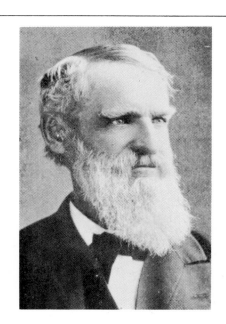

DAVID Van NOSTRAND (*left*)
(1811–1886)
Book publisher
Engraving by George E. Perine

JOHN MILLS Van OSDEL (*right*)
(1811–1891)
First architect in Chicago and the West

KILIAEN VAN RENSSELAER (*left*)
(1595–1634)
Dutch diamond merchant, purchased large
estates in America
Courtesy New-York Historical Society

MARIANA GRISWOLD VAN
RENSSELAER (*right*)
[Mrs. Schuyler Van Rensselaer]
(1851–1934)
Art and architecture critic; poet
*Painting by William A. Cossin. Courtesy Museum of
the City of New York*

STEPHEN VAN RENSSELAER (*left*)
(1764–1839)
Landowner, civic leader; founded Rens-
selaer Polytechnic Institute; known as "The
Patroon"
*Engraved by George Parker from a painting by Charles
Fraser*

LARDNER VANUXEM (*right*)
(1792–1848)
Geologist
Courtesy Peabody Museum, Harvard University

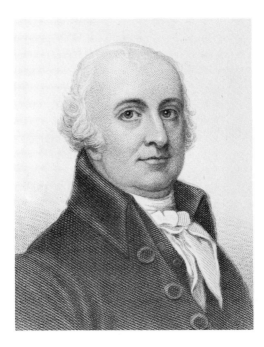

RICHARD VARICK (*left*)
(1753–1831)
Revolutionary officer, aide to Washington;
mayor of New York City
*Engraved by H. B. Hall & Sons after a painting by
Gilbert Stuart*

GEORGE VASEY (*right*)
(1822–1893)
Botanist, authority on grasses
Courtesy New York Botanical Garden

MATTHEW VASSAR *(left)*
(1792–1868)
Brewer, investor; founded Vassar College
Engraving by J. C. Buttre

VICTOR CLARENCE VAUGHAN
(right)
(1851–1929)
Pioneer American bacteriologist; physician,
educator
Courtesy New York Academy of Medicine

CALVERT VAUX *(left)*
(1824–1895)
Landscape architect, planned parks in New
York City

THORSTEIN BUNDE VEBLEN *(right)*
(1857–1929)
Economist, social theorist, educator

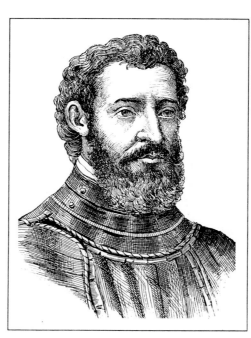

ELIHU VEDDER *(left)*
(1836–1923)
Painter, illustrator

GIOVANNI ᴅᴀ **VERRAZANO** *(right)*
[Giovanni da Verrazzano]
(*c.* 1485–*c.* 1528)
Italian explorer, discovered New York har-
bor

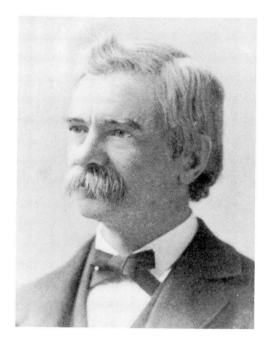
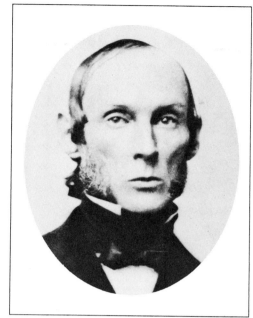

ADDISON EMERY VERRILL (*left*)
(1839–1926)
Zoologist, educator, editor

JONES VERY (*right*)
(1813–1880)
Transcendentalist poet, wrote religious sonnets

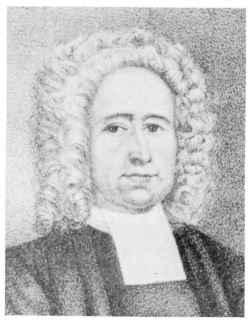

WILLIAM VESEY (*left*)
(1674–1746)
Anglican clergyman in New York

AMERIGO VESPUCCI (*right*)
[Americus Vespucius]
(1451–1512)
Italian navigator, claimed exploration along American coast; source of name "America"
Engraved by Charles Burt after a painting by Bronzino

FRANCIS VIGO (*left*)
[Joseph Maria Francesco Vigo]
(1747–1836)
Fur trader, aided in conquest of Northwest Territory
Courtesy Vigo Chapter, Daughters of the American Revolution

HENRY VILLARD (*right*)
[Ferdinand Heinrich Gustav Hilgard]
(1835–1900)
Railroad promoter, investor, journalist

JOHN HEYL VINCENT (*left*)
(1832–1920)
Methodist clergyman, a leader in Sunday
school and Chautauqua movements

FRED M. VINSON (*right*)
[Frederick Moore Vinson]
(1890–1953)
Chief Justice of U.S., 1946–1953; Congress-
man, Secretary of the Treasury under
Truman
Courtesy Library of Congress

LEONARD WELLS VOLK (*left*)
(1828–1895)
Sculptor

CONSTANTIN FRANÇOIS DE
CHASSEBOEUF, COMTE DE VOLNEY
(*right*)
(1757–1820)
French geographer in U.S.
Painting by Gilbert Stuart

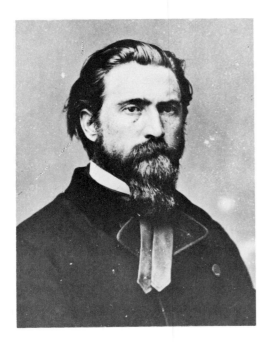

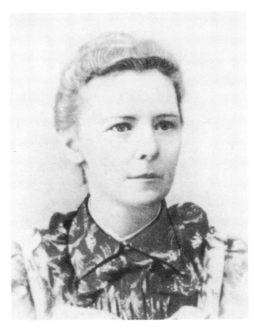

DANIEL WOLSEY VOORHEES
(*left*)
(1827–1897)
U.S. Senator, Congressman, lawyer
Courtesy National Archives, Brady Collection

ETHEL LILIAN VOYNICH (*right*)
[nee Ethel Lilian Boole]
(1864–1960)
Novelist, translator; wrote *The Gadfly*

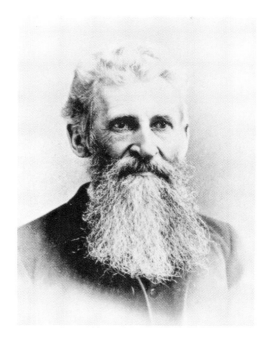
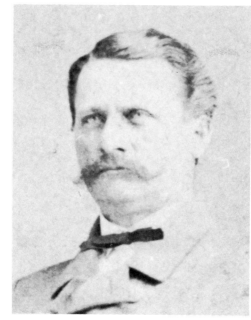

CHARLES WACHSMUTH (*left*)
(1829–1896)
Paleontologist

JAMES IREDELL WADDELL (*right*)
(1824–1886)
Confederate naval officer
Courtesy Confederate Museum

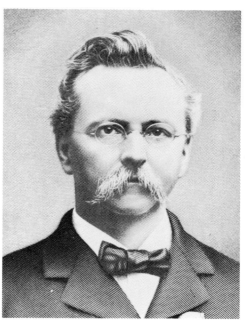
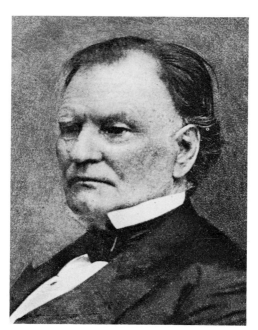
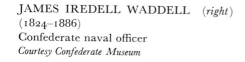

JOHN ALEXANDER LOW WADDELL
(*left*)
(1854–1938)
Bridge engineer, developed modern vertical-lift bridge
Courtesy Smithsonian Institution

BENJAMIN FRANKLIN WADE (*right*)
(1800–1878)
U.S. Senator, abolitionist; advocate of harsh Reconstruction measures

JEREMIAH WADSWORTH (*left*)
(1743–1804)
Revolutionary officer, Congressman, Connecticut businessman
Painting by John Trumbull

ADAM WILLIS WAGNALLS (*right*)
(1843–1924)
Book publisher

HONUS WAGNER (*left*)
[John Peter Wagner; Hans Wagner]
(1874–1955)
Baseball shortstop, charter member of Baseball Hall of Fame

JONATHAN MAYHEW
WAINWRIGHT (*right*)
(1792–1854)
Protestant Episcopal bishop, a founder of New York University

RICHARD WAINWRIGHT (*left*)
(1817–1862)
Naval officer, commanded the *Hartford* in Civil War

RICHARD WAINWRIGHT (*right*)
(1849–1926)
Naval officer, hero of battle of Santiago Bay; superintendent, U.S. Naval Academy

MORRISON REMICK WAITE (*left*)
(1816–1888)
Chief Justice of U.S., 1874–1888
Engraving by Henry B. Hall, Jr.

CHARLES MELTON WALCOT
(*right*)
(c. 1816–1868)
Comedian, playwright
Photograph by Napoleon Sarony

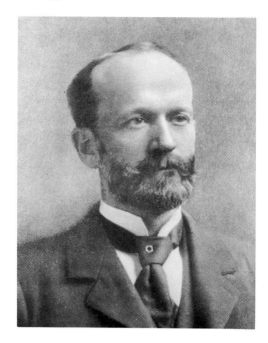

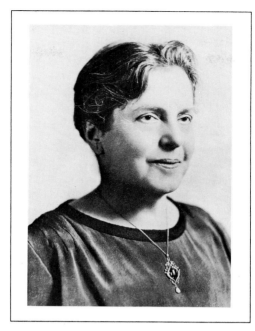

CHARLES DOOLITTLE WALCOTT
(*left*)
(1850–1927)
Geologist, paleontologist; secretary, Smithsonian Institution

LILLIAN D. WALD (*right*)
(1867–1940)
Social worker, reformer; founded Henry Street Settlement, New York
Courtesy Henry Street Settlement House

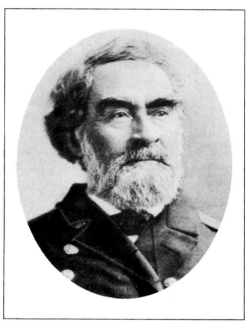

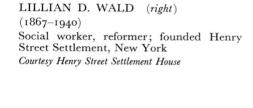

HENRY WALKE (*left*)
(1808–1896)
Union naval officer, Civil War

AMASA WALKER (*right*)
(1799–1875)
Economist, businessman, educator; a founder of Oberlin College
Engraving by F. T. Stuart

FRANCIS AMASA WALKER (*left*)
(1840–1897)
Statistician, census director, economist; president, Massachusetts Institute of Technology
Courtesy Massachusetts Institute of Technology

JOHN BRISBEN WALKER (*right*)
(1847–1931)
Publisher, automobile manufacturer; pacifist

LEROY POPE WALKER (*left*)
(1817–1884)
Confederate Secretary of War, general

MARY EDWARDS WALKER (*right*)
(1832–1919)
Physician, reformer, advocate of woman's rights
Courtesy National Archives, Brady Collection

ROBERT J. WALKER (*left*)
(1801–1869)
U.S. Senator, Secretary of the Treasury under Polk, Governor of Kansas Territory; financier

SEARS COOK WALKER (*right*)
(1805–1853)
Mathematical astronomer
Courtesy Lick Observatory

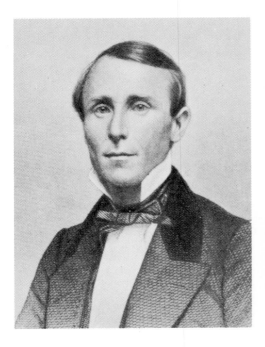

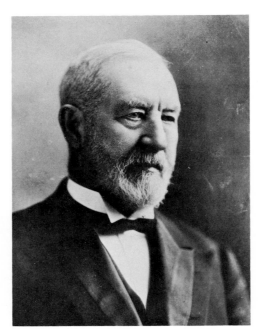

WILLIAM WALKER (*left*)
(1824–1860)
Adventurer, led uprisings in Central America; conquered Nicaragua

HENRY WALLACE (*right*)
(1836–1916)
Agricultural journalist, writer; owned and edited *Wallaces' Farmer*
Courtesy James W. Wallace

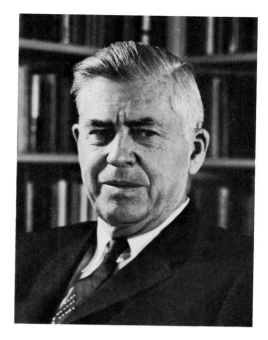
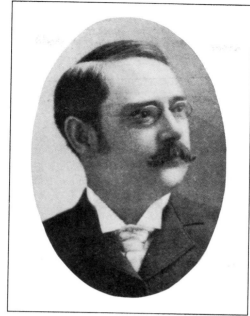

HENRY AGARD WALLACE *(left)*
(1888–1965)
Vice-President of U.S., 1941–1945; Secretary of Agriculture under F. D. Roosevelt, Secretary of Commerce under F. D. Roosevelt and Truman
Courtesy Henry A. Wallace

JOHN FINDLEY WALLACE *(right)*
(1852–1921)
Railroad engineer; first chief engineer, Panama Canal

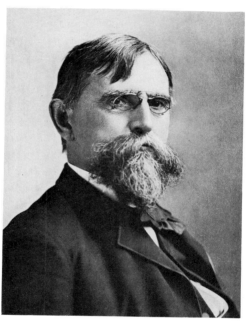
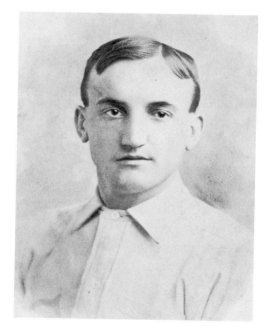

LEW WALLACE *(left)*
[Lewis Wallace]
(1827–1905)
Union general in Civil War, diplomat; author of *Ben Hur*
Photograph by Napoleon Sarony

RODERICK J. WALLACE *(right)*
[Bobby Wallace]
(1873–1960)
Baseball infielder, manager, scout, umpire; member of Baseball Hall of Fame
Courtesy National Baseball Hall of Fame

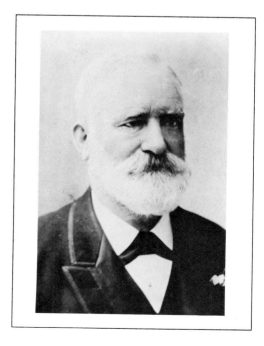
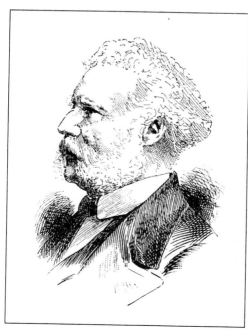

WILLIAM WALLACE *(left)*
(1825–1904)
Wire manufacturer, rolling-mill operator; developed electrical equipment
Courtesy Smithsonian Institution

HENRY JOHN WALLACK *(right)*
(1790–1870)
Actor, theatrical manager

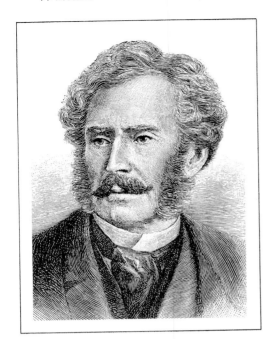

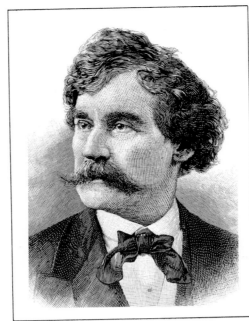

JAMES WILLIAM WALLACK *(left)*
(c. 1795–1864)
Actor, theatrical manager

JAMES WILLIAM WALLACK *(right)*
(1818–1873)
Actor

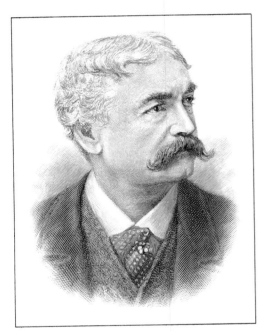

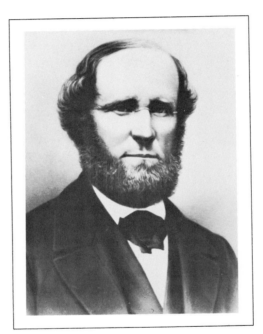

LESTER WALLACK *(left)*
[John Johnstone Wallack]
(1820–1888)
Actor, playwright, theatrical manager

BENJAMIN DANN WALSH *(right)*
(1808–1869)
Entomologist
Courtesy Illinois State Historical Library

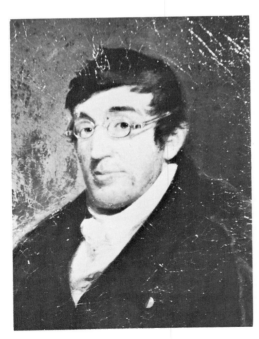

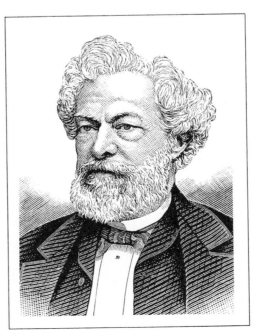

ROBERT WALSH *(left)*
(1784–1859)
Journalist, editor, educator, diplomat
Painting by John Neagle. Courtesy Georgetown University News Service

THOMAS USTICK WALTER *(right)*
(1804–1887)
Greek Revival architect; designed wings and dome of Capitol, Washington, D.C.

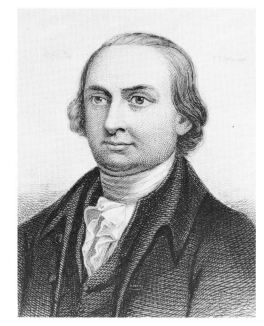

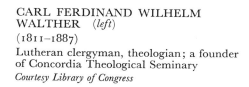

CARL FERDINAND WILHELM
WALTHER (*left*)
(1811–1887)
Lutheran clergyman, theologian; a founder
of Concordia Theological Seminary
Courtesy Library of Congress

GEORGE WALTON (*right*)
(1741–1804)
Signer of Declaration of Independence,
U.S. Senator
Engraving by Henry B. Hall

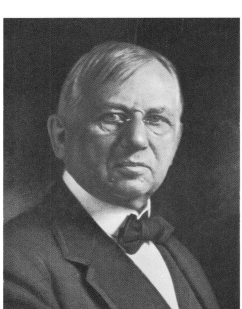

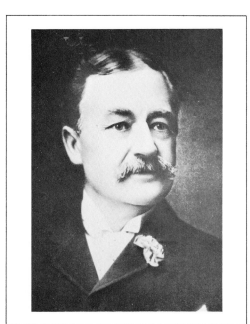

JOHN WANAMAKER (*left*)
(1838–1922)
Department-store owner; Postmaster General under Benjamin Harrison
Engraving by E. G. Williams & Bro.

AARON MONTGOMERY WARD
(*right*)
(1843–1913)
Merchant, established mail-order house
Courtesy Northwestern University

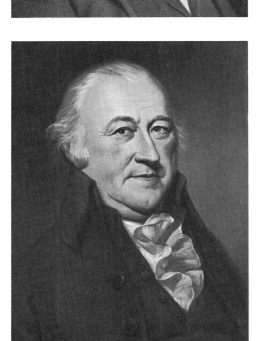

ARTEMAS WARD (*left*)
(1727–1800)
Revolutionary general, Congressman
Painting by Charles Willson Peale. Courtesy Independence National Historical Park

ARTEMUS WARD (*right*)
[Charles Farrar Browne]
(1834–1867)
Humorist, journalist, lecturer

ELIZABETH STUART WARD (*left*)
[nee Mary Gray Phelps]
(1844–1911)
Novelist, poet

FREDERICK TOWNSEND WARD
(*right*)
(1831–1862)
Military adventurer in China, predecessor
of C. G. ("Chinese") Gordon

GENEVIEVE WARD (*left*)
[Lucy Geneviève Teresa Ward]
(1838–1922)
Actress, singer

HENRY AUGUSTUS WARD (*right*)
(1834–1906)
Naturalist
Courtesy University of Rochester Library

JAMES EDWARD WARD (*left*)
(1836–1894)
Shipowner

JOHN QUINCY ADAMS WARD
(*right*)
(1830–1910)
Sculptor; created statue of Washington for
Sub-Treasury Building, Wall Street

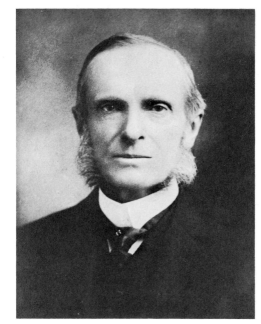

LESTER FRANK WARD *(left)*
(1841–1913)
Sociologist, geologist, paleontologist, educator
Courtesy Brown University

RICHARD HALSTED WARD *(right)*
(1837–1917)
Physician, microscopist, educator

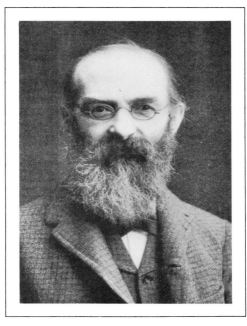

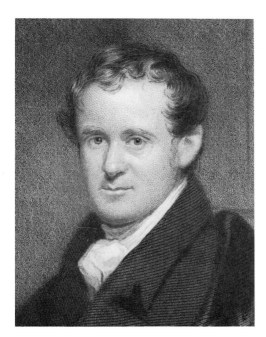

WILLIAM HAYES WARD *(left)*
(1835–1916)
Orientalist, journalist, Biblical scholar

HENRY WARE *(right)*
(1794–1843)
Unitarian clergyman, educator
*Engraved by C. E. Wagstaff and Joseph Andrews
from a painting by James Frothingham*

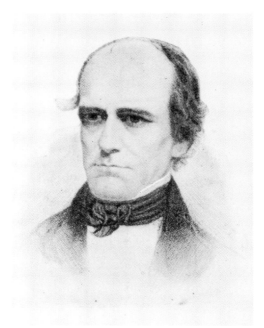

WILLIAM WARE *(left)*
(1797–1852)
Historical novelist, Unitarian clergyman

WILLIAM ROBERT WARE *(right)*
(1832–1915)
Architect, pioneer in architectural education in U.S.

DAVID WARFIELD (*left*)
(1866–1951)
Actor

CHARLES DUDLEY WARNER (*right*)
(1829–1900)
Editor, essayist

OLIN LEVI WARNER (*left*)
(1844–1896)
Sculptor

POP WARNER (*right*)
[Glenn Scobey Warner]
(1871–1954)
Football coach
Courtesy Stanford University

WORCESTER REED WARNER
(*left*)
(1846–1929)
Machine-tool manufacturer, designed and
built observatory telescopes
Courtesy Warner & Swasey Co.

EARL WARREN (*right*)
(1891–)
Chief Justice of U.S., 1953– ; Governor
of California
Courtesy Library of Congress

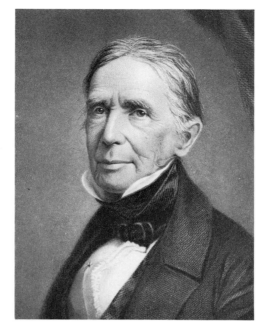

GOUVERNEUR KEMBLE WARREN (*left*)
(1830–1882)
Union general in Civil War; military engineer
Courtesy Library of Congress, Brady Collection

JOHN COLLINS WARREN (*right*)
(1778–1856)
Surgeon, educator; gave first public demonstration of ether anesthesia
Engraving by H. W. Smith

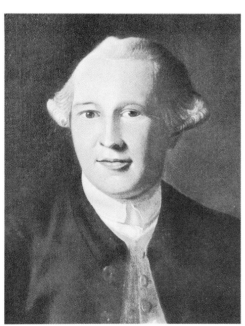

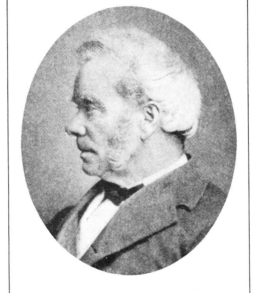

JOSEPH WARREN (*left*)
(1741–1775)
Physician, Revolutionary leader in Massachusetts
Painting by John Singleton Copley

JOSIAH WARREN (*right*)
(c. 1798–1874)
Reformer, inventor; founded town of Modern Times, Long Island

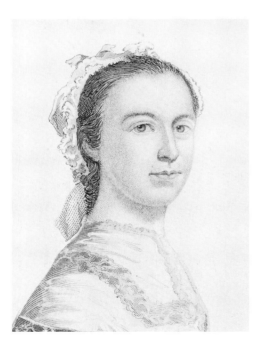

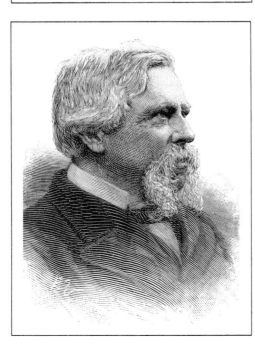

MERCY WARREN (*left*)
[nee Mercy Otis]
(1728–1814)
Historian, poet, political satirist
After a painting by John Singleton Copley

SAMUEL D. WARREN (*right*)
(1818–1888)
Paper manufacturer

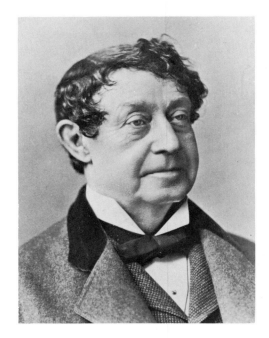

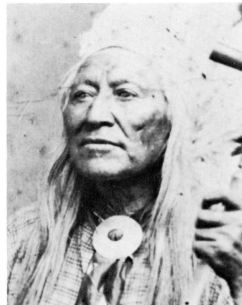

WILLIAM WARREN (*left*)

(1812–1888)

Actor

Courtesy Walter Hampden Memorial Library at The Players, New York

WASHAKIE (*right*)

(*c.* 1804–1900)

Shoshone Indian chief, befriended white settlers

Courtesy Mercaldo Archives

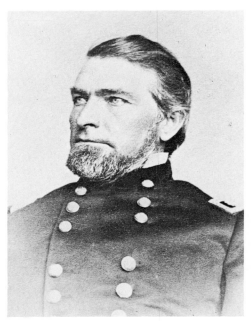

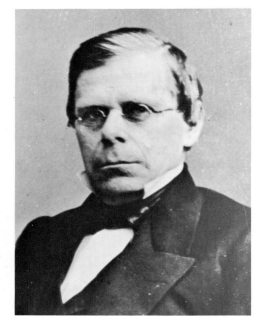

CADWALLADER COLDEN WASHBURN (*left*)

(1818–1882)

Lawyer, industrialist, Congressman; Governor of Wisconsin; Union general in Civil War

Courtesy Library of Congress, Brady Collection

ISRAEL WASHBURN (*right*)

(1813–1883)

Lawyer, Congressman, Governor of Maine; a founder of Republican party

Courtesy National Archives, Brady Collection

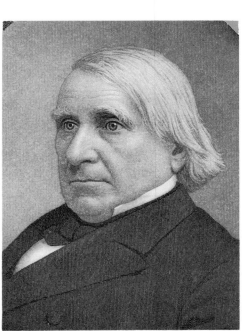

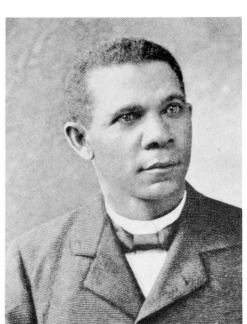

ELIHU BENJAMIN WASHBURNE (*left*)

(1816–1887)

Lawyer, Congressman, minister to France, Secretary of State under Grant

Engraving by Samuel Sartain

BOOKER TALIAFERRO WASHINGTON (*right*)

(1856–1915)

Educator, writer, lecturer; established Tuskegee Institute

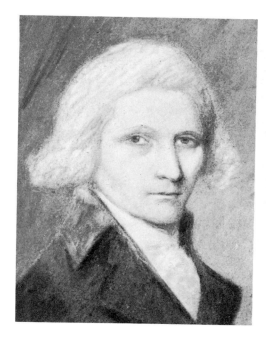
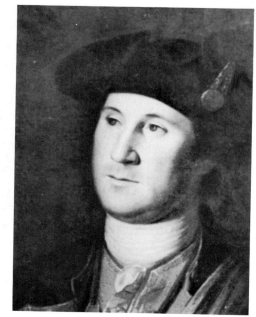

BUSHROD WASHINGTON *(left)*
(1762–1829)
Associate justice, U.S. Supreme Court
Painting attributed to James Sharples, Sr. Courtesy Independence National Historical Park

GEORGE WASHINGTON *(right)*
(1732–1799)
President of the United States, 1789–1797
Painting by Charles Willson Peale. Courtesy Washington and Lee University

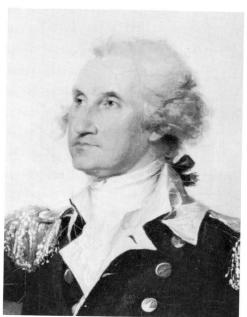
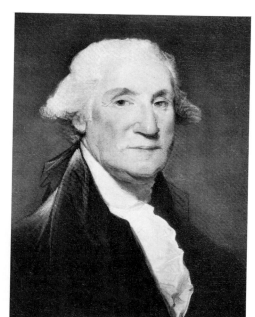

GEORGE WASHINGTON *(left)*
(see above)
Painting by John Trumbull. Courtesy Henry Francis du Pont Winterthur Museum

GEORGE WASHINGTON *(right)*
(see above)
Painting by Gilbert Stuart

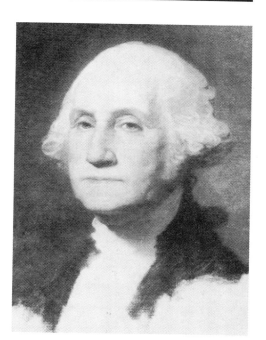

GEORGE WASHINGTON *(left)*
(see above)
Painting by Gilbert Stuart

GEORGE WASHINGTON *(right)*
(see above)
Sculpture by Houdon

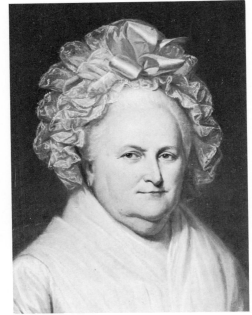

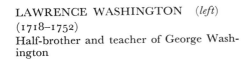

LAWRENCE WASHINGTON (*left*)
(1718–1752)
Half-brother and teacher of George Washington

MARTHA WASHINGTON (*right*)
[Mrs. George Washington, Mrs. Martha Custis, nee Martha Dandridge]
(1732–1802)
First lady, 1789–1797
Painting by Charles Willson Peale. Courtesy Independence National Historical Park

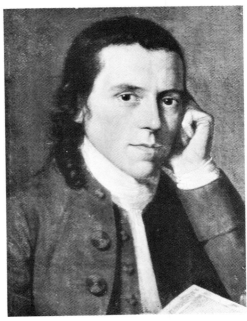

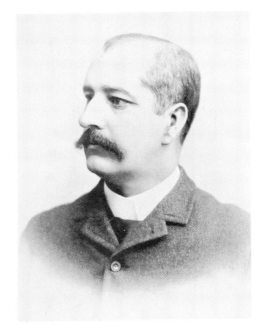

BENJAMIN WATERHOUSE (*left*)
(1754–1846)
Pioneer in vaccination in America; physician, educator
Painting by Gilbert Stuart

STANLEY WATERLOO (*right*)
(1846–1913)
Journalist, novelist

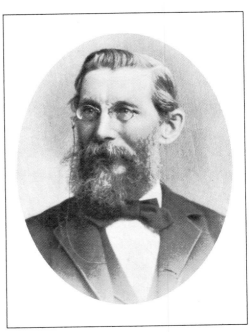

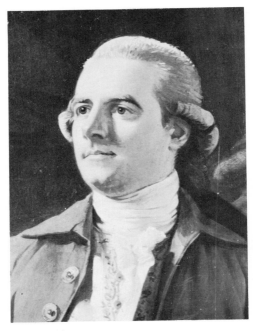

LEWIS EDSON WATERMAN (*left*)
(1837–1901)
Fountain-pen inventor, manufacturer

ELKANAH WATSON (*right*)
(1758–1842)
Agriculturist, canal promoter; sponsored first county fair in U.S.
Painting by John Singleton Copley. Courtesy New York State Library

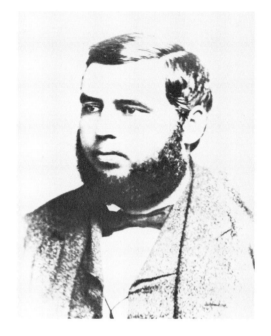
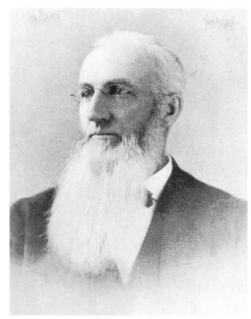

JAMES CRAIG WATSON (*left*)
(1838–1880)
Astronomer
Courtesy McMaster University

SERENO WATSON (*right*)
(1826–1892)
Botanist

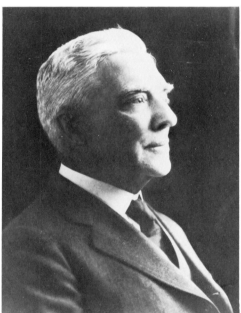
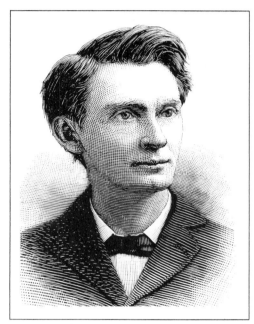

THOMAS AUGUSTUS WATSON
(*left*)
(1854–1934)
Telephone technician, shipbuilder; early associate of Alexander Graham Bell
Courtesy American Telephone & Telegraph Co.

TOM WATSON (*right*)
[Thomas Edward Watson]
(1856–1922)
Populist political leader, U.S. Senator, writer, editor

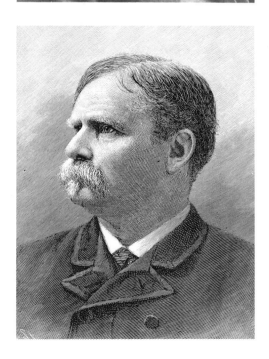
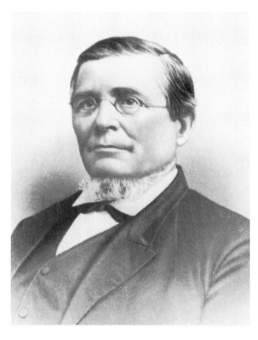

HENRY WATTERSON (*left*)
["Marse Henry"]
(1840–1921)
Journalist, editor, Congressman; edited *Louisville Courier-Journal*

THOMAS HILL WATTS (*right*)
(1819–1892)
Confederate Attorney General, Civil War Governor of Alabama
Engraved by F. G. Kernan. Courtesy Alabama State Chamber of Commerce

ALFRED R. WAUD (*left*)
(1828–1891)
Artist, illustrator, sketched Civil War episodes for *Harper's Weekly*
Photograph by Timothy H. O'Sullivan. Courtesy Library of Congress

FRANCIS WAYLAND (*right*)
(1796–1865)
Baptist clergyman, philosopher; president of Brown University
Engraving by H. W. Smith

FRANCIS WAYLAND (*left*)
(1826–1904)
Lawyer, educator; dean of Yale Law School

ANTHONY WAYNE (*right*)
["Mad Anthony" Wayne]
(1745–1796)
Revolutionary general, Congressman
Painting attributed to James Sharples, Sr. Courtesy Independence National Historical Park

JAMES BAIRD WEAVER (*left*)
(1833–1912)
Populist political leader, Union officer in Civil War, Congressman

ALEXANDER STEWART WEBB
(*right*)
(1835–1911)
Union general in Civil War; awarded Medal of Honor; president, College of the City of New York

JAMES WATSON WEBB (*left*)
(1802–1884)
Newspaper publisher, diplomat
Engraving by George E. Perine

WILLIAM HENRY WEBB (*right*)
(1816–1899)
Shipbuilder

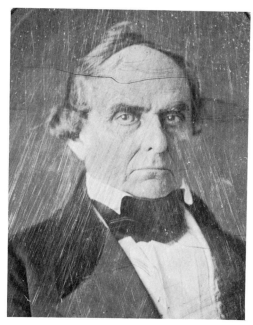

JOSEPH M. WEBER (*left*)
(1867–1942)
Comedian, partner in Weber and Fields comedy team

DANIEL WEBSTER (*right*)
(1782–1852)
Lawyer, orator, U.S. Senator, Congressman; Secretary of State under W. H. Harrison, Tyler, and Fillmore
Courtesy New-York Historical Society

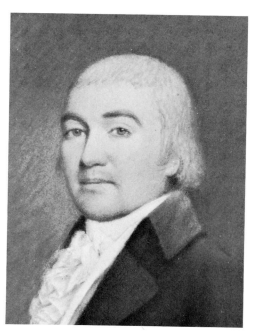

JOHN WHITE WEBSTER (*left*)
(1793–1850)
Harvard chemistry professor, hanged for murder of Dr. George Parkman

NOAH WEBSTER (*right*)
(1758–1843)
Lexicographer, grammarian, writer; a founder of Amherst College
Painting attributed to James Sharples, Sr. Courtesy Independence National Historical Park

THURLOW WEED (*left*)
(1797–1882)
Newspaper publisher, New York political leader
Painting by J. B. Flagg

MASON LOCKE WEEMS (*right*)
[Parson Weems]
(1759–1825)
Anglican clergyman, bookseller; author of popular biographies; originated George Washington cherry-tree story

JOHN FERGUSON WEIR (*left*)
(1841–1926)
Painter, educator; first director, Yale School of Fine Arts

JULIAN ALDEN WEIR (*right*)
(1852–1919)
Painter, etcher
Courtesy Peter A. Juley & Son

ROBERT WALTER WEIR (*left*)
(1803–1889)
Painter, teacher of painting

WILLIAM HENRY WELCH (*right*)
(1850–1934)
Pathologist, bacteriologist, educator, editor; "dean of American medicine"
Courtesy Johns Hopkins University

ANGELINA WELD (*left*)
[nee Angelina Emily Grimké]
(1805–1879)
Abolitionist, feminist

THEODORE DWIGHT WELD (*right*)
(1803–1895)
Abolitionist leader

GIDEON WELLES (*left*)
(1802–1878)
Republican leader, Secretary of the Navy
under Lincoln and Andrew Johnson
Engraving by J. M. Butler

CAROLYN WELLS (*right*)
(1869–1942)
Writer of mystery novels and juvenile
stories; anthologist of humorous verse
Courtesy Library of Congress

DAVID AMES WELLS (*left*)
(1828–1898)
Economist

HENRY WELLS (*right*)
(1805–1878)
Early express operator, organized Wells,
Fargo and Co., and the American Express
Co.
Courtesy Wells Fargo Bank, History Room

HORACE WELLS *(left)*
(1815–1848)
Dentist, pioneer in use of surgical anesthesia
Engraving by Henry B. Hall

BARRETT WENDELL *(right)*
(1855–1921)
Literary scholar, writer, educator

BENNING WENTWORTH *(left)*
(1696–1770)
Governor of Colonial New Hampshire
Painting by Joseph Blackburn

CHARLES WESLEY *(right)*
(1707–1788)
Methodist clergyman, hymn writer; secretary to Governor Oglethorpe of Georgia

JOHN WESLEY *(left)*
(1703–1791)
Founder of Methodism, served as missionary in Georgia

DANIEL BAIRD WESSON *(right)*
(1825–1906)
Firearms developer, manufacturer; partner in Smith & Wesson Co.

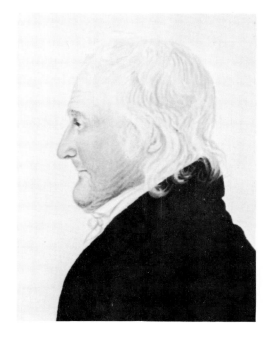

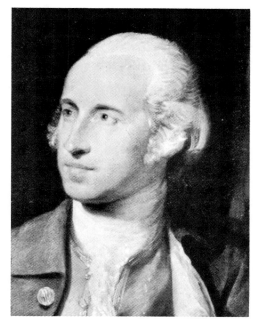

BENJAMIN WEST (*left*)
[Isaac Bickerstaff]
(1730–1813)
Mathematician, astronomer, educator; noted for almanacs
Courtesy Brown University

BENJAMIN WEST (*right*)
(1738–1820)
Painter
Painting by Gilbert Stuart

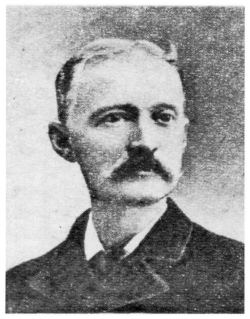

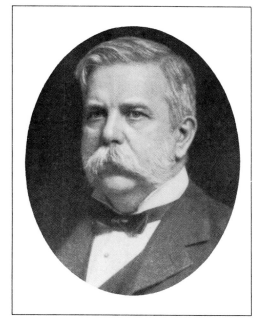

EDWARD NOYES WESTCOTT (*left*)
(1846–1898)
Banker, novelist; wrote *David Harum*

GEORGE WESTINGHOUSE (*right*)
(1846–1914)
Inventor, manufacturer; organized Westinghouse Electric Co.

EDWARD WESTON (*left*)
(1850–1936)
Electrical innovator, manufacturer

EDWARD PAYSON WESTON (*right*)
(1839–1929)
Long-distance walker, hiked from New York to San Francisco in 70 days

FREDERICK WEYERHAEUSER
(*left*)
(1834–1914)
Lumber magnate
Courtesy Weyerhaeuser Company

EDITH WHARTON (*right*)
[nee Edith Newbold Jones]
(1862–1937)
Novelist
Courtesy American Academy of Arts and Letters

JOSEPH WHARTON (*left*)
(1826–1909)
Industrialist; a founder of Swarthmore
College and benefactor of the University of
Pennsylvania

PHILLIS WHEATLEY (*right*)
(*c.* 1753–1784)
Poet, freed slave

HENRY WHEATON (*left*)
(1785–1848)
Lawyer, diplomat, historian of international
law, Supreme Court reporter

DANIEL DENISON WHEDON (*right*)
(1808–1885)
Methodist Episcopal clergyman, editor;
compiled Bible commentaries

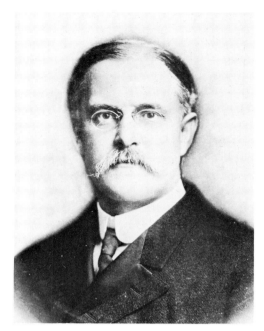

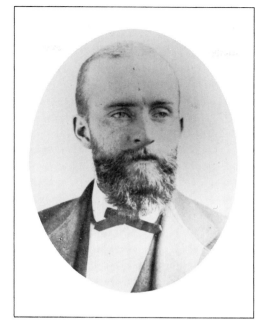

BENJAMIN IDE WHEELER *(left)*
(1854–1927)
Educator, philologist, classical scholar;
president, University of California
Courtesy University of California

GEORGE MONTAGUE WHEELER
(right)
(1842–1905)
Surveyor, supervised topographical map-
ping of the West
*Courtesy Henry L. Abbot Collection, Corps of Engi-
neers Museum*

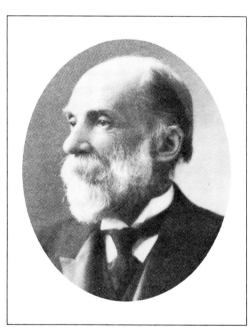

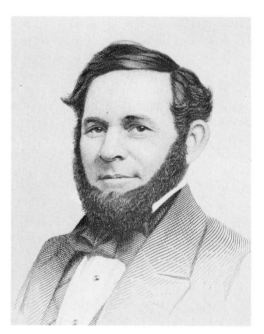

JOSEPH WHEELER *(left)*
(1836–1906)
Confederate general; U.S. Congressman;
general, Spanish-American War

NATHANIEL WHEELER *(right)*
(1820–1893)
Sewing-machine manufacturer
Engraving by W. G. Jackman

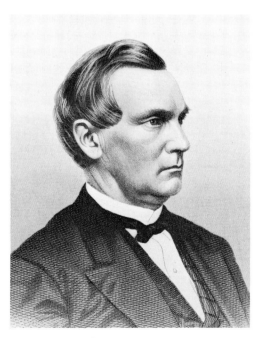

SCHUYLER SKAATS WHEELER
(left)
(1860–1923)
Electrical-equipment manufacturer, inven-
tor

WILLIAM ALMON WHEELER *(right)*
(1819–1887)
Vice-President of U.S., 1877–1881; lawyer,
Congressman
Engraving by George E. Perine

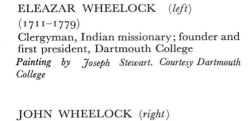

ELEAZAR WHEELOCK (*left*)
(1711–1779)
Clergyman, Indian missionary; founder and first president, Dartmouth College
Painting by Joseph Stewart. Courtesy Dartmouth College

JOHN WHEELOCK (*right*)
(1754–1817)
Second president of Dartmouth College, central figure in *Dartmouth College v. Woodward*
Courtesy Dartmouth College

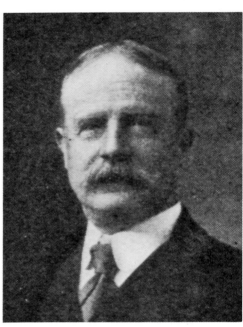

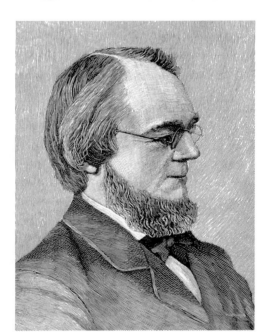

EDMUND MARCH WHEELWRIGHT (*left*)
(1854–1912)
Boston architect

EDWIN PERCY WHIPPLE (*right*)
(1819–1886)
Editor, critic, writer, lecturer

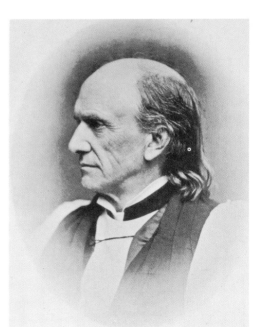

HENRY BENJAMIN WHIPPLE (*left*)
(1822–1901)
Protestant Episcopal bishop, obtained reform in treatment of Indians

SQUIRE WHIPPLE (*right*)
(1804–1888)
Civil engineer, pioneer bridge designer
Courtesy James Kip Finch

WILLIAM WHIPPLE (*left*)
(1730–1785)
Revolutionary patriot, jurist; signer of Declaration of Independence

GEORGE WASHINGTON WHISTLER (*right*)
(1800–1849)
Railroad engineer, father of James Abbott McNeill Whistler
Engraving by W. G. Jackman

JAMES ABBOTT McNEILL WHISTLER (*left*)
(1834–1903)
Painter, etcher
Courtesy Eric Schaal

ANDREW DICKSON WHITE (*right*)
(1832–1918)
Educator, historian, diplomat; co-founder, first president, Cornell University

CANVASS WHITE (*left*)
(1790–1834)
Engineer, helped supervise construction of Erie Canal
Engraving by W. G. Jackman. Courtesy Smithsonian Institution

DAVID WHITE (*right*)
(1862–1935)
Geologist, paleobotanist

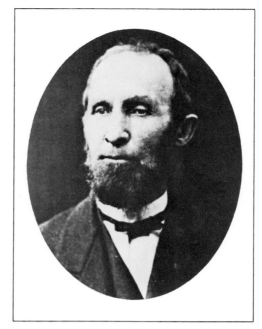

EDWARD DOUGLASS WHITE *(left)*
(1845–1921)
Chief Justice of U.S., 1910–1921; U.S. Senator

ELIJAH WHITE *(right)*
(1806–1879)
Physician, Oregon pioneer
Courtesy Oregon Historical Society

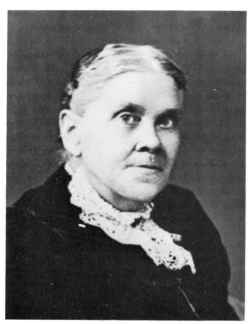

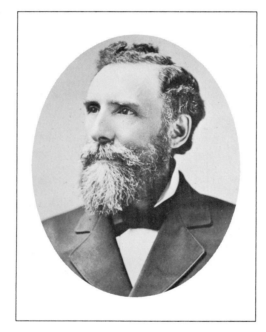

ELLEN WHITE *(left)*
[nee Ellen Gould Harmon]
(1827–1915)
Seventh-Day Adventist leader
Courtesy General Conference of Seventh-Day Adventists

EMERSON ELDRIDGE WHITE *(right)*
[Emerson Eldredge White]
(1829–1902)
Educator, textbook writer; president, Purdue University
Courtesy Purdue University

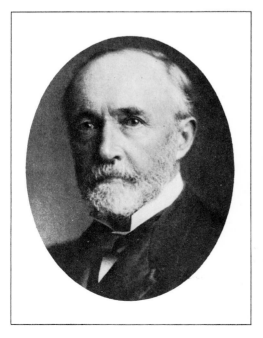

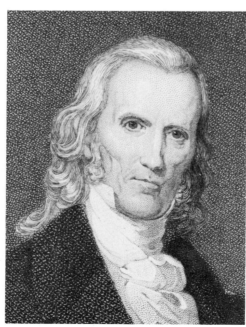

HORACE WHITE *(left)*
(1834–1916)
Journalist, editor, writer on economics

HUGH LAWSON WHITE *(right)*
(1773–1840)
U.S. Senator, lawyer, jurist
Engraved by Thomas B. Welch from a painting by Emanuel Leutze

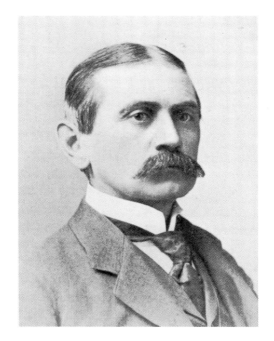

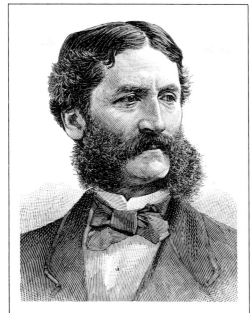

JOHN WILLIAMS WHITE (*left*)
(1849–1917)
Classical scholar, philologist

RICHARD GRANT WHITE (*right*)
(1821–1885)
Journalist, critic, writer, editor

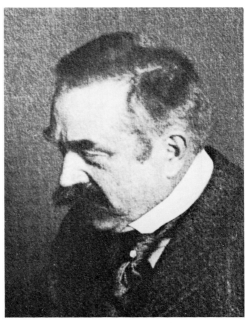

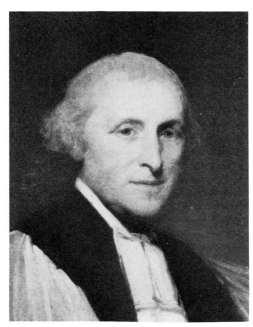

STANFORD WHITE (*left*)
(1853–1906)
Architect, partner in McKim, Mead &
White; murdered by Harry K. Thaw
Courtesy Steinman, Cain & White

WILLIAM WHITE (*right*)
(1748–1836)
Clergyman, leader in organizing Protestant
Episcopal Church in U.S.
Painting by Gilbert Stuart

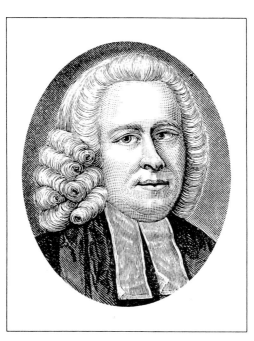

WILLIAM ALLEN WHITE (*left*)
(1868–1944)
Kansas newspaper editor, proprietor of
Emporia Gazette; reformer, writer

GEORGE WHITEFIELD (*right*)
(1714–1770)
English Methodist evangelist, toured U.S.
seven times

BRAND WHITLOCK (*left*)
(1869–1934)
Diplomat, lawyer, writer
Painting by Franz Van Holder

CHARLES OTIS WHITMAN (*right*)
(1842–1910)
Zoologist
Courtesy University of Chicago

HELEN WHITMAN (*left*)
[nee Sarah Helen Power]
(1803–1878)
Poet, essayist, fiancée of Edgar Allan Poe

MALCOLM DOUGLASS WHITMAN
(*right*)
(1877–1932)
Tennis champion, member of first U.S.
Davis Cup team

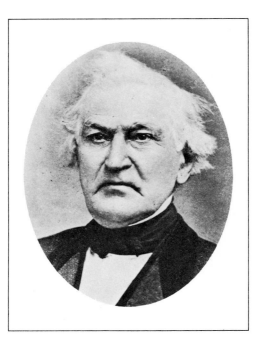

WALT WHITMAN (*left*)
[Walter Whitman]
(1819–1892)
Poet
Courtesy Library of Congress, Brady-Handy Collection

DAVID WHITMER (*right*)
(1805–1888)
Early Mormon leader
Courtesy Library of Congress

AMOS WHITNEY *(left)*
(1832–1920)
Tool and gun manufacturer; co-founder,
Pratt & Whitney

ELI WHITNEY *(right)*
(1765–1825)
Inventor of the cotton gin; pioneer firearms
manufacturer
*Engraved by D. C. Hinman from a painting by
Charles B. King*

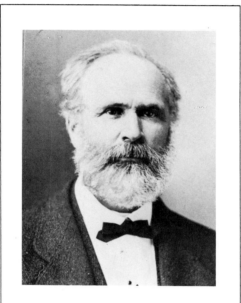

HARRY PAYNE WHITNEY *(left)*
(1872–1930)
Financier, sportsman

JOSIAH DWIGHT WHITNEY *(right)*
(1819–1896)
Geologist, mineralogist, educator
Courtesy Smithsonian Institution

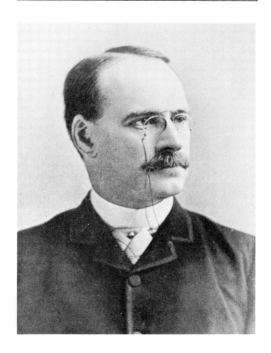

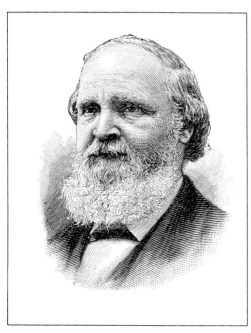

WILLIAM COLLINS WHITNEY
(left)
(1841–1904)
Financier, lawyer, sportsman; Secretary of
the Navy under Cleveland

WILLIAM DWIGHT WHITNEY
(right)
(1827–1894)
Philologist, Sanskrit scholar, Orientalist,
educator

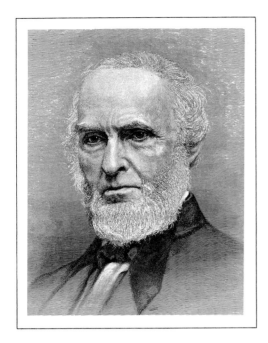

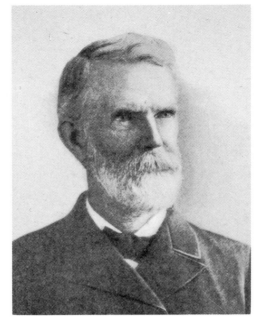

JOHN GREENLEAF WHITTIER
(*left*)
(1807–1892)
Poet

JAMES PYLE WICKERSHAM (*right*)
(1825–1891)
Educator, a founder and president of
National Education Association

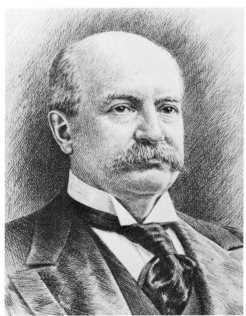

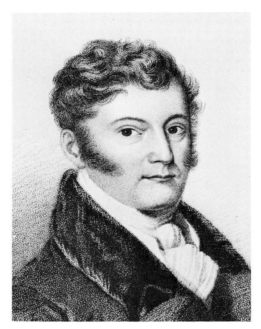

PETER ARRELL BROWN
WIDENER (*left*)
(1834–1915)
Street-transportation magnate, art collector,
philanthropist

PRINCE MAXIMILIAN ZU WIED
(*right*)
(1782–1867)
German naturalist; wrote of travels in U.S.

KATE DOUGLAS WIGGIN (*left*)
[nee Kate Douglas Smith]
(1856–1923)
Writer, leader in kindergarten movement;
wrote *Rebecca of Sunnybrook Farm*

EDWARD WIGGLESWORTH (*right*)
(*c.* 1693–1765)
Theologian, educator, clergyman

ELLA WHEELER WILCOX (*left*)
[nee Ella Wheeler]
(1850–1919)
Journalist, poet

STEPHEN WILCOX (*right*)
(1830–1893)
Boiler inventor, manufacturer
Courtesy James Kip Finch

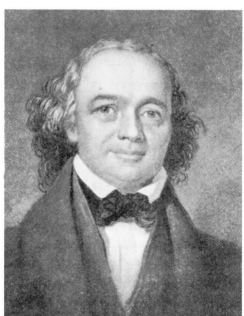

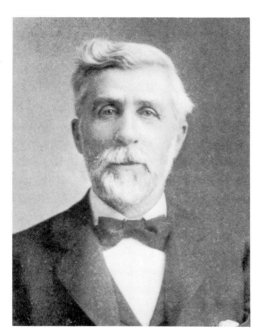

RICHARD HENRY WILDE (*left*)
(1789–1847)
Lawyer, Congressman, Italian scholar, poet
Engraving by Sartain

BURT GREEN WILDER (*right*)
(1841–1925)
Zoologist, educator

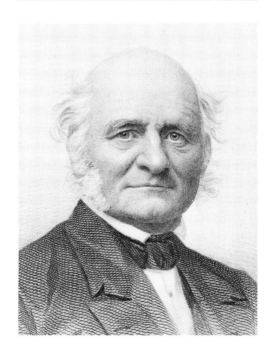

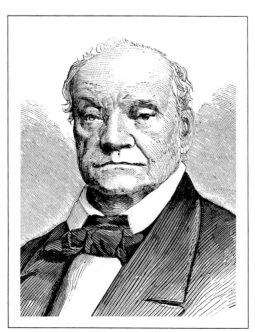

MARSHALL PINCKNEY WILDER
(*left*)
(1798–1886)
Merchant, horticulturist, developed Wilder
Rose
Engraving by H. W. Smith

THOMAS WILDEY (*right*)
(1783–1865)
Founder of first Odd Fellows Lodge in
America

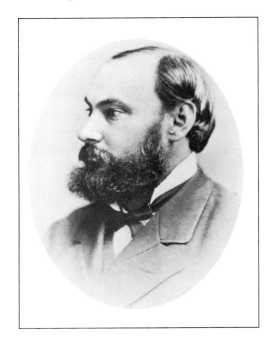

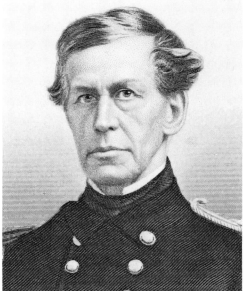

HARVEY WASHINGTON WILEY
(*left*)
(1844–1930)
Chemist, educator; influenced enactment of
Pure Food and Drug Act
Courtesy Purdue University

CHARLES WILKES (*right*)
(1798–1877)
Naval officer, explored Antarctic; captured
Confederate commissioners Slidell and
Mason from the *Trent* during Civil War
Engraving by Alexander H. Ritchie

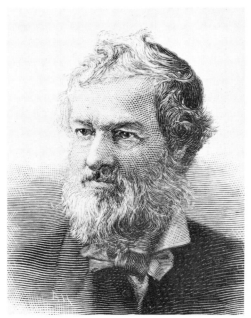

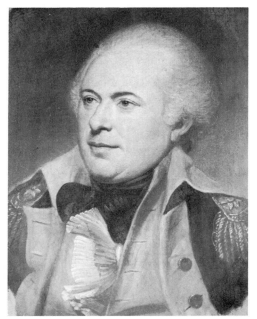

SAMUEL WILKESON (*left*)
(1817–1889)
Journalist, reported battle of Gettysburg for
The New York Times
After a photograph by Napoleon Sarony

JAMES WILKINSON (*right*)
(1757–1825)
Revolutionary general, Governor of Louisi-
ana Territory; involved in Burr conspiracy
*Painting by Charles Willson Peale. Courtesy Inde-
pendence National Historical Park*

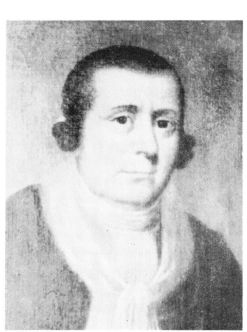

JEMIMA WILKINSON (*left*)
(1752–1819)
Religious zealot

JOHN WILKINSON (*right*)
(1821–1891)
Confederate naval officer
Courtesy U.S. Navy Department

EMMA WILLARD (*left*)
[nee Emma Hart]
(1787–1870)
Pioneer in women's education; writer
Engraving by John Sartain

FRANCES ELIZABETH CAROLINE
WILLARD (*right*)
(1839–1898)
Temperance leader, writer; president of
Woman's Christian Temperance Union
Engraving by H. B. Hall's Sons

SIMON WILLARD (*left*)
(1753–1848)
Clock innovator, manufacturer

BERT WILLIAMS (*right*)
[Egbert Austin Williams]
(*c.* 1876–1922)
Comedian, song writer, starred in Ziegfeld
Follies

ELEAZAR WILLIAMS (*left*)
(*c.* 1789–1858)
Missionary among Indians; claimed to be
Dauphin of France
*Engraved by J. C. Buttre from a painting by Joseph
Fagnani*

HENRY SHALER WILLIAMS (*right*)
(1847–1918)
Paleontologist, educator
Courtesy Cornell University

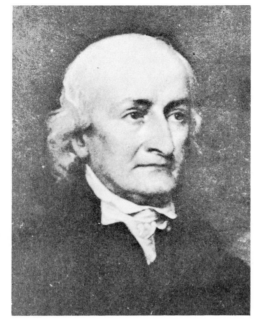

WILLIAM WILLIAMS (*left*)
(1731–1811)
Signer of Declaration of Independence

HUGH WILLIAMSON (*right*)
(1735–1819)
Revolutionary patriot, scientist; member of
Continental Congress, signer of the Constitu-
tion; Congressman
Painting by John Trumbull

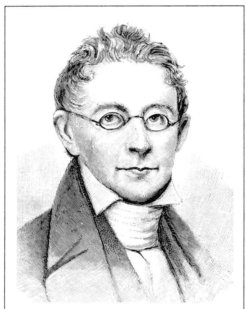

THOMAS WILLING (*left*)
(1731–1821)
Philadelphia banker, civic leader, jurist;
first president, Bank of North America and
Bank of the United States
Painting by Gilbert Stuart

NATHANIEL WILLIS (*right*)
(1780–1870)
Journalist, editor; founded *Youth's Com-
panion*

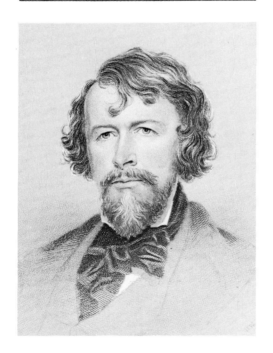

NATHANIEL PARKER WILLIS
(*left*)
(1806–1867)
Journalist, editor, writer, poet
*Engraved by H. W. Smith from a painting by Charles
Loring Elliott*

SAMUEL WENDELL WILLISTON
(*right*)
(1852–1918)
Paleontologist, geologist, educator

JOHN NORTH WILLYS *(left)*
(1873–1935)
Automobile manufacturer, diplomat
Courtesy Automobile Manufacturers Association, Inc.

DAVID WILMOT *(right)*
(1814–1868)
U.S. Senator, Congressman, jurist; author
of Wilmot Proviso

ALEXANDER WILSON *(left)*
(1766–1813)
Ornithologist
Engraved by David Edwin from a painting by Rembrandt Peale

ALLEN BENJAMIN WILSON *(right)*
(1824–1888)
Sewing-machine inventor, manufacturer
Courtesy Clarence P. Hornung Collection

EDMUND BEECHER WILSON *(left)*
(1856–1939)
Biologist, embryologist, educator
Courtesy New York Academy of Medicine

FRANCIS WILSON *(right)*
(1854–1935)
Musical-comedy actor, writer

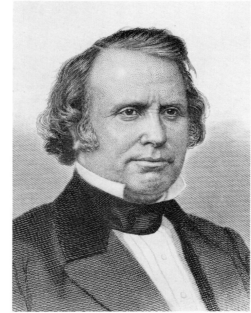

HALSEY WILLIAM WILSON (*left*)
(1868–1954)
Reference-book publisher
Courtesy H. W. Wilson Co.

HENRY WILSON (*right*)
[Jeremiah Jones Colbath]
(1812–1875)
Abolitionist politician, U.S. Senator; Vice-
President of U.S., 1873–1875
Engraving by Alexander H. Ritchie

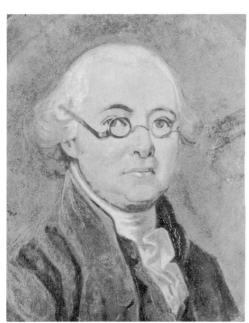

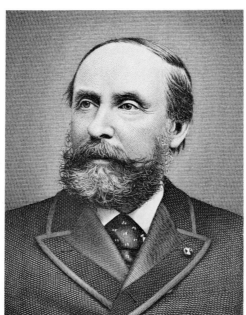

JAMES WILSON (*left*)
(1742–1798)
Lawyer, pamphleteer, jurist; signer of
Declaration of Independence and Constitu-
tion; associate justice, U.S. Supreme Court
*Painted by Philip F. Wharton from a painting attrib-
uted to James Peale. Courtesy Independence National
Historical Park*

JAMES GRANT WILSON (*right*)
(1832–1914)
Biographer, critic, editor, publisher
Engraving by E. G. Williams & Bro.

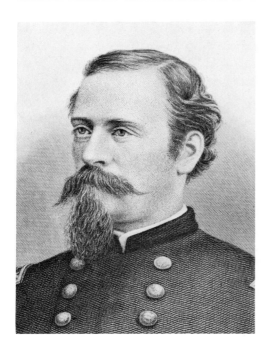

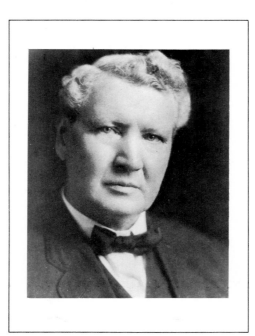

JAMES HARRISON WILSON (*left*)
(1837–1925)
Union general in Civil War; general,
Spanish-American War; engineer

WILLIAM BAUCHOP WILSON
(*right*)
(1862–1934)
Labor leader, Congressman; first Secretary
of Labor (under Wilson)
Courtesy U.S. Department of Labor

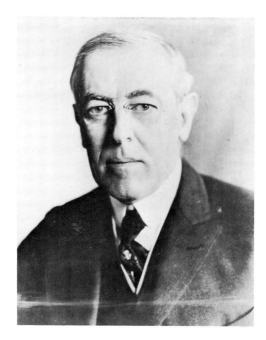

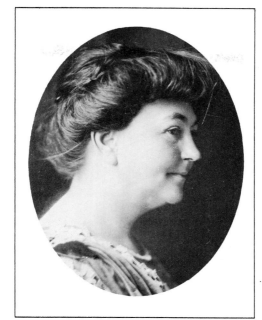

WOODROW WILSON (*left*)
[Thomas Woodrow Wilson]
(1856–1924)
President of the United States, 1913–1921
Courtesy New-York Historical Society

Mrs. WOODROW WILSON (*right*)
[nee Ellen Louise Axson]
(1860–1914)
First lady, 1913–1914
Courtesy Library of Congress

Mrs. WOODROW WILSON (*left*)
[Mrs. Edith Bolling Galt; nee Edith Bolling]
(1872–1961)
First lady, 1915–1921
Photograph by Arnold Genthe. Courtesy Princeton University Library

ALEXANDER WINCHELL (*right*)
(1824–1891)
Geologist, paleontologist, educator

NEWTON HORACE WINCHELL
(*left*)
(1839–1914)
Geologist, archaeologist; founded *American Geologist*
Courtesy University of Minnesota

OLIVER FISHER WINCHESTER
(*right*)
(1810–1880)
Arms manufacturer, developed repeating rifle

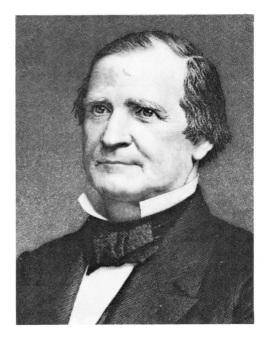

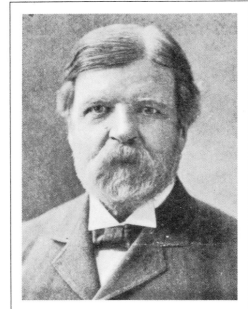

ENOCH COBB WINES (*left*)
(1806–1879)
Prison reformer, educator
Engraving by John Sartain. Courtesy Presbyterian Historical Society

FREDERICK HOWARD WINES (*right*)
(1838–1912)
Pioneer in prison reform and public health administration

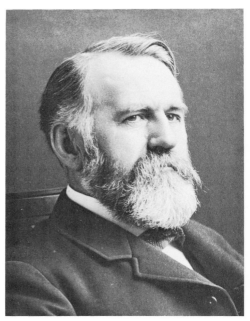

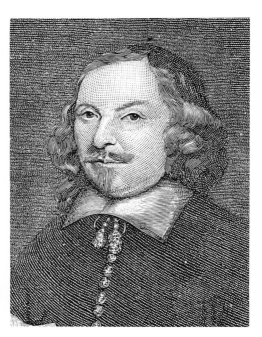

JOSEPH WINLOCK (*left*)
(1826–1875)
Astronomer, mathematician
Courtesy Harvard University

EDWARD WINSLOW (*right*)
(1595–1655)
Mayflower Pilgrim; a founder and governor of Plymouth Colony

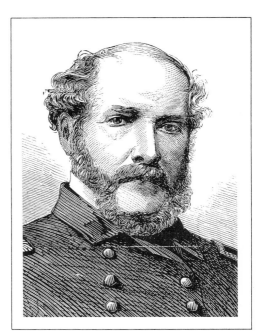

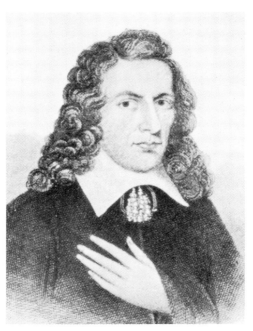

JOHN ANCRUM WINSLOW (*left*)
(1811–1873)
Union naval officer in Civil War; sank the Confederate raider *Alabama*

JOSIAH WINSLOW (*right*)
(c. 1629–1680)
Governor of Plymouth Colony

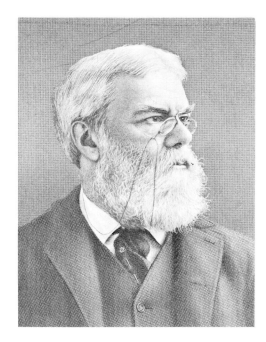

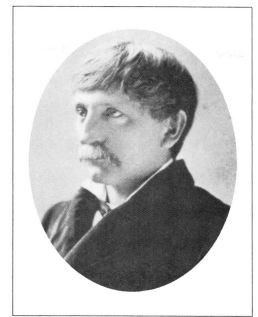

JUSTIN WINSOR (*left*)
(1831–1897)
Librarian, historian
Engraving by J. A. J. Wilcox

WILLIAM WINTER (*right*)
(1836–1917)
Drama critic, biographer, essayist, poet

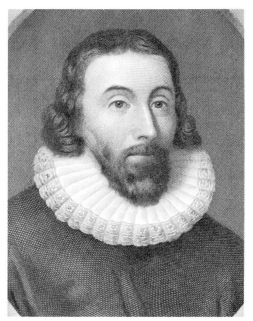

JOHN WINTHROP (*left*)
(1588–1649)
First governor of Massachusetts Bay Colony
Engraved by Frederick Girsch from a painting attributed to Van Dyck

JOHN WINTHROP (*right*)
(1606–1676)
Governor of Connecticut Colony

JOHN WINTHROP (*left*)
(1714–1779)
Astronomer, physicist, mathematician, educator
Painting by John Singleton Copley

THEODORE WINTHROP (*right*)
(1828–1861)
Novelist

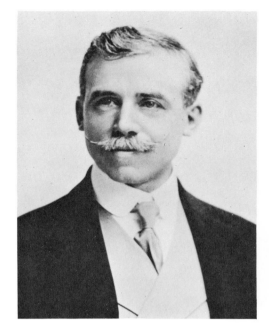
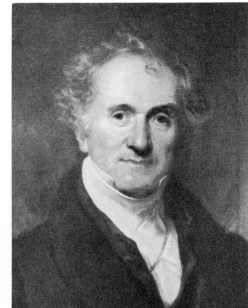

ALEXANDER WINTON *(left)*
(1860–1932)
Pioneer automobile designer, manufacturer
Courtesy Automobile Manufacturers Association, Inc.

WILLIAM WIRT *(right)*
(1772–1834)
Lawyer, Attorney General under Monroe
and John Quincy Adams
Painting by Henry Inman

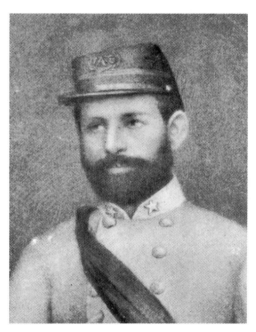
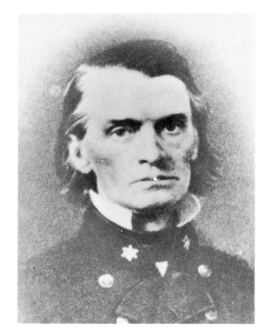

HENRY WIRZ *(left)*
(1822–1865)
Confederate officer, commandant of Andersonville Prison

HENRY ALEXANDER WISE *(right)*
(1806–1876)
Congressman, diplomat, Governor of Virginia; Confederate general
Courtesy New-York Historical Society

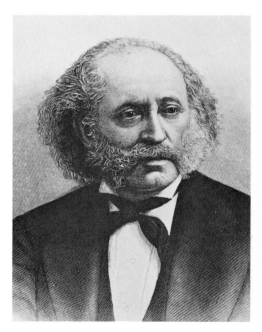
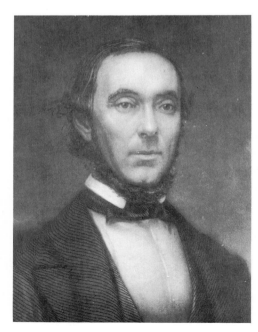

ISAAC MAYER WISE *(left)*
[Isaac Mayer Weis]
(1819–1900)
Rabbi, editor; a founder and first president,
Hebrew Union College

JOHN WISE *(right)*
(1808–1879)
Pioneer balloonist; traveled 804 miles during
one ascent
Engraving by Thomas B. Welch

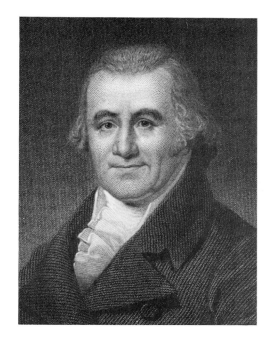

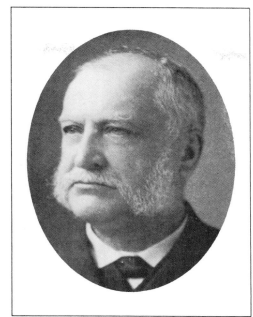

CASPAR WISTAR (*left*)
(1761–1818)
Physician, educator; wrote first American textbook on anatomy
Engraved by W. G. Jackman from a painting by Samuel B. Waugh

ISAAC JONES WISTAR (*right*)
(1827–1905)
Penologist; founded Wistar Institute of Anatomy and Biology

OWEN WISTER (*left*)
(1860–1938)
Novelist; wrote *The Virginian*

FREDERICK CLARKE WITHERS (*right*)
(1828–1901)
Architect; designed Jefferson Market Court House, New York City

JOHN WITHERSPOON (*left*)
(1723–1794)
Presbyterian clergyman, theologian; president, College of New Jersey (Princeton); signer of Declaration of Independence
Painting by Charles Willson Peale. Courtesy Independence National Historical Park

OLIVER WOLCOTT (*right*)
(1726–1797)
Revolutionary general, signer of Declaration of Independence; Governor of Connecticut
Painting by Ralph Earle. Courtesy Connecticut State Library

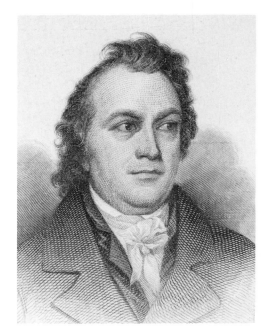

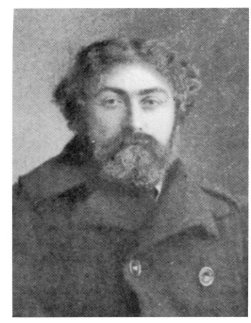

OLIVER WOLCOTT (*left*)
(1760–1833)
Governor of Connecticut, Secretary of the Treasury under Washington and John Adams
Engraved by Joseph Andrews and W. H. Tappan from a painting by John Trumbull

CHARLES ERSKINE SCOTT WOOD (*right*)
(1852–1944)
Writer, author of *Heavenly Discourse*

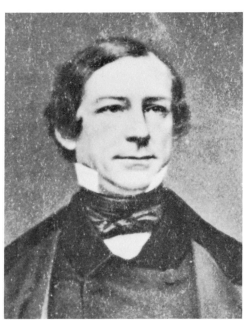

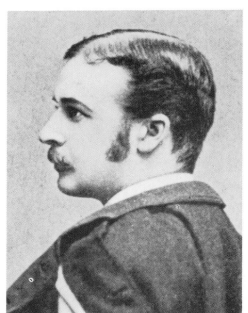

FERNANDO WOOD (*left*)
(1812–1881)
Tammany Hall leader, Congressman, mayor of New York
Courtesy New-York Historical Society

HALSEY WOOD (*right*)
[William Halsey Wood]
(1855–1897)
Architect

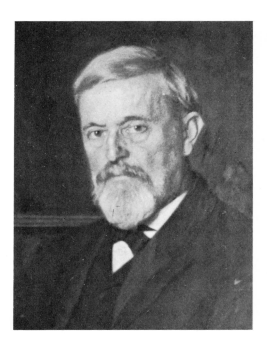

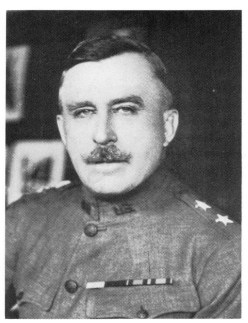

HORATIO CHARLES WOOD (*left*)
(1841–1920)
Physician, botanist, educator
Painting by J. L. Wood. Courtesy University of Pennsylvania

LEONARD WOOD (*right*)
(1860–1927)
Physician, general; military governor of Cuba; governor general of Philippines

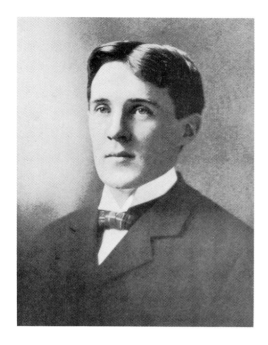

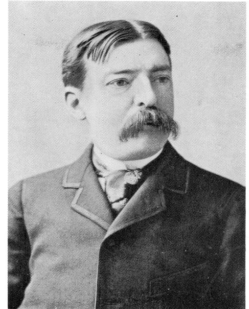

ROBERT WILLIAMS WOOD *(left)*
(1868–1955)
Physicist, educator, writer

GEORGE EDWARD WOODBERRY
(right)
(1855–1930)
Essayist, literary critic, editor, poet, educator

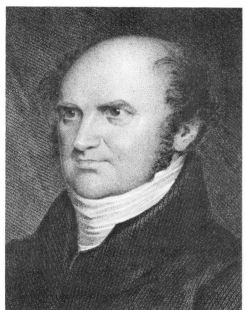

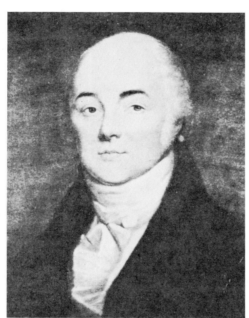

LEVI WOODBURY *(left)*
(1789–1851)
U.S. Senator, Secretary of the Navy under Jackson, Secretary of the Treasury under Jackson and Van Buren; associate justice, U.S. Supreme Court
Engraving by J. B. Longacre

JAMES WOODHOUSE *(right)*
(1770–1809)
Chemist, physician; pioneer in plant chemistry
Courtesy University of Pennsylvania

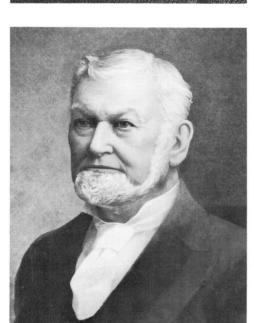

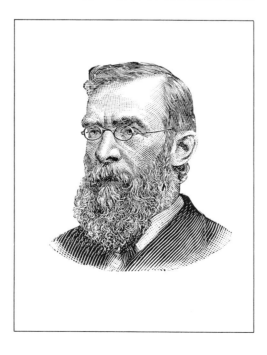

WILFORD WOODRUFF *(left)*
(1807–1898)
Mormon leader
Courtesy Church of Jesus Christ of Latter-Day Saints

CALVIN MILTON WOODWARD
(right)
(1837–1914)
Educator, leader in manual-training high-school movement

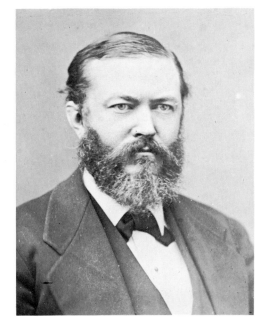

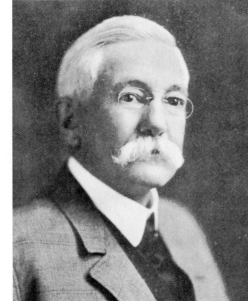

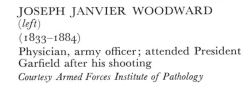

JOSEPH JANVIER WOODWARD
(*left*)
(1833–1884)
Physician, army officer; attended President
Garfield after his shooting
Courtesy Armed Forces Institute of Pathology

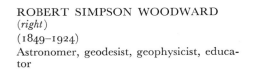

ROBERT SIMPSON WOODWARD
(*right*)
(1849–1924)
Astronomer, geodesist, geophysicist, educator

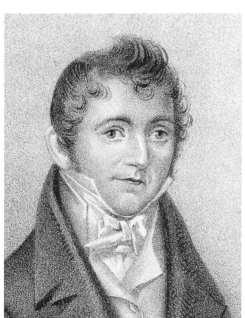

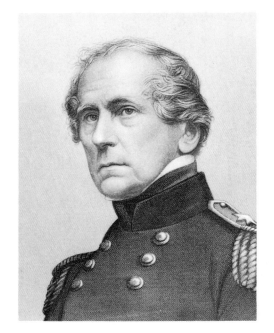

SAMUEL WOODWORTH (*left*)
(1784–1842)
Journalist, playwright, poet; wrote "The
Old Oaken Bucket"

JOHN ELLIS WOOL (*right*)
(1784–1869)
Mexican War general, Union general in
Civil War
*Engraved by J. C. Buttre from a photograph by
Mathew Brady*

JOHN WOOLMAN (*left*)
(1720–1772)
Itinerant Quaker minister, abolitionist,
known for his *Journal*
Drawing by Robert Smith

THEODORE DWIGHT WOOLSEY
(*right*)
(1801–1889)
Classical scholar, writer, editor; president of
Yale College
Painting by John Sartain. Courtesy Burndy Library

CONSTANCE FENIMORE WOOLSON
(*left*)
(1840–1894)
Novelist

FRANK WINFIELD WOOLWORTH
(*right*)
(1852–1919)
Merchant, founded chain of five-and-ten-cent stores

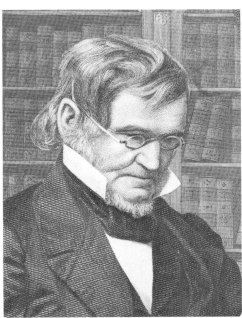

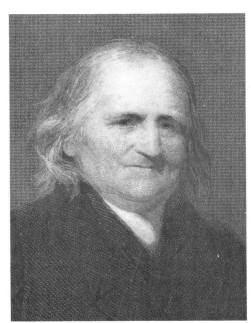

JOSEPH EMERSON WORCESTER
(*left*)
(1784–1865)
Lexicographer, rival of Noah Webster in "The War of the Dictionaries"
Engraving by George E. Perine

NOAH WORCESTER (*right*)
(1758–1837)
Clergyman, editor, pacifist
Engraved by Frederick Halpin from a painting by Francis Alexander

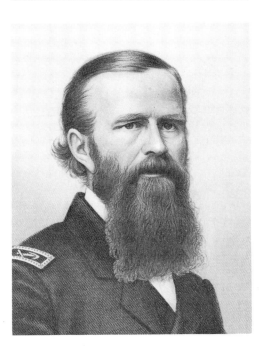

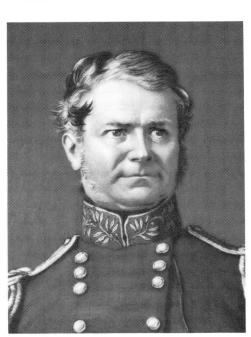

JOHN LORIMER WORDEN (*left*)
(1818–1897)
Union naval officer, commanded the *Monitor* against the *Merrimac*
Engraving by J. C. Buttre

WILLIAM JENKINS WORTH (*right*)
(1794–1849)
Army officer in War of 1812 and Mexican War
Engraving by John Sartain

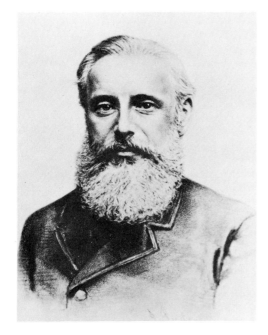

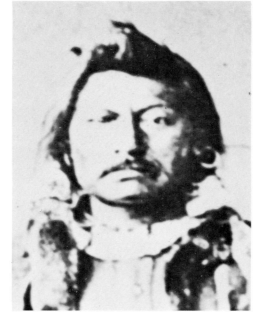

HENRY ROSSITER WORTHINGTON
(*left*)
(1817–1880)
Hydraulic engineer, manufacturer; invented direct steam pump
Courtesy James Kip Finch

WOVOKA (*right*)
[Jack Wilson]
(c. 1856–1932)
Paiute Indian prophet
Courtesy Mercaldo Archives

Baron FERDINAND PETROVICH
von WRANGEL (*left*)
[Baron Ferdinand von Wrangell]
(1794–1870)
Russian governor of Alaska; opposed sale of Alaska to U.S.

ARTHUR WILLIAMS WRIGHT
(*right*)
(1836–1915)
Physicist

BENJAMIN WRIGHT (*left*)
(1770–1842)
Pioneer civil engineer, supervised construction of major part of Erie Canal
Courtesy James Kip Finch

CARROLL DAVIDSON WRIGHT
(*right*)
(1840–1909)
Statistician, educator; first commissioner, U.S. Bureau of Labor

CHAUNCEY WRIGHT (*left*)
(1830–1875)
Philosopher

ELIZUR WRIGHT (*right*)
(1804–1885)
Insurance reformer, actuary, abolitionist
Courtesy Professor Quincy Wright

FRANCES WRIGHT (*left*)
[Fanny Wright]
(1795–1852)
Social reformer
Engraving by J. C. Buttre

FRANK LLOYD WRIGHT (*right*)
(1869–1959)
Architect

GEORGE WRIGHT (*left*)
(1847–1937)
Baseball infielder, sporting-goods manufacturer
Courtesy National Baseball Hall of Fame

GEORGE FREDERICK WRIGHT
(*right*)
(1838–1921)
Geologist, Congregational clergyman

HARRY WRIGHT (*left*)
(1835–1895)
Organizer and manager of first all-professional baseball club
Courtesy National Baseball Hall of Fame

HORATIO GOUVERNEUR WRIGHT
(*right*)
(1820–1899)
Union general in Civil War; military engineer

JOSEPH WRIGHT (*left*)
(1756–1793)
Portrait painter
Courtesy New-York Historical Society

MABEL WRIGHT (*right*)
[nee Mabel Osgood]
(1859–1934)
Writer of nature books

ORVILLE WRIGHT (*left*)
(1871–1948)
Aviation pioneer
Courtesy Meserve Collection

SILAS WRIGHT (*right*)
(1795–1847)
Lawyer, Congressman, U.S. Senator, Governor of New York
Courtesy National Archives, Brady Collection

WILBUR WRIGHT (*left*)
(1867–1912)
Aviation pioneer
Courtesy Meserve Collection

WILLIAM WRIGLEY, Jr. (*right*)
(1861–1932)
Chewing-gum manufacturer
Courtesy William Wrigley Jr. Company

ALEXANDER HELWIG WYANT
(*left*)
(1836–1892)
Landscape painter

JOHN ALLAN WYETH (*right*)
(1845–1922)
Surgeon, pioneer in medical education

JEFFRIES WYMAN (*left*)
(1814–1874)
Anatomist, physician; first curator, Peabody
Museum, Harvard University
Courtesy Harvard University Archives

GEORGE WYTHE (*right*)
(1726–1806)
Jurist, lawyer, educator; signer of Declara-
tion of Independence
Engraving by James B. Longacre

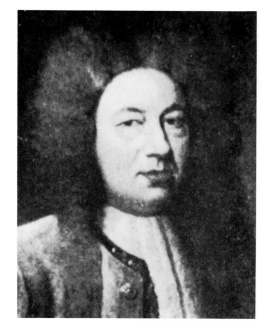

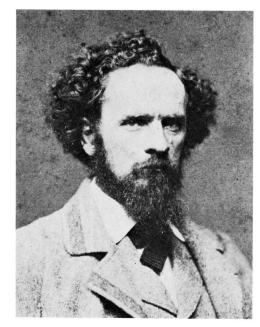

ELIHU YALE *(left)*
(1649–1721)
English official of East India Company;
benefactor of Yale University
Courtesy Yale University

LINUS YALE *(right)*
(1821–1868)
Lock inventor, manufacturer
Courtesy Library of Congress

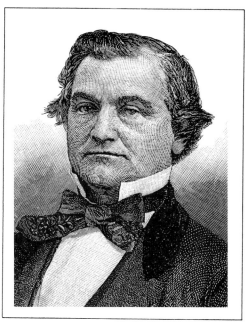

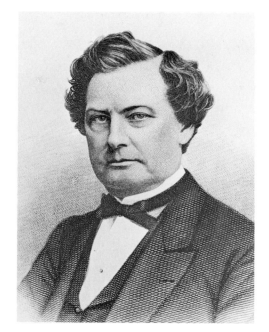

WILLIAM LOWNDES YANCEY
(left)
(1814–1863)
Congressman, secessionist leader; Con-
federate diplomat

RICHARD YATES *(right)*
(1815–1873)
Civil War Governor of Illinois; U.S. Sena-
tor, Congressman
Courtesy Chicago Historical Society

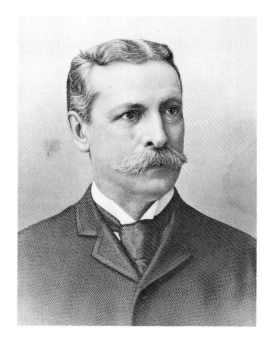

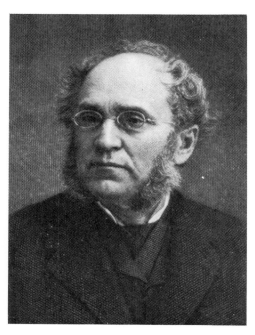

CHARLES TYSON YERKES *(left)*
(1837–1905)
Financier, Chicago transit magnate; donat-
ed Yerkes Observatory
Engraving by J. K. Campbell

EDWARD LIVINGSTON YOUMANS
(right)
(1821–1887)
Scientific writer, editor; founded *Popular
Science Monthly*

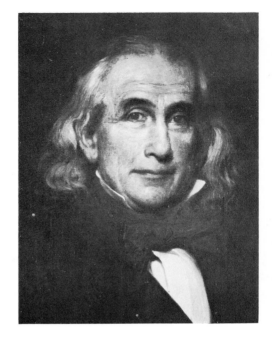

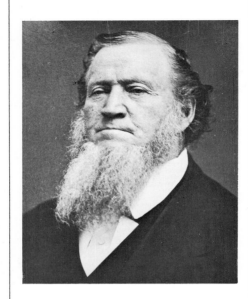

AMMI BURNHAM YOUNG (*left*)
(1798–1874)
Architect
Courtesy American Institute of Architects

BRIGHAM YOUNG (*right*)
(1801–1877)
Mormon leader, established the Mormon
Church in Utah
Courtesy Church of Jesus Christ of Latter-Day Saints

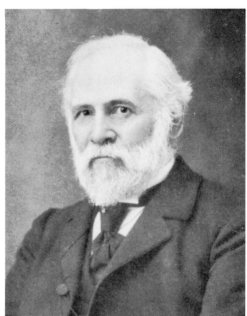

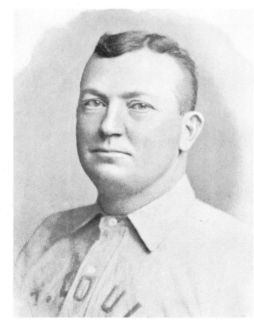

CHARLES AUGUSTUS YOUNG
(*left*)
(1834–1908)
Astronomer, educator

CY YOUNG (*right*)
[Denton True Young]
(1867–1955)
Baseball pitcher, member of Baseball Hall
of Fame
Courtesy National Baseball Hall of Fame

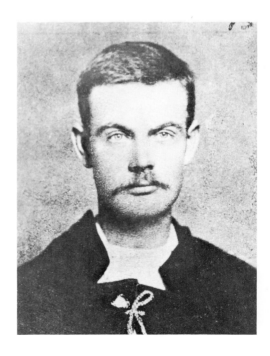

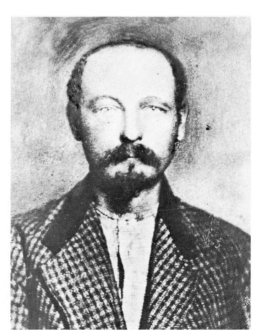

BOB YOUNGER (*left*)
[Robert Ewing Younger]
(*d.* 1889)
Western outlaw
Courtesy Mercaldo Archives

COLE YOUNGER (*right*)
[Thomas Coleman Younger]
(1844–1916)
Western outlaw, leader of the Younger
brothers
Courtesy Mercaldo Archives

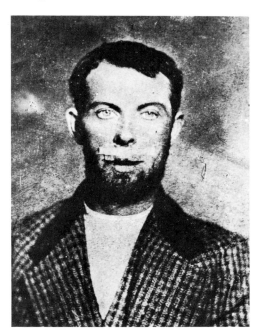

JIM YOUNGER
[James Henry Younger]
(1848–1902)
Western outlaw
Courtesy Mercaldo Archives

FANNIE BLOOMFIELD ZEISLER
(*left*)
[nee Fannie Blumenfeld]
(1863–1927)
Pianist

FLORENZ ZIEGFELD (*right*)
(1869–1932)
Theatrical producer
Courtesy Museum of the City of New York

NIKOLAUS LUDWIG, Count von
ZINZENDORF
(1700–1760)
German Moravian clergyman, established
congregations in Pennsylvania

SUPPLEMENT

STEPHEN ALEXANDER (*left*)
(1806–1883)
Astronomer, educator; original member, National Academy of Sciences

ELMER APPERSON (*right*)
(1861–1920)
Pioneer automobile manufacturer

STEPHEN MOULTON BABCOCK
(*left*)
(1843–1931)
Agricultural chemist, developed test for determining fat content of milk

BERNARD MANNES BARUCH (*right*)
(1870–1965)
Financier, adviser to U.S. Presidents

THOMAS BULFINCH (*left*)
(1796–1867)
Writer; author of popular mythologies
Courtesy Thomas Bulfinch

HERMON CAREY BUMPUS (*right*)
(1862–1943)
Biologist, educator; director, American Museum of Natural History; president, Tufts College
Courtesy Tufts University

WILLIAM THOMAS COUNCILMAN (*left*)
(1854–1933)
Pathologist, educator

THEODORE DREISER (*right*)
(1871–1945)
Novelist

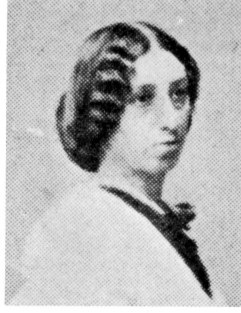

WILLIAM BRANCH GILES (*left*)
(1762–1830)
Lawyer, Congressman, U.S. Senator, Governor of Virginia
Painting by Gilbert Stuart

LUCRETIA PEABODY HALE (*right*)
(1820–1900)
Writer, author of *The Peterkin Papers*
Courtesy Smith College Archives

HERMAN HOLLERITH (*left*)
(1860–1929)
Tabulating-machine inventor; a founder of IBM
Courtesy Herman Hollerith, Jr.

WILLIAM BUTLER HORNBLOWER
(*right*)
(1851–1914)
Lawyer

MORRIS KETCHUM JESUP (*left*)
(1830–1908)
Financier, philanthropist; benefactor of American Museum of Natural History

ALEXANDER BRYAN JOHNSON
(*right*)
(1786–1867)
Semanticist, philosopher, economist

JOHN MACLEAN (*left*)
(1800–1886)
Educator, mathematician, classicist; president, College of New Jersey (Princeton)
Courtesy Princeton University Archives

CHARLES HILL MORGAN (*right*)
(1831–1911)
Engineer, inventor, pioneer in paper-bag and wire manufacturing
Engraving by Alexander H. Ritchie

MORRIS HICKY MORGAN (*left*)
(1859–1910)
Classicist, educator

ALBERT NICKERSON MURRAY
(*right*)
(1873–1966)
Printing executive

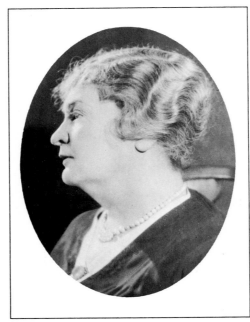

ANTON RUBINSTEIN (*left*)
(1829–1894)
Russian pianist, composer; toured U.S.

ANNE SULLIVAN (*right*)
[Mrs. Anne Mansfield Macy]
(1866–1936)
Educator of the blind; teacher and friend of
Helen Keller
Courtesy American Foundation for the Blind, Inc.

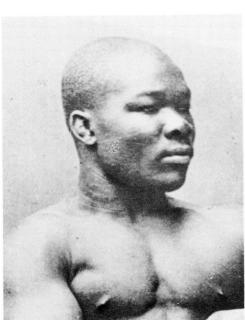

JOE WALCOTT
(1872–1935)
Welterweight boxing champion

PERSONS NOT INCLUDED

The following list includes notable persons the editors wished to include in this book. In each case, however, research failed to produce either an available portrait or an authentic one.

Ethan Allen (1738–1789)
Johnny Appleseed [John Chapman] (c. 1775–1845)
Crispus Attucks (c. 1723–1770)
Hackaliah Bailey (1775–1845)
Vasco Núñez de Balboa (1475–1517)
Anthony Benezet (1713–1784)
James A. Bland (1854–1911)
Mary Elizabeth Bliss (d. 1909)
James Bogardus (1800–1874)
George Phillips Bond (1825–1865)
Zabdiel Boylston (1679–1766)
William Bradford (c. 1590–1657)
William Bradford (1663–1752)
Anne Bradstreet (c. 1612–1672)
Carter Braxton (1736–1797)
Jacob Broom (fl. 1787)
Joseph Brown (1733–1785)
Nicholas Brown (1729–1791)
David Bushnell (c. 1747–1824)
William Byrd (1652–1704)
Juan Rodríguez Cabrillo (d. 1543)
Antoine de la Mothe, Sieur Cadillac (c. 1656–1730)
Mark Catesby (c. 1679–1749)
Ezekiel Cheever (c. 1615–1708)
John Clayton (c. 1685–1773)
Cochise (fl. 1861–1871)
Francisco Vásquez de Coronado (1510–1554)
Crazy Horse (c. 1849–1877)
Alexander Jackson Davis (1803–1892)
Benjamin Day (1838–1916)
Stephen Day (c. 1594–1668)
Henry Deringer (1786–1868)
Hernando de Soto (c. 1500–1542)
Jeremiah Dixon (fl. 1763–1767)
Daniel Greysolon, Sieur Duluth (1636–1710)
Henry Dunster (c. 1609–1659)
George Henry Evans (1805–1856)
Thomas Fitzsimons (fl. 1787)
George Fox (1624–1691)
Simon Girty (1741–1818)
Thomas Godfrey (1736–1763)
Sir Ferdinando Gorges (c. 1566–1647)
Button Gwinnett (c. 1735–1777)
George Hackenschmidt (b. 1878)
Nathan Hale (1755–1776)

Isaac Hollister Hall (1837–1896)
John Wesley Hardin (1853–1895)
John Harvard (1607–1638)
Louis Hennepin (c. 1640–c. 1701)
John Hesselius (1728–1778)
Robert Hoe (1784–1833)
Thomas Hooker (c. 1586–1647)
Henry Hudson (d. 1611)
Joshua Humphreys (1751–1838)
Anne Hutchinson (1591–1643)
Mrs. Thomas Jefferson (1748–1782)
Louis Jolliet (1645–1700)
Kapiolani (d. 1841)
Eusebio Francisco Kino (c. 1645–1711)
Sarah Kemble Knight (1666–1727)
Jean Lafitte (c. 1780–c. 1826)
Jacques Laramie (d. 1821)
Pierre Gaultier de Varennes, Sieur de La Vérendrye (1685–1749)
Ann Lee (1736–1784)
Jesse Lee (1758–1816)
Nancy Hanks Lincoln (d. 1818)
Eliza Lucas (1722–1793)
James Mackay (c. 1759–1822)
Francis Makemie (c. 1658–1708)
Jacques Marquette [Père Marquette] (1637–1675)
Charles Mason (1730–1787)
Massasoit (d. 1661)
John Melish (1771–1822)
Christian Metz (1794–1867)
André Michaux (1746–1802)
John Mitchell (d. 1768)
Samuel A. Mitchell (1792–1868)
John Moody (1868–1958)
Luis de Moscoso de Alvarado (fl. 1530–1543)
Sir Francis Nicholson (1655–1728)
Jean Nicolet (1598–1642)
Hezekiah Niles (1777–1839)
Ninigret (fl. 1650)
Philip Nolan (1771–1801)
Timothy O'Sullivan (1840–1882)
Francis Daniel Pastarius (1651–1720)
Sam Patch (c. 1807–1829)
Molly Pitcher [Mary McCauley] (c. 1754–1832)
Pontiac (d. 1769)
Rufus Porter (1792–1884)
Powhatan (c. 1550–1618)
William Prescott (1726–1795)
John Francis Eugene Prud'homme (1800–1892)
Pierre Esprit Radisson (1636–c. 1710)
Alexander Hay Ritchie (1822–1895)
William Rittenhouse (1644–1708)

Caesar Rodney (1728–1784)
John Rolfe (1585–1622)
Betsy Ross (1752–1836)
Sacagawea (c. 1787–1812)
Haym Salomon (c. 1740–1785)
Adam Seybert (1773–1825)
James Sharples, Sr. (1752–1811)
Daniel Shays (c. 1747–1825)
Jedediah Strong Smith (1798–1831)
Squanto (d. 1622)
Solomon Stoddard (1643–1729)
William Lewis Sublette (c. 1799–1845)
Henry Schenck Tanner (1786–1858)
Edward Taylor (c. 1645–1729)
David Thompson (1770–1857)
Henry de Tonty (1650–1704)

Nathaniel Beverly Tucker (1784–1851)
Nat Turner (1800–1831)
Jean Baptiste Bissot, Sieur de Vincennes (1668–1719)
François Marie Bissot, Sieur de Vincennes (1700–1736)
Nathaniel Ward (c. 1578–1652)
William Charles Wells (1757–1817)
John White (fl. 1585–1593)
Marcus Whitman (1802–1847)
Narcissa Prentiss Whitman (d. 1847)
Michael Wigglesworth (1631–1705)
Roger Williams (c. 1603–1683)
John Wise (1652–1725)
Caspar Wistar (1696–1752)
Jethro Wood (1774–1834)
Patience Lovell Wright (1725–1786)
John Peter Zenger (1697–1746)

SOURCES OF PICTURES

The editors are grateful to the following organizations and individuals for their generous assistance in supplying many of the portraits used in this book.

A & P Food Stores. New York, New York.

Miss Elizabeth Sergeant Abbot. Chestnut Hill, Pennsylvania.

Abraham & Straus. Brooklyn, New York.

Acacia Mutual Life Insurance Company. Washington, D.C.

Adams National Historic Site. Quincy, Massachusetts.

Aeolian Corporation. East Rochester, New York.

Malcolm D. Aitken. Mountain View, California.

Alabama State Chamber of Commerce. Montgomery, Alabama.

Alaska Historical Library and Museum. Juneau, Alaska.

Alexandria-Washington Masonic Lodge No. 22. Alexandria, Virginia.

B. Altman & Company. New York, New York.

Amateur Athletic Union of the United States. New York, New York.

American Academy of Arts and Letters. New York, New York.

American Antiquarian Society. Worcester, Massachusetts.

American Baptist Historical Society. Rochester, New York.

American Forests. Washington, D.C.

American Foundation for the Blind, Inc. New York, New York.

American Institute of Architects. Washington, D.C.

American Iron and Steel Institute. New York, New York.

American Museum of Natural History. New York, New York.

American Osteopathic Association. Chicago, Illinois.

American Philosophical Society. Philadelphia, Pennsylvania.

American Telephone and Telegraph Company. New York, New York.

American Tobacco Company. New York, New York.

Amherst College. Amherst, Massachusetts.

Andover-Newton Theological School. Newton Centre, Massachusetts.

Antioch College. Yellow Springs, Ohio.

Arkansas History Commission. Little Rock, Arkansas.

Mrs. Mabel H. Assheton. New York, New York.

Augustana College. Rock Island, Illinois.

Automobile Manufacturers Association, Inc. Detroit, Michigan.

Babcock & Wilcox Company. New York, New York.

Oliver Baker Associates. New York, New York.

Barnum Museum. Loan Collection of Elizabeth Sterling Seeley. Bridgeport, Connecticut.

Percival P. Baxter. Portland, Maine.

Stanley O. Bezanson. Needham, Massachusetts.

Mrs. Millicent Todd Bingham. Washington, D.C.

Professor George W. Bishop, Jr. Knoxville, Tennessee.

Miss Julia Bloomfield. San Francisco, California.

Bloomingdale Properties. New York, New York.

The Borden Company. New York, New York.

Boston Athenæum. Boston, Massachusetts.

Boston Public Library. Boston, Massachusetts.

Boston Symphony Orchestra. Boston, Massachusetts.

Boston University Archives. Boston, Massachusetts.

Bowdoin College. Brunswick, Maine.

Bowdoin College Museum of Art. Brunswick, Maine.

R. R. Bowker Company. New York, New York.

George P. Brett, Jr. Southport, Connecticut.

British Museum. London, England.

Brooklyn Museum. Brooklyn, New York.

Brown University. Providence, Rhode Island.

Browning Arms Company. Ogden, Utah.

Bryn Mawr College. Bryn Mawr, Pennsylvania.

Buffalo and Erie County Historical Society. Buffalo, New York.

Thomas Bulfinch. Weston, Massachusetts.

Mrs. Dorothy Burgess. Dover, Massachusetts.

George Burke Public Relations. New York, New York.

Burndy Library. Norwalk, Connecticut.

The Butterick Company, Inc. New York, New York.

Mrs. Harriet Ropes Cabot. Boston, Massachusetts.

Florian A. Cajori. Denver, Colorado.

California Academy of Sciences. San Francisco, California.

California Historical Society. San Francisco, California.

Canadian Pacific Railway. Montreal, Canada.

Carnegie Library. Pittsburgh, Pennsylvania.

The Catholic Banner. Charleston, South Carolina.

Catholic Telegraph. Cincinnati, Ohio.

Chicago, Burlington and Quincy Railroad Company. Chicago, Illinois.

Chicago Historical Society. Chicago, Illinois. Mr. Paul M. Rhymer.

Chicago Natural History Museum. Chicago, Illinois.

Chiropractic Institute of New York. New York, New York.

Milbourne Christopher Collection. New York, New York.

Church of Jesus Christ of Latter-Day Saints. Salt Lake City, Utah.

The Cleveland Museum of Art. Cleveland, Ohio.

The Cleveland Natural Science Museum. Cleveland, Ohio.

College of Physicians of Philadelphia. Philadelphia, Pennsylvania.

Colonial Williamsburg, Inc. Williamsburg, Virginia.
Columbia University. Avery Library. New York, New York.
Columbia University. College of Physicians and Surgeons. New York, New York.
Columbia University. Columbiana Collection. New York, New York.
Columbia University Library. New York, New York. Mr. Charles Mixer. Mrs. Patricia Park.
Condé-Nast Publications, Inc. New York, New York.
Confederate Museum. Richmond, Virginia.
Connecticut Agricultural Experiment Station. New Haven, Connecticut.
Connecticut Historical Society. Hartford, Connecticut.
Connecticut State Library. Hartford, Connecticut.
Cornell University. Collection of Regional History and University Archives. Ithaca, New York. Mr. John Buchanan.
Cornell University. Liberty Hyde Bailey Hortorium. New York State College of Agriculture. Ithaca, New York.
Cornell University Medical College. New York, New York.
Cornell University. New York State College of Agriculture. Ithaca, New York.
Corning Glass Works. Corning, New York.
Corps of Engineers Museum. Henry L. Abbot Collection. Fort Belvoir, Virginia
Hubert V. Coryell. Laguna Beach, California.
The Cottrell Company. Westerly, Rhode Island.
John Crerar Library. Chicago, Illinois.

Dalhousie University. Halifax, Nova Scotia, Canada.
Dartmouth College. Hanover, New Hampshire.
Daughters of the American Revolution. Vigo Chapter. Vincennes, Indiana.
Dayton Chamber of Commerce. Dayton, Ohio.
Deere and Company. Moline, Illinois.
Delaware County Historical Society. Chester, Pennsylvania.
Detroit News. Detroit, Michigan.
Detroit Public Library. Automotive History Collection. Detroit, Michigan.
Detroit Public Library. Burton Historical Collection. Detroit, Michigan.
Miss Louise H. DeWolf. Bristol, Rhode Island.
Dickinson College. Carlisle, Pennsylvania.
Doubleday and Company. New York, New York.
The Dropsie College, Philadelphia, Pennsylvania.
Drexel and Company. Philadelphia, Pennsylvania.
Duke University. Durham, North Carolina.
Philip Dunne. Beverly Hills, California.
E. I. du Pont de Nemours and Company, Inc. Wilmington, Delaware.

George Eastman House. Rochester, New York.
Emory University. Atlanta, Georgia.

William Filene's Sons Company. Boston, Massachusetts.
The Filson Club. Louisville, Kentucky.
James Kip Finch. New York, New York.
Firestone Tire and Rubber Company. Akron, Ohio.
First Church of Christ Scientist. Boston, Massachusetts.
First Congregational Church. Cambridge, Massachusetts.
First Congregational Church. Columbus, Ohio.
First Presbyterian Church. Detroit, Michigan.
James Thomas Flexner. New York, New York.
Forbes Library. Northampton, Massachusetts.
Franklin Institute. Philadelphia, Pennsylvania.
Free Library of Philadelphia. Philadelphia, Pennsylvania. Miss Dorothy Litchfield.

Freer Gallery of Art. Washington, D.C.
Frick Art Reference Library. New York, New York.

Isabella Stewart Gardner Museum. Boston, Massachusetts.
Garner Memorial Museum. Uvalde, Texas.
Woody Gelman. New York, New York.
General Electric Company. Schenectady, New York.
Geographical Society of Philadelphia. Philadelphia, Pennsylvania.
Georgetown University News Service. Washington, D.C.
Gimbel Brothers. New York, New York.
Ginn and Company. Boston, Massachusetts.
Glacier National Park. West Glacier, Montana.
Goodyear Tire and Rubber Company. Akron, Ohio.
Goucher College. Baltimore, Maryland.
Greenfield Public Library. Greenfield, Massachusetts.
Gregory's Old Master Gallery. New York, New York.
Groton School. Groton, Massachusetts.
Solomon R. Guggenheim Foundation. New York, New York.

Walter P. Hampden Memorial Library at The Players. New York, New York. Mr. Louis A. Rachow.
Harding Home and Museum. Marion, Ohio.
Albert Harkness. Providence, Rhode Island.
Harvard University Archives. Cambridge, Massachusetts. Mr. Kimball Elkins.
Harvard University Biological Laboratories. Cambridge, Massachusetts.
Harvard University Divinity School. Andover-Harvard Theological Library. Cambridge, Massachusetts.
Harvard University Graduate School of Business. Boston, Massachusetts.
Harvard University. Houghton Library. Cambridge, Massachusetts.
Harvard University. Peabody Museum. Cambridge, Massachusetts.
Harvard University Theatre Collection. Cambridge, Massachusetts.
Haverford College. Haverford, Pennsylvania.
Joseph Hawthorne. Toledo, Ohio.
William Randolph Hearst, Jr. New York, New York.
D. C. Heath & Company. Boston, Massachusetts.
William C. Henning. Cedar Rapids, Iowa.
Henry Street Settlement House. New York, New York.
Norman Herreshoff. Bristol, Rhode Island.
Miss Josephine U. Herrick. New York, New York.
Hershey Chocolate Corporation. Hershey, Pennsylvania.
Historical Society of Delaware. Wilmington, Delaware.
The Hitchcock Chair Company. Riverton, Connecticut.
Herman Hollerith, Jr. Oxford, Maryland.
Sidney Homer, Jr. New York, New York.
Johns Hopkins University. Baltimore, Maryland.
Johns Hopkins University. Welch Medical Library. Baltimore, Maryland.
Clarence P. Hornung Collection. New York, New York.
Houghton Mifflin Company. Boston, Massachusetts.
Earle P. Hubbard. Poultney, Vermont.
J. L. Hudson Company. Detroit, Michigan.
Huntley House Museum. Edinburgh, Scotland.

Illinois Central Railroad. Chicago, Illinois.
Illinois Institute of Technology. Chicago, Illinois.
Illinois State Historical Library. Springfield, Illinois.
Independence National Historical Park. Philadelphia, Pennsylvania. Mr. David H. Wallace.
Indiana Historical Society Library. Indianapolis, Indiana.

Kurt Jafay. Denver, Colorado.

Jefferson Medical College. Philadelphia, Pennsylvania.

Thomas Jefferson Memorial Foundation. Charlottesville, Virginia.

Jervis Library. Rome, New York.

Jewish Daily Forward. New York, New York.

Jewish Encyclopedic Handbooks, Inc. New York, New York.

Jewish Theological Seminary of America. New York, New York.

Roger Johnson. Hadley, Massachusetts.

Journal of General Physiology. New York, New York.

Peter A. Juley and Son. New York, New York.

Jumel Mansion. New York, New York.

Kansas City School District. Kansas City, Missouri.

Kansas City Star. Kansas City, Missouri.

Kansas State Historical Society. Topeka, Kansas.

Jefferson Randolph Kean. Washington, D.C.

Kent Free Library. Kent, Ohio.

Kenyon College Archives. Gambier, Ohio.

The Kroger Company. Cincinnati, Ohio.

Lackawanna Historical Society. Scranton, Pennsylvania.

Ladies' Hermitage Association. Hermitage, Tennessee.

Lafayette College. Easton, Pennsylvania.

Maurice du Pont Lee. Wilmington, Delaware.

Lehigh University. Bethlehem, Pennsylvania.

Libby-Owens-Ford Glass Company. Toledo, Ohio.

Library of Congress. Washington, D.C. Mr. Milton Kaplan. Mr. Carl Stange. Miss Virginia Daiker.

Lick Observatory. Mount Hamilton, California.

Eli Lilly and Company. Indianapolis, Indiana.

Litchfield County Historical Society. Litchfield, Connecticut.

Little, Brown and Company. Boston, Massachusetts.

Ralph Lowell. Boston, Massachusetts.

Robert Lowell. New York, New York.

Lowell Observatory. Flagstaff, Arizona.

Mrs. Margaret Dole McCall. Bronx, New York.

McLoughlin House National Historic Site. Oregon City, Oregon.

McMaster University. Hamilton, Ontario, Canada. Professor Gunhard-Æstius Oravas.

Madison Square Garden. New York, New York.

Maryland Historical Society. Baltimore, Maryland.

Massachusetts General Hospital. Boston, Massachusetts.

Massachusetts Institute of Technology. Cambridge, Massachusetts.

Mrs. Marjorie Post May. Washington, D.C.

Mayo Clinic. Rochester, Minnesota.

Medical College of Georgia. Augusta, Georgia.

Donald H. Menzel. Cambridge, Massachusetts.

Mercaldo Archives. Richmond Hill, New York.

G. & C. Merriam Company. Springfield, Massachusetts.

Meserve Collection. Morristown, New Jersey. Mrs. Dorothy Kuhnhardt.

Methodist Church. Board of Missions. New York, New York.

Methodist Historical Society. Boston, Massachusetts.

Metropolitan Museum of Art. New York, New York. Mr. A. Hyatt Mayor.

Fred Meyer. Escanaba, Michigan.

Michigan State University. East Lansing, Michigan.

Middlebury College. Middlebury, Vermont.

Modern Language Association of America. New York, New York.

Montana State College. Bozeman, Montana.

Moravian College. Harvey Memorial Library. Bethlehem, Pennsylvania.

Mount St. Vincent-on-Hudson. Bronx, New York.

Museum of the City of New York. New York, New York. Mr. Sam Pearce.

Muséum National d'Histoire Naturelle. Paris, France.

Naismith Memorial Basketball Hall of Fame, Inc. Springfield, Massachusetts.

National Archives. Brady Collection. Washington, D.C.

National Baseball Hall of Fame and Museum. Cooperstown, New York. Mr. Sid C. Keener.

National Cash Register Company. Dayton, Ohio.

National Gallery of Art. Washington, D.C.

National Golf Links of America. Southampton, New York.

National Grange. Washington, D.C.

National Library of Medicine. Washington, D.C.

Newark Public Library. Newark, New Jersey.

Newberry Library. Chicago, Illinois.

New Brunswick Museum. Webster Collection. New Brunswick, Canada.

New England Conservatory of Music. Boston, Massachusetts.

Newhall-Saugas Chamber of Commerce. Newhall, California.

New Hampshire Historical Society. Concord, New Hampshire.

New Harmony Workingmen's Institute. New Harmony, Indiana.

New Jersey Historical Society. Newark, New Jersey.

New York Academy of Medicine. New York, New York.

New York Botanical Garden. Bronx, New York. Mr. H. W. Rickett.

New York City Department of Health, New York, New York.

New-York Historical Society. New York, New York.

New York Journal-American. New York, New York.

New York Public Library. New York, New York. Miss Romana Javitz.

New York State Library. Albany, New York.

New York State Museum and Science Service. Albany, New York.

New York University. New York, New York.

New York University Medical Center. New York, New York.

New York Zoological Park. Bronx, New York.

John A. Nietz. Pittsburgh, Pennsylvania.

North Carolina State Department of Archives and History. Raleigh, North Carolina.

Northwestern University. Evanston, Illinois.

Oakland Municipal Art Museum. Oakland, California.

Oberlin College. Oberlin, Ohio.

Miss Dorothy Ochtman. Greenwich, Connecticut.

Ohio Historical Society Library. Columbus, Ohio.

Ohio State University. Columbus, Ohio.

Ohio University. Athens, Ohio.

Ohio Wesleyan University. Delaware, Ohio.

Miss Georgia O'Keeffe. Abiqulu, New Mexico.

Old South Church. Boston, Massachusetts.

Oneida Limited. Oneida, New York.

Oregon Historical Society. Portland, Oregon.

Mrs. Celeste Phelps Osgood. Onset, Massachusetts.

Pach Brothers. New York, New York.

Paterson Museum. Paterson, New Jersey.

Paulist Communications. New York, New York.

Pennsylvania Academy of the Fine Arts. Philadelphia, Pennsylvania.

Pennsylvania Historical and Museum Commission. Harrisburg, Pennsylvania.

Pennsylvania State University. University Park, Pennsylvania.

Philadelphia College of Pharmacy and Science. Philadelphia, Pennsylvania.

Phillips Exeter Academy. Exeter, New Hampshire.

Pillsbury Company. Minneapolis, Minnesota.

The Lydia E. Pinkham Medicine Company. Lynn, Massachusetts.

Enoch Pratt Free Library. Baltimore, Maryland.

Pratt Institute. Brooklyn, New York.

Pratt & Whitney Company, Inc. West Hartford, Connecticut.

Presbyterian Historical Society. Philadelphia, Pennsylvania.

Princeton Theological Seminary. Princeton, New Jersey.

Princeton University Archives. Princeton, New Jersey. Mr. M. Halsey Thomas.

Princeton University Library. Princeton, New Jersey. Mr. Alfred L. Bush.

Proctor and Gamble Company. Cincinnati, Ohio.

Purdue University. Lafayette, Indiana.

Radcliffe College. Cambridge, Massachusetts.

Rand McNally & Company. Skokie, Illinois.

Remington Arms Company. Ilion, New York.

Remington Rand Corporation. New York, New York.

The Ring. New York, New York.

John and Mabel Ringling Museum. Sarasota, Florida.

Rockefeller Institute. New York, New York.

John A. Roebling's Sons Corporation. Trenton, New Jersey.

Franklin D. Roosevelt Library. Hyde Park, New York.

Nicholas G. Roosevelt. Philadelphia, Pennsylvania.

Theodore Roosevelt Association. New York, New York.

Rutgers University. New Brunswick, New Jersey.

St. Louis County Historical Society. Duluth, Minnesota.

Sandwich Historical Society. Sandwich, Massachusetts.

Santa Rosa Chamber of Commerce. Santa Rosa, California.

John Nevin Sayre. Nyack, New York.

Eric Schaal. New York, New York.

S. M. Schonbrunn. Washington, D.C.

G. Schirmer, Inc. New York, New York.

Scripps-Howard Newspapers. New York, New York.

Sears, Roebuck and Company. Chicago, Illinois.

Mrs. Henry B. Selden. New London, Connecticut.

Mrs. Ernest Thompson Seton. Santa Fe, New Mexico.

General Conference of Seventh Day Adventists. Washington, D.C.

Sierra Club. San Francisco, California.

Singer Manufacturing Company. New York, New York.

Smith and Wesson. Springfield, Massachusetts.

Smith Brothers Cough Drops. New York, New York.

Smith College Archives. Northampton, Massachusetts.

Smithsonian Institution. Washington, D.C. Mr. Robert Vogel.

Smithsonian Institution. Bureau of American Ethnology. Washington, D.C.

South Carolina Historical Society. Charleston, South Carolina.

Southwest Museum. Los Angeles, California.

Sperry Rand Corporation. New York, New York.

Springfield Republican. Springfield, Massachusetts.

Squibb Division of Olin Mathieson Chemical Corporation. New York, New York.

Standard Brands, Inc. New York, New York.

Stanford University Libraries. Stanford, California.

State Historical Society of Colorado. Denver, Colorado.

State Historical Society of Wisconsin. Madison, Wisconsin.

Francis Steegmuller. New York, New York.

Steeplechase Amusement Park. Brooklyn, New York.

Steinman, Cain and White. New York, New York.

Stevens Institute of Technology. Hoboken, New Jersey.

Stratford Historical Society. Stratford, Connecticut.

Levi Strauss & Company. San Francisco, California.

Studebaker Corporation. South Bend, Indiana.

Swift and Company. Chicago, Illinois.

Tamiment Institute Library. New York, New York.

Miss Lea Taylor. Highland Park, Illinois.

Temple Israel. Boston, Massachusetts.

Temple University Medical Center. Philadelphia, Pennsylvania.

Tennessee Conservation Department. Nashville, Tennessee.

Texas State Library. Austin, Texas.

Theosophical Society. Wheaton, Illinois.

Theosophical Society. Adyar, Madras, India.

Theosophical University Press. Pasadena, California.

Seth Thomas Clock Company. Thomaston, Connecticut.

Tiffany and Company. New York, New York.

Times-Picayune Publishing Corporation. New Orleans, Louisiana.

Timken Roller Bearing Company. Canton, Ohio.

Harry S. Truman Library. Independence, Missouri.

Tufts University. Medford, Massachusetts.

Tulane University. New Orleans, Louisiana.

Tuskegee Institute. Tuskegee, Alabama.

Underwood Corporation. New York, New York.

Union Carbide Plastics Company. Union Carbide Corporation. New York, New York.

Union College. Schaffer Library. Schenectady, New York.

United Lodge of Theosophists. New York, New York.

United States Armed Forces Institute of Pathology. Washington, D.C.

United States Department of Agriculture. Washington, D.C.

United States Department of Defense. Washington, D.C.

United States Department of Labor. Washington, D.C.

United States Department of the Navy. Washington, D.C.

United States Department of State. Washington, D.C.

United States Department of the Treasury. Washington, D.C.

United States Geological Survey. Denver, Colorado.

United States Golf Association. New York, New York.

United States Military Academy. West Point, New York.

University of California. Berkeley, California.

University of Chicago. Chicago, Illinois. Mr. Frank G. Burke.

University of Cincinnati. Cincinnati, Ohio.

University of Glasgow. Glasgow, Scotland.

University of Kansas Medical Center. Kansas City, Kansas.

University of Kentucky. Lexington, Kentucky.

University of Massachusetts. Amherst, Massachusetts.

University of Michigan. Ann Arbor, Michigan.

University of Michigan. Michigan Historical Collections. Ann Arbor, Michigan.

University of Minnesota. Minneapolis, Minnesota.

University of Missouri. Columbia, Missouri.

University of North Carolina. Chapel Hill, North Carolina.

University of Pennsylvania. Philadelphia, Pennsylvania.

University of Pennsylvania Medical College. Philadelphia, Pennsylvania.

University of Rochester. Rochester, New York.
University of the South. Sewanee, Tennessee.
University of South Carolina. South Caroliniana Library. Columbia, South Carolina.
University of Texas Library. Austin, Texas.
University of Vermont. Burlington, Vermont.
University of Wisconsin. Madison, Wisconsin.
University of Wisconsin. College of Agriculture. Madison, Wisconsin.
University of Wyoming. Laramie, Wyoming.
Utah State Historical Society. Salt Lake City, Utah.

Vanderbilt University. Nashville, Tennessee.
Vassar College. Poughkeepsie, New York.
Henry R. Viets, M.D. Boston, Massachusetts.
Virginia Historical Society. Richmond, Virginia.
Virginia Military Institute. Lexington, Virginia.
Virginia Museum of Fine Arts. Richmond, Virginia.
Virginia State Library. Richmond, Virginia.

Benjamin H. Walker. New York, New York.
Henry A. Wallace. South Salem, New York.
James W. Wallace. Des Moines, Iowa.
The Warner and Swasey Company. Cleveland, Ohio.
Washington and Lee University. Lexington, Virginia.
Washington State Historical Society. Tacoma, Washington.
Washington University. St. Louis, Missouri.
Watchtower Bible and Tract Society. Brooklyn, New York.
George F. Weber. Gainesville, Florida.

Wellesley College. Wellesley, Massachusetts.
Wells College. Aurora, New York.
Wells Fargo Bank. San Francisco, California.
West Virginia Department of Archives and History. Charleston, West Virginia.
Western Reserve Historical Society. Cleveland, Ohio.
Western Reserve University. Cleveland, Ohio.
Weyerhaeuser Company. Tacoma, Washington.
Mrs. Erwin S. Whatley. Montrose, Alabama.
Dr. Maynard C. Wheeler. New York, New York.
The White House. Washington, D.C.
The White House Collection. Washington, D.C.
College of William and Mary. Williamsburg, Virginia.
Wilmington Public Library. Wilmington, North Carolina.
H. W. Wilson Company. New York, New York.
The Henry Francis du Pont Winterthur Museum. Winterthur, Delaware.
Professor Harvey Wish. Cleveland, Ohio.
Wittenberg College. Springfield, Ohio.
Worcester Historical Society. Worcester, Massachusetts.
Quincy Wright. Charlottesville, Virginia.
William Wrigley Jr. Company. Chicago, Illinois.
Wyoming Historical and Geological Society. Wilkes-Barre, Pennsylvania.

Yale and Towne, Inc., a subsidary of Eaton Manufacturing Co., New York, New York.
Yale University. New Haven, Connecticut. Mr. Robert E. Daggy.
Yale University Art Gallery. New Haven, Connecticut.

BIBLIOGRAPHY

The following bibliography provides a selective list of those published sources of American portraits that were most useful in compiling the present volume. Works concerned with city and county history have generally not been included, the list being restricted to books, periodicals, etc., of national import containing considerable numbers of American portraits worth reproducing.

American Encyclopædia of Biography. Hightstown, New Jersey, Metropolitan Publishing and Engraving Co., 1893.

America's Greatest Men and Women. St. Louis, Vandawalker and Co., 1894.

Annals of Iowa. Iowa City, State Historical Society, 1863 to present.

Appleton's Annual Cyclopædia. 20 vols. New York, D. Appleton and Co., 1876–1895.

Appleton's Cyclopedia of American Biography, ed. by James Grant Wilson and John Fiske. 6 vols. New York, D. Appleton and Co., 1887–1889. Revised edition with supplement. New York, D. Appleton and Co., 1898–1900.

The Arena. Boston, Arena Publishing Co., 1889–1909.

Ballou's Pictorial Drawing Room Companion. Boston, F. Gleason, 1851–1859.

Bayley, Frank William, *Five Colonial Artists of New England.* Boston, privately printed, 1929.

Bigelow, Samuel F., and Hagar, George J., eds., *The Biographical Cyclopedia of New Jersey.* New York, National Americana Society, c. 1910.

Biographical and Historical Memoirs of Mississippi. 2 vols. Chicago, The Goodspeed Publishing Co., 1891.

The Biographical Cyclopædia and Portrait Gallery, with an Historical Sketch, of the State of Ohio. 6 vols. Cincinnati, Western Biographical Publishing Co., 1883–1895.

The Biographical Cyclopedia of Representative Men of Maryland and the District of Columbia. Baltimore, National Biographical Publishing Co., 1879.

The Biographical Cyclopedia of Representative Men of Rhode Island. Providence, National Biographical Publishing Co., 1881.

The Biographical Dictionary and Portrait Gallery of Representative Men of Chicago, St. Louis and the World's Columbian Exposition. Chicago and New York, American Biographical Publishing Co., 1893.

Biographical Encyclopædia of Connecticut and Rhode Island of the Nineteenth Century. New York, Metropolitan Publishing and Engraving Co., 1881.

Biographical Encyclopædia of Illinois of the Nineteenth Century. Philadelphia, Galaxy Publishing Co., 1875.

The Biographical Encyclopædia of Kentucky. Cincinnati, J. M. Armstrong and Co., 1878.

Biographical Encyclopædia of Maine of the Nineteenth Century. Boston, Metropolitan Publishing and Engraving Co., 1885.

Biographical Encyclopædia of Massachusetts of the Nineteenth Century. New York, Metropolitan Publishing and Engraving Co., 1879.

The Biographical Encyclopædia of Ohio of the Nineteenth Century. Cincinnati and Philadelphia, Galaxy Publishing Co., 1876.

The Biographical Encyclopædia of Pennsylvania of the Nineteenth Century. Philadelphia, Galaxy Publishing Co., 1874.

A Biographical History of Eminent and Self-Made Men of the State of Indiana. Cincinnati, Western Biographical Publishing Co., 1880.

A Biographical History, With Portraits, of Prominent Men of the Great West. Chicago, Manhattan Publishing Co., 1894.

The Book Buyer. New York, Charles Scribner's Sons, 1867–1915.

The Bookman. New York, Dodd, Mead and Co., 1895–1933.

Bowen, C. W., *History of the Centennial Celebration of the Inauguration of George Washington.* New York, D. Appleton and Co., 1892.

Bramhall, Frank J., *The Military Souvenir: A Portrait Gallery of Our Military and Naval Heroes.* New York, J. C. Buttre, 1863.

Bugbee, James M., ed., *Memorials of the Massachusetts Society of the Cincinnati.* Boston, Society of the Cincinnati, 1890.

Buttre, Lillian C., *The American Portrait Gallery.* 3 vols. New York, J. C. Buttre, 1877.

Carson, Hampton L., *The Supreme Court of the United States.* Philadelphia, J. Y. Huber Co., 1891.

Century Magazine. New York, The Century Co., 1881–1930. See also *Scribner's Monthly.*

Chamberlain, J. L., ed. *Universities and Their Sons.* 5 vols. Boston, R. Herndon Co., 1898–1900.

Clews, Henry, *Twenty-eight Years in Wall Street.* New York, Irving Publishing Co., 1887.

Crafts, Wilbur F., *Successful Men of Today.* New York, Funk and Wagnalls Co., 1894.

The Critic. New York, The Critic Printing and Publishing Co., 1881–1906.

Davis, William T., ed., *The New England States.* 4 vols. Boston, D. H. Hurd and Co., c. 1897.

Demorest's Magazine Portrait Album. New York, Demorest's Family Magazine, n.d.

Depew, Chauncey M., ed., *One Hundred Years of American Commerce.* 2 vols. New York, D. O. Haynes and Co., 1895.

Dunlap, William, *A History of the Rise and Progress of the Arts of Design in the United States*, ed. by Frank W. Bayley and Charles E. Goodspeed. 3 vols. Boston, C. E. Goodspeed and Co., 1918.

Dunning, Albert E., *Congregationalists in America*. Boston and Chicago, The Pilgrim Press, 1894.

Duyckinck, Evart A., *National Portrait Gallery of Eminent Americans*. 2 vols. New York, Johnson, Fry and Co., 1861–1862.

Duyckinck, Evart A. and George L., *Cyclopedia of American Literature*. 2 vols. Philadelphia, Rutter & Co., 1877.

The Eclectic Magazine of Foreign Literature, Science and Art. New York, 1844–1907.

Eminent Women of the Age. Hartford, Connecticut, S. M. Betts and Co., 1868.

Essex Antiquarian. Salem, Massachusetts, Essex Institute, 1897–1909.

Essex Institute Historical Collections. Salem, Massachusetts, published for the Essex Institute, 1859 to present.

Fairman, Charles E., *Art and Artists of the Capitol of the United States*. Washington, D.C., U.S. Government Printing Office, 1927.

Farmer, Lydia Hoyt, *What America Owes to Women*. Buffalo, Chicago, and New York, Charles Wells Moulton, 1893.

First Citizens of the Republic. New York, L. R. Hamersly and Co., 1906.

Fiske, John, *How the United States Became a Nation*. Boston, Ginn and Co., 1904.

French, H. W., *Pioneers of Art in America: Art and Artists in Connecticut*. Boston, Lee and Shepard, New York, C. T. Dillingham, 1879.

Gallery of Players from the Illustrated American. New York, The Illustrated American Publishing Co., 1894.

Garrison, Wendell P., and Jackson, F., *William Lloyd Garrison*. 4 vols. New York, Century Co., 1885–1889.

Gleason's Pictorial Drawing Room Companion. See *Ballou's Pictorial Drawing Room Companion*.

Greeley, Horace, *The American Conflict*. 2 vols. Hartford, Connecticut, O. D. Case and Co., 1864.

The Green Bag. Boston, The Boston Book Co., 1889–1914.

Hall, Henry, ed., *America's Successful Men of Affairs*. 2 vols. New York, The New York Tribune, 1895–1896.

Hamersly, L. R., *Biographical Sketches of Distinguished Officers of the Army and Navy*. New York, L. R. Hamersly, 1905.

Hanaford, Phebe A., *Daughters of America; or, Women of the Century*. Augusta, Maine, True and Co., n.d.

Harper's Magazine. [*Harper's New Monthly Magazine.*] New York, Harper and Brothers, 1850 to present.

Harper's Weekly. New York, Harper and Brothers, 1857–1916.

Harrison, Mitchell C., ed., *Prominent and Progressive Americans*. 2 vols. New York, The New York Tribune, 1902–1904.

Harvard Graduates' Magazine. Boston, The Harvard Graduates' Magazine Association, 1892–1934.

Herringshaw, Thomas W., *The Biographical Review of Prominent Men and Women of the Day*. Philadelphia and Chicago, Elliott and Beezley, 1889.

Herringshaw's Encyclopedia of American Biography of the Nineteenth Century, ed. by Thomas William Herringshaw. Chicago, American Publishers' Association, 1901.

Holloway, Laura C., *Famous American Fortunes and the Men Who Made Them*. Philadelphia, Garretson and Co., 1883.

Holloway, Laura C., *The Ladies of the White House; or, In the Home of the Presidents*. Vol. 1. Philadelphia, Bradley and Co., 1882. Vol. 2. New York, Funk and Wagnalls, 1886.

Hunt, Freeman, *Lives of American Merchants*. New York, Derby and Jackson, 1858.

Hutton, Laurence, *Curiosities of the American Stage*. New York, Harper and Brothers, 1891.

The Illustrated American. New York, The Illustrated American Publishing Co., 1890–1899.

The Illustrated London News. London, George C. Leighton, 1870 to present.

Illustrious Americans. Philadelphia and Chicago, International Publishing Co., c. 1896.

Jones, A. D., *The Illustrated American Biography*. 3 vols. New York, J. Milton Emerson and Co., 1853–1855.

King, Moses, ed., *King's Views of the New York Stock Exchange*. New York, Moses King, 1897.

King, Moses, ed., *Notable New Yorkers of 1896–1899*. New York, Moses King, 1899.

King, Moses, ed., *Philadelphia and Notable Philadelphians*. New York, Moses King, 1902.

The Knickerbocker Gallery: A Testimonial to the Editor of the Knickerbocker Magazine from its Contributors. New York, Samuel Hueston, 1855.

Lamb's Biographical Dictionary of the United States, ed. by John Howard Brown. 7 vols. Vol. 1. Boston, Cyclopædia Publishing Co., 1897. Vols. 2–4. Boston, James H. Lamb Co., 1900–1901. Vols. 5–7. Boston, Federal Book Co. of Boston, 1903.

Leonard, John William, *History of the City of New York, 1609–1909*. New York, The Journal of Commerce and Commercial Bulletin, 1910.

Frank Leslie's Illustrated Newspaper. [*Leslie's Illustrated Weekly.*] New York, Frank Leslie's Publishing House, 1855–1922.

Lester, Charles Edward, *Artists of America*. New York, Baker and Scribner, 1846.

Lewis, William Draper, ed., *Great American Lawyers*. 8 vols. Philadelphia, The John C. Winston Co., 1907–1908.

Livingston, John, *Portraits of Eminent Americans Now Living*. New York, John Livingston, 1854.

Longacre, James B., and Herring, James, *The National Portrait Gallery of Distinguished Americans*. 4 vols. Philadelphia, Henry Perkins, 1835–1839.

Lossing, Benson John, *Biographical Sketches of the Signers of the Declaration of Independence*. New York, George F. Cooledge and Brother, 1848.

——, *Harper's Popular Cyclopædia of United States History*. 2 vols. New York and London, Harper and Brothers, 1898.

——, *Pictorial History of the Civil War in the United States of America*. 2 vols. Hartford, Connecticut, T. Belknap, 1866.

McCabe, James D., *Great Fortunes, and How They Were Made*. Cincinnati and Chicago, E. Hannaford and Co., 1870.

McClure's Magazine. New York and London, S. S. McClure, Ltd., 1893–1929.

McNeill, George E., ed., *The Labor Movement: The Problem of Today*. Boston, A. M. Bridgman and Co., 1887.

Magazine of American History. New York, Historical Publication Co., 1877–1893.

Maine Historical and Genealogical Recorder. 9 vols. Portland, Maine, S. M. Watson [etc.], 1884–1898.

Maine Historical Society. Collections. Portland, Maine, The Society, 1831–1906.

Massachusetts Historical Society. Proceedings. Boston, The Society, 1791 to present.

Men of Affairs in New York. New York, L. R. Hamersly, 1906.

Mitchell, Donald Grant, *American Lands and Letters.* 2 vols. New York, Charles Scribner's Sons, 1897–1899.

Morris, Charles, ed., *Men of the Century.* Philadelphia, L. R. Hamersly and Co., 1896.

Munsey's Magazine. New York, Frank A. Munsey, 1889–1929.

National Academy of Science. Biographical Memoirs. Washington, D.C., 1877 to present.

The National Cyclopædia of American Biography. New York, James T. White and Co., 1891– .

The New England Historical and Genealogical Register. Boston, S. G. Drake [etc.], 1847 to present.

New England Magazine. Boston, J. N. McClintock and Co., 1884–1917.

New York Genealogical and Biographical Record. New York, The New York Genealogical and Biographical Society, 1870 to present.

Osborn, N. G., ed., *Men of Mark in Connecticut.* Hartford, Connecticut, William R. Goodspeed, 1906.

Our Famous Women. Hartford, Connecticut, A. D. Worthington and Co., 1894.

The Outlook. New York, J. B. Ford and Co., 1870–1893. New York, The Outlook Co., 1893–1935.

Park, Lawrence, *Gilbert Stuart.* 4 vols. New York, W. E. Rudge, 1926. (Dover Publications, Inc., 1967.)

Parton, James, *et al., Eminent Women of the Age.* Hartford, Connecticut, S. M. Betts and Co., 1868.

Patten, William, ed., *The Book of Sport.* New York, J. F. Taylor and Co., 1901.

Paul, Howard, and Gebbie, George, *The Stage and Its Stars, Past and Present.* 2 vols. Philadelphia, Gebbie and Co., 1887.

Pennsylvania Magazine of History and Biography. Philadelphia, The Historical Society of Pennsylvania, 1877 to present.

Perry, William Stevens, *Episcopate in America.* New York, Christian Literature Company, 1895.

Phelps, Alonzo, *Contemporary Biography of California's Representative Men.* San Francisco, A. L. Bancroft and Co., 1882.

Popular Science Monthly. New York, D. Appleton and Co., 1872 to present.

Representative Men of Connecticut, 1861–1894. Everett, Massachusetts, Massachusetts Publishing Co., 1894.

Representative Men of Massachusetts, 1890–1900. Everett, Massachusetts, Massachusetts Publishing Co., 1898.

Review of Reviews. New York, The Review of Reviews Corporation, 1890–1937.

Saint-Mémin, Charles B. J. F. de, *The St.-Mémin Collection of Portraits.* New York, E. Dexter, 1862.

Sanderson, John, ed., *Biographies of Signers of the Declaration of Independence.* 9 vols. Philadelphia, R. W. Pomeroy, 1823–1827.

Scharf, J. Thomas, and Westcott, Thompson, *History of Philadelphia, 1609–1884.* 3 vols. Philadelphia, L. H. Everts and Co., 1884.

Scribner's Magazine. New York, Charles Scribner's Sons, 1887–1939.

Scribner's Monthly. New York, Scribner and Company, 1871–1881. Continued as *Century Magazine.*

Seilhamer, George O., *Leslie's History of the Republican Party.* Vol. 1. New York, L. A. Williams Publishing and Engraving Co., n.d. Vol. 2. New York, The Judge Publishing Co., n.d.

Shea, John D. G., *The Story of A Great Nation; or, Our Country's Achievements.* New York, New York Publishing and Manufacturing Co., 1886.

Sketches of Men of Mark. New York, New York and Hartford Publishing Co., *c.* 1871.

Sketches of Successful New Hampshire Men. Manchester, New Hampshire, John B. Clarke, 1882.

Souvenir Programme of the Actors' Fund Fair, Madison Square Garden, May 2–7, 1892. New York, J. W. Pratt and Son, 1892.

Stedman, Edmund Clarence, and Hutchinson, Ellen Mackay, *A Library of American Literature from the Earliest Settlement to the Present Time.* New edition. 11 vols. New York, William Evarts Benjamin, 1894.

Stiles, Henry R., ed., *The Civil, Political, Professional and Ecclesiastical History and Commercial and Industrial Record of the County of Kings and the City of Brooklyn, New York, from 1683–1884.* 2 vols. New York, W. W. Munsell and Co., 1884.

Thacher, James, *American Medical Biography.* 2 vols. in 1. Boston, Richardson and Lord, 1828.

The United States Biographical Dictionary. Kansas Volume. Chicago and Kansas City, S. Lewis and Co., 1879.

The United States Biographical Dictionary and Portrait Gallery of Eminent and Self-made Men. Illinois Volume. Chicago, Cincinnati, and New York, American Biographical Publishing Co., 1876.

The United States Biographical Dictionary and Portrait Gallery of Eminent and Self-made Men. Iowa Volume. Chicago and New York, American Biographical Publishing Co., 1878.

The United States Biographical Dictionary and Portrait Gallery of Eminent and Self-made Men. Minnesota Volume. New York and Chicago, American Biographical Publishing Co., 1879.

The United States Biographical Dictionary and Portrait Gallery of Eminent and Self-made Men. Missouri Volume. New York, Chicago, St. Louis, and Kansas City, United States Biographical Publishing Co., 1878.

The United States Biographical Dictionary and Portrait Gallery of Eminent and Self-made Men. Wisconsin Volume. Chicago, Cincinnati, and New York, American Biographical Publishing Co., 1877.

Wallack, Lester, *Memories of Fifty Years.* New York, Charles Scribner's Sons, 1889.

Waterloo, Stanley, and Hanson, John Wesley, Jr., eds., *Our Living Leaders.* Chicago and Philadelphia, Imperial Publishing Co., 1896. Also published as *Famous American Men and Women,* Chicago, Wabash Publishing House, 1896.

Webb, Mary Griffin and Edna Lenore, eds., *Famous Living Americans.* Greencastle, Indiana, Charles Webb and Co., 1915.

Weed, Thurlow, *Life of Thurlow Weed.* 2 vols. Boston and New York, Houghton, Mifflin and Co., 1884.

Willard, Frances E., and Livermore, Mary A., *American Women.* New York, Chicago, and Springfield, Ohio, Mast, Crowell, and Kirkpatrick, 1897.

Wilson, James Grant, ed., *The Memorial History of the City of New York.* 4 vols. New York, New York History Co., 1892–1893.

Winsor, Justin, ed., *The Memorial History of Boston.* 4 vols. Boston, J. R. Osgood and Co., 1880–1881.

———, ed., *Narrative and Critical History of America.* 8 vols. Boston, Houghton, Mifflin and Co., 1889.

The World's Work. New York, Doubleday, Page and Co., 1900–1932.

Youmans, William J., ed., *Pioneers of Science in America.* New York, D. Appleton and Co., 1896.

INDEX OF VARIANT NAMES

Persons with variant names—pseudonyms, aliases or, in the case of women, maiden or married names—are listed in the portrait section under the name by which they are best known. If a person is not found in the alphabetical portrait section under a known name, the following index should be consulted for a possible variant listing.

Index of Variant Names

"Jones, Mother". *See* Jones, Mary, 344
Joseph, James. *See* Sylvester, James Joseph, 604
Judson, Edward Zane Carroll. *See* Buntline, Ned, 87

Kane, Margaret Fox. *See* Fox, Margaret, 219
Katz, Max. *See* Malini, Max, 411
Kean, Mrs. Charles. *See* Kean, Ellen Tree, 349
Kelly, "King." *See* Kelly, Michael Joseph, 353
Kemble, Frances Anne. *See* Kemble, Fanny, 354
Kerr, Orpheus C. *See* Newell, Robert Henry, 450
Kientpoos; Kintpuash. *See* Jack, Captain, 331
Killion, John Joseph. *See* Kilrain, Jake, 357
Kirtland, Samuel. *See* Kirkland, Samuel, 360
Kiskadden, Maude. *See* Adams, Maude, 5
Kiyo' Kaga. *See* Keokuk, 356
Kling, Florence. *See* Harding, Mrs. Warren G., 273
Knight, Elizabeth Gertrude. *See* Britton, Elizabeth, 77
Kochańska, Praxede Marcelline. *See* Sembrich, Marcella, 557
Koerber, Leila. *See* Dressler, Marie, 173
Kolta, Buatier de. *See* Buatier, Joseph, 85
Kooweskowe. *See* Ross, John, 532
Kortright, Eliza (Elizabeth). *See* Monroe, Mrs. James, 432

Laighton, Celia. *See* Thaxter, Celia, 614
Lajoie, Larry. *See* Lajoie, Napoleon, 365
Lalawethika. *See* Tenskwatawa, 613
Lambert, Louis. *See* Gilmore, Patrick Sarsfield, 241
La Montagne, Clara. *See* Morris, Clara, 437
L'Amy, Jean Baptiste. *See* Lamy, John Baptist, 366
Lane, Carrie. *See* Catt, Carrie Chapman, 106
Lea, Anna. *See* Merritt, Anna, 425
Lease, Mrs. Charles L. *See* Lease, Mary Elizabeth, 373
Le Breton, Emily Charlotte. *See* Langtry, Lily, 368
Lee, Alice Hathaway. *See* Roosevelt, Mrs. Theodore (1861–1884), 530
Lee, Light-Horse Harry. *See* Lee, Henry, 375
Lee, "Rooney." *See* Lee, William Henry Fitzhugh, 376
Leipziger, Nathan. *See* Leipzig, Nate, 377
Leonard, Helen Louise. *See* Russell, Lillian, 536
Lesley, J. P. *See* Lesley, Peter, 378
Leslie, Mrs. Frank. *See* Leslie, Miriam Florence, 379
Lewis, Charles Bertrand. *See* Quad, M., 507
Libby, Pauline. *See* Frederick, Pauline, 222
Lillie, Gordon William. *See* Pawnee Bill, 476
Lind-Goldschmidt, Mme Jennie. *See* Lind, Jenny, 384
Lippincott, Sara Jane. *See* Greenwood, Grace, 255
Littleton, Mark. *See* Kenney, John Pendleton, 355
Livingston, Chancellor. *See* Livingston, Robert R., 387
Livingston, Sarah Van Brugh. *See* Jay, Mrs. John, 336
Locke, David Ross. *See* Nasby, Petroleum V., 447
Locke, Frances Sargent. *See* Osgood, Frances Sargent, 462
Longworth, Mrs. Nicholas. *See* Longworth, Alice Roosevelt, 390
Lord, Mary Scott. *See* Harrison, Mrs. Benjamin (1858–1948), 279
Lothrop, Harriet. *See* Sidney, Margaret, 565

McCardle, Eliza. *See* Johnson, Mrs. Andrew, 339
McGillicuddy, Cornelius Alexander. *See* Mack, Connie, 403
Macie, James Lewis. *See* Smithson, James, 576
McIntosh, Mrs. Caroline. *See* Fillmore, Mrs. Millard (1813–1881), 206

MacKaye, James Morrison Steele. *See* MacKaye, Steele, 404
Macy, Mrs. Anne Mansfield. *See* Sullivan, Anne, 704
Madison, Mrs. James. *See* Madison, Dolly, 409
Maeder, Clara Fisher. *See* Fisher, Clara, 209
Ma-ka-tae-mish-kia-kiak. *See* Black Hawk, 57
Mann, Harriet. *See* Miller, Olive Thorne, 428
Mann, Mrs. Horace. *See* Peabody, Mary Tyler, 478
Mapes, Mary Elizabeth. *See* Dodge, Mary Mapes, 167
Markham, Charles Edward Anson. *See* Markham, Edwin, 413
Marlborough, Duchess of. *See* Vanderbilt, Consuelo, 636
"Marse Henry." *See* Watterson, Henry, 657
Masterson, William Barclay. *See* Masterson, Bat, 417
Matoaka. *See* Pocahontas, 492
Maxim, Isaac Weston, Jr. *See* Maxim, Hudson, 419
Médicis-Jodoigne, Charles Euchariste de. *See* Sajous, Charles, 541
Mendl, Elsie de Wolfe. *See* De Wolfe, Elsie, 163
Michikinikwa. *See* Little Turtle, 385
Miller, Cincinnatus Miner. *See* Miller, Joaquin, 427
Miller, Mrs. Harriet. *See* Miller, Olive Thorne, 428
Milner, Moses Embree. *See* California Joe, 97
Milton, Frances. *See* Trollope, Frances, 625
Minnewit, Peter. *See* Minuit, Peter, 429
Mitchell, Donald Grant. *See* Marvel, Ik, 415
Mitchell, Helen Porter. *See* Melba, Mme Nellie, 421
Modrzejewska, Helena. *See* Modjeska, Helena, 431
Modrzejewski, Ralph. *See* Modjeski, Ralph, 431
Moore, Carry Amelia. *See* Nation, Carry, 447
Morrison, Clara. *See* Morris, Clara, 437
Motier, Marie Joseph Paul Yves Roch Gilbert du. *See* Lafayette, Marquis de, 365
Mozee, Phoebe Anne Oakley. *See* Oakley, Annie, 457
Muggeridge, Edward James. *See* Muybridge, Eadweard, 445
Munson, Margaret Elizabeth. *See* Sangster, Margaret E., 543
Murfree, Mary Noailles. *See* Craddock, Charles Egbert, 137

Nevitte, Emma Dorothy Eliza. *See* Southworth, Mrs. E. D. E. N., 578
Nichols, Charles Arthur. *See* Nichols, Kid, 451
Northumberland, Duke of. *See* Percy, Sir Hugh, 483
Norton, Lillian. *See* Nordica, Lillian, 454
Nox, Owen. *See* Cory, Charles Barney, 134

O'Bail, John. *See* Cornplanter, 133
O'Callahan, Delia. *See* Friganza, Trixie, 224
Ogden, Anna Cora. *See* Mowatt, Anna, 442
Ohiyesa. *See* Eastman, Charles Alexander, 186
O'Neale, Peggy; O'Neill, Peggy. *See* Eaton, Margaret, 187
Opid, Helena. *See* Modjeska, Helena, 431
"Oscar of the Waldorf." *See* Tschirky, Oscar, 628
Osgood, Mabel. *See* Wright, Mabel, 690
Ossoli, Marchioness. *See* Fuller, Margaret, 226
Otis, Mercy. *See* Warren, Mercy, 653

Palmer, William Henry. *See* Heller, Robert, 290
Parker, Quanah. *See* Quanah, 507
Parton, Sarah. *See* Fern, Fanny, 203
Patterson, Elizabeth. *See* Bonaparte, Elizabeth, 64
"The Patroon." *See* Van Rensselaer, Stephen, 639
Paul, John. *See* Jones, John Paul, 344
Payne, Dorothea. *See* Madison, Dolly, 409

Index of Variant Names

"Westover, Ghost of." *See* Byrd, Evelyn, 93
Wheeler, Ella. *See* Wilcox, Ella Wheeler, 673
Whitney, Mrs. Myra. *See* Gaines, Myra, 229
Wilkins, Mary Eleanor. *See* Freeman, Mary Wilkins, 222
Williams, Egbert Austin. *See* Williams, Bert, 675
Willing, Anne. *See* Bingham, Anne Willing, 55
Willis, Sara Payson. *See* Fern, Fanny, 203
Wilson, Jack. *See* Wovoka, 688

Wilson, Mrs. Lorenzo Madison. *See* Evans, Augusta Jane, 196
Winterbotham, Ann Sophia. *See* Stephens, Ann Sophia, 587
Wixom, Emma. *See* Nevada, Emma, 449
Woodhull, Mrs. Canning. *See* Claflin, Victoria, 116
Worth, Nicholas. *See* Page, Walter Hines, 468

Young, Denton True. *See* Young, Cy, 694

Table of Contents to Index

INDEX

725

Index

744

Index